The Astrophotography Manual

A Practical and Scientific Approach to Deep Sky Imaging

2nd Edition

Chris Woodhouse

Routledge
Taylor & Francis Group

NEW YORK AND LONDON

First published 2017
by Routledge
711 3rd Avenue, New York, NY 10017

and by Routledge
2 Park Square, Milton Park, Abingdon, Oxon OX14 4RN

Routledge is an imprint of the Taylor & Francis Group, an informa business

Notices
Knowledge and best practice in this field are constantly changing. As new research and experience broaden our understanding, changes in research methods, professional practices, or medical treatment may become necessary.

Practitioners and researchers must always rely on their own experience and knowledge in evaluating and using any information, methods, compounds, or experiments described herein. In using such information or methods they should be mindful of their own safety and the safety of others, including parties for whom they have a professional responsibility.

Product or corporate names may be trademarks or registered trademarks, and are used only for identification and explanation without intent to infringe.

Library of Congress in Publication Data
A catalog record for this book has been requested.

ISBN: 978-1-138-05536-0 (pbk)
ISBN: 978-1-138-06635-9 (hbk)
ISBN: 978-1-315-15922-5 (ebk)

Typeset in Adobe Garamond Pro and Myriad Pro by Chris Woodhouse
additional book resources: *http://www.digitalastrophotography.co.uk*

Publisher's Note
This book has been prepared from camera-ready copy provided by the author.

Contents

I was once asked by a 7-year old,
"Why do you take pictures of space"?

After a moment's reflection I replied,
"Because it is difficult."

Preface to the Second Edition

An edition with further refinement, insights and to expand the hobbyist's horizons.

The last four years have been a whirlwind of activity. From a complete newbie to a credible amateur has been both challenging and huge fun. The first edition was constrained by time and economics. I'm glad to say the feedback has been extremely encouraging; the pitch of the book was just right for the aspiring amateur and intermediate astrophotographer and in particular, readers liked the cogent write-ups on PixInsight, the fact it was up to date with the latest trends and, oh, by the way, please can we have some more? Some topics and imaging challenges were left untold in the first edition and since new developments continue to flourish in astrophotography, there is now sufficient content to fill an effectively "new" book.

When I authored my original photographic book ,*Way Beyond Monochrome*, it was already 350 pages long. The second edition, with considerable new content, pushed that to over 530 pages. That took 6 years to write, which was acceptable for the mature subject of classical monochrome photography. The same cannot be said of astrophotography and I thought it was essential to reduce the project time to a few years, in order to preserve its relevance.

I only write about things I have direct experience of; so time and money do limit that to some extent. Fortunately I have owned several systems, in addition to many astronomy applications for Mac OSX, Windows and Apple iOS. As time goes by, one slowly acquires or upgrades most of your equipment. There comes a point, after several years, that the cumulative outlay becomes daunting to a newcomer. As a result I have introduced some simpler, lower-cost and mobile elements into the hardware and software systems.

In the first edition, I deliberately dedicated the early chapters to the fundamentals. These included a brief astronomy primer, software and hardware essentials and some thought-provoking content on the practical limitations set by the environment, equipment and camera performance. I have not edited these out as these are still relevant. In the second edition, however, the new content concentrates on new developments; remote control, imaging techniques and an expanded section on PixInsight image processing.

Many readers of the first edition particularly liked the practical chapters and found the processing flow diagrams very useful. You should not be disappointed; in the second edition, after the new PixInsight tutorials, there are several case studies covering new techniques, again featuring PixInsight as the principal processing application. These illustrate the unique challenges posed by a particular image, with practical details on image acquisition, processing and from using a range of equipment.

Astrophotography still has plenty of opportunity for small home-made gizmos and there are additional practical projects too in this edition to stretch the user, including software and hardware development. After some further insights into diagnostics, there is an extensive index, glossary, bibliography and supporting resources. The website adds to the book's usefulness and progression to better things:

www.digitalastrophotography.co.uk

Clear skies.
chris@digitalastrophotography.co.uk

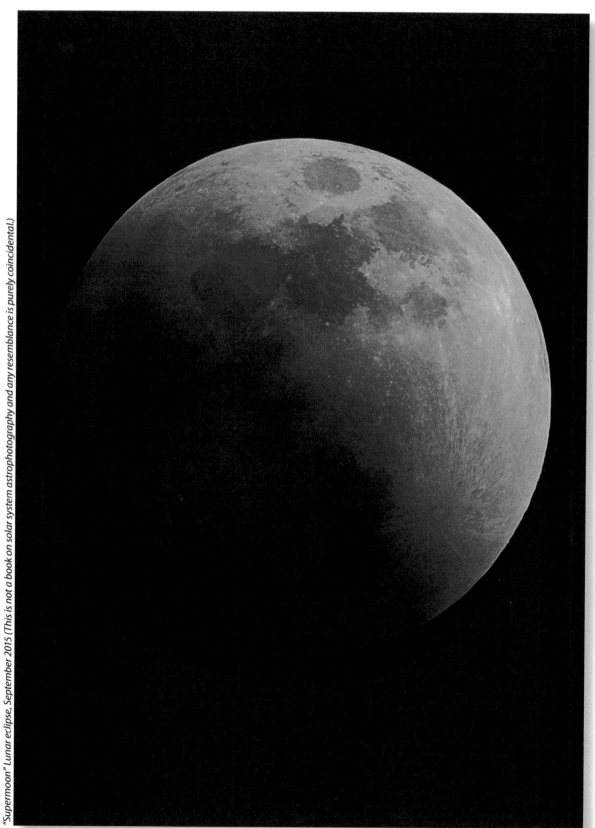

"Supermoon" Lunar eclipse, September 2015 (This is not a book on solar system astrophotography and any resemblance is purely coincidental.)

About the Author

My wife is resolved to the fact that I do not have "normal" hobbies.

Chris was born in England and from his teenage years was fascinated by the natural sciences, engineering and photography, all of which he found more interesting than football. At the weekend he could be found building or designing some gadget or other. At school he used a slide-rule and log books for his exams at 16. Two years later, scientific calculators had completely displaced them. He studied Electronics at Bath University and by the time he had completed his masters degree, the computer age was well under way and 8-bit home computers were common. After a period designing military communication and optical gauging equipment, as well as writing software in Forth, Occam, C++ and Assembler, he joined an automotive engineering company.

As a member of the Royal Photographic Society, he gained LRPS and ARPS distinctions and pursued a passion for all forms of photography, mostly using traditional monochrome techniques. Not surprisingly, this hobby, coupled with his professional experience led him to invent and patent several highly regarded f/stop darkroom meters and timers, still sold throughout the world. During that time digital cameras evolved rapidly and photo ink-jet printers slowly overcame their annoying limitations. Resisting the temptation of the early optimistic digital promises, he authored a book on traditional monochrome photography, *Way Beyond Monochrome*, to critical acclaim and followed with a second edition to satisfy the ongoing demand.

Digital monochrome appeared to be the likely next avenue for his energy, until an eye-opening presentation on astrophotography renewed a dormant interest in astronomy, enabled by the digital cameras. Astrophotography was the perfect fusion of science, electronics and photography. Like many before, his first attempts ended in frustration and disappointment, but he quickly realized the technical challenges of astrophotography responded well to a methodical and scientific approach. He found this, together with his photographic eye and decades of printing experience, was an excellent foundation to produce beautiful and fascinating images from a seemingly featureless sky. The outcome was *The Astrophotography Manual*, acclaimed by many readers as the best book on the subject in the last 15 years and he was accepted as a Fellow of the Royal Astronomical Society, founded in 1820.

Acknowledgements

This book and the intensive research that it demands would not have been possible without the ongoing support of my wife Carol (who even dug the footings for my observatory) and the wider on-line community. Special thanks go to Sam Anahory and Lawrence Dunn for contributing a guest chapter each on their respective specialty.

This edition is dedicated to Jacques Stiévenart, who piqued my interest in photography and astronomy. In the 1970s, he showed me how to silver a mirror and print a small black and white picture of the moon, taken through his home-made 6-inch Newtonian using a Zeiss Ikonta held up to the eyepiece. It was made all the more exotic since we only had a few words of each other's language. Such moments often inspire you when you are a kid.

It is one of the pleasures of this hobby to share problems and solutions with other hobbyists and this edition builds upon the knowledge and wisdom of many astrophotographers. This hobby is a never-ending journey of refinement, knowledge and development. It is a collaborative pursuit and I welcome any feedback or suggestions for this book or the next edition.

Chris Woodhouse ARPS, FRAS

Introduction

It is always humbling to consider the great achievements of the ancients,
who made their discoveries without access to today's technology.

Astronomy is such a fascinating subject that I like to think that astrophotography is more than just making pretty pictures. For my own part, I started both at the same time and I quickly realized that my knowledge of astronomy was deficient in many areas. Reading up on the subject added to my sense of awe and also made me appreciate the dedication of astronomers and their patient achievements over thousands of years. A little history and science is not amiss in such a naturally technical hobby. Incredibly, the science is anything but static; in the intervening time since the last book, not only has the general quality of amateur astrophotography improved greatly, but we have sent a probe 6.5 billion km to land on a comet traveling at 65,000 km/h and found firm evidence of water on Mars. In July 2015 the New Horizons space probe, launched before Pluto was downgraded to a minor planet, grazed past the planet 12,000 km from its surface after a 9.5 year journey of 5 billion km. (It is amazing to think that its trajectory was calculated using Newton's law of universal gravitation, published in 1687.)

From the earliest days of human consciousness, mankind has studied the night sky and placed special significance on eclipses, comets and new appearances. With only primitive methods, they quickly realized that the position of the stars, the Moon and the Sun could tell them when to plant crops, navigate and keep the passage of time. Driven by a need for astrology as well as science, their study of the heavens and the belief of an Earth-centric universe was interwoven with religious doctrine. It took the Herculean efforts of Copernicus, Galileo and Tycho, not to mention Kepler, to wrest control from the Catholic Church in Europe and define the heliocentric solar system with elliptical orbits, anomalies and detailed stellar mapping.

Astronomers in the Middle East and in South America made careful observations and, without instruments, were able to determine the solar year with incredible accuracy. The Mayans even developed a sophisticated calendar that did not require adjustment for leap years. Centuries later, the Conquistadors all but obliterated these records at a time when ironically Western Europe was struggling to align their calendars with the seasons. (Pope Gregory XIII eventually proposed the month of

Year [Circa]	Place	Astronomy Event
2700 BC	England	Stonehenge, in common with other ancient archaeological sites around the world, is clearly aligned to celestial events.
2000 BC	Egypt	First Solar and Lunar calendars
1570 BC	Babylon	First evidence of recorded periodicity of planetary motion (Jupiter) over a 21-year period.
1600 BC	Germany	Nebra sky disk, a Bronze age artifact, which has astronomical significance.
280 BC	Greece	Aristarchus suggests the Earth travels around the Sun, clearly a man before his time!
240 BC	Libya	Eratosthenes calculates the circumference of the earth astronomically.
125 BC	Greece	Hipparchus calculates length of year precisely, notes Earth's rotational wobble.
87 BC	Greece	Antikythera mechanism, a clockwork planetarium showing planetary, solar and lunar events with extraordinary precision.
150 AD	Egypt	Ptolemy publishes *Almagest*; this was the astronomer's bible for the next 1,400 years. His model is an Earth-centered universe, with planet epicycles to account for strange observed motion.
1543 AD	Poland	Copernicus, after many years of patient measurement, realizes the Earth is a planet too and moves around the Sun in a circular orbit. Each planet's speed is dependent upon its distance from the Sun.
1570 AD	Denmark	Tycho Brahe establishes a dedicated observatory and generates first accurate star catalog to 1/60th degree. Develops complicated solar-system model combining Ptolemaic and Copernican systems.
1609 AD	Germany	Kepler works with Tycho Brahe's astronomical data and develops an elliptical-path model with planet speed based on its average distance from the Sun. Designs improvement to refractor telescope using dual convex elements.
1610 AD	Italy	Galileo uses an early telescope to discover that several moons orbit Jupiter and Venus and have phases. He is put under house arrest by the Inquisition for supporting Kepler's Sun-centered system to underpin his theory on tides.

fig.1a *An abbreviated time-line of the advances in astronomy*
is shown above and is continued in fig.1b. The
achievements of the early astronomers are wholly
remarkable, especially when one considers not only
their lack of precision optical equipment but also the
most basic of requirements, an accurate timekeeper.

Year [Circa]	Place	Astronomy Event
1654 AD	Holland	Christiaan Huygens devises improved method for grinding and polishing lenses, invents the pendulum clock and the achromatic eye-piece lens.
1660 AD	Italy	Giovanni Cassini identifies 3 moons around Saturn and the gap between the rings that bear his name. He also calculates the deformation of Venus and its rotation.
1687 AD	England	Isaac Newton invents the reflector telescope, calculus and defines the laws of gravity and motion including planetary motion in *Principia*, which remained unchallenged until 1915.
1705 AD	England	Edmund Halley discovers the proper motion of stars and publishes a theoretical study of comets, which accurately predicts their periods.
1781 AD	England	William Herschel discovers Uranus and doubles the size of our solar system. Notable astronomers Flamsteed and Lemonnier had recorded it before but had not realized it was a planet. Using his 20-foot telescope, he went on to document 2,500 nebular objects.
1846 AD	Germany	Johann Galle discovers Neptune, predicted by mathematical modelling.
1850 AD	Germany	Kirchoff and Bunsell realize Fraunhofer lines identify elements in a hot body, leading to spectrographic analysis of stars.
1908 AD	U.S.A.	Edwin Hubble provides evidence that some "nebula" are made of stars and uses the term "extra-galactic nebula" or galaxies. He also realizes a galaxy's recessional velocity increases with its distance from Earth, or "Hubble's law", leading to expanding universe theories.
1916 AD	Germany	Albert Einstein publishes his *General Theory of Relativity* changing the course of modern astronomy.
1930 AD	U.S.A.	Clyde Tombaugh discovers planet Pluto. In 2006, Pluto was stripped of its title and relegated to the Kuiper belt.
1963 AD	U.S.A.	Maarten Schmidt links visible object with radio source. From spectra realizes quasars are energetic receding galactic nuclei.
1992 AD	U.S.A.	Space probes COBE and WMAP measure cosmic microwaves and determines the exact Hubble constant and predicts the universe is 13.7 billion years old.
2012 AD	U.S.A.	Mars rover *Curiosity* lands successfully and begins exploration of planet's surface.
2014 AD	ESA	*Rosetta* probe touches down on comet 67P after 12-year journey.
2015 AD	ESA	*New Horizons* probe flies past Pluto

fig.1b Astronomy accelerated once telescopes were in common use, although early discoveries were sometimes confused by the limitations of small aperture devices.

October be shortened by 10 days to re-align the religious and hence agricultural calendar with the solar (sidereal) year. The Catholic states complied in 1583 but others like Britain delayed until 1752, by which time the adjustment had increased to 11 days!)

The invention of the telescope propelled scholarly learning, and with better and larger designs, astronomers were able to identify other celestial bodies other than stars, namely nebula and much later, galaxies. These discoveries completely changed our appreciation of our own significance within the universe. Even though the first lunar explorations are over 45 years behind us, very few of us have looked at the heavens through a telescope and observed the faint fuzzy patches of a nebula, galaxy or the serene beauty of a star cluster. To otherwise educated people it is a revelation when they observe the colorful glow of the Orion nebula appearing on a computer screen or the fried-egg disk of the Andromeda Galaxy taken with a consumer digital camera and lens.

This amazement is even more surprising when one considers the extraordinary information presented on television shows, books and on the Internet. When I have shared back-yard images with work colleagues, their reaction highlights a view that astrophotography is the domain of large isolated observatories inhabited with nocturnal Physics students. This sense of wonderment is one of the reasons why astrophotographers pursue their quarry. It reminds me of the anticipation one gets as a black and white print emerges in a tray of developer. The challenges we overcome to make an image only increase our satisfaction and the admiration of others, especially those in the know. When you write down the numbers on the page, the exposure times, the pointing accuracy and the hours taken to capture and process an image, the outcome is all the more remarkable.

New Technology

The explosion of interest and amateur ability fuels the market place and supports an increasing number of astro-based companies. Five years on after writing the first edition, the innovation and value engineering continue to advance affordable technology in the form of mechanics, optics, computers, digital cameras and in no small way, software. The digital sensor was chiefly responsible for revolutionizing astrophotography but it itself is now at a crossroads. Dedicated imaging cameras piggy-back off the sensors from the digital camera market, typically DSLRs. At one time CCDs and CMOS sensors were both used in abundance. Today, CMOS sensors dominate the market place and are the primary focus of sensor development, increasing in size and pixel density. Their pixel

size, linearity and noise performance are not necessarily ideal for astrophotography. New CCDs do emerge from Sony but these are a comparative rarity and are typically smaller than APS-C. It will be interesting to see what happens next; it may well drive a change in telescope optics to move to small field, shorter focal length and high resolution imaging. At the same time, the CCD sensor in my QSI camera has become a teenager.

It was not that long ago that a bulky Newtonian reflector was the most popular instrument and large aperture refractors were either expensive or of poor quality and computer control was but a distant dream. The increasing market helps to make advanced technology more affordable or downsize high-end features into smaller units, most noticeably in portable high-performance mounts and using the latest manufacturing techniques to produce large non-spherical mirrors for large reflector telescopes.

At the same time computers, especially laptops, continue to reduce in price and with increased performance and battery life. Laptops are not necessarily ideal for outdoor use; many are switching to miniature PCs (without displays or keyboards) as dedicated controllers, using remote desktop control via network technologies. New software required to plan, control, acquire and process images is now available from many companies at both amateur and professional levels. Quite a few are free, courtesy of generous individuals. At the same time, continued collaboration on interface standards (for instance ASCOM weather standards) encourages new product development, as it reduces software development costs and lead-times. If that was not enough, in the last few years, tablet computing and advanced smart phones have provided alternative platforms for controlling mounts and can display the sky with GPS-located and gyroscopically-pointed star maps. The universe is our oyster.

Scope of Choice

Today's consumer choice is overwhelming. Judging from the current rate of change, I quickly realized that it is an impossible task to cover all equipment or avenues in detail without being variously out of date at publishing. Broad evaluations of the more popular alternatives are to be found in the text but with a practical emphasis and a process of rationalization; in the case of my own system, to deliver quick and reliable setups to maximize those brief opportunities that the English weather permits. My setup is not esoteric and serves as a popular example of its type, ideal for explaining the principles of astrophotography. Some things will be unique to one piece of equipment or another but the principles are common. In my case, after trying and

Year [Circa]	Astrophotography Event
1840	First successful daguerreotype of Moon
1850	First successful star picture
1852	First successful wet-plate process
1858	Application of photography to stellar photometry is realized
1871	Dry plate process on glass
1875	Spectra taken of all bright stars
1882	Spectra taken of nebula for first time
1883	First image to discover stars beyond human vision
1889	First plastic film base, nitro cellulose
1920	Cellulose acetate replaces nitro cellulose as film base
1935	Lowered temperature was found to improve film performance in astrophotography applications
1940	Mercury vapor film treatment used to boost sensitivity of emulsion for astrophotography purposes
1970	Nitrogen gas treatment used to temporarily boost emulsion sensitivity by 10x for long exposure use
1970	Nitrogen followed by Hydrogen gas treatment used as further improvement to increase film sensitivity
1974	First astrophotograph made with a digital sensor
1989	SBIG release ST4 dedicated astrophotography CCD camera
1995	By this time, digital cameras have arguably ousted film cameras for astrophotography.
2004	Meade Instruments Corp. release affordable USB controlled imaging camera. Digital SLRs used too.
2010	Dedicated cameras for astrophotography are widespread, with cooling, combined guiders; in monochrome and color versions. Consumer digital cameras too have improved and overcome initial long exposure issues.
2013	New low-noise CCDs commonly available with noise levels below 1 electron per square micron
2015-	Low-noise CMOS chips starting to make inroads into popular astrophotograhy cameras.

fig.2 *A time-line for some of the key events in astrophotography. It is now 30 years since the first digital astrophotograph was taken and I would argue that it is only in the last 5 years that digital astrophotography has really grown exponentially, driven by affordable hardware and software. Public awareness has increased too, fuelled by recent events in space exploration, documentaries and astrophotography competitions.*

using several types of telescope and mount, I settled on a hardware and software configuration that works as an affordable, portable solution for deep sky and occasional planetary imaging. By choosing equipment at the upper end of what can be termed "portable", when the exertion of continual lifting persuaded me to invest in a permanent observatory, I was able to redeploy all the equipment without the need for upgrading. Five years on, astronomy remains a fascinating subject; each image

is more than a pretty picture as a little background research reveals yet more strange phenomena and at a scale that beggars the imagination.

About This Book

I wrote the first edition with the concept of being a fast track to intermediate astrophotography. This was an ambitious task and quite a challenge. Many astrophotographers start off with a conventional SLR camera and image processing software like Photoshop®. In the right conditions these provide good images. For those users there are several excellent on-line and published guides that I note in the bibliography. It was impossible to cover every aspect in detail, limited by time, page count and budget. My aim in this book is to continue where I left off: covering new ideas, advanced image processing, more advanced practical projects and fresh practical examples that cover new ground. This book is firmly focused on deep-sky imaging; my own situation is not ideal for high magnification work and any references to planetary imaging are made in passing.

The book is divided into logical sections as before: The first section covers the basics of astronomy and the limitations of physics and the environment. The second section examines the tools of the trade, brought up to date with new developments in hardware and software, including remote control, automation and control theory. The third section continues with setting up and is revised to take advantage of the latest technology. In the following section we do the same for image capture, looking at developments in process automation, guiding, focusing and mosaics.

The PixInsight content in the first book was very well received and several readers suggested I write a PixInsight manual. I am not a guru by any means and it would take many years of work to be confident enough to deliver an authoritative tome. Writing for me is meant to be a pleasure and the prospect of a software manual is not terribly exciting to either write, or I suspect, to read. Bowing to this demand, however, the image calibration and processing section provides further in-depth guides to selected processes in PixInsight and additionally uses PixInsight to process the new practical imaging assignments.

The assignments section has been revised and expanded: A couple of case studies have been removed, including the solitary planetary example. Some specialize in this field and they are best suited to expand on the extreme techniques required to get the very best imaging quality at high magnifications. As before, each case study considers the conception, exposure and processing of a particular object that, at the same time, provides an opportunity to highlight various unique techniques.

A worked example is often a wonderful way to explain things and these case studies deliberately use a variety of equipment, techniques and software. More recently these use my software of choice, namely Sequence Generator Pro, PHD2, PixInsight and Photoshop. The subjects are typically deep-sky objects that present unique challenges in their acquisition and processing. Practical examples are even more valuable if they make mistakes and we learn from them. Some examples deliberately include warts and present an opportunity to discuss remedies.

On the same theme, things do not always go to plan and in the appendices before the index and resources, I have updated the chapter on diagnostics, with a small gallery of errors to help with your own troubleshooting. Fixing problems can be half the fun but when they resist several reasoned attempts, a helping hand is most welcome. In my full-time job I use specialized tools for root-cause analysis and I share some simple ideas to track down gremlins. Astrophotography and astronomy in general lends itself to practical invention and not everything is available off the shelf. To that end, new practical projects are included in the appendices as well as sprinkled throughout the book. These include a comprehensive evaluation of collimation techniques for a Ritchey Chrétien telescope and ground-breaking chapters on designing and implementing an observatory controller, its ASCOM driver and a Windows Observatory controller application. It also includes a chapter on setting up a miniature PC as an imaging hub, with full remote control.

As in the first edition, I have included a useful bibliography and a comprehensive index. For some reason bibliographies are a rarity in astrophotography books. As Sir Isaac Newton once wrote, "If I have seen further it is by standing on the shoulders of Giants." The printed page is not necessarily the best medium for some of the resources and the supporting website has downloadable versions of spreadsheets, drawings, program code, videos and tables, as well as any errata that escaped the various editors. They can be found at:

www.digitalastrophotography.co.uk

Share and enjoy.

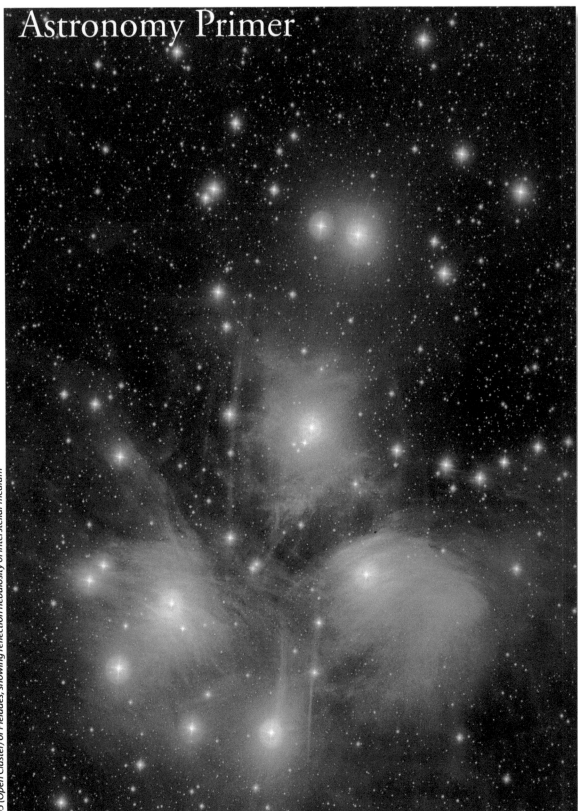

Astronomy Primer

M45 (Open Cluster) or Pleiades, showing reflection nebulosity of interstellar medium

The Diverse Universe of Astrophotography

A totally absorbing hobby, limited only by your imagination, patience and weather.

Amateur astrophotography can be an end in itself or a means of scientific research and in some cases, a bit of both. It might be a surprise for some, but amateur astronomers, with differing degrees of patronage, have significantly contributed to our understanding of the universe, in addition to that from the scientific institutions. As an example, Tom Boles in Suffolk, England has identified over 149 supernova with his private observatory; these brief stellar explosions are of scientific importance and their spectra help determine the size and expansion of the universe. The professional large observatories cannot cover the entire sky at any one time and so the contribution from thousands of amateurs is invaluable, especially when it comes to identifying transient events. I might chance upon something in my lifetime but I have less lofty goals in mind as I stand shivering under a mantle of stars.

Astrophotography is not one hobby but many: There are many specialities and individual circumstances, as well as purpose. Depending on viewing conditions, equipment, budget and available time, amateur astronomers can vary from occasional imagers using a portable setup, to those with a permanent installation capable of remote control and operational at a moment's notice. The subjects are just as numerous too; from high magnification planetary, and deep sky imaging, through medium and wide-field imaging in broad or selective wavelengths. Then there is lunar and solar photography as well as environmental astrophotography, which creates wonderful starry vistas. As with any hobby, there is a law of diminishing returns and once the fundamentals are in place, further enhancements often have more to do with convenience and reliability than raw performance. My own setup is fit for purpose and ultimately its limiting factor is my location. Any further purchase would do little to increase my enjoyment. Well, that is the official line I told my better half!

A Public Health Warning

The next few pages touch on some of the more common forms of astrophotography and the likely setups. Unlike digital photography, one-upmanship between astrophotographers is rare but even so, once you are hooked, it is tempting to pursue an obsessive frenzy of upgrades and continual tuning. It is important to realize that there is a weak link in the imaging chain and that is often your location, light pollution, weather, stable atmosphere, obscuration and family commitments. Suffice to say, I did warn you!

Lunar Imaging

The Moon is the most obvious feature of the night sky and easily passed over for more sexy objects. Several astronomers, including the late Sir Patrick Moore, specialized in lunar observation and photography. Being a large and bright object, it does not mandate extreme magnifications or an expensive cooled CCD camera. Many successful lunar photographs use a modest refractor telescope with a consumer CCD-based webcam adapted to fit into the eyepiece holder. The resultant video image jumps around the screen and

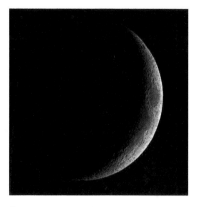

fig.1 The lunar surface is best shown with oblique lighting, in the area between light and shadow. A different part of the Moon is revealed on subsequent nights. This picture and the one below were taken with a micro 4/3rds camera body, fitted to the end of a modest telescope.

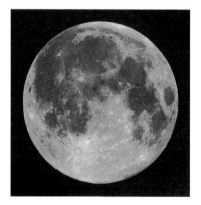

fig.2 A full moon has a serene beauty but the reflected illumination adds considerably to any light pollution. This is likely to restrict any other imaging to bright planets or clusters. I have a theory that full moons only occur on clear nights.

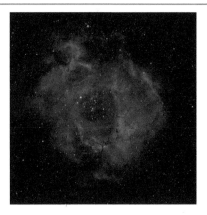

fig.3 *The Rosette Nebula appears as a small cluster of stars when observed through a short telescope. The nebula is almost invisible, even in a dark sky. Our eyes are the limiting factor; at low intensities, we have monochromatic vision and in particular, our eyes are less sensitive to deep red wavelengths, which is the dominant color for many nebulae.*

fig.4 *By way of comparison, if a digital camera is substituted for the human eye, we are able to record faint details and in color too. The above image has been mildly processed with a boost in shadow detail to show the detailed deep red gas clouds in the nebula. This is a large object, approximately 3x wider than the Moon.*

many frames are blurred. The resulting video is a starting point; subsequent processing discards the blurred frames and the remainder are aligned and combined to make a detailed image. Increasingly, digital SLRs are used for lunar photography, either in the increasingly popular video modes or take individual stills at high shutter speeds. The unique aspect of the Moon, and to some extent some planets too, is that their appearance changes from night to night. As the Moon waxes and wanes, the interesting boundary between light and shade, the terminator, moves and reveals the details of a different strip of the lunar surface. No two nights are precisely the same.

Planetary Imaging

The larger and brighter planets, Jupiter, Saturn, Venus and to a lesser extent Mars, have very similar challenges to that of lunar imaging. These bright objects require short exposures but with more magnification, often achieved with the telescope equivalent of a tele-converter lens. A converted or dedicated webcam is often the camera of choice in these situations since its small chip size is ideally matched to the image size. Some use digital SLRs but the larger sensors do create large video files and only at standard video frame rates between 24 frames per second (fps) and 60 fps. I have made pleasing images of Jupiter and Mars using just a refractor with a focal length of just over 900 mm combined with a high-quality 5x tele-converter and an adapted webcam.

These and the smaller planets pose unique challenges though and are not the primary focus of this book. Not only are they are more tricky to locate with portable setups but to show sufficient surface detail requires high magnification. At high magnification, every imperfection from vibration, tracking errors, focus errors and most significantly, atmospheric seeing is obvious. The work of Damian Peach sets the standard for amateur imaging. His astonishing images are the result of painstaking preparation and commitment and his website (*www.damianpeach. com*) is well worth a look.

Solar Imaging

Solar imaging is another rewarding activity, especially during the summer months, and provided it is practised with extreme care, conventional telescopes can be employed using a purpose-designed solar filter fitted to the main and guide scope. Specialist solar scopes are also available which feature fine-tuned filters to maximize the contrast of the Sun's surface features and prominences. The resulting bright image can be photographed with a high-speed video camera or a still camera.

Large Deep Sky Objects

One of the biggest surprises I had when I first started imaging was the enormous size of some of the galaxies and nebulae; I once thought the Moon was the biggest object in the night sky. Under a dark sky one may just discern the center of the Andromeda Galaxy with the naked eye but the entire object span is six times the width of our Moon. It is interesting to ponder what ancient civilizations would have made of it had they perceived its full extent. These objects are within the grasp of an affordable short focal-length lens in the range 350-500

mm. At lower image magnifications accurate star tracking is less critical and even in light polluted areas, it is possible to use special filters and reduce the effect of the ever-present sodium street light. Successful imagers use dedicated CCD cameras or digital SLRs, either coupled to the back of a short telescope or with a camera telephoto lens. Typically, the camera system fits to a motorized equatorial mount and individual exposures range from a few 10s of seconds to 20 minutes. Short focal length telescopes by their nature have short lengths and smaller diameters with correspondingly lightweight focus tubes. The technical challenges associated with this type of photography include achieving fore-aft balancing and the mechanical performance of the focus mechanism and tube as a result of a heavy camera hanging off its end. If you live under a regular flight path, a wide field brings with it the increased chance of aircraft trails across your images.

Small Deep Sky Objects

The smaller objects in the night sky require a longer focal length to make meaningful images, starting at around 800 mm. As the magnification increases, the image brightness reduces, unless the aperture increases at the same rate. This quickly becomes a lesson in practicality and economics. Affordable refractor telescopes at the time of writing have typically a 5-inch or smaller aperture and at the same time, reflector telescopes have between 6- and 10-inch apertures. Larger models do exist, to 16 inches and beyond, but come with the inherent risk of an overdraft and a hernia. The longer exposures required for these highly magnified objects benefit from patience, good tracking and a cooled CCD camera. At higher magnifications, the effect of atmospheric turbulence is noticeable and it is usually the weakest link in the imaging chain.

Environmental Imaging

I have coined this phrase for those shots that are astronomy-related but typically involve the surrounding landscape. Examples include images of the Northern Lights or a wide-field shot of the Milky Way overhead. Long exposures on a stationary tripod show the customary star trails, but shorter exposures (or slow tracking) with a wide-angle lens can render foreground and stars sharply at the same time. Digital SLRs and those compacts with larger sensors make ideal cameras for these applications and a great place to start with no additional cost. At a dark field site, a panorama of the Milky Way makes a fantastic image.

Other Activities

Spectroscopic analysis, supernova hunting, asteroid, minor planet, exoplanet, comet and satellite tracking are further specializations for some astrophotographers. Supernova hunting requires a computer-controlled mount directing a telescope to briefly image multiple galaxies each night, following a programmed sequence. Each image in turn is compared with prior images of the same object. The prize is not a pretty image but the identification of an exploding star. Each of these specialities have interesting technical challenges associated with object location, tracking and imaging. For instance, on *Atlantis'* last flight it docked with the International Space Station. Thierry Legault imaged it with a mobile telescope as it transited the Sun. The transit time was less than a second and he used a digital SLR, operating at its top shutter speed and frame rate to capture a sequence of incredible images, paparazzi-style. His amazing images can be seen at *www.astrophoto.fr*.

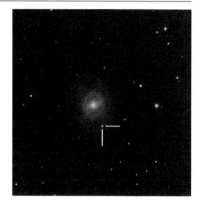

fig.5 A few months after I started using a CCD camera for astrophotography, a supernova was announced in the galaxy M95. I recorded an image of the dim galaxy (top) and used the Internet to identify the supernova position. The color image below was taken a few years later by which time the supernova has disappeared. I now have software that allows one to compare two images taken of the same object from different nights. This automatically identifies any "new" stars or, as in the case of a supernova in our own galaxy, a star that just becomes suddenly very much brighter. Galaxies are the favorite location for likely supernova, as they contain the most stars. A friend was imaging a galaxy as a supernova exploded. His series of unprocessed images proved useful to NASA since they showed the event unfolding between the separate image captures.

Space

The thing about space is when you think you have seen it all, something truly bizarre shows up.

Astrophotographers have many specialities to pursue but in the main, the images that adorn the multitudinous websites consist of stars, special events, planets and deep sky objects. This chapter and the next few give an astronomical grounding in the various objects in space and the systems we use to characterize, locate and measure them. It is not essential to understand astronomy to obtain good pictures, but I think it helps to decipher the lingo and adds to the enjoyment and appreciation of our own and others' efforts.

Stars

The points of light that we see in the night sky are stars, well, almost. Our own Sun is a star, but the planets of our solar system are not, they merely reflect our own Sun's light. Every star is a gravitationally bound luminous sphere of plasma; a thermonuclear light bulb. With the naked eye, on a dark night, you might see up to 3,000 after a period of dark adaptation. That number decreases rapidly as light pollution increases. A star may have its own solar system, but its distance and brightness is such that we cannot directly observe any orbiting planets, even with the help of space-borne telescopes. In recent years in the never-ending search for extraterrestrial life, the presence of planets has been detected outside our own solar system but only by the effect of their gravitational pull on their home star's position. Not all stars are equal; they can be a range of masses, temperatures and brightnesses. Stars have a sequence of formation, life and decay, starting in a nebula and subsequently converting their mass into electromagnetic radiation, through a mechanism governed by their mass, composition and density. Hertzsprung and Russell realized that the color and intensity of stars were related and the diagram named after them shows this pictorially (fig.1). Most stars comply with the "main sequence" on the diagram, including our own Sun. Notable exceptions are the intensely dense white dwarfs and the huge red giants, some of which are so large, we could fit our entire solar system within their boundary. There are countless stars in a galaxy but at the end of a star's life, if it explodes and briefly becomes a supernova, it can outshine its entire parent galaxy. In our own Milky Way galaxy, documentary evidence suggests on average, there are about three supernova events per century.

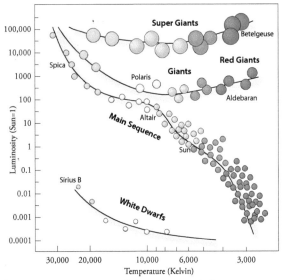

fig.1 *The Hertzsprung-Russell diagram, named after its developers, shows the relationship and observed trend between the brightness and color of stars. The color is directly related to temperature. Ninety percent of stars lie on a diagonal trend known as the main sequence. Other groups and some familiar stars are also shown. At one time, scientists thought that stars migrated along the main sequence as they age. More recent study suggests a number of different scenarios, depending on the makeup, mass and size of the star.*

From a visual standpoint, although stars may be different physical sizes, they are so distant from Earth, they become singular points of light. The only star to be resolved as something other than a point of light, and only by the largest telescopes, is the red giant Betelgeuse in the constellation Orion. It is puzzling then that stars appear in photographs and through the eyepiece in varying sizes, in relation to their visual intensity. This is an optical effect which arises from light scatter and diffraction along the optical path through our atmosphere, telescope optics and the sensitivity cut-off of our eyes or imaging sensor. Stars as single objects are perhaps not the most interesting objects to photograph, although there is satisfaction from photographing double stars and specific colored stars, such as the beautiful Albireo double. Resolving double stars has a certain kudos; it is

a classical test of your optics, seeing conditions, focus and tracking ability of your setup.

When imaging stars, the main consideration is to ensure that they all are circular points of light, all the way into the corners of the image, sharply focused and with good color. This is quite a challenge since the brightness range between the brightest and dimmest stars in the field of view may be several orders of magnitude. In these cases, the astrophotographer has to make a conscious decision on which stars will over-saturate the sensor and render as pure white blobs and whether to make a second, or even third reduced exposure set, for later selective combination. Very few images are "straight".

Constellations

Since ancient times, astronomers have grouped the brighter stars as a means of identification and order. In nontechnical terms, we refer to them as constellations but strictly speaking, these star patterns are asterisms and the term constellation defines the bounded area around the asterism. These are irregular in shape and size and together they form a U.S. state-like jigsaw of the entire celestial sphere. This provides a convenient way of dividing the sky and referring to the general position of an object. The 12 constellations that lay on the path of our companion planets' orbits (the ecliptic) have astrological significance and we know them as the constellations of the Zodiac.

Star Names

Over thousands of years, each culture has created its own version of the constellations and formed convenient join-the-dot depictions of animals, gods and sacred objects. It has to be said that some stretch the imagination more than others. Through international collaboration there are now 88 official constellations. The brightest stars have been named for nearly as long. Many, for instance "Arcturus" and "Algol", are ancient Arabic in origin.

For some time a simple naming system has been used to label the bright stars in a constellation: This comprises of two elements, a consecutive letter of the Greek alphabet and the possessive name of the constellation or its abbreviation. Each star, in order of brightness, takes the next letter of the alphabet: For instance, in the constellation Centaurus, the brightest star is Alpha Centauri or αCen, the next is Beta Centauri or βCen and so on. Beyond the limits of the Greek alphabet, the most reliable way to define a star is to use its coordinates. As the number of identifiable stars increases, various catalog systems are used to identify over 1 billion objects in the night sky.

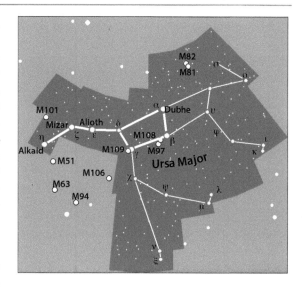

fig.2 The above illustration shows the constellation Ursa Major, of which the main asterism is commonly known as the Big Dipper, The Great Bear, The Plough and others. Many stars are named and take the successive letters of the Greek alphabet to designate their order of brightness. Several galaxies lie within or close to this constellation; the M-designation is an entry in the famous Messier catalog.

Deep Sky Objects

A deep sky object is a broad term referring to anything in the sky apart from singular stars and solar system objects. They form the basis of most astrophotography subjects and include nebulae, clusters and supernova remnants.

Star Clusters

As stars appear to be randomly scattered over the night sky, one would expect there to be groups of apparently closely packed stars. Clusters are strictly groups of stars in close proximity in three dimensions. They are characterized into two groups: Those with a loose sprinkling of approximately 100 to 1,000 younger stars, such as Pleiades, are termed an open cluster and often have ionized gas and dust associated with them. Those with 10,000 or more densely packed stars are older are referred to as globular clusters of which, in the Northern Hemisphere, M13 in the constellation Hercules is a wonderful example.

Although we can detect clusters in neighboring galaxies, they are too distant to resolve as individual stars. The clusters we commonly image are located in our own Milky Way galaxy. As well as being beautiful objects, clusters contain some of the oldest stars in the galaxy and are subject to intense scientific study too.

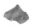

An image of star cluster is a showcase for good technique. It should have good star resolution and separation, extended to the dimmer stars at the periphery but without highlight clipping at the core. The stars should show good color too. This requires a combination of good tracking, focus, exposure and resolution and is the subject of one of the later case studies.

Star vistas can be wide-angle shots showing thousands of stars, the Milky Way or a landscape picture where the night sky plays an important part of the image. By their nature, they require lower magnifications and less demanding on pointing and tracking accuracy. They do, however, highlight any focus, vignetting or resolution issues, especially at the edges of an image.

Double and Binary Stars

A double star describes a distinguishable pair of stars that appear visually close to one another. In some cases they really are, with gravitational attraction, and these are termed visual binaries. Binary stars are one stage on, a pair of stars revolving around a common center of gravity but appear as one star. Amazingly, scientists believe that over 50% of Sun-like stars have orbiting companions. Most binary stars are indistinguishable but sometimes with eclipsing binaries the light output is variable, with defined periodicity.

Variable Stars

Variable stars have more scientific significance than pictorial. A class of variable star, the Cepheid Variables, unlocked a cosmic ruler through a chance discovery: In the early 20th century, scientists realized that the period of the pulsating light from many Cepheid Variables in our neighboring galaxy, the Small Magellanic Cloud, showed a strong correlation to their individual average brightness. By measuring other variable stars' period and intensity in another galaxy, scientists can ascertain it's relative distance. Supernova hunting and measuring variable stars require calibrated camera images rather than those manipulated for pictorial effect.

Nebula

A nebula is an interstellar cloud of dust, hydrogen, helium, oxygen, sulfur, cobalt or other ionized gas. In the beginning, before Edwin Hubble's discovery, galaxies beyond the Milky Way were called nebulae. In older texts, the Andromeda Galaxy is referred to as the Andromeda Nebula. Nebulae are classified into several types; diffuse nebulae and planetary nebulae.

Diffuse Nebulae

Diffuse nebulae are the most common and have no distinct boundaries. They can emit, reflect or absorb light. Those that emit light are formed from ionized gas, which as we know from sodium, neon and xenon lamps radiate distinct colors. This is particularly significant for astrophotographers, since the common hydrogen, oxygen, sulfur and nitrogen emissions do not overlap with the common sodium and mercury vapor lamps used in city lighting. As a result, even in heavily light-polluted areas, it is possible to image a faint nebula through tuned narrowband filters with little interference. Diffuse nebula can also be very large and many fantastic images are possible with short focal-length optics. The Hubble Space Telescope has made many iconic false color images using "The Hubble Palette", comprising narrowband filters tuned to ionized hydrogen, oxygen and sulfur emissions which are assigned to green, blue and red image channels.

Planetary Nebulae

These amazing objects are expanding glowing shells of ionized gas emitted from a dying star. They are faint and tiny in comparison to diffuse nebula and require high magnifications for satisfactory images. They are not visible to the naked eye and the most intricate details require space-telescopes operating in visible and non-visible electromagnetic spectrums. The first planetary nebula to be discovered was the Dumbbell Nebula in 1764 and its comparative brightness and large 1/8th degree diameter render it visible through binoculars. Only the Helix Nebula is bigger or brighter.

Supernova Remnants

One other fascinating nebula type forms when a star collapses and explodes at the end of its life. The subsequent outburst of ionized gas into the surrounding vacuum, emits highly energetic radiation including X-rays, gamma waves, radio waves, visible light and infrared. The Crab Nebula is a notable example, originating from a stellar explosion (supernova), recorded by astronomers around the world in 1054. Amazingly, by comparing recent images with photographic evidence from the last century, astronomers have shown the nebula is expanding at the rate of about 1,500 kilometers per second. After certain classes of supernova events there is a gravitational collapse into an extremely dense, hot neutron star. Astronomers have detected a neutron star at the heart of the Crab Nebula. They often give off gamma and radio waves but also have been detected visibly too.

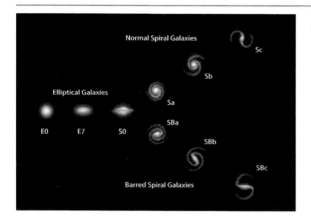

fig.3 When Edwin Hubble discovered that galaxies exist outside our own, he went about classifying their types from their appearance. The original scheme above is the most famous, the "Hubble Sequence" and was added to later by other astronomers. The elliptical galaxies are designated with an "E" followed by an index x, spiral galaxies normally with a central bulge and two or more arms are designated "Sx" of which some have a center barred structure, designated "SBx". The remaining class ("S0") is known as lenticular and although they feature a central bulge in the middle of a disk-like shape, they have no observable spiral structure.

Galaxies

As mentioned already, the existence of other galaxies outside our own was a late realization in 1925 that fundamentally changed our view of the universe. Galaxies are gravitationally bound collections of millions or trillions of stars, planets, dust and gas and other particles. At the center of most galaxies, scientists believe there is a super massive black hole. There are billions of galaxies in the observable universe but terrestrial astrophotography concerns itself with the brighter ones. There are approximately 200 brighter than magnitude 12, but at magnitude 14 the number rises to over 10,000. The brightest is the Large Magellanic Cloud, a neighbor to our Milky Way and easily visible to the naked eye by observers in the Southern Hemisphere. Charles Messier in the 18th century cataloged many other notable examples and are a ready-made who's who.

Galaxies come in all shapes and sizes, making them beautiful and fascinating. Many common types are classified in fig.3. Most of the imaging light from galaxies comes from their stars, though there is some contribution from ionized gases too, as in nebulae. Imaging galaxies requires good seeing conditions and low light pollution since they are in general, less luminous than stars or clusters and have less distinct boundaries. In general, a good quality image of a galaxy is a balance of good surrounding star color, galaxy color and extension of the faint galaxy periphery, without sharp cut-offs into the background or over exposing the brighter core. This requires careful exposure and sensitive manipulation and quite possibly an additional shorter exposure sequence for the surrounding brighter stars. Supplementary exposures through narrowband filters (tuned to ionized gases, or infrared) can enhance and image but in general, since these filters pass very little light, the exposure times quickly become inconveniently long and only practical when applied to the brightest galaxies.

Quasars may appear as stars, but in fact are the bright cores of very distant galaxies and are the most luminous things in the universe. They were first identified through their radio wave emissions and only later linked to a faint, visible, heavily red-shifted dot. The extreme energies involved with their emissions is linked to the interaction of gas and dust spiralling into a black hole. A few quasars are visible from Earth and within the reach of amateur astrophotographer's equipment.

Solar System Objects

The prominent planets in our solar system were identified thousands of years ago. The clue to how is in the name. Derived from the ancient Greek, "planet" means wanderer, and in relation to the background of wheeling stars, Mercury, Venus, Mars, Jupiter, and Saturn appeared in different positions each night. Unlike the continual annual stately cycle of star movement, these planets performed U-turns at certain times in the calendar. Those planets closer to the Sun than the Earth are called inferior planets (Venus and Mercury) and correspondingly Mars, Jupiter, Saturn, Uranus and Neptune are called superior planets. By definition, planets orbit a sun and need to be a significant distinct ball-like shape of rock, ice and gas. The definition is a bit hazy and as such Pluto was demoted in the 20th century, after much debate, to a minor planet (of which there are many).

The Keplerian and Newtonian laws of motion amazingly predict the precise position of our planets in the night sky. Within planetarium programs, their position has to be individually calculated but from an imaging standpoint, for the short duration of an exposure, their overriding apparent motion is from the earth's rotation, which is adjusted for by the standard (sidereal) tracking rate of a telescope.

From Earth, some planets change appearance: Planets appear larger when they are close to "opposition" and closest to Earth. Mercury and Venus, being closer to the

Sun than the Earth, show phases just as our Moon does, and Jupiter, Saturn and Mars change their appearance from planet rotation and tilt.

The massive Jupiter spins very quickly and completes a revolution in about 10 hours. This sets a limit on the exposure time of a photograph to about 90 seconds at medium magnifications and less with more. Above this time, its moons and the surface features, most notable of which is the giant red spot, may become blurred.

Saturn, whose iconic ring structure has inspired astronomers since the first telescopic examination, has an interesting cycle of activity. These rings, which in cosmic terms are unbelievably thin at less than 1 kilometer, have an inclination that changes over a 30-year cycle. In 2009, the rings were edge-on and were almost invisible to Earth but will reach a maximum 30° inclination during 2016-17.

Mars rotates at a similar rate to Earth. Terrestrial photographs of Mars show some surface details as it rotates. In addition, there are seasonal changes caused by the axial tilt and its highly eccentric orbit. From an imaging standpoint, this affects the size of its white polar ice cap of frozen carbon dioxide during the Martian year (lasting about two Earth-years). Its size is under 1/120th degree and requires a high magnification and stable atmospherics for good results. It is a challenging object to image well.

Asteroids, Satellites and Meteorites

At various times, these too become subject to photographic record. Of these, asteroids are perhaps the least interesting to the pictorialist until they fall to Earth. These lumps of rock or ice are normally confined to one of our solar system's asteroid belts, but in our prehistory, may have been knocked out of orbit by collisions or gravitational interactions of the planets. One of the largest, Vesta, has been subject to special up-close scrutiny by the Dawn spacecraft. Indeed, debris from a Vesta collision in space fell to Earth as meteorites. On rare occasions asteroids pass closer to Earth than the Moon.

Satellites, especially when they pass in front of the Moon or Sun in silhouette, are visually interesting and require forward planning. More commonly, satellite images are indistinct reflections of sunlight against a dark sky. There are thousands of man-made satellites circling

When we observe a distant galaxy, we are only seeing the stars and none of the planets. Even taking into consideration the extra mass of planets, dust and space debris, the rotational speed of the observed galaxies can only be explained if their overall mass is considerably higher. The hypothesized solution is to include "dark matter" into the mass calculation. Dark matter defies detection but its presence is inferred from its gravitational effect. In 2012 the Hadron particle collider in Switzerland identified a new elementary particle, the Higgs Boson, with a mass 125x that of a proton. It is an important step along the way to explaining where the missing mass is in the observable universe.

the Earth. The most well known have published orbital data which can be used within planetarium programs to indicate their position or line up a computer-controlled telescope. They orbit from 180 km or more away at a variety of speeds, depending on their altitude and purpose.

Meteorites are not in themselves special objects, merely the name we give natural objects when they make it to the Earth's crust. They are mostly comprised of rock, silicates or iron. Specimens are of important scientific value, for locked inside, there can be traces of organic material or of their source atmosphere. During their entry into our atmosphere, their extreme speed and the friction with the air heats them to extreme temperatures, leading to their characteristic blazing light trail and occasional mid-air explosions. The larger ones are random events, but there are regular occurrences of meteor showers that beckon to the astrophotographer.

Meteor showers occur when the Earth interacts with a stream of debris from a comet. This debris is usually very fine, smaller than a grain of sand and burns up in our atmosphere. These events are regular and predictable and produce a celestial firework display for a few successive nights each year. The events are named after the constellation from which the streaks appear to emanate. Famous meteor showers are the Perseids in August and the Leonids in November, which produce many streaks per hour. Often the most spectacular photographs make use of a wide-angle lens on a static camera and repeated exposures on a time-lapse for later selection of the best ones.

Special Events

Over thousands of years, astrologers have attached significance to special astronomical events. The most well known, yet strangely unproven, is the "Star of Bethlehem" announcing Jesus' birth, which may have been a supernova explosion. These events include special causes, like supernova, where an individual star can achieve sufficient short-lived intensity to be visible during the day, or the sudden appearance of a bright comet. Many other

events consider the relative positions of a planet and the Sun, the Moon and the Sun, the phases of the Moon or the longest day or night. Modern society has disassociated itself from Astrology, but the rarity of some events encourages astronomers and physicists to travel the world to study eclipses, transits or another one-off event. The good news for astronomers is that, apart from supernova, everything else is predictable. (Edmond Halley realized that most comets too have a predictable orbit and appearance.) For an imaging standpoint, the luck and skill of capturing a rare event adds to the satisfaction of the image. As they say, "chance favors the prepared mind" and astrophotography is no different.

Exoplanets

In recent years, amateurs have joined in the search for exoplanets, made feasible by low-noise CCD cameras and high quality equipment. With care, one can not only detect known exoplanets through their momentary lowering of their host star's flux but potentially find new ones too by the same means. A highly specialized area but one which is introduced in a later chapter. The image in this case is not of the planet itself (it is too dim) but a graph of the host star's light output with a characteristic and regular dip.

Comets

Comets become interesting when they pass close to the Sun. In space, they are lumps of ice and rock circling in enormous orbits. As their orbit passes close to the Sun, the characteristic tail and tiny atmosphere (coma) develops. The tail points away from the Sun and arises from the effect of solar radiation and wind on the comet's volatile contents. Short-period comets, with orbits of less than 200 years, are widely predicted, and with a little luck, can

A photograph of stars close to the Sun, taken by Arthur Eddington during a total solar eclipse in 1919, when compared to a photograph of the same stars with the Sun not present, showed a tiny deflection. It was the first measurement to substantiate that light-beams could be bent by gravity, predicted in Einstein's general theory of relativity.

be photographed in good conditions. More occasional visitors are often detected by the various near-earth object telescopes long before they become more readily visible. A bright comet discovered in September 2012, name ISON, passed close to the Sun in January 2014 and many hoped it would provide an opportunity for unique images. A photograph of a comet is a wonderful thing, but to image it as it passes through another landmark site, such as a star cluster, makes it memorable. Since the stars and comet are moving in different directions and speed, one must decide whether to track the stars or not during the brief exposure. However, ISON was imaged by Damian Peach and others as it approached the Sun but it never made it past perihelion and the solar radiation was too much for the muddy snowball. It should have been renamed comet Icarus!

Lunar Eclipses

A lunar eclipse occurs when the Moon, Earth and Sun are in a direct line and the Moon is in Earth's shadow. We can still see the Moon, which is illuminated from scattered light through our atmosphere, and it often takes on a reddish appearance. A time sequence of a lunar eclipse from 2007 is shown in fig.4.

Solar Eclipses

A solar eclipse occurs when the Earth, Moon and Sun are in a direct line and the Moon blocks our view of the Sun. By amazing coincidence, the Moon and Sun have the same apparent size, and eclipses may be partial, where the Moon clips the Sun, or total, which provides a unique opportunity to image the solar corona safely. A total solar eclipse will only be visible from a select 100-kilometer wide tract of the Earth's surface, and avid observers will travel to far flung corners of the world to get the best view of a "totality".

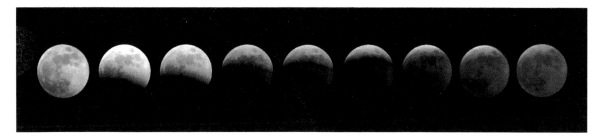

fig.4 This lunar eclipse was captured in March 2007 and assembled from a sequence of still photographs, taken with a consumer digital SLR mounted on a tripod and fitted with a 210 mm zoom lens.

Planetary Transits

Mercury and Venus, the "inferior" planets, lie closer to the Sun than the Earth. On the rare occasions that they pass in front of the Sun, they are in transit. Man-made satellites also transit the Moon and Sun for a few seconds. Photographing the Sun during a transit requires the same mandatory precautions as any other form of solar photography. Transits occur when the nearer object is smaller than the more distant object. (Occultations occur when it is the other way around and it is possible to get transits and occultations between planets too.) In 2065, Venus transits Jupiter and in 2067, Mercury occults Neptune. I'll pass on that one.

Superior and Inferior Conjunctions

These are general terms for line-ups of astronomical bodies from an observer's standpoint. These may be between planets, a planet and the Moon or Sun or other combinations. From an imaging standpoint it is interesting when one can make an image of two close important bodies, though the brightness difference often makes it a challenge. Planetarium programs are very adept at predicting these events and can produce timetables for their occurrence.

Opposition

Another particular event, opposition, occurs when two bodies are on opposite sides of the sky from an observed position. This is of most significance to astrophotographers since when a superior planet is in opposition, it generally is at its closest point to earth and hence its apparent size will be a maximum. Jupiter increases its apparent size by 66%. Mars' change is more extreme and its apparent diameter increases by more than 600%. It is good practice to image planets when they are close to their opposition.

Equinoxes and Solstices

These regular events occur when the Earth is at a specific point in its orbit around the Sun. In the case of the equinox, the tilt of the earth's axis is tangential to the Sun and it has the unique characteristic that night and day are of equal length. It does not have any significant imaging significance, but it does for our celestial coordinate system. There are two equinoxes per year (spring and autumn) and the celestial coordinate system uses the Sun's position at the spring equinox to define an absolute reference point for measuring right ascension. (We will discuss coordinate systems in more detail later on.) There are also two solstices each year, in winter and summer. These mark the shortest and longest day and occur when the tilt of the Earth's axis is in line with the Sun. Their significance for photography mostly relates to the number of available hours for imaging!

Catalogs

It is easy to forget that the availability of detailed planetarium and catalog data on personal devices was only made possible by the patient and astonishing dedication of generations of astronomers.

Astronomical catalogs are an invaluable resource to the astrophotographer. They are the à la Carte menu of the cosmos. One can easily imagine, although the first astronomers recorded the very brightest stars onto fanciful charts, as soon as telescopes were used to methodically survey the heavens, the number of objects increased exponentially. This created the need for systematic catalogs by type, position and brightness. One of the earliest catalogs dates from the first millennia and lists more than 1,000 stars in detail, and interestingly includes the fuzzy outlines of the Andromeda Galaxy and the Large Magellanic Cloud.

Classification

As observations became more sophisticated, it was necessary to find ways of classifying stars and organizing them in logical ways. Johann Bayer started the convention of prefixing the constellation name with a letter from the Greek alphabet in the order of their brightness, a system that is still in use today. John Flamsteed, in his star atlas of 1725, listed stars using numbers combined with the constellation in the order of their right ascension. (John Flamsteed was the first Astronomer Royal at the Greenwich Observatory. The observatory was built on the meridian and his telescopes pivoted in altitude only and so it was convenient for him to label stars in the order they crossed the line of sight.)

In 1781 the French astronomer Charles Messier published "Nebulae and Star Clusters". Crucially, this was not a star catalog but one of deep sky objects. He used a simple index, prefixed with "M" to identify these objects; for example, M31 is the Andromeda Galaxy. Since observations with a telescope at that time only showed the most discernible deep sky objects, it follows that these objects in turn are prime subjects for amateur astrophotography. The Messier catalog is very convenient and arguably the backbone of amateur astrophotography. Indeed, at star parties "The Messier Marathon" is a challenge to see how many of his catalog items (there are 110) you can view in one night.

One hundred years on another significant catalog, the New General Catalog (NGC), compiled by J. Dreyer, listed about 8,000 objects, stars and deep sky objects and remains a useful comprehensive catalog, in use today. It is astonishing to realize that these early catalogs were compiled by hand, without the help of computers or photographic records, but by patient observation and often in poor conditions.

The "Guide Star Catalog" (GSC) is another important catalog, initially compiled to support the Hubble Space Telescope and now also used by amateurs with plate-solving software. (Plate-solving is a technique that recognizes the relative positions and brightness of stars in an image against a catalog database and derives the actual image scale, position and rotation to incredible accuracy.)

In the following century, as telescopes continued to improve and crucially photography allowed astronomers to see fainter objects, the catalogs expanded exponentially. In the early 20th century the Henry Draper Catalog listed more than a quarter of million stars, and later still, using satellite imagery, the Tycho-2 catalog identifies positions and color information of 2.5 million stars in the Milky Way.

In practice, many common objects have several names, corresponding to their listing in each of the popular catalogs, and in addition, descriptive names based on their appearance. Thankfully, we do not need to pore over large books of numbers but can use planetarium programs on computers, smart phones or tablets to select objects for viewing or imaging, display its image and display its relative size and brightness. Many planetarium programs can also command a telescope to point to an object via a number of connections, from external RS232 serial, through Bluetooth and WiFi, wired Ethernet and remotely over the Internet.

Today the main catalogs are available in digital formats and are freely available; for example from U.S. and European Space Agency websites. Clearly in the early days, as new objects were identified, the catalogs expanded and overlapped previous editions. Subsequently, as measurement techniques improved, those with more accurate measurements of position, brightness and color replaced earlier surveys. Even so, stars and galaxies are on the move, relative to Earth and to each other and so any catalog's accuracy will change in time. This perhaps has less significance for the amateur but for scientific use, renewed surveys are required to update their databases.

Too Much Data?

Several commonly available catalogs are compiled, employing filters to generate data sub-sets for specific purposes, for instance, all stars brighter than a certain magnitude. Even with digital computers, too much data can obscure or slow down the search and display for what you want to view, the proverbial needle in a haystack. It is sobering to realize that the Hubble Space Telescope was *upgraded* to a ruggedized 486-based PCs running at 25 MHz clock speed and the Chandra X-Ray space observatory, with a VAX computer, is roughly equivalent to a 386-based PC. Hubble's main computer has just 10 GB of drive space, less than 1/200th of the capacity or speed of the computer writing this! Robustness in this extreme environment is more important than speed.

Catalogs for Astrophotographers

There are two main types of catalog today, the detailed star-based measurement intensive astrometric databases and catalogs of interesting objects. The second form is the most useful for astrophotographers. For deep sky objects, subsequent to the ubiquitous Messier catalog, Sir Patrick Moore generated a supplementary hit list of 109 objects in his Caldwell Catalog. He noticed that Messier had excluded objects that were only visible in the southern hemisphere and had missed quite a few interesting bright deep sky objects too. Since Messier had already taken the "M" prefix, Moore used his middle name Caldwell and used "C" instead. His catalog is listed in numerical order of degrees away from Polaris (declination).

In addition to these two, a group of astronomers selected 400 deep sky objects from the 5,000 listed in John Herschel's Catalog of 1864, all of which are observable from mid northern latitudes and with a modest telescope. It is called the Herschel 400. About 60 objects in the Herschel 400 also occur in the Messier or Caldwell catalogs.

The astrophotographer has more objects to photograph than a lifetime of clear nights. The choice is bewildering and thankfully many planetarium programs offer recommendations for a given night. The huge astrometric databases are of more importance to the scientific community but can be used for plate solving and supernova detection in amateur systems. Most are available as free downloads from the Internet and most planetarium programs are able to load and access them selectively. If too many are enabled at the same time, the star map is cluttered with multiple names for each object. To add to the fun, several popular objects have multiple common names and their catalog number is useful to remove ambiguity.

Catalog	Date	Objects	Notes
Messier "M"	1771	110	Deep space objects, including galaxies, nebulae and clusters, visible from Northern Hemisphere
Herschel "H"	1786	2,500	Deep space objects, including galaxies, nebulae and clusters, visible from Northern Hemisphere. Later revision by son doubled object count
	1864	5,000	
NGC/IC	1888	5,386	Revised Herschel Catalog but had errors that evaded several attempts to correct. Extensively used.
BSC or YBS	1908	9,110	Bright star catalog, brighter than magnitude 6.5
Melotte	1915	245	Open and Globular clusters
Barnard	~1923	370	Dark Nebulae
Collinder	1931	471	Open Star clusters
ADS	1932	17,000	Aitkin Double Star Catalog
Abell	1958-89	4073	Galaxy Clusters
Sharpless	1953-59	312	HII and planetary nebula and supernova remnants
Herschel 400	1980	400	400 deep space items from the Herschel Catalog - use "NGC"
GSC1 GSC2	1989	20M 1B	Catalog to magnitude 15 and 21 for space telescope navigation. (Stars)
Hipparcos "HIP"	1993	120,000	Extremely accurate positional and motion star data
Caldwell "C"	1995	109	109 deep space bright objects missed by Messier or in Southern Hemisphere, by Sir Patrick Caldwell Moore
Tycho-2	1997	2.5M	Star catalog with revised proper motion, brightness and color data
USNO-B1	2003	1B	Stars and galaxies, over 80 GBytes of data
NOMAD	2005	1.1B	Merged data from HIP, Tycho-2, USNO-B1
RNGC/IC	2009	5,000	Revised and corrected Herschel Catalog

fig.1 *The table above lists some of the more common catalogs that one finds in planetarium programs, books and references. Some of these are included since they are used, not necessarily to identify objects to image, but in support of plate-solving software. This accurately locates an image's center by comparing the star positions and intensities with the catalog database. There are many more specialist catalogs, which can be found on the Internet and imported into planetarium programs, such as comet, satellite and asteroid databases.*

Four Dimensions and Counting

Locating an object in 3-D space from a spinning and wobbling planet, which orbits a star, which orbits its galactic center that itself is receding from most other galaxies is … interesting.

I have to admit that when I first started astronomy I found the multiple references to time and coordinate systems extremely confusing. It took some time, helped by the research for this book, to fully appreciate and understand these terms. As the famous quote goes, "time is an illusion" and as it happens, so too are coordinate systems.

Consider the lonely astronomer, sitting on his planet observing billions of stars and galaxies floating around in space, all in constant motion with respect to each other and his own planet, which is spinning and rotating around its solar system in turn rotating around its host galaxy. One can start to appreciate the dilemma that faces anyone who wants to make a definitive time and coordinate-based system.

The solution is to agree a suitable space and time as a reference. Even something as simple as the length of an Earth day is complicated by the fact that although our Earth spins on its axis at a particular rate, since we are simultaneously moving around the Sun, the length of a day, as measured by the Sun's position, is different by about 4 minutes. An Earth-based coordinate system for measuring a star's position is flawed since the Earth is spinning, oscillating and orbiting its solar system, galaxy and so on. In fact, one has to make first-order assumptions and make corrections for second-order effects. Our Earth's daily rotation is almost constant and the tilt of the axis about which it rotates varies very slowly over 26,000 years (over an angular radius of 23°). Incredibly, this slow shift was detected and measured by Hipparchus in 125 BC. The name given to the change in the orientation of the Earth's axis is "precession" and the position of the North Celestial Pole (NCP) moves against the background of stars. Currently Polaris is a good approximation (about 45 arc minutes away) but in 3,200 years, Gamma Cephei will be closer to the NCP.

The upshot of all this is that there are several coordinate and time systems, each optimized for a purpose. The accuracy requirements will be different for science-based study, versus more humble, down-to-earth systems employed by amateur astronomers. Even so, we are impacted by the small changes in our reference systems, for instance a polar scope, designed to align a telescope to the NCP has a reticle engraved to show the position of Polaris (fig.1). Ideally, a polar reticle requires an update every 10

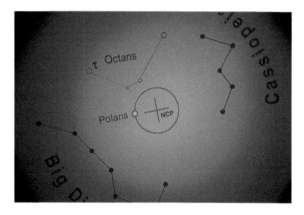

fig.1 This view through a polar scope shows a typical reticle that indicates the relative position of Polaris with the North Celestial Pole (NCP). This reticle was accurate in the epoch J2000 and but in 2013 it is necessary to place Polaris a little off-center in the bubble and closer to the NCP by about 10%.

years to accommodate the Earth's precession and indicate the revised position of Polaris with respect to the NCP.

Time Systems

Local Time (LT)
This is the time on our watch, designed for convenience. Most countries make an hour correction twice a year (daylight saving) to make the daylight hours fit in with sunrise and sunset. As one travels around the Earth, the local time in each country is designed to ensure that the daylight hours and the Sun's position are aligned.

Universal Time (UT)
Perhaps the most common time system used by amateur astronomers is Universal Time. This is the local time on the north-south Meridian, which passes through Greenwich, London. It has a number of different names, including Greenwich Mean Time (GMT), Zulu Time and Coordinated Universal Time (UTC). It is synchronized with the Earth's rotation and orbit and is accurate enough for practical purposes. Each night at a given time, however, a star's position will change. This is attributable to the 4-minute time difference between a 24-hour day and a sidereal day.

Atomic Time

Time systems based on astronomical events are ultimately flawed. The most stable time systems are those based on atomic clocks; over the course of a decade, small changes in the Earth's rotational speed add up. Atomic clocks use the ultra stable property of Cesium or Rubidium electronic transitions. If one uses Global Positioning Satellite (GPS) signals to locate and set your time, one is also benefitting from the stability of atomic clocks.

Barycentric or Heliocentric systems

Rather than use the Earth as a reference, this time system uses the Sun as the reference point for observation. This removes the sub-second errors incurred by the change in Earth's orbit between measurements. One use of this system is for the timing of eclipsing binary stars.

Local Sidereal Time

Local sidereal time is a system designed for use by astronomers. It is based on the Earth's rotation and does not account for its orbit around the Sun. Its "day" is 23 hours, 56 minutes and 4.1 seconds and allows one to form an accurate star clock. If you look at the night sky at a given LST each night, the stars appear in the same position. It is the basis of the Equatorial Coordinate system described later on.

Other Time References

Julian Dates (JD)

Julian dates are a day-number system that allows users to calculate the elapsed time between two dates. The formula converts dates into an integer that allows one to quickly work out the interval. For example, the 22nd January 2013 is JD 2456315. (A similar idea is used by spread-sheet programs to encode dates.) An example of an on-line calculator can be found at:
http://aa.usno.navy.mil/faq/index.php

Epoch

An epoch is a moment in time used as a reference point for a time-changing attribute, for instance, the coordinate of a star. Astrometric data often references the epoch of the measurement or coordinate system. One common instance, often as a check-box in planetarium and telescope control software, is the choice between J2000 and JNow, that is the coordinate system as defined in 2000 AD and today. As the years progress, the difference and selection will become more significant. In many cases, the underlying software translates coordinates between epochs and is transparent to the practical user.

Coordinate Systems

Horizontal Coordinates

There are several fundamental coordinate systems, each with a unique frame of reference. Perhaps the most well known is that which uses the astronomer's time and position on earth, with a localized horizon and the zenith directly above. The position of an object is measured with a bearing from north (azimuth) and its elevation (altitude) from the horizon, as shown in fig.2. This system is embodied in altazimuth telescope mounts, which are the astronomy equivalent of a pan and tilt tripod head, also abbreviated to "alt-az mounts".

There are pros and cons with all coordinate systems; in the case of horizontal coordinates, it is very easy to judge the position of an object in the night sky but this information is only relevant to a singular location and time. In the image-planning stage, horizontal coordinates, say from a planetarium program, are an easily understood reference for determining the rough position of the subject, if it crosses the north-south divide (meridian) and if it moves too close to the horizon during an imaging session.

Equatorial Coordinates

Unlike horizontal coordinates, a star's position, as defined by equatorial coordinates, is a constant for any place and time on the Earth's surface. (Well, as constant as it can be in the context of star's relative motion and Earth's motion within its galaxy.) For a given epoch,

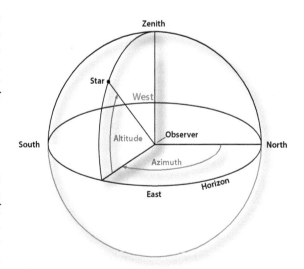

fig.2 *This schematic shows the normal horizontal coordinate scheme, with local horizon and true north references. The zenith is directly overhead. Celestial coordinates in this system are only relevant to your precise location and time.*

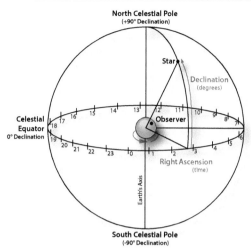

fig.3 This schematic shows the equatorial coordinate scheme, with celestial horizon and celestial pole references. Celestial coordinates in this system relate to the Earth and can be shared with users in other locations and at other times. Right ascension is measured counter-clockwise; a full circle is just less than 24 hours.

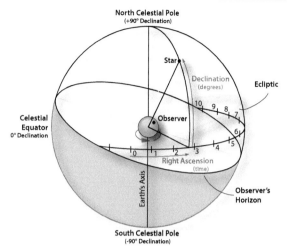

fig.4 This schematic expands on that in fig.3. It shows how the celestial horizon and the observer's horizon can be inclined to one another. In one direction the observer can view objects beneath the celestial equator. The ecliptic is shown crossing the celestial equator at the Vernal Equinox, defining 0 hour's right ascension reference point.

planetarium programs or the handset with a programmable telescope mount will store the equatorial coordinates for many thousands of stars. It is a simple matter with the additional information of local time and location on the Earth for a computer to convert any star's position into horizontal coordinates or display on a computer screen.

Equatorial coordinates are a little hard to explain, but as with horizontal coordinates, they have two reference points. The first reference point is the North Celestial Pole, as shown in fig.3, located on the imaginary line of the Earth's axis of rotation. A star's declination is the angular measure from the celestial equator. For instance, the polestar (Polaris) is very close to the North Celestial Pole and has a declination of 89.5°. If one observes the stars from the North Pole, one would see a fixed set of stars endlessly going around in a circle and parallel to your local horizon. In this special case a star's declination is equal to its altitude.

The second reference point lies on the celestial equator, from which the stars bearing is measured in hours, minutes and seconds (for historical reasons) rather than degrees. Unlike the azimuth value in horizontal coordinates, which is measured clockwise from true north, the star's bearing (right ascension) is measured counter-clockwise from the zero-hour reference point. This reference point is explained in fig.4 and corresponds to a special event, on the occasion of the Spring Equinox, where the Sun, moving along the ecliptic, crosses the celestial equator. (The ecliptic can conversely be thought

of as the plane of the Earth's rotation as it orbits the the Sun. It moves with the seasons and is higher in the sky during the summer and lower in the winter.)

From an observer's standpoint, say at the latitude of the UK or north America, the North Celestial Pole is not at the zenith but some 30–40° away, and the stars wheel around, with many appearing and disappearing across the observer's horizon. (The North Celestial Pole is directly above the North Pole and hence Polaris has been used as a night-time compass for thousands of years.)

The equatorial coordinate system is quite confusing for an observer unless they are equipped with an aligned telescope to the NCP; unlike horizontal coordinates, the right ascension for any given direction is continually changing. Even at the same time each night, the right ascension changes by 4 minutes, the difference between a day measured in universal and sidereal time. (If you look very closely at the right ascension scale of a telescope, fig.5, you will notice a small anomaly, accounting for the time difference, between 23 and 0 hours.) Unlike the horizontal coordinate system, an astronomer armed with just a compass and equatorial coordinates would be unable to locate the general direction of an object.

The beauty, however, of the equatorial system is that any star has a fixed declination and right ascension and an equatorial mounted and aligned telescope only needs to rotate counter-clockwise on its right ascension axis in order to follow the star as the Earth spins on its axis. In addition, since all the stars move together

along this axis, an image taken with an aligned system does not require a camera rotator to resolve every star as a pinprick of light.

Equatorial coordinates are not a constant, however, even if one discounts star movements: a comparison of the readouts of a star position for successive years show a small change, due to the Earth's precession mentioned earlier, and serves as a reminder that the absolute position of a star requires its coordinates and epoch. In practice, the alignment routine of a computerized telescope mount or as part of the imaging software soon identify the initial offset and make adjustments to their pointing model. Linked planetarium programs accomplish the same correction through a "synch" command that correlates the theoretical and actual target and compensates for the manual adjustment.

Other Terms

Galactic Coordinates

Galactic coordinates are used for scientific purposes and remove the effect of the Earth's orbit by using a Sun-centered system, with a reference line pointing towards the center of the Milky Way. By removing the effect of Earth's orbit, this system improves the accuracy of measurements within our galaxy.

Ecliptic, Meridian and Celestial Equator

There are a couple of other terms that are worth explaining since they come up regularly in astronomy and astrophotography. The ecliptic is the apparent path of the Sun across the sky, essentially the plane of our solar system. The planets follow this path closely too and planetarium programs have a view option to display the ecliptic as an arc across the sky chart. It is a useful aid to locate planets and plan the best time to image them.

The meridian is an imaginary north-south divide that passes through the North Celestial Pole, the zenith and the north and south points on the observer's horizon. This has a special significance for astrophotographers since with many telescope mounts, as a star passes across the meridian, the telescope mount has to stop tracking and perform a "meridian flip". (This flips the telescope end-to-end and side-to-side on the mount so that it can continue to track the star without the telescope colliding with the mount's support. At the same time, the image turns upside down and any guiding software has to change its polarity too.) During the planning stage it is useful to display the meridian on the planetarium chart and check to see if your object is going to cross the meridian during your imaging session so that you

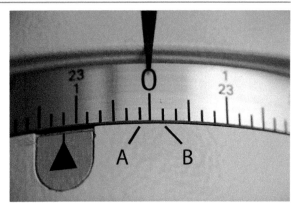

fig.5 *This close up shows the right ascension scale from an equatorial telescope mount. Each tick-mark is 10 minutes and upon closer inspection one notices that the tick mark, labelled A is slightly closer to 0 than the one labelled B. This accounts for the fact that the right ascension scale is based on sidereal time, whose day is about 4 minutes short of the normal 24 hours in universal time.*

can intervene at the right time, perform a meridian flip and reset the exposures and guiding to continue with the exposure sequence.

The celestial equator has been mentioned briefly before in the discussion on equatorial coordinates. The plane of the celestial equator and our Earth's equator are the same, just as the North Celestial Pole is directly above the North Pole. The effect of precession, however, means that as the tilt of the Earth's axis changes, so does the projection of the celestial equator and the stars will appear to shift in relation to this reference plane.

Degrees, Minutes and Seconds

Most software accepts and outputs angular measures for longitude and latitude, arc measurements and declination. This may be in decimal degrees (DDD. DDD) or in degrees, minutes and seconds. I have encountered several formats for entering data and it is worthwhile to check the format being assumed. Common formats might be DDDMMSS, DDD° MM' SS" or DDD:MM:SS.

In each case a minute is $1/60^{th}$ degree and a second is $1/60^{th}$ of a minute. In astrophotography the resolution of an image or sensor (the arc subtended by one pixel) is measured in arc seconds per pixel and the tracking error of a telescope may be similarly measured in arc seconds. For instance, a typical tracking error over 10 minutes, without guiding, may be ± 15 arc seconds but a sensor will have a much finer resolution of 1 to 2 arc seconds per pixel.

Distance

The fourth dimension in this case is distance. Again, several units of measure are commonly in use, with scientific and historical origins. The vastness of space is such that it is cumbersome to work with normal measures in meters or miles. Larger units are required, of which there are several.

Light-Years

Light-years are a common measure of stellar distances and as the name suggests, is the distance travelled by light in one year, approximately 9×10^{15} meters. Conversely, when we know the distance of some cosmic event, such as a supernova explosion, we also know how long ago it occurred. Distances in light-years use the symbol "ly".

Astronomical Unit

The astronomical unit or AU for short is also used. An AU is the mean Earth-Sun distance at about 150×10^{9} meters. It is most useful when used in the context of the measurement of stellar distances in parsecs.

Parsecs

A distance in parsecs is determined by the change in a star's angular position from two positions 1 AU apart. It is a convenient practical measure used by astronomers.

In practice, a star's position is measured twice, 6 months apart. A star 1 parsec away would appear to shift by 1 arc second. It has a value of approximately 3.3 light-years. The parsec symbol is "pc". The further the star's distance, the smaller the shift in position. The Hipparcos satellite has sufficient resolution to determine stars up to 1,000 pc away.

All these measures of large distances require magnitude uplifts; hence kiloparsec, megaparsec, gigaparsec and the same for light-years.

Cosmic Distance Ladders

I have always wondered how some of the mind-numbing distances are determined with any certainty. The answer lies in a technique that uses cosmic distance ladders. Astronomers can only directly measure objects close to Earth (in cosmic terms). Using a succession of techniques, more distant objects can be estimated by their emission spectra, light intensity and statistics.

In these techniques, the red-shift of a distant star's spectrum indicates its speed and hence distance from Earth using the Hubble Constant equation, whereas closer to home, the period and brightness of a variable star is a good indicator of its distance. These techniques overlap in distance terms and allow one to multiply up the shorter measures to reach the far-flung galaxies.

distance	km	AU	ly	pc
Earth to Moon	3.8×10^{5}	2.5×10^{-3}	1.2 lsec	1.2×10^{-8}
Earth to Sun	1.5×10^{8}	1	8.3 lmin	4.8×10^{-6}
Sun to nearest star	4.0×10^{13}	2.7×10^{5}	4.2 ly	1.3
Sun to center of Milky Way	2.6×10^{17}	1.7×10^{9}	2.8×10^{4} ly	8.2×10^{3}
nearest galaxy	2.1×10^{19}	1.4×10^{11}	2.2×10^{6} ly	6.8×10^{5}
furthest we can see	1.2×10^{23}	8.0×10^{14}	1.3×10^{10} ly	3.8×10^{9}

fig.6 Some example distances in alternative units; kilometers, astronomical units, light-years and parsecs. Note the vast range of distances favors different practical units. Parsec distances over 1,000 pc cannot be measured in the classical way from two observations.

Limits of Perception

*In the UK, if I had known how many clear nights there would be in the year,
I would have taken up fishing.*

The chance of success from a night's imaging improves with a little planning. Before committing to hours of exposure and precious clear skies, it pays to consider a few preliminaries, the most basic of which is frame size. The combination of telescope and camera should give the object the right emphasis within the frame. There are simple calculations that give the field of view in arc minutes, which you can compare with the object's size listed in a planetarium program. I have two refractors and two field flatteners, which in combination give four different fields of view (FOV). High quality imaging takes time and the next thing is to check if there is sufficient opportunity to deliver the required imaging time. There are several considerations: the object's declination, the season, the brightness of the object over the background illumination, sky quality and in part the resolution of the optical / imaging system.

Magnitude

A number of terms loosely describe brightness in many texts, namely, luminosity, flux and magnitude. Luminosity relates to the total light energy output from a star; flux is a surface intensity, which, like an incident light reading in photography, falls off with distance. The brightness or magnitude of a star is its apparent intensity from an observed position. The magnitude of a star or galaxy in relation to the sky background and the sensitivity of the sensor are the key factors that affect the required exposure. Most planetarium programs indicate the magnitude information for any given galaxy and most stars using a simple scale. This will be its "apparent" magnitude.

Apparent Visual Magnitude

Simply put, this is the luminosity of a star as it appears to an observer on Earth. Just as with light measurements in photography, astronomical magnitudes are a logarithmic measure, which provide a convenient numerical index. Astronomy magnitudes employ a scale where an increase of one unit decreases the intensity by 2.5x, and five units by 2.5^5 or 100x. At one time, the magnitude scale definition assigned Polaris with a magnitude of +2.0 until the discovery that it was actually a variable star! The brightest star (apart from our own sun) is Sirius at -1.47 and the faintest object observable from the Hubble Space Telescope is about +31, or about 2.4×10^{13} dimmer.

A mathematical simplification arises from using logarithmic figures; adding the logarithms of two values *a* and *b* is identical to the log of (*a* x *b*). This is the principle behind a slide-rule (for the younger readers, as seen in the movie *Apollo 13* when they calculate its emergency re-entry). In astronomy, any pair of similarly sized objects with a similar difference in magnitude value have the same brightness ratio. Similarly, if the magnitude limit for visual observation is magnitude 4 and a telescope boosts that by a factor, expressed in magnitude terms, say 5, the new magnitude limit is 9. A visually large object, such as a galaxy, will not appear as intense as a star of the same magnitude, as the same light output is spread over a larger field of view.

The table in fig.1 sets out the apparent magnitude scale and some example objects with the number of stars that reach that magnitude. At the same time, it indicates the limitations imposed by the sensitivity of the human eye under typical light pollution as well as the exponential number of stars at lower magnitudes. Further down the table, at the lowest magnitudes, the practical benefit of using a telescope for visual use can be seen, and that improves even further when a modest exposure onto a CCD sensor replaces the human eye. At the bottom of the table, the limit imposed by light pollution is removed by space-borne telescopes, whose sensors can see to the limits of their electronic noise.

The Advantage of Telescopes

A telescope has a light-gathering advantage over the eye, easily imagined if we think of all the light pouring into the front of a telescope compared to that of the human iris. The advantage, for a typical human eye with a pupil size of 6 mm, in units of magnitude is:

$$gain\ (magnitude) = 2.5 \cdot log\left(\frac{aperture\ (mm)}{6}\right)^2$$

In the conditions that allow one to see magnitude 5 stars, a 6-inch (15 cm) telescope will pick out magnitude 12 stars, and with an exposure of less than 1 hour, imaged with a cooled CCD, stars 250x fainter still, at magnitude 18 in typical suburban light pollution.

visibility	apparent magnitude	# objects brighter	example / notes
human eye urban sky	-1	1	Sirius (-1.5)
	0	4	Vega
	1	15	Saturn (1.5)
	2	50	Jupiter (-2.9 to -1.6)
	3	<200	Andromeda Galaxy (3.4)
human eye dark sky	4	500	Orion Nebula (M42)
	5	1,600	Uranus (5.5-6.0)
	6	4,800	Eagle Nebula (M16)
binoculars with 50-mm aperture	7	14,000	Bode's Nebula (M81)
	8	42,000	Crab Nebula (M1)
	9	121,000	M43 Nebula in Orion
typical visual 8-cm aperture	10	340,000	NGC4244 Galaxy
	11	-	Little dumbbell (M76)
typical visual 15-cm aperture	12	-	beyond Messier Catalog
	13	-	Quasar 3C 273
typical visual 30-cm aperture	14	-	Galaxy PGC 21789 nr. Pollux
	15	20,000,000	IC 4617 Galaxy nr. M13
10-cm refractor, CCD 10x 30 seconds suburban sky	16	-	faint star in image with simple stacking, about 20,000 times more sensitive than by eye alone
10-cm refractor, CCD 10x 300 seconds suburban sky	18	-	faint star in image with simple stacking, about 1,000,000 times more sensitive than by eye alone
suburban sky	20	-	typical background magnitude in suburb
Hubble Space Telescope	31	-	galaxies 13.3 billion light-years distant

fig.1 *This table highlights the limits of perception for the aided and unaided eye over a range of conditions and indicates the number of objects within that range. The advantage of CCD imaging over an exposure of 5–50 minutes is overwhelming. For Earth-based imaging, the general sky background and noise, indicated by the shading, will eventually obscure faint signals, from about magnitude 18 in suburban areas. The Hubble Space Telescope operates outside our atmosphere and air pollution, and at its limit can detect magnitude 31 objects. Its sensitivity is approximately 150,000 times better than an amateur setup.*
It is important to note that magnitude, when applied to a large object, such as a nebula or galaxy, applies to the total amount of light being emitted. Two galaxies of the same magnitude but different sizes will have different intensities and will require a different exposure to have equal pixel values.

Absolute Magnitude

This is a measure of an object's intrinsic electromagnetic brightness and when evaluated in the visual wavelength range is termed absolute visual magnitude. Photographers are aware that the intensity of a light source reduces with distance, for instance the light intensity from a flashgun obeys the inverse-square law (for each doubling of distance, the light reduces by 4x). This same is true of cosmic light sources. Absolute magnitude is similar to apparent magnitude when measured from a fixed distance of 10 parsecs. (Since meteors and asteroids are very dim, compared to the nuclear furnace in a star, they use a magnitude definition set at 100 km and 1 AU distance respectively.) Absolute magnitude is of most interest to scientists, especially in the computation of an object's distance. For astrophotographers, the apparent magnitude from Earth is more useful, and for amateur supernova hunting, significant changes in a star's magnitude, compared to the star's standard photometry, indicate a possible discovery.

Optics

Advertising and consumer pressure tempt us to over-indulge in telescopes purchases for astrophotography. There are many optical and physical properties that distinguish a "good" telescope from a "bad" one, and just like with any other pursuit, knowing what is important is the key to making the correct purchasing decision. In the case of resolution, the certainty of an optical performance, backed up by physical equations, is a beguiling one for an engineer and I have to frequently remind myself that these are only reached under perfect atmospheric conditions (which I have yet to encounter). The needs of the visual observer and astrophotographer are different too since the human eye has a higher resolution than a conventional sensor (though with less sensitivity). Expensive apochromatic refractors focus all wavelengths of light at the same point, a quality valued by visual users or those imaging with a color camera. It has less significance if separately focused exposures are taken through narrowband or individual red, green or blue filters and combined during image processing.

Astrophotography has similarities to any other kind of photography; the final image quality has many factors and the overall performance is a combination of all the degradations in the imaging chain. It is easy to misinterpret the image and blame the optics for any defects. Long before digital cameras were popular, the premium optics, from companies such as Leica and Carl Zeiss, had more resolution than could be recorded on fine grain film. If a lens and a film independently have a resolution

of 200 line pairs per millimeter (lp/mm), the system resolution is closer to 140 lp/mm. At the advent of digital photography, it was not uncommon to find self-proclaimed experts conducting a lens test using a digital body with a sensor resolution of just 50 lp/mm, half that of a typical monochrome film! It was amusing and annoying at the same time. The sensor plays a pivotal role in the final resolution achievable in astrophotography (just how much we discuss later on).

Resolution?

In photography, many amateurs and not a few professionals confuse resolution and sharpness. They are not completely unrelated, but in an image they convey very different visual attributes. In simple terms, resolution is the ability to discern two close objects as separate entities. Photographic resolution tests often use alternate black and white lines in various sizes and orientations and astronomers use, not surprisingly, points of light. The common lp/mm resolution measure used in photography does not relate well to celestial object separations defined by angles. For that reason astronomers quote angular resolution, quoted in arc seconds or radians.

Post-exposure image manipulation cannot restore lost image resolution, but image sharpness can be increased later on using photo software. (Mild sharpening of an image may improve the actual perceived resolution of some coarser image details but often at the same time bludgeons delicate detail.) Image sharpness has no agreed measure but is our perception of contrast between adjacent light and dark areas, especially in the transition area.

The following example illustrates the difference between resolution and sharpness: On my journey into work, there is a string of electric pylons and power lines across the horizon. In the distance, I can clearly see the lines slung between the pylons arms and each line appears "sharp" in the clear morning air. As I draw closer, my eyes resolve these lines as pairs of electrical conductors, several inches apart; that is resolution.

This is also a useful analogy for astrophotography; in many images the stars appear randomly sprinkled throughout an image with plenty of space between them and like the power lines on the horizon, we do not necessarily require a high resolution to see them, only contrast. Continuing with the analogy, we do not require a high resolution to appreciate the clouds behind the pylons and in the same sense images of nebulae and galaxies have indistinct object boundaries, in addition to which, many popular nebulae span a wide angle and do not require a high optical magnification or resolution. In these cases, not only is the seeing and optical resolution often better than the resolution of the sensor, but also the long exposure times required for dim deep sky objects often over-expose foreground stars, which bloat from light scatter along the optical path, destroying optical resolution. On the other hand, a high angular resolution is required to distinguish individual stars in globular clusters and double stars.

Resolution, Diffraction Limits and FWHM

Although a star is a finite object, it is so distant that it should focus to an infinitely small spot in an image. Due to diffraction and even with perfect optics, it appears as a diffuse blob with pale circular bands. The brightest part

fig.2 *This shows a simulated diffraction-limited star image and a profile of its intensity. The measure FWHM, which can be an angular measure, or a dimension on an image or sensor is read at a point where the image intensity is 50% of the peak.*

Many optical equations use radians for angular measure. They have the property that for very small angles, the sin or tan of that angle is the same as the angle expressed in radians. This provides a handy method to simplify formulae for practical use. There are 2π radians in 360 degrees and as most of us are more familiar using degrees, nanometers and millimeters, rather than radians and meters, you will encounter, in more convenient equations, the numbers 206 in varying powers of 10 to convert angular resolution into arc seconds.

of the blob is at its center and a measure of its blobbiness is its diameter at which its intensity is half its peak value (fig.2). This defines the Full Width Half Maximum, or FWHM for short, and is often an information call-out within most image capture and focusing programs. (Most focus algorithms assume the optimum focus occurs when a star's FWHM (or a related measure, Half Flux Diameter) is at a minimum.) The minimum FWHM (in radians) of a point image is dependent upon the wavelength λ and aperture D by the equation:

$$FWHM = 1.03 \cdot \frac{\lambda}{D}$$

The same physics of light diffraction limits our ability to distinguish neighboring stars and is similarly dependent upon the aperture and wavelength. The theoretical resolution determined by Lord Rayleigh, referred to as the Rayleigh Criterion, is shown below, for resolving two close objects, in radians, through a circular aperture D and wavelength λ:

$$resolution(radians) = 1.22 \cdot \frac{\lambda}{D}$$

Conveniently, both the FWHM and Rayleigh Criterion have very similar values and can be treated as one and the same in practical calculations.

Either equation can be made more convenient by expressing the angular resolution in arc seconds:

$$resolution = 0.251 \cdot \frac{\lambda(nm)}{D(mm)}$$

The interesting feature of these equations is the resolution improves with aperture, and significantly, is irrespective of the focal length or magnification. The simulated image sequence in fig.3 shows two equal intensity stars at different degrees of separation. The point at which the two blobs are distinguished occurs when the peaks are at the Rayleigh Criterion distance or approximately one FWHM distance apart. These equations work for a simple refractor; those telescopes with central obstructions have more diffraction for the same aperture.

Astronomical Seeing

Astronomical seeing is an empirical measure of the optical stability of our atmosphere. Turbulence causes rapid (~10–30 ms), localized changes in air density and parallel beams are deviated through refraction.

fig.3 *These three simulated illustrations show diffraction-limited images from two identical stars at different angular separations. The profiles underneath show the separate and combined image intensities. The image on the left has the two stars separated by half the FWHM distance and although it is oblong, the two stars are not distinguishable. The middle image, at the Rayleigh Criterion separation, shows a clear distinction and exhibits a small dip in central intensity. This separation is just a little larger than the FWHM width of a single star. The right-hand image shows clear separation at a distance of 1.5 FWHMs apart.*

Astronomers look through about 20 miles of atmosphere (looking straight up) and double that, closer to the horizon. Turbulence makes stars shimmer or blur when viewed through a telescope. At any one time the light beams pass through adjacent small air pockets (a few centimeters across) with different refractive indices. This occurs mostly in the denser air near the ground or from tiny convection currents within the telescope tube. At high magnifications, typical with planetary imaging, the individual video frames jump about the screen, some are badly blurred and others remarkably sharp. When the light path has a consistent refractive index, a frame is sharp and when it is variable, blurred. During longer exposures, the photons from these sharp, blurred and displaced images accumulate onto the sensor, creating a smeared star image. Seeing affects angular resolution and it is measured in the same units (arc seconds). Astronomical forecasts of seeing conditions around the Earth are available from websites, some examples of which are shown in figs. 4 and 5 opposite. Others include "metcheck" and various applications for mobile devices such as Scope Nights. Humidity and pressure readouts from portable devices also help to predict atmospheric transparency and mist.

For a prime site, a seeing condition of 0.5 arc seconds is possible but values in the range of 1.5–3.5 are more typical for most of us. More often than not, the prevailing seeing conditions will limit the resolution for any given telescope. The table in fig.6 shows the theoretical limits of visible light resolution for several common amateur telescope sizes in relation to typical seeing conditions. It is quite sobering to realize the limitation imposed by typical seeing conditions through the atmosphere is equivalent to a telescope with an aperture in the region of 3 inches (75 mm).

Seeing conditions are particularly sensitive to perturbations in the dense atmosphere closest to Earth, and generally improve with altitude and proximity to large expanses of water (due to the moderating effect on thermal generation). The mountain observatories in Hawaii and the Canary Islands are good examples of prime locations. Seeing conditions also change with the season and the amount of daytime heating. The local site has an immediate bearing too; it is better to image in a cool open field than over an expanse of concrete that has received a day's sunshine. Astronomers choose remote sites not to be anti-social; they just need to find high altitude, clear skies, low light pollution and low air turbulence. Knowing and predicting the prevailing conditions is a key part of our day-to-day activity. In some countries especially, each opportunity is a precious one.

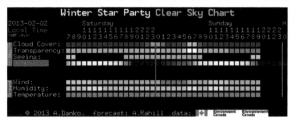

fig.4 This screen capture is of a typical clear sky chart for a site in North America. It is available from www.cleardarksky.com

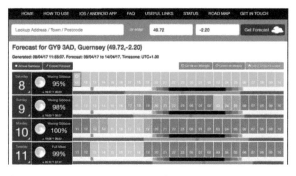

fig.5 Another forecast site, this time from First Light Optics

Other Atmospheric Effects

We become increasingly aware of light pollution as soon as we take up astronomy. As we have seen earlier, light pollution masks the faint stars and nebula. This light is scattered back from atmospheric aerosols, dust and water vapor and places a (typically) orange-yellow fog over proceedings. A full moon too has a surprisingly strong effect on light pollution and puts a damper on things. After it has been raining, the air is often much cleaner and the effects of light pollution are slightly reduced due to better atmospheric transparency. Atmospheric transparency can be forecast and is included in the readouts in figs. 4 and 5 along with dew point, moon-phase, humidity and wind.

Why then do so many sources recommend buying the largest affordable aperture and that "aperture is king"? Larger apertures technically have the potential for better resolution, but above all, capture more light. For visual use, the extra aperture is the difference between seeing a dim galaxy or not. For imagers, the extra light intensity delivers an opportunity for shorter exposure times or more light captured over a fixed period, which reaps benefits in sleep deprivation and lower image noise.

Not all telescope designs are equal; there are some subtle differences between the optical performance of the various telescope architectures; the more complex have additional losses in transmission, reflection and diffraction at each optical boundary. Of the telescope designs, for any given aperture, refractors are the simplest optically and have the highest image contrast, followed

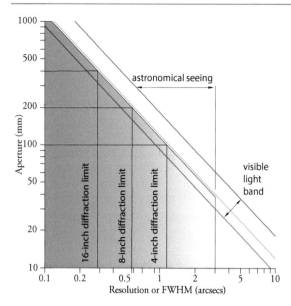

fig.6 The chart above indicates the diffraction-limited resolution for visible light, in arc seconds, for any given aperture in relation to the limits imposed by typical seeing conditions.

by Newtonian reflectors and then folded designs which, for the moment, we will collectively call Schmidt-Cassegrain's or SCTs. On top of the limitations of the optical path, vibration, flexure, focus shifts, tracking accuracy and atmospheric effects contribute to the blurring of the eventual star image. If it was going to be easy, it would not be nearly as rewarding or half as much fun!

Imaging Resolution

The term sensor describes the light sensitive device that resides in a camera. Digital sensors are quite complex and they have their own chapter. For now, a single light-sensitive element on the sensor, or photosite, corresponds to a pixel in the image. It converts photons into an electrical signal. This signal is amplified, sampled and stored as a digital value. An imaging sensor has a grid of photosites of fixed pitch, typically in the range of 4–7 microns. The photosites simply accumulate electrons, triggered by incident photons and largely irrespective of wavelength. To make a color "pixel" requires a combination of exposures taken through red, green and blue filters. This can either be achieved from separate exposures taken through a large filter placed in front of the entire sensor or a single exposure through a color filter mosaic fixed over the sensor (Bayer array). Astrophotographers use both approaches, each with benefits and drawbacks and these are discussed later on.

The pitch of the photosite grid has a bearing upon image resolution. Up to now, the discussion has revolved around angular resolution. To consider the physical relationship between angular and linear resolution on an imaging sensor we need to take account of the focal length f_L of the optics.

The angle subtended by 1 pixel (arc seconds per pixel) is given by the following simplified equation from basic trigonometry (f_L in mm):

$$arsecs/pixel = 206 . \frac{pixelspacing(microns)}{f_L}$$

Classical (Nyquist) sampling theorems might suggest two pixels are required to resolve a pair of stars but experts settle on a number closer to 3.3 adjacent pixels to guarantee the resolution of two points. (Stars do not always align themselves conveniently with the sensor grid and must consider all angles. The pixel spacing on the diagonal is 40% larger than the grid axis.) The angular resolution of a CCD is 3.3x its arc second/pixel value and changes with the focal length of the optics.

It is interesting to compare this to the diffraction limit and calculate the equivalent pixel pitch for the same resolution:

$$3.3 . 206 . \frac{pixelspacing}{f_L} = 0.251 . \frac{\lambda}{D}$$

This simplifies, assuming green light to:

$$pixelspacing(microns) = 0.18 . \frac{f_L}{D}$$

In the case of my refractor, it has a measured focal length of 924 mm and an aperture of 132 mm and I use it with a sensor with a pixel pitch of 5.4 microns. The telescope has a diffraction-limited resolution (x) of approximately 1.0 arc second, but the sensor's resolution (y) is 4.0 arc seconds. For the CCD to match the diffraction-limited performance of the optics, it would require a smaller pitch of 1.4 microns. That might look quite damning but there is another consideration, the effect of astronomical seeing: The CCD resolution of 4.0 arc seconds is only marginally worse than typical seeing conditions (z) of say 3.0 arc seconds in a suburban setting. The system resolution is a combination of all the above and defined by its quadratic sum:

$$\sqrt{\left(x^2+y^2+z^2\right)} = 5.1 \; arcsecs$$

The system resolution is a combination of the individual values and is always less than the weakest link in the imaging chain. This resolution is further degraded by star tracking issues too, which can be significant during unguided exposures. (Guided exposures in a well adjusted system typically have less than one arc second of error.)

To sum up, in this typical setup, the telescope's optical diffraction has little influence on the final resolution and more surprisingly, the CCD is the weakest link. The seeing and CCD resolution are similar though, and while sensors with a finer pitch can be used (albeit with other issues), in astrophotography the most difficult thing to change is one's environment. All these factors are weighed up in the balance between resolution, image requirements, field of view, signal strength, cost and portability. The conventional wisdom is to have a CCD whose arc seconds/pixel value is about 1/3rd of the limiting conditions; either the seeing condition or the diffraction limit (normally on smaller scopes).

Dynamic Range

In the early days of digital imaging, many wedding photographers preferred the results from color negative film as it captured a larger brightness range than a digital camera. In effect, what they were saying was that film could distinguish a higher ratio of light levels between highlights and shadows. Comparing analog and digital systems, however, is not easy; there is more at play here than just the difference in light levels; there is tonal resolution too, and this is where film and digital sensors are very different.

Astrophotography is particularly demanding on the dynamic range of a sensor. In any one image, there may be bright stars, very dim clouds of ionized gas and somewhere in the middle, brighter regions in the core of a galaxy or nebula. The Orion Nebula is one such subject that exceeds the abilities of most sensors. Extensive manipulation is required to boost the dim clouds, maintain good contrast in the mid range and at the same time emphasize the star color without brightening them into white blobs. For this to be a success, the original image data needs to not only record the bright stars without clipping but also to capture the dim elements with sufficient tonal resolution so that they both can withstand subsequent image manipulation without degradation.

In one respect, the dynamic range of a sensor is a simple measure of ratio of the largest signal to the lowest, expressed either as a ratio or in decibels (dB) calculated by:

dB= 20 . log (light ratio)

In photography, dynamic range is related to bit depth, which is measured by the number of binary digits output from the sensor's analog to digital converter (ADC). A 16-bit ADC has 2^{16} voltage levels, over 65,000:1. In practice, this is not the whole story: Firstly, many sensors require less than one electron to change the output value and then there is image noise. The other fly in the ointment is that sensors are linear devices and we are accustomed to working in logarithmic units; in a digital image, there are fewer signal levels per magnitude at the dark end than at the bright end of the exposure scale.

Full Well Capacity, Bit Depth and Noise

Just as with system resolution, there is more to dynamic range than one single measure. First there is bit depth: Consumer cameras record JPEG files and these are made with three 8-bit values each for red, green and blue. That is just 256 levels per color channel, even though the sensor may have more detailed information, typically 16–32x better. Color fidelity in astrophotography is not a primary concern, but low color noise and fine tonal resolution in the shadow areas are essential qualities in the original downloaded file. Image capture programs obtain the maximum bit depth possible from the sensor, similar to the RAW file formats found on advanced digital cameras. For example, the Kodak KAF8300M monochrome sensor has a 16-bit readout and one might assume that it has 65,000 output levels. There is a snag; this sensor only requires 25,000 electrons to saturate (max-out) a photosite. In reality, it has 25,000 states, equivalent to just over 14-bit. This number of electrons is known as the Full Well Capacity and varies between sensor models. This is not the end of the story; random electrons introduced during the sensor readout process further reduce the effective dynamic range. This concept is a little difficult to appreciate but noise affects a sensor's dynamic range and set a minimum exposure requirement.

The previous formula sets the effective dynamic range. In the case of the KAF8300M sensor, the read noise is typically 7 electrons, yielding a dynamic range of 3,570:1 or about 12-bit. The 16-bit ADC in the sensor has sufficient resolution above the signal resolution to ensure that it does not introduce sampling noise, which is of more concern in high-quality audio reproduction.

We also need to go back and consider the linear nature of imaging sensors: Starting at a data level of 1, successive doubling of light intensity (think aperture stops on a camera lens) produce pixel values in the sequence 1, 2, 4, 8, 16, 32, 128, 256, 512 and so on. At the dark end, there are no intermediate values and the tonal resolution is 1 stop. At the other extreme, there are 256 values between 256 and 512 giving a tonal resolution of 1/256 stop. Fortunately in conventional photography the human eye can discriminate smaller density changes in print highlights than it can in shadow areas, by a factor of about 5x and thankfully the highlights are the key to any photograph.

The challenge of astrophotography is that much of the interesting information is not only invisible to the visual

observer but has to be boosted out of the shadows through intense image manipulation. The astrophotographer needs all the tonal resolution they can muster in the shadow regions. The numbers tell a worrying story too: How can smooth images be stretched out of a signal with only 3,570 data levels? The answer is that it is highly unlikely from a single image exposure. We are jumping ahead of ourselves a little but it is good to know that the astrophotographer has two ways to significantly improve the dynamic range of an image. We will discuss again in more detail later on but for now, here is a preview.

Improving Dynamic Range

The wonderful thing about noise is that it is mostly random. If you flip a coin enough times, the number of heads or tails will be about the same. The same is true with astrophotography. If an image pixel wants to be 1,001.67 units, successive exposures from the sensor will be either 1,001 or 1,002 in the main or occasionally numbers further out, due to noise. Assuming an even noise distribution, the values of 1,002 or higher will occur twice as often as the value 1,001 or lower in subsequent exposures. If many (aligned) images have their pixel values averaged, the math can achieve an intermediate level, close to the true noiseless value.

With an increasing number of averaged exposures of the same subject, the random noise in the image is reduced and the Signal to Noise Ratio (SNR) is improved by:

$$factor = \sqrt{no\ of\ samples}$$

For example, if 10 samples are taken with the KAF8300M sensor, the read noise is reduced to about 2.2 electrons and the dynamic range is closer to 25,000 / 2.2 = 11363:1 (equivalent to a bit depth between 13 and 14-bit).

It is standard practice to combine (integrate / stack) multiple images to improve the image SNR, to boost shadow resolution (and noise) to enhance faint nebulosity and extend galaxy perimeters as well as remove one-off events such as cosmic rays and plane trails.

The second trick is to cheat! For those of you who are familiar with advanced digital photography, you will likely know that a subject with a high dynamic range can be captured by combining long and short exposures

fig.7 This enlarged section of a single CCD sensor bias frame shows the read noise from the sensor. It has a standard deviation of 22, that is 68% of all values are in the range of ±22. Each electron is 2.6 units, so the read noise is 8.5 electrons.

fig.8 This enlarged section of the average of 50 CCD sensor bias frames shows the read noise from the sensor. It has much less randomness and has a standard deviation of 4, a little higher than the predicted value of 3.1 due to other artefacts.

of the same scene that have been individually optimized for their shadow and highlight regions. Photographers can use a fancy Photoshop plug-in to combine them but I'm not a fan of its unnatural smudgy ethereal look. In astrophotography, however, it is considerably easier to disguise the boundaries since there are fewer bright mid-tones in an image.

In practice, a simple combination of optimized exposure sequences for bright stars, bright nebulosity and dim nebulosity will improve the dynamic range of an image. The grouped images are aligned and averaged and then the (three) stacked images are aligned and selectively combined, for instance using Photoshop. Here, each image is assigned to a layer and each is blended using a mask generated from inverted image data. The result is a photo-fit of bright stars, bright nebulosity and dim nebulosity with a dynamic range many times greater than the imaging sensor. The masks are tuned to ensure smooth transitions between the image data in the three layers. This trick is not always required but there are a few objects, the Orion Nebula being one, where it is a helpful technique to capture the entirety of its huge brightness range with finesse. Using a combination of exposure lengths, the dynamic range is extended by the ratio of the longest and shortest time, as much as 100x or about 5 magnitudes. The same is true for imaging the enormous Andromeda Galaxy (M31), although less obvious. The core of the galaxy saturates a CCD sensor in under 2 minutes but the faint outer margins require 10 minutes or longer to bring out the details. (The processing details for M31 appear in one of the first light assignment chapters.)

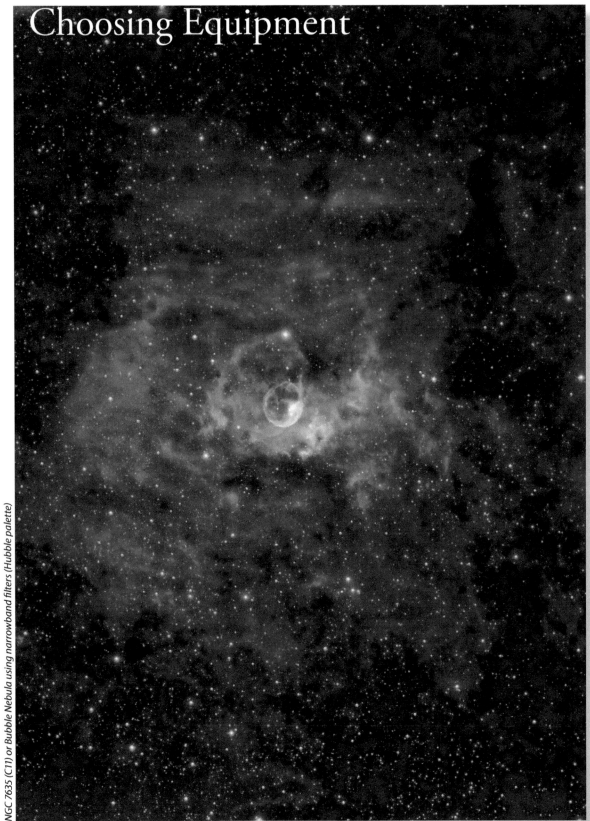

Choosing Equipment

NGC 7635 (C11) or Bubble Nebula using narrowband filters (Hubble palette)

The Ingredients of Success

Some practical considerations to steer one through the maze of options. After all, success breeds success.

When I was planning the chapters on equipment selection, I wondered how to go about it in a logical way. In my case, I started off by buying an entire used outfit and basically played with it. Over time I worked out what to keep, upgrade, change or modify. Looking back, I might have rationalized the essential requirements for astrophotography and then made more sense of the overwhelming equipment choice. It is very easy to deviate into exciting details and lose sight of the bigger picture. What follows is a mixture of practical considerations and more technical qualities that you look for when you choose and setup equipment. The themes noted here resonate through later chapters and become a guiding influence on system setup. Some of these terms may be unfamiliar at present but will be explained later. These requirements broadly group into three areas: planning, equipment and imaging essentials.

Planning
- Location
- Safety
- Power
- Comfort
- Weather and Planning
- Timing

Equipment
- Familiarity
- Mechanical Integrity and Stability
- Tracking and Alignment
- Autoguiding
- Dew control
- Focus and Focusers
- Essential Software

Imaging Essentials
- Cleanliness
- Sensor Size
- Pixel Size
- Sensitivity
- Image Noise Reduction
- Calibration
- Optical Correction
- Setting Up and Note Taking

Planning

Location

An early decision is whether or not to have a permanent installation; assemble a portable setup in the back yard each time or to travel to a dark site for your photography. Light pollution and the typical atmospheric conditions for a general location set the upper performance limit for astrophotography. Dark sites offer the best conditions but one must be willing, ready and able to set up at a remote dark site each time the weather looks good. On the other hand, the convenience of a back yard beckons, but with the possibility of greater light pollution, an interrupted horizon and the neighbor's insecurity lights. Early enthusiasm can wane and although we might start off with good intentions, the practicalities and effort of remote site operation may be worthwhile for just a few guaranteed prolonged imaging runs in fantastic conditions or in a social context. In my case, I have a worthy dark site about 20 miles away on the coast, with low light pollution and a convenient grassy car park, set in the marshlands of east Essex, but I have not tried it.

Most of us would love the turn-key convenience of a permanent observatory but cannot justify the cost or eyesore, especially if the weather limits its use. With a little practice it is possible to deploy a portable setup and be imaging within an hour. If a shower takes you by surprise, a large waterproof cover can be thrown over in seconds and at the same time permit a setup to remain for a few days. The installation decision influences the equipment choice, since telescopes, mounts, counterweights and tripods are neither light or small. After all, a portable setup needs to be just that, portable, and it is surprising just how quickly the repeated assembly of a large articulated mass in cold dark damp conditions can reduce the appeal of this hobby! For example, my first acquisition was a used 8-inch Meade LX200 SCT, weighing in total at around 43 kg. The previous owner had bought it for his retirement but quickly changed to a lighter telescope. It is not just a case of lifting a large weight; equipment requires transport, carrying and assembly, often in the dark, without tripping, damage or injury. The box for the LX200 head filled the back of my car on its own. The same story plays out in the many adverts for large,

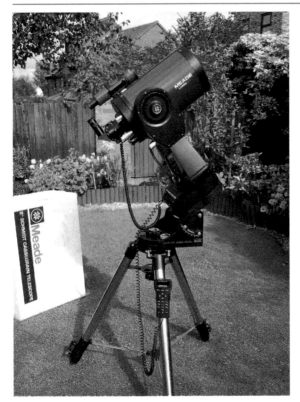

fig.1 *This 8-inch Meade LX200 telescope with an equatorial
wedge is a handful for a portable setup; the equivalent
10- and 12-inch versions weigh considerably more
and are better suited for a permanent installation.*

used telescopes. In a permanent setting however, larger and heavier mounts, scopes and installations are a one-time problem. These systems remain fully assembled and the cables routed permanently so that remote operation is safe and feasible. In a portable setup, the needs are different: There will be trade-offs in weight and rigidity and all the mechanical and electronic components must endure repeated assembly without failure or damage. In these situations, refractor telescopes are certainly more compact and robust during transport and do not require alignment before use.

Safety

It goes without saying to "be safe" but I'm compelled to highlight a few things on personal safety. The conditions and the remote locations that astrophotography encourage can create some unique situations. Clearly lighting is essential; a powerful torch and a wind-up spare, in case the batteries fail. You may also have to consider personal security in a remote location; although mobile phones are commonplace, there may be no signal at the site and someone should know where you are. Increasingly, there

is also the subject of physical safety and the best practice of lifting and moving large heavy pieces of equipment (in the dark). Those vehicles with a flat load-space (like a van or wagon) are particularly back-friendly since they allow heavy objects to be slid in and out without lifting with a bent back. Capped boots are a sensible precaution too; a dewy counterweight once slipped through my fingers and missed my sandaled feet by a few inches.

Power

Power has its own safety considerations. Most astronomy equipment requires 12–14 volts DC, but some devices, like USB hubs, only require 5, for which I use an encapsulated 12 to 5 volt DC converter. (A few mounts also use 24 or 48 volts.) Lead-acid cells are the most common source for mobile DC power. They conveniently store a high capacity (measured in amp-hours) but this lowers after each discharge/charge cycle, an effect which accelerates with the level of discharge. There are several lead-acid battery designs; those ones for hobby-use are best; they are designed to be more tolerant of deep discharge, whereas car battery versions are optimized to deliver bursts of high current but quickly lose charge capacity after repeated cycling. Gel-filled batteries or AGM designs are maintenance free and do not need to be kept upright. Large capacity lithium-ion batteries, up to about 24 Ah are also available, but at premium prices. These are considerably lighter and smaller than the lead acid versions.

Power supply quality is important too and the DC supply to a CCD camera should have as little electrical noise as possible. A simple solution is to use two batteries; one for the imaging and guiding cameras and the other for the "noisy" motor and switching functions such as dew heaters, focus control and the telescope mount. Battery charging is a potentially hazardous activity. Dead or damaged batteries should not be used but properly recycled. Modern batteries require a little care to prolong life and capacity. Some do not like over-charging or being charged too quickly. If in doubt, check the recommendations for charging and use the recommended charger.

For a domestic site, mains power is also an option but only with care: Any mains extension cable run out through the back yard or buried in the back yard should not only be armored to protect from accidental rupture but employ an earth leakage current breaker (ELCB) at the power source. Just as significantly, many regulated DC power supplies, including some that are supplied by mount OEMs, are designed for indoor use only. Dew and general dampness go hand-in-hand with astronomy and there is an obvious risk of electrocution or failure with

fig.2 *The combination of frugal power management
settings in the MacBook Pro with an external lithium-
ion battery is sufficient for a full night's imaging.
The orange plastic armor and keyboard cover add
some protection against knocks and dew.*

In a portable setup, the laptop is the computer of choice, preferably with a battery life in excess of 5 hours. Aggressive power saving settings are great but remember to turn off the sleep-mode or your imaging run could unexpectedly terminate! Some models have hot-swappable batteries but most are internal. An alternative is to use a reserve high capacity lithium-ion battery. These have a programmable output voltage and are supplied with multiple adaptors to suit the most popular laptops. A third option is to use an inverter. These convert 12 volt DC into AC mains, which then supplies the laptop's power adaptor. As before, check the models are safe for outdoor operation. Lastly, some power supplies are floating and to avoid potential static discharges, connect all the equipment together before powering up.

Comfort

Astrophotography is physically demanding, especially in cold conditions. The manual exertion during the setup may keep you warm but the body cools down with the extended inactivity during image-capture. It's the same with hill walking; you need to layer up when you stop exerting yourself. When I'm watching the exposures roll in I add a few layers and put on a ridiculous hat, gloves and warm boots. Over extended imaging times, food, drink and diversion are essential. I use an iPod rather than the vehicle radio or mobile phone to preserve the important batteries. A number of laptops and tablets have touch sensitive controls and will not work with conventional gloves. If you look around, gloves are now available with conductive fingertips. Extreme cold does have one advantage though; it keeps the insects at bay.

some models. One alternative is to place the power supply in the house or in a suitable enclosure and use a length of heavy-duty speaker cable to carry DC, with minimal loss, to the telescope. The same safety considerations apply to domestic plug-in-the-wall power adaptors and desktop computers sited in outdoor situations. They need protection from moisture and should be appropriately earthed. Spare mains sockets should be kept away from moisture and fitted with a plastic child safety cover for good measure. If there is any doubt, ask a qualified electrician to check over your installation. The only stars you should be seeing are those through the telescope!

fig.3 *This SkySafari® application on an iPad® can plan a night's imaging, from left to right, determining when the object will cross the
meridian, checking the field of view for the telescope and sensor combination and essential object information, including magnitude.*

Insects like astronomers, so mosquito repellent and bite cream are a few more essentials to keep in mind.

Weather and Planning

It happens to all of us: The cloud is unbroken and each weather front merges into an unending overcast month and you have almost come to the point of giving up astronomy. Then, one evening, surprise, it is clear. We suddenly have an opportunity for imaging ... of what exactly? Meteorology is not an exact science but weather systems are predictable to some extent (even in the UK). It is possible to recognize cloud sequences from cold and warm fronts and the characteristics associated with areas of high pressure. A little knowledge of clouds certainly comes in handy; for instance, small cumulus clouds in the evening generated by thermals are more likely to disperse than high cirrus clouds signalling a warm front. The on-line weather reports and those with dedicated sky forecasts are a useful resource to anticipate clear skies in the next 48-hour period although the timing may be slightly out. During the day, the local cloud conditions help to realign the forecast, especially if corroborated with information from other sources, say a weather station.

Next, we have to decide what to image. Many objects, especially those at lower declinations have a preferred season when they are visible for some of the night. Ideally, they will have an altitude of about 30° in the east (for those of us in the northern hemisphere) at the start of the night, which maximizes imaging time. Those objects nearer the pole never set and those over 70° from the celestial horizon (for UK sites) are safe bets too. At a latitude of +50°, objects with a DEC between -10° to -90° will never have an altitude greater than 30° and will be a challenge to image. Planetarium programs usually have a "tonight's best" option, usually for short term visual purposes. Luckily every object's visibility is predictable and it helps to identify those objects that will be optimally positioned each month beforehand. You can make a target list with a planetarium program or an application like AstroPlanner. These identify those objects that are in a good starting position for an imaging run, for each month of the year. For example, the high declination objects or those low declination objects whose altitude is about 30° in the east at dusk. (Charles Bracken's *The Astrophotography Sky Atlas* has a comprehensive set of maps for all seasons and latitudes.) Ideally, I set up at dusk when my object's position is low on the Eastern horizon. By the time I have calibrated the mount and set the focus, it will have risen sufficiently to clear my neighbor's roof line. I also check the azimuth of the target and note if, and when, it is going to cross between east and west over the meridian (if the image acquisition system requires manual intervention). Before using Sequence Generator Pro I had to stop the exposure, flip, realign the target and restart autoguiding and the imaging sequence with the mount on the opposite side.

Timing

Imaging is not a quick fix (well, other than short planetary videos). It is really frustrating to start a promising imaging sequence only to be obliged to break off before you have enough imaging data to make a quality image. To prevent this, a quick evaluation of the likely overall exposure duration and available time helps. Image quality benefits hugely from multiple exposures (or "subs" as astrophotographers call them), the more the merrier. Dim galaxies and nebula benefit from at least 10 hours of data or more, especially

fig.4 *This polar scope setting application on an iPad not only shows the position of Polaris as viewed through the eyepiece but a readout of the Hour Angle (HA) which can be quickly set directly on the mount's RA scale (after a one-time calibration).*

fig.5 *Good planning helps with the setup too. Here, the balance point for the telescope (fully assembled and in focus) is marked on the dovetail plate with a piece of white tape and aligns with a corresponding marker for quick and easy balance setup.*

when using narrowband filters. For high quality images it is normally necessary to image over several nights and combine images. Again, programs like Sequence Generator Pro are intelligent and remember what you were imaging and how far through the intended exposure plan you were when you shut down. They can start up and continue on another night with ease.

The Internet once more is a useful resource to plan exposures: An Internet search of the deep sky object often links to other's images that usefully indicate the equipment setup and exposure details, possibly with the same sensor. Some bright objects might be captured in a single night, others require perseverance over several.

Equipment

Familiarity

Equipment and software setups soon become quite complex and complete familiarity really helps with quick and reliable operation. This reduces "real-time" frustration, which often occur in portable setups or after a software update. My better half calls it "playing" but a few daylight dry-runs to practice assembly, balancing and alignment make night-time operation second nature. Some preparatory work can make this easier still; for instance, the balance points can be marked on the telescope dovetail plates for instant assembly and the polar scope reticle calibrated to the RA scale and centered during daylight. The mass of a dangling cables affect balance and tracking and loose cables may catch during slewing. I found Velcro cable-ties were an easy way to secure cables from snagging and relieve stress on the connectors. In addition, I made simple colored markers with electrical tape around each end of the many USB cables. This is a quick way of identifying which cable is which, handy for when a single device requires a power reset, without disturbing the scope-end of things.

Little things like systematic storage, say using clear and labelled plastic food storage boxes, protects small items from dew and dust and avoids rummaging in the dark. The smaller boxes can be organized into larger ones for imaging, observing and common accessories, which helps when loading up. I save the silica gel bags from various purchases and pop them in for good measure.

Understanding the software operation is essential and often underestimated: My early setup used 8 pieces of software, six of which interact (C2A, Maxim DL, FocusMax, MaxPoint, ASCOM and EQMOD) with many USB devices (camera 1, camera 2, focuser, filter wheel, GPS receiver, EQ6 Mount and a USB over Cat 6 extender). It saves a lot of time to pre-configure

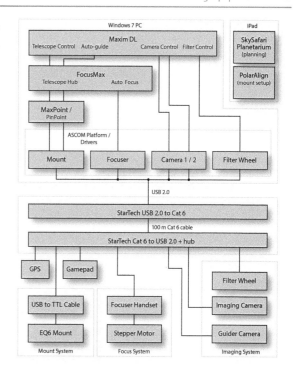

fig.6 *This figure illustrates the information flow between the software applications and the hardware of my initial system. It looks more complicated than it is in practice but it does illustrate the need for preparation and familiarity with the software and hardware settings and connectivity. In this setup, the full planetarium program resides on an iPad and a simple one in Maxim DL.*

each to work with the others and enter the site (time, horizon, location) and equipment data (camera type, mount type, focal length, pixel resolution, filter setup and so on) that most of these programs individually require. Even when you think everything is perfect, software can kick back; in some versions of Windows, if a USB camera plugs into a different port connector, the operating system demands the driver file is loaded again, causing unnecessary aggravation, especially at a remote site, without the CD or Internet.

I am not the first or last to waste imaging time due to poor preparation: Recently, after a SSD drive upgrade to my laptop, I failed to realize that the PC clock had changed to daylight saving, confusing my alignment and plate solving attempts for two precious clear nights. The software startup sequence can be established during a dry run and the hardware drivers checked beforehand for reliable operation on each of the different USB ports, especially after any software upgrade or update.

One simple way is to record the power-up sequence. This increases the chances that the equipment connects

fig.7 The back end of a telescope is sometimes more important than the front end. For a precise and robust assembly of this William Optics field-flattener, the 2" adaptor and nosepiece are unscrewed from the focus tube and field-flattener. The clamp system is replaced by a threaded custom adaptor that screws both items together firmly and squarely. There is a small global industry which manufactures and designs adaptors for every conceivable requirement, made known to all via the Internet.

flawlessly and follows a reliable alignment and calibration sequence, including polar alignment, focus, star alignment, object location, autoguider calibration and exposure determination. It helps to try out alternatives using the simulator driver versions of camera, focuser and mount interfaces in the comfort of the home. Astrophotography challenges our ability to remain clear headed; few of us are at our best at night and I use a laminated checklist for repeatability. It can also include the essential data for the telescope and imaging configurations that are required by the imaging software. I have included an example checklist in the *Resources* section.

Mechanical Integrity and Stability

A stable imaging platform is vital in any imaging setup and is equally if not more important than the optical quality of the telescope. Every vibration, slippage, flex or movement, degrades the final image. It might seem pedantic, but a little attention to every detail ensures the best possible result. For example, in a previous chapter the calculation for a telescope resolution hovered around one arc second or 1/3600th of a degree. That is equivalent to a 0.005 mm movement over 1 m! Working from the ground up, the tripod or pier and the telescope mount must be as inert as possible and minimize vibration, slippage or flexure. This is principally a combination of mass and stiffness. A permanent pier set in concrete is very rigid,

even more so if it is de-coupled from external sources of vibration. For portable setups, a rigid and secure tripod is essential, with feet that do not slip or slowly sink into the ground under load. Adjustable tripod legs can flex and sometimes the locking design does not secure in all directions. Height is not important in imaging and one way to minimize leg flex is to extend them as little as possible and choose a tripod with locking legs that prevent lateral movement too. Loose cables are another source of error; they can catch on things as the mount swings around or flop about and change the balance of the telescope.

The telescope mount has the lead role in the imaging system's performance. Even without tracking, the mount's many mechanical interfaces affect general stability. Mounts vary enormously in weight, stiffness, payload and price. When planning the equipment budget, the mount takes the top spot. Conventional wisdom suggests that for the best results, the weight of the scope, camera and hardware should not exceed 2/3rds of the mount's payload capacity. It is also essential that the mount cannot move about on the tripod or pier. This requires tightening all four polar adjustment knobs on the mount and re-tightening any base fixings after polar alignment (which requires the mount to move). In the case of a tripod mounted system, if the mount locates around a raised cylindrical spigot, check for a snug fit.

fig.8 Little things count: Tripod spikes provide a secure footing but an oversize nylon washer prevents the spike sinking into soft ground. The underside of a pillar extension, shimmed with electrical tape for a snug fit and with three sandpaper pads. When clamped, these grip to the tripod top plate and prevent accidental rotation.

If it is not, insert a few shims or packing to eliminate the possibility of lateral movement.

The need for stability equally applies to the telescope, especially flexure from the back half of the telescope. The focus mechanism, field-flattener and filter/camera system need to be secure and orthogonal to the optical axis. This may require a little ingenuity in some cases: For example, many standard telescopes are equipped for observing use, with 2-inch and 1.25-inch clamping systems for diagonals and eyepieces. The imaging adaptors often make use of these but the weight of heavier cameras cause flex or slip. The less expensive adaptors use a single screw fixing, which not only marks the tube but will almost certainly wobble on the other axis. The up-market versions use a brass ring, clamped at three points but these too do not guarantee an optimum assembly. Any tilt or flex has a direct impact on the shape and focus of stars around the image periphery. It is always better to screw things together to ensure an aligned and stiff assembly and a scour of the Internet will often locate a threaded adaptor to mate items together or a machining company who can make an affordable custom design. In the cold I use a pair of rubber gloves to grip damp accessories that have tight threads.

Mechanical play, sometimes known as backlash or hysteresis, is a consequence of mechanical tolerances. Each mechanical interface has a little gap or flexure that results in backlash between each gear, belt and bearing. Backlash is not an issue if things only move in one direction; it becomes a problem when a motor changes direction (or when the balance point flips over and the engagement forces reverse). It can be measured by noting the amount of reverse movement needed before a system starts to change direction. It is normal to have a small amount of play in any system but it is prudent to check your mount for severe issues, as consistent factory adjustment is not guaranteed, even in premium products.

With the mount fixed on a tripod and the clutches secured, if you can feel play with a gentle twisting motion in either motor axis, some immediate attention is required. For a quick backlash measurement, mount the telescope as normal, disable the mount tracking and attach a reticle eyepiece or an imaging camera. Center a terrestrial object by using the mount's slew controls on the handset. When a feature is close to the reticle, slow the mount slew-speed down and approach slowly from one direction. Set the slew speed to the sidereal rate (1x) or less and use the opposite slew control button to reverse the direction of the telescope. The approximate value of backlash for a 1x slew rate is the duration of the button press (in time) before the mount starts to move. This time, multiplied by 15, gives the approximate value in arc seconds. Gear engagement is often adjustable, either by the user or manufacturer, though you can never eliminate it entirely. Most guiding and alignment software will also measure it during its calibration routine and account for any residual backlash in its operation. It is important to note that the effect of backlash mostly affects the initial star alignment accuracy of a telescope and the accuracy of subsequent slews to an object, but it can also interfere with autoguiding performance, when the declination motor changes direction or arising from a balance issue in the right ascension axis when an in-balance is not opposing the tracking.

The easiest way to measure your mount's PE is to use one of the special utilities. These small programs, several of which are free, measure a star's precise position on a CCD sensor over several mount worm-gear cycles and record the mount's periodic error. Other programs analyze this data and after filtering out the effect of high frequency errors from seeing conditions, correlate the periodic error's frequency characteristic with the gear periods for popular mounts. They smooth and plot the error amplitudes for each mechanical component and enable the user to identify any particular mechanical issues. In many mounts, the principal contributor to PE is the RA worm gear. Often, the motor control board or PC software has a facility to store correction values for each worm-gear angle and replay them during tracking. This is Periodic Error Correction or PEC and although it does not cancel out the PE contribution from the other gears, it does improve the overall level.

Tracking and Alignment

In theory, an equatorial mount tracks a star's movement around the sky with a single motor: A star's declination is fixed and an equatorial mount only has to rotate around the right ascension (RA) axis. (This is true so long as the RA axis points directly to the celestial pole, there are perfect tolerances in the mount system and atmospheric refraction does not exist.) Ours is not a perfect world, however, and two issues, periodic error and drift, compromise performance.

Periodic Error or PE is the consequence of the dimensional tolerances of the drive system in the mount. As the RA motor turns, the imperfections of the mechanics cause

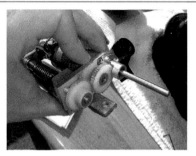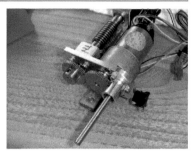

fig.9 This used Meade LX200 telescope was an early model with nylon gears. From accidental abuse, the teeth had worn
badly and needed replacing. On the left the motor, two gears and worm gear can be clearly seen in relation to the large
diameter altitude axis gear. The other two close-ups show before and after the gear drive clean and upgrade.

the mount to run a little fast or slow at different angles and the image does not track perfectly. The error from each part of a rotating system repeats itself each turn, hence the name. These errors combine to form a complex cycle of tracking errors. During a long exposure, these cause a star's image to elongate, to an oval or worse. We measure PE in terms of angular error; typical peak-to-peak values range between 4–60 arc seconds. The more advanced mounts use optical encoder systems and self-correct their mechanical to sub arc second values.

Price and brand are not always a guarantee of good PE performance; many forums bear testimony to the performance differences between identical models, which is an unavoidable outcome of the statistical nature of manufacturing tolerances. In addition to physical tolerances, grit or debris trapped in the lubricant of the gear mechanism can create an abrupt tracking error. Some of the more confident engineers in the community will thoroughly de-grease, clean and re-lube the gear system of a used or even a new mount. This is not a task for the faint hearted and only considered after the warranty situation, ease of access and a risk assessment is completed! After some tense moments, I successfully replaced, aligned and cleaned the gears in my used Meade LX200 to huge effect (fig.9).

My current equatorial mount has a better than average PE and I use Periodic Error Correction (PEC) to improve it further. It is practically sufficient and I'm not tempted to tune the mechanical components further. Even so, for a typical setup, my PE is often larger than the telescope resolution, remaining CCD resolution and astronomical seeing combined. For that reason, deep sky imaging requires autoguiding to remove the residual error and ensure small tight star images. Many specifications focus on the peak to peak magnitude of the PE but the rate of change is often more important, since it is difficult to correct a rapidly changing error through mount motor adjustments.

If the mount's RA axis is misaligned with the celestial pole an additional tracking issue, "drift", occurs. When the rotation of stars and that of the telescope are not perfectly concentric, the stars slowly and steadily drift out of view. The rate of drift is minimized by improving the mount's polar alignment and its sensitivity is also dependent on the star's position. Alignment is covered in detail in later chapters but for now we assume it can be improved through the use of a polar scope, computer assisted polar alignment or by repeated drift-rate observations and adjustment. Some techniques obtain a close but not perfect alignment in a few minutes. High precision drift alignment uses more of the potential imaging time and is a chore in freezing conditions but worth the effort in permanent installations. Some modern mounts track automatically in both axes to compensate.

There appears to be an insatiable interest in perfecting polar alignment and reducing periodic error on the Internet forums. These go to the extreme of replacing or upgrading gears, bearings, complete overhauls of new equipment and extensive use of numerous polar alignment routines. It seems to be a goal in itself to achieve perfect alignment and run long unguided exposures without star elongation. I apply the 80–20 rule to polar alignment and mechanical performance and use autoguiding to correct for both drift and periodic error during exposure. In context, if one tripod leg sinks 1 mm, it defeats advanced polar alignment.

Autoguiding

Practically and within reason, autoguiding corrects for periodic error and drift. Autoguiding, as the name implies, automatically guides the mount to track a star. It is achieved by a small software application that takes repeated short exposures of a star, using a still or video camera, either through a slave telescope or via an image splitter attached to the imaging scope. The autoguider software records the initial pixel position of the star and

calculates small corrections to the both motors after each exposure to correct for any tracking error. These adjustments are sent back to the mount's motor control board, either directly to the mount's guide port connector or via the mount's control software. The improvement is significant; one mount has a (peak-to-peak) periodic error of 12 arc seconds and with autoguiding this reduces to 1.5 arc seconds. The average error is less than 0.2 arc seconds, considerably better than the diffraction-limited resolution of the optics.

Autoguiding is not a cure-all, however; it assumes a reasonable level of mechanical and alignment integrity in the first place and it is a good idea to first check the mount's raw performance and alignment accuracy. For instance, to check the polar scope one could, after a one-time extensive drift alignment, set up the polar scope, as if to perform an alignment and note the precise position of Polaris for future reference.

Dew Control

The need for dew control varies by region, season and by telescope type too. As the air temperature falls at night its relative humidity increases. At the dew-point temperature, air is fully saturated and cannot hold any more water vapor. Below the dew point, excess water vapor condenses onto cold surfaces. Those surfaces which are exposed are worse affected and optical surfaces will not work with condensation on them. Long dew shields (lens-hoods) certainly help but do not entirely eliminate the problem. In reflecting telescopes the primary optics are generally well protected at the bottom of the telescope tube. In the case of truss design reflector, a cloth shroud will similarly shield the primary mirror but the secondary mirror will require mild heating.

Those designs with glass optics at the front will likely need gentle warming; just enough to prevent condensation forming. (You should avoid aggressive heating as it will create your very own poor seeing conditions within the telescope's optical path.) This is conveniently achieved by passing current through an electrically resistive band (dew heater tape) which wraps around the telescope near to the exposed optical surface. The dew heater tape plugs conveniently into a 12 volt power source for full power or a pulsed supply for finer regulation. With dew control, prevention is always better than cure; it is best to turn on the dew heaters a few minutes before you remove the lens cap. Removing condensation takes a lot of heat and the heated surface will then produce image-blurring air currents until it cools down.

Focus and Focusers

Several refractor telescopes from competing companies share the same optical cells, sourced from the same Far-Eastern supplier. Their major difference lies in the other aspects of the telescope. Putting aside optical quality for the moment, these include the finish, internal baffling, sundry accessories and most importantly, the focus mechanism. Precise focus is critical and it took me some time to realize just how important it is for high-quality imaging. A poor focuser design is a source of intense frustration. In the more demanding setups the precise focus position may require updating during an imaging session to account for thermal effects on optics and tubes, as well as any differences in focus between each colored filter.

Focus mechanisms must be a dilemma for telescope manufacturers; the needs of the visual user are less demanding and it makes no sense to design in cost for a performance that is superfluous to many customers. In

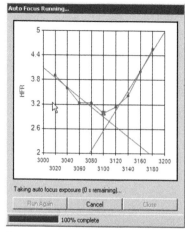

fig.10 Focusing is critical and difficult to do well in all conditions. Here is a "V" curve from SGP of a RCT, where the collimation is a little off. (Centrally obstructed scopes are the most challenging to autofocus and the slopes either side of the minima are not necessarily equal.) The latest versions of SGP's focus algorithms now work well with the "donuts" from out-of-focus SCT and RCTs. V-curves are also employed by Maxim DL and FocusMax (which was a free utility that had a similar proactive community as PHD2). In practice I found it required some effort to make it work reliably and it has since been made into a commercial product by CCDWare. These all work on the basis of acquiring images at different focus settings and minimizing the half flux density (HFD) of a star (or stars) for a range of focus positions. The optimum position is the lowest point, or the intersection of the V-curve. The slope of the V-curve is consistent for an optic. SGP uniquely samples many stars in its autofocus routine but takes a single reading at each focus position.

astrophotography, the combined mass of the imaging equipment places considerable load on a focus drawtube and more importantly, the need for maintaining precise focus and stability. A good focus mechanism is strong, does not slip or flex in any direction under load and, when the focus position is changed, the image should not shift significantly.

Even with a substantial mount, touching the focus knob on a telescope will cause the image to jump about, making assessment tricky. For that reason it is really handy to focus a telescope via an electronically driven motor attached to the focus knob. The better designs use a gearbox reducer and a stepper motor, which enable fine control and absolute positioning, usually via a serial or USB interface. Several companies specialize in upgrade focus mechanisms, with and without motor actuation. Some telescope manufacturers even offer third-party focusers as a point-of-sale option for imaging use.

You might be wondering just how essential is accurate focus for high-quality imaging? A star is smaller and brighter when it is in focus, since all the photons fall on the fewest number of pixels (this also maximizes the signal to noise ratio). It was a revelation, however, to realize just how sensitive the focus position is: As an example, a short telescope of 400 mm focal length and a 100 mm aperture has a diffraction-limited image disk diameter of 2.7 arc seconds. A focus error of 0.1 mm blurs this to a circular patch 13 arc seconds wide, about 5x wider and covering 20 pixels of a typical CCD sensor! Correspondingly, the photon intensity per pixel will be, even accounting for average seeing conditions, about 20x less.

A stepper motor driven focuser controlled by an autofocus program makes the most of the mechanical abilities of a quality focus mechanism. These autofocus programs reliably determine a more accurate focus position and in less time than manual methods and accommodate backlash adjustment at the same time. They vary in sophistication, but most work on the principle of minimizing the width (FWHM or HFD) readout for a bright star. Some programs can save precious imaging time and autofocus with just a few exposures and a prior saved profile with a resolution of 0.01 mm or better.

Essential Software

Software is clearly a necessity for digital astrophotography and at the same time is the most difficult subject to give specific guidance on. The basic applications used in astrophotography are a planetarium, mount controller, image-capture and image-processing. These are only a fraction of what is available: It is easy to collect multiple software applications and utilities like confetti. Many are free or reasonably priced, like the thousands of "apps" for mobile phones. The trick is to be selective; in addition to the essentials, an autoguiding program, polar alignment utility and an autofocus program are the most useful for imaging.

One of the dilemmas with software is there is no consistent feature boundary between software genres and many applications overlap functions with others. The variety and permutations are almost endless. One way to look at this problem is to turn it around and consider the necessary functions rather than applications. Where the functions reside is matter of product selection and preference.

The main planetarium function is to display a chart of the sky for planning purposes, for any geographic time and place, with the essential information for thousands of objects. There are many varieties for computers, tablets and smart-phones. They commonly have additional functions to point and synchronies the telescope mount to an object and show the field of view for an eyepiece or camera. These programs, especially those with high-resolution graphics, use a good share of the microprocessor time and memory as they calculate and update thousands of star

fig.11 The popular SkyWatcher EQ6 mount has what looks like a RS232 serial connector on the facia. This is a serial port but at 5 volt TTL levels and can only be plugged into the SynScan handset or a special interface that operates at TTL levels. The SynScan handset has a second smaller connector to allow external RS232 control, often via a USB to Serial converter. (RS232 operates with ± 12 volt signal levels and direct connection to the mount would damage the motor control board.) There are many USB to Serial converters but not all are reliable in this function. Those from Keyspan or use the Prolific chip-set have favorable reports.

positions each second on screen. Once a system is imaging, there is little need for the planetarium function and the application merely wastes computer power. There are many planetarium program styles; some are educational and graphics intensive, others more scientific in approach, with simpler graphics, aimed at practical astronomers. Several excellent programs are free but those with movies and pretty graphics can exceed £100. Most use or can access the same star catalogs for reference but the controls, ease of use and interfaces vary widely. I often use an iPad application to plan my imaging sessions; the intuitive screen controls and built in GPS are equally convenient in the daytime or at night.

Mount control is an equally diverse function. A telescope mount houses a motor-control board that connects to an external handset or computer, which has the essential functions of alignment, object selection, slewing and tracking. After physical polar alignment, which, say, points the RA axis within 5 arc minutes of the pole, the mount needs to know exactly where the stars are. It already roughly knows, within the field of view of a finder scope, but it needs precise registration to improve pointing accuracy. The basic registration function has two steps; slewing the mount to where it thinks a star is, followed by manually centering the star with the handset controls and synchronizing the mount. Basic registration or alignment calibrates both motor positions for a single star and in a perfect world every other star falls into place. Sadly, mechanics and physics play their part and to compensate, the more advanced alignment functions repeat the registration process with several bright stars in different parts of the sky. A hand controller typically uses three stars to align itself but the sophisticated computer programs use more to build a more accurate pointing model. It is easy to go over-board; ultimately, we just need to place the object we wish to image onto the sensor and then rotate and fine tune the camera position to give the most pleasing composition.

In the case of a mount with a handset you require an external computer interface too, either directly into the mount or via the handset. This is when things become complicated. For example, the popular Sky-Watcher® EQ mount has two software interface protocols; the one between the supplied SynScan™ handset and the mount and a basic one with an external computer. The physical connection possibilities are numerous and are shown in fig.12. In each case, a computer, tablet or mobile device, controls the mount using a simple command protocol. (Mobile devices can control a mount too but are unable to image or autoguide.) For this particular mount, a

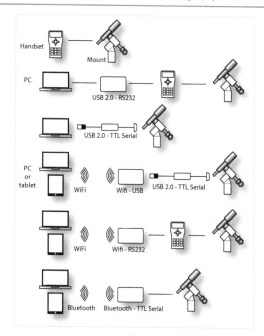

fig.12 There are many ways to physically control a mount; the SkyWatcher EQ series probably has the most permutations and like other mounts has thriving third-party support for software and hardware alternatives. It is a good idea to thoroughly prove your basic connection reliability before attempting wireless connections, which may not be fast enough for autoguiding.

free third-party application EQMOD entirely displaces the handset and allows advanced control of the mount, multipoint alignment, tracking, periodic error correction and guiding directly through a PC interface via wired or wireless interfaces. This program in turn accepts commands from the planetarium and autoguiding applications that are linked to it through ASCOM. This example serves as an illustration on just how complicated these systems can become. For success it makes sense to start off simply and check things work before introducing additional hardware and software complexity.

After mount control, a dedicated image-capture program is desirable for camera control, image download and storage of high bit-depth files. (It is also possible to get by, without specific image capture software, by using a standard camera with a simple cable or timer release.) Image-capture programs allow remote operation and have drivers for most dedicated astronomy cameras, webcams, Canon EOS and increasingly other leading brands of DSLR too. Many photographic cameras are enabled for tethered operation through their USB port.

In addition to the key functions to control exposure and download images to disk, capture programs display

an image preview and provide essential data to gauge exposure, including maximum pixel values, noise levels, star FWHM and image histograms. They can also set and report the CCD temperature and filter wheel position. Many dedicated image-capture programs have a function to disable guiding and sensor cooling during the image download to reduce power supply interference and in turn, amplifier noise in the sensor. Interruptions during a USB image download may show banding on some sensors.

Image processing requires several sequential functions that are performed by the capture software, dedicated image processing software or a standard photographic product like Photoshop. An imaging session produces multiple exposures either in color or as separate monochrome files. Processing these images is a long journey. The key image processing steps are calibration, alignment, stacking and a group of functions that collectively enhance the image. Calibration, alignment and stacking functions are included in several image-capture programs or available as a separate utility. Image enhancement functions also reside in many astronomy programs as well as Photoshop. Here again, many functions overlap between application types and the user has a choice of how to process an image. Photoshop is a universal tool in photography but image calibration, alignment, stacking and advanced processing techniques require dedicated programs. Image enhancement is a huge subject and worthy of its own book and it is important to realize that there is no one way to process an image: Each application has a range of tools for reducing noise, sharpening, enhancing faint detail, improving color saturation and so on, some of which will be more or less effective for your particular image than a similar function in another application. It is an area for patient experimentation on a cloudy day.

There are several utility functions that are particularly helpful in a portable setup; polar scope alignment, autofocus and plate solving functions. I use a small iPad application to determine my location and time via GPS and display the hour angle of Polaris to set up the polar scope. I can polar align my mount in a few minutes and quickly move onto general star alignment.

Of those systems with an electronic focuser, the remote focus application can be standalone or imbedded in the image-capture software. They obtain consistent and accurate focus without the need to touch the focuser. They can also quickly apply a predetermined focus offset to compensate for a change in temperature or filter selection, or perform an autofocus routine between exposures. Some of the recent developments achieve highly accurate focus by using software to analyze the diffraction pattern of a bright star taken through a focus mask.

Plate-solving is a small luxury that delivers extremely quick and accurate alignment. Depending on its implementation in the application, this function provides benefits all-round; precise mount alignment without the necessity of centering alignment stars, effortless mount re-alignment to a prior image, precise automatic image stacking and supernova detection. A plate solving routine correlates the stars in an image with a star catalog of the general area and calculates the precise image center, rotation and scale in arc seconds per pixel. It is smugly satisfying on a cold night to simply polar-align the scope, retire to the couch and watch the telescope automatically slew, expose and self calibrate its alignment with a dozen stars. The satisfaction grows when a slew to the object places it dead center in the image, ready for focus confirmation, autoguider calibration and a night of imaging. It is quite surprising just how useful plate solving is in general astrophotography and although some might claim it to be an indulgence, for me it was important enough to make the move from OSX to Windows 7, to enable effective remote control with a minimum of time at the scope. (TheSkyX uniquely features plate solving in its OSX version.)

Imaging Essentials

Without digital sensors astrophotography would be a very different affair. In a single decade, they have changed the popularity and quality of astrophotography beyond recognition. They deserve a detailed analysis of their workings and shortcomings but just now we consider only the simpler specifications and requirements.

Cleanliness

In the days of film-based photography and darkrooms, with a little care, one could avoid the need to "spot" a darkroom print. Those precautions are still valid today and in digital photography, we need to be equally careful to avoid dirt on the sensor or optics. Astrophotography is more demanding; a dim dust spot on the original image becomes a black hole after image manipulation. The calibration techniques (described later on) that compensate for variations across the sensor can also improve the appearance of dust spots. These techniques work up to a point but are ineffective if the dust pattern changes between imaging and calibration.

A dust speck becomes smaller and more pronounced the closer it is to the sensor and indeed the shadow diameter can infer its position along the optical path. It is easy enough to inspect and clean optics and filters but sensors need more care. Cleaning a sensor is not without

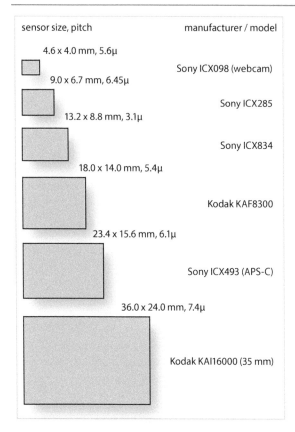

sensor size, pitch　　　　manufacturer / model

4.6 x 4.0 mm, 5.6μ　　　Sony ICX098 (webcam)

9.0 x 6.7 mm, 6.45μ　　Sony ICX285

13.2 x 8.8 mm, 3.1μ　　Sony ICX834

18.0 x 14.0 mm, 5.4μ　　Kodak KAF8300

23.4 x 15.6 mm, 6.1μ　　Sony ICX493 (APS-C)

36.0 x 24.0 mm, 7.4μ　　Kodak KAI16000 (35 mm)

fig.13　CCD sensors used in astrophotography vary considerably in size and will give a different field of view with the same optics. This full scale depiction illustrates some of those commonly used in astrophotography cameras.

focal length [mm]	aperture [mm]	optical FWHM [μm]	+seeing FWHM [μm]	pixel pitch [μm]
400	70	3.8	6.2	2.1
500	80	4.2	7.4	2.5
600	100	4.0	8.4	2.8
700	110	4.3	9.5	3.2
900	130	4.7	11.9	4.0
1,500	200	5.0	19.0	6.3
2,000	250	5.4	25.0	8.3

fig.14　The table above lists some generic telescope configurations and the optimum pixel pitch for resolving stars. The optical FWHM is the diffraction-limited value, calculated for green light. The +seeing FWHM is the combination of the optical resolution and a seeing condition of 2.5 arc seconds. At long focal lengths astronomical seeing dominates the overall performance. A small pixel captures less signal (the pixel size is less than the pitch although its efficiency can be offset somewhat by better micro-lensing). In the case of short focal length scopes, resolution may be a worthwhile sacrifice for better image noise.

risk; they are delicate devices that can be ruined from the wrong cleaning technique. SLR cameras have a mode that expose their sensor for cleaning but a dedicated astrophotography CCD sensor is often inaccessible and requires disassembly to gain access, which may invalidate its warranty. A few dust specs are normal but excessive dust within a sealed camera unit may require a service by the manufacturer. If you do choose to clean your own, proceed with care, check the available resources on how to proceed and observe the normal precautions of a clean environment, natural fiber clothing and static electricity protection. (Some sensors are fitted in a sealed cavity, filled with dry argon gas and cannot be opened without causing potential condensation issues.)

A few sensible precautions reduce the chance of dust build-up. In a portable setup, the camera / filter / telescope are frequently disassembled for transport. Any optical surfaces should only be exposed in a dust-free environment and capped as quickly as possible. It also helps to cap the telescope at both ends and store small items in a clean container with a bag of desiccant. Many cameras have threaded adaptors and protective caps. I find push-on plastic caps are lacerated by the end threads. I use threaded dust caps for C and T-mounts to avoid this potential source of contamination. Screw in covers for T-threads are quite common and an Internet search will locate a source for the less common C-mount caps.

Sensor Size

Camera choice is ever increasing. More DSLRs, mirror-less interchangeable lens cameras, astronomical CCDs and video cameras appear each year. As far as the context of this chapter is concerned, whichever camera you choose, it will have pros and cons. Apart from cost, your choice (or choices), should consider a number of things. One of the surprises to many is the need for a wide field of view to image large nebula and galaxies.

The ratio of sensor size to focal length determines the field of view and although full size (35 mm) digital cameras are now common, many telescopes are unable to produce an image circle large enough to cover a full frame sensor, or do so with significant shading (vignetting) at the corners. Most telescopes have an image circle

that covers the smaller APS-C sensor size. Many of the popular deep sky objects (for example, the Messier objects) will only occupy a part of the sensor area and an image will require cropping for aesthetic reasons. Conversely, very large objects can be imaged by photographing and assembling a mosaic of several partially overlapping exposures, but this takes a lot more time and effort. If you wish to try out different things and if funds allow, two sensor and telescope sizes will broaden the range of possible deep sky subjects, providing the telescope's image circle covers the larger sensor. This is where a telephoto lens on an SLR comes in handy or a medium format camera lens adapted to fit a CCD for those few wide-field shots.

Pixel Size

The sensor pixel size (pitch) affects image resolution and can limit the overall optical resolution of the combined optical system and prevailing seeing conditions. If the pitch is too large, the resolution is compromised, too small and fewer photons will land on each pixel for a given exposure, with the outcome that electrical noise is more noticeable. Large megapixel counts sell consumer cameras but in the case of astrophotography, less may be more, as the pitch has to decrease to accommodate more pixels within the same area. In general terms, for a sensor to resolve the light falling on it, with small optics the sensor's pitch should be about 1/2 that of the telescope's diffraction limit (FWHM) and for larger telescopes, about 1/3 of the typical seeing conditions. The table in fig.14 suggests the theoretical pixel pitch to match the resolution of some focal length and aperture combinations. In practice, using a sensor with a larger pitch size (or "binning" a sensor with a small pitch) can improve image noise and lower resolution.

Sensitivity

The sensitivity or quantum efficiency of a sensor is a measure of its ability to convert photons into electrons. It changes between models and varies with wavelength. High efficiencies are obviously desirable for visible wavelengths and especially, in the case of deep sky objects, deep red wavelengths associated with Hydrogen Alpha (Hα) emission nebula. Typical peak values for sensitive CCDs are in the range of 50–75%. Many popular SLRs have built-in infrared cut-off filters that reduce their Hα sensitivity to about 20%, although these filters can be replaced or modified by third-party specialist companies to improve Hα sensitivity. The benefit of a high efficiency is twofold; shorter exposures and better image noise from a given imaging session.

Image Noise Reduction

Sensors are not perfect and teasing faint details from an image's background places extreme demands on the initial file quality. Of the various imperfections, sensor noise is the most detrimental to image quality. If an exposure has a poor signal to noise ratio, it will show up clearly in the final manipulated image. Noise refers to any additional unwanted image-forming signal and is typically made up of constant and random elements. There are several sources of noise in a camera system, each of which has a unique effect and remedy. The two most significant types of sensor noise are thermal (dark) noise and read noise.

I have to digress to explain a little about noise, even though it is explained in a later chapter. Thermal noise adds random electrons to each sensor pixel. The average count increases linearly with time and temperature and its randomness also increases. In many sensors, the electron rate per second doubles for each 6–8°C increase. To combat this many imaging CCDs have cooling systems that lower the temperature by 20–40°C. This significantly reduces the average and random level of non image-forming electrons. (In comparison, consumer cameras do not have cooled sensors and their electronics warm up with extended use.) The average level of thermal noise can be removed from an image by subtracting a dark-frame (an image taken with the lens cap on) using the same exposure duration and sensor temperature. Unfortunately this does *not* remove the random thermal noise.

Read noise originates in the interface electronics and is present in every exposure, including zero-length exposures. Again, there is random and constant element. The random noise level is a critical specification for astronomy CCD cameras and as discussed in the prior chapter, low levels increase the effective dynamic range. The constant element is called bias noise and like dark noise, can be subtracted. Out of camera, the image forming photons themselves have noise, referred to as shot noise.

The key to remove any random noise is to take multiple exposures and combine them. Combining (averaging) the results from multiple events reduces the randomness. It is standard practice to acquire and combine multiple exposures to reduce random image noise. For each doubling of the exposure count, the noise of the averaged images reduces by 40%.

So, to reduce all forms of image noise requires a series of calibration and averaging processes:

1 average multiple dark-frames to isolate the mean temperature and duration contribution for each pixel

2 average multiple zero-length exposures to isolate the mean electronic circuit difference (bias) between pixels

3 acquire multiple image exposures

4 subtract (calibrate) the mean effects from each image frame, pixel by pixel

5 average multiple, calibrated image frames to reduce the random noise, (think smooth)

The sensors and exposure chapter, as well as the one on image calibration explain things in more detail.

Calibration

Image calibration improves image quality as part of the process to reduce image noise. In addition to reducing thermal and circuit noise, it also addresses a third source of imperfection caused by the small gain variations between pixels. Each pixel signal is amplified and sampled into a digital signal and small variations, including the effect of optical transmission, dust spots and reflections affect the perceived signal strength. Luckily, this is measurable from another set of exposures, this time taken of a uniformly lit target. These image "flats" are used in calibration to normalize each exposure by applying a correction factor, rather than an offset, for each pixel.

Image calibration requires some effort on the part of the astrophotographer and makes good use of a cloudy day. It requires many exposures to measure the average image errors for bias noise, dark current and the system gain for each pixel on the sensor. A complete set of calibration files

fig.15 *This filter wheel (shown with the cover removed) is inserted between the field-flattener and the sensor. A USB-controlled motor positions each filter over the aperture. An off-axis guider mirror can be seen behind the UV/IR filter. The guider camera is screwed in place of the silver cap on the right.*

may take several days to generate but can be reused, with care, for many imaging sessions with the same optical setup. These files are statistically averaged and the calibration process uses these image files to subtract and normalize the pixel anomalies within each of the image files before alignment and combining (stacking).

Camera Filtration

Color images require color filtration in one form or another since all photo sensors are monochromatic. Color cameras achieve this with a fixed RGB color filter mosaic (Bayer array) precisely aligned in front of the sensor elements. An unfiltered sensor requires three separate exposures, taken through colored filters, one at a time, to form a color image. A common solution is to fix the filters in a carousel or filter wheel directly in front of the sensor, a kind of cosmic disco light. Later, combining the three separate images during image processing forms a color image. In the latter case, separate filtration provides additional flexibility when we replace the common red, green and blue filters with specific narrowband filters, tuned to the common nebula emission wavelengths.

Filters can also reduce the effect of light pollution. Light pollution comes from all light sources, the most prevalent of which are from low-pressure sodium and mercury-vapor street lamps. Luckily, these sources emit distinct wavelengths that do not correspond to the nebula emissions but do unfortunately adversely affect images taken with sensors fitted with Bayer arrays. Light pollution filters block the majority of these unwanted wavelengths but transmit the remaining visible spectrum. They are not a perfect solution and require careful color correction during image processing. Separate RGB filters and narrowband filters also minimize the effect of common light pollution wavelengths by using carefully selected transmission characteristics. In particular the red and green filter pass-bands exclude the yellow sodium-lamp wavelength.

Interface and Software Support

Modern astrophotography CCDs use USB 2.0 interfaces and come with Microsoft Windows drivers. In addition, there may be an ASCOM driver for the camera and additionally, dedicated driver support within the imaging software. ASCOM in their own words is "a many-to-many and language-independent architecture, supported by most astronomy devices which connect to Windows computers." In basic terms, standards help with inter-connectivity and reduce software development costs. There is no equivalent in Mac OSX but there is no reason why it could not be done. As such, hardware

support in OSX is highly dependent upon the individual image-capture and planetarium software provider.

Consumer cameras are a mixed bag and some are capable of remote operation or image download through a USB interface. Although low cost T-adaptors exist for most camera bayonet mounts, remote triggers and compatible remote control software do not. In the case of my Fuji X cameras, although tethering software exists, it is awkward to use for long-exposure astrophotography.

Optics

The optical design of a telescope is quite different from the telephoto lenses we fit onto photographic cameras. Although they have longer focal lengths, those with simpler optics with a few elements are optimized for visual use but not for imaging onto a large sensor. (Photographic lenses are also optimized for a focusing distance of about 20x their focal length, whereas telescopes are optimized for infinity.) Most telescope designs, either based on glass optics (refractors) or mirrors (reflectors) require additional optical modules in the optical path to produce round, tightly focused stars from corner to corner on a flat sensor. When I started astrophotography, I incorrectly assumed the touted benefits of apochromatic and triplet designs implied excellent imaging quality too.

In the scope of this chapter the telescope choice is the sum of its parts: The principal characteristics, its aperture and focal length need to match the imaging field of view and the focuser design needs to be robust enough for imaging. As far as the optics are concerned, there are some differences between designs. Apochromatic performance will reduce color fringing on color

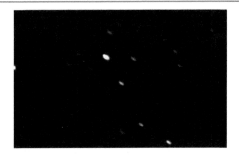

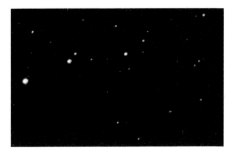

fig.16 These three T2-adaptors for Fuji X, Micro 4/3 and M42 cameras have different lengths to compensate for the varying camera lens mount to sensor distance. They ensure the T-thread to sensor distance is the same 55 mm distance. Many field flatteners are deliberately optimized for a flange to sensor distance of 55 mm.

fig.17 The top two images were taken from a short (500 mm) focal-length APO refractor, without and with a field-flattener. The top image shows the effect of a curved focus-plane at the corner of an image, the image beneath has been optically corrected. The two 3D plots were generated by CCDInspector® software, which calculates the plane of focus from the shape of the stars in an image. The slight tilt in the plane of focus, which can be seen in the bottom plot, is likely to be attributable to a droop in the clamp and lightweight focus mechanism.

sensors though it is of lesser significance with narrow band or LRGB imaging. Some optical configurations are naturally better suited for imaging but in the case of many, a good telescope for visual use is not necessarily the last word in imaging.

A standard refractor telescope has just two or three glass elements at the front end and irrespective of its optical prowess, focuses light onto a curved plane. When stars are in focus in the middle of a flat sensor, the stars near the edge are elongated and fuzzy (fig.17). A long focal length or small central sensor will be less sensitive to these issues but shorter scopes / larger sensors will show obvious focus issues and distortion at the image periphery. For imaging purposes, you need a special lens module, called a field-flattener, which is fitted just in front of the sensor. Field flatteners typically have two or three glass elements and have a generic optical design compatible with a range of focal lengths and apertures. Some advanced telescopes, (astrographs) incorporate these additional elements within the telescope body and are specifically optimized for astrophotography. Some field flatteners also change the effective focal length. Most are "reducers", which shorten the effective focal length, give a wider field of view and improve the focal ratio. The most common have a power of about 0.8x. There are two other common sizes 0.63x and 0.33x especially suited for the longer focal lengths found on Schmidt-Cassegrain Telescopes (SCTs).

The distance between the field-flattener and the sensor is critical for optimum performance and it takes some experimentation to find the best position. The reward is sharp round stars across the entire image. The camera-end of a field-flattener is often fitted with a T(2)-thread that assumes the sensor spacing is 55 mm. There are many compatible camera adaptors (fig.16), which automatically maintain this sensor spacing but in the case of filter wheels and astronomical CCDs, some careful measurement and juggling with spacers is required to find the sweet spot.

In the case of most Newtonian reflector telescope designs, the principal imaging aberration is coma. As the name suggests, stars assume the appearance of little comets. The issue is more apparent at the image periphery and with faster focal ratios. This is not a flaw in the optical elements as dispersion is for glass optics; it is physically not possible to design a parabolic mirror that eliminates the problem. Again, larger sensors are most affected and in a similar fashion to the issues with simple refractors, a coma corrector lens reduces the effect when placed in front of the sensor. Some coma correctors are optimized for imaging and have additional lenses which improve the field flatness at the same time.

The Newtonian reflector is the granddaddy and there are many derivative designs, with folded light-paths and additional lenses at the top end or sometimes in the focus tube, to trade-off optical defects (aberrations). Some of these designs replace the parabolic and plane mirrors in a Newtonian with hyperbolic or spherical mirrors. Each is a compromise between economy and performance. As manufacturing methods improve, designs that were previously reserved for professional observatories have become affordable to the enthusiast. At one time it was the APO refractor, then the Schmidt Cassegrain, now it is the turn of the Ritchey Chrétien design, with its pair of hyperbolic mirrors, the most famous of which is that used in the Hubble Space Telescope. Some designs have wonderful double-barrelled names and are worthy astrographs and are described in greater detail later on. Depending on the configuration, a purchase may require an additional corrector lens to ensure pinpoint stars on large format sensors.

Setting Up and Note Taking

The setup process for a portable system is extensive. In my location, imaging opportunities are sometimes weeks apart, if not months and it is easy to forget an essential step that causes a hang-up later on. Using a simple checklist is a simple solution or, for more advanced users, set this all down into a small program (scripting language) that runs like a macro in Windows. Automation is fantastic until something goes wrong, so it is best to pursue that goal after you one is satisfied that the system is reliable during manual operation.

Note taking is a basic and useful activity. Although most imaging software includes essential information in the image file header, a few choice notes help with future setups. Some imaging software, such as Maxim DL and Sequence Generator Pro save setup "configurations"; storing all the hardware and software settings in one click. In the same manner, some autofocus programs do the same; focusing algorithms can re-use saved focus information and "V" curves from a prior session, assuming it has the same optical configuration.

In addition to manual note taking, most programs produce a log-file. These are stored as simple text files and are a useful resource for debugging problems and as a record of activity. Many software providers ask for a copy of the log file before they will actively debug code. In the case of autoguiding, log files document the telescope pointing error after each autoguider exposure. A number of utility programs can interpret this log to produce a periodic error characteristic for your telescope mount or recommend backlash and other settings.

New Tools

An exciting time, when new products and concepts challenge the establishment.

Over the last few years, a plethora of new technology and books have hit the shelves. Astrophotography has not yet reached the point of saturation in the marketplace and, unlike digital photography in general, each year brings genuine advances in the functionality, performance and value of both equipment and software. The emergence of new tools and processes since the first edition was published has generated another books-worth of content. The following reflects upon some of the latest trends, some of which are reviewed elsewhere in more detail. At the same time, despite the advancing commercial offerings, there is still room for practical projects, novel invention and customization.

Software

Imaging Software

Arguably, it is software that has progressed most significantly. Towards the end of 2014, an increasing number of users discovered the elegant power of Sequence Generator Pro and the revamped guiding software PHD2. For me, these displaced Maxim DL5 as my acquisition software of choice and its ease and reliability enabled me to meet my publishing deadlines. In a poll of PixInsight users, SGP featured strongly as the imaging software of choice. Its functionality has continued to evolve and yet it maintains simple ergonomics and reliability. Increasingly, these acquisition applications are integrating free plate-solving software (Elbrus, PlateSolve2, Astrometry.net) to improve pointing accuracy and assist with meridian flips. Increasingly, at their respective levels of sophistication, these apps are great value and all that one needs, unless there is a compelling need to use a separate application to automate data acquisition or control complex observatory systems. Even here, armed with a little knowledge, custom designs are within reach of those with some technical skills. This is not the only application to improve; the authors of APT and Nebulosity have also been busy updating their data acquisition programs with added functionality and broader compatibility. At the same time Software Bisque has continued to develop TheSkyX and crucially, for some, slowly expanded the hardware compatibility for the Mac OS X platform. Maxim DL also released a

version 6 with task multi-threading, to improve device responsiveness. Its extensive application interface often makes it the choice of professionals using automation programs such as ACP. As hardware prices tumble, increasing numbers of astrophotographers are using multiple systems to make the most of the weather and, on the horizon, is the prospect of acquisition programs being able to coordinate multiple imaging devices. BackyardEOS has also gone through several iterations and offer a fuller feature set, including a version called BackyardNikon.

PHD and FocusMax were two popular freeware programs. Time moves on and PHD2 is now an open-source program that has developed into a sophisticated fully-featured guiding program by expanding on its core strengths but without losing its "Push Here Dummy" simplicity. PHD2 development coincided with SGP's and collaboration resulted in the two programs interacting seamlessly. FocusMax has been updated too, with a less cluttered interface and wider compatibility. It is now a commercial application though, available from CCD-Ware, and is more expensive than Sequence Generator Pro (that has its own improved focus algorithms). Not all software-assisted focusing works by minimizing the star diameter (FWHM or HFD value); software-assisted Bahtinov "grabbers" can now evaluate camera images and determine the optimum focus position. Some, like those from GoldAstro, have re-engineered the diffraction mask principle and optimized it for computer image analysis. In good seeing conditions, its enhanced design can discriminate within the depth of focus, as well as provide useful collimation information at the same time.

These data acquisition programs often benefit from plate-solving programs and the choice continues to expand. At the time of writing PinPoint was the paid application with Elbrus, AstroTortilla and Astrometry.net being the popular free apps (TheSkyX professional has a built-in one). Since then, locally served PC-based versions of Astrometry.net allow all-sky plate-solves without the need for an Internet connection and Plate-Solve2, generously provided by PlaneWave Instruments® is another free alternative. PinPoint has evolved too, increasing its compatibility with different catalogs (USNO A2.0, UCAC 2,3,4) and using Astrometry.net

to kick-start its own plate-solving algorithms that rely on an approximate starting position.

Most astronomy software at the time of writing is 32-bit, though the majority of operating systems they are currently running on are 64-bit. A transition is required at some point as applications need to access more memory, for instance to support scientific pursuits such as exoplanet hunting, which requires comparing multiple images. For older applications, that have evolved over several platforms, making the change is a big deal; others, with well-written C# code (pronounced C-sharp) may accomplish this with comparative ease.

Environmental Software

All these advances are somewhat irrelevant if the weather is poor, or the user misses an opportunity to make the most of a clear night. Weather forecasting has become ever more sophisticated and available. The Internet has dozens of specialized weather applications and websites, offering useful information for astronomers, including light levels, seeing conditions, humidity, cloud (of course), moon and satellite timing. Some specialize in short-term forecasting, up to 15-minutes ahead, that can offer warnings of approaching showers or squalls. It is now possible to get a weather feed directly into the imaging software from *www.openweathermap.org* through an ASCOM driver.

An Internet connection is not always available and on the hardware side, weather sensing has also become an integral part of the astrophotographer's arsenal. High quality solid-state pressure, temperature and humidity measurements not only provide ancillary information for image headers but the data itself can be used dynamically by advanced mount systems to update the refraction parameters of its pointing or tracking model. Infrared, capacitive and ultrasonic sensors are now common place to measure sky temperature (and hence cloud cover), rain and wind speed respectively for safety systems. These monitor sky conditions and allow data acquisition programs to execute start-up or shut-down sequences to park equipment, warm up cameras and close roof systems. To enable this to happen effectively, collaboration between the ASCOM community and hardware providers recently agreed on standards to not only define common environmental parameters and protocols but also allow for future expansion as control systems become even more advanced. Environmental data is essential information for building a pointing and tracking model that accommodates changes in atmospheric conditions. Lastly, PC clocks are not particularly accurate and can drift by several seconds over a week. In order for a mount to point accurately, without closed-loop syncing, requires an accurate clock. On boot-up, an automatic internal clock adjustment, using any one of the web-served Network Time Protocol (NTP) servers, sets things up within fractions of a second.

Processing Software

The processing programs also continue to evolve. In 2015, the PixInsight program proposed a revised form of FITS file that promoted an extended capability (XISF). It is a bold move, the FITS file format has been around for 35 years! Individual tools in PixInsight continue to be refined, or dropped in favor of new tools, and just as importantly, enterprising users have found ways of combining these tools using scripts to implement advanced features, some of which will be familiar to Photoshop users. Adobe continue to develop Photoshop, slowly increasing the amount of 32-bit support. It suffices for many, but I prefer the optimized astrophotography tools offered by the dedicated programs. In the last year Serif, an established software company, has launched Affinity, an image processing application for digital photographers. It is keenly priced and available for both Mac, PC and iOS platforms. It is quickly picking up many admirers and for the astrophotographer, offers high-bit and stacking options. It is well worth investigating.

Hardware

Mounts

Mount design has moved on too. At the top end, optical encoders are increasingly being used for high precision pointing and tracking or effectively removing periodic error. This technology is migrating downwards to give lower-end mounts a sense of direction at power up, improve pointing accuracy and to give the larger Dobsonian telescopes the ability to locate objects more easily. It used to be the case that a small mount was a "lightweight" performer too. With the growing number of amateur users, a number of manufacturers have produced more portable mounts that inherit the qualities of their larger siblings, Paramount, SkyWatcher and iOptron amongst others.

An increasing number of super-compact new models cater for camera users, typically with RA-only motors and with ST4 guider interfaces, ideal for wide-field imaging and travelling. Typically they assume the user will use a stout photographic tripod and tripod head. Even though some have polar scopes, drift arising from the typical alignment errors set an upper limit for the exposure time. In these cases, long exposures are only practical with wide angle lenses and proportionally less for longer focal lengths. With environmental imaging in mind, some units, like the SkyWatcher Star Adventurer offer

partial tracking rates which provide a nice compromise for wide-field landscapes; by equally blurring the sky and landscape.

Some "out of the box" thinking has been applied by iOptron and Avalon to the geometry of the traditional German Equatorial configuration, which allow for compact systems and remove the traditional equatorial mount constraint of imaging through the meridian. With aircraft luggage restrictions and premiums, the AstroTrac® system is another re-think that produces a very compact travel unit for wide-field imaging.

With wide-field imaging, periodic error is of lesser concern than overall drift. The QHY PoleMaster has turned polar alignment on its head and is an enabler for portable systems to polar align in minutes to an accuracy of a pier mounted system and without using plate solving. Its simplicity masks an ingenious and robust alignment procedure and it relies upon tracing a star's rotation about either celestial pole to determine the true center, determines the hour angle and then provides a magnified view to center the alignment star using the mechanical adjusters on the mount.

Imaging Hardware

Not surprisingly, advances on the optical side are no less significant but less radical. There are an increasing number of affordable 5-element astrographs with modest apertures, Ritchey Chrétien prices continue to fall and more companies are concentrating on modified Dall-Kirkham reflectors, to improve on the usable field of a dual mirror configuration. As customers become more discerning, companies have responded to the criticism of poorly designed and assembled focusers and switched to precision rack and pinion designs to avoid slippage. (Focus control systems have proliferated too as folks work out that most stepper motors conform to a standard arrangement of four motor coils.) Takahashi are still the dominant player for quality wide-field, large aperture instruments but more affordable alternatives are closing the performance gap.

On the camera side, things become interesting. Many dedicated astrophotography cameras take advantage of CCD sensors, made for consumer cameras that had their brief moment of fame in the last decade. I cannot think of a current digital SLR or mirror-less camera model that uses a CCD. A new form of imaging, using thousands of short exposures from a high speed CMOS camera is finding favor with some, since it can be used to side-step guiding issues and seeing noise. CCDs are, however, still being developed, especially in the smaller sizes and almost entirely by Sony. These sensors have extremely low read noise and pack 9 or 12 MP into a sub APS-C chip. Full-frame SLRs using CMOS devices continue to drop in price and many opt for these for creating panoramas of the Milky Way. Up until recently, Canon was the only DSLR company to introduce astronomy-orientated products in the form of the APS-C chipped EOS 20Da and more recently the EOS 60Da. In the last year Nikon has entered the fray with its full-frame Nkon D810A camera. Though few telescopes support the field of view, full-frame digital SLRs continue to lower in price. The larger sensors have a high pixel count yet retain sensible pixel spacing. Although most digital cameras can be pressed into service, it really helps if the imaging applications support their operation over USB. At the same time small video cameras, suitable for solar planetary imaging are becoming increasingly available but the high data rate and USB3/Firewire interfaces pose a challenge for some computer hardware as well as the fact that some video capture devices do not readily comply with common media protocols.

Hardware (Other)

Moore's law (from 1965!) is still resonant today. Current computing trends continue to shrink PCs. Of particular note to astronomers are the range of miniature PCs, designed for media use, that pack a full solid-state Core-I5 or I7 system in a small box just 4" square. At the same time, used with some care, they consume just 8 W of 12-volt power and are ideal for extended battery operation. Even smaller, PC sticks are capable of running Windows for data acquisition and control. The more enterprising engineers amongst us have also discovered the benefits of low-cost robotic computing units in the form of Raspberry Pi and Arduino units. These are being used in a number of configurations to control observatories and make remote operation a joy, a practical example of which is shared in a later chapter.

Beyond Imaging

Interestingly, as amateur systems become more reliable and repeatable, they are increasingly being used for research purposes. Professional observatories simply cannot cover the entire sky all the time and in the case of exoplanet searches, private observatories are collaborating to measure tiny fluctuations in a star's brightness that may imply a planetary transit. There are many variables at work here and it requires a statistical body of evidence to confirm the momentary but cyclic fluctuation in output. Just think, aliens on that planet may be measuring the momentary reduction in the Sun's apparent brightness as the Earth transits! In a more light-hearted manner, some astrophotographers are adding the distance information

from the astrometry data into their images to create the illusion of 3-D. A friend and colleague agreed to show how in one of the practical examples. The printed page is not the ideal medium for showing the end result and the outcome is available on the supporting website at: *www.digitalastrophotography.co.uk*

New Instrumentation Interfaces

INDI

The Instrument Neutral Distributed Interface (INDI) provides a framework for the control of various devices relating to astronomy and astrophotography. It has been around for a while but only recently has started to gain momentum, notably by the PixInsight development team.

In very simple terms it tries to accomplish the same as ASCOM does for Windows, and more, since this open source library is based on XML and is uniquely cross-platform. Its library currently supports Linux, BSD and OS X. (Windows support is in progress.) Like ASCOM, it is heavily reliant on contributions by 3rd parties rather than being developed by a commercial entity. Unlike ASCOM, it is not universally supported by hardware manufacturers and at the moment the list of supported devices is modest, but increasing.

INDI is very compact too, with some users running full imaging systems from a Raspberry Pi credit-card sized computer. These units were designed to promote computer science in schools and developing countries, with a modest 1GHz clock rate and up to 1GB RAM. They run Linux and support programming in several languages. If one keeps things simple and the programming overheads low, it is amazing what one can accomplish with low power devices. Those astrophotographers with a science or computing background and with time on their hands may find product development a fascinating avenue in which to expand their hobby interests and to meet specific needs. Others may relish the possibilities for distributed systems and automation outside of the classic Windows environment. A glance at the website *www.indilib.org* is filled with jargon and obscure (to some) references and confirms that this is not yet a system for those who want to plug and play. I am confident that will change in time.

ASCOM Web

The motivation behind INDI is also stirring in the ASCOM community to address its outdated dependence on one operating system. It is hard to miss ASCOM in astrophotography, even if one is using a Mac and one of the few applications that has drivers for your hardware.

ASCOM's set of interface definitions have been around for many years but is limited to Microsoft Windows platforms. Today ASCOM clients and drivers communicate through a protocol called COM (and increasingly .NET). This allows the client application and drivers to be written in different languages, providing a considerable degree of flexibility. The drivers can run within the application process or outside in a server process (in process and out of process) but in both cases, the application and driver are constrained to run on the same PC. Remote operation is possible, as with all windows programs, using Microsoft Remote Desktop, TeamViewer or similar. In these applications, it is only the human interface that is remote and the application and driver are still on the PC and the applications run on the Windows platform.

The solution (yes, you guessed it) is the Internet. In this case the Internet (or local area network) is used to communicate between client applications running on any number of platforms and a PC server process that runs the COM driver and connects to the hardware. To do this securely, it is proposed that the communications between the applications and the driver use standard secure http protocols with JSON data encoding. This requires a little work at either end to encode and decode the data passed between the driver and the application, as well as other Internet software to ensure security and access control.

With a little ingenuity, this latest venture allows an application on virtually any portable or alterative platform to control astronomy devices via a PC hardware interface. By moving the resource-intensive applications to a remote device it additionally allows one to use local PC bricks or sticks at the observatory site, solely running the hardware interfaces via an Internet connection.

Revolution

Change is the only constant. That applies to hardware and software and in the coming years I think it is likely that small enterprises will challenge the dominance of the established players in the market. This is especially true in software as it requires less financial investment and will be perfect for retiring professional software engineers. For users that are more discerning or with more specialized needs, simply making products more affordable is not enough. As the customer base becomes more experienced, they will distinguish between user and product error and challenge the industry to reduce manufacturing variability and improve reliability. With many public forums on the Internet, it is increasingly difficult to hide poor customer service or products. To quote the late Douglas Adams, "Technology is a word that describes something that doesn't work yet."

General Equipment

I have found it is an unnatural act to keep to a budget, make the right choices (at the beginning) and prioritize correctly.

In any hobby, there is a legitimate enjoyment from choosing and owning well-made equipment as well as using it to its full potential. In some, however, equipment comparisons become excessively dominant and a jousting contest between rival camps. Fortunately, I see little evidence of that between astronomers, who are more pragmatic in outlook and generous to each other with praise and encouragement, regardless of their hardware. In the previous chapter, the essential ingredients identified for astrophotography should, in theory, guide the user with their equipment choice. Telescope and mount comparisons are a popular subject covered in many general astronomy books, my favorite being *Stargazing with a Telescope* by Robin Scagell, which evaluates the essential equipment for astronomy. This book has invaluable and pragmatic advice on the various choices of general equipment from the author's extensive experience. Equipment choice and budget is a purely personal thing; what works for one may not be the optimum for another and as with photography, the best system is the one you use, not the one you stroke affectionately in its box (which is why my large format camera ended on eBay)! Astrophotography in particular has specific needs over general visual astronomy and without unduly repeating what has already been published, fig.1 suggests the key items for the astrophotography shopping-list to suit a range of budgets and sophistication.

Spoiled for Choice

The U.S., Japan, Russia and to a lesser extent Europe are the main players in optical design. The top-end equipment is often hand-crafted in the county of design but where there is potential for economy of scale, typically at the middle and lower end of the market, component manufacture is moved to the Far East. These components mostly comprise optical cells, castings, turned metal parts and labor-intensive assembly operations. In some cases, several companies will use the same optical cell, or an entire assembly will be re-badged with minor cosmetic changes. To achieve the required price-point, telescopes and mounts are value engineered and it is this rather than the actual source country that sets the quality level. This essential thrift affects component assembly tolerances and component finish. This is not altogether a bad thing,

since it provides us with an opportunity to purchase a functionally OK part, at a discount price and spend time and resources tuning and upgrading it as required. As with most things there is a law of diminishing returns and also a level beneath which the product is best avoided altogether.

Dealer Choice

Perhaps the most important part of a key purchase decision is who to buy it from. Dealer choice is an important consideration. The specialist dealers are often practicing astronomers with hands-on knowledge. These are more than box-shifters and give pragmatic advice depending on your needs. I'm a strong believer that if you value their service, they should have your business. In the UK at least, I have found the dealers to be refreshingly collaborative and an enquiry with one will lead to another that has stock or deals with a different brand that better suits your needs. On several occasions this advice has made me rethink my requirements and avoided costly equipment overkill. This is a very different experience from those special deals one finds in a newspaper advert or ordering from a catalog, which sells everything from furnishings to electronics. Small telescopes are increasingly available in photographic stores too but these retailers are less likely to offer meaningful advice or after-sales help. Astrophotography is still testing the boundaries of feasible economy and customer equipment-tuning and adjustment is part of the game. It is generally not a plug'n'play experience, as it is with computer equipment and digital cameras. A bargain is not a bargain if you make the wrong choice or you are unable to use a product to its full potential. As a result, the experience and backing of your dealer easily outweigh their premium over a discount warehouse or grey import deal.

Specifications and Misleading Claims

As the customer base becomes more educated they are, at the same time, more susceptible to the allure of "badges", especially at the lower price points. The potential buyer should be aware that the execution (by which I mean design and implementation) of a feature is as important as the feature itself. Telescopes with fancy glass names or designated as "APO" may not perform as well as a

first steps	hooked	obsessive	consumed
lightweight equatorial mount with motorized RA axis, and tripod	heavier equatorial mount with computer control over both axis, sturdy tripod to match	heavier duty mount, axis encoders and heavy duty tripod	pier mounted heavy duty mount (installation) in observatory
small aperture (60–80 mm) telescope or camera optics	4-inch apochromatic refractor or 6–10 inch reflector with fine focus control	big aperture APO refractor, reflector or astrograph, high-quality motorized focuser	wide aperture APO refractor, or folded reflector astrograph, with piggy-back short focal length APO for wide-field
diagonal and reticle eyepiece for alignment	guidescope and guider camera / module	off-axis guider	off-axis guider / sky model
telescope to camera adaptors (if required) including telescope to T-adaptor and T-adaptor for camera	field flattener or coma reducer to suit telescope, focus spacers	integrated correction optics or screw coupled for rigidity	permanent installation, channeled wiring, remote operation through wired slave computer or relay
camera (preferably with a re-movable lens) and or webcam	CCD camera or digital SLR, controlled through USB	cooled large CCD camera or CCD video camera	integrated large format cooled CCD with filter wheel a adaptive optics guider
remote release for camera, spare batteries or USB cable and PC for control	computer system, with USB or serial control of cameras and telescope	computer system controls positioning, alignment, focusing, guiding and image capture	total software control of all functions, automated scripting and remote operation
PC, smart phone or tablet with planetarium software	PC controls telescope and guiding functions	automatic multipoint scope and polar alignment	house in the country
light pollution filter (either screw-in or clip in (for Canon cameras)	dew heater, manual filter wheel for monochrome CCD, narrow band filters	USB controlled filter wheel for monochrome CCD, range of RGB and narrowband filters	travel abroad to take advantage of dark-field sites and special events
simple image processing software, for image stacking and manipulation	image capture software, with calibration, alignment and stacking features	autofocus, astrometric, platesolving and supernova detection features	a considerable amount of spare time, money and an understanding spouse
£1,000+	£3,000+	£9,000+	£20,000+

fig.1 *This slightly tongue-in-cheek table of suggested systems classifies the level of sophistication and cost from aspiring to committed astrophotographers. The pricing is a conservative guide only and assumes a mix of new and used equipment and is not dissimilar to enthusiast and professional DSLR outfits. This can be a starting point to help plan the overall budget for your setup.*

well-executed simpler design. The same applies to mount design. For the astrophotographer, there is little merit if a mount with an integrated handset and an amazing deep sky database is not capable of slewing and tracking a star accurately under load.

In essence, the would-be buyer has to do some background research; the on-line forums are a good place to discover if there any obvious equipment short-comings and at the same time, the bargains. Since everything has to come together to make a successful photograph, an Internet image search for say a globular cluster and the model name will show what is possible. For instance,

some otherwise optically excellent telescopes are let down by their focuser. It is not uncommon to find an upgraded used model in which the improvements have already been implemented by the first owner. Purchasing used models and accessories in general can be very useful but keep in mind that refractor models age better than mirror based designs. On-line astronomy classifieds do provide some measure of seller feedback, as does eBay, but rogue sellers do exist. Face-to-face selling is preferable, especially if the equipment is delicate and prone to damage from shipping, usually as a result of the original packaging having been discarded.

Mounts and Mounting

The choice of mount is more important than that of the optics. It will ultimately limit the quality of your images through its ability to track accurately and support the telescope assembly without wobbling. The mass, maximum load and price often correlate and for portable setups, a conscious compromise is required on this account. If the budget allows, my advice is to buy better than you initially need, so that the next telescope upgrade does not trigger an expensive mount change at the same time.

Mounts used by amateurs for astrophotography come in two main types, both of which are polar aligned. These are the German Equatorial Mount (GEM) and a fork mount & wedge combination. Figs.2 and 5 show the main features of both, in this case, setup for general visual use. (For astrophotography, the diagonal and eyepiece is removed and replaced with the optical correctors, filter and camera system.)

German Equatorial Mount

This is perhaps the most common all-purpose mount for amateurs. In this case, "amateurs" refers to small to medium mounts; the very largest professional observatories use fork mounts and camera rotators for economic and practical reasons. The GEM is compatible with both refractor and reflector telescope designs and has the useful capability of simple polar alignment through a polar scope, aligned with its motor axis. An advantage of this simple polar alignment is that the tripod does not have to be precisely levelled and orientated towards the celestial pole. The telescope attaches using a dovetail adaptor plate that come in two standard sizes; Vixen (31 mm wide) and Losmandy (75 mm wide). Since the mount, tripod and telescope are separate, the smaller, lighter components also facilitate transport and storage. Price, size and mass vary enormously; the lower-end models may use low-pressure aluminum castings, plastic and mild steel

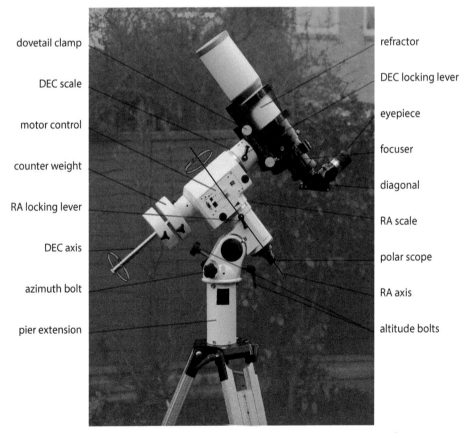

dovetail clamp

DEC scale

motor control

counter weight

RA locking lever

DEC axis

azimuth bolt

pier extension

refractor

DEC locking lever

eyepiece

focuser

diagonal

RA scale

polar scope

RA axis

altitude bolts

fig.2 *This figure shows the main features of a German Equatorial Mount or GEM, with a refractor set up for visual astronomy in which the control and power cables have been disconnected for clarity. It is sitting on a pier extension (though not actually required with this short refractor) to avoid the back end of the telescope touching the tripod legs when the telescope is aimed close to the meridian. In this design, the polar scope aligns to Polaris through the hollow RA motor axis.*

fixings whereas the high-end models often are machined from solid alloy, use ceramic bearings, hardened stainless fixings and precision gearing. Belt, friction and gear drives are used by different companies and advanced features such as optical encoders fitted to the motor axis can improve tracking and pointing accuracy as a result of immediate closed-loop position feedback. There are two physical drawbacks of the GEM design: imaging through the meridian and leg clashes.

Meridian Flips and Leg Clashes

During normal tracking, the main body of the GEM rotates around the RA axis. At the point at which the counterbalance shaft is horizontal and pointing east, the telescope will be pointing due south or north (at the meridian) depending on its declination setting. (In the Southern Hemisphere, the counterbalance shaft points west.) As the mount continues to track, the camera-end of the telescope continues to lower and may collide with the tripod legs at high altitude. To avoid this, the mount controller detects when the telescope crosses the meridian and flips the telescope 180° in both the DEC and RA axes, so that it is pointing to the same spot before the flip but from the opposite side of the mount.

For the user, this poses a few issues that need intervention; "the same spot" may be a little way off, the camera image is rotated 180 degrees and an auto guider system requires its sense of direction corrected. In practice, most GEM mounts will continue to work without issue past the meridian for a few degrees and in some systems the user can set a precise limit, before any touch condition can occur. The resumed image sequence may require a small adjustment to re-center the object and the guider software told to flip the guider polarities on one or more axis, depending on the guider configuration. Realignment may take several minutes and require repeated slews and exposures, or more swiftly using plate solving to establish a pointing correction.

With bulky telescopes, leg clashes may occur just *before* the telescope reaches the meridian, especially on mounts that are fitted directly to a tripod. A pier extension can lift the scope away from a leg obstruction and a permanent or mobile pier support allows an even greater freedom of movement without fear of obstruction.

Other GEM Considerations

Selecting a GEM model can be quite tricky and may be an expensive mistake. Appearances are skin-deep and unlike a telescope, how do you evaluate and rate the claims of the internal mechanical performance? Budget is only a guide; every model, no matter how expensive,

fig.3 *This pier extension on a Berlebach ash tripod is a reasonable compromise so long as it can be secured without flexure. The tripod legs lock with excellent stability and the metal extension lifts the mount, reducing the interference between the filter wheel on my long refractor and the legs.*

will have different user experiences. In the last few years there have been a growing number of competent mounts in the £700–£1500 range that compete with the old favorite, the SkyWatcher NEQ6. At the other end of the range, above £4000, there is less consensus between users. At this level users have very specific needs and there are distinct genres; the established models (typically from the U.S. and Japan) and the more radical offerings (Europe). Whatever the price, the mechanism sets the performance; comparisons of weight, maximum load and mounting options are a good place to start. That being said, the thorny subject of software reliability (firmware and application) is also a major consideration for imagers and more difficult to quantify. Maximum load specifications should be treated with caution: The maximum load for imaging purposes will be less than that for visual use and the supplier's specification may include the counterweights as well as the optical system. Some designs are more sensitive to accurate telescope balancing than others, which pop up later as a tracking or guiding problem. The lightweight designs may be sensitive to cable drag or external disturbances, for the same reason.

The obvious purchasing consideration is the precision of the mount; periodic error, backlash and positioning accuracy. Any particular model's specification is a starting point. This is usually a range of values according to the manufacturing tolerances, with tighter control and less variation in the high-end mounts. There are several drive mechanisms to choose from; friction, belt and gear, each with their supporters. Some companies

use stepper motors and others use DC brush-less motors with positional feedback. The implementation, however, is as important as the design architecture (just as there are awful carbon-fiber bicycle frames and fantastic steel frames). For instance, gear systems have less flexure but the mechanical interfaces have potential for backlash and periodic error, the opposite of toothed belt-drives. A few companies use friction drives; an interesting solution, similar to a rim-driven record turntable. These work on the principle of large diameter metal disk driven by a small plain-metal wheel connected to a DC motor. Since there is no actual coupling, as with a gear or belt system, it requires precision optical encoders on each axis to give position feedback. As a result, the motor control is more complicated and expensive but corrects for its own issues, including changes over time. (This simple metal to metal friction interface is not unique, it is the basis of the popular Crayford focuser mechanism too.) The software implementation for these advanced mechanisms is a key part of the system performance. The mount's own control loop has to accurately track the telescope on one or both axes and at the same time react to guiding commands and dither and track accurately without excessive delay or overshoot. This is not an easy task and from my own experience, to get the best from these advanced systems requires a rigid, permanent installation and to operate without guiding.

Mounts with low periodic error are sought after and highly regarded. Even when autoguiding, it is equally important that the mount does not exhibit sudden changes in periodic error, since these errors are difficult to measure and correct within a few exposure cycles. Sudden large changes to PE are often attributable to grit trapped in a gear system's lubricant and more confident users will strip, clean and carefully lubricate their gear system to improve its performance; indeed some mount designs have easy gear access for user-servicing and upgrading.

Weight is not the only consideration for portable use. Some mounts do not have a provision for a polar scope, to facilitate quick alignment, others have no handset and require a PC to run (although this is less of an issue for the astrophotographer, it is convenient to leave the computer at home for observing only). At the other extreme, some models are capable of remote operation, via an Internet connection and maintain their alignment by using precision shaft encoders which determine the mounts absolute position. These can maintain sub-arc second tracking and alignment without manual intervention on a permanent remote site.

It is an interesting time for the buyer right now. In the higher price bracket, novel designs (Gemini, Mesu,

fig.4 This Meade LX200 is a typical example of an integrated telescope and fork mount (sometimes called an Alt-Az mount). Both motor axes are employed to track stars and although precise guiding can be accomplished (through say the top-mounted refractor) there is a risk of field rotation and elongated stars in the image.

10Micron and Avalon) are challenging the established standard precision belt or gear-driven worm-drive (AstroPhysics, Losmandy, Takahashi and Paramount). It is very much a buyer's market and the Internet forums are buzzing with opinion and discussion, perfect to while away those cloudy evenings. In the £1,000 bracket, SkyWatcher iOptron models dominate the market.

Fork and Wedge

Unlike the GEM, a fork mount is often a permanently connected part of a telescope system, typically a Schmidt Cassegrain derivative, an example of which is shown in fig.4. In its standard configuration, the fork mount moves in altitude and azimuth and is not orientated towards the celestial pole. Unlike a GEM, this type of mount requires accurate levelling and alignment with true north to track stars accurately. Even if it does, it moves along horizontal and vertical axis. The stars in the meantime endlessly wheel around the pole celestial pole and during a long exposure, stars will show some field rotation. This elongation increases

with distance from the tracked star (typically the one used for guiding) and proximity to the celestial pole. There are two ways to correct for field rotation; precisely rotate the camera during the exposure or align the fork mount axis with the celestial pole using a wedge. Most opt for a wedge (shown in fig.5) which, assuming the base is level, inclines the mount by your current latitude to align the azimuth axis with the celestial pole. Wedges are under considerable load in the mount assembly. It goes without saying that the more substantial versions are more stable and several third-party vendors offer heavyweight upgrades. I found the lightweight one in fig.5 to be a little springy under load.

Unlike a GEM system, a fork mount can track through the meridian but this architecture is not without its own unique drawbacks; the combined weight of the telescope and motorized fork mount make portability an issue and a fork mount may not image near the pole, since at high declinations a collision is likely between the camera system and the fork arms and base. In a similar manner to setting meridian limits, upper DEC limits are set in the system software to avoid system damage, typically at about 75 to 80° in DEC. In another twist, a Hyperstar® system attaches a color camera at the front of a folded reflector telescope, in place of the secondary reflector and blanks off the rear optical port. This allows full freedom of movement, albeit with a shorter effective focal length and an equally faster aperture.

In terms of product choice, the purchase decision has to consider the combined merits of optics and mount, typically between models in Meade's and Celestron's range. In each case, the mount is designed and scaled to suit the size and specification of the optics. (Schmidt Cassegrain telescopes are also available as an optical tube assembly or OTA, for mounting on an equatorial mount.)

Tripods and Piers

Cost-conscious designs often target the unexciting tripod for compromise. Light-weight models packaged

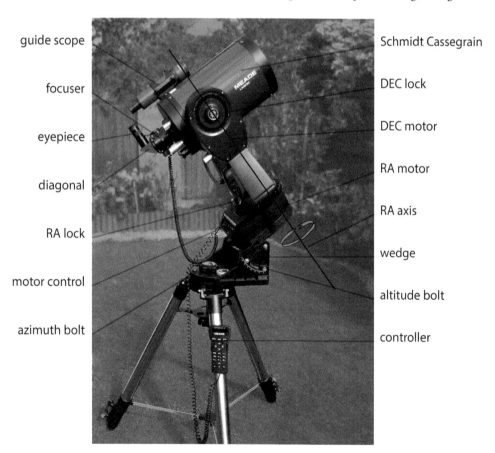

guide scope — focuser — eyepiece — diagonal — RA lock — motor control — azimuth bolt — Schmidt Cassegrain — DEC lock — DEC motor — RA motor — RA axis — wedge — altitude bolt — controller

fig.5 The scope in fig.4 has been mounted on an equatorial wedge, which inclines the mount by the observer's latitude, to alignmen with the celestial pole. At high declination settings a bulky camera or diagonal and eyepiece may collide with the fork arms or base but, unlike the setup in fig.4, images do not suffer from field rotation.

with a mount benefit from upgrading: there are several companies that make piers and tripods (in aluminum, carbon fiber, steel and ash) supplied with adaptor plates to suit the popular mounts. The better models have firm clamps on the adjustable legs, leg bracing and tight leg-to-mounting plate interfaces. The heavier models may have screw-adjusted feet for accurate levelling. Several companies choose ash hardwood for the legs, as this has a natural ability to absorb vibration. The simplest test is to firmly grip and man-handle the tripod's mounting plate; the tripod should remain firm and while viewing, the effect of a small tap on the telescope should dissipate within a few seconds. Some tripods appear strangely short: For imaging purposes, the telescope height is of little concern and a tripod is more stable when its leg extension is at a minimum, providing of course that it does not topple over during the process of attaching the telescope and counterweights.

The base makes a difference too. In a portable setup soft ground can yield over time and balconies or decking may suffer from vibrations, say from passing traffic. In the case of soft ground, a concrete paving slab placed under each foot spreads the load and keeps the system stable. Similarly the concrete pier foundation in an observatory installation should be isolated from the floor of the observatory. Observatories not only provide convenience and a permanent installation but offer some shelter from the wind too. A mobile windbreak or strategically placed car may equally provide some shelter from a prevailing breeze in a temporary setup.

Most mounts are designed with damp outdoor use in mind and use stainless steel fixings and aluminum throughout. Hardware is one of those things that succumb to economy; for instance, the popularity of after-market hardened stainless steel adjustment Alt/Az bolts for the SkyWatcher EQ6 mount tells its own story. There may be other occasions too when a little "finishing off" can improve a value-engineered product, to improve its performance and protect your investment; one that comes to mind is to upgrade the dovetail clamp to a machined rather than cast design that offers better support.

Telescopes

Telescope optics come in a dizzy array of sizes, types and cost. By comparison, choosing a telescope mount is quite an easy task; GEM or Alt/Az and the model is determined by budget and biceps. A recommendation may be useful to a newcomer but potentially alienate others with an opinion. Choice is a good thing, especially if you can filter down to a few alternatives: There are many telescope models of a certain type and a surprising number of telescope

model	weight [kg]	load [kg]	Price [£]	description
AP Mach 1	15	20	6,700	gear-driven worm gear
Avalon Linear	12	20	3,500	belt-driven
Celestron CG-5	19	8	560	gear-driven worm gear
Celestron CGEM	19	18	1,785	worm gear and encoder
Gemini G53 F	20	45	4,500	direct drive, encoders
GM 1000HPS	19.5	25	6,500	belt, worm and encoder
iOptron IEQ30	7	14	1,200	gear-driven worm gear
iOptron IEQ45	20	25	1,500	gear-driven worm gear
Losmandy G8	10	14	2,080	gear-driven worm gear
Losmandy G11	16	28	3,270	gear-driven worm gear
Mesu 200	26	65	5,000	direct drive, encoders
Orion Sirius	14	9	1,200	gear-driven worm gear
Orion Atlas	16	18	1,275	gear-driven worm gear
Paramount MX	23	41	7,250	belt-driven worm gear
SkyWatcher EQ5	14	9	520	gear-driven worm gear
SkyWatcher EQ6	16	18	960	gear-driven worm gear
SkyWatcher EQ8	25	50	2,500	belt-driven worm gear
Takahashi EM-11	6	7	4,050	belt-driven worm gear
Takahashi EM-200	15	15	6,000	gear-driven worm gear

fig.6 *Specifications alone are not sufficient to select a telescope mount. The above list of equatorial mounts show a huge 10x price range and only an approximate corresponding increase in payload. The values are approximate, as published values are a guideline. In many cases you are paying for quality and not quantity, which is hard to specify on paper. The Orion and SkyWatcher mounts share many components.*

types too; the double-barrelled offerings certainly have a grandiose mystique. All telescopes use glass lenses, mirrors or a combination of both. In years gone by, one bought a 3- to 4-inch achromatic refractor with glass optics or a Newtonian reflector with a 6- to 10-inch aperture. (For the same money, a Newtonian reflector offers a much larger aperture, then and now.) Since those days, refractor designs have evolved into APO triplets but reflector designs have undergone a complete revolution.

The wonderful thing about optics, compared to say analog electronics, is their designs obey simple physical laws and the outcome is predictable. Since computers had the ability to ray-trace, optical design accelerated by accurately modelling and optimizing designs without

the need for expensive prototypes. It is possible to directly compare telescope types, according to the laws of optics, in terms of contrast and aberrations, and the next few pages generalize on the differences between optical arrangements. These comparisons set an upper limit on likely performance but the actual real world experience is limited by imaging conditions and the physical execution of a particular design.

Glass Versus Mirror

Glass and mirror systems have unique pros and cons. When light reflects off a mirrored surface, all colors reflect along the same path and the resultant image has no colored fringes (chromatic aberration) around the stars. Not all the light is reflected and there is some diffraction from the mirror edge. A simple glass optic bends (refracts) light, with some transmission losses, diffraction and additionally suffers from an optical property, dispersion, that causes different colors of light to bend by different amounts, producing chromatic aberration. (A simple lens will bend blue light more than red light.) This may appear as one-nil to the reflector but the image formed by a parabolic mirror, commonly found in a Newtonian reflector, has its own unique optical defect, coma, which is increasingly obvious the further way you get from the image center.

The image plane of a telescope is an imaginary surface upon which the stars come to focus. Ideally, this should be flat and coincident with the imaging sensor. Unfortunately, both systems have curved image planes and both require optical correction to make them suitable for high-quality imaging onto a large sensor. These issues can be minimized by introducing an additional lens or mirror elements or a combination of both into the optical system.

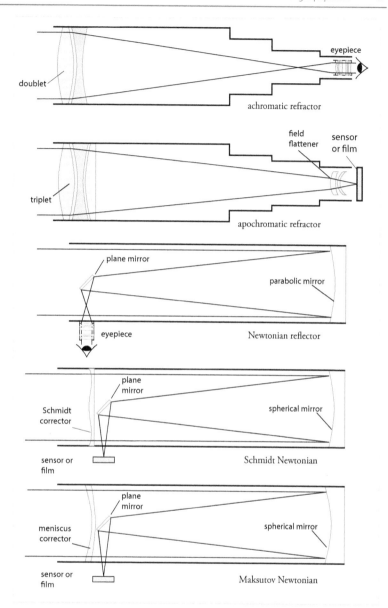

fig.7 *These telescopes essentially are as long as the focal length of the design. At the top is a simple refractor doublet design, in this case set up for visual use. Beneath that is a triplet design, using positive and negative lens elements with different dispersion characteristics to minimize chromatic aberration. A field-flattener lens is inserted before the camera to ensure a flat focus plane across the whole sensor area. The three Newtonian designs show increasing sophistication: The classic simply uses a parabolic mirror but the bottom two are optimized for astrophotography and make use of a more economical spherical mirror and a glass corrector. These are designed for imaging and their focus point extends further outside the telescope body, which gives room to insert the motorized focuser, filter wheels and the camera system.*

design	advantages	disadvantages
refractor	robust to handling, quick to reach temperature, highest imaging contrast, sealed tube has less tube-current problems, relatively compact, easy to care for, focus point allows easy camera coupling, with care, glass optics unlike mirrors are virtually maintenance free, range of focal lengths from very short to long	color fringes (apochromatics less-so), field curvature at image periphery, much higher cost for aperture compared with a reflector design, front optics prone to condensation, practical size limit, longer models can clash with tripod legs at high altitudes, range of eyepiece heights for viewing
Newtonian reflector	lowest price for aperture, no color fringing, condensation is less likely, big sizes, open tube has less cool down time than sealed reflector designs, fixed mirror cannot shift image, smaller central obstruction than folded designs below	off-axis camera, mirrors tarnish, focus point is sometimes too short for imaging, lower contrast than refractor, coma at image periphery, require adjusting and less robust than refractor designs, short focal lengths less common, larger mirrors take longer to cool down, tube currents, diffraction spikes, poor wind resistance
Schmidt Newtonian	better control of aberrations, spherical mirror is cheaper, sealed tube has fewer air currents, flat field, large aperture sizes, no diffraction spikes, smaller central mirror gives better contrast ratio than Newtonian, no diffraction spikes, fixed mirror cannot shift image	sealed tube has longer cool-down period, some not suited for wide-field imaging, others have short back focus, off-axis camera, long tube as Newtonian, some adjustments and eventual mirror tarnishing, more expensive than Newtonian but less than a refractor, some coma
Maksutov Newtonian	as Schmidt Newtonian but fewer aberrations, arguably the ultimate optical quality for a reflector design, larger, flatter field than Maksutov Cassegrain, fixed mirror cannot shift image	as Schmidt Newtonian but meniscus corrector plate is thicker with a longer cool-down period, off-axis camera, long tube length as Newtonian, some adjustments and eventual mirror tarnishing, most expensive of Newtonian family

One of the interesting things about astrophotography is the demand placed upon the optics: Everyday photographic subjects are surprisingly forgiving of optical defects whereas small intense points of light show up every flaw. These demands multiply with aperture; as the glass or mirror-area doubles, the quality control becomes increasingly difficult. Telescopes are also used at full aperture, unlike photographic lenses, which are often stopped down to improve image quality. (Interestingly, an image of a bright star using a stopped-down camera lens will show diffraction effects caused by the non-circular aperture.) Diffraction is also the culprit for the characteristic 4-point spike around bright stars on those reflector telescopes that use a secondary mirror support, or "spider" in the optical path. The physics of diffraction cause, in general, the simplest optical designs to have the highest image contrast. Since each optical boundary introduces a little more diffraction, a refractor has a higher image contrast than a Newtonian, which in turn is higher than the more complex folded reflector designs. Similarly, each optical surface fails to reflect or transmit 100% of the incident light, with the consequence of slightly dimmer and lower contrast images.

Refractor Designs

The first telescopes were refractors, made from a positive primary lens and a negative eyepiece lens (often using available spectacle lenses) and produced an upright image. These are attributed to Galileo, who improved on the implementation and used them to observe the moons of Jupiter. Today, we use the later Keplerian designs that use a positive eyepiece lens and produce an inverted virtual image. These designs produce a wider field of view, higher magnifications and longer eye relief (the distance from the eyepiece to the eye).

Today, multi-coated, multiple cemented or air-spaced elements replace the simple single-element primary and eyepiece lenses of the 1600s. Combinations of positive and negative elements with different dispersion characteristics reduce chromatic aberration in the doublet design and better still in the triplet designs, often tagged with the term APO. Aspherical elements, now common in photographic lenses, are appearing in some astronomy products too.

When used for imaging, refractors require further compound elements just in front of the sensor, to flatten the plane of focus, or modify the effective focal length. These "field flatteners" are normally a matched add-on lens, but in the case of astrographs, they are built into the telescope. Most refractor designs can image over an APSC sized sensor with minimum darkening of the corners (vignetting), the better ones cover full frame 35 mm or larger. This specification is referred to as the image circle diameter. The image circle is altered by the addition of a field-flattener or reducer.

Newtonian Designs

The layout of a Newtonian is optimized for visual use; the focus position is quite close to the telescope body and may not give enough room to insert coma correctors, filters and cameras. The open body of a Newtonian reflector cools down quickly but unprotected mirrors may also tarnish more quickly than in an enclosed design. Some Newtonians are optimized for imaging with a slightly shorter tube, to extend the focus position.

The Schmidt Newtonian design addresses some of these limitations. It has a sealed tube with a glass corrector element at the front upon which the secondary mirror is mounted. The primary mirror is now spherical, which is more economical and the deletion of the mirror spider removes the diffraction spikes on bright stars. The corrector plate reduces aberrations and produces a flatter field. These designs are ideally suited for a narrow field of view and as with the Newtonian it is necessary to check that in a particular model there is enough back-focus for imaging purposes (short-tube version).

The last of the sealed tube Newtonian designs is the Maksutov Newtonian, which further improves upon the Schmidt Newtonian, with lower aberrations and is arguably the best of the Newtonian designs. The meniscus corrector plate at the front of the telescope is thicker than the Schmidt Newtonian glass element with the possibility that if the telescope has been stored in a warm place it will take longer to cool down to ambient temperature. During the cooling period, the possibility of focus shift and air turbulence arise. In all of these designs, the primary mirror is fixed (in so much that it is not moved to achieve focus) and has screw adjustments to tilt the plane and precisely align (collimate) the optics to produce round stars. These same adjustments may need periodic correction or after transporting between sites. Some adjustments can be achieved visually using a defocused star, others may require a laser collimator to align the optical surfaces.

Folded Designs

Advanced folded telescope designs were once very expensive but since Meade and Celestron led the way with affordable designs, they have become increasingly popular. The optical tube assembly is very compact. A 2,000 mm, 200-mm aperture telescope is only 450 mm long and 6.5 kg, compared to a Newtonian, with the same aperture and half the focal length is 920 mm long and about 9 kg. Whereas all the Newtonian designs use a flat secondary mirror, the folded designs use a convex secondary to extend the focus point beyond the primary mirror. The primary mirror has a hole in its center, through which the image passes and has a long black tube, or baffle, to prevent light

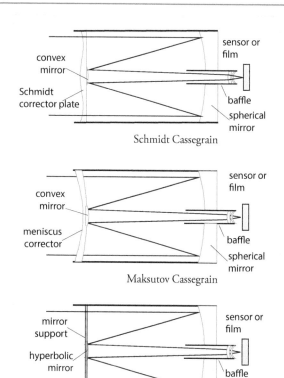

fig.8 *The schematics above and the table on the next page compare the folded telescope design concepts. The top two both use an economical spherical main mirror and are similar to their Newtonian namesakes, with Schmidt and meniscus glass corrector plates at the front and a secondary mirror attached to its rear face. In these designs, the principal difference is the secondary mirror is convex, which allows the folded geometry to work and the focus position to be behind the main mirror. These designs are commonly referred to as "CATs", "SCTs" or catadioptric (simply meaning a combination of lens and mirror) and require a field-flattener lens for quality imaging onto a large sensor. The Ritchey Chrétien design at the bottom uses two hyperbolic mirrors. These are more expensive to make but the large image circle has significantly less coma than the others, although there is still some field curvature. There is no front corrector plate and the secondary mirror is supported on a spider, which generates diffraction spikes on stars. The best known implementation of an "RCT" is the Hubble Space Telescope. The Ricardi Honders and Harmer Wynne mentioned in the table opposite (not shown) are two less common variations that use slightly different configurations of glass and mirror elements, trading off aberrations for field of view and speed.*

design	advantages	disadvantages
Schmidt Cassegrain	compact tube length made possible by convex secondary mirror, corrector plate reduces aberrations of all-mirror design, on-axis camera mounting, use of spherical mirrors keeps costs down, no diffraction spikes, versatile	less contrast than Newtonian designs, coma still present if secondary mirror is spherical, movable mirror can cause image shift during focus and tracking, not common in short focal lengths, "Jack of all trades"
Maksutov Cassegrain	good control of aberrations, spherical mirror is good value, sealed tube has less air currents, flat field, large aperture sizes, no diffraction spikes, smaller central mirror gives better contrast ratio than Newtonian, straight through imaging path, compact tube, back focus accommodates imaging equipment	slightly less contrast than Newtonian version, those with moving primary mirror can cause image shift during focus and tracking, not common in short focal lengths, typically lower focal ratios than Schmidt Cassegrain designs
Ritchey Chrétien	all fixed-mirror design has no color aberrations and hyperbolic surfaces eliminate coma, used by professional observatories (including Hubble Space Telescope), good choice for long focal length, large illuminated field from larger secondary mirror	mirror supports introduce diffraction spikes, hyperbolic mirrors are expensive, field curvature may require optical correction for imaging, contrast is less than Mak Newt (due to larger secondary mirror), hyperbolic mirrors are sensitive to small collimation errors
Ricardi Honders	hybrid folding design delivers short focal length and fast apertures in compact form	fast system necessitates great care with alignment and focusing
Harmer Wynne	another hybrid, parabolic and spherical mirrors with corrector deliver large image circle, wide field and fast apertures	current models only in larger and expensive sizes

straying to where it is not wanted. These incur additional diffraction which lowers the image contrast slightly over simpler optical designs. These designs, with their large aperture and long focal lengths, excel at planetary imaging onto small-chipped video cameras.

The Schmidt and Maksutov designs, as with their Newtonian cousins, offer increasing levels of refinement and lower aberrations. For high-quality imaging over a large sensor, a field-flattener is required. In these designs, many combine image reduction and field flattening, with the outcome that a 2,000 mm f/10 design transforms into a 1,260 mm f/6.3 or 660 mm f/3.3. The shorter focal lengths are more useful for imaging nebulas and the larger galaxies, with the added advantage of plenty of light gathering power. Some scopes with longer focal lengths achieve focus using two systems; a small external standard focus mechanism with limited travel and by moving the primary mirror back and forth along the optical path. This moving mirror can be an Achilles' heel since it is very difficult to engineer a sliding mirror mechanism without introducing lateral play.

In practice, the coarse focusing is achieved with the primary mirror and then the mechanism is locked. Even locked, tiny amounts of mirror movement can cause the image to shift during long exposures. If the guiding system uses independent optics, an image shift in the main mirror can cause image quality problems. One solution is to use an off-axis guider, which monitors and corrects image shift through the imaging system from flexure and focusing.

The Ritchey Chrétien, (RCT or simply RC) is a specialized version of the folded reflector design that uses two relatively expensive hyperbolic mirrors to eliminate coma rather than use a glass compensator. Since, there is no front glass element, large aperture designs are feasible, suitable for professional observatories. The optical design is not free from field curvature and requires a field-flattener for imaging onto a large sensor. The Hubble Space Telescope is a RC design with a 2,400 mm mirror with a focal length of 57.6 m! A typical amateur 200 mm aperture telescope, with a focal length of 1,625 mm is only 450 mm long and 7.5 kg. These systems have a fixed primary mirror and use extension tubes or an adjustable secondary mirror to achieve focus.

Aperture Fever

It is a wonderful time to be an amateur astronomer. The choice and quality is fantastic and it is easy to overindulge. The thing to remember with all these remarkable instruments is that although larger apertures do enable visual observation of dimmer objects and shorter exposures, they do not necessarily provide better resolution in typical seeing conditions. Seeing conditions are a phenomenon occurring between air cells a few centimeters across and

fig.9a *A standard red dot finder, or RDF, which projects a variable intensity red led dot onto a window, a system that is tolerant of the viewer's eye position.*

fig.9b *An advanced red dot finder, with dew shields front and rear and clear end caps to combat the effects of condensation.*

fig.9c *A refractor based finder scope, with right angled finder, eyepiece and illuminated reticle.*

fig.9d *The right angled finder can be replaced by a focuser and small CCD camera for autoguiding.*

larger apertures have greater susceptibility. (The effect of turbulence within a telescope tube increases too with the number of times the light beam passes through it. Newtonian designs have two passes and the SCT family three.)

Long focal lengths and high magnification amplify any issues, and at the same time, it is pertinent to remember that a larger aperture does nothing to overcome the effect of light pollution. Some texts suggest, in the UK at least, that imaging quality tails off above a 250 mm aperture. (A 250 mm aperture has a diffraction-limited resolution of about 0.5 arc seconds, equivalent to outstanding seeing conditions.) I don't want to spoil your moment as you unpack your 300 mm aperture lens and if my words of "wisdom" may feel a little sober, I will finish on a positive note: A big aperture enables shorter and hence more sub-exposures in any given time and combined, they improve the signal to noise ratio. Subsequent image processing gives a cleaner result. There you go now, do you feel better?

Finders

For imaging purposes I rarely use a finder, with one exception, planetary imaging. There are two principal finder types, a red-dot finder (RDF) or a short-focus refractor with an aperture of about 30–60 mm. Most optical finders have a cross-hair reticle and the better finders illuminate them too. Some finders like the one in fig.9c,d are large enough to be used with an eyepiece, or can be fitted with an adaptor that holds a small imaging camera, for autoguiding purposes (avoid helicoid focus mechanisms, they are not as rigid). Before use, a finder needs to be aligned with the host telescope. I normally center the telescope on a distant pylon (using an eyepiece with a reticle and without using a diagonal) and then adjust the finder to the same spot. The RDF models typically have two axis adjustment and the refractor style are secured in tube rings with three soft-tipped adjustment bolts that are adjusted in pairs.

Dew can be an issue with finders too; the Baader model in fig.9b has a short dew-shield at each end and see-through end caps, which can be removed just before use. The 60 mm objective of the refractor unit in fig.9c dews-up quickly and requires a dew heater tape for reliable autoguiding.

Diagonals and Eyepieces

Visual astronomers take great care and set aside a considerable part of their budget for quality eyepieces and a high efficiency diagonal. These are a lesser priority for the astrophotographer, who can make the most of good value mid-range products. The purpose of a diagonal is to make observations at a comfortable head angle. (Newtonian telescope designs already have the eyepiece at right angles to the telescope and do not require one.) Diagonals come in two varieties, those that flip the image and those that do not. Finders often use non-inverting prisms but viewing diagonals have a single silvered mirror surface and have a laterally reversed image. Diagonals come in two sizes, 1.25- and 2-inch, of which the 2-inch version is more versatile.

Eyepiece prices range widely from £20 or so to £250 or more. A premium is paid for good eye relief (a comfortable viewing distance from the lens) and wide angle views. For a modest budget, I selected five focal lengths from 6.5 to 32 mm from Meade's 5000 series, including several previously owned. These have good eye relief, a 60° apparent field of view and have a twist-up rubber eyecup. By choosing models in the same range, I can swap them over with only a minor focus adjustment, since these are "par-focal". Baader®, Celestron®

and others have similar ranges. Higher up the scale, Tele Vue®, and Pentax® both have an enviable reputation for their eyepiece models. There are many optical configurations and just like telescopes, are a compromise between price, weight, transmission, field of view and aberrations. In addition to eye relief, there are some further considerations when choosing an eyepiece which is irrespective of its design; the magnification of your telescope, field of view and exit pupil size.

Magnification

The magnification for a system is calculated by the ratio of the focal lengths:

$$magnification = \frac{f_L(telescope)}{f_L(eyepiece)}$$

There are useful limits to achievable magnification, based on the diffraction limit imposed by the telescope aperture and seeing conditions. The upper limit is approximately 2x the aperture (mm) but can be lower due to seeing conditions. A focal length may be too short for your telescope's ability.

Field of View (FOV)

Every eyepiece has an apparent field of view. The size and cost of an eyepiece increases with angle. The actual angle of view through a telescope is calculated with the simple formula:

$$True\ FOV = \frac{Eyepiece\ FOV \cdot f_L(eyepiece)}{f_L(telescope)} \quad or \quad \frac{Eyepiece\ FOV}{magnification}$$

The right combination of telescope and a wide angle eyepiece can give breathtaking views. Wide angle eyepieces have up to 100° apparent field of view.

Exit Pupil

Exit pupil size is less obvious: We all know our eye's pupil diameter is at its maximum in dark conditions but it also shrinks as we get older. If your system has a considerably larger exit pupil size than your own eye, much of its light output is wasted. A typical human adult pupil size is 5–6 mm and the exit pupil size of a telescope system is derived by the following equation, where D is the telescope aperture:

$$ExitPupil = \frac{D \cdot f_L(eyepiece)}{f_L(telescope)} \quad or \quad \frac{D}{magnification}$$

Although low magnification views are brighter, a lower limit is set by our pupil diameter. This is reached when the magnification is D(mm) / 6. In practice, with several telescopes and eyepieces, some eyepieces will be compatible with all and some of the shortest and longest focal lengths will not.

Dew Control

Not all of us live in the Atacama Desert and dew is one of those things we have to learn to live with. As air cools, the amount of water vapor it can carry reduces. For example, a dry day at 20°C with air at 40% relative humidity cools during late evening. By the time it reaches 5°C, the air is at 100% relative humidity and any further cooling will precipitate dew onto cool surfaces or as airborne water droplets. There are two essential tips to combat dew; avoidance is better than cure and do not overdo any heating.

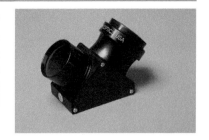

fig.10 This William Optics® 2″ diagonal, with 1.25″ eyepiece adaptor, fits into a 2″ eyepiece holder. The coupling can be unscrewed and replaced with a screw fitting for direct attachment to an SCT telescope.

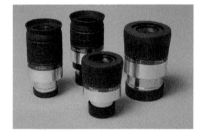

fig.11 A selection of eyepieces from 6.5 to 32 mm focal length.

fig.12a The DewBuster™ controller has several temperature-regulated outputs and fixed power levels for multiple dew heater tapes.

fig12b Dew heater tapes are available for telescopes, guide scopes and eyepieces.

Avoidance works by creating a mini environment that prevents dew forming. A long lens hood or dew shield will slow down telescope cooling and gently heating the exposed optics both make the telescope a little warmer than the surrounding air and prevents dew forming. Some telescope designs are more susceptible than others. Most refractors have built in dew-shields and Newtonian designs without a glass corrector plate have their optics at the base of a long tube which effectively shields the primary mirror. SCTs are particularly vulnerable with their exposed front optics and require an accessory dew shield.

Dew heater tapes are the most common method to gently heat optics. These flexible resistive bands wrap around the telescope tube close to the exposed optical surface. These come in multiple lengths to suit different tube diameters and are also available in small sizes to suit eyepieces and finders.

Dew heater tapes work with a 12-volt power supply but applying full power may overheat a telescope and cause image-robbing air currents, akin to turbulence. Dew control systems lower the rate of heating by pulsing the current on and off with an electronic switch (pulse width modulation or PWM). The better ones do this in a way that does not create electrical interference to the power supply or a sensitive cameras. Even so, I recommend using a separate power supply for the "noisy" functions; dew heater, mount and focuser modules.

Most dew controllers have a simple dial to alter the rate of heating. The right setting is noted after a little trial and error; the aim being to create a small temperature offset between the telescope and ambient conditions. The innovative DewBuster™ controller in fig.12 does just that. It monitors two temperature probes; one in the air and one under the heater tape. It maintains a user-adjustable offset between the two. If I had designed an automatic dew controller for myself, it would have been like this. It just works.

Hobbyist Dew Heater Controllers

Dew controllers are a magnet for hobbyists. Various circuits exist using oscillators and switching transistors. It is relatively straightforward to make a variable pulse width oscillator and switch current with a power transistor or field effect transistor. An Internet search finds many "555" timer-based designs in a few seconds. The design issue that may not be apparent to non-electronic engineers is how to switch a few amps on and off without creating interference; both transmitted along the power lines and as radio frequency interference. Interference can create havoc with USB communications and CCD cameras (and some mounts, as I discovered). I required a

simple low-cost controller to embed in an interface box. Rather than develop a printed circuit board from scratch I choose to modify an 80W PWM motor control module available from Amazon. This switches up to 3 amps with a switching frequency in the kilohertz. There are many poor designs that generate considerable electrical interference. I chose one whose photograph showed lots of surface mount components, including some output power resistors and diodes, to reduce interference.

Reducing interference occurs in two stages; avoidance and screening. The PWM module was a well designed CE-rated unit and a simple test, using an AM radio close by, did not detect radio frequency interference. I placed 10nF capacitors across the output for good measure and an inductive choke on the power feed to the unit to filter any high-frequency transients in the power line. One might think the next step is to filter the switching circuit, with say a capacitor on the gate of the transistor. This slows the switching slew rate down but at the same time this linear operation will increase the power dissipation in the transistor, for which it is not designed. A better solution is to place 1 watt resistor and series capacitor across the output help to dissipate any back voltage generated by the switching of an inductive load. My unit already had this on its circuit board.

The operating frequency of most commercial dew heaters is approximately 1 hertz or less and is determined by two main timing components, a resistor and capacitor. If you can identify them and the PWM circuit board allows, it may be possible to replace these with much larger values to lower its switching frequency. If you suspect the PWM unit is generating interference, placing the assembly in a die cast aluminum box and using shielded cables for both power and dew heater output reduces radiated radio frequency emissions. I initially routed standard dew heater cables away from sensitive USB or power lines but subsequently swapped over to microphone cable, which employs an independent grounded shield. This cable, with filtering at the connectors, is routed through my telescope mount with no apparent issue.

My system works well and there is no apparent difference in the noise level of images taken with it switched on or off. I cannot replicate the clever feature of the DewBuster, which accelerates warming to a threshold, so I switch my dew heater system on 10 minutes before imaging, with the lens cap in place. I keep an eye on the humidity and dew point and when the humidity tops 85%, I increase the temperature offset to about 8°C. Over 95%, atmospheric transparency reduces and impairs image contrast, and it is time to go to bed.

Imaging Equipment

Imaging requires a complex system of hardware and software to run for hours without issue. The options increase every day and making choices is not easy.

In the previous chapter the essentials for mount, scope and viewing equipment were outlined with an emphasis on imaging rather than visual astronomy. This chapter looks at the specialist imaging items; cameras, filters, field flatteners, focal reducers, autoguiders, focus control, interfacing and software. This is where the fun starts.

There are numerous options available to the astrophotographer that cover a range of budgets and sophistication. Things can be exceedingly simple – a normal camera on a static tripod or mount – or they can quickly become more sophisticated, using dedicated CCD cameras with a motorized filter wheel and autoguiders. Without the digital sensor, modern astrophotography would be a very different experience. Understanding the limitations of a digital sensor is pretty significant and your choice of camera has a large impact on system choices and budget. Their various properties play a pivotal role in the end result and these properties are mentioned throughout the book. They are also brought together in their own chapter in the imaging processing section.

Using your existing digital camera (often fitted with a CMOS sensor) with a motorized mount is a great place to start and for some, this solution will meet their needs for some time. There are several excellent books that concentrate on conventional camera-based astrophotography. Initially this was the domain of the digital SLR, but increasingly this can also be with one of the many mirrorless cameras that have interchangeable lenses, either using their telephoto lens or attached to the rear of a telescope using a simple adaptor. I have plenty of conventional cameras and although I do not ignore them in this book I concentrate on dedicated CCD cameras for reasons that will become apparent.

Conventional Digital Cameras

It makes sense to try astrophotography using your existing digital camera. All the main camera brands have their devotees and critics and although I might be shot for saying so, there is not much to choose between them. In astrophotography however, there are a few specialist requirements that favor a few brands. The most obvious are remote operation and good quality long exposures.

Remote Operation

SLR and mirror-less cameras are both capable for use in astrophotography. One quickly realizes that red sensitivity is another important attribute and many photographic cameras block deep red wavelengths with their infra-red blocking filter. I discovered my Fuji X-Pro 1 camera could detect the IR emitter on a TV remote control and figured it might be excellent for use on a telescope. The only problem was I had to use a cable release and hang around with a stopwatch. Some of the later models in the range have an electronic remote release, which can also accept an electronic interval timer or connected to their own dedicated image tethering software. Even so, it has to be said that this is not the easiest solution for two reasons: seamless remote operation and focusing. Focusing is an unavoidable requirement in any setup. Even with 10x

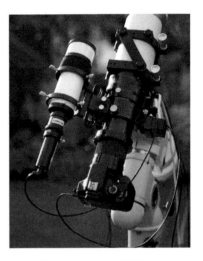

fig.1 This telescope has a field-flattener fitted directly between the focuser and a digital SLR. A short finder scope has a small guide camera fitted to it to facilitate accurate guiding over long exposures. The guide camera was more expensive than the SLR!

fig.2 Long exposures quickly deplete camera batteries and it is not always convenient to change them once an imaging session has started. Battery substitutes are available, which allow a DC power feed. These, however, are powered by mains, so a small adjustable DC-DC module can be used instead to power the adaptor from a 12-volt supply.

image magnification on its LCD screen, it is very difficult to judge the precise focus on any star, even with a focusing aid such as a Bahtinov Mask. With the right software, however, and tethered operation over a USB connection, things become much tidier; imaging software takes repeated images whilst you adjust the focus and plots the star size, using Full Width Half Max or Half Flux Diameter (FWHM or HFD) for each exposure. The best focus is achieved when the width is at its lowest value. Although several camera brands supply general software utilities for remote capture, it is the third-party apps and full astrophotography programs that have the tools to assess focus accuracy and these work best when they are fully integrated.

fig.3 A color CMOS sensor is made up of a grid of light sensitive diodes, overlaid with a color Bayer filter array and a micro-lens matrix on top, to improve optical efficiency.

At present, the best-supported SLR brand by astronomy programs is Canon EOS although some of the high-end astrophotography programs like Maxim DL and others increasingly support others. Nikon has released an astrophotography specific version of the D810 to compete. Modern cameras operate via their USB connections but not all support long exposures (greater than 30 seconds) directly. Those models and the older pre-USB models can be triggered with a modified electric cable release and an interface circuit to a PC. One popular source of adaptors is Shoestring Astronomy. Long exposures consume batteries and a full-nights imaging requires several changes. The process of changing batteries can disturb the imaging alignment and for uninterrupted operation, a battery adaptor powered from 12 volts is a better option. (The battery adaptors supplied by the OEMs or third-party retailers comprise a battery adaptor and a small DC power supply, powered by mains.) With a little ingenuity a small variable DC-DC converter module can be housed in a small plastic box and adjusted to provide the exact same DC voltage at the camera end, from a DC voltage. This is a safer and reliable alternative and it can share the mount's power source.

Image Quality

Camera shake from a SLR mirror and shutter is not an issue during long exposures, as any vibration fades in milliseconds. There are a few settings on a camera, however, that you need to take care of to extract the best quality. All digital cameras have a long-exposure noise-reduction option, which takes and subtracts a single dark frame exposure from the image. This is not sufficient for high-quality astrophotography and should be disabled. It is also really important to use unmolested RAW files in the highest possible bit depth and without any interference from any in-camera processing. For best results, images are stored in the camera's native RAW file format and to reduce thermal noise, any toasty "Live View" option is turned off whenever possible. RAW files are not always what they seem; keen-eyed amateurs noted that some older Nikon cameras process RAW files and mistakenly treated faint stars as hot-pixels and remove them. Additionally RAW files are not quite as unadulterated as we are led to believe. All the cameras I have tried have to some extent manipulated the RAW data in camera. This undisclosed manipulation is often detected in weird dark current results and requires special attention during image calibration prior to stacking.

fig.4 A monochrome CCD sensor is made of chains of sensor elements, in this case, overlaid with a micro-lens matrix. The CCD is a more linear device for measuring photons than a CMOS sensor and is ideal for scientific study. In both the CCD and CMOS sensors, the photo-active regions do not cover 100% of the sensor surface, as they have to make room for the interface electronics. The design of the micro-lens ensures that most of the incident light is focused onto active regions of silicon, improving detection efficiency.

Image processing, especially with deep sky images, severely distorts the tonal range to show faint detail and requires the highest tonal resolution it can muster. Most digital cameras have 12- or 14-bit resolution in their sensor electronics. These produce 2^{12} (4,096) to 2^{14} (16,384) light levels for red, green and blue light, stored in a 16-bit file format. Image processing on the

fig.5 *This Canon EOS 60Da is ready for action. It is fitted with a T-ring adaptor and T-thread to 2-inch nosepiece with a Hutech® IDAS light-pollution filter screwed into the front. In practice the EOS is set in manual exposure mode to allow remote operation from its USB port. This combination works well with a short, fast focal length scope. If camera optics are used, it is best to use them at full aperture to avoid strange diffraction patterns from the polygon shaped aperture (see below). Some other makes of camera also require a "shoot without lens" option enabled, to work with a T-adaptor.*

combined image files averages between exposures and creates a higher tonal resolution that ideally uses 32-bits per channel. JPEG files on the other hand have just 8-bits per channel resolution and this is insufficient to withstand extreme image processing without displaying abrupt tone changes (posterization). Choosing a RAW file format also bypasses any in-camera high-ISO noise reduction modes that generally mess things up. In-camera noise reduction typically blurs the image to reduce the apparent noise but in doing so, destroys fine detail. For a static subject there are far more effective means to reduce shadow noise and astrophotographers use multiple exposures combined with statistical techniques to reduce image noise in dim images. This important subject has a full explanation in later chapters.

It is easy to imagine the benefits of remote operation: In addition to the welcome convenience during a long exposure sequence there are sometimes less obvious benefits to imaging quality too. A third, lesser-known benefit of remote operation occurs during the conversion from the separate RAW sensor element values to a RGB color image. Camera RAW files require processing (DeBayering) to create a color image from the individually filtered sensor values. The standard RAW converters used by photographers and the standard RAW converters apply some averaging (interpolation) between adjacent sensor elements for pictorial smoothness. (Some cameras additionally have an anti-alias filter, a sort of mild diffuser, in front of the sensor that accomplishes the same thing.) In general photography, an anti-alias filter trades resolution for smoothness and is most needed to depict straight lines without jagged edges or strange colored banding. While this is important for normal pictures it is all but irrelevant to astrophotography as there are no straight lines. Several astrophotography programs use their own optimized algorithms (especially for star-fields) that preserve and later convert the individual RGB information into a 16- or 32-bit RGB FITS or TIFF image file. If you can, choose remote tethered image capture, using an astrophotography program, rather than store on the memory card. Photography and astrophotography have different visual needs and the specialist capture programs are optimized for the purpose.

Color Sensitivity

The individual sensor elements (some texts refer to these as photosites) in a CMOS or CCD have a broad color sensitivity that extends from ultraviolet (UV), through visible and includes infrared (IR) light. Video camcorder "night-shot" modes make good use of the extended infrared sensitivity but this is not a desirable feature in either general photography and astronomy. Infrared light will focus to a different point through any refractive optic and even color-corrected compound elements will refract visible and infrared light to a different extent. The outcome is a blurred image. (Mirrors reflect all light by the same amount but any glass-based correction optic may introduce the problem just before the sensor.) The answer is to block IR (and UV) light from the sensor. The filters used in a color sensor's Bayer array are not sufficient and an additional IR blocking filter is required to stop infrared light reaching the sensor.

In general, the efficiency of a photographic camera is less than that of a filtered monochrome CCD and in some models, the added IR filter further reduces the light intensity of deep red light. (The primary color of emission nebula is a deep red from ionized hydrogen (Hα) at 656 nm and an even deeper red from ionized sulfur (SII) at 672 nm.) In these instances, a longer exposure

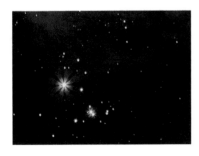

fig.6 *This cropped image was taken with a Canon EOS, fitted with a 300 mm f /4 L lens, accidentally set to f/5.6. After image processing, the faint diffraction patterns from the non-circular aperture become obvious and detract from the image. I should have used full aperture and sharpened the softer image.*

is required to detect the faint glow, with the added risk of higher image noise and over-exposed stars in the region.

The standard Canon EOS camera bodies currently have the best third-party software support but at the same time their IR filters reduce the intensity of these important wavelengths by 80%. Nikon, Canon and Fuji all market specially filtered bodies ideal for astrophotography (the Nikon D810A, EOS 60Da and Fuji X-T1 IR). These cameras are not cheap and many use a consumer model or a used body and the services of a third-party company to remove or replace the infrared blocking filter. This modification improves the deep red sensitivity and depending on whether the IR filter is simply removed or replaced, may affect color balance and autofocus.

Light Pollution

A camera's color sensor is also sensitive to visible light-pollution. Although light-pollution filters block the principal street-lamp colors and reduce the background light intensity, they also reduce star intensity at the same time and require color correction to remove their characteristic blue or green color cast. These filters mount in the camera lens throat (Canon EOS) or on the end of a T-thread to telescope adaptor (1.25- or 2-inch). Light pollution filters can perhaps be more accurately described as nebula filters, since they pass the specific nebulae emission wavelengths, which thankfully are not the same as those found in urban light pollution. The result is that image contrast is improved and requires less manipulation to tease out faint details. Whilst on the subject of light pollution, the intense reflected light from a full Moon can wreck a night's imaging. No light pollution filter can remove this broad-band sky illumination but narrow-band filters are still effective for imaging emission nebulae.

Thermal Noise

Thermal noise adds random signal to each sensor photosite, that accumulate over time and at a rate that increases with temperature. This noise consists of a general background rate, called the dark current, and a random noise element too, which increases with the background rate. The dark current typically doubles for every 6–8°C rise and luckily, subtracting a matched dark frame from each image virtually eliminates its effect. With each doubling of the dark current, however, the random noise increases by 1.4x. A simple dark frame subtraction will not reduce random noise (it actually increases it) and the only way to reduce its effect is to combine many images. It requires twice as many averaged exposures to return the signal to noise ratio to its former (cooler) value for a 6–8°C rise.

Manufacturers have not yet resorted to cooling their sensors and unfortunately they gradually warm up with extended use, especially if the LCD screen is on. In addition to general thermal noise, some cameras (especially the older models) exhibit "amplifier glow", which increases with exposure time and temperature and shows up as a general fogging of the image around a corner or edge. The most recent consumer EOS bodies have improved sensor and micro-lens efficiency and those with the lowest pixel density currently have the best dark noise performance. (At a point in time, the consumer EOS 1100D /Rebel T3 model has a 14-bit RAW file output, remote control capability and exhibits lower image noise than its higher pixel-count APS-C cousins.)

For the best performance with a conventional camera, choose a modern camera with a low pixel count, take many averaged exposures with via tethered control and download the images, avoiding using the rear LCD panel for extended periods of time and hot conditions. Easy!

Dedicated CCD cameras

In the beginning, SLR cameras used both CCD and CMOS sensors in equal measure. Although CCD sensors have less noise, CMOS sensors have become more commonplace since they are cheaper to produce, use less power and through gradual development have narrowed the gap to a CCD's noise performance. High-quality dedicated astrophotography cameras still use CCDs exclusively, with the exception of some small format cameras designed for autoguiding and planetary imaging. These two applications only require short exposures and in practice are more tolerant to image noise.

The uptake of camera sensors into astrophotography is quite slow. For example, in 2016, the Kodak KAF8300 8 megapixel sensor is still a popular large format model for astrophotography. Olympus launched several cameras with the KAF8300 sensor in 2004! This is not necessarily a bad thing; few telescopes have the imaging field of view to cover the latest full frame (24 x 36 mm) sensors and the latest APS-C sensors have more resolution than the effective imaging system. Most CCDs are made by Sony and Kodak and come in a range of sizes and resolutions. The larger ones often require a physical shutter and have interlaced rather than progressive readouts. These require a little more care; moving shutters can disturb dust in the sensor housing and interlaced outputs may need a processing adjustment to ensure alternate lines have the same intensity.

Dedicated CCD cameras represent a substantial investment. There is no way of softening the blow but a used one is about the same price as a new semi-professional SLR. These are hand-made niche products

fig.8 This dedicated CCD sensor is electrically cooled and the extracted heat is dissipated from the body fins with the help of small fans at the rear. The front plate of this particular model can be tilted via the three screws to obtain precise alignment, though this is only a practical proposition if the rest of the optical assembly is rigid and repeatable. The sensor is protected by a coated fused quartz window but will require further protection from UV and IR light, normally provided by the standard filter designs in the filter wheel or a light pollution filter.

sensor / camera	chip size (w x h) (mm)	pixels (w x h)	pitch (microns)	read noise (e / micron²)	full well capacity (e / micron²)	gain e / ADU	dynamic range # levels	QE %	dark current e/sec @-10°C per micron²
ICX814	12.4 x 9.9	3388 x 2712	3.7	3.1 (0.8)	18,000 (1310)	0.16	5,800	75	0.002 (0.0002)
ICX834	13.2 x 8.8	4,250 x 2,838	3.1	1.6 (0.51)	9,000 (936)	0.13	5,625	75	0.002 (0.0002)
ICX694	12.5 x 10	2,758 x 2,208	4.5	3.1 (0.68)	19,000 (938)	0.17	6,130	77	0.002 (0.0001)
KAF8300	18 x 13.5	3,358 x 2,536	5.4	8 (1.48)	25,000 (857)	0.38	3,100	54	0.02 (0.0007)
ICX493	23.4 x 15.6	3,900 x 2,616	6	7 (1.16)	25,000 (694)	0.38	3,500	55	0.02 (0.0006)
KAI11002	36 x 24	4,008 x 2,672	9	11 (1.22)	60,000 (740)	0.92	5,500	50	0.7 (0.0086)
EOS 40D ISO 400	22.2 x 14.6	3,944 x 2,622	5.6	7 (1.25)	12,000 (382)	0.18	1,700	33	N/A
EOS 40D ISO 800	22.2 x 14.6	3,944 x 2,622	5.6	5 (0.89)	6,000 (191)	0.09	1,100	33	N/A
EOS 1100D ISO 800	22.2 x 14.6	4,352 x 2,874	5.1	4 (0.78)	5,000 (192)	0.07	1,100	36	N/A

fig.7 The table above lists some of the available CCD parameters and compares them to two Canon EOS bodies. (OEM camera sensor data is not always readily available and these figures are from specialist websites that measure and compare photographic cameras.) The full well capacity is the number of electrons required to saturate a pixel and this, divided by the read noise, derives the effective dynamic range of the pixel. Normalized values are also shown per square micron. Although all sensors have considerably less than 16-bit resolution, the combination of many image exposures (with noise) will average to an intermediate value and improve the effective dynamic range. The other item of interest is its efficiency. There are some differences between CCDs but the comparison between a monochrome CCD with separate RGB filters and a CMOS sensor with a Bayer array is misleading for color imaging.

fig.9 The back of the sensor has a number of electrical interfaces. In this case, it has a standard USB input socket and unusually, three USB output sockets for low-power peripherals, such as a guide camera or filter wheel. Power is provided by a 12-volt socket and a further socket provides opto-isolated switched outputs to a standard ST4 guide port on a telescope mount.

without economies of scale. Having said that, each year more astronomy CCD cameras are launched and with better sensor performance for the same outlay. Model turnover is much slower than that of consumer cameras and dedicated CCD cameras hold their value for longer. There is a big demand for used cameras and I sold my Meade and Starlight Xpress cameras with ease on the Internet. Once you have a CCD, there are only really three reasons for upgrading: better noise, bigger area or more pixels. The latter two will be practically capped by the telescope's imaging field of view, the resolution limit of the system and seeing conditions.

Remote Operation and Image Quality
Dedicated astrophotography cameras use USB 2.0 interfaces although a few video cameras use IEEE 1394 (FireWire®) for remote operation. These cameras have few, if any external controls and no LCD display. This simpler operation requires less interface electronics and consequently less power, heat and electrical noise. A large sensor can take 20 seconds or more to transmit a full image over USB. This is not ordinarily an issue but during focusing and guiding, it becomes tedious and introduces delays. For that reason many dedicated sensors have the ability to swiftly output a small area (sub-frame) of the full image – for instance, a 100 x 100 pixel image around a star that is being tracked or focused. The high-end imaging programs include drivers for the popular cameras and all take advantage of more generic ASCOM camera commands (the BIOS of the astronomy world). The stripped-down nature of dedicated

cameras has the additional benefit of producing an unmolested image file, that can be read off the sensor with the minimum of delay and which can then be externally manipulated at will. It is also possible to have bare sensors without anti-aliasing filters (a mild diffuser) and these deliver the full resolution of the sensor.

Light Pollution

Dedicated cameras come in color and monochrome versions. The "one-shot" color cameras use the familiar color Bayer array and share some of the limitations of their photographic cousins and as a consequence are equally susceptible to light pollution. The monochrome versions have a significant advantage over one-shot and color sensors, since the user has complete control over filtration. With a monochrome sensor, a single filter is placed over the entire sensor, one at a time and all the sensor elements contribute to every exposure. The designs of the individual filters (RGB, luminance and narrowband) maximize the contrast between the deep sky objects and the sky background. The specialist dichroic red, green and blue filters are subtly different to their microscopic cousins in a Bayer array. The spectrums of the red and green filters deliberately do not overlap and effectively exclude the annoying yellow sodium street lamp glow that is the major element of light pollution. You can see this in fig.15, which shows the spectra of a Baader Planetarium dichroic filter set.

In addition to the normal RGB filters, there are a number of narrowband filters, precisely tuned to an ionized gas emission wavelength. These pass only the desirable light emissions from nebulae but block light pollution, so much so that "narrowband" imaging is very popular with city-bound astrophotographers. The Hubble Space Telescope uses Hα, OIII and SII dichroic filters, the "Hubble Palette". This produces fantastic false-color images, by assigning the separate exposures to red, green and blue channels in a conventional color image. (Examples of color mapping appear in the processing and practical sections.)

attribute	dedicated astro CCD	conventional digital camera
easy to use	These require a PC and specific capture software, 12 V power and USB interface.	...as CCD and can be used with a remote timer release and no PC. Battery power is limiting.
easy color imaging	A monochrome sensor requires 3 or more exposures and software combination, color sensors are slightly more convenient and require deBayering in the PC software.	Requires single exposure for color image and later RAW file conversion for best results. Narrow-band images are not optimum with a color sensor due to transmission efficiency.
large format & economy	Dedicated CCDs in general and the larger sensors in particular, are expensive and the same price as a professional full format DSLR.	Consumer APS-C sensor photographic cameras can be as little as 1/10th of the price of a medium sized CCD, full format cameras may not be covered by telescope's image circle.
image noise	Dedicated CCDs have lower dark noise and better efficiency, due to sensor design and chip cooling further reduces thermal noise.	The electronics in these cameras become warm during long exposures, worsening the CMOS noise performance even further.
resolution	Monochrome sensors have slightly better resolution than a color sensor of the same pixel dimensions. CCD resolution may be lower than a modern CMOS sensor.	Some cameras have very high megapixel counts, in excess of 12 megapixels but the resolution is not usable in many cases and the small pixel size has poor signal to noise performance.
red sensitivity	Dedicated CCDs do not have an IR blocking filter and offer better deep red sensitivity, useful for narrowband imaging.	Cameras have IR blocking filters that reduce the deep red sensitivity, though they can be removed or replaced by a third party.
ease of focus	Dedicated CCDs have good support in astro programs for accurate focusing with rapid downloads and sub frames.	Difficult to focus on LCD screen and require astro capture program to find accurate focus. Some offer liveview over USB that can aid focus measurement in capture program.
dynamic range	CCDs have a high full-well capacity and coupled with their read noise have a dynamic range of ~12 to 13 stops	Cameras at ISO 800 typically have much lower dynamic range at about 10 stops but this can increase if the ISO rating is set lower, with the inherent problems of longer exposure.
other	Monochrome CCDs with RGB or narrow-band filters are designed to exclude common light pollution wavelengths.	Color CCDs or photo cameras require additional filters to reduce the effects of light pollution on color exposures.

fig.10 This table summarizes the main differences between dedicated astronomy CCDs and general purpose cameras, press-ganged into telescope service. The better imaging quality of a CCD comes at a price both in economy and convenience though the pricing gap is closing rapidly as more companies offer alternative products. Full-frame DSLRs are increasing affordable but not all telescopes produce an image circle that will cover the entire sensor. The increasingly large image file sizes require a longer download time.

Color Sensitivity

Dedicated cameras are the epitome of less-is-more; without the infrared blocking filter, they have a better deep-red sensitivity than their SLR counterparts, limited to the sensor itself. They still need a UV and IR blocking filter (often called a luminance filter or "L") but these astronomy screw-in ones do not impair the deep red wavelengths. The decision between one-shot color and monochrome is really one of priorities: Monochrome sensors offers more versatility but with the extra expense of a separate filters or a filter wheel and require a longer time to take separate exposures to make up a color image. Arguably, there is better resolution and color depth using a monochrome sensor through separate filters,

fig.11 *This vintage Philips SPC800 webcam (similar to the SPC900) has had its lens unscrewed and the monitor clamp removed. You can see the tiny CCD chip. The adaptor shown here converts the lens thread to a T-thread but others exist which allow the camera to insert into a 1.25-inch eyepiece holder. Both adaptors are threaded on the telescope side to accept an infrared blocking filter. Philips have OSX and Windows drivers on their support website. The AVI video stream is widely compatible with imaging software.*

since all sensor elements contribute in all exposures. A common technique is to combine adjacent red, green or blue pixels (binning) to colorize a high-resolution monochrome image, taken through a plain UV/IR blocking filter. Our color vision does not have high spatial resolution and the brain is fooled by a high-resolution image with a low-resolution color wash. (Binning is a technique that we will discuss more about later on but in essence it combines 2x2, 3x3 or 4x4 adjacent pixels, with a 2x, 3x or 4x reduction in resolution and an equivalent improvement in signal to noise ratio.)

Thermal Noise

Many dedicated CCD sensors employ an electric cooling system by mounting the sensor chip onto a Peltier cooler (or may have water-cooling). This special heat sink has a sandwich construction and effectively pumps heat from one side to the other when a voltage is applied across it. Alternating n- and p-type semiconductors are the "meat" and have the unique property of creating a thermal gradient between the opposite surfaces. A single Peltier cooler can reduce a sensor temperature by about 25°C, with immediate benefits to thermal noise. Some cameras have a 2-stage cooler that can keep a sensor about 40°C lower than ambient temperature. The practical limit to cooling is around the -20°C mark. At this temperature, in all but the darkest sites, sky noise is dominant in the image and there is no observable benefit from further cooling. Extreme cooling may also cause ice to form on the cold sensor surface and for that reason most CCD modules have a desiccant system to reduce the chance of condensation in the sensor chamber. Desiccants can saturate over time and higher-end camera models seal the sensor cavity and fill it with dry argon gas or have replaceable desiccant inserts.

Cameras for Planetary Imaging

Apart from taking still images of very dim objects, another popular pursuit is planetary imaging. The closer planets are considerably brighter than deep sky objects and present a number of unique imaging challenges. Planetary imaging is done at high magnifications, usually with a special tele-converter (Barlow lens) on the end of a telescope of a focal length of about 1,000 mm or longer. Even at this long focal length the image is physically very small and will fit onto a small sensor. Since these only span the central portion of the telescope's field of view, there is no need for a field-flattener. There is a likely requirement for a considerable focus extension though, conveniently accomplished by screwing together several extension tubes, which either fit directly to the focuser draw-tube or as a series of T2 extension tubes. With my refractor, I use a 4-inch draw-tube extension, my custom adaptor to an SCT thread, a SCT to T2 adaptor, a 40 mm T2 extension tube, T2 to 1.25-inch coupler and then the Televue 5x Powermate®! The image fits neatly onto the small sensor but at this magnification, finding the object is challenging, even with a good finder scope. At high magnifications astronomical seeing is obvious and the trick is to take a few thousand frames at 7–60 frames per second and then align and combine the best of them. The difference between a single frame and the final result is nothing short of miraculous. (My equipment and locality is not ideal for solar-system work and I have removed the prior example of planetary imaging and processing to concentrate on deep sky objects in the second edition.)

fig.12 *An alternative to the webcam is this DMK color video camera, with the same resolution but a better CCD. The camera is fitted with a C-thread, a throwback to the old Cine days. An adaptor converts to T-thread and to the Tele Vue Powermate® tele-converter via its own T-thread adaptor. Other DMK cameras in the range offer higher resolutions and higher video speeds, as well as monochrome sensors, ideal for solar imaging with narrow band filters.*

These challenges suit a sensitive CCD video camera. These output a video file via USB or FireWire. Many start with a modified webcam. A popular choice is a Philips Toucam or SPC900 CCD model for about £50. These models are long out of production and used prices remain high. Even so, this is an inexpensive way to start and the modification is simple; a threaded adaptor replaces the lens, which allows the camera to fit into an eyepiece holder and hold an IR blocking filter. There are several after-market adaptations, including support for long exposures and cooling. Several companies offer dedicated (or adaptations of security products) CCD-based designs, with higher resolution, lower noise and full control over video exposure, frame rate and video format. These do give better results than webcams and with more convenience. A low cost webcam is remarkably good, however, and a lot of fun.

Choosing a CCD camera

CCD cameras are available in a number of configurations; with integrated cooling, in-built guider, off-axis guider and integrated filter wheel to name the most common. I have made a few changes over the years and can relate to the dilemma of product selection. The final choice is a balance of performance and size. The largest sensors are not necessarily the best in terms of sensitivity and noise. I initially used a planetarium program to show the field of view with my various combinations of telescope and field flatteners, with respect to the objects I wish to image. My original KAF8300 sensor was too big for the smaller objects, even with my longest scope, but too small for the largest nebulas and galaxies with my shorter scope. I chose a smaller, more sensitive Sony monochrome sensor to suit the smaller deep sky objects and that works, without cropping, using a 1.25" diameter filters. I used L, RGB and Hα filters in a filter wheel with an off-axis guider tube. Later on, I realized the field of view was too small for wide field objects and I replaced it with another KAF8300-based model, with an integrated 8-filter wheel, an off-axis guider and bought a long and short focal length refractor to cover the range of magnifications.

As you can tell, there is no perfect camera for all purposes; the sensor choice alone is a compromise between size, pitch, well depth, read noise, thermal noise, sensitivity, efficiency and gain. The specifications for a range of popular sensors are shown in fig.7 with their computed dynamic range and effective bit depth. There can be small differences in the final camera specification between camera manufacturers that use the same chip and sometimes they use different quality grades too.

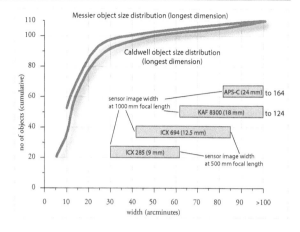

fig.13 *The size of the sensor and the focal length choice may be too big or small for the deep sky object. This graph shows how many Messier objects are smaller than a certain angular width, in comparison to four common sensors for a focal length range of 500–1,000 mm. Only 2 Messier objects are wider than 100 arc minutes.*

Filters and Filter Wheels

With a color camera, the built-in Bayer color filter array is fixed over the sensor. It is possible to additionally place a narrowband filter in front of it but this lowers the overall sensor efficiency below that of the same filter with a monochrome sensor. An unfiltered sensor allows complete control over the filtration and a full choice of how to image an object. To produce a color image with a monochrome sensor, you combine the exposures through different colored filters. For conventional color, these are red, green and blue. In practice any combination of three filters can be assigned to the red, green and blue values in a color pixel to create a false-color image. Common practical combinations are LRGB, LRGBHα, HαSIIOIII and RGB. A stronger general luminance signal through a plain UV/IR ("L") blocking filter will out-perform the luminance combination or red, green and blue signals but may suffer from chromatic aberrations that degrade image resolution. In another twist some imagers create a more interesting luminance image by combining luminance and Hα exposures, which suppresses light pollution more effectively. Other combinations create interesting pictorial effect on nebulous clouds.

Unlike general photographic filters, imaging filters for astronomy are made by thin-film deposition (dichroic). This technology enables precision notch filters (which remove a particular color band), narrowband (which only passes a very specific color range) and combinations of both. Baader, Astronomik and Astrodon are three prominent manufacturers that offer a full

fig.14 You can see the five 2-inch filters in this Starlight Xpress filter wheel (with the cover removed). The small motor drive is to the left and the off-axis guider attachment is to the right. The dichroic filters look odd from an angle and are actually LRGB and Ha. The unit is powered from the USB interface and consumes about 100 mA.

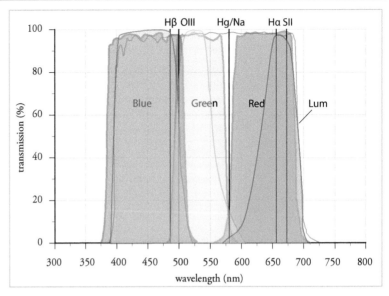

fig.15 With care, separate red, green and blue dichroic filters can be designed to include the important nebula emission wavelengths for hydrogen, oxygen and sulfur and exclude the principal light pollution colors for mercury and sodium (Hg/Na). This graph is reproduced with permission from a Baader Planetarium GmbH original.

fig.16 These three T-adaptors are designed to keep the same spacing between the T-thread and the camera sensor, in this case for micro 4/3rds, Fuji X and Pentax 42 mm cameras, all of which have different distances between their sensors (or film) and the camera lens flange. This ensures a 55 mm overall spacing, give or take a millimeter and is a standard recognized by many OEMs. Since you can always add spacing but not remove it, most OEMs' camera systems aim for a few millimeters less than 55 mm, to allow for additional filters in the optical path and fine trimming with 42-mm diameter washers.

range. As mentioned before, these filters are specifically designed as a set to exclude the principal street lamp emissions (fig.15). Thin film deposition also enables particularly effective anti-reflection coatings, which generally improve image contrast and removes flare around bright stars. I use a set of RGB filters, with both a luminance and a light pollution filter (used in unfavorable conditions) in addition to a narrowband set comprising of Hα, SII, OII wavelengths.

It is possible to individually screw these filters in front of the sensor housing. If frequent filter changes are required, however, this setup is inconvenient and prone to compromise alignment. More usefully, the filters are secured in a filter wheel carousel and rotated into place by remote control. These carousels commonly hold 5, 7 or 8 filters, in a range of sizes, including the eyepiece sizes of 1.25-inch and 2-inch and unmounted in sizes 31, 32.5, 36, 49.7 and 50.8 mm. Filter wheels normally have a serial or USB interface for remote control and through ingenious methods using magnetic or optical pickups, identify each filter position (and with precision too). Some filter wheels have enough internal space in which to fit an off-axis guider pickup; a small angled mirror that reflects some of the image to an externally mounted guide camera. An off-axis guider is an effective way to eliminate any differential flexure between the guider and main image and potentially enables the best tracking performance. An example of a large filter wheel, which can take up to 5 large filters or 7 small ones is shown in fig.14. This particular one also has an off-axis guider attachment for a separate guide camera. The best designs place the off-axis guider in front of the filter wheel so that the brief autoguider exposures pick up the maximum signal level. This does, however, have the small issue that small focus adjustments, required for each filter, will translate into small degrees of de-focus at the guide camera.

Sensor Spacing

It is worth mentioning a little on the precise optical path length at this point. The filter wheel inserts between the field-flattener or coma corrector and the camera. The optical design of a field-flattener has an optimum distance from the coupling to the sensor. A common spacing is 55–57 mm, similar to the T-mount standard. The combined distance from the sensor plane to the face of the T-thread should be within ±1 mm for best results. (For the same reason, T-thread adaptors for different photographic cameras are different lengths, so that the overall T-thread to sensor distance is 55 mm.) Dedicated CCDs often have matching filter wheels or integrate with them to accomplish the same coupling to sensor distance. Hopefully the distance is spot on or a little less than required, in which case T-thread extension tubes and plastic Delrin® shims in 1 and 0.5 mm thicknesses are combined to fine-tune the separation. The physical separation is shorter than the optical distance, since the sensor cover glass and filter can be quite thick, normally around 2–3 mm and generally increases the optical path by 1–1.5 mm. (The optical path of a medium is its thickness multiplied by its refractive index; in the case of glass, about 1.5x)

There is another less obvious advantage to exposing through individual filters over a one-shot color CCD or conventional photographic camera that improves image quality through refractor telescopes. When imaging through individual or narrowband filters, it is possible to fine-tune the focus for each wavelength. As it is not a requirement to have all light colors focusing at the same point at the same time, it is possible to use a cheaper achromatic rather than apochromatic refractor. (There are limits – if the focal length is significantly different for different wavelengths, the image scale will be slightly different too and will require careful registration to form a color image.) Individual focus positions become a practical proposition with a motorized focuser, since you can work out the optimum focus position for each color and store the offsets in the filter wheel driver software (or alternatively autofocus after a filter change). When the imaging software finishes an exposure, it commands the filter wheel to change, reads the focus offset for the new filter and passes it to the focuser driver before starting the next exposure. I found that even with an APO refractor, the combination of the apochromatic triplet and a two-element field-flattener adds a tiny amount of focus shift that can produce slightly soft stars in the outer field. It also helps to choose all your filters from the same range; not everyone owns a motorized focuser, and an LRGB and narrowband filter set is approximately parfocal (focus at the same point) and are designed to work together to achieve good color balance.

Field-Flatteners and Focal Reducers

The need to buy a field-flattener for an APO telescope was a big surprise to me. Coming from a photographic background I naively assumed that telescopes, like telephoto lenses, could image perfectly onto a flat sensor. A field-flattener is a weak negative lens and combined with other elements can change the image magnification at the same time. Most often they reduce the image magnification that decreases the effective focal length, increases the effective aperture, reduces exposure times and shrinks the image circle. In the case of refractor designs this is often in the range of 0.65–0.8x. The longer focal lengths of SCT (around 2,000 mm) have two common flattener/reducer ratios of 0.63 and 0.33x. In the latter case, a

fig.17 This TMB designed field-flattener has a 68 mm clear aperture and with the right telescope optics can cover a full frame 35 mm sensor. It is designed around a fixed sensor spacing assumption for the longer William Optics FLT refractors but a little experimentation reveals that results improve with about 10 mm additional spacing with shorter focal lengths.

fig.18 My other field-flattener, which will work with focal lengths from 500 to 1,000 mm has a unique feature: The optics are mounted within a helical focuser and can be moved back and forth, allowing for continuous adjustment of the lens to sensor distance.

fig.19 This graph from CCDInspector shows the field curvature for alternative field-flattener to sensor spacing (in 0.5 mm increments). The optimum position has 15% field curvature on this sensor.

2,000 mm f/10 SCT becomes a 660 mm f/3.3. The telescope manufacturers normally offer a matching field-flattener alternatives. A browse on the Internet will quickly find web images with the same setup as your own and is a great starting point to establish your equipment's potential. It is handy to remember that a good quality image cannot happen by accident but a poor image can be due to poor technique!

In the case of refractor designs, the curved focus plane of two similar scopes will also be similar and as a result, there is a certain degree of compatibility between field flatteners and telescopes. Aperture and focal length affect the degree of field curvature. My William Optics 68-mm TMB field-flattener also appears to be an Altair Astro and Telescop Service part for 700 to 1,000 mm focal lengths. Theoretically, the optical design is optimized for a precise optical configuration but there is a degree of flexibility: The spacing between the flattener and the sensor has a bearing on the degree of flattening and it is worthwhile experimenting with different spacing to optimize the result. The manufacturers often give enough information on flattener spacing and sensor-flange distances to establish a useful starting point.

fig.20 This close-up shot of a filter wheel shows the small mirror of the off-axis guider protruding into the field of view but not sufficient to obscure the imaging camera.

The obvious question is how to find the sweet spot? If the spacing is not quite right, the star images at the edge of field become slightly elongated and show aberrations more readily when the focus is not spot-on. It can be quite a laborious process to take a series of images, changing the spacing, focusing each time, and poring over images to see which one is the best. Fortunately, there is at least one program that will make this task much easier: Since I have six combinations of telescope and field-flattener, I invested in CCDInspector by CCDWare. This program monitors the quality of star images in real time or after the event. One of its features measures star elongation, FWHM, intensity and direction to determine field flatness, curvature, fall-off and tilt, in numbers, graphs and pictures that clearly indicate the optimum position. Some examples in the next chapter show the extreme field curvature of a short focal length telescope. Of note is the indication of tilt – where the plane of focus may be flat but not precisely parallel to the sensor. A field-flattener/reducer exacerbates out-of-focus stars and minor misalignments. Some of the larger CCD cameras have an adjustable faceplate to align the camera angle. This can be useful if the sensor is in a rigid assembly, screw-fitted throughout but futile if the flattener, filter wheel or camera use a 1.25- or 2-inch eyepiece clamp, as these are less robust couplings.

fig.21 The Lodestar™ guide camera is 1.25-inches in diameter and will fit into an eyepiece holder or screw into a C-thread for a more rigid assembly.

In other configurations, astrographs have built-in field flatteners, ready for astrophotography and some of the OEM's also offer matched reducers and converters, to modify shorten or lengthen the effective focal length. The faster the focal ratio, the more sensitive the system will be to tilt and position. Newtonian designs require coma correctors, both for visual and imaging use for pinpoint stars in the outer field and there is a choice of independent or OEM products to choose from. The designs for these are generic and optimized for a small range of apertures rather than focal lengths. Through an eyepiece, the eye can adjust for small changes in focus, but a sensor cannot. Although coma correctors flatten the field somewhat, some are specifically labelled as coma/field flatteners, optimized for imaging use. The designs of the more useful ones add a back-focus distance sufficient to insert an off-axis guider and filter wheel in front of the camera.

fig.22 The rear of the Lodestar guider camera has a mini-B USB socket, through which it takes its power and supplies the imaging data. It has an additional connector with opto-isolated outputs for direct connection to the ST4 guide port on a telescope mount.

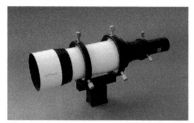

fig.23 *This 60-mm aperture finder scope, with a focal length of 225 mm, should be sufficient to guide sufficiently well in typical seeing conditions. In perfect conditions and with a long focal length imaging scope, off-axis guiding is more robust.*

Autoguiders

In a perfect world, telescope mounts would have perfect tolerances, tracking rate and alignment to the celestial pole, no flexure and there would be no atmospheric refraction. In these conditions, there would be no requirement for autoguiding. In some cases this is a practical possibility; especially with permanent setups, extensively polar aligned using a mount with stored periodic error correction and for 10-minute exposures or less with a shorter focal length telescope. For the rest of the time, autoguiding is a fantastic means to deal with reality. Within reason, it can correct for many small mechanical and setup issues. In essence, a star (or increasingly stars) are briefly imaged every few seconds or so and their position measured relative to a starting point and small corrections issued to the mount's motor control board for both RA and DEC motors. To do this you need three things; a guide camera, an optical system and something to calculate and issue the mount corrections.

Guide Cameras

Thankfully guiding does not require a large expensive sensor and it actually helps if it is small and sensitive with a fast download speed. Some guide sensors are integrated in up-market imaging CCD modules or otherwise bought as a separate camera. Ideally, this is a small separate monochrome CCD still camera, often 1.25 inches in diameter or a webcam (that is able to take long exposures). It can also give an extra lease of life to one of the early CCD imagers, like the original Meade DSI range. Others choose a sensitive CCD marketed specifically for guiding and which include a ST4 guide output (effectively four opto-isolated switch outputs for N, S, E & W control). The Starlight Xpress Lodestar® is a popular choice and equivalent models are offered by QHY, SBIG, ATIK and Skywatcher to name a few. The Lodestar slides neatly into a 1.25-inch eyepiece holder or can screw into a C-mount adaptor for a more secure and repeatable assembly. It is possible to guide with a webcam too, though a color CCD is less sensitive and will require a brighter star for guiding. Since guider corrections are not predictive but reactive, the delay or latency of the correction should be as small as possible but not so rapid to try and guide out seeing conditions. To speed up image downloads through the USB, the better CCD models have the ability to output a sub-frame centered on the guide star.

Guider Optics

The best position for a guide camera is to take a sneak peek through the imaging telescope, focuser and reducer, adjacent to the main imaging sensor. In this position the guide camera has precisely the same alignment as the imaging camera and will automatically correct for any flex in the mount, telescope and focus tube assembly. One way to achieve this in practice is to reflect a part of the peripheral image to a sensor before the light passes through the filter system, using an off-axis guider. You can see the small mirror in fig.20 that splits some of the image off to an externally mounted guide camera. The two adjustments on the periscope fix the mirror intrusion and the focus position of the camera. Since the off-axis guider moves with the imaging camera it tracks any focus changes. Using the screw coupling in fig.21, this is a one-time calibration.

It is not always possible to use an off-axis guider, either because you do not own one or do not have the space to insert it in-between the field-flattener and the sensor. This is the case with a T-coupled digital SLR. In this situation a

fig.24 *This piggy-back partnership of a refractor and a Meade LX200 SCT can be configured so that either will act at as the guide camera for the other. The refractor is fixed to a Losmandy plate that is screwed firmly to the SCT. The counterweights can be slid along a dovetail bar and extended, balancing both axes.*

fig.25 This screen grab from PHD shows the DEC and RA tracking error. It can show the error or the correction values along the time axis.

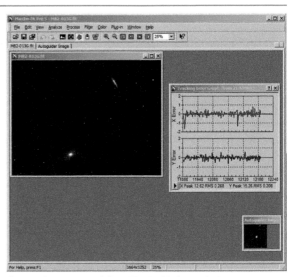

fig.26 This screen grab from Maxim DL shows the image capture and guider images, together with the tracking graph, which displays the positional error every second or so. The graph is a useful confirmation that everything is going smoothly. There are several options for showing errors (in pixels or arc seconds) and the mount corrections.

separate telescope or guide scope, mounted alongside or directly to the imaging scope is required. This can be effective but any difference in the flex between the imaging systems will show up as a guiding error. (This is a particular issue with those SCT designs with moveable mirrors, as the guiding system cannot correct for any mirror shift that occurs during an exposure.) One of the interesting things is the guide scope does not have to be the same focal length as the imaging scope but can be considerably shorter and still deliver accurate guiding information. The ability to detect a guiding error is determined by the pixel pitch, focal length of the guider optics and the ability to detect the center of a star.

Guider software calculates the exact center of a star not only from the bright pixel(s) in the middle but the dimmer ones at the edge too. It can calculate the center extremely accurately, to about 1/10th of a pixel or better. When we take into consideration that astronomical seeing often limits the image resolution, say 1–3 arc seconds, the accuracy of the guiding should only need to be practically compatible at a system level. The practical upshot is that you use a guide scope with a focal length that is a fraction of the imaging scope. Since longer guider exposures even out seeing, the aim is to have a guider system with an angular resolution about 2x finer than the seeing conditions (the overall performance is a combination of the angular resolution imposed by tracking, optics, seeing and imaging pixel size). As a guide, the minimum focal length in mm can be determined by the following formula:

$$\frac{2 \cdot 206 \cdot pixel\ pitch\ (\mu m) \cdot centroid\ resolution\ (pixels)}{seeing\ (arcsecs)}$$

In the case of the Starlight Xpress Lodestar, with a pixel pitch of 8.4 μm, seeing of 2 arc seconds and a guider resolution of 1/10th pixel, the minimum guider focal length would be 173 mm. In practice, the root mean squared (RMS) error for the finder scope system shown in fig.23 was about 2.5 arc seconds peak-to-peak on a summer's night and influenced by the seeing conditions during the short, 1-second exposures.

Guider Control

Guider control will need a computer somewhere along the line. There are some stand-alone systems, the granddaddy of which is the SBIG ST-4, that gives its name to the popular mount control interface. More recently the SBIG SG-4 and the Celestron NexGuide guiding systems automatically calibrate, lock onto the brightest star and issue guiding pulses to an ST4 guider port on a telescope mount. These systems comprise a guide camera with an integrated micro controller and a simple interface. These are ideal for setups without a PC and using a photographic camera. The alternative is to use a guide camera and autoguider software on a PC (in this case meaning any personal computer; Windows and Apple OSX operating systems are both capable for image capture and guiding). Modern autoguider software, after performing an initial calibration that measures the orientation and scale of the guider image, takes an exposure and identifies a bright star. It then takes repeated exposures, calculates the positional error and issues the necessary mount adjustment after each exposure. Some of the better systems rapidly download a portion of the image and also adjust for backlash on the declination axis, either automatically or as a manual adjustment.

Autoguider software may be a stand-alone program or incorporated into the imaging software, of which Maxim DL® and TheSkyX® are the best known. PC control offers more options than stand-alone systems, including full

control over guide aggressiveness; dither, anti-backlash settings as well as the physical means of moving the telescope (pulse guiding and ST4). This last choice is not without some controversy: An ST4 guider port accepts direct simple N, S, E & W control signals into the mount, whereas pulse guiding takes the required correction and accounts for any periodic error correction and issues corrections through the handset or PC serial link. To my engineering mind, pulse guiding is more intelligent, as potentially contrary commands can be combined in software rather than fight each other at the motor. (For instance, the RA motor is always moving at the tracking rate and guiding should never have to be that severe that the RA motor stops moving or reverses direction, it merely has to speed up or slow down a little.) Having said that, I have successfully used both on a SkyWatcher EQ6 mount but your experience may differ with another mount and its unique motor control setup. I would try pulse guiding if you are also using a PC to correct for periodic error or ST4 control if not.

The most popular (and free) stand-alone autoguiding program is PHD2 ("push here dummy") for Apple and Windows platforms and is compatible with both still cameras and webcams. Several image capture programs, including Nebulosity and Sequence Generator Pro, interface with PHD2 so that it temporarily stops guiding (and potentially hogging computer and USB resources) during image download. Guiding can sometimes be inexplicably stubborn and some users prefer two other free alternatives, GuideMaster and GuideDog, both of which favor webcams as guide cameras.

Focuser Equipment

We have said it before but it is really important to obtain accurate focus to achieve high-quality images. With a 3-dimensional photographic subject, closing the aperture down and increasing the depth of focus can disguise some focus inaccuracy. This is no such charity in astrophotography; accurate focus not only makes stars appear smaller and brighter but the higher image contrast requires less severe tonal manipulation. Interestingly, if there are any optical aberrations near the edge of an image, they become more obvious if the image is slightly out of focus. Two key considerations dominate the choice of focuser equipment: mechanical integrity and control.

Focus Mechanisms

Many telescopes are shipped with a focus mechanism designed for the light duty demands of visual use and these mechanics struggle with the combined weight of a camera and filter wheel. Some manufacturers offer a heavy-duty alternative for imaging, or an adaptor to one of the popular third-party designs. There are three main types of focuser design; the Crayford, rack and pinion (R&P), and the helicoid mechanism. Although the helicoid is extensively used on photographic lenses, it is only practical proposition for short focal length telescopes that do not require a large focus travel or motor control. Crayford and R&P designs make up the majority of the product offerings and as before, although the design architecture influences performance so too does its execution.

The Crayford focusing mechanism was originally designed for amateur astronomers as an economical alternative to the rack and pinion design. Opposing roller or Teflon® bearings support a focusing tube and push it against a sprung loaded metal roller. This roller is fitted to the axis of the focusing

fig.27 This underside view of a focus mechanism shows the "rack" of the rack and pinion mechanism. These groves are slanted to improve lateral and longitudinal stability. Other designs are orthogonal and although cheaper to make, can suffer from lateral play.

fig.28 A Crayford design simply has a smooth metal surface on the underside of the focus tube. This can be a milled surface or a metal bar. For optimum grip it should be kept clean and free of lubricants. This view of the underside of my original telescope's Crayford focuser shows the polished metal bar that is clamped by friction alone to the metal rod passing between the focus knobs. The tension adjuster is in the middle of the black anodized supporting block. The multiple holes are for aligning the bearings that run along the focus tube, so it runs true. The focus adjuster on the right hand side has a reduction drive within it for precise manual operation.

fig.29 This view shows the stepper motor, assembled onto the end of the focuser shaft. In this case the knobs are removed and the motor's own gear reducer scales down the stepper motor resolution to ~4 microns/step. Usefully, it has a temperature sensor mounted on the connector, that quickly tracks ambient changes. Some designs employ the focuser's gear reducer and have a simpler motor mechanism.

fig.30 This is the control module for the popular Lakeside focus system. It houses the PC stepper motor interface and you can use it to manually change the focus position and compensate for temperature effects in the focus position. A USB port enables it to be controlled by a computer; essential for autofocus operation. It connects via a ribbon cable to the motor. I made a custom motor cable, so that it was easier to route through my telescope mount's body.

control and grips the focusing tube by friction alone. This system has no backlash but can slip under heavy load. (Unlike photography where one is typically pointing the lens horizontally, in the case of astrophotography, you are often lifting and lowering the camera mass with the focus mechanism.) Mechanical tolerances play an important part of the overall performance: I had two Crayford mechanisms that had good grip at one end of their travel but became progressively weaker towards the other end. I could not find a tension setting that allowed the focus tube to move smoothly and without slipping across the entire focus range. In my own setup, I quickly replaced the original Crayford mechanisms with a quality rack and pinion focuser.

Rack and pinion focus mechanisms replace the friction drive with a toothed gear-train. Gears do not slip but suffer from backlash. In this case a change in the focus knob direction does not immediately translate into a change in focus. Backlash is easily overcome by approaching the focus position from one direction only and if the focuser is motorized, this direction can be automated. The implementation again is crucial; I purchased a new telescope with its latest rack and pinion focus mechanism, (replacing a previous lightweight Crayford design). There was no slippage in travel but the tube wiggled from side to side and up and down unless the focus lock was tight. This made manual adjustment impractical and was unusable as part of a motor-driven system. I have learned to be more cautious; I always test a new focus mechanism for smooth operation over the entire focusing range and I make sure it can lift the imaging equipment and hold it without slipping. I also check for lateral play as well, which can ruin an image from movement during an exposure or tilt. This may be detected by hand or by looking through a medium eyepiece and noting the image shift as you adjust the focus position. (Even a high-quality focuser may have a slight image shift between focus positions.)

Motorized Focusing

Both Crayford and R&P focusers normally have a geared reduction drive on the focusing knob for fine control and where there are gears, there is backlash. Motor drives are available in a number of configurations, some of which are more suitable for remote operation and autofocus programs. The motors themselves couple to the focusing mechanism by varied ingenious solutions. Some motors directly couple to the focus shaft and require removal of a focus knob. Others use toothed belts and pulleys around the focus knob. The DC servomotor or stepper motor is normally held in position by a bracket fastened to the focus mechanism. DC motors combined with Crayford focus mechanisms offer an economical way of hands-free focusing, using a small, wired control-paddle. For computer control, stepper motor varieties offer precise, repeatable absolute positioning, especially when attached to a rack and pinion focuser. Any movement is precisely defined by a number of steps rather than an analog voltage and duration on a DC servomotor.

Even though R&P focusers will inevitably exhibit backlash, the better control programs drive to the final focus position from one direction only, normally against gravity, eliminating its effect. Microtouch systems are designed for Feather Touch focusers but there are many other motor control systems that can be used with Feather Touch and other focus mechanisms, via an array of ingenious brackets, for example those from Robofocus, Lakeside Astro, Rigel Systems and Shoestring Astronomy.

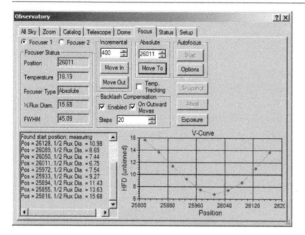

fig.31 This screen grab from Maxim DL shows an automated
focusing sequence. The graph shows the width (half
flux width in this case) of the star as the focus tube
is slowly stepped in. It then works out the optimum
position and moves the focus tube back to that
point. The whole process takes a few minutes.

A highly regarded manufacturer of R&P focusers is Starlight Instruments, who manufacture the Feather Touch® range and also a matching direct-coupled stepper motor drive system. Their focusers come in a number of sizes and compatible with many refractor and reflector designs. I used a 3-inch and 3.5-inch Feather Touch focuser on my refractors, fitted with Micro Touch® motors that are controlled by a small module. It was not possible to fit all my telescopes with these motors and I changed over to Lakeside Motor units and a single embedded module in my interface box. These modules remember the focuser position when it is switched off and I return the focuser to a reference position on the scope during my shutdown process. In that way, the absolute focus position is known if I switch scopes. A good focuser is a precision assembly and expensive to manufacture. The control modules, have a simple button interface, remote PC control and often feature automatic temperature compensation. This last feature is an interesting one; when a telescope changes temperature, it expands or contracts and the focus position changes. In some cases the focus shift is sufficient to

degrade an image and needs to be compensated for. By logging the precise focus position for a range of ambient conditions, a focus steps/degree compensation value may be determined, although the elements of an optical assembly can heat and cool at different rates and the steady state and transient focus position may be different. The focus motor control box monitors the ambient temperature and it (or the PC) issues a small adjustment to the motor position. To avoid image shift during an exposure it is better for the PC to decide when to adjust the focus, normally between exposures. Motorized focusers are brilliant but they have a drawback; the motor and gearbox lock when un-powered and without a clutch mechanism prevent any manual focus adjustment using the focus knob. You need to use the module's buttons and provide a power source for visual work.

Other high-quality after-market focusers include those from Baader, APM telescopes and MoonLite Telescope Accessories, who specialize in Crayford style designs, offer many adaptors for refractor and reflector applications, as their own DC and stepper motor control systems.

Interfacing

The primary electrical interfaces used by astronomy equipment are USB, serial, Bluetooth, WiFi and occasionally FireWire. In the early days, nearly all devices communicated via simple serial interfaces and many mounts and accessories still do. The reasoning is simple; there is no need for speed, the technology is inexpensive and significantly, it reliably transmits over 30 m of cable with ease. Since digital cameras have become more popular, transmitting megapixels requires a more capable interface. The answer initially was FireWire but soon became USB 2.0. This interface is increasingly adopted by mounts, filter wheels, cameras, focuser and GPS receivers. Ten years ago, desktop and portable computers had one or two serial ports. Today a serial port is a rarity and USB 2.0 (and 3.0) ports are the norm. USB, unlike serial communications usefully deliver power to a peripheral device (up to 500 mA at 5 volts). It would be wonderful to have a computer with a single cable running to the telescope (or wireless connection) at which a USB hub connected to all the devices.

fig.32 My Mk1 electronics hub houses
a 24 Ah sealed lead-acid cell and
a powered 4-way USB extender
over Cat 5 module in a sealed
plastic box. The Summer Projects
chapter gives construction details
of a much improved Mk2 version,
keeping the power supply external.

There is a snag; USB maybe fast and expandable but it is limited to a 5-m cable length between devices. This is only just long enough for a PC positioned close by and too short for remote control from a comfortable distance. A powered hub or extender increases this in 5-m increments but this is not always practical (or reliable). Wireless technologies are not the solution either; Bluetooth is a short-range, low speed system and is often used with portable computing devices to control telescope positioning. WiFi is more capable, in both speed and range, but as yet, no simple device reliably converts WiFi into a universal USB hub that works with astronomy products (other than a full blown remote computer). Several other astrophotographers have tried promising WiFi to USB interface modules with mixed success.

All hope is not lost; there are two potential solutions for remote control, both of which use network technologies:

1 remote control of a basic PC that is situated close to the telescope, by WiFi or Ethernet cable
2 wired remote control with a USB extender that is based on Ethernet cable transmission technologies

Good old serial RS232 lingers on in several astronomy applications for controlling simple hardware. Although few modern computers have a serial port these days, there are many USB to serial converters to fill the void; those from Keyspan and using Prolific chip sets find favor. Although serial communication is slow, there is no need for speed and unlike USB with its 5-m range, serial communications will work at 9,600 bits per second through 30 m of low capacitance cable.

The first solution is a practical one if an observatory protects the local PC from the elements. There are several programs that allow a remote PC or Mac to be operated remotely by another. Some, like TeamViewer and Microsoft Remote Desktop, are free. They can also use an Internet link, for really remote control, or WiFi for living-room comfort. Not all of us have a permanent installation, however, and I prefer not to leave a PC or laptop out overnight in dewy conditions.

I initially chose the second, more novel solution for my temporary setups. It allows my computer to reside in the house or car, away from potential damage. It employs a USB extender over Cat 5/6 cable, manufactured by StarTech and others. At one end is a 4-way USB powered hub with an Ethernet RJ connector. A second small box connects to the computer's USB port and has a RJ connector too. The two boxes can be up to 100 m apart, joined with Cat 6 Ethernet cable and transmit data at full USB 2.0 speeds. To date, this arrangement has worked reliably with every USB camera, mount and accessory I have connected, with the exception of 60 frames per second (fps) uncompressed video. You can expand the hub too; I added a second powered USB hub, not only to extend the number of ports but also to isolate the power supply between the cameras and the other electrically noisy peripherals.

Interface Speed

At one time, beguiled by promising reviews on various forums, I swapped a power hungry laptop for a tiny netbook with a 12-hour battery life. Whilst the image capture, guiding and simple planetarium programs ran concurrently, I soon realized that the images had strange stripes across them. The forums suggested it was a USB speed issue but after upgrading the hard drive to a solid-state model and streamlining the system, although it dramatically improved overall performance, the stripes persisted. I then discovered that some CCDs need to download their images over USB without any interruption, since any delay affects the image data in the sensor. Although this banding effect is small, it is exaggerated by subsequent image processing. In the end, swapping back to a laptop fixed the problem. Although the laptop processor speed was only twice as fast, the laptop had additional graphics and interface electronics that reduced the burden on the microprocessor. Whichever interface solution you choose, it should be able to cope with fast image downloads and in the case of planetary imaging, up to a 60 fps video stream without dropping frames. Reliability is the key to success.

Software and Computing

Astronomy software options are expanding and becoming ever more sophisticated, at a rate to rival that of the digital camera revolution in the last decade. In addition to commercial applications, several astronomers have generously published free software applications that cover many of our essential needs. Many application prices are low and one can buy and try dozens of astronomy programs for the price of Adobe Photoshop CS6. To give an idea of the range I have shown a list of popular software applications, pricing and general capabilities at the time of writing.

Computing Hardware

Laptops are the obvious choice for portability or for a quick exit from a damp shed. My MacBook Pro is an expensive computer and although I ruggedized it to protect it from accidental abuse, I could have chosen a less expensive Windows laptop for the same purpose. Battery life is an obvious priority for remote locations and an external lithium battery pack is an effective, if expensive, means to supplement the computer's internal battery to deliver a long night's use. For those with an observatory, assuming it is weather-proof, you can permanently install an old desktop PC or seal a low-power miniature PC into a weather-proof box. The demands placed on the computer hardware are not as extreme as that needed for modern PC games or video processing and it is possible that a retired PC from an upgrade may be ideal for the purpose. There are some gotcha's – as I mentioned before, a netbook may appear to be sufficiently powerful and inexpensive but a 1.6 GHz, 1 GB netbook had insufficient processing resources for image capture from an 8 megapixel CCD camera. Any computer will require several USB 2.0 ports and possibly FireWire, Serial and Ethernet too. Having a network option allows for later remote operation. Backup is essential and a high capacity external hard drive is essential to store the gigabytes of image and calibration data that astrophotography quickly acquires. After each night's imaging, I copy the image data over to my external drive and keep that safe. It pays to keep the original data since, as your processing skills improve, another go at an old set of image files may produce a better end result.

Operating Systems

Alternative operating systems are a favorite punch bag for Internet forums. After writing my last book, I favored Apple Mac OSX rather than Windows XP. I use Macs and PCs daily and although I prefer the OSX experience, there are simply more astronomy programs available for the Windows platform. Having said that, one only needs a working system so a choice of say 10 rather than 3 planetarium applications is not a big deal. A more important issue though is hardware support: In OSX, the astrophotographer is reliant on the application (or operating system) directly supporting your hardware. That can also apply to Windows applications but usefully, many hardware manufacturers support ASCOM, a vendor independent group of plug and play device drivers that provides extensive hardware and software compatibility. ASCOM only works in a Windows environment and although Mac software will improve with time, presently the image capture, focuser and planetarium applications do not support all available astronomy hardware.

I started down the Mac road for astronomy and was able to put together a system, including a planetarium (Equinox Pro / Starry Night Pro / SkySafari), image capture (Nebulosity), autoguiding (PHD) and image processing (Nebulosity and Photoshop). I produced several pleasing images with this combination and could have continued quite happily on a MacBook Pro with its 9-hour battery life. As my technique improved, I became more aware of alignment and focusing issues and I eventually abandoned the otherwise excellent Nebulosity and PHD for Maxim DL, MaxPoint and FocusMax on a Windows platform. (The only application that offers full control in OSX is TheSkyX with its add-ons.) Things move on and my system has evolved to TheSkyX, PHD2 and Sequence Generator Pro in Windows.

Image processing software is increasingly sophisticated and a modern computer will process images quickly. Most current astronomy applications are 32-bit but some (for example PixInsight) only work in a 64-bit environment. A purchased version of Windows 7 has two install DVDs; a 32-bit and 64-bit version. The real advantage of 64-bit Windows 7 is that it can access more than 4 GB of memory to support multiple applications. A few useful utilities will only run in 32-bit windows (for example PERecorder) but over time these will become the exceptions. Windows platforms come and go; I quickly moved from XP to Windows 7, skipping Vista, resisted the tablet temptation of Windows 8 and finally moved over to Windows 10. I still use my MacBook Pro and by using Boot Camp, I can run both Windows for control, capture and image processing and OSX 10.11 for publishing. I am fortunate to have a foot in both camps (more by luck than judgement) and the best of both worlds!

Software Choices

Astronomy software packages offer a dizzy range of capabilities: Some do a single task very well; others take on several of the major roles of telescope control, acquisition and image processing. There are two major integrated packages; Maxim DL and TheSkyX. Neither is a budget option (~$600) but they are able to display, control, capture, autofocus, guide, align and process images (to varying degrees). Maxim DL includes their own drivers for many astronomy peripherals and connect to other hardware using ASCOM. TheSkyX is developed by the same company that manufactures the exquisite Paramount equatorial mounts and not surprisingly, their software has close ties to their own equipment, SBIG cameras and additionally promote their own interface standard X2 for other vendors. Recently they have expanded TheSkyX hardware compatibility with native

software	price (2014)	PC	Mac	plane-tarium	mount control	guide	plate solve	focus	SLR cam	CCD cam	cal	stack	process
integrated packages													
Maxim DL	£399-$599	Y			Y	Y	Y	Y	Y	Y	Y	Y	Y
TheSkyX	$349	Y	Y	Y	Y	Y	Y	Y	Y	Y	Y		
AstroArt	€129	Y			Y	Y	Y	Y	Y	Y	Y	Y	Y
planetariums													
Stellarium	Free	Y	Y	Y	Y								
Starry Night Pro	$249	Y	Y	Y	Y								
Sky Safari	$50		Y	Y	Y								
CDC	Free	Y		Y	Y								
Red Shift	$60	Y		Y	Y								
C2A	Free	Y		Y	Y								
Skymap Pro	$110	Y		Y	Y								
Equinox Pro (deceased)	$40		Y	Y	Y			Y	Y				
MegaStar	$130	Y		Y	Y								
Celestia	Free	Y	Y	Y									
Sky Tools 3	$179	Y		Y	Y								
AstroPlanner	$45	Y	Y	Y									
image acquisition													
DSLR Camera	$50	Y						Y	Y				
APT (Astro Photography Tool)	€12	Y			Y	**	**	Y	Y	Y			
Backyard EOS	$50	Y							Y				
Nebulosity	$80	Y	Y			** PHD		Y	Y	Y	Y	Y	Y
Images Plus Camera Control	$239	Y						Y	Y	Y	Y	Y	Y
Sequence Generator Pro	$99	Y			Y	**	**	Y	Y	Y			
focus													
FocusMax	$149	Y						Y					
DSLRShutter	Free	Y	Y						Y				
control programs													
Maxpilote	Free	Y			Y	** PHD	**						
CCD Commander	$99	Y											
CCD Autopilot	$295	Y											
photo editing													
GIMP	Free	Y	Y										Y
Affinity Photo	£40	Y	Y									Y	Y

fig.33 I thought it would be a good idea to trawl the Internet and create an extensive list of software titles used in astrophotography. It is a daunting task to list them all, let alone document the capabilities of each. These two tables then are an indicator of the choice available in 2017 of the more popular programs and utilities, their operating system compatibility and general functions. The choice, pricing and features will change over time but even so it serves as a useful comparator. In addition to these are numerous others on mobile platforms (iOS and others).

software	price (2017)	PC	Mac	plane-tarium	mount control	guide	plate solve	focus	SLR cam	CCD cam	cal	stack	process
Picture Window Pro	$90	Y	Y										Y
Photoshop Elements	£50	Y	Y										Y
Photoshop (per year)	$120	Y	Y										Y
integrated image processing software (see acquisition and packages also)													
PixInsight	€206	Y	Y								Y	Y	Y
AIP	€195	Y									Y	Y	Y
IRIS	Free	Y							Y		Y	Y	Y
image processing utilities													
FITS liberator	Free	Y	Y										
Deepsky Stacker	Free	Y									Y	Y	
CCDStack 2	$199	Y									Y	Y	
Straton (star removal)	€15	Y											Y
Noiseware	Free	Y											Y
Background Subtraction Toolkit	Free	Y											Y
Image J / AstroImageJ	Free	Y	Y										Y
Noel Carboni Actions	$22	Y	Y										Y
Keith's Image Stacker	$15		Y									Y	
GradientXterminator	$50												Y
StarStax	Free	Y	Y										Y
Annie's Astro Actions	$10	Y	Y										Y
Noise Ninja	$129	Y	Y										Y
Astrostack	$59		Y									Y	Y
plate-solving software													
PinPoint	$199	Y					Y						
Astro Tortilla	Free	Y					Y						
PlateSolve 2	Free	Y					Y						
Astrometry.net	Free	Y					Y						
standalone autoguider software													
GuideDog	Free	Y				Y							
PHD / PHD2	Free	Y	Y			Y							
Metaguide	Free	Y				Y							
Guidemaster	Free	Y				Y							
planetary imaging (video camera file support and unique processing)													
Astro IIDC	$110		Y							Y			
Lynkeos	Free		Y							Y		Y	Y
Registax	Free	Y										Y	Y
AutoStakkert! 2	Free	Y								Y	Y	Y	Y
K3CCDTools	$50	Y								Y	Y	Y	Y
WinJUPOS	Free	Y											Y

fig.33 (continued) *Some packages, marked***, *have guider and plate solving capability by linking to freeware applications, for example PHD, PHD2, astro tortilla and Elbrus. Most software is distributed through the Internet rather than by CD / DVD. An Internet search and browse of each software title will find its website and its latest features and pricing.*

support of ASCOM and Maxim DL drivers. No application is perfect and many users selectively augment their capabilities with the additional features of FocusMax or the unique abilities of specialist image processing and manipulation applications such as Deep Sky Stacker, AstroArt and PixInsight to name a few. Usefully, the major applications are scriptable for automated control and have the ability for enhancement through plug-ins and remote control.

Deciding which applications to choose is a difficult and personal process. You will undoubtedly get there after a few false starts and as your experience grows you will likely move away from the simpler applications to the heavyweight ones. Thankfully, many companies offer a full-featured trial period with which to evaluate their product. This may give adequate time to check for hardware compatibility and basic performance (providing you have clear skies).

It is quite tempting to continually change applications and workflows, as a result of forum suggestions and early experiences. Something similar occurred in photography with the allure of magic film and developer combinations and it is perhaps better to stick to one system for a while and become familiar with it, before making an informed decision to change to something else. Choosing applications is not easy and I think it helps to consider how each application meets the individual needs of the principal functions:

Planetarium and Telescope Control
There are many applications covering these functions, with the principal difference between programs being their hardware compatibility and ergonomics. Some are very graphical, others less so, with correspondingly lower demand on computer resources. For imaging purposes, they all have sufficient data and precision to plan and point most mounts to the target object. I own the pretty and educational PC/Mac fully featured programs but often use a simpler iPad application SkySafari, for image planning or simply enter the target object into the Maxim catalog tab. Some fully featured packages, like Starry Night Pro, acquire images too, either directly or through an interface to a separate application. C2A is fast and free. It has a simple quick interface yet extends its capabilities through links to other programs such as Maxim and PinPoint for alignment, imaging and plate solving. Once the imaging sequence is under way, the planetarium is largely redundant. For this purpose, I rate the planetarium applications by their ease of navigating around the sky; searching for an object, displaying its information, zooming in and displaying the camera's

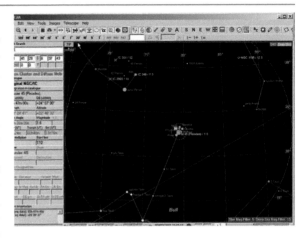

fig.34 *CDC and the lesser known C2A (above) planetariums are both free. They are able to reference multiple catalogs and have object filters to just display the information you need without being obscured by millions of stars and labels. They can also interface to image capture programs and a telescope mount, to direct it to the object on the display and perform basic sync functions. The simpler graphics on this application use less computing power than the more expensive image based planetariums.*

field of view for any particular time in relation to the horizon and meridian. These are basic requirements but there is an amazing difference in the usability of available programs.

If the pictorial aspects of a planetarium are not required but one simply requires a planning tool to identify promising targets, AstroPlanner and Skytools 3 offer an alternative database selection approach, selecting promising objects using a set of user-entered parameters. These may be a combination of position, size, brightness and so on. These also interface to mount control and alignment programs as well as direct target input into image acquisition programs. Most mount manufacturers define an interface control protocol that allows PC/Mac/mobile control through a serial or USB port. Physically, these either couple directly to the scope or via the mount control handset. Some of these drivers are fully-fledged applications too, emulating handset controls and settings on a computer. In the case of the popular SkyWatcher EQ mounts, an independent utility, EQMOD (free), largely replaces the handset and allows direct PC to mount control, including PEC, modelling, horizon and mount limits, gamepad control and pulse-guiding as an ASCOM compatible device.

Several mount interface utilities have a database of prominent guide stars and in the instance of EQMOD and MaxPoint can calculate a pointing model from a series of synchronized alignments across the sky. A pointing

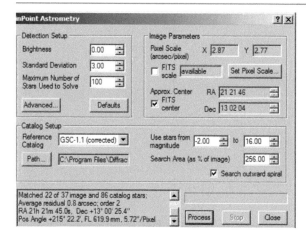

fig.35 *A typical plate-solve result from Maxim DL. Using the
selected image and an approximate image scale and
position, it accurately calculates the image scale, rotation
and center position. This result can be used in a variety
of ways; including building an alignment model for
the telescope, synchronizing the telescope position to
the planetarium application or a prior image and for
aligning and combining images during processing.*

model can account for the mechanical tolerances of the
mount, sky refraction and polar alignment and generally
improves the pointing accuracy, which leads nicely onto
the subject of Astrometry.

Astrometry

Slipping in between camera and mount control is plate
solving and astrometry. This function correlates an image
with a star database and accurately calculates its position,
scale and rotation. There are many stand-alone applica-
tions that include: PinPoint (a light edition is provided
with some premium versions of Maxim DL), Elbrus,
PlateSolve2, AstroTortilla and Astrometry.net (all free),
the last of which is web-based. (There is a locally served
version of Astrometry.net server too.) Premium versions
of TheSkyX also have plate solving capabilities. Used in
conjunction with camera and telescope control programs,
a pointing model for the sky is quickly established. It is a
wonderful thing to behold, as the telescope automatically
slews to a sequence of stars, exposes, correlates to the star
database and updates its accuracy. It is not necessary to
manually center a guide star each time; the program just
needs to know generally where it is pointing and the
approximate image scale and does the rest. This feature
improves the general pointing accuracy or more simply,
for a single object alignment, a plate-solve nearby and a
sync with the telescope controller quickly determines the
pointing error and necessary adjustment.

Plate solving additionally enables precise alignment to
a prior image. This is a very useful facility for an imaging
session that spans several nights and that requires the
same precise image center. For these purposes a real-time
plate-solve program is required for quick positional feed-
back. These programs also provide the muscle to identify
a supernova, replacing the age-old technique of flicking
between two photographs.

Camera Control and Acquisition

The thing that sets the acquisition applications apart is
their hardware compatibility and automation. The actual
function is straightforward but there are many more
camera interfaces than there are mount protocols. Many
photographers start astrophotography with a handy SLR
and most applications will download RAW files from
Canon, Nikon and some of the other major brands. Some
of these applications support dedicated CCD cameras
too. The fully-featured applications include sequencing,
filter wheel and focuser control as well as the ability
to pause autoguiding during image download. Before
choosing an application, double-check it reliably sup-
ports your hardware or indeed, future upgrade path, via
its support web page or from a forum search. Bad news
travels fast and it is often apparent how long it takes to
fix a bug or update a driver. Nebulosity is a cross platform
favorite that also includes image-processing capabilities.
For Windows, Sequence Generator Pro is critically ac-
claimed and worth every cent. In addition there are the
heavyweights, Maxim DL and TheSkyX, both of which
have a subscription-based upgrade path.

Guiding and Focusing

The program choice for guiding software is considerably
easier. There are only a few standalone applications, of
which PHD2 is far and away the most popular. You
can also use the guiding functions within a package
like Maxim DL, TheSkyX or AstroArt. When choosing
the application the compatibility and ease of use are
the primary considerations. Most applications support
guiding via a ST4 port but not all can pulse-guide. Some
applications only can use a webcam as a guide camera
and require a bright star for tracking.

A good focus application should be able to acquire
images, measure star profiles and control the focus posi-
tion. The focus module suppliers normally provide a
stand-alone focus control application and a driver (often
ASCOM compliant), to run with the focus applications.
Again, the big packages include integrated autofocus
modules and interestingly both TheSkyX and Maxim
DL acknowledge and promote FocusMax (originally

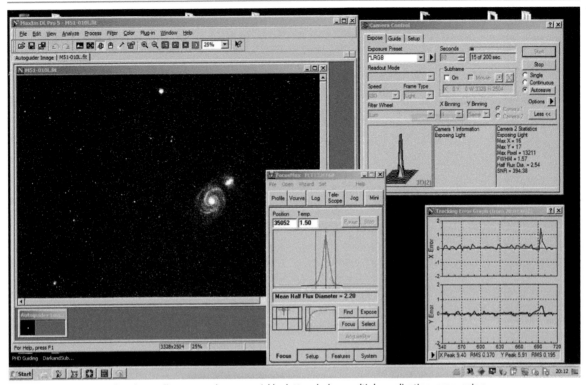

fig.36 Laptops are great but the small screen can become quickly cluttered when multiple applications are running
at the same time. In particular, FocusMax quickly proliferates windows across the screen. When I am at home,
I use a second monitor so that I can place all the windows next to each other, just like Houston control!

free but now marketed by CCDWare) as an enhanced tool to augment their own autofocus module. FocusMax expands the functionality; once it has characterized a setup, it obtains precise focus in less than 60 seconds, remotely. If the full version of PinPoint is installed, it can also directly interface to a telescope and perform an automatic slew to a star of the right magnitude, focus and return. Utilities such as these keep me in the warm and away from insects.

On the subject of staying in the warm and getting some sleep, I recently invested in a cloud detector (fig.37). This little device detects temperature, light, rain and cloud and with an add-on, wind speed. Using a RS232 data link, a small program on the PC (or Mac) shows the environment status. It also has an alarm state that will execute a script. I originally set mine to cause an alarm on my iPhone using an iOS App called the "Good Night System". The unit also has a relay output to indicate bad conditions and can also execute a script for more advanced control options. More recently, ASCOM safety device drivers use its information to provide "safe to open" and "safe for imaging" status to the roof and imaging control applications.

Software Automation (Scripting)

Automation is a specialist requirement that performs a sequence of actions to run on the computer, rather like a macro. Some imaging programs (for example Sequence Generator Pro) have considerable automation functionality built in, other mainstream packages are script-enabled. A script is a programmed sequence of actions; for instance, the startup, focus, alignment, imaging sequence and shutdown for unmanned operation. Scripts look intimidating at first and there are two methods to avoid an abrupt learning curve; the first is to find an existing script that can be simply modified, the second is to use an external program, like ACP, CCDAutoPilot

fig.37 A useful acquisition for a permanent installation is a cloud detector. This AAG CloudWatcher uses an IR and temperature sensor. A heated rain detector is included too, as is an anemometer input.

or CCD Commander that provide an accessible way of creating an instruction sequence. Most of the practical chapters use Sequence Generator Pro; this modern software may not have the overall expansion capabilities of Maxim DL (via scripting) but the package offers accessible and reliable automation that covers all the bases and at a modest price.

Image Processing

Image processing is a huge arena but essentially can be thought of as a sequence of distinct steps, starting with calibration, alignment and stacking to more advanced processing and enhancement, by both mathematical algorithms and user choice. Some applications offer a full suite, (for instance AstroArt, Maxim DL, Nebulosity and PixInsight), others specialize in processing video files, (RegiStax, AutoStakkert and Keith's Image Stacker) or in a particular aspect of image processing, like DeepSkyStacker that calibrates, aligns and stacks exposures. The program choice is particularly tricky, since there are few hard and fast rules in image processing and the applications are constantly being refined. The practical chapters use a number of different programs to give you an idea of the software capabilities.

Image processing skills develop gradually and at a later date, you will almost certainly be able to produce a better final image from your original exposures, either due to processing experience or the tools at your disposal. (Did you remember that suggestion to duplicate image files on a large external storage drive?) Some of the image-processing applications are overwhelming at first. The trick is to keep things simple at the start, develop your own style and identify where additional tools might be of assistance. These tools exist because the otherwise heavyweight Adobe Photoshop is not purposed for astrophotography and its highly specialized needs. One reason is that many editing functions are limited to 16-bit processing and the initial severe manipulations required in astrophotography are more effective in 32-bits. Photoshop or similar programs may usefully serve a purpose after the core image processing, for photographic manipulation and preparation for publishing. That is not to say that image enhancement is impossible with these imaging programs but it requires a good knowledge of layers, masking and blending techniques. These sequences can often be stored and used again at a later stage. A number of useful astronomy Adobe "actions" are bundled and sold by astrophotographers for image manipulation; a popular example being the astronomy tools by Noel Carboni. Other devious techniques using multiple layers and blending options

are to be found scattered, like the stars, across countless websites. I have learned more about sensors and digital manipulation in 2 years of astrophotography than in 10 years of digital photography.

Utilities

The most useful of the utilities improve the reliability of your polar alignment, exposure, optical alignment and mount control. There are perhaps more polar alignment utilities than there are decent imaging nights in a UK year. I can see the appeal if one has an observatory and can dedicate an entire night to polar alignment but for a mobile setup, I find a polar scope and autoguiding are sufficient. A polar misalignment of 5 arc minutes gives a worse case drift-rate of about 1.3 arc seconds per minute. The recent PoleMaster from QHY is a camera-based polar scope that achieves sub 30 arc seconds alignment in about 5 minutes!

Exposure calculation is particular interesting. It is not a trivial subject and there are no hard and fast rules. The optimum exposure depends upon many factors that are unique to your equipment and sky conditions. Exposure utilities are often plug-ins to image capture programs and compute an optimum exposure based on a target signal to noise ratio, sky illumination, number of sub exposures and sensor noise characteristics. There is considerable science behind these utilities but they are not as reliable as normal photographic tools and an exploratory image is often a better approach.

Image analysis tools, for example CCDInspector, can be quite useful to check the optical properties of an image. Among its tools, it can derive field tilt and curvature from individual star shapes throughout the image and measure image vignetting from the background intensity fall-off. These assist in setting the right field-flattener distance and confirming the couplings and sensor are orthogonal to the optical path.

There are numerous other utilities, many free, which provide useful information; Polaris hour angle, alternative times systems, GPS location, compass, electronic level, meteor shower calendar to name a few. Some reside on my iPad, others make their way to Windows. Remote control has enabled several companies to set up dedicated remote-site operations that are rented out to astronomers all over the world. Their locations are chosen carefully, in areas of frequent clear skies and low light pollution. The details of two typical operations can be found at *www.itelescope.net* and *www.lightbuckets. com*. It is like being a grandparent with grandchildren; you do not need to own a telescope to do deep sky imaging and you can hand it back when it goes wrong!

A Portable System

There is no single perfect trade-off between portability and performance. It is a personal thing.

Many hobbies inexorably become more elaborate, expensive and larger as time goes on. Astrophotography is no different and to reverse the trend, this chapter concentrates on portable and less expensive systems. Here, the aim is to put together an effective imaging rig that uses a conventional photographic camera and lens (or a small refractor) coupled to a compact motorized mount. In my mind, the purpose of such a system is to take images that one is unable to make at home; this might be to simply take advantage of better atmospheric conditions or imaging objects in a rural landscape using wide-angle lenses or refractors (up to a focal length of 500 mm). This excludes the lightest mounts and given the likely circumstances of portable imaging it also assumes that a single night (or two) is sufficient to complete all the exposures for a subject. To assemble a system, we start with what one wishes to image (defined by the imaging system) and then ensure the mount and ancillary equipment make it work effectively.

Imaging System

Camera Choice

It is quite likely that one already owns a small refractor suitable for "grab and go". I have two small-aperture refractors that I use with a QSI CCD camera. Even so, both combinations are quite heavy when one adds the rings, dovetail plate, motorized focuser and so on. My QSI model has a built-in filter wheel and its substantial weight makes fore-aft balancing a challenge on a lightweight optic. To lighten the load, as well as the financial burden, I propose to use a much lighter Canon EOS DSLR and try a Fuji X-T1 mirror-less camera too. Since my son absconded with an ear-marked EOS 1100D, I bought an EOS 60Da, that is supplied with a modified IR blocking-filter that is optimized for astrophotography. Both cameras work autonomously with the same intervalometer (using a 2.5-mm jack plug) or remotely from a PC using tethered operation via a USB cable (the Fuji additionally has basic WiFi remote control too). Canon EOS models have long enjoyed fully-integrated operation with most image acquisition programs (with and without long-exposure adaptors). Windows 10 has the EOS hardware drivers built in and it is a simple matter to connect, by selecting the Canon option in the

fig.1 Five Carl Zeiss Contax lenses, an adaptor and an EOS 60Da provide an economic range of wider perspectives than short refractors, that start from about 350-mm focal length.

acquisition program's camera chooser. Tethered operation with the Fuji X-T1 requires their additional HS-V5 software, however, which runs outside the standard astro capture programs and at the time of writing does not support exposures over 30 seconds.

Lens Choice

My 98- and 71-mm aperture refractors have a focal length of 500 and 350 mm respectively. They fit to any conventional or dedicated astro camera body with an appropriate adaptor. To achieve a wider field of view though requires a much shorter focal length. This is outside the realm of standard telescope optics and suits standard camera optics.

One of the outcomes of modern digital imaging is the departure of the main consumer camera companies from traditional prime lens manufacture. Their product lines are full of lightweight autofocus zooms with image stabilization. As a result, an extensive industry has evolved that creates adaptors for mating classic optics to virtually any make of digital camera. The make of camera no longer dictates the make of lens, especially if autofocus is not required. If the lens flange to sensor distance is less than the back focus of the lens (at infinity), there is almost certainly an adaptor to suit.

As convenient as autofocus and zoom lenses are in conventional imaging, their lightweight mechanics and

complex optics are not ideal for astrophotography. For a wider field of view I chose to use conventional manual-focus prime lenses, made from glass, aluminum and brass. Traditional lenses have a much simpler optical formula too, with less optical surfaces and better mechanical stability. These come from the film era and there are many used models to chose from.

I have owned too many 35-mm camera systems over the years, including Olympus, Pentax, Nikon, Canon, Leica and Contax. Ideally, I wanted several lenses from the same stable and compiled the performances of key focal lengths from different vendors, using a mixture of first-hand experience and published technical reviews. Although there are some amazing Leica telephoto lenses, notably the 180 mm f/3.4, they still command high prices and their best wide-angle lenses are arguably those for their rangefinder cameras. These have a short back-focus and are not compatible with the EOS (but will work on the Fuji). I chose 5 lenses from Carl Zeiss' Contax range and a nicely made lens adaptor for both bodies. Carl Zeiss has an excellent reputation and is noted for its wide-angle designs and, in common with Leica philosophy, maintain good image quality across the entire frame. This range offers better value for money (used) and, avoiding those with f/1.4 apertures, for the same money as the 71-mm refractor system, I acquired a 28 f/2.8, 50 f/1.7, 85 f/2.8, 135 f/2.8 and 200 f/4 (fig.1). There are wider lenses in the Carl Zeiss range but these designs are not optimized for small digital sensors and tend to have poor chromatic aberration in the outer field. For the few occasions that I require a wider field of view, I may try one of the inexpensive Korean Samyang ultra-wide lenses that are available in both EOS and Fuji X mounts.

A favorite hobby-horse of digital camera lens reviews is bokeh. This relates to the appearance of out-of-focus areas in an image and is affected by the aperture shape. Many older lenses have apertures with 5–7 blades and consequently have a polygon-shaped opening causing polygon-shaped out-of-focus highlights. This is not ideal for astrophotography either, as this shape causes a star-burst diffraction pattern around each bright star (especially after image stretching). Consequently, the plan is to use these optics close to full aperture with a near circular opening. (The optimum aperture of a lens is typically about 1 f/stop down from full aperture.) This still adds a benefit of several f/stops over the typical f/5.6–f/8 refractors and reduces the need for high ISO camera settings and extended exposures. Using a lens near full aperture is bound to have some quality fall-off at the extreme edges. In this case the worse areas are effectively cropped by the smaller size of the APS-C sensor but will still require careful flat-frame correction to compensate for vignetting.

When fitted to the camera, all these lenses are secure with no wobble, a welcome improvement over many T-mount adaptors. T-mount adaptors do, however, facilitate screw-in 2-inch filters. Imaging with a Color Filter Array (CFA) camera often benefits from using a light pollution filter. These filters are commonly available for screwing into the telescope coupling with a few exceptions: For some years Astronomik® have sold a clip-in filter that fits inside an EOS camera throat. IDAS light pollution filters are well known too and they have recently launched a filter that slips behind the EOS bayonet and is held in place by the camera lens (fig.2). Fortunately, the traditional aperture coupling levers of the Carl Zeiss lenses fit neatly into a small gap around the filter.

The camera body is bolted directly to a dovetail bar that fits to a lightweight but rigid dual-saddle plate, with a guide scope at the other end (fig.3).

fig.2 *Light pollution filters are often useful with color cameras since the Bayer array does not exclude the principal low pressure sodium lamp and other common light-pollution wavelengths. When an EOS is used with an ordinary lens it may not be possible to find a screw-in filter that will fit the lens, or it is too expensive, on account of the size. In this situation, IDAS make a drop-in filter that is held in place by an EOS lens or adaptor. Astronomik make a similar system that clips into the camera's mirror box.*

fig.3 *This lightweight side-by-side saddle plate assembly is made from Geoptik components and has a Vixen clamp on one side and a dual Losmandy/ Vixen clamp on the other. These have moving jaws rather than a simple bolt not only for rigidity but also to prevent marring the dovetail bars. This will accommodate a variety of modest imaging systems on one side and a guide scope on the other.*

To reduce camera wobble, I avoided couplings that had compliant cork or rubber pads. Both EOS and Fuji cameras typically deplete a battery in a few hours and, depending on how they are mounted, may require dismounting to exchange with a fresh one. This is too intrusive for extended imaging. Fortunately, both cameras have accessory battery adaptors for external power. The EOS 60Da is supplied with an adaptor but the Fuji X-T1 requires the additional purchase of the vertical grip and adaptor. These require a mains power supply to feed them a DC voltage that is safe for indoor use only. In the field (literally) a small DC step-down module conveniently provides the appropriate DC voltage from a 12-volt lead-acid cell, as in the prior chapter.

Mounts

The focal length and mass of the optical system set the needs for the telescope mount. Long exposures and focal lengths require sub arc-second tracking, and conversely shorter focal lengths and fast apertures reduce the requirement. In the extreme case of panoramic sky-scapes, taken with an ultra wide lens, photographers may even use a 50% tracking rate to render the land and sky with equal sharpness. In this case the angular resolution of the system can tolerate a tracking error of several arc *minutes* during the exposure. I selected a more general purpose mount with enough performance headroom to track well with a focal length of 500 mm, around 1.2 arc seconds RMS.

In recent years there has been a growing number of highly portable mounts to cater for newcomers and travelers. These are designed to carry photographic cameras or small refractors. The simplest models have a motorized RA axis and employ a standard tripod head (normally a robust ball and socket model with a panning capability) to attach the camera and with which to provide a fixed DEC adjustment. These rely upon accurate polar alignment to minimize drift and most have a guide port for correction of RA tracking errors. Of these, the novel AstroTrac stands out (fig.4). Its unique scissor design claims a remarkable typical periodic error of just 5 arc seconds and folds to the size of a short refractor. That is a good result for any mount and at that level (provided it is accurately polar aligned) delivers sharp stars using a short telephoto lens. The AstroTrac's scissor design imposes a 2-hour imaging limit though, after which it requires resetting the camera onto the target.

GEM mounts have the advantage of continuous tracking and once the image is centered, it is possible to image for the entire night without touching the unit. The inexpensive models are based on traditional worm drives and generally have less accurate tracking; caused by a mixture of broader tolerances, coupled with a smaller RA worm-gear radius. Periodic error varies between models and units, typically in the range of 10–60 arc seconds peak-to-peak. For all those models with an ST4 guider interface, or pulse guide capability, a suitable autoguider system should reduce this to 2 arc seconds peak-to-peak or better.

Tracking is a function of drift and periodic error (PE). Although using a short exposure can minimize drift, it is a less successful strategy for PE. A typical worm drive introduces several arc seconds of PE in 30 seconds and in practice requires Periodic Error Correction (PEC) and guiding to eliminate. Since drift affects both axes, to guarantee excellent tracking with the longer focal lengths requires a mount with autoguider capabilities in DEC and RA. Drift is mostly a function of polar misalignment and in those systems that use a conventional polar scope, the alignment accuracy is typically 5 arc minutes.

fig.4 A super-light minimalist system: A carbon fiber tripod, a ball and socket head with a pan facility, AstroTrac mount and a Fuji X-T1. The AstroTrac is powered for many hours with 8 AA cells. The shutter is set to T and the exposures are made with an intervalometer. The images are stored to SD cards and the camera runs for several hours from a freshly charged battery.

fig.5 This iOptron IEQ30 Pro model is less than 8 kg in weight. It has a polar scope, GPS and stainless steel counterweight bar, which stows inside for transport.

My AstroTrac's polar scope is lightly secured by three small magnets on an articulated arm, that rotates around the RA axis. In practice, after carefully centering the reticule, I found that my polar alignment changed with the arm position and limited the alignment accuracy to about 10 arc minutes (without resorting to drift alignment). The misalignment sets a practical limit on the exposure duration/focal length; for example, a 10 arc minute alignment error causes a drift of up to 13 arc seconds during a 5-minute exposure. In context, that is about 5-pixels worth (on an EOS 60Da fitted with a 300-mm lens) and adds to any periodic error.

fig.6 The polar scope reticle of the iOptron is used at a fixed orientation and the mount is adjusted to move Polaris to the position shown on the handset.

fig.7 The new PoleMaster from QHY is an even more effective alternative: This small camera and lens assembly screws into the polar scope hole via an adaptor and using its software, enables excellent polar alignment in just a few minutes.

The effects of seeing, PE and drift errors are additive. The coarse angular resolution when imaging with a wide-angle lens dwarfs such tracking errors. Longer focal lengths are more demanding and for high quality imaging, I prefer to guide on both axes when using focal lengths over 85 mm or when I require long exposures with narrowband filters.

An ideal mount is less than 8 kg, capable of delivering good tracking up to 500-mm focal length and within a £1,000 budget. SkyWatcher (Orion), Celestron, Vixen, and iOptron have promising contenders. A typical example is the iOptron iEQ30 Pro (fig.5). This relatively new company is actively developing innovative mounts and quickly learning from their early ventures. This model uses stainless rather than the customary chrome-plated steel throughout and although it uses aluminum castings for the structural components, they are finished well. The stepper motors are quiet and efficient and the adjusters are well thought out. It has the normal computerized keypad as well as a standard ST4 guide port, a RS232 serial port for external control and is supported by an ASCOM driver.

Polar Alignment

This mount, like many, is equipped with a polar scope. This one rotates with the RA axis and uses a spirit level to set a reference reticle

orientation. In common with every other one I have bought, the reticle required centering before first use. In this design, two adjustments are required; angle and centering. It is easier to align the spirit level angle to the reticle before centering the reticle. First, level the mount base and center the spirit level on the polar scope collar. Loosen the two grub screws on the collar and align the 12 o'clock reticle position at the top using a suitable target (like a TV aerial). To do this, first center the target in the reticle and then elevate with the altitude adjuster. Now,

fig.8 The PoleMaster PC software steps you through the alignment process and is easy to use; typically within 5 minutes. The screen shot above shows the final step of the alignment process. The altitude and azimuth adjusters are carefully turned to align the red and green targets (on the left of the screen).

carefully rotate the loosened reticle barrel to line it up. After tightening these two grub screws, center the reticle using adjustments to the three grub screws. Unlike the Paramount and original Skywatcher reticles, this model is used at a fixed angle. Polaris' hour angle and declination are then read off the handset and the star is moved into that position using the mechanical adjusters (fig.6). In practice, this is quick to do and quite accurate.

Assisted Polar Alignment

Polar scopes and bad backs do not mix and only achieve coarse alignment. It is always possible to improve polar alignment by using drift analysis but this takes precious imaging time. This is an ideal opportunity to use a QHY PoleMaster. This novel accessory comprises a little camera mounted to a CCTV lens and attaches to the mount, typically where the polar scope peeks out (fig.7). It aligns a mount with exceptional accuracy (30 arc seconds or better) in about 5 minutes and uniquely does not first require aligning to the RA axis. From the comfort of one's laptop, it notes the position of an off-axis star, as you rotate the mount, and calculates the pixel position of the North Celestial Pole. Having done that, and after rotating a mask to line up with the three brightest neighboring stars, it quickly decides where Polaris should be in the image (fig.8). With ongoing visual feedback it is an easy task to alter the altitude and azimuth bolts to move Polaris into that position. The practical speed and accuracy of the calibration is limited by seeing conditions and although it is about twice the price of a typical polar scope, it can be fitted to most mounts via an adaptor plate. (As a bonus, since it does not require to be accurately aligned to the RA axis, if one were to fix it to a panning head screwed onto the AstroTrac central bolt, it would improve the polar alignment over the current polar scope arrangement.)

Initial Tracking Evaluation

It is worth checking the native periodic error of any new mount before using it in earnest. Significant periodic error is to be expected from an inexpensive mount, even after permanent PEC. When the residual error changes slowly though it should guide out easily, though the backlash and stiction that can occur with lower quality bearing surfaces may complicate matters (especially in DEC).

To evaluate the PE, PEC and guiding performance fit a guide camera directly to the imaging telescope. It also makes sense to choose a focal length that represents the most challenging setup (in my case about 500 mm) and use an autoguiding program that displays tracking error measurements and has an option to disable its guider outputs. I use PHD2 autoguider software

fig.9 *This mount and camera assembly requires balancing in three axes; two about the DEC axis, by sliding the dovetails back and forth and about the RA axis, by sliding the counterweight along the shaft. Good balance is an essential precaution with light-weight mounts, to avoid stressing their motor systems. (In practice, there would also be a dew heater tape wrapped around both sets of optics.)*

(which in common with most other autoguider packages resolves a star centroid to less than 1/10th of a pixel) to measure tracking errors to sub-arc second measurement accuracy. PHD2 also has a range of guiding algorithms that can be successively evaluated later on to establish the optimum guiding parameters.

Aim the guide scope at a star (one at low declination and near the meridian) and run the autoguider's calibration routine. To evaluate the native PE run the autoguider with its outputs disabled and let the software simply record the tracking error. PHD2's tracking graph can usefully be set to either pixels or arc seconds on its vertical axis. For an arc second evaluation, it additionally requires the correct focal length and pixel size in the camera and guiding settings. (PHD2 normally uses an ASCOM command to read the pixel size directly from the camera driver.)

In the case of the iOptron, as if to prove my earlier point, the initial tracking performance had a cyclical 90 arc second peak-to-peak error over the 8-minute worm period. This mount features permanent PEC, however, which is calculated by the mount itself: In this process, the autoguider is set going but with its outputs enabled and the "record PEC" option is selected from the handset's menu. This instructs the mount to record the RA correction pulses from the guider system over one worm cycle. It uses these to calculate a correction value for each angle of the worm. Having recorded the PE, set the "PEC playback on" option in the handset menu to enable PEC. This is a simple process and in practice is a balance between long exposures and correction latency versus short exposures and seeing

noise. In this case, using 1-second exposures to record the PE, PEC reduced the error by a factor of 10. (As the firmware evolves, it is likely that future releases will measure guider pulses over several worm cycles to make a more accurate assessment, or make use of an external program to generate a correction file.) With PEC, the residual tracking errors change at a slower rate and are easier to guide out, using longer guider exposures that are less suspectable to seeing, though it usually takes a few experiments to decide on the best combination of exposure, aggression and filtering. This may take some time and it is better to establish ballpark settings before embarking on an expedition.

Other System Components

My normal QSI CCD camera has the convenience of an off-axis guider port to share the imaging optics. In this system, however, the Canon (or Fuji) system has no provision for off-axis guiding and autoguider exposures are taken with a Starlight Xpress guide camera screwed into a 200-mm f/4 guide scope alongside the imaging camera. Both are attached to a Vixen-style saddle plate, such that they are balanced in DEC on two axes and a third axis, in RA, with a counterweight adjustment (fig.9). With the clutches disengaged, the freely moving RA and DEC axes makes balancing quick and easy.

A full system requires some more elements: In its minimalist state, it requires just one power connection for the mount, assuming the unguided camera is focused manually, uses internal batteries and saves RAW files to its memory cards (fig.4). Fully fledged, with computer control, it requires five power feeds for camera, dew heater controller, mount, computer and digital focuser in addition to four USB connections for mount, two cameras and focuser (fig.10).

To keep the software simple and affordable, a mixture of C2A planetarium and PHD2 with Nebulosity (or APT) is sufficient for simple projects. For more complex sequences, including unattended autofocus, image centering and automatic meridian flip, Sequence Generator Pro is a good choice. These systems use a mixture of built in drivers or use ASCOM. If you prefer to use an Apple Mac, an equivalent system requires Equinox Pro and PHD2 with Nebulosity again. In either platform and at more expense, TheSkyX Professional integrates all these functions. In fig.10, a fully-loaded system uses all four USB ports of an Intel NUC. Two 24 Ah lead-acid cells supply power via cable splitters (using in-line XLR connectors). Plastic-coated spring clips on the legs hold Velcro pads to which the focuser, dew heater and NUC are attached. The NUC links to a WiFi access point when it powers up and is controlled remotely via from an Apple iPad, using Microsoft's Remote Desktop application (described in the chapter *Wireless / Remote Operation*). In fig.10, the various modules are scattered about and the wiring here is an untidy mess at the mount end, requiring bundling and routing to avoid cable drag.

If system weight is not the primary concern, another 6 kg moves one into a different league. The used Avalon mount in fig.11 was twice the price of the iOptron but benefits in all respects from superior mechanical properties and can cope with heavier telescopes if required. The mount (and tripod) have useful carry-handles too. The assembly in fig.11 was optimized by constructing a small master interface box to house the control modules and provide dedicated DC power for the camera, mount, PC and dew-heater tapes. I replaced the NUC with an Intel M3 stick, saving on weight and power, which can be seen hanging under the mount. The matching accessory aluminum T-Pod, also from Avalon, was a small indulgence and is wonderfully light, yet very rigid.

fig.10 A compact deep-sky imaging system in development. It uses a DSLR for capture and the guide scope is mounted directly to the 98-mm f/6.3 refractor using a robust bracket and rotated onto axis for better balance. A DC converter safely provides power for the EOS battery adaptor. Modules and PC are attached via Velcro straps to the tripod legs.

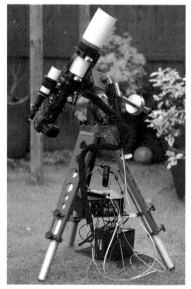

fig.11 The same imaging system on an Avalon Linear, with optimized cable routing, full module integration and an Intel Stick® computer.

Setting Up

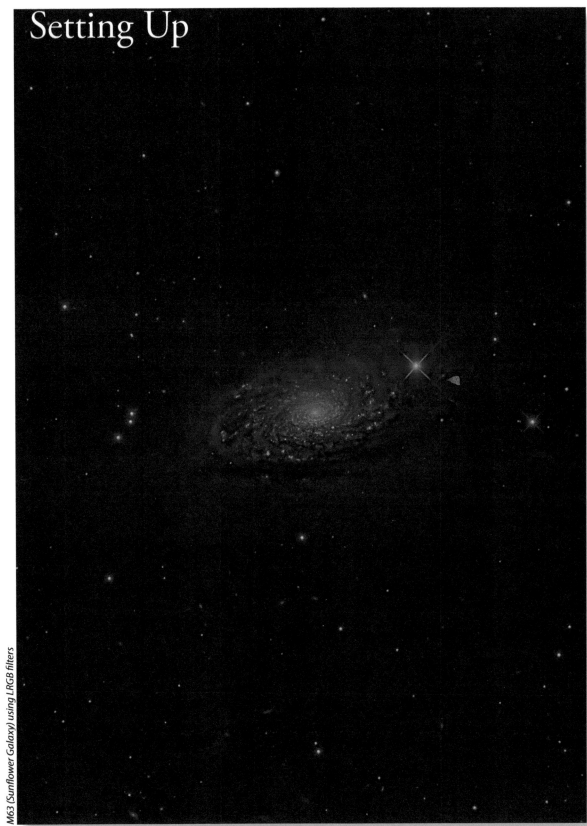

M63 (Sunflower Galaxy) using LRGB filters

Hardware Setup

A little preparation goes a long way.

The emphasis of this section is to turn theory into practical tips for the installation and equipment setup for astrophotography. In general, the first chapter principally concerns itself with the hardware setup and the second looks at software, although there is some inevitable cross-over. Setting up includes one-time calibrations and adjustments, as well as those repeated start-up activities that benefit from becoming second nature. There is also an element of chicken and egg: a degree of assembly and installation is required for instance before one can successfully do the one-time alignments. In practice, it may need a few iterations to get everything just so. So, I propose to start with the basics, the actions that occur each time, and circle back to the one-time settings that require attention.

Mount

Siting an observatory or a temporary setup benefits from a little planning. For instance a clear view of the celestial pole is handy for a quick mount alignment and although there are alternative methods, these take longer and are better suited for a permanent setup. Any installation should be situated on stable ground but additionally one should also consider the site, in regard to general safety, especially in a public place. Tripod spikes or rubber feet are fine on hard ground but when the ground is soft, they sink in, ruining alignment and images. With soft earth, a quick solution is to place a paving slab under each tripod leg. Decking may be convenient in muddy conditions but will transmit vibrations to the mount as you walk about, unless you isolate the pier or tripod from the surrounding surface. The better tripods have leg braces and clamps at the leg pivot to improve the overall rigidity. Some general-purpose tripods have extending legs, primarily to raise a telescope to a comfortable viewing height. This is not necessary for imaging and astrophotographers should only extend the legs for stability and levelling purposes.

An open space presents a wonderful vista but it is not a necessity for deep sky imaging. To avoid the worst of the light pollution and the degrading effect of the atmosphere, imaging ideally starts from 30° above the horizon. At 30° altitude, the optical path passes through twice as much atmosphere as it does straight up. This not only affects transparency and seeing but the angle introduces some refraction too. (My first eager attempts to image Jupiter at low altitudes and at high magnifications produced terrible color fringing on the planet. I thought I was at the limit of the telescope optics. When I tried again some weeks later, with Jupiter high in the sky, the problem had almost disappeared.)

Bright lamps in the surrounding area can be another cause of grief: Even though your scope may have a long dew shield, stray light from a bright light source can flare inside and affect the final image. Open truss designs are particularly susceptible and one should use an accessory cloth light-shield. Usefully, my local council switch off the street illumination after midnight, not out of consideration to astronomers but to save money. An observatory is not something you can relocate on a whim and several blogs relate to "a-ha" moments. For instance, some domed observatories are designed so the door only opens when the dome opening is in line with it. Since the roof and scope positions are linked, the access should be feasible when the scope is in its standard park position.

Tripod and Mount Alignment

It helps the initial alignment procedure if a fork-mounted telescope is levelled and aligned with true north. Some have built-in inclinometers and compasses, others can compute any misalignment after synching on a few stars. In the case of an equatorial mount, or a wedge-mounted fork, although the RA axis simply has to align with the celestial pole, there is some benefit from accurate levelling as it improves the accuracy of the polar scope setting and the first alignment slew.

Levelling a tripod is easier if you think of it in terms of east to west and north to south. Place one of the legs facing north (fig.1) and away from you and slightly extend all three legs. Place a spirit level across the two other legs east to west. Adjust one of these legs to level the mount. Turn the spirit level 90° and adjust the north leg to level north to south. You only ever need to adjust two legs to level a tripod.

I like to set up the mount in the back yard before it gets too dark. Since blundering into a steel patio chair, I use this opportunity to remove all the discarded toys, garden equipment and hose pipes from the surrounding area and the pathway back to the control room!

*fig.1 The quickest way to set up a tripod
is to forget it has three legs. Hold
the compass away from the metal
mount to reduce the magnetic error.
Align one leg to point true north (or
south) and balance across the other
two legs east-west. Turn the level
about and alter the north (or south)
leg to give north-south balance.
On soft ground the legs will slowly
sink in over time, especially with
the additional weight of the mount
and telescope. A small offset of a
few millimeters can ruin otherwise
perfect polar alignment. An effective
way to avoid this is to place the
tripod legs on a solid or wider
platform, like a paving slab or brick.*

Polar Alignment

I think more words are exchanged on this subject than on any other topic in astrophotography. It appears to be a badge of honor to claim unguided exposures over 10 minutes with no apparent drift. This is the problem; when a mount is out of alignment, stars, especially those at low declinations, slowly drift in declination during an unguided exposure. This drift creates an image with oval star shapes or worse. The drift rate can be calculated from the declination and the polar alignment error or vice versa.

It is important to put this into context: If during a 10-minute unguided exposure, at a declination of 50°, the drift is 3 arc seconds (about the same as the seeing conditions) the polar alignment error is about 1.8 arc minutes. In this example if we assume the tripod feet are a meter apart and one foot sinks by 0.5 mm, this introduces a 2 arc minute error! In a temporary setup the practical solution is to autoguide and do a simple polar alignment. A setup using Maxim DL and MaxPoint or TheSkyX, can measure polar alignment error by sampling star positions. Using a calibrated polar scope on the SkyWatcher EQ6 mount and aligning to the HA angle of Polaris, my polar alignment error is typically 5 arc minutes, whereas the one on my Paramount MX regularly achieves an accuracy of 1 arc minute (fig 2). Some sources suggest to polar align a bare mount. Keeping in mind the sensitivity to the tripod's stability, this alignment is prone to change as the weight of the telescope, cameras and counterweights flex the mount and tripod and, on soft ground, the feet sink in.

There are dozens of polar alignment programs: Some use a method that compares the position of two or 3 widely spaced stars and do not rely on Polaris. These systems have the benefit of working equally well for those in the Southern Hemisphere as well as the north. These work by syncing the mount to one or more stars and then moving to another. By assuming the error in the star position is caused by the polar misalignment, it can theoretically be adjusted out by changing the mount's altitude and azimuth bolts. It sometimes takes a few iterations to achieve a good result. Several programs embed this general concept, including MaxPoint (Windows) and TheSkyX (Windows / OSX). It works well but if you have flexure in the mount or telescope, the result is no better than from using a polar scope. Some of the modern designs have complex integrated sky-modelling software, which after multiple star alignments identify and cancel out refraction, flexure, cone angle and polar alignment by tracking on both axes. The 10Micron mounts use this method; you manually align the mount to three stars and then you use the mount adjusters to center a fourth star. The 3 star (or more) alignment is repeated and the effect of the remaining alignment error is removed by the mount's electronics tracking both RA and DEC motors to achieve long unguided exposures.

Drift Alignment

The most reliable and accurate polar alignment method measures and eliminates the problem; the rate and drift direction of a star. It is not something that can be done quickly and for the best accuracy it may take an entire night. For this reason, those with a permanent setup favor it, but some experienced users with a portable setup can achieve reasonable accuracy within an hour. It assumes, once a star has no measurable drift, the mount must be aligned. The effort is a good investment in a permanent setup and will be usable for

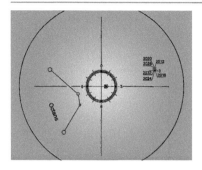 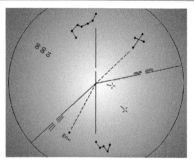

fig.2 Three examples of a polar scope reticle. The one on the left is latest version to ship with the SkyWatcher mounts and is similar to iOptrons. All three can be used in Northern and Southern Hemispheres and have scales with multiple positions for different epochs. The reticle in the middle does not require any positional information since it rotates and aligns to multiple stars at the same time. The other two require alignment to a single star (Polaris in the Northern Hemisphere) at an angle most conveniently indicated by an application on a computer or smart phone.

several months. Natural forces, in the shape of precession and ground movement over the seasons, will eventually degrade any alignment. Drift alignment is also one of the few reliable means to polar align a fork-mounted telescope that is bolted to a wedge.

The drift alignment process measures and eradicates drift in DEC for two stars: First, you adjust the mount's azimuth until there is no detectable drift, say over 10 minutes, for a star near the southern meridian. Then you repeat the process, using the mount's altitude adjuster, and for a star in the east or west (fig.3). Stars with a low declination are the most sensitive to drift and the process ideally selects two stars at a similar DEC, of about 10-25°, so that the observations in the east or west are not too close to the horizon.

The altitude and azimuth adjustments interact to some extent and to improve accuracy, repeat the process. There are of course several computer programs that can also assist. These mostly use a webcam to measure the rate of drift and calculate the adjustment. Some even suggest the precise change by overlaying target marks on the displayed image. Drift alignment instructions vary and cause endless confusion. The instructions assume the astronomer knows which way is north in an image! The direction of north and the adjustment depend upon which hemisphere you are in, the telescope design, whether you are viewing through a diagonal and which side (east/west) of the mount the telescope is on. If you accidentally move the mount in the wrong direction it will be obvious, as the drift rate will increase. The many programs, descriptions and videos on the drift method can be overwhelming so in simple terms though, irrespective of your particular circumstances, these are the three golden rules:

1 mount azimuth corrects the DEC drift of a star near the meridian
2 mount altitude corrects the DEC drift of a star in the east or west
3 the drift rate is higher at low declinations, so use stars close to the celestial equator.

For imagers, one method is to attach a webcam to a telescope, align the camera sensor axis parallel to the dovetail plate and use a polar alignment application. For still-camera users, I found an elegant method on a forum, using a long camera exposure and the east/west mount slew control. As the mount slews in RA each star leaves a trail. If the mount is not polar-aligned,

fig.3 When you align the mount it is important to adjust the altitude and azimuth bolts in unison; loosening one and tightening the other. In this picture I replaced the malleable OEM bolts with a high-quality after-market version. Many high-end mounts have markings on their adjusters to facilitate precise and repeatable movements and whose polar alignment systems give a direct readout in arc minutes or fractions of a turn.

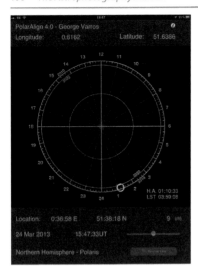

fig.4 This screen shot from an Apple iOS polar alignment application uses the iPhone or iPad's GPS receiver to set the time and location and displays the position of Polaris on a scale. This is shown visually and as an Hour Angle, which can be set directly on the RA scale (fig.17).

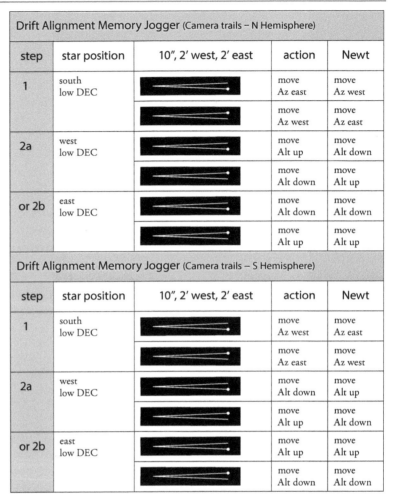

Drift Alignment Memory Jogger (Camera trails – N Hemisphere)

step	star position	10", 2' west, 2' east	action	Newt
1	south low DEC		move Az east	move Az west
			move Az west	move Az east
2a	west low DEC		move Alt up	move Alt down
			move Alt down	move Alt up
or 2b	east low DEC		move Alt down	move Alt down
			move Alt up	move Alt up

Drift Alignment Memory Jogger (Camera trails – S Hemisphere)

step	star position	10", 2' west, 2' east	action	Newt
1	south low DEC		move Az west	move Az east
			move Az east	move Az west
2a	west low DEC		move Alt down	move Alt up
			move Alt up	move Alt down
or 2b	east low DEC		move Alt up	move Alt up
			move Alt down	move Alt down

fig.6 A few telescope handles are available from retailers and are very useful if you are repeatedly carrying your telescope. In this case, I fashioned one from a strong leather belt and attached it between the tube rings using two large bolts. One could also make it out of metal. Do not use plastic; unlike leather it may become brittle in the cold and snap.

fig.5 This table is designed to be used with a still camera. A star trail is made by taking a long exposure, during which the mount is slewed west and then east. The return trail diverges if there is a polar alignment error. To increase the accuracy, increase the exposure time to discern smaller drift rate errors.

the outward and return legs of a star trail diverge and form a V-shaped fork. To distinguish between the two lines, the mount is left to track the star for a few seconds at the start of the exposure to form a nice blob (fig.5). I use this method to confirm alignment with portable mounts that have slew controls.

In practice, to create a star trail, aim the scope at a star due south (in the Northern Hemisphere) and near the celestial equator (DEC=0). Start a 2-minute exposure and after 5 seconds, press and hold the W slew control on the handset (or computer) for a minute (set to a 1x slew rate). Now press the E button for another minute, or until the exposure ends. The star leaves a trail on the sensor, with a blob to mark the start. If you have perfect alignment on that axis the image is a single line with a blob at one end. If you do not, you will see a fork similar to that in fig.5. To improve the accuracy, extend the exposure time to 10 seconds (stationary) and then 2 x 2 minutes or longer whilst slewing. Fig.5 indicates where to point the telescope and depending on the direction of the fork, what adjustment is needed.

The process is quite robust and even works if the pointy end of the fork is not in the image. If you find the fork image is rotated 180° then the camera is upside down. The expose/adjust process is repeated until the lines converge to a single line with a blob at one end. Once the azimuth is set, aim the scope due east or west and repeat the process, only this time use the altitude adjustments to cancel the drift. To reduce the residual error further, repeat the entire process.

Electronic Polar Scope

More recently, an innovative product from QHY has revolutionized the process of polar alignment. It uses a video camera fitted with a small lens to act as a polar scope. The PoleMaster is able to attain sub 30-arcsecond accuracy within 5 minutes. It can be attached to any GEM mount, typically sitting where the orifice of the polarscope would be, pointing generally in the direction of the RA axis. As long as it does not move during the alignment process, it can be held in place by virtually any means. Accurate RA axis alignment is not necessary; at one point in the process, the accompanying software requests the user to roughly center Polaris and to click on a peripheral star. After rotating the mount around its RA axis, the software tracks the star trail and works out the pixel corresponding to the celestial pole (North or South). After rough alignment, it provides a magnified live view of Polaris and its target position, allowing the user to adjust the Altitude and Azimuth bolts to fine tune the alignment. Those users who have advanced plate solving systems confirm accuracies around 20 arc seconds.

Optics

Assembly

Given the opportunity, assemble the telescope and imaging components together in a well-lit space and check for any obvious dust on the optical surfaces. Having said that, the combined weight and length of my largest refractor requires some spacial awareness when I pass through a doorway. Most telescopes are kept assembled to a dovetail plate for convenience usually via a mounting plate or tube rings that clamp the telescope. Handling a telescope is tricky and to improve things, fit a handle between the tube rings on a refractor. I use an old sturdy leather belt, cut down to length so that it bridges the tube rings with a few inches to spare (fig.6). The belt has a 6 mm hole drilled near each end and is bolted to the top of each tube ring. After checking the optics are clean, pop the lens cap back on. If the telescope was last set up for visual use with a diagonal, remove it and insert extension tubes to achieve a similar focuser position with a camera. A diagonal introduces several inches into the optical path length. The best option is usually an extension tube, preferably before or after the focuser tube. The aim is to minimize any extended leverage, by the mass of the camera system, on the focus mechanism. In the case of my short refractor, the adaptor for my aftermarket focuser is an effective extension tube but for the longer one, I screwed in a 2-inch long extender into the rear of the focus tube. In the early days, I converted an inexpensive 2-inch Barlow lens into an extension tube, by simply removing the optical element. I quickly abandoned this idea when I noticed the sag caused by the weight of the camera and filter wheel assembly and the play in both 2-inch clamps.

fig.7 On the left is a high-quality 2-inch, brass compression-ringed adaptor with three fixings, next to a 2-inch nosepiece adaptor from my field-flattener. The adaptor on the right replaces the other two items, converting a 68-mm focus tube thread to a 2-inch SCT thread that screws securely into the field-flattener.

fig.8 The small rectangular mirror of this off-axis guider attachment can be seen in the throat and in front of the filter wheel with the guide camera top right.

fig.9 The view of the sensor and off-axis guider mirror as seen through the front of the telescope. This is a central view. Move your eye position around and confirm that the pickup mirror does overlap the sensor from any viewing angle.

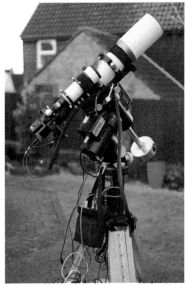

fig.10 Tuning the assembly is a never ending task. Compared to the prior assembly with the NEQ6 mount, the cables on this assembly are much neater. Another astronomer suggested to use a nylon sock to keep the leads together. This works wonderfully. It is slippery, flexible, light and allows the lead lengths to be tuned. Cable snags are a lot less likely. I need to buy a second one for the dew heater leads on the other side of the mount. On this mount the cables are external. Those mounts with internal cabling simplify the routing and maintain good balance at all orientations.

The next three items are the field-flattener, filter wheel and camera. I keep the filter wheel and camera screwed together for convenience and choose a field-flattener on the day, depending upon the host telescope. After screwing these two together double-check all the rotation features for play: In many systems there are several. Those that use three small fasteners to grip an internal circular dovetail are prone to work loose. The better ones are nylon tipped; they gently clamp and allow the assembly to rotate. I check these grub screws periodically and gently tighten them to remove any play from the coupling. Both of my Feather Touch focus tube assemblies have their own rotation features, as does the adjustable field-flattener. One uses a sophisticated clamp and the other has handy serrated knobs on the end of the three fasteners.

Unless you have a high-end mount, the chances are you will be assembling the autoguiding system next. This may be a piggy-back scope, adapted guide scope or an off-axis guider. If these are dedicated for the purpose, you can save time by keeping them in their in-focus position using their focus-lock feature. It is useful to know that precise focusing is not required for guide cameras and some applications prefer a *slightly* out of focus image, as it helps to establish the precise center of a bright star.

If you are using an off-axis guider it is important that the pickup does not obscure the sensor (figs.8, 9). This is normally a set and forget item. A convenient way to do this is to first set the filter wheel to the clear filter so that you can see the sensor. Attach this to your fastest telescope and slide the pickup mirror into the off-axis guider but not so far that it obscures the imaging sensor in any way when viewed through the front of the telescope. If the pickup grazes the sensor's optical path, you may not only shade it but the obstacle will generate diffraction. Next, assemble the telescope to the mount, preferably before fitting any wiring to the telescope; it is hard enough to carry the ungainly mass of a telescope without the additional trip hazard of trailing cables.

When attaching the telescope to the mount there are a couple of tips to keep things safe and to avoid damage. Some mounts have sensitive drive systems and the assembly should be carried out with the drive clutches disengaged to prevent damage. During the assembly the unbalanced system may also suddenly swing round. The trick is to reduce the imbalance at any time so that you can easily support the telescope in any position. On the mount, loosen the clutches and swing the counterweight bar so it points downwards (often called the home position). For stability, slide and fix a counterweight onto the bar. Loosen the dovetail plate clamp and, cradling the scope, gently place or slide it into the dovetail so that the balance markers line up. With one hand holding the scope in place, quickly tighten the dovetail clamp and pop in the safety screw or tether. Hold the counterweight bar firmly and *carefully* assess the balance. If the assembly requires a second counterweight, now is the time to fit it and adjust both so that the counterweight end just swings down of its own accord.

From here, it is safe to fit the various cables and wiring. **Remember to connect all cables before turning the power on; this applies to both power and communication cables.** Extend the dew shield and wrap the dew heater tape around the telescope. This should be immediately behind the dew shield and as close as possible to the exposed optical elements. In damp conditions, I keep the lens cap on until the dew heater system has been on for a few minutes. Route the various cables from the computer to the cameras, focuser, filter wheel, dew heater and so on. If the connectors stick

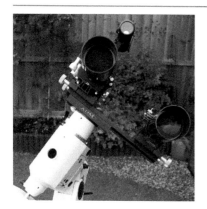

fig.11 This assembly needs not only balancing fore-aft but also left to right about the DEC axis. This is done with a horizontal counterweight bar and the telescopes pointing directly up. In this case, the imaging scope is considerably heavier than the guide scope and the side-by-side saddle plate is offset to balance the assembly. (The cables and cameras have been left off for clarity.)

fig.12 To balance this guide scope on a SCT, weights are attached to a thin dovetail bar that runs underneath the optical tube. The weights are slid fore-aft to balance the scope when the tube is horizontal and screwed in/out to balance the scope in the vertical orientation.

out too far and are at risk of catching on things, like tripod legs, consider changing the standard cables to those with right-angled connectors. Next, look out for potential cable snags; Velcro® cable ties are inexpensive and are an excellent way to keep the cabling from dangling, as is nylon mesh to bundle cables together. To keep the balance consistent, route cables close to the DEC axis (fig.10). (I attach a cable clip to one of the spare holes in the middle of my dovetail plate.) Set the focuser to the approximate focus position. (I set the focuser stepper motor's "home position" close to the in-focus position and to the nearest 10-mm marking on the engraved scale. In that way it is easy to re-establish if I lose the reference position.) Once everything is assembled, you are ready to fine-tune the balance.

Balancing

The general concept ensures that the telescope is balanced about the declination and right ascension axes, so that the mount's motors are not put under undue strain. Final balancing should be completed with the full setup, including cameras, guide scopes and cabling. For simple setups with in-line cameras, this is a simple two-axis check:

1 Tighten the DEC clutch and slacken the RA clutch and swing the counterweight bar to the horizontal. Without letting go, slide the counter weights back and forth until it is balanced. If the bearings are stiff, gently move the assembly in each direction and aim for a similar resistance to movement. Some mounts have electronic balancing and give a balance indication by monitoring the motor current in each direction.

2 To check the scope's balance about the DEC axis, with the counterweight bar horizontal, tighten the RA clutch. Support the telescope horizontally, slacken the dovetail clamps and carefully ease the dovetail back and forth to adjust the fore-aft balance point. Remember to do this without the metal lens cap. Carefully tighten the dovetail clamps and if you have not already done so, screw in a safety stop or hook a safety cord around the tube rings and extended dovetail plate to prevent any accidental slippage.

That's the theory. There are invariably a few complications: With heavy cameras, the focus travel also affects the DEC balance and ideally the focuser should be at the focus position for balancing. It speeds things up for next time to mark the balance position on the dovetail plate against a marker placed on the dovetail clamp (I use a slither of white electrician's tape). If the scope has a large off-axis mass, for instance a Newtonian design or a heavy off-axis guide scope, it may require additional balancing around the DEC axis:

3 With the counterweight bar still clamped horizontally, rotate the telescope to point straight up and balance about the DEC axis. In the case of a dual mounting bar arrangement (fig.11) slide the mounting bar along the dovetail clamp. A Newtonian or a lopsided assembly may require more ingenuity.

Balancing on this third axis can be quite tricky: A long scope may foul the tripod legs and a Newtonian scope has to be rotated in its mounting rings, without shifting it longitudinally, to place the focuser and camera in line with the DEC axis. (If you fit a third mounting ring, butted to the front of one of the main rings, you can use loosen the main rings and use

this third ring as a fore-aft reference.) Other methods include an oversize dovetail plate to which a weight is attached to one side. Some mounts are more forgiving than others. Those mounts that use an all belt-drive, rather than a worm or direct drive, benefit from careful balancing. Finally, just as you achieve perfect balance, I'll mention that those mass-produced models that use a traditional worm-gear drive may actually benefit from a small imbalance to reduce backlash!

Deliberate Imperfections

I was uncertain whether to discuss this aside here or in the section on tracking and guiding. With all this emphasis on accuracy, strange that it may seem, a small imbalance in DEC and RA is sometimes to our advantage, especially on an amateur gear-driven mount. We can infer from a prior discussion on gear meshing, tolerances and backlash, that a small imbalance keeps the gears engaged in one direction and since the gears never disengage, backlash does not occur. In the case of the RA axis, the mount always rotates in the tracking direction and any autoguiding merely alters the tracking speed. If there is any imbalance about the RA axis, it is better for it to act against the tracking direction, to ensure the gears are always engaged. For a user in the Northern Hemisphere and with the counterweights on the west side, the weight is slightly biased to the scope side. The opposite is true for users in the Southern Hemisphere. After a meridian flip, the imbalance should be in the opposite direction. One method is to balance the mount slightly to the counterweight side and then add a small mass on the telescope side (e.g. fix a small aluminum clamp to the end of the dovetail bar). After a flip to the west side, remove the mass so the imbalance opposes the tracking motion again.

The RA axis is the easy part and in an ideal situation the DEC motors are stationary during tracking. Unfortunately life is never that simple and real-world conditions often require the DEC motor to move in either direction to facilitate dither and correct for drift and refraction effects. When the DEC gear system changes direction, backlash rears its ugly head. I upgraded my mount principally to improve DEC backlash but it does not have to be that drastic (or expensive), as there are two anomalies that may reduce the effect of backlash in the DEC axis to a reasonable level. These are deliberate polar misalignment and a small telescope fore-aft imbalance.

In the case of polar misalignment, we know from drift analysis that there is a constant but small movement of the guide star in the DEC axis from polar misalignment. (Note the drift changes direction after a meridian flip.) We can use this to our advantage by noting the direction of the drift and instructing the autoguiding software to solely issue corrections in the opposing direction. In this way, the DEC motors only move in one direction. After a meridian flip, the guiding polarity is switched over too. Problem solved? Well, not quite. During an exposure this can be a very effective technique but if you dither between exposures (introduce small deliberate movements between exposures that randomize hot pixel positions) it may cause some issues. The problem arises if these small movements, typically in the order of a few arc seconds, require a DEC movement in the direction of the prevailing drift. The guiding software will not be able to move in that direction until the natural drift catches up. It will eventually but it can waste valuable imaging time. Some autoguiding software (like PHD2) has an option to only dither using RA movements for this very reason.

A second trick is to create a slight imbalance in the scope around the DEC axis. This ensures the worm gear is engaged in one direction, although this is unlikely to address any backlash in the gear train between the motor and the worm gear. There will also come a point during an exposure sequence when the telescope is pointing upwards (its center of gravity is vertically in line with the DEC axis) and there is no effective imbalance. This is often the position when backlash is most apparent. There have been occasions when a light breeze caused my tracking error to hop between ± 4 pixels and the guider tracking graph resemble a square wave. (An example image during one of these schizophrenic occasions is shown in the diagnostics section.)

Most autoguiding applications have a backlash compensation feature. This adds a large additional movement to any correction if it is in the opposing direction to the previous correction. The backlash value is often set in seconds (of tracking duration). When the value is too low, it may take many autoguider iterations to overcome backlash and reverse the mount direction. When it is about right, a DEC alignment error will correct itself after a few autoguider iterations. If the value is too high, the mount will overshoot and oscillate. When this happens the tracking error changes direction after each autoguider iteration and is easily detected on the autoguider tracking graph.

One-Time Calibrations

One-time calibrations are just that. These are the equipment checks, calibrations and settings that you depend on for subsequent effective start-ups. For a portable setup, these are principally calibrating the polar scope and the mount's park or home position. Added to this, prepared quick settings are invaluable. A permanent setup will additionally perform a full mount calibration, though in practice, this is something that will require repeating several times a year, or after swapping instruments.

Polar Scope Calibration

For many, polar scope calibration and defining the home position are two adjustments that improve the accuracy of general alignment and tracking. A polar scope is a small low-power telescope that is used to align an equatorial mount with a celestial pole. It typically has a field of view of a few degrees, is mounted within or parallel to the mount's RA axis and usually has a reticle for alignment to Polaris or delta Octantis (for users in the Southern Hemisphere). If the polar scope is not parallel to the RA axis it will require fine-tuning. In the case of those that rotate with the mount, a quick check using a convenient daylight target is all that is required. Fig.12 and 13 highlight a typical process, which is carried out with the power off.

The first step is to align to a useful target (fig.13). Use the mount adjustment bolts to align the center crosshair on a daylight target, release the RA clutch and rotate the mount. As the polar scope rotates with the mount, check to see if the crosshair wanders. If it does, the polar scope needs adjustment. Many have three small adjustment screws that hold the reticle in position and enable precise centering. To make an adjustment, slacken one screw by a fraction of a turn and tighten another by the same amount, until the crosshair remains centered on the same spot as you rotate the mount. It is easy to over-correct and the trick is to make several partial adjustments, checking the alignment after each go. I'm fortunate that there is a large altitude adjustment range on my EQ6 mount and I check the alignment in daylight by aiming at a bracket on my neighbor's TV aerial.

Not all polar scopes are designed to rotate. These models have a circular grid and after independently aligning the mount, a tilt plate places Polaris at the appropriate spot on the grid. A YouTube search quickly finds alternative methods for different telescope mounts.

Less obviously, the Earth's precession causes its axis to shift slowly and the Celestial Pole appears to wander. As a result, a reticle like that in fig.2a is good for about 10 years before it needs an update. Some of the more upmarket reticles have a number of different engravings for different decades (fig.2 b,c).

Some polar scopes, like those supplied with SkyWatcher mounts, simply show the position of Polaris with respect to the North Celestial Pole, and others, like AstroPhysics and Losmandy, align three stars around the pole or have a grid. For those that align on several stars, the mount is adjusted and the polar scope reticle is rotated to align all three stars into their respective locations. For those that use a single reference point, the polar scope requires to be set at a known rotation to align the mount. On the amateur mounts, the reticle is often assembled at an arbitrary angle within the mount and requires calibration. Many have a central crosshair and a circular ring, on which is either a small bubble or grid. If a mount is accurately aligned to the North Celestial Pole, Polaris prescribes a little circle along this circular ring over a 24-hour period. (Remember stars rotate counter-clockwise about the North Celestial Pole and clockwise around the South Celestial Pole). If you know where Polaris should be on its 24-hour orbit, it is a simple matter to mechanically align the mount with the altitude and azimuth adjusting bolts. One trick is to use the RA scale on a mount to set the hour angle of Polaris. To do this, you need a zero reference point to set the current hour angle for Polaris, whose value is often displayed in polar alignment apps.

To determine the zero reference point, when Polaris is at the top of the circle it is said to be in transit and its hour angle is 0. Since a polar scope

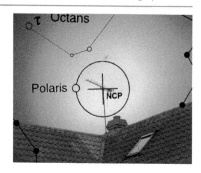

fig.13 *For a polar scope to be useful, it needs to be accurately centered. On the SkyWatcher EQ mounts, this is confirmed by lining up the central cross with a suitable target (for example, a TV aerial), rotating the mount in RA and checking the crosshair does not wander. If it does, carefully center the reticle using the retention grub screws shown in fig.14.*

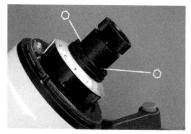

fig.14 *Three small grub screws hold the reticle in place in an EQ polar scope, two of which are indicated in the figure. These are adjusted in pairs to center the crosshair. First, slacken one by 1/8th turn and tighten another by the same amount. The secret is to only make very small adjustments and remove half the error each time. Once set, this should be a one-time only calibration.*

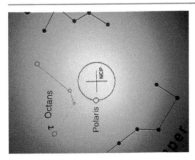

fig.15 *Center an object on the cross hair and lift the mount using the altitude bolt until it sits on the circle. Swing the bubble to that point. This marks the Polaris transit position.*

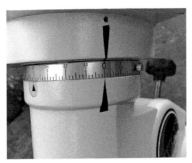

fig.16 *This figure shows two markers. The top one is a home position marker that lines up with the main pointer on the left hand side of the image. The bottom marker lines up with the home position marker when the Polaris bubble is in the transit position shown in fig.15.*

fig.17 *In this case the hour angle for Polaris is 18:00 hours and the mount is swung round to align 18:00 with the marker tape to align the polar scope. (For those in the south, it is 6:00.)*

is a simple refractor, the view is inverted and it actually appears at the bottom, at the "6 o'clock" position. The trick is to rotate the polar scope to this position and mark the transit position on the mount's RA scale. The simplest way to do this is to aim the polar scope crosshair at a stationary point and then use the latitude bolts to lower the mount until it is on the large circle. Rotate the polar scope until the small Polaris bubble is centered on this point and mark the transit position. In the case of the popular EQ6 mount figs.15–17 show how to calibrate a marker point. In fig.16, once the transit position is established, the RA scale locknut is loosened and the scale set so that the home position marker, transit marker and the zero on the RA scale line up. Fig.17 shows the marker in action, aligning Polaris to an 18:00 hour angle. In addition, the EQMOD program has a utility that fixes the transit position and the current hour angle under computer control. This example uses the SkyWatcher EQ6 mount but a similar principle is used later to fabricate a RA scale for the up-market Paramount MX mount (details in the Summer Projects chapter).

Mount Home Position

The home position is a set mount orientation that is used as a reference point from which it measures its movement. This position normally defines a set position for the mount gears and also has the telescope pointing into a certain orientation. Some also refer to this as the "park" position and when a mount powers up, many models assume the home or park position is the starting point for a star alignment routine. The home position can have the telescope pointing directly towards the celestial pole and with the counterweight bar pointing downwards, or an arbitrary point in space, defined by accurate position sensors (as is the case with the Paramount mounts). In the case of an EQ6 mount, use the vertical position and set the RA scale to zero hour and the DEC scale to 90°. As the last part of the assembly process, support the telescope, release the clutches and rotate the mount to align the two scales before locking the clutches and turning the mount on.

The home position has another use too: Periodic error correction (PEC) changes with worm-gear angle and for those mounts without gear position sensors, the PEC software assumes a consistent starting point. In the case of the simpler SkyWatcher EQ5/6 mounts, at the end of the night, "park" the mount to the home position before turning the power off. If it is not, the worm gear will be in the wrong position for the PEC to be effective and it will require a new periodic error analysis or a manual method to align the worm gear. (On an EQ6 mount the end of the worm gear can be seen under a screw cover and it is possible to manually align the worm gear, by aligning the flat chamfer of the shaft with a reference point.)

To establish a home position accurately level the tripod and park the mount, using the keypad or computer program before powering down. Release the RA clutch and rotate the counterweight bar until it is perfectly horizontal (fig.18). Adjust the RA scale to 6 or 18 hours, depending on which side it is pointing. Swing the counterweight down so the RA scale reads 0 hours and lock the RA clutch. Release the DEC clutch and rotate the dovetail plate until the fixed side is horizontal. Set the DEC scale to 0° (that is, pointing towards the horizon). Fig.17 shows this for a NEQ6 mount. With practice, you will already have Polaris within the field of view of the polar scope. Once you are aligned to the pole, the first alignment star is within

a degree, making a plate-solve or manual alignment effortless. Once the park position, home position and polar scope are fixed, it speeds up subsequent setups.

Optical Alignment

With the telescope mounted it is important to know the optical alignment is good to go. Depending on the model and its robustness, a telescope may require optical alignment from time to time. Refractors do not normally have a facility for adjustment and once their optical integrity is confirmed and provided they are handled with care, they can be relied upon to keep their performance. Reflector models are a very different beast and the more sensitive models may require alignment before each imaging session, especially after transportation. Alignment involves tilting the mirror assemblies to ensure the optical axes are aligned and centered. The process is called collimation and in broad terms, when a telescope is collimated, an out-of-focus star shows concentric diffraction rings (fig.20) through the eyepiece or camera. This is quickly confirmed using a bright star, or an artificial star (an illuminated pinhole) positioned about 50 m away. Some models (for instance SCTs) just have a facility

fig.18a Setting the home position starts with adjusting the RA scale to 18 hours when the counterweight bar is horizontal. My counterweight bar is not quite straight and I repeat the measurement on the other side until I get the same slight offset on the spirit level. (Note: The mount is not powered and the clutches are simply slackened and the mount moved by hand.)

fig.18b Now that the RA scale is accurately set, rotate the mount until it reads zero hours (with the counterweight bar pointing down) and then loosen the DEC clutch and rotate the dovetail plate until it is horizontal. Set the DEC scale to zero (above). The home position is now set by rotating the dovetail plate 90°. (In the case of a side by side dovetail plate, set the DEC scale to 90° in the illustration above.)

to adjust the secondary mirror angle with the aid of 3 screws (fig.19). In this case, a star is centered and one or more of the three adjusters are turned fractionally, until the diffraction rings are perfectly even and concentric.

Newtonian, Ritchey Chrétien and other telescopes are more complex and both mirrors may require adjustment. Many of the adjustments interact and there is a prescribed order to make the process less frustrating. A word of caution: There are many different telescopes out there, and before attempting any tuning, please read the manufacturer's instructions. There will be some fixings that are set in the production process and should not be touched. This is not a time for over-confidence.

A small industry supplies accessories to collimate telescopes with eyepiece-mounted lasers and targets.

Similarly the Internet is a rich source of YouTube videos and websites offering advice on specific models. Fig. 21 shows a simplified collimating sequence for a Newtonian telescope. These adjustments are made by fractional turns to the three screws on the secondary mirror or to those on the primary mirror. The tilt adjustments work in relation to each of the three adjuster positions. It is advisable to combine small clockwise and counter-clockwise turns rather than a large turn to a single adjuster. If the primary mirror has opposing screws (one for adjustment, the other for locking), the locking screw should always be backed off before any adjustment is made. In practice, collimation can be particularly challenging and a later chapter shows just how much, comparing collimation techniques for a Ritchey Chrétien.

fig.19 *This SCT has three collimating adjusters for the secondary mirror. These are often Phillips bolt heads but placing a screwdriver near the optics is not without risk. A well known upgrade is to replace these with ergonomic "Bob's Knobs".*

fig.20 *These idealized out-of-focus Airy disks of a star assume a telescope with a central obstruction. When a telescope is properly collimated, these rings are concentric.*

Imaging System Alignment

Once the general telescope optical alignment is set up, it is the turn of the field-flattener and camera. This again is a one-time setup that can then be quickly repeated at future sessions. In an ideal assembly the camera sensor is perpendicular to the optical axis and is spaced appropriately so that stars are in focus across the entire surface. The optical design of a field-flattener assumes an optimum spacing to the sensor plane. In many cases these modules have a T2-thread coupling and adopt the T2 flange spacing specification of 55 mm. Some are a millimeter or so longer. There are a few exceptions and you will need to check the data sheet. Either side of the optimum distance, the focus plane will have more curvature and stars will become progressively radially elongated at the image corners. Extreme cases remind me of the "jump into hyperspace" look.

Consumer cameras and their associated T-thread adaptors will reliably put their sensors within 0.5 mm of the optimum distance. Dedicated CCDs do not comply so readily. They will have an arbitrary sensor to flange distance, depending on whether they have an in-built filter wheel, off-axis guider or an adjustable faceplate. Using the available dimensions you should be able to predict the coupling to sensor distance within a few millimeters. Intervening filters will increase the effective optical path length and so at the end of the day, a little experimentation is called for. For this you need a method of adjusting the sensor spacing. There are a number of options depending on the flattener design. The William Optics Field Flattener IV conveniently has an internal helicoid mechanism that shifts the optical cell over a 20-mm range. Each WO scope has a different spacing requirement and the recommended settings work well.

The others require a combination of extension tubes and spacer rings. Extension tubes are available in a range of lengths from 5 mm to 40 mm and may additionally require thin spacer rings, such as those by Baader, to fine-tune the overall spacing. To find the correct spacing requires a series of test exposures, each at different spacer settings and then selecting the best one. In practice, for each spacing setup, carefully focus the image and take several short exposures (about 10 seconds). Choose the best image from each set (the one with the smallest stars) and compare these "best shots" for star elongation in the corners. Sometimes the result is obvious, or at least can be halfway between two obvious extremes. This soon becomes visually challenging and it helps to zoom the image to 200% in order to see the shape of a stars on the screen. Of course, a computer can calculate star roundness very easily and not surprisingly there is a software utility that can automate this evaluation. CCDInspector from CCDWare is one popular program that analyses a star-field and the individual star shape. From this it can calculate field curvature and tilt, as well as contrast, vignetting and focus. The illustrations in fig.23 show some typical results and what they imply.

On the subject of tilt, it does not make much sense to have a perfectly flat focus plane, if it is not parallel to the sensor. Tilt may arise from the assembly tolerances and in the case of a dedicated CCD sensor, the alignment of the sensor chip to its mounting flange (fig.22). Unfortunately there is no avoiding the fact that the normal 1.25- or 2-inch couplings, used for eyepiece mounting, are not designed for demands of an imaging system. Yes, you might be lucky, but the reality is that these are seldom designed for a repeated secure and orthogonal coupling. The best systems use screw-thread

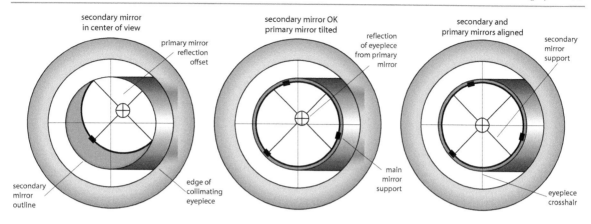

fig.21 *The three illustrations above outline the process of collimating a Newtonian telescope using a sighting tube and assuming that the mirror is already centered with the eyepiece. On the left, only part of the primary mirror can be seen. The first step is to tilt the secondary mirror until the primary mirror can be seen in its entirety and centered in the reflection. Having done this, the primary mirror is tilted to ensure the reflection of the crosshair is also centered with the crosshair in the sighting tube.*

couplings throughout and in the case of the otherwise excellent Field Flattener IV, it requires a custom threaded adaptor to close-couple it to the rear of the focus tube. In this case, I could not find an SCT to 68-mm threaded adaptor and had one custom made for £50 (fig.7). I consider this a good investment to support my heavy filter wheel / CCD assembly and as well as for lighter ones too.

On the subject of mounting SLR bodies, especially EOS models, I have discovered that not all T-adaptors are created equal: Some models are deliberately slimmer so their spacing can be fine-tuned or to accommodate a light pollution filter in the optical path. Some models have an oversize slot for the bayonet lock; I have had several EOS T-adaptors and some do not lock securely, with the result that the camera body can move between or during exposures. There are some premium models out there and sometimes the additional investment is required to make the most of the overall outlay.

Guide Scope Alignment

In the previous chapter we reasoned that a guide camera system does not require the same angular resolution as the imaging camera for effective guiding. Of more importance is the rigidity of the system and minimizing differential flexure. In the case of an off-axis guider, the full resolution of my Starlight Xpress Lodestar camera is wasted. I normally bin exposures 2x2, speeding the image download time and improving the signal to noise ratio for these short exposures. When I'm using a digital SLR I sometimes use a finder scope or a converted lightweight refractor for guiding. The large sensor on the camera is well matched to wide-field shots and at low magnification, a guide scope with a focal length of around 200 mm is sufficient. This little system is quite light and conveniently fits into a normal finder scope shoe. An optional helical focus tube replaces the diagonal on the finder scope. The thread is lockable and is preferably pre-set to the right spacing for instant focus.

If you are using a setup like that in fig.11 a lightweight SkyWatcher Startravel refractor makes an excellent guide scope. It has a focal length of 400 mm and an 80 mm aperture. It also sports a focus tube that conveniently ends in a T-thread. I dedicate mine to autoguiding, pre-focus it, and lock

fig.22 *The front face of this Starlight Xpress camera has an adjustable faceplate. Using the three screws (next to opposing lock-screws), the faceplate can be tilted to ensure the camera sensor is orthogonal to the optical axis. Keeping things in perspective, if the camera is coupled to the scope using a 2-inch nosepiece, then this adjustment has little bearing on the final alignment. In my case, I check and adjust the alignment using the home-made jig shown in the appendices. A good starting point is to square off the faceplate using a feeler gauge to set an even gap.*

fig.23 These three screen grabs from
CCDInspector show a 3-D plot of
the focus plane, all from analyzing
a star-field image. The top plot
shows the extreme field curvature
for a short focal length APO triplet
refractor without a field-flattener.
The middle plot is interesting, since
it has no circular symmetry and the
slight curve in one dimension, which
indicates a slight tracking issue.
The final curve at the bottom is
a good result, with a percentage
curvature figure in single figures
and no apparent tilt. Programs
like CCDInspector can be very
useful in diagnosing issues and
setting up focus and alignment
in an imaging system.

the focus mechanism. I screw the guide camera into a T-to-C-thread adaptor with a T-thread extension tube that screws directly into the back of the focus tube. This makes a rigid and instantly repeatable assembly (fig.25).

Mount Limits

Everything is almost ready for connecting up to the computer but there are a few last one-time things to make note of: Now is the time to define your local horizon (normally a series of coordinates) and more importantly, to check for leg clashes especially when imaging near the meridian at high declinations. In each case, you need to slew the mount about and it is safer to do this standing by the mount and using the mount's handset.

In the instance of the horizon – some computer programs accept a text file with a series of altitude/azimuth angles that define the local horizon. Others have sliders which set the horizon altitude for each compass point to the same effect. Another method of working out the local horizon is to make a panoramic image at the imaging site using a camera mounted on a level tripod. The programs differ in the detail but after merging the dozen or so images into a panorama, crop the image so that it forms a full circle. If you apply a square grid (for instance a Photoshop view option) it allows you to work out the horizon altitude in degrees. Even if the local horizon extends below 30° altitude, it makes sense to limit imaging to 30° and above. TheSkyX can interpret a panorama and define an imaging horizon.

Most mounts continue to track past the meridian for 10° or more unless software settings instruct otherwise. This is normally the point when leg clashes occur. Wide-bodied filter wheels and exposed electrical connectors make matters worse. Leg clashes damage sensitive equipment and it is important to know the safe limits of movement. To establish these, mount your worst offending scope (normally the longest one) and from the home position, rotate it so that counterweight bar is horizontal. Now rotate the scope to point straight up and check if the scope can swing past the legs without obstruction. The trick is to repeat this at slightly different RA positions until the scope just clears the legs. Note this RA value, either from the RA readout from the handset or from the mount setting rings. Depending on the model, enter this value into the mount's handset or keep for later inclusion into the PC control software.

Lastly, fork-mounted telescopes often have limited clearance for bulky cameras at high declinations. The fork arms are simply not wide enough or long enough to allow a camera to swing through unimpeded. Most mount control programs have a maximum declination setting to avoid clashes of this kind, above which it will not be possible to image.

fig.24 These Delrin® shims fit a T2
thread and come in a number of
thicknesses up to 1.0 mm. These
enable precise spacing and also
change the angle of a threaded
assembly. If they are difficult to pass
over the thread, I make an angled
cut and slip them over with ease.

Planetary Imaging Setup

Planetary imaging is quite unlike deep sky imaging. The subject is much smaller and brighter than your typical cluster or galaxy and requires a completely different approach. This involves operating at high magnification and fast shutter speeds. The effect of astronomical seeing is very obvious at high magnification and the image is constantly on the move like a demented blancmange. This combination presents a unique set of challenges and has a similarly unique solution. It is a great way to spend a few hours, however, making the most of the clear air after a passing shower and still having an early night. (The Bibliography includes references to specialists in this field.)

Planetary Cameras

Thankfully the high surface brightness and the small image size are a good match for a small video camera and the resulting short exposures are less affected by atmospheric conditions. These video cameras commonly operate at 15, 30 or 60 frames per second (fps). The more sophisticated models use a CCD rather than a CMOS sensor and can operate at intermediate and longer exposure times too. The setup may require an alternative electronic hook-up to that used for still photography. In practice, my otherwise excellent USB 2.0 hub system cannot cope with 60 fps uncompressed video but does work at lower frame rates, or when the video stream is compressed. Other cameras may require faster and less common interfaces, such as USB 3.0 or FireWire. These high speed protocols often have a limited maximum transmission distance and may require a PC close by the telescope mount. FireWire in particular, once popular on Apple Macintosh computers, is no longer included as standard on the latest models.

Magnification

High magnifications require a long focal length. The prominent planetary imagers, of whom Damian Peach is perhaps the best-known amateur, use Schmidt Cassegrain designs, whose natural focal length is over 2,500 mm, possibly combined with a 2x focal length extender (Barlow). For average seeing conditions the recommended image scale of 0.25 arc seconds/pixel is often cited, reducing to 0.1 in excellent conditions. I use my longest refractor and a 5x Tele Vue Powermate extender, which gives an overall focal length of about 4,500 mm and with my CCD's 5.6 micron pixel size conveniently delivers 0.25 arc second/pixel. The field of view is tiny, around 2.4 x 2 arc minutes (compared to about 50 x 40 for standard imaging) and the image is very sensitive to any focus error. There is no need for a field-flattener for this tiny field of view but it does require some ingenuity to get the required sensor spacing. The 5x Powermate does not in itself drive a longer focus travel but the absence of the field-flattener requires a series of tubes to supplement the focuser travel. On my refractor, I have concocted an assembly that extends the back of the focuser tube by about 4.5 inches (fig.28). It looks frail but fortunately, these are all screw couplings, bar one. My latest 250 mm f/8 RCT works well with a 2.5X Tele Vue Powermate but has less image contrast.

Targeting

In a permanent setup, a good pointing model and an accurate clock setting should locate a planet with 10 arc seconds and certainly within the field of view. With a portable setup, aiming the telescope with such a small field of

fig.25 *This picture of the back end of my guide scope shows the guide camera assembly on the silver focus tube. Shortly after taking this picture, I connected the camera to my computer and set up the focus on a distant pylon. All the components are screwed together securely. Focusing wastes precious time and requires the astrophotographer to be close to hand or use a remote control. The focus lock on the far right holds the focus tube firmly in place and the other components are quickly and repeatedly assembled for fuss free operation.*

fig.26 *Part of the allure of this hobby is the opportunity to develop your own solutions. My new mount required a pillar extension, similar to the one marketed by SkyWatcher for their EQ range, to lift the mount and scope to reduce the likelihood of leg collisions. I designed and had this made by a local machine shop for about £200.*

fig.27 *This Philips SPC880 webcam
has had its lens unscrewed. The
telescope adaptor on the left
screws into the remaining thread.
The sensor is just 4 x 4.6 mm. The
better models use CCDs rather
than CMOS sensors and a little
industry has set itself up modifying
these inexpensive cameras to do
long exposures and improve their
noise levels. The most popular
are those from Philips with the
SPC 900 and SPC880 being the
most sought after models.*

fig.28 *This is the assembly I use to
attach a video camera to my
refractor. There are seven items
in this 120-mm focus extension:
From the left, a DMK video camera
with a C-to-T-thread adaptor,
followed by the Tele Vue T-thread
adaptor to the 5x Powermate.
The Powermate inserts into a
high-quality 1.25-inch eyepiece
to T-adaptor, screwed to a 40
mm T-thread extension tube
and a Meade SCT to T-thread
extension tube. On the far right
is the adaptor from fig.7, which
converts the large thread on the
rear of the focuser tube to a SCT
thread (2-inch 24 tpi). Whew!*

view is a challenge and is made much easier after a little preparation. On the night, I focus to an approximate position and center the planet using a finder scope fitted with an illuminated reticle. The first time you try this, it may take some time to find the target but it can be made less hit and miss by doing a coarse calibration beforehand:

1 Establish an approximate focus position in daylight by pointing the telescope at a distant object. Record the focus position (this is where a digital readout can be quite useful).
2 At the same time, fit and align a finder scope to the same point. (Although the moon is a good focus target it is too large to align the finder scope to, which is why I suggest to do this in daylight.)
3 On the first night, polar align the mount and set the approximate focus position.
4 Locate any bright object in the sky and on the screen. Center it and quickly adjust the three-way finder scope mounting so that it exactly aligns to the same position.

On the next imaging occasion you should be able to point the scope to within 5 arc minutes of the target and will probably detect its presence by the sky-glow in the surrounding area. (Some telescope drivers have a spiral search facility that can be useful in these circumstances.) Once the planet (or moon crater) is on the screen check the video preview for a few minutes. The polar alignment should be sufficiently good that the image does not wander more than say 20% of the image width after a few minutes. Drift is only a concern in keeping the object roughly centered during the exposure, since the individual sub-second exposures freeze any motion. The overall video can last for a few minutes. In the case of Jupiter, which rotates every 9 hours, its surface features and moons start to blur on exposures exceeding 2 minutes. To prevent the moon drifting out of view in a high magnification setup, change the mount to track at a lunar rate.

Conclusions

The particular practical issues that face the astrophotographer are very much dependent upon their circumstances and particular equipment. I have tried to highlight all those little things I have discovered along the way that make things that bit easier, faster or more reliable. A considerable part of it involves searching for a particular adaptor and a bit of lateral thinking. Everyone I speak to has, at some stage, developed their own solutions for a particular problem. Their generous nature and the Internet often mean we all benefit from their discoveries. I am hoping the ideas I have set down here can be translated to your needs or prompt the idea for a solution. The images in the first edition were entirely taken with a portable setup, whose setup time improved through practice and practical construction. In the end I was routinely setting up a fully aligned system within 20 minutes.

When it comes to problem solving, the complexities of software setup and operation are even more entertaining and, unlike their mechanical counterparts, are often hidden from view. A few are brave enough to write their own programs, for those companies that excel in all things mechanical may not fare so well in to the ever-changing world of operating systems, communication protocols and hardware drivers.

Software Setup

In the ever-changing world of operating systems, updates and upgrades,
it is optimistic to assume that it will be "all right on the night".

If you think that astronomy hardware has evolved rapidly in the last decade, that is nothing compared to astronomy software. In the same period the depth, breadth and platform support has increased exponentially and continues to do so. Interestingly, software development has been equally active on two fronts, amateur and professional. It is evident that several mount manufacturers emerged from purely mechanical engineering origins and their Achilles' heel is software and firmware. In a few cases, some drivers and applications written by amateurs, often without commercial gain, outclass the OEM versions. At the same time, inexpensive applications for tablets and smart phones offer useful portable utilities. This explosion in software titles presents a fantastic opportunity and a bewildering dilemma at the same time. I hope the chapter on imaging equipment simplified some aspects. What follows is a high-level guide to installing, calibrating and using astronomy software for image capture. As you can imagine, no two installations are the same but at the same time there are many common threads that run through any system.

Installing software

Base System

I dedicate a computer for imaging and set it up to run lean and mean. I disable fancy power-sapping themes and animations but it does make some of the screen grabs look old-fashioned. A fresh install of Windows, without the bells and whistles, makes the most of battery power. After the software installation is complete, I create a power saving profile in advanced power management, which ensures the computer is never allowed to go to standby (including the USB system) and the screen, cooling strategy and maximum processor usage is scaled back as far as possible. I implement this for both battery and mains operation, since in my case, when I connect the external battery pack, the computer acts as though it were charging. For a 2.5 GHz Core I5 processor, I can run at 50% max processor usage during image capture. With care and a SSD hard drive upgrade, my laptop (a MacBook Pro) runs Windows 7/10 for about 2 hours longer than normal. By dedicating a machine for the purpose, I do not use it for e-mail or browsing. It connects through a hardware firewall and I

disable Windows firewall and power robbing drive scanning. My software, utilities and drivers are downloaded via another machine and stored on a remote drive. These archives are kept up to date with the last two versions of any particular driver or application, just in case the latest version introduces bugs. I install these programs directly from an external drive or memory stick. For backup, I copy all imaging data to a dedicated external drive. When everything is working smoothly, I create a complete backup (for Mac OSX I use a utility called Winclone to back up the Windows partition).

Application and Drivers

There are no hard and fast rules but there is definitely a preferred installation sequence that minimizes issues. This follows up the data highway, from the hardware to the highest-level application. When I updated my system from 32-bit to 64-bit Windows 7 and on to Windows 10, the following sequence installed without a hitch, though it took several hours to complete, most of which were consumed by innumerable Windows updates. The recommended sequence is as follows and concludes with a system backup:

1 hardware drivers (PC system, cameras, filter wheels, focusers, USB-serial converters)
2 ASCOM platform (from ascom-standards.org)
3 ASCOM device drivers (from ascom-standards.org or the manufacturer)
4 image capture applications
5 utilities (focusing, plate solving, polar alignment)
6 planetarium
7 planning and automation applications
8 image processing applications
9 utilities (polar alignment, collimation, etc.)

In general, once you expand the zip file, run the installer and follow the instructions. There are a couple of things to note: Some applications and occasionally the installation programs themselves require to be run as an administrator or using an administrator account. I select this as the default for ASCOM, Maxim, Sequence Generator Pro, Starry Night Pro, FocusMax and MaxPoint. Some programs also require additional software to run, including the Windows .Net 4.0 & 3.5 frameworks and Visual Basic. The

installation programs normally link to these downloads automatically. Other utility programs, such as Adobe Acrobat Reader and Apple QuickTime, are free downloads from the Internet. Some ASCOM savvy programs, such as Starry Night Pro require a modification to the ASCOM profile settings before they will install. This may change with time and you should check the ASCOM website or user groups for the latest recommendation.

At the time of writing, most astronomy programs are still 32-bit and do not require a 64-bit operating system (though they will run in one). There are a few 64-bit applications, PixInsight for example, and these will not run in a 32-bit version of Windows. This will increasingly be the case over the coming years and several mainstream applications will need to move over. Windows 7 has some tools to run Windows XP compatible software but I found a few programs, such as PERecorder, stubbornly refuse to run in a 64-bit environment. If you do upgrade operating systems, many astronomy programs store configuration and setting files that can be copied over to the new installation. You may need to check their contents with a text file editor and change any paths from "/Program Files/" to "/Program Files (x86)". A number of programs have a finite number of activations and you must deactivate or de-register them before formatting the drive upon which they run. The most notable example is Adobe Photoshop. If, like me, you run Windows on a Mac and run the otherwise excellent Parallels, the Windows operating system repeatedly believes you are running on new hardware and demands a new activation. I gave up after the 5th activation. I resisted the change to Windows 8, but succumbed to Windows 10 as it offers a multiple screen remote-desktop facility.

There are a couple of things to watch with installing catalogs. The venerable General Star Catalog (GSC) is used by PinPoint for plate solving and also by planetariums for displaying stars. These often require the same astrometry data but in different compression formats. I normally put one version in a specific folder in My Documents and another, for plate solving, in the plate-solve program folder. Some planetariums have an associated catalog compiler that converts the otherwise disparate formats into a single version dedicated for purpose. C2A and others have extensive catalog management support and compilers for their planetarium, as does TheSkyX.

In Mac OSX, there is no such equivalent to ASCOM and all programs are required to support hardware directly. Thankfully, there is a degree of collaboration between companies and several different programs work with each other to support the bulk of popular equipment. Nebulosity, Starry Night Pro, TheSkyX and PHD2 are available on both platforms and offer some choice for a basic working system. Using Macs is not a crusade for me and I can live with PCs since Windows 7.

fig.1 This Orion WiFi control module is also sold as the Southern Stars SkyFi unit. It enables serial (RS232, TTL serial and USB) commands to be sent over a wireless network. A piece of software called a virtual COM port on the PC masquerades as a standard serial port but actually converts the serial data to transmit over Ethernet cables or WiFi. These units also allow a smart phone or tablet to connect to a telescope mount. There are similar units which use Bluetooth but these have less bandwidth and range (and use less power too) and can be used for non-time-critical applications.

First time setups
Just as with the software installation, the initial setups follow a logical ground-up logic. I start with the network and general communications, including virtual COM ports, before I start on the specialist hardware.

Communications
Communications can take several forms, including serial, USB and Ethernet. Sometimes those forms are a hybrid – for instance the SkyFi unit converts WiFi into a serial hardware interface and the computer issues serial commands through a WiFi link (fig.1). In Windows, this is done through a virtual COM

port. The program thinks it is sending serial commands but in fact it is sending commands through USB or WiFi. Some USB to serial adaptors have virtual COM port utilities or you can use a free utility like "HW VSP3" from *www.hw-group.com*. One issue that arises with setting up the communications is Windows security. If you have enabled a software firewall, it may be necessary to grant safe passage for your programs in the firewall settings.

Powering Up

With all the hardware connected and assuming the hardware drivers have been installed, the first power-up triggers Windows to register the different devices. (There are always exceptions; my video camera requires the camera to be plugged in for the driver installation.) This should be a once-only event but you may see the "installing new hardware" icon tray pop-up if you swap over USB port connections. Swapping USB ports between sessions can prompt for the hardware driver to be loaded again and can re-assign COM ports. (Consistent, fixed hardware configurations using an interface box prevent this from happening.) After all the hardware is physically connected, the next task is to initialize all the software settings. This is a lengthy task and I recommend listing the common

settings and use as a handy reference. I have captured many of the common settings in fig.3. It is a case of patiently going through each of the programs in turn, through every settings dialog box and fill in the relevant information. There will be a few instances where programs will read data from other sources but having a crib sheet is useful. The good news is that most programs allow you to save program configurations: Maxim DL, TheSkyX, Starry Night Pro, Sequence Generator Pro, PHD2 and FocusMax can load and save complete configurations. In the case of my four combinations of focal length and field-flattener, I create one configuration and then duplicate it another three times. I then modify the few values related to field of view, focal length and angular resolution. The few that remain are updated by a subsequent calibration; for instance guider resolution and focus parameters.

Finally there is the linking of the programs through their ASCOM interfaces (fig.2). This is a confusing subject for many users. It is possible to daisy-chain programs through others to a final piece of hardware. Fig.2 shows an example of the ASCOM connectivity between programs and a suggested connection order. Those ASCOM drivers that accept multiple connections, are called hubs. ASCOM developed a multi purpose hub called POTH (plain old telescope handset) to satisfy multiple program connections to a mount. It has expanded since then to encompass other roles too. Many modern telescope drivers, MaxPoint, FocusMax and others also act as a hub for mount control. The configuration is a one-time only setup but one needs to take care; the daisies in the chain sometimes have to be in a certain order. For instance, to reap the benefit of accurate pointing for all connected programs, MaxPoint should connect directly to the mount driver and not be further up the linked chain. This program linking can also trigger multiple programs to start up and run when you connect say, Maxim DL to the mount. Fault tolerance is not astronomy software's strong suit and I had issues with connection time-outs with Maxim DL 5, FocusMax, MaxPoint and focusers. These time-outs often required a Windows Task Manager intervention or a

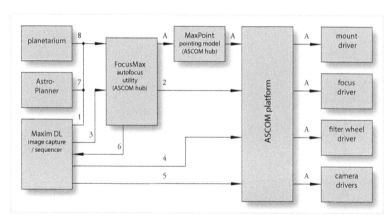

fig.2 The inter-connectivity between applications can be quite confusing. In the example above the arrows indicate which is linking to which and a proposed "connection" order. The "A"s are links that connect programs automatically when the need arises. In this system FocusMax and MaxPoint can both work as a hub, but MaxPoint (a sky modelling program) is downstream of FocusMax so that all applications benefit from the sky model. For example, the first step is to connect Maxim DL "mount" to the FocusMax telescope hub. If FocusMax is already setup to call MaxPoint and MaxPoint is already set up to connect to the mount ASCOM driver, the instruction from Maxim DL 5 actually prompts FocusMax, MaxPoint and mount driver programs to load and run automatically. I found there are a number of alternative start-up sequences and after having some connectivity issues, some of which required a PC re-boot, I disabled the automatic connections and manually opened each application and connected to the other devices.

full reboot to fix. Although FocusMax has options to automatically connect to focuser, telescope and camera system (in other words, it virtually boots the entire system), I manually connect Maxim to the FocusMax telescope hub and connect FocusMax to the focuser before connecting Maxim's focus control to FocusMax (fig.2). Optec Inc. released an all-purpose hub called the Optec ASCOMserver which additionally allows two connections to like devices. This hub, unlike some of the original ASCOM platform packaged ones, is transparent to all commands and therefore can serve specialist equipment.

First Light

It normally takes several nights to figure everything out, establish some of the remaining settings and iron out the wrinkles. These include approximate focus positions, the optimum spacing for the field-flattener and the precise effective focal length of the system. These are often used to generate the initial starting parameters for autofocus routines. This is the time to setup some default exposure sequences, check plate solving works, find the best settings for guiding, align the finders and setup folders for images and program settings. A logbook with the key information is surprisingly handy to remind oneself of

some setting or other. Once you have everything working, it is tempting to continually tinker and update programs. Unless there is a specific benefit to an update, it is better to resist. I'm accustomed to keep all my software up to date but I have had more issues with updates or upgrades (that I did not need) and have wasted valuable imaging time as a result. There are a myriad of settings so listed below are a few more things that can trip up the unwary.

Plate Solving

Plate solving is one of those things I always marvel at. It's a pretty cool idea but the different programs sometimes need a little assistance to get going. Some, like PinPoint, require an approximate starting point and pixel scale (or seek it from astrometry.net). Others also need the approximate orientation of the image. There are numerous free plate solving applications now that for general pointing purposes are fast and reliable, including all-sky solves, where there is no general positional information with the image. The catalog choice affects performance. The common GSC catalog is great for short and medium focal lengths but you may find it is insufficient for work with very small fields of view associated with longer focal lengths. In this case, you may need to set up an alternative catalog with more stars. Many imaging programs read the telescope position and

optics	mount	cameras	guider	focuser	filters	plate solve	planetarium
Telescope: type focal length aperture **Field Flattener:** spacing reduction **Guide Scope:** focal length	**Connections:** driver name COM port or IP address baud rate polling rate GPS port **Location:** time time zone daylight savings? epoch longitude latitude altitude horizon limits meridian limits **Other:** pier flip reporting slew settle time slew rate settings guider method guider rate sync behavior flip behavior	**Hardware:** driver name CCD temp setting download time line order gain **Image:** pixel size binning pixel count angular resolution field of view (FOV) read noise dark noise **Calibration:** dark current levels from calibration masters; for different binning and exposure times.	**Hardware:** driver name line order binning **Image:** pixel size binning pixel count angular resolution field of view dark cal file angle **Guiding:** calibration time exposure time settling criteria backlash setting aggressiveness guide method flip behavior X calibration Y calibration	**Hardware:** driver name port baud rate home position **Calibration:** approx focus posn. slope or aperture backlash setting focus exposure focus binning find-star setting microns per step	**Hardware:** driver name port #filters filter names focus offsets reversible? change time exposure weight	**Environment:** catalog path epoch timeout setting pixel scale default exposure default binning star count **Other:** reject small stars magnitude range expansion %	**Location:** longitude latitude time altitude time zone horizon epoch **Display:** horizon object filters grid settings cardinal settings catalog choice **Other:** telescope connections imaging connections plate solve connections camera FOV setting

fig.3 Each application and utility will require essential data about your system to operate correctly. I have listed a reasonably exhaustive list of the parameters that a full system is likely to require. In a few cases applications can read parameters from others, with which they link to, but this is not always the case. It is "simply" a matter of systematically going through all the settings boxes in all your programs, filling in the details and saving the profiles. Maxim DL and Sequence Generator Pro also have the benefit of being able to store sets of equipment configurations for later recall, speeding up the settings for a particular session.

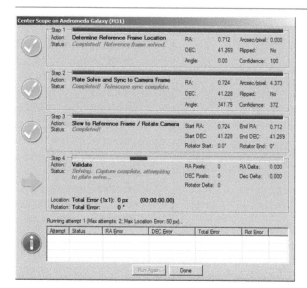

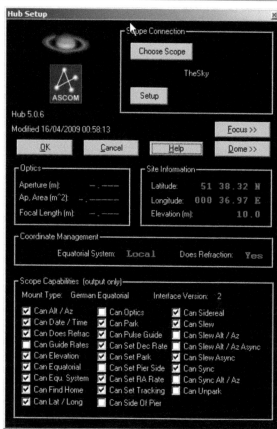

fig.4 With plate solving, the need for extensive sky modelling to achieve good pointing accuracy is removed. With just a basic polar alignment, Sequence Generator Pro will automatically slew to the target area, image, plate-solve and automatically center, image, plate-solve and confirm the positional error to the intended coordinates. It repeats this until the desired accuracy is achieved. In the case of the Paramount mounts they have to be homed after power-up before they will perform a slew command. Once my MX mount is homed, SGP will center the image to within a few pixels within one iteration of its automatic center routine.

use this as a suggestion to speed things up and minimize the chances of a false match. In the interests of time, I also limit the match to 50 stars and stars brighter than magnitude 15. I don't believe matching to more makes it any more accurate for practical purposes and certainly takes longer. Model making may require many plate-solves and the time soon mounts up. For the same reason I use a short 2x2 binned exposure; the image is not only brighter but it downloads in a fraction of a second. Plate solving is particularly powerful when it is automated as part of routine to find and locate an image, at the beginning of an imaging sequence or after a meridian flip, to automatically carry on from where it left off. Sequence Generator Pro usefully has that automation built in (fig.4).

Meridian Flips

Imaging through the Meridian can also trip up the unwary: The two main issues are aligning back to the target and guiding after a meridian flip on an equatorial mount (fig.5). Before we get to that, it is important that you have set the mount slew limits so there is no chance of crunching the camera or filter wheel into the tripod.

fig.5 When a German Equatorial Mount flips, the autoguider program or the mount has to account for the image flip on the guide camera. If left uncorrected, the RA errors would increase exponentially. In the case of an autoguider program making the adjustment, the telescope driver is required to tell the software on what side of the pier it is sitting. In this example, the ASCOM profile settings show that "Can Side of Pier" is unchecked, which might effectively block meridian flip controls on some mounts.

The better mounts will place the object squarely in the frame once more (but reversed) after a meridian flip. Others may be a little off as the result of backlash and flexure. One neat trick is to use plate solving in Maxim (or the automatic center command in Sequence Generator Pro) to re-center the frame:

1 load the original image at the start of the exposure sequence and plate-solve it
2 instruct the mount to slew to that position
3 take a short exposure and plate-solve it
4 sync the mount to the plate-solved position
5 select the original image, plate-solve it and tell the mount to slew to the plate-solve center

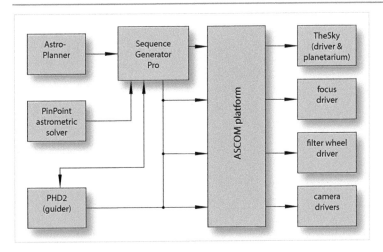

fig.6 *My current Windows setup is more streamlined and reliable. AstroPlanner feeds target data into Sequence Generator Pro (SGP). SGP automates targeting, focusing and sequenced acquisition with simple to use and powerful features, including fully automatic meridian flips. The automation is sufficient for all-night hands-free operation that, with Maxim DL, required an external control program or scripting to facilitate. PHD2, the latest version of this free guiding program, interacts with the mount and SGP to handle guiding, dither and takes care of DEC compensation and guider orientation after a meridian flip. PinPoint is one of a number of plate solving programs that can be called from SGP to facilitate centering and accurate mosaic alignment. In this setup TheSkyX is being used as a planetarium and a mount driver for a Paramount MX. (It also has its own guiding, focusing and basic sequence features too included in the camera add-on.)*

The image should now be precisely centered as before, only flipped over. The mount's sense of direction is flipped and so too are the autoguider corrections. The whole arena of meridian flipping is complicated by the fact that some mount drivers accurately report on the mount orientation, some applications work it out for themselves and in some cases, the polarity of the movement controls is reversed automatically by the mount driver. In the case of an EQ6 mount, I just need to select "Auto Pier Flip" in the autoguider settings to reverse RA polarity after a meridian flip. In Maxim, you also have the option to reverse one or both axis without re-calibration. To find out what works, choose an object in the south just about to pass over the meridian, calibrate the guider system and run the autoguider. Once the mount flips over (either automatically or manually), stop the guider, select a new guide star and start guiding again. Check the guider graph – if either the RA or DEC corrections have the wrong polarity, their error trace will rapidly disappear off the graph. Sequence Generator Pro automates this meridian flip sequence and can additionally instruct a rotator to orientate the camera to its prior alignment.

Autoguiding

Some premium setups may not require guiding if the mount has effective periodic error correction (gear tolerance correction) and no drift (as the result of extensive periodic error correction and polar alignment). Some of the latest mounts use a closed loop control system and, in conjunction with a sky model based on multiple star alignments, accurately track using both RA and DEC motors. For the rest of us, we normally require some form of autoguiding system. Even a perfect mount with perfect alignment will exhibit tracking issues as the object's altitude moves closer to the horizon, due to atmospheric refraction. At 45°, the effect is sufficient to cause a 5 arc second drift over a 10-minute exposure. A sky model is designed to remove this effect.

The software setup for guiding is often complex though some programs, notably PHD2, do their best to keep things simple. It has to accommodate mechanical, optical, dynamic and atmospheric conditions and that is before it tries to work out which way to move! For those with well-behaved mounts, a few button presses is all that is required.

fig.7 *The free program FITSLiberator is shown here displaying the header file for a FITS image. It is a mine of information about the image, how and where it was taken and with what equipment and exposure parameters. This useful program has image processing capabilities too and in its last version (3), operates as a stand-alone utility.*

When that does not produce the desired result a good deal more analysis is required. Although some mechanical aspects, for example balance and alignment have been already covered, this might not be sufficient and for that reason autoguiding, model building and tracking have their own dedicated chapter later on, that fully explore guiding issues and remedies.

Image File Formats

Most of us are familiar with the various camera file formats, the most common of which is JPEG. This is frequently deployed on consumer cameras and is a compressed, lossy 8-bit format, though it is always an option on high-end equipment too. For astronomy, the only time we use JPEG is perhaps to upload the final image to the web or to have it printed. The high-quality option on any camera is now the RAW file, an "unprocessed" file. These are normally 12- or 14-bit depth images stored in a 16-bit file format. TIFF files are less common as a direct camera format but usefully store in 8-, 16-, 32- and 64-bit lossless formats. Dedicated CCD cameras issue a true RAW file. When used with a dedicated image capture program these are commonly stored in a FITS format. The "flexible image transport system" is an open format extensively used in the scientific community and works up to 64-bit depth. Just as with the other image file formats, the file contains more than just the image. It has a header that contains useful information about the image. This allows details of an image to be stored for later use. In astronomy, this includes things like place, time, exposure, equipment, sensor temperature and celestial coordinates.

A typical imaging night may capture hundreds of files and the FITS header is often used to automatically sort and order the files into separate objects, equipment and filter selection by the image processing programs. During the software setup, it is a good idea to find the part of your image capture program that defines custom fields in the FITS header and check it is adding all the useful information (fig.7). It can save time during batch processing, as it helps group like-images together.

Video Capture

It is very satisfying to take short duration videos of what appears to be a hazy object and process them into surprisingly clear objects. The humble webcam produces a simple compressed video stream, the more advanced models have the ability to output RAW video data and at a shorter exposures and higher frame rates too (fig.8). A shorter individual exposure is useful to minimize the effect of astronomical seeing and is especially useful on bright objects such as Jupiter. There are a number of video formats (codecs), including BY8 and UYVY. The PC receives these and saves as a compressed or uncompressed AVI video format for later processing. Some video cameras already conform to the Windows standard (DirectShow) but others require drivers to control specific features and settings. The better software can record an uncompressed raw video file, rather than a processed, compressed and DeBayered color image. This is an expanding arena and the ASCOM.org website has some general purpose drivers and resources that might be customized for your camera model. The complexity and variety of various formats and models make coding, however, a challenge.

fig.8 Video sequences by their nature require control over shutter speed, frame rate, gain and gamma, as well as the color codec. At 60 fps, the DMK camera challenges a USB hub's bandwidth and requires direct connection to a PC. Here, DMK's own application software, IC Capture AS, is happy to run alongside an imaging program. Since the alignment between frames is carried out in software, there is no need to use autoguiding. It is quite straightforward to point to the planet or moon, acquire a short video and nudge the mount (to create a mosaic) and repeat at intervals to find the movie that has the best seeing conditions. At present, there are no ASCOM drivers for the DMK devices.

Wireless / Remote Operation

Moore's law is alive and kicking.

Remote operation is an extremely convenient, if not mandatory, requirement for astrophotography. For the duration of time it takes to acquire images with depth, it makes no sense to sit out in the open, even in an enclosed observatory. There are different levels of "remote operation", some of which may not occur in the same continent. In this study we are within a stone's throw, where it is easy to reset power or USB connections in the case of a problem. I operate my system from indoors and initially used a USB extender over CAT5 cable with considerable success. Using this configuration I was able to prove the reliability of the entire system with the applications running on an indoor desktop PC. It did not, however, allow me to acquire video images, since the bandwidth of its USB 2.0 hub was insufficient to stream uncompressed video at 60 fps. This and the fact that in some instances it required three nested USB hubs, prompted an evaluation of other means of remote control. There was something else; at a recent outreach event at a local school it was apparent that I required a wireless system to remove trip-hazards between the computer and the telescope mount.

For some time a number of astrophotographers have searched for a reliable wireless system, concentrating their search on WiFi-based USB hubs. These have existed for some time but always with specific hardware in mind (typically printers and storage devices). At the time of writing, the conflicting protocols did not allow general USB connectivity over WiFi. With the advent of miniature PCs, however, commonly used in multimedia configurations, it has occurred to many that one of these devices may be a better option than leaving a laptop out in the dew. Located at the mount as a local computer running the application software it is remotely controlled through its network interface by a virtually any PC, iOS device or Mac in a less extreme environment.

Small Is Beautiful

This chapter looks at the implementation of such a control hub, using one of the recent Intel NUC (Next Unit of Computing) series of PCs (fig.1). These are fully functional computers that can operate Windows or Mac OS, are approximately 4-inches square and consume less than 10 watts at 12 volts. My particular unit has a

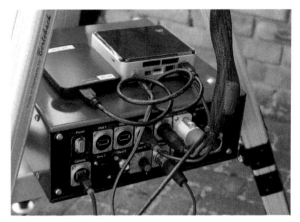

fig.1 An Intel Core i5 NUC®, sitting on top of my interface box and attached to an external USB 3.0 128 GB SSD. This system is self-contained and just needs a 12-volt power feed. It is controlled remotely through its WiFi interface. The interface box is made of steel and the top of the NUC's aluminum enclosure is plastic to allow the BlueTooth and WiFi antenna to operate. With this size and power usage, it is safe to place the NUC and SSD drive into a small plastic box and permanently mount it inside an observatory.

Core-i5 processor, 4 USB-3.0 hubs, Ethernet, HDMI and DisplayPort connections. A small Qualcomm® card provides dual channel WiFi (802.11 a/b/g/n) and Bluetooth 4.0 capability and there is space inside for up to 16 GB RAM and a mSATA solid state drive. Using three batteries; "clean", "dirty" and "PC", the entire imaging system is self-contained under the mount. The WiFi network connects to a home broadband router and allows remote control from a range of devices, including a Mac, iPad, PC or any other device that will run remote desktop software. In operation, the NUC is not connected to a keyboard, mouse or display and hence it requires some specific setups that allow it to power up, log in, shut down and connect to the WiFi network automatically. Unlike Bluetooth, WiFi has a longer range and a higher bandwidth which allows for feasible remote control above 54 Mbps. In this particular case I'm using a home network but also it is possible to implement a direct computer to computer network too, either through WiFi, a direct Ethernet cable connection or via powerline adaptors in a wired observatory setting.

Of course, a remote PC in the observatory is nothing new. In this particular implementation the NUC is dedicated to the task and is not encumbered by power-hungry Windows themes, drive scanners or unnecessary software. For that reason one must take sensible precautions and use it exclusively with known websites and through secure, firewall-based connections. The reward is a computer that works extremely quickly, since it uses solid-state memory and reliably too, since the short USB connections to the equipment introduce negligible latency. In a permanent setup, it is entirely feasible to house it in a sealed plastic container, with a few small cutouts to facilitate the wired connections (as in the chapter on building an Arduino-based observatory controller).

Remote Control Software

There is a wide choice of remote control software, many of which are free. I use Microsoft Remote Desktop (MRD), which is available for PC, Mac and IOS and whose protocol (Windows Remote Protocol, or WRP) is built into the Windows operating system. Another popular choice is TeamViewer, which requires installation on the host computer and operates through the World Wide Web. This application is often the top choice when the observatory is truly remote, even in a different country. For my setup I use MRD as it is less intrusive and allows direct connections when I am away from home.

The objective here is to have the NUC connected to power and USB peripherals at the mount. It is powered up with its power button and then operated remotely, either via a home network, cable or a direct connection, using MRD. It should be able to be shutdown and restarted remotely and its connections to the network should be automated so that there is no need for a monitor, mouse or keyboard.

To do this requires a few prerequisites:

1 It needs to be set up to accept remote access.
2 The NUC has to power up without a logon screen.
3 It has to automatically connect or generate the WiFi network.
4 It also needs a method to be re-booted or shutdown remotely, since one can only log off in MRD.
5 It needs a network setup and a consistent IP address for each of the access methods (WiFi router, direct WiFi, cable) so a remote connection is possible.

Setting Up the NUC for MRD (1)

Windows remote desktop compatibility is built into the Windows Pro operating systems and just needs to be enabled: In the NUC's control panel dialog, select "System and Security" and click "Allow remote access" under the System heading. Now click "Allow a program through Windows Firewall" and scroll down to check that remote desktop is enabled for home and private networks through the firewall. This will allow remote access to the NUC, assuming you have the correct IP address, user name and password.

Automatic Login (2)

For the PC to fully boot, one needs to disable the logon password screen. In Windows, this is clearly a security bypass, so Microsoft do not make it obvious. In Windows 7, if you type "netplwiz" in the Start menu box, it brings up the User Accounts dialog. Deselect "Users must enter a user name and password to use this computer". This may require an admin password to confirm the setting but once enabled the NUC powers-up and is ready to go within 10 seconds without any keyboard or mouse interaction. (A further setting in the PC's BIOS setup enables automatic boot with the application of power.)

Shutdown and Restart (3,4)

A normal computer, set up with keyboard, screen and mouse allows you to restart and shut it down. Under remote control, this is not necessarily the case, since some OS versions only allow a remote user to log off. One way to overcome this is to create two small command files, with their shortcuts conveniently placed on the desktop that just require a double-click to execute. These point to one-line text files, named "shutdown.cmd" and "restart.cmd". You can create these in moments using the Windows notepad application. In the following, note that Windows versions may use a slightly different syntax:

Windows 7 restart:
 "psshutdown -r -f -t 5"
Windows 7 shutdown:
 "psshutdown -s -f -t 5"
Windows 8/10 restart:
 "%win32%\system32\shutdown /r /f /t 5"
Windows 8/10 shutdown:
 "%win32%\system32\shutdown /s /f /t 5"

For this to work, Windows 7 specifically requires the PSTOOLS archive in its system folder. In practice, the psshutdown.exe is extracted from the ZIP file and put in the windows/system32 folder. (This archive is available from technet.microsoft.com.) For convenience I placed these .cmd files in a folder with my astro utilities, created a shortcut for each and then dragged then to the desktop. Executing these suspends the MRD connection. (The

fig.2 This simple text file is executed as a command. In this case to shut down a Windows 7 computer, forcing applications to quit. Next to it on the desktop next is the shortcut to the text file, allowing remote control. Note the slightly different protocol for Windows 8 and 10 in the main text. When you execute this, you will lose remote control.

fig.3 The startup folder includes two shortcut; the first is to a locally served Astrometry.net plate-solver and the second is to execute the network shell command-line routine in the Windows/System32 folder, with in-line instructions to connect to the home WiFi network. The command line includes the SSID. In practice, the text "SSID" here is replaced by your WiFi network name. This information is obtained by right-clicking the shortcut and clicking Properties > Shortcut. This may not always be necessary if you have instructed your PC to connect to your preferred network elsewhere in one of the numerous alternative network settings dialogs.

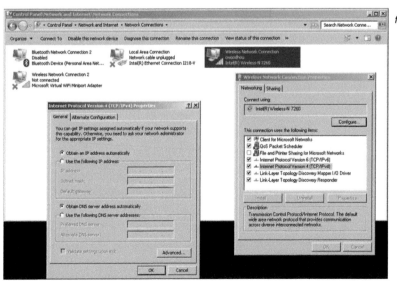

fig.4 In the case of an automated connection to a WiFi router, check the wireless network connection TCP/IPV4 properties. If you have set up your router to give the NUC a static IP address, then you can leave the general settings to automatic, as shown opposite. This is my preferred approach for reliable and repeatable connections. To set up a consistent IP address for a wired connection requires a different approach, shown in fig.5.

"f" or "/f" syntax in the above commands is useful in a lock-up situation as it force-quits all applications. The number 5 refers to a delay in seconds. I find this is sufficient time to double-click the shortcut and then quit the remote control connection before the NUC loses communication (fig.2).

Network(s) Setup (5)

Home Network

At home, the most convenient way to connect to the NUC is via a wireless router. To do this, MRD requires the IP address of the NUC WiFi connection. Most routers dynamically assign IP addresses, depending on the order of connection. That poses a problem if the IP address changes every time it connects, since one cannot talk to the NUC "user" to find out what it is! The answer is to create a static IP address. Luckily a good router allows one to set a static IP address for a particular connection (fig.4). The instructions are similar but vary slightly between router models. It is very easy with my Airport Extreme; I type in the MAC address of the NUC computer connection (found in the wireless network connection status, often called the "physical address" and which comprises of six groups of two hexadecimal characters) and assign an IP address, something like 10.0.1.8. When connected to the router, this becomes the IPv4 address of the connection, found in the Network Connection Details screen on the NUC, or by typing "ipconfig" in a Windows command screen.

In the MRD profile settings on the remote PC or iPad, enter this same IP address as the "PC name" and your normal NUC user name and logon password into the fields of the same name. MRD allows for multiple profiles (or "Desktops") and I typically have three; home router, direct WiFi and direct cable connection.

In practice, it is useful to check these system set-ups with the NUC hooked up to a display, mouse and keyboard. (If something goes wrong, you still have control over the NUC.) Next, try and connect to your home network with the applicable SSID security passwords to ensure it is set up for auto-connection. To do this, check the settings in "Network and Sharing Center", on the "manage wireless networks" tab.

With these settings the NUC boots with power application and sets up the network connection. Next, head over to your remote PC/Mac/iOS device and connect. On the initial connection, there is often a dialog about accepting certificates and are you really, really sure? (These pesky reminders reoccur until one instructs MRD to permanently trust this address.)

Ad-Hoc Network

If you are away from home, there is no router to assign the IP address for the NUC. It is still possible to connect both computers with an ad-hoc network. This is a direct link between the NUC and your remote PC/Mac/iOS device. This requires a little ingenuity to set up, since a wireless service can only have one set of properties. In Windows 7:

1 Click on the network icon in bottom right of the taskbar, and Click Open Network and Sharing Center or Control Panel>Network and Internet>Network and Sharing Center
2 Click Manage Wireless Networks > Add
3 Manually create a network profile
4 Enter your preferred network name (SSID), and no authentication (open) or encryption
5 Uncheck "Start connection automatically" and "Connect even if the network is not broadcasting"
6 Click Close
7 Click Start on the desktop and in the dialog box type "CMD", then Enter
8 At the command prompt type:

 "netsh wlan set profileparameter name=SSID "
 "connectionType=IBSS"

In the above, substitute "SSID" for the name of your ad-hoc network. This will change the connection type to ad-hoc and you will no longer have to type in the network key. As before, to get the ad-hoc network to setup automatically when the NUC powers up, we can add a command to the startup folder (fig.3) and removing or swapping over the one for the home router.

1 Click Start > All Programs > right click Startup and click Open
2 Right-click on empty space and click New > Shortcut
3 Type in "netsh wlan connect SSID" (again, substitute "SSID" for the name of your ad-hoc network)
4 Click next and enter a name for the command, something like "auto ad-hoc"
5 Click Finish

You also need to set up a static IP address for the ad-hoc network: In the Network Connections window, right-click on the wireless network icon and select properties. Click on Internet Protocol Version 4 (TCP/IPv4) and Properties. The General tab is normally used for the router connection and is typically set to Obtain an IP address (and DNS server address) automatically. To set up a static ad-hoc address, click on the Alternative

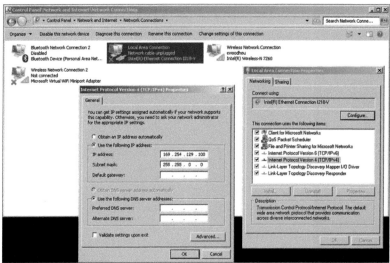

fig.5 In the case of an ad-hoc connection
 to a remote computer, check the
 wireless network connection TCP/
 IPV4 properties. In the alternative
 configuration, set the IP address
 of the client computer, but make
 the last set of digits unique.

fig.6 In the case of a wired connection to a remote computer, check the Local Area
 Connection TCP/IPV4 properties. In the general tab, type in an IP address
 in the same range as the client computer, but change the last set of digits.
 Both client and remote computer should have the same subnet mask.

Configuration tab. Click User configured and type in an IP address. Pressing the tab button should automatically update the Subnet mask boxes (fig. 5). If the network cannot connect with the primary address within 2 minutes, it defaults to the alternative (static) address, allowing ad-hoc connection. The easiest way to do this is to look at the physical address of your client computer and copy its IP address over to the NUC, but change the fourth number. The subnet for both computers should be the same. With an ad-hoc network, you need to wait 2 minutes for the NUC to default to the alternative configuration and then search and join with the client computer.

Wired Network
WiFi connections are convenient but not always necessary. It is also possible to connect the NUC and the PC with an Ethernet cable. Normally one needs a crossover variety between PCs. The MacBook auto-detects the connections and can works with an ordinary patch cable. (It sometimes fails on the first connection attempt, but connects on the second.) The cable connection is faster, most notably during image updates on screen, and is less susceptible to interference from other users. To connect to the NUC one needs to set the IP address (fig.6). This is found in the LAN hardware IPv4 properties and this address is also entered as the PC name in a MRD profile, along with the customary NUC user name and password (fig.7).

fig.7 On the client computer, remote access requires three
 pieces of data: the IP address in the PC name box, your
 remote computer's user name and its password.

Ethernet Through Mains
If your NUC is in a protected environment and has a local mains supply, a third variation is to use a pair of powerline adaptors, which transmit a high frequency data carrier over the domestic mains circuit. With these, place one next to the NUC and the other close to either

*fig.8 A typical Ethernet over mains (powerline) adaptor is an alternative to a hard-wired
Ethernet connection, provided you have a safe mains installation at the observatory.
Once paired, it allows direct access to a connected computer or if configured through
a router, to any Windows, iOS, Android or Mac device on your home network.
This one has a modest speed of 200 Mbps but others go up to 1,200 Mbps
and use live, neutral and earth connections for more robust transmissions.
I seal mine in an IP65 enclosure within the observatory, kept company
by a small bag of desiccant. In practice, I connect the LAN system before
powering-up the PC, to ensure it assumes the right LAN configuration.*

your broadband router or the host PC. Set the router to a static IP address for the NUC's MAC address and use this in the MRD profile for both remote and Internet connection. Alternatively, add an alternative static IP address in the NUC's Ethernet adaptor IPv4 properties, for direct cable connection to a host PC. These devices operate at a range of speeds, up to 1,200 Mbps and avoid the need to thread another cable from the observatory to Houston Control. There are a range of models, with the more advanced versions using the earth wire as well as live and neutral, to improve range and robustness. Some offer multiple ports too, for additional accessories. In practice, for these to configure themselves correctly, I found I needed to connect these up fully to both computer systems before switching the NUC on. In practice, my wired connection over 550 Mbps powerline adaptors is considerably more responsive than the WiFi. This is particularly useful if you wish to extend the remote desktop over two displays and became possible with the introduction of Windows 10. It is the principal reason I use Windows 10 over Windows 7 (fig.10).

In Operation

Depending on whether I am at home or at a dark site, I have two startup shortcuts on the NUC, like the one described above, one for the home network and another for the ad-hoc. The home network automatically configures itself on power-up to the available WiFi or LAN network for wireless and cable operation. I keep one on my desktop and the other in the Startup folder; switching them over before a change of venue. With the alternative static address, I am able to connect to the NUC after a 2-minute wait. To connect, the IPv4 address is entered into a MRD profile as the PC Name along with the NUC's Windows user name and password, as before.

On my iPad, MacBook or iMac, I have several MRD connection profiles, two for home and another for away. When I power the NUC down, or restart it, after hitting the command shortcut on the desktop, I close the MRD connection before the NUC powers down. That leaves things in a state that makes a subsequent re-connection

more reliable. I have also noticed that MRD works more reliably, after making changes to the connection settings, if the application is closed down and opened again.

To ensure the NUC runs fast and lean I change the desktop theme to a classic one, without power hungry animations or background virus checking (though Windows Defender checks any installable files). Automatic updates are disabled and the computer is only connected to the World Wide Web through a hardware firewall. Browsing is restricted to safe websites for drivers or on secure forums. In the advanced power settings, to prevent Turbo Boost that doubles the processor clock speed and power consumption, I set the maximum processor power state to 80% and apply aggressive power savings throughout the advanced power settings (but disable shutdown / sleep / hibernate modes). The important exception to the rule is to maintain uninterrupted USB and network communications. To ensure this, disable the USB power saver options both in the advanced power settings and in the device driver properties accessed via the hardware manager.

*fig.9 During the setup phase (including the installation of the
operating system, drivers and applications) it is useful to
connect the NUC to a monitor, mouse and keyboard as a
normal computer and check it runs the hardware correctly
for a few weeks. In this case, it is communicating over a
USB over CAT 5 interface system to the mount's USB hub.*

(These recommendations are not only applicable to remote operation but to any PC connected to astro-hardware.)

Lastly, although this NUC has a 128-GB solid state drive (SSD), I store the exposures to an external drive for convenience. At first, since the NUC had four USB 3.0 ports, I used a high-speed USB 3.0 memory stick. Unfortunately this particular model would not permit the NUC to power down while it was inserted. There are some peculiarities around USB 3.0 operation and eventually, I installed a 128 SSD drive into a USB 3.0 caddy as an image repository. If you format the drive as FAT32 rather than NTFS it is readily accessed by any computer without the need of special utilities. (In the past I have tried NTFS to HFS+ file system-interchange utilities, but after several corrupted files and poor support from the supplier, I made the decision to avoid the reliability issues entirely, rather than take a chance with valuable data.)

Moore's Law (After Gordon Moore)

The opening picture shows the initial deployment of the NUC in a portable setup, sitting on the tripod's accessory tray under the mount. It is now sited within the observatory, nestling against the drive caddy and a bag of rice, to keep things arid. Observatories are great but it is a chore to dismount equipment off a pier and lose precious alignment and modelling data just for an occasional field visit. A second highly-portable imaging system is the logical solution (described in its own chapter). The NUC is ideal; its small footprint has 4 USB ports, a 12-volt DC power feed and additional connections. Ideal that is, until you see the next development: Stick computing. These PCs are just 38 x 12 x 120 mm and make the NUC look obese. As Will Smith declared in *Independence Day,* "I have got

to get me one of these!" The Intel versions come in a few configurations: I use a Core M3 version, which has 64 GB SSD, 4 GB memory, USB 3.0, WiFi and Bluetooth built in (fig.11). It has a separate 5-volt, 3-amp DC power supply, fed via a USB-C cable. This is the same cable used by the latest Apple Macbooks. I do not use AC power in the open for safety reasons so I use a high quality 3-amp 12–5 volt DC–DC converter module via a power cable adaptor with a DC plug on one end and a USB-C adaptor on the other. The smaller form factor of the PC also means that it runs warmer than the NUC and this model has active cooling. A full installation of Windows 10 Pro, with all the image acquisition and control software occupies 20 GB. That assumes a compact planetarium such as C2A. (This figure increases rapidly if The Sky X is installed with its All-Sky catalog or large astrometric catalogs, such as USNO A-2 or the larger UCAC catalogs.) A micro-SD card slot boosts the storage potential by another 128 GB, ideal for storing images and documents. Moore's law certainly seems to be alive and kicking.

The forums are a wonderful source of information and while discussing the feasibility of using a PC stick for astrophotography, I was made aware of an alternative to using an ad-hoc network for direct WiFi connection. This uses a wireless access point (AP), rather than an ad-hoc protocol. Access points, unlike ad-hoc networks operate at the full adaptor speed. There are ways of doing this manually but it is convenient to use a utility like Connectify. In a few mouse clicks, it modifies the existing WiFi connection into two, one for the Internet and the other for remote access, with or without Internet sharing. Either connection can be used for remote control; in both cases, one uses the IP address of the

fig.10 Just to give an idea of how useful a two-screen remote operation can be, this screen grab is of a Macbook pro connected to an external monitor (two-screen requires Windows 10). From the left is Sequence Generator Pro, my observatory app, AAG CloudWatcher and PHD2 on the 20-inch monitor and TheSkyX planetarium and telescope control occupies the laptop screen on the right. If you operate this over WiFi, the screen update may be too slow. A LAN solution, as described in the text, is quicker.

IPV4 connection for the PC Name in Remote Desktop (shown in the WiFi properties tab) and in the case of the access point (also known as a hot-spot when it allows Internet sharing), note the SSID name and security password. On the host computer connect its WiFi to this SSID and then in MRD, select the configuration for the access point IP address and connect with the remote computer's login and password. It works, but the effective data rate is much slower than with other configurations.

In practice, connected via my home router, the stick worked very well and with an un-powered 4-way USB hub, drove a USB to serial converter, Lodestar X2, focus module and QHY PoleMaster. In AP mode, however, the WiFi range of the stick is limited and a faster and more reliable alternative is to use a small USB-powered WiFi router. My one operates at 300Mbps and is just 2.5 inches square (fig.12). These can be set up to work as an access point, router or extender and in practice works reliably over 30 m (100 feet). I prefer to use it configured as an access point, connected via its Ethernet port using a USB to Ethernet adaptor. I use the stick's own WiFi connection for Internet use and connect to the TP-Link with my computer or iPad, running MRD.

fig.11 A Core M3 Intel computing stick. The HDMI connector on the end gives a sense of scale. It has one USB-3.0 connector, supplemented by another two on its power supply (connected via a USB-C cable).

Really Remote Operation

Folks are increasingly setting up remote rural observatories and operating them over the Internet. The configuration here is also the basis for such a system. In practice it needs a few more settings to allow remote Internet access. There are two principal methods: to use a VPN (virtual private network) or allow direct communication through the router's firewall. The VPN route is arguably more secure and in effect, both computers log into an Internet server and talk to one another. An Internet search identifies a range of paid and free VPN services. The other method configures your firewall to allow a direct connection. Using the setup utility for your Internet router, add the IPv4 address to Port 3389 in your router. At the same time make sure you are using a strong password for your astro PC with plenty of strange characters, capitals and alphanumerics. Remote access uses the IP of your broadband router. Since a default router configuration dynamically assigns an address upon each power-up, one either has to set up a static address, or leave the unit powered and check its address by typing in "whatismyip.com" in a browser window. If in doubt, the Internet is a wonderful resource for the latest detailed instructions on how to change network settings.

fig.12 The diminutive TP-Link TL-WR802N USB-powered WiFi AP/router/ bridge/repeater can be either located at the mount or by the host computer. You can connect to the PC via a USB/Ethernet adaptor and use the PC WiFi to connect to the Internet. Windows will default to using Ethernet for Internet access unless you disable the Automatic metric for both adaptor's advanced IPv4 properties and assign a lower number to the WiFi adaptor than to the Ethernet adaptor.

Other Remote Controls

In addition to remote computer operation, you may require further remote controls; for instance to provide facilities for resetting USB and power to individual devices. It is a fast moving area and Ethernet controlled power devices are starting to hit the market. There is an ASCOM switch device interface definition and a driver for power control using Digital Loggers Inc. Web Power Switch. These are currently designed with U.S. domestic power sockets but I am sure European versions will follow soon. (Simple relay board systems already exist but have exposed live terminals that require safe handling and housing.)

Switching USB connections will not be too far behind. A simple relay or switch may not suffice since, whilst it is okay for switching AC and DC power, USB 2.0 is a high-speed interface and all connections and circuits need to have the correct inductive and capacitive characteristics (impedance). If they do not, the signal is degraded and may become unreliable. For those with an electronics background another way is to configure a web-linked Arduino-based module to reset USB power and data signals. The alternative is to call an understanding neighbor or spouse! In the last year the first commercial Arduino-based observatory controllers have hit the market, dedicated to managing power, USB connections, focuser and dew heater control and are worth looking out for.

Image Capture

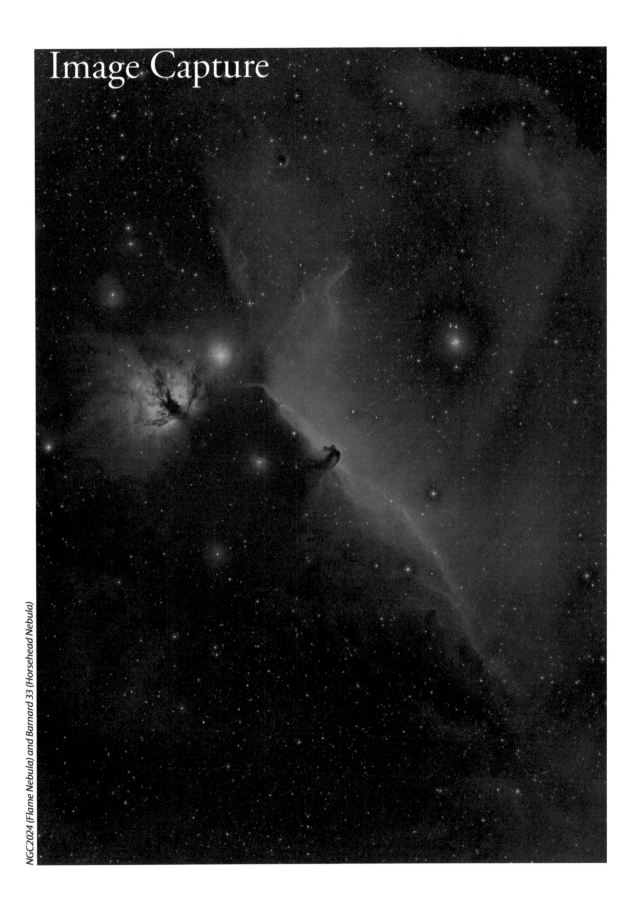

NGC2024 (Flame Nebula) and Barnard 33 (Horsehead Nebula)

Sensors and Exposure

*Understanding how sensors work and their real-world limitations
are key to achieving high-quality images.*

Sensors, exposure, and calibration are inextricably linked. It is impossible to explain one of these without referencing the others. Electronic sensors are the enabler for modern astrophotography and without them it would be a very different hobby. Putting the fancy optics and mounts to one side for a moment, it is a full understanding of the sensor and how it works (or not) that shapes every imaging session. We know that astrophotographers take many exposures but two key questions remain, how many and for how long? Unlike conventional photography, the answer is not a simple meter reading. Each individual session has a unique combination of conditions, object, optics, sensor and filtering and each requires a unique exposure plan. A list of instructions without any explanation is not that useful. It is more valuable to discuss exposure, however, after we understand how sensors work, the nature of light and how to make up for our system's deficiencies. Some of that involves the process of calibration, which we will touch upon here but also has its own chapter later on. The discussion will get a little technical but it is essential for a better understanding of what we are doing and why.

Sensor Noise

Both CMOS and CCD sensors convert photons into an electrical charge on the individual photosites and then use complicated electronics to convert the accumulated electrical charge into a digital value that can be read by a computer. Each part of the process is imperfect and each imperfection affects our image quality. The conversion process and some of these imperfections are shown in fig.1. Looking at this, it is a wonder that sensors work at all. With care, however, we can control these imperfections to acceptable levels. Working systematically from input to output, we have incident light in the form of light pollution and the light from a distant object passing through the telescope optics. The light fall-off from the optics and the

dust on optical surfaces will shade some pixels more than others. The photons that strike the sensor are converted and accumulated as electrons at each photosite. It is not a 1:1 conversion; it is dependent upon the absorption of the photons and their ability to generate free electrons. (The conversion rate is referred to as the Quantum Efficiency.) During the exposure, electrons are also being randomly generated thermally; double the time, double the effect. Since this occurs without light, astronomers call it dark current. These electrons are accumulated along with those triggered by the incident photons. The average dark current is also dependent on the sensor temperature and approximately doubles for each 7°C rise. (By the way, you will often see electrons and charge discussed interchangeably in texts. There is no mystery here; an electron has a tiny mass of 9×10^{-31} kg and is mostly charge (1.6×10^{-19} coulombs).

When the overall charge is read by an amplifier, there is no way to tell whether the charge is due to dark current, light pollution or the light from a star. The story is not over; each pixel amplifier may have a slightly different gain and it will also introduce a little noise. For simplicity we have gathered all the noise mechanisms within the electronic circuits and given them the label "read noise". Finally the amplifier's output voltage is converted into a digital value that can be read by a computer. (The gain of the system

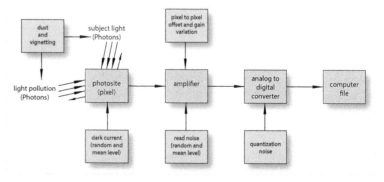

*fig.1 This simplified schematic shows the principal signals and sources of error in
a sensor and its associated electronics at the pixel level. Understanding how
to minimize their effects is key to successful astrophotography. A deliberate
omission in this diagram is the effect of the random nature of photons striking
the pixel. This gives rise to shot noise and is discussed at length in the main text.*

is calculated from the number of electrons required to increase the digital count by one.) The process that converts the voltage to a digital value has to round up or down to the nearest integer. This small error in the conversion is called quantization noise, which can become noticeable in low signal areas. As luck would have it, the techniques we use to generally minimize noise also improve quantization noise too. Quantization noise becomes evident when a faint image signal undergoes extreme image stretching to increase its contrast.

Light and Shot Noise

Over many years, scientists argued that light was a wave or a particle. Einstein's great insight was to realize it was both. In our context, it is helpful to think of light as a stream of particles. The more particles, or photons, per second, the brighter the light. We see light as a continuous entity but in fact, the photons that strike our eyes or a sensor are like raindrops on the ground. Whether it is raining soft or hard, the raindrops land at random intervals and it is impossible to predict precisely when the next raindrop will fall, or where. All we can reliably determine is the average rate. It also applies equally to light, either arising from light pollution or from the target star. Any exposure of a uniformly lit subject, with a perfect sensor that introduces no noise of its own, will have a range of different pixel values, distributed around a mean level. This unavoidable randomness has no obvious work-around. The randomness in the pixel values is given the term shot noise. If you pause to think about it, this is quite a blow; even a perfect sensor will still give you a noisy image! Shot noise is not only restricted to incident light, it also applies to several noise mechanisms in the sensor and sensor electronics, mostly generated by thermal events.

Signals, Noise and Calibration

So what is noise? At its simplest level, noise is the unwanted information that we receive in addition to the important information, or signal. In astrophotography,

The random (shot) noise level is defined as a statistical range around the average signal value, in which 68% of the signal values occur. This value is defined as a Standard Deviation or 1 SD. All signals, whether they are from deep sky or general sky glow have a noise level (1 SD) that happens to be equal to the square root of the mean signal level. With this rule, we can easily calculate the signal to noise ratio for any signal level.

Mathematically speaking, if on average, photons strike a sensor at 100 per second, in one second:

$$SNR = \frac{100}{\sqrt{100}} = 10$$

In 100 seconds (or the average of ten 10-second exposures):

$$SNR = \frac{10000}{\sqrt{10000}} = 100$$

noise originates from several electronic sources and from light itself. For our purposes, the signals in astrophotography are the photons from the deep sky object that are turned into electrical charge in the sensor photosites. Practically, astrophotography concerns itself with all sources of signal error. These are broadly categorized into random and constant (or consistent) errors. So long as we can define the consistent errors in an image, they are easy to deal with. Random errors are more troublesome: Image processing inevitably involves extreme stretching of the image tones to reveal faint details. The process of stretching exaggerates the differences between neighboring pixel values and even a small amount of randomness in the original image appears objectionably blotchy after image processing. The random noise from separate light or thermal sources cannot be simply added, but their powers can. If a system has three distinct noise sources with signal levels, A, B and C, the overall noise is defined by:

$$total\ noise = \sqrt{A^2 + B^2 + C^2}$$

Dealing with unwanted errors involves just two processes, calibration and exposure. Calibration deals with consistent errors and exposure is the key to reduce random errors. For now, calibration is a process which measures the mean or consistent errors in a signal and removes their effect. These errors are corrected by subtracting an offset and adjusting the gain. Since no two pixels on a sensor are precisely the same, the process applies an offset and gain adjustment to each individual pixel. The gain adjustment not only corrects for tiny inconsistencies between the quantum efficiency and amplifier gain of individual pixels but usefully corrects for light fall-off at the corners of an image due to the optical system, as well as dark spots created by the shade of a dust particle on an optical surface. This takes care of quite a few of the inaccuracies called out in fig.1. Briefly, the calibration process starts by measuring your system and then during the processing stage, applies corrections to each individual exposure.

These calibrations are given the names of the exposure types that measure them; darks, reads and flats. Unfortunately, these very names give the impression that they remove all the problems associated with dark noise, read noise and non-uniform gain. They do not. So to repeat, calibration only removes the constant (or mean) errors in a system and does nothing to fix the random ones. Calibration leaves behind the random noise. To establish these calibration values we need to find the mean offset error and gain adjustment for each pixel and apply to each image.

Exposure and Random Error

Although random noise or shot noise is a fact of physics and cannot be eliminated, it is possible to reduce its effect on the signal. The key is locked within the statistics of random events. As photons hit an array of photosites their randomness, that is, the difference between the number of incident photons at each photosite and the average value, increases over time, as does the total number of impacts. Statistics come to the rescue at this point. Although the randomness increases with the number of impacts, the randomness increases at a slower rate than the total count. So, assuming a system with a perfect sensor, a long exposure will always have a better signal to noise ratio than a short one. Since the electrons can only accumulate on a sensor photosite during an exposure, the pixel values from adding two separate 10-second exposures together are equivalent to the value of a single 20-second exposure.

The practical outcome is that if an image with random noise is accumulated over a long time, either as a result of one long exposure, or the accumulation of many short exposures, the random noise level increases less than the general signal level and the all-important signal to noise ratio improves. If you stand back and think about it, this fits in with our general experience of normal daylight photography: Photographers do not worry about shot noise since the shot noise level is dwarfed by the stream of tens of millions of photons per second striking the camera sensor that require a fast shutter speed to prevent over-exposure.

There is an upper limit though, imposed by the ability of each photosite to store charge. Beyond this point, it is said to be saturated and there is no further signal increase with further exposure. The same is true of adding signals together mathematically using 16-bit (65,536 levels) file formats. Clearly, if sky pollution is dominating the sky and filling up the photosites, this leaves less room for image photons and so reduces the effective dynamic range of the sensor that can be put to good use on your deep sky image.

Exposure Bookends

The practical upshot of this revelation is to add multiple exposures that, individually, do not saturate important areas of the image. Stars often saturate with long exposures and if star color is of great importance, shorter exposures will be necessary to ensure they do not become white blobs. The combining of the images (stacking) is done by the image processing software using 32-bit arithmetic, which allows for 65,536 exposures to be added without issue. At the same time, each doubling of the exposure count adds a further bit of dynamic range, due to the averaging effect on the signal noise and equally reduces the quantization noise in the final image. If the exposures are taken through separate filters (e.g. LRGB) the image processing software (after calibrating the images and aligning them) combines the separate images to produce four stacks, one for each filter. This is done on a pixel by pixel basis. The combined exposure has a similar quantization noise level as a single exposure but when the averaging process divides the signal level to that of a single exposure, the quantization level is reduced. In general, the random noise improvement is determined by the following equation:

$$factor = \sqrt{N \; (number \; of \; averaged \; samples)}$$

So, the long exposure bookend is set to an individual exposure time that does not quite saturate the important parts of the image, for example, the core of a galaxy.

The other bookend has yet to be determined; how low can we go? Surely we can take hundreds of short exposures and add (or average) them together. The answer is yes and no. With a perfect sensor, you could do just that. Even a real sensor with only shot noise would be game. So how do we determine the minimum exposure? Well, in any given time, we have a choice of duration and number of exposures. The key question is, what happens if we take many short exposures rather than a few long ones? For one thing, with multiple exposures it is not a crisis if a few are thrown away for any number of singular events (guiding issue, cosmic-ray strike, satellite or aircraft trail etc.). To answer this question more precisely we need to understand read noise in more detail.

Read Noise and Minimum Exposure

The catchall "read noise" within a sensor does not behave like shot noise. Its degree of randomness is mostly independent of time or temperature and it sets a noise floor on every exposure. Read noise is a key parameter of sensor performance and it is present in every exposure, however brief. Again it is made up of a mean and random

value. The mean value is deliberately introduced by the amplifier bias current and is removed by the calibration process. The random element, since it is not dependent on time (unlike shot noise) is more obvious on very short exposures. Read noise is going to be part of the decision making process for determining the short exposure bookend. To see how, we need to define the overall pixel noise of an image. In simple terms the overall signal to noise ratio is defined by the following equation, where t is seconds, R is the read noise in electrons, N the number of exposures and the sky and object flux are expressed in electrons/second.

This equation is a simplification that assumes the

$$SNR = \sqrt{N} \cdot \frac{object\ flux \cdot t}{\sqrt{sky\ flux \cdot t + R^2}}$$

general sky signal is stronger than the object signal and calibration has removed the mean dark current. This equation can be rearranged and simplified further. Assuming that the read noise adds a further $q\%$ to the overall noise, it is possible to calculate an optimum exposure t_{opt}, that sets a quality ratio of shot noise from the sky exposure to the read noise for a single pixel:

$$t_{opt} = \frac{R^2}{\left((1+q)^2 - 1\right) \cdot sky\ flux}$$

Empirically, several leading astrophotographers have determined q to be 5%. The sky flux in e / second can be calculated by subtracting an average dark frame image value (ADU) from the sky exposure (ADU measured in a blank bit of sky) using exposures of the same duration and temperature. The gain is published for most sensors as electrons/ADU:

$$sky\ flux = \frac{(background\ value - darkframe\ value) \cdot gain}{time\ (secs)}$$

Interestingly, a 5% increase in overall noise mathematically corresponds to the sky noise being 3x larger than the read noise. A 2% increase would require sky noise 5x larger than the read noise, due to the way we combine noise. At first glance, the math does not look right, but recall that we cannot simply add random noise. For instance, using our earlier equation for combining noise sources, if read noise = 1 and sky noise is 3x larger at 3, the overall noise is:

$$total\ noise = \sqrt{1^2 + 3^2} = 3.1623 \approx 3.0 + 5\%$$

The above equation suggests the total noise is just made up of sky noise and read noise. This simplification may work in highly light-polluted areas but for more rural locations they are more evenly balanced. If we account for the shot noise from the subject, a minimum exposure is estimated by halving the optimum exposure t_{opt} for the sky noise alone; assuming our prior 5% contribution assumption and the following simplified formula:

$$t_{min}(sec) = \frac{5 \cdot R^2}{sky\ flux\ (electrons\ /\ sec)}$$

The exposure t_{min} marks the lower exposure bookend and something similar is assumed by some image acquisition programs that suggest exposure times. The recipe for success then is to increase the exposure or number of exposures, to reduce the effect of random noise on the signal. It is important to note that all these equations are based on single pixels. Clearly, if the pixels are small, less signal falls onto them individually and read noise is more evident. It might also be evident that the calibration process, which identifies the constant errors, also requires the average of many exposures to converge on a mean value for dark noise, read noise and pixel gain.

Between the Bookends

In summary, each exposure should be long enough so that the read noise does not dominate the shot noise from the incident light but short enough so that the important parts of the image do not saturate. (Just to make life difficult, for some subjects, the maximum exposure prior to clipping can be less than the noise-limited exposure.) At the same time we know that combining more exposures reduces the overall noise level. So, the key question is, how do we best use our available imaging time? Lots of short exposures or just a few long ones? To answer that question, let us look at a real example:

Using real data from a single exposure of the Bubble Nebula fig.2, fig.3 shows the predicted effective pixel signal to noise ratio of the combined exposures over a 4-hour period. It assumes that it takes about 16 seconds to download, change the filter and for the guider to settle between individual exposures. At one extreme, many short exposures are penalized by the changeover time and the relative contribution of the read noise. (With no read noise, the two summed 5-minute exposures have the same noise as one 10-minute exposure.) As the exposures lengthen, the signal to noise ratio rapidly improves but quite abruptly reaches a point where longer exposures have no meaningful benefit. At the same time with a long exposure scheme, a few ruined frames

have a big impact on image quality. In this example, the optimum position is around the "knee" of the curve and is about 6–8 minutes.

The sensor used in fig.2 and fig.3 is the Sony ICX694. It has a gain of 0.32 electrons/ADU and a read noise of 6 electrons. The blank sky measures +562 units over a 300-second exposure (0.6 electrons /second). It happened to be a good guess, assuming 5% in the t_{min} formula above. It suggests the minimum sub exposure time to be 300 seconds, the same as my normal test exposure. If I measure some of the faint nebulosity around the bubble, it has a value of +1,092 units. Using the equation for t_{opt} and using the overall light signal level, t_{opt} =302 seconds. The graph indication bears out the empirical 5% rule and the equations are directionally correct. In this particular case it illustrates a certain degree of beginner's luck as I sampled just the right level of faint nebulosity.

So, the theoretical answer to the question is choose the Goldilocks option; not too long, not too short, but just right.

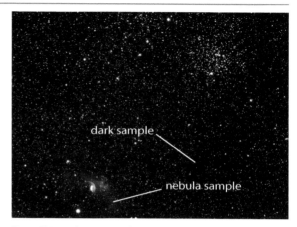

fig.2 This single 300-second exposure around the Bubble Nebula has areas of dim nebulosity and patches in which the sky pollution can be sampled. To obtain the signal generated by the light, I subtracted the average signal level of a 300-second dark frame from the sample.

Practical Considerations

Theory is all well and good but sometimes reality forces us to compromise. I can think of three common scenarios:

1) For an image of a star field, the prime consideration is to keep good star color. As it is a star field, the subsequent processing will only require a gentle boost for the paler stars and noise should not be a problem on the bright points of light. The exposure should be set so that all but the brightest stars are not clipping but have a peak value on the right hand side of the image histogram between 30,000 and 60,000. This will likely require exposures that are less than the minimum exposure t_{min}. Since the objects (the stars) are bright, it may not require as many exposures as say a dim nebula. An image of a globular cluster requires many short exposures to ensure the brightest stars do not bloat but the faint stars can be resolved.

2) For a dim galaxy and nebula, in which bright stars are almost certainly rendered as white dots, the important part of the image are the faint details. In this case the

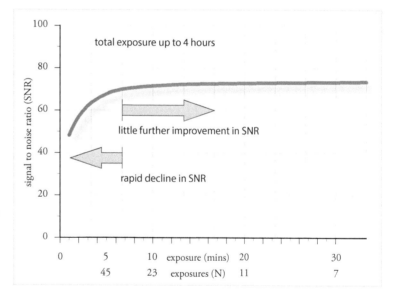

fig.3 This graph uses the sampled values from fig.2 to calculate the total pixel SNR for a number of exposure options up to but not exceeding 4 hours. It accounts for the sensor's read noise and the delay between exposures (download, dither and guider settle). It is clear that many short exposures degrade the overall SNR but in this case, after about 6 minutes duration, there is no clear benefit from longer exposures and may actually cause highlight clipping.

exposure should be set to somewhere between t_{min} and t_{opt}. This image will require a significant boost to show the fine detail and it is important to combine as many exposures as possible to improve the noise in the faint details.

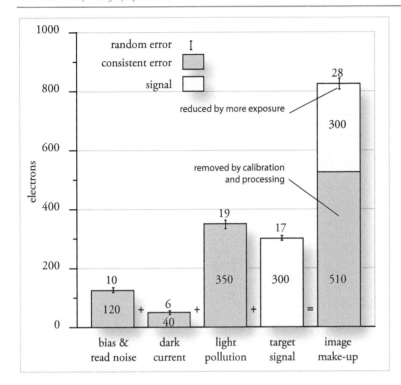

fig.4 Showing how the various signals and noise combine in a pixel is quite a hard concept to get across in a graph. The salmon-colored blocks are unwanted signals, either as a result of light pollution or sensor errors. They can be averaged over many exposures and effectively subtracted from the final image during the calibration process. The short bars represent the variation in the levels caused by random noise. Random noise can never be eliminated but, by increasing the exposure or number of combined exposures, its value in relation to the main signal can be reduced. It is important to realize that every pixel will have a slightly different value of signal, mean noise and noise level.

3) In some cases it is important to show faint details and yet retain star color too. There are two principal options named after card games; cheat and patience. To cheat, the image is combined from two separate exposure schemes, one optimized for bright stars and the other for the faint details. The alternative is to simply have the patience to image over a longer period of time with short exposures.

Location, Exposure and Filters

While we were concentrating on read noise, we should not forget that the shot noise from the sky pollution is ruining our images. In 2) and 3) above, sky pollution and the associated shot noise take a considerable toll. Not only does it rob the dynamic range of the sensor, forcing us to use shorter exposures, but it also affects the accuracy of our exposure assessment. The t_{min} equation assumes sky pollution is at about the same intensity as faint object details (and the shot noise is similar). In many cases light pollution can exceed the all important object intensity.

If they are about equal, the noise will always be about 41% worse than the subject shot noise alone. If sky pollution is double the subject intensity, it impacts by a massive 123% increase. You would need to have 5x more exposure to get to the same level of noise as one without light pollution. No matter how many exposures you take, the noise performance is always going to be compromised

by the overwhelming shot noise from sky pollution. The only answer is to find a better location or to use filtration.

You often come across city-bound astrophotographers specializing in wide-field narrowband imaging. There is a good reason for this. They typically use a short scope, operating at f/5 or better with narrowband filters optimized for a nebula's ionized gas emission wavelengths (Hα, SII, OIII and so on). These filters have an extremely narrow pass-band, less than 10 nm and effectively block the sodium and mercury vapor light-pollution wavelengths. Read and thermal noise dominates these images. Long exposures are normal practice and a fast aperture helps to keep the exposure time as short as possible. In addition to narrowband filters and with a growing awareness of sky shot noise, there is an increasing use of light-pollution filters in monochrome as well as one-shot color imaging.

The effectiveness of light pollution filters vary with design, the subject and the degree of light pollution. Increasingly, with the move to high-pressure sodium and LED lighting, light pollution is spreading across a wider bandwidth, which makes it more difficult to eliminate through filtration. The familiar low-pressure sodium lamp is virtually monochromatic and outputs 90% of its energy at 590 nm. Most light pollution filters are very effective at blocking this wavelength. High-pressure sodium lamps have output peaks at 557, 590 and 623 nm

with a broad output spectrum that spreads beyond 700 nm. Mercury vapor lamps add two more distinct blue and green wavelengths at 425 and 543 nm and make things more difficult to filter out. It is possible though, for instance, the IDAS P2 filter blocks these wavelengths and more. They are not perfect however. Most transmit the essential OIII and Ha wavelengths but some designs attenuate SII or block significant swathes of spectrum that affect galaxy and star intensity at the same time. In my semi-rural location, I increasingly use a light pollution filter in lieu of a plain luminance filter when imaging nebula, or when using a consumer color digital camera.

Object SNR and Binning

At first, object SNR is quite a contrary subject to comprehend. This chapter has concentrated firmly on optimizing pixel SNR. In doing so, it tries to increase the signal level to the point of clipping and minimize the signal from light pollution and its associated shot noise. The unavoidable signal shot noise and read noise is reduced by averaging multiple exposures. Long exposure times also accumulate dark current and its associated shot-noise. To shorten the exposure time it helps to capture more light. The only way to do that is to increase the size of the aperture diameter. Changing the f/ratio but not the aperture diameter does not capture more light. In other words, the object SNR is the same for a 100 mm f/4 or a 100 mm f/8 telescope. If we put the same sensor on the back of these two telescopes, they will have different pixel SNR but the same overall object SNR, defined only by the stream of photons through the aperture for the exposure time.

Similarly, when we look at the pixel level, we should be mindful that a sensor's noise characteristics should take its pixel size into account. When comparing sensors, read noise, well depth and dark noise are more meaningful if normalized per square micron or millimeter. If two sensors have the same read noise, dark noise and well depth values, but one has pixels that are twice as big (four times the area) as the other, the sensor with the smaller pixels has:

- 4x the effective well capacity for a given area
- 4x the effective dark current for a given area
- 2x the effective read noise for a given area

Since the total signal is the same for a given area, although the well capacity has increased, the smaller pixels have higher levels of sensor noise. In this case bigger pixels improve image quality. If we do not need the spatial resolution that our megapixel CCD offers, is there a way to "create" bigger pixels and reduce the effect of sensor noise? A common proposal is binning.

Binning and Pixel SNR

Binning is a loose term used to describe combining several adjacent pixels together and averaging their values. It usually implies combining a small group of pixels, 2x2 or 3x3 pixels wide. It can occur within a CCD sensor or applied after the image has been captured. So far we have only briefly discussed binning in relation to achieving the optimum resolution for the optics or the lower resolution demands of the color channels in a LRGB sequence. As far as the sensor noise and exposure performance is concerned, it is a little more complex. If we assume 2x2 binning, in the case of the computer software summing the four pixels together, each of the pixels has signal and noise and the familiar \sqrt{N} equation applies. That is, the SNR is improved by $\sqrt{4}$, or 2.

When binning is applied within the sensor, the charge within the four pixels is accumulated in the sensor's serial register before being read by the amplifier. It is the amplifier that principally adds the read noise and is only applied once. The pixel signal to read noise ratio improves by a factor of 4. It is easy to be carried away by this apparent improvement and we must keep in mind that this improvement relates to sensor noise and not to image noise. Image noise arising from the shot noise from the object and background sky flux will still be at the same level relative to one another, irrespective of the pixel size. (Although the binned exposure quadruples the pixel signal and only doubles the noise, there is a reduction in spatial resolution that reduces the image SNR.)

One of the often cited advantages of binning is its ability to reduce the exposure time. If the signal is strong and almost fills the well capacity of a single pixel, then binning may create issues, since the accumulated charge may exceed the capacity of the serial register. Some high performance CCDs have a serial register with a full well capacity twice that of the individual photosites and many use a lower gain during binned capture. (The QSI683 CCD typically uses a high gain of 0.5 e-/ADU in 1x1 binning mode and lowers it to 1.1 e-/ADU in binned capture modes.)

Significantly, in the case of a CMOS sensor, the read noise is associated with each pixel photodiode and there is no advantage to binning within the sensor. A number of pixels can be combined in the computer, however, with a \sqrt{N} advantage though. You cannot bin a bayer image either.

In the case of a strong signal, imaging clipping is avoided by reducing the exposure time but at the same time this reduces the signal level with respect to the sensor noise, potentially back to square one. Binning is, however, a useful technique to improve the quality of weak signals, not only for color exposures but also when used for expediency during framing, focusing and plate solving.

Focusing

The difference between an excellent and an "OK" focus position may only be ten microns. The effect on the image is often far greater.

In earlier chapters the importance of accurate focusing was discussed at some length, as well as the need for good mechanical robustness in the focus mechanism. Here, we will look at the various focusing aids and their reliability, along with a few considerations that may catch you out during an imaging session. It assumes that any conventional astrophotography optic is fitted with a motorized focuser (preferably computer controlled) and that conventional shorter focal-length photographic optics are focused by hand.

Required Focusing Accuracy

If you can think of the cone of light from the aperture of your telescope to the sensor, it is perhaps easier to imagine how, if the focus position is wrong, it does not see the tip of the cone but a circular patch. A long thin cone is less sensitive to focusing position than a short fat one, corresponding to a small and large focal ratio. The large aperture SCT telescopes with f/3.3 focal reducers are notoriously difficult to focus, not only in the middle but also at the edges of the image. The demands of astrophotography require something better than "focusing by eye". For all those cameras that have automatic control and the facility to capture images through a USB interface, it is possible to use a HFD (half flux diameter), FWHM (full width, half max) or HFR (half flux radius) readout. These feature in most image capture programs to optimize the focusing position, moving the focuser automatically using a utility such as FocusMax, manually through the computer or with the focuser's hand control.

In the example used for the illustrations, the sensitivity of the focus position is apparent in the slope of the V-curves in figs.1 and 2. The slope is measured in pixels per focus step. In this example a pixel subtends 1.84 arc seconds and a focus step is 4 μm. A 0.5 mm focus shift increases the HFD to a whopping 7.5 pixels or 13.8 arc seconds.

Focus and Forget?

There are a number of considerations that prevent a simple one-time only focus being sufficient for an imaging night: Those using monochrome CCD cameras with RGB filters may require a slightly different focus position for each of the filters as even a well color-corrected telescope may have a slightly different focal length for different wavelengths. The focusing will be close, but the size of stars in each of the images will be slightly different. When they are combined later, the overlapping different diameters cause a color halo that is hard to remove. Another consideration is the optical thickness of the filter glass; are they all the same? Glass has an optical thickness that is approximately 1.5x its physical thickness. My light pollution filter has a physical thickness of 2.5 mm, but my LRGB filters are only 2 mm. That

fig.1 This is the focus control panel from Maxim DL 5, showing a completed focus cycle and V-curve. Note the control panel has backlash compensation facilities.

fig.2 As fig.1 but this time using a freeware version of FocusMax. The slope figures are stored and used subsequently to speed up autofocus the next time around.

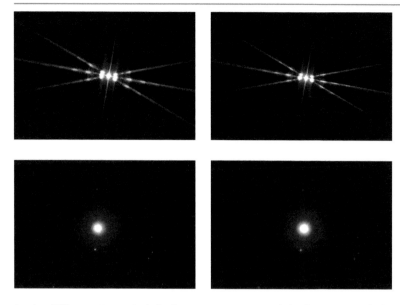

fig.3 These images were taken with a
Fuji X-Pro 1, through a 618 mm
f/6.3 refractor at slightly different
focus positions, with and without
a Bahtinov mask. Using the 10x
preview feature of the camera and
the mask, it was surprisingly easy
to distinguish between the focus
position on the left and a slight
focus shift on the right, by judging
when the middle diffraction spike
bisected the cross. The difference
was more obvious on the LCD
screen than in this reproduction.
The actual focus position moved
by 50 steps or 0.2 mm between
shots. That is similar to one step
in the focus curve in fig.1.

is, the difference in optical thickness is 0.25 mm and the focus point shifts when the filters are swapped over. If a filter wheel is used, their driver or ASCOM setup may have the facility to store focus offsets for each filter. This allows an image capture program to change the filter, read the focus offset and instruct the focuser to move by that amount (or the difference between their absolute settings).

In addition to focusing for individual colors, all cameras, including ones with color Bayer arrays, are affected by expansion and contraction of the telescope as its temperature changes. Fortunately, my own telescopes are kept in an ambient environment and the UK weather does not normally have large temperature swings between day and night. Other regions are not as temperate. Some telescope manufacturers reduce the problem by using carbon fiber in the telescope body; not only for weight reasons but also as it has a low rate of thermal expansion. Even so, during an imaging session it is good practice to confirm and alter the focus as required at intervals during the night in case the optics are affected. Some image capture programs facilitate this by triggering an autofocus if the ambient temperature changes by more than a set amount. (The ambient temperature is typically sensed by the focus control module.) Most programs, or the control boxes themselves, can actually learn the focus shift per degree and, once programmed, will sense and move the focus position automatically. This may not be such a good idea; if the focus travel produces a lateral shift in the image during the exposure, it will cause a smeared image. I use a technique that checks the temperature in-between exposures and autofocuses if it detects a change of more than 0.7°C.

It is useful to keep a record of the focus position for your different optical arrangements. This saves time during setting up and allows one to immediately optimize the focus, through manual or automatic means, and proceed swiftly to aligning the mount with the sky. It is useful to know the focus position is usually recorded in the image's FITS header (as is the ambient temperature, if it is monitored. This allows one to calculate the focus / temperature relationship for a particular optical configuration. At the same time, remember the auto guider focus. For an off-axis guider, once you have the main imaging camera focused, adjust your guide camera too

fig.4 The Bahtinov mask used to create
the diffraction spikes in fig.3.
These are normally inexpensive
laser-cut plastic, scaled to
the telescope's aperture.
The following website offers
instructions on how to create your
own. Any opaque material will do,
but it normally involves a sharp knife
at some point. Please cut safely and
take appropriate precautions and
use the right kind of cutting rule:
http://astrojargon.net/
MaskGenerator.aspx

fig.5 This screen shot from Nebulosity 3 shows the focus readout and star appearance from successive DSLR frames. It shows the star, its profile and readouts and graphs of intensity and HFR (half the HFD). In practice, you change the focus position to lower the HFR value as much as possible. If you change the focus by hand, wait until the vibrations settle down before evaluating the readout.

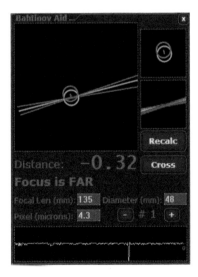

fig.6 This screen grab from APT shows the Bahtinov grabber in action. The readout uses the optical focal length and aperture to calculate the f/stop and with the imaging sensor pixel pitch, calculates a readout in pixels.

to its sweet spot by optimizing the guide star's FWHM or HFD readout in the capture program. As the main optic's focus position changes to accommodate temperature changes, the off-axis guider focus position will track automatically. In either off-axis or independent guider optics, a small amount of de-focus often helps with autoguiding centroid detection and it is normal practice, once the focus position for the guider system is established, to lock its position for future sessions.

Focusing Aids

Bahtinov Mask

I bought a Bahtinov mask (fig.4) for my refractor but never used it for some time; my image capture programs already had electronic readouts of star size and autofocus capability. It was only during the research for this book that I decided to evaluate it on my Fuji digital camera and assess its sensitivity and repeatability. To my surprise with the camera's magnified preview function I found it surprisingly accurate. (In the case of the Fuji, this is a manual focus aid that enlarges the image preview by 10x.) The Bahtinov mask produces diffraction spikes from a bright star that intersect when it is in focus. If the focus is slightly off, the central spike moves away from the center and the spacing between the three spikes becomes uneven. The difference between the two pictures in fig.3 is easily discernible on the back of the camera LCD display and were just 50 steps apart in focus position (0.2 mm). This step size is similar to those in fig.1, produced by the autofocus routine in Maxim DL. I repeated the test several times and, without peeking, was able to reproduce the focus position within ±10 steps, or ±0.04 mm. It helps if you choose a bright star, typically one of the guide stars, to make the diffraction spikes show up clearly on the LCD display. I have included the two images of the focus star too for comparison. It would have been impossible to focus the telescope as precisely without using the mask.

HFR / HFD Readout

The next step in sophistication is to use a camera that is capable of remote control and image download. Fig.5, screen grabbed from Nebulosity 3, shows a continuous readout of star intensity and the star HFR width. As the focus improves, the intensity increases and the width reduces. The graphs conveniently show how well you are doing. The focus position can be changed manually (allowing vibrations to die down each time) or electronically, until you achieve a minimum HFD value. This method works well with astronomical CCD cameras and digital SLRs with USB control, in this case a Canon EOS 1100D through its USB interface.

Computer Assisted Focusing Masks

As good as our eyes are, computers are much better at analyzing images and an enterprising amateur, Niels Noordhoek, developed a small application to analyze the image from a standard Bahtinov mask (such as the ones in fig.3) to measure the precise intersection error. It is affectionately referred to as the Bahtinov Grabber but the frequently referenced Internet link to this free utility no longer works. Sadly the inventor passed away and the original application with him, but the idea lives on; the Astro Photography Tool (APT) acquisition software includes a Bahtinov Grabber focusing utility to "read"

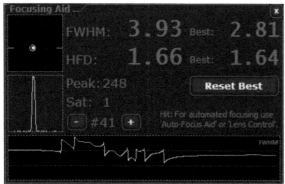

fig.7 *If the Bahtinov grabber struggles with wide-angle lenses, the more conventional FWHM readout (here in live mode), is a convenient way to find focus. The graph at the bottom shows the trend and in this case, the vibration caused by touching the camera lens too.*

fig.8 *These two focusing masks are from GoldFocus. On the left is their high-precision focus mask, that creates 5 intersecting diffraction lines. Its accuracy exceeds that of using a Bahtinov mask visually by some margin. On the right is their combination focus and collimation mask. It too can obtain high focus accuracies and at the same time gives diagnostic information on optical collimation.*

the image intersection error (fig.6). Here the position of the three diffraction lines are computed and plotted to determine the intersection offset. The offset changes with focus position and the aim is to achieve a zero value. In practice I found this technique less effective with wide-angle lenses (200 mm or less focal length) as their diffraction lines are less distinct. Fortunately APT offers a more traditional FWHM readout too (fig.7) which can make use of a DSLR's "liveview" feature, if present.

The standard Bahtinov mask has angled slits at 40° to each other and is designed for visual inspection. By changing the angle of the slits in the mask to make the diffraction lines more acute, it is possible to make the system more sensitive to focus errors. While this is very difficult to read by eye, a computer has no difficulty and several applications exist in the public domain and in some commercial products. One of those is the GoldFocus mask system. This variation uses 5 grating orientations to ensure a high sensitivity to tiny amounts of de-focus. These masks come with their own software (fig.9). There is a second version of the mask with 9 slit sections that generate 3-axis focusing information that effectively provides an indication of optical collimation (fig.8) and its use in this regard is covered extensively in a later chapter.

In practice, the acquisition software downloads a sequence of sub-frames to a folder, which is monitored by the GoldFocus application. After several downloads, the software starts to integrate the images (to reduce the effect of seeing) and form a stable evaluation of the de-focus amount (measured in pixels). It can be used in a trial and error mode but more usefully has a basic autofocus routine. The misalignment of the diffraction spikes and the focuser position has a linear relationship and the software

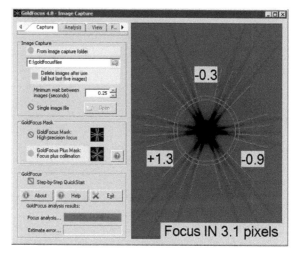

fig.9 *The GoldFocus software's specialized software does something similar to the Bahtinov Grabber with its unique masks. It too has a readout in fractions of a pixel to refine the focus position. Here it is using the combination mask to provide 3-axis collimation values and focusing information.*

compares the de-focus amount for several focus positions to calculate a steps / pixel factor for the particular optical system (fig.9). With this value, it is able to converge on a focus position with comparative ease in a few iterations. Like all focus mask tools, it requires the mask to be positioned over the optics during focusing and removed for imaging and as an autofocus tool, it requires further hardware to accomplish this automatically for unattended operation. It is very easy to establish the one-time precise relative focus position for each filter in steps. After calibration, one simply uses the pixel readout and multiplies by the steps/pixel calibration value (noting the direction).

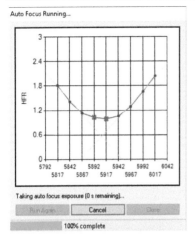

fig.10 The focusing routine in Sequence
 Generator Pro assumes that the
 image is already at approximate
 focus. It measures the half
 flux density around that point
 and optimizes the focus. It
 uniquely measures many stars'
 HFD in each exposure to gain
 a more reliable measure.

fig.11 Sequence Generator Pro uniquely focuses images using multiple HFD
 measurements from one image, improving speed and reliability. The autofocus
 settings dialog box has many options; not only for the number and spacing of
 autofocus measurements but also the triggers for autofocus, based on frame count,
 temperature, time or filter changes and after meridian flips. This powerful set of
 features allows quick and easy focus management without resorting to scripting.

Autofocus

The adjustment that minimizes a measured star width can be performed automatically. Maxim DL has autofocus capabilities that use the approximate focus position and then measure the HFD values for a series of evenly stepped focus positions on either side. It then calculates the optimum focus point. Fig.1 shows the focus program interface and a typical set of focus point results, termed the V-curve. The slopes of the "V" are defined by the focal ratio of the telescope and the focuser step size and essentially remain unchanged. This autofocus program repeats the same sequence each time and does not appear to learn from prior measurement. An alternative autofocus utility, FocusMax, which interfaces to Maxim DL and TheSkyX, benefits from characterizing the V-curve. After several measurements it creates an equipment profile. With this it can autofocus in much less time than the standard Maxim DL routine, by simply measuring the HFD at two different points and using the slope of the V to calculate the optimum focus position. Fig.2 shows a typical V-curve from FocusMax. In addition to this intelligence, FocusMax is able to select appropriate stars of the right magnitude that it knows will give reliable focusing and, after telescope calibration, slew away from the target to find a prominent star, autofocus and slew back. It also dynamically alters the autofocus exposure time depending on the star flux to

improve the accuracy of the measurement. For many years FocusMax was freeware but it is now a commercial product, available from CCDWare.

Automated Controls

Focusing is one of those things that require constant monitoring. In addition to manual intervention there are a number of options, depending on the image capture software. The major acquisition applications, Maxim DL, TheSkyX and Sequence Generator Pro, do have some automated features that enable temperature compensated focus tracking and focus shifts with filter changes. I'm not convinced by the repeatability of temperature effects and these open-loop focus changes, determined by prior evaluation, can repeat focus errors in the original analysis. Maxim DL and TheSkyX also have the capability of temporarily slewing to a medium brightness star to improve on the autofocus reliability. Both these powerful programs have the capability for external scripting and more sophisticated control, which can determine when to autofocus, based on a number of predetermined conditions. These external programs add an amazing amount of automation and remote control capability using another layer of software (and cost).

My focusing technique changed with experience and after switching acquisition software. Originally, I captured

image exposures (taken through an APO refractor) by cycling through the LRGB filters, in turn, without using focus offsets. I had read mixed reports on the reliability of temperature compensated focusing (arising from both optical and physical changes) and did not have focus shift data for a wide temperature range for all my configurations. To cap it all, since my imaging sessions were relatively short, focusing was almost a one-time event to avoid the occasional software hang-up after the autofocus routine changed the filter.

This rather cavalier approach completely changed when I switched my image capture software to Sequence Generator Pro. In addition to filter offset and temperature compensating options it has simple and effective autofocus triggers that guarantee accurate focus throughout an extended imaging session, without the need for additional external control applications. The reliability of my current system allows for unattended imaging and I now acquire the required number of exposures, one filter event at a time, which reduces the number of filter changes and autofocus events. With each optical configuration, I achieve approximate focus by moving to a pre-determined setting and then set up SGP to autofocus at the start of the sequence and when certain conditions are met:

1 at the beginning of the imaging sequence or resume
2 after a filter change (or with a prescribed offset)
3 after a temperature change of 0.7°C or more
4 after an elapsed time
5 after a meridian flip (optional for refractors but essential for reflector designs, on account of potential mirror movements)

Other options are available (as can be seen in fig.11), including time span and frame count, for example. SGP unusually does not determine the focus by examining the diameter of a single star but assesses many stars across the frame. This has an advantage of accommodating a best overall focus position in the presence of field curvature and also is less particular to star choice. The early versions were very effective with refractor systems but had difficulty reliably measuring the diameters of star donuts, commonly produced by de-focusing a centrally-obstructed optic. Since 2016, the focus algorithms have been re-designed and the autofocus is greatly improved and equally robust with centrally-obstructed optics, such as the increasing number of RCTs and SCTs.

Backlash Considerations

Mechanical backlash is a further issue to contend with during automated focusing and is a potential gotcha. It is fairly obvious that gear-based rack and pinion focuser mechanisms have mechanical play but when motorized, both they and Crayford-based autofocus systems are affected. The backlash arises in the gearbox mechanism that reduces the servo or stepper motor drive to the focuser pinion. Backlash values can be quite high too, several of mine have a value equivalent to the depth of focus. Without care and attention, it is easy to be caught out as unfortunately there is no unified way of dealing with it. Backlash only becomes a problem when a mechanism changes direction. In a focuser system the forces are not balanced as they are in the imaging system, about each mount axis. The camera system will always be at the bottom end of the assembly, trying to extend the focuser via gravity. In some cases this force may be sufficient to guarantee one-sided gear engagement, irrespective of the focuser drive direction. Happy days. In many cases, however, this is not the case and other means are required. Software and focusing technique are the solutions.

One way is to always reach the focuser position from one direction, with a movement that is larger than the backlash amount. Implementations vary. Some imaging applications, (Maxim DL, FocusMax, Sequence Generator Pro) have facilities to overcome backlash by deliberately overshooting and reversing when asked to move in a particular direction. That particular direction is normally outwards, so that the final inwards move is against gravity. It is not difficult to implement but strangely, TheSkyX does not have a backlash facility, nor does the GoldFocus autofocus application. These rely upon the focuser moving in one direction to reach the autofocus position and / or the focuser hardware providing a built in backlash compensation facility. Not all focuser modules have this capability and it is not provided for by ASCOM methods. Progressive HFD/FWHM measurements from one extreme to the other are not the issue; it is the final all-important move back to the optimum position that may suffer from backlash. There is a very simple test that can confirm if you think you may have a backlash issue affecting your autofocus routines: After the autofocus routine has completed and moved to the final position, take a 10-second exposure and note the focus information (HFD/HFR/FWHM/pixel). Move the focuser outboards by a few millimeters (say 100 steps) and then move back in by the same amount. Repeat the exposure and measurement. If it is significantly different, you have a problem, and requires your software or hardware supplier to provide a facility for backlash compensation. In my case, my Lakeside focuser modules have a unique firmware version with programmable backlash and crucially, I have disabled backlash compensation in all the autofocus routines, to avoid unpredictable interactions.

Autoguiding and Tracking

A perpetually thorny subject, laid bare to develop into robust strategies.

One way or another, successful imaging requires a telescope to track the star's apparent motion, to an incredible accuracy, over the duration of each exposure. For focal lengths of about 1,000 mm, critical work may require ±1/7,000° RMS (±0.5 arc seconds). In context, this is equivalent to the thickness of plastic food wrap film at a distance of 5 m. For many, this is achieved by autoguiding in combination with good polar alignment. Others use a precise tracking model and dispense with guiding altogether. For clarity, they now have their separate chapters. Autoguiding and modeling have many interactions, however, since they are applied to the same dynamic system.

The Case for Autoguiding

Autoguiding issues appear frequently on the forums and it is easy to see why; it is a complex dynamic interaction of image acquisition, mechanics and increasingly, software, all of which differ from one user to another and even between imaging sessions. One of the frustrating aspects is that autoguiding can perform one night and play up on another, without any apparent reason. To understand why and what can be done about it, we need to understand what is happening. In a perfect system, there is already a lot going on, and when you add in all the sources of error in the mount and imaging system, it is a wonder that autoguiding works at all. Some premium mount manufacturers already improve their mount's tracking accuracy by using closed-loop position feedback systems. This improves things to a point that autoguiding can be dispensed with or made considerably easier (depending on the individual setup and object position).

To start with, let's look at what is meant to happen with autoguiding, then add in all the real-world effects, see how they affect performance and then develop some coping strategies. The first question should be, do we need autoguiding in the first place?

After careful polar alignment and using a mount with no appreciable periodic error (say less than 1 arc second) do you need autoguiding? Well, maybe. Let us assume for one moment that we are using a perfect mount and consider polar alignment again. Theoretically, a mount can be accurately aligned to a celestial pole. There is some debate on what "accurate" is in

relative terms to the imaging scale but let us assume 2 arc minutes or better. If the celestial pole is visible, the ingenious QHY PoleMaster accessory achieves sub arc minute accuracy quickly and easily. To achieve this using traditional methods potentially erodes precious imaging time. Even so, the effect of a slight movement or sag in the mount or support can ruin any alignment: For example, a tripod has its feet 1 m apart. If the north foot sinks by 1 mm, it changes the RA axis altitude by 4 arc minutes, that will make a star drift by about 4 arc seconds during a 5-minute exposure at a declination of 10°. As one is blissfully unaware of the subsidence, only autoguiding can detect and recover the drift. If the imaging system is resting on a compliant surface, excellent tracking requires autoguiding for traditional telescope focal lengths (350 mm or above).

The perfect mount does not exist. A few mounts with shaft encoders achieve <1 arc second peak-to-peak periodic error (PE), the rest typically are in the range of 3–30 arc seconds peak to peak over a worm-gear cycle (without correction). Periodic error correction (PEC) only removes the principal worm error, leaving residual errors from the motor and transmission system. Excellent results are achievable with PEC. My Paramount MX achieves 1.2 arc seconds peak-to-peak, comparable to seeing noise and approaching the accuracy of encoder-based systems. Other mounts use toothed belt reduction drives and dispense with worm gears altogether. The nature of this transmission system gives rise to more complex tracking errors that exhibit no convenient cyclical nature to measure and correct. The case for autoguiding is growing.

If that was not enough, even if we have a perfect mechanical system, physics deals a body-blow; at low altitude, standard tracking does not take into account increasing atmospheric refraction that affects a star's apparent position. Image registration during the calibration process will account for average shifts between exposures, but over a long exposure it may have an additional effect: For example, during a 10-minute exposure at an altitude of 30°, the effect of increasing atmospheric refraction introduces an apparent tracking error of about 7 arc seconds. Similar considerations apply to any optical flexure, especially those in moveable mirror systems (e.g. SCTs).

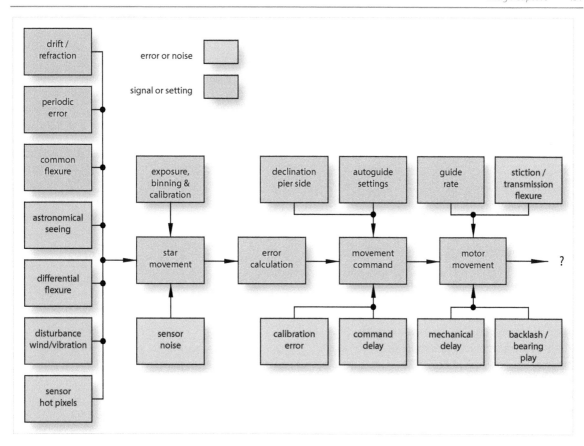

fig.1 There is no escaping the fact that an autoguiding system is complex and one has to appreciate the many possible sources
of error to consistently obtain good results. Understanding its behaviors is the fastest route to optimize performance.

The outcome therefore is that some form of autoguiding is needed in most situations, either to make up for alignment or mount mechanical errors or as a safety net in case there is some unexpected event that shifts the image.

Autoguiding in the Real World

The autoguiding process is a repetitive loop. After an initial calibration, which computes the scale and orientation of the image axis, it establishes a reference position for a guide star. An autoguiding loop has the following high-level cycle:

1 expose image, typically 0.5–15 seconds
2 download image or sub-frame and compute exact center of the guide star (centroid)
3 calculate error between this and the reference position
4 work out and issue correction movement commands to the mount for one or both axes
5 mount moves by correction amount (in addition to tracking)
6 delay / repeat cycle

This is a theoretical ideal and looks simple enough. With that in mind, it is time to meet the system in all its complexity. Fig.1 outlines a typical system; the salmon-colored boxes are the intended signal sources and processes, the grey boxes are the things that mess things up. Just as with any other classical system, we call these sources of error "noise". The system has a number of issues:

1 The system measures the apparent error in the guide star position. Our intent is to guide out the legitimate errors: drift, periodic error and common-mode flexure (affects both imaging and guide camera). At the same time, we are trying to avoid adversely reacting to the other inputs, namely astronomical seeing, differential flexure and other transient disturbances like ground vibration or a gust of wind. If PE, drift and common flexure are the signals, astronomical seeing, differential flexure (the guider and imaging camera flex independently) and other disturbances are considered as noise. An effective autoguiding system must prevent noise from influencing the movement corrections.

2 The mount may not move as intended: As we discussed in the hardware sections, a mount is a complex machine. Every gear, belt, motor, bearing and worm has tolerances. These manifest themselves mostly as stiction, backlash and in a dynamic sense, delay.

3 The system is a giant feedback loop, and like every other feedback loop the control signal is a reaction to an error signal. In an audio amplifier, this occurs faster than the ear can detect. In this system, the mount reacts to an error several seconds after the error event has occurred. If the error is slow to change, the system will keep pace or catch up. In the case of a rapidly changing error, it will likely struggle, since by the time the mount has corrected itself, the error will be something else again. This is one of the reasons that a mount's peak to peak PE performance is not the whole story; the rate of change of PE is equally, if not more important on its guiding performance. In the worst case scenario, conditions reinforce the error and the corrections make matters worse and the mount oscillates.

All these issues conspire, in differing degrees for each user, to make autoguiding a challenge and ultimately a compromise. To resolve issues in the field, it helps to understand each of these in a little more detail. It is convenient to treat them separately but since their effects interact, there will be some inevitable cross-over and repetition throughout the discussion. In one sense, this is a simple engineering dynamic control problem, familiar to electronic and mechanical engineers. A degree in engineering is not a pre-requisite, however, but some of the diagnostic tools that engineers use, in simplified form, provide valuable insights into what is happening in the system and clues on the best control strategy. Taking this one step at a time, we first consider guider hardware followed by the input signal (tracking error) and noise sources (everything else). Finally we move on to the imperfect mechanical system that does not quite react in the way we want.

Guider Hardware

An inappropriate choice of guider hardware adds further sources of noise to your base system, mostly in the form of differential flexure, guide star definition and optimal guide star selection. Guider hardware was briefly discussed in the earlier chapter *Imaging Equipment*. Here we briefly recap and look at the specifics that affect guiding performance in terms of optics, cameras and mechanical mounting.

Guider Optics

Optical configurations fall into two main categories: independent optics (guide scope) or shared with the imaging camera (off-axis guider or OAG). The best is not a foregone conclusion and, as usual, there are several considerations that affect the best choice for your system. The implementation as well as the configuration is just as important too; for instance, guide scopes may be an inexpensive 80-mm f/5 doublet refractor, a 50-mm f/4 finder, a re-purposed camera lens or anything in between. The principal benefit an independent guide scope has over an off-axis guider is its broader field of view and the ability to independently aim and pick a guide star. In some cases too it is the only option, since there is insufficient space in the main imaging path to introduce an off-axis guider pickup (a common issue when one is using a DSLR as the imaging camera behind a field flattener).

On the other hand, the rigidity of the guider focus assembly and the mounting hardware leave much to be desired in many cases, adding to the problem. Differential flexure can occur in a side-by-side mounting arrangement and crucially within the main optical system. The most notorious source is caused by mirror movement in reflector telescopes but also may occur less obviously in the main telescope's focus tube and camera assembly. The flexure problem becomes more acute at long focal lengths and this is when an OAG comes into its own. Since they share the same optical path as the imaging camera, they see the same angular flexures and record them accurately for correction. OAGs do not have it all their own way, and have to cope operating at the periphery of the imaging circle via a small pick-up mirror and in some cases behind the imaging filters, further attenuating the light level of distorted stars. Their smaller field of view is often locked with the main imaging camera. Guide star selection is restricted and is often a compromise between the perfect imaging camera framing and angle and a position that offers a suitable guide star both before and after a meridian flip.

The focal length and guiding resolution is also a consideration but less important than one might think: Since the guider software can determine sub-pixel star centroid accuracy, as a rule of thumb, if the imaging focal length is no more than 10x the imaging focal length, you should have sufficient tracking resolution.

Guide Cameras

Like optical configurations, there are two main camera styles in common use for autoguiding; low-noise, sensitive CCD still cameras, epitomized by the Starlight Xpress Lodestar and increasingly low-noise CMOS video cameras, with a long-exposure capability. In some cases the

guide camera is integrated within the imaging camera body, or the camera is part of a stand-alone guider system with optics, software and control. Traditional guide cameras have an ST4-compatible guider port or link via USB to a parent imaging camera that has one. The ST4 interface, provides a set of relay (or more typically, opto-isolated) switched outputs that tell the mount to move N, S, E or W. If the telescope mount has a guide port, it will typically be to the same specification, utilizing a 6-way RJ-12 connector. The ST4 pinout is allegedly a standard but over time, a few variations have manifested themselves on guide cameras and mounts. The most common deviation is a simple reversal of the pinout (fig.2) obtained by flipping the connector over at one end of the flat cable. This traditional interface is increasingly being replaced by software-based guiding controls that are integrated with their tracking control systems. At the same time, an increasing number of small-pixel CMOS cameras, based on a 1.25-inch diameter body and at a much lower price-point, are being used for guiding. The sensitivity and noise level is not yet that of the CCD sensors but they work well enough with bright guide stars and as a bonus many generate video too, through the Windows DirectShow interface, to act as a virtual eyepiece or planetary imager.

Determining the Real Tracking Error

Sensor Noise

The key to effective autoguiding is to first minimize the input's "noise" level and then find a way to minimize its effect on the output signal (motor movement command). Assuming you have taken the necessary precautions to ensure a rigid mount and optical assembly, the principal "noise" sources are sensor noise and astronomical seeing. Sensor noise affects the accuracy of the apparent star tracking error. Autoguiding exposures are short and although we can discount thermal noise, read noise, hot pixels and bias are very noticeable, compared to the brief exposure of a few dim guide-stars. The algorithms that determine the center of a star can confuse it

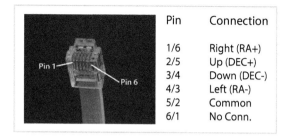

Pin	Connection
1/6	Right (RA+)
2/5	Up (DEC+)
3/4	Down (DEC-)
4/3	Left (RA-)
5/2	Common
6/1	No Conn.

fig.2 A typical ST4 guider RJ-12 connector with two common alternative pinout implementations. So much for a standard!

with a nearby bright pixel. Image noise in the vicinity of a guide star also affects the reliability of the centroid calculation. It seems unlikely that a few pixels can have that much effect but they do.

The autoguiding software does not simply identify the brightest pixel in the image of the star, that is far too coarse, but also measures the surrounding dimmer pixels and uses the light fall-off to calculate the precise center to sub-pixel accuracy. In this way, autoguiding programs resolve to 1/10th of a pixel or better. If a star is represented by a single pixel, the guider software does not have much to work on and it actually helps if the star intensity fades off gradually over the surrounding pixels. If there are only a few pixels associated with a star image, a little sensor noise is more likely to affect the centroid calculation. In a paper by Craig Stark, the author of the original PHD guiding program, he suggests that sensor noise can introduce a calculation error of 0.2 pixels, equivalent in my system to 0.6 arc seconds. Maxim DL and PHD2 usefully display the signal to noise ratio of each exposure to highlight the guide star's general suitability and have filtering and binning options to improve the signal to noise ratio.

Hot Pixels

In addition to thermal and read noise, most CCD cameras have hot pixels (whose number increase slowly with age). These are the cause of more headaches. A hot pixel close by a guide star can skew the calculation or worse, as they may be interpreted as an unmoving star (and

Why not chase seeing? Technically, you can take frequent short exposures and issue guiding commands to correct the perceived tracking error or a proportion of it. Even though these commands will be equally random in magnitude and direction as the seeing conditions, the underlying drift and PE will be corrected in the long term. There is one drawback, however. In the short term, the mount will be trying to react to the seeing conditions, a few seconds after the event. The outcome is that the mount will physically move around more than is required by the underlying PE and drift. The high-frequency seeing conditions will add to this pointing error and star images will become even larger, or worse, elongated.

you believed that flat-line tracking graph)! Just as with imaging cameras, there are strategies to minimize the effect of sensor noise and hot pixels shown in fig.1. The simplest solution is to calibrate each exposure before assessing the guide star location. Both PHD2 and Maxim DL allow you to calibrate the guide exposure by subtracting a dark frame. PHD2 has a utility that exposes and averages several dark frames over a range of exposures and then during guiding, subtracts this from each guide exposure.

Seeing is a real imaging problem too since it causes, even with perfect tracking, an image to wobble during a long exposure. The professional observatories, like the VLT in the Atacama Desert, use a laser and adaptive optics to correct for the seeing conditions in real time. This produces smaller, brighter and better-defined stars and features. Adaptive optic units work in a similar manner to anti-vibration lens technology in camera lenses. They tilt a lightweight lens element (or mirror) in milliseconds that has the effect of shifting the image. Unlike a telescope mount, they are agile, do not use gears and are adept at correcting small errors very quickly. Adaptive optic units are also available for amateur astronomers and although the measurement and correction system is fast enough to cope with rapid mount fluctuations, those based on still cameras are often too slow to correct for fast-changing seeing conditions.

Sensor Focus

Ironically, the surrounding pixels are perhaps more important than the central one and explains why a small amount of defocus on an under-sampled guide camera improves centroid determination and helps with saturated guide stars. This is not an excuse for poor focus, however, especially with a centrally-obstructed telescope, such as Newtonians, SCTs and RCTs. In these instruments, a de-focused star quickly becomes a donut. The smallest amount of seeing noise will change the location of the hot spot around the donut and can make the tracking jump about. My 10-inch RCT has some field curvature that is quite apparent in the field of view of the off-axis guider. I also own several refractors which have flatter fields and in this case, the off-axis guider tube is optimized for focus with the RCT. Diffraction provides the necessary blur and the small amount of coma with the shorter refractors is of little consequence.

Applying a bad pixel map is better still as it is more robust to changes in exposure duration and temperature. (PHD2 also measures the SNR of each guide exposure and has an option that can additionally adjust the exposure to reach a minimum setting.) Maxim DL also has the option to apply a full image calibration to each guider exposure. These techniques are often sufficient to calibrate guide camera images and maximize the signal to noise ratio so the star centroid calculation is as robust as possible.

There is also a little trick that effectively deals with hot pixels in Maxim DL5. The steps below were suggested in a forum post by Terry Platt of Starlight Xpress:

1 Take a zero length exposure using the "dark" setting in Maxim and save it to the calibration folder.
2 Take a 2-second dark exposure, open up Maxim's calibration dialog and select it to generate a bad pixel map.
3 Create a calibration group using the zero exposure dark image as a dark frame and select the hot pixel map in the box provided.
4 Turn the dark frame autoscale option off, if the guide camera has no temperature control.

In operation, set "no calibration" for the main imaging camera (camera 1) and "full calibration" for the guider (camera 2). In effect, each guide camera exposure has a bias frame subtracted from it (using the zero exposure dark frame) and then the hot pixels are removed. (If these terms are unfamiliar, we cover calibration later on in its own chapter.)

Astronomical Seeing and Tracking Error

After optimizing your location and conditions and choosing high-altitude subjects, there is not a lot more you can do about seeing, other than wait for a better night. For effective autoguiding, we need some help to minimize its effect. Fortunately the clue lies within the apparent tracking error data. The graph in fig.3 shows the measured tracking error for a bright star on a NEQ6 mount running with its ST4 guide cable unplugged. It was measured with a free utility, PERecorder, using a webcam, operating at about 25 frames per second. (TheSkyX PE/PEC utility performs a similar function using a still camera, normally with 1-second exposures to reduce the latency.) The tracking graph in the top left window shows several versions of the data; light grey for the actual tracking error, dark blue for the PE without the drift, green for the noise (most of which is seeing) and red for the filtered and smoothed error resulting from the worm drive in the mount. The most significant thing is the relative changes in error over a given period. The graph in fig.3 measures the apparent

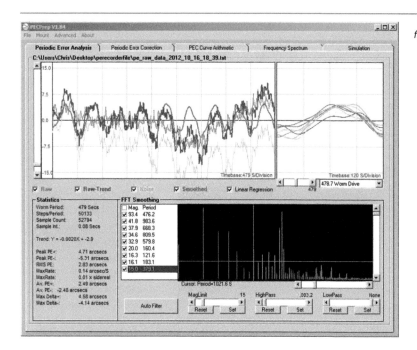

fig.3 *This screen grab from the free utility PECPrep, shows the actual guide star error in pale grey in the top left graph and a number of filtered results too in different colors. The smooth red trace represents the assumed worm periodic error, the blue trace is the raw trend and the residual noise, represented by the green trace, principally caused by seeing and other errors. The graph on the right hand side shows frequency filtered errors to select the worm induced tracking error. The successive errors from each worm cycle are overlaid to show the correlation. When they are averaged and inverted they can be applied as a periodic error correction curve in EQMOD (fig.9).*

tracking error over 9 worm cycles, each of 8 minutes' duration. The vertical scale is in arc seconds. From this it is possible to measure the individual contributions to the apparent tracking error:

- The drift rate is about 15 arc seconds over 6 cycles, or 0.005 arc seconds / second, or 3 arc seconds in 10 minutes.
- Periodic error is about ±5 arc seconds peak to peak, maximum rate of change can be calculated from the maximum slope of the worm drive graph on the right hand side, about 6 arc seconds over 120 seconds or 0.05 arc seconds / second.
- Seeing is about 2–3 arc seconds in magnitude and changes rapidly between individual samples.

This performance is typical of a modest telescope mount that has been polar aligned and operated in a typical suburban environment. These figures tell an interesting story:

- The apparent tracking error is very different from the actual tracking error between measurements.
- The real tracking error changes at a slow rate.
- The real tracking error will eventually become large enough to require correction.
- The effect of astronomical seeing on the measured star position (compared to the last sample) is up to 50x greater than caused by the underlying tracking error caused by PE and drift.

Between successive exposures, the apparent tracking error is almost entirely due to seeing arising from atmospheric turbulence. Its effect on the apparent star position completely swamps the real tracking error. For that reason it is essential that the autoguiding system does everything possible to distinguish and correct the real tracking errors and ignore the comparatively large and random measurement errors caused by seeing. The traces in fig.3 suggest that seeing rapidly changes the apparent position of a star. The phenomenon is complex; not only are there extremely quick shifts, in the 10–100 ms range, but it has a localized effect too. At any one instant, different parts of the image will have different displacement errors, explaining why a high magnification 30 fps video of a planet wobbles around like Jell-O between successive frames.

The effect of seeing has a random effect on the measured star position; the image shift is equally likely to occur in any direction and the probability of a big shift is progressively less likely than a small shift. In practical terms, a long exposure of a small, tightly focused star becomes a diffuse circular blob over time. Thankfully, the randomness works in our favor and the center of the blob formed by a long exposure is coincident with the center of the star.

So, to reduce the effect of seeing on the measured tracking error, we need to lengthen the guider exposures. A long exposure averages all the micro shifts of the star over time and produces a diffuse blob, centered on the actual star position. In other words, a longer exposure lowers the effect of seeing noise on the tracking

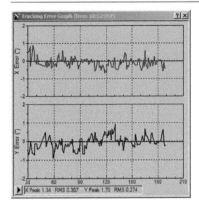 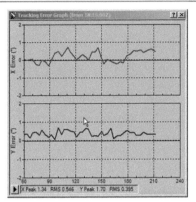 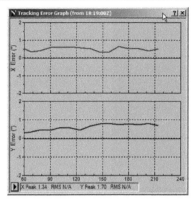

fig.4 These three guider graphs from Maxim DL were taken with the guider outputs disabled and show the apparent tracking error in arc seconds over a few minutes. They were all generated in a half-hour period, the only difference between them is the guide exposure time. From the left these are 0.5, 3 and 10 second exposure settings. You can easily see the effect of exposure time on seeing noise. The 10-second trace is smooth and shows a slight drift in DEC and very little noise in either trace. Even with a 3-second exposure the middle graph still has some seeing noise, smoother and at about half the peak variation of that in the session using 0.5-second exposures. All guide exposures were fully calibrated and in this case, the guide image SNR was high in all cases, at 150, 545 and 690 respectively. If I had chosen a faint guide star then the sensor noise would have contributed further to the apparent tracking error and would have also been improved by increased exposure time.

error measurement. In fig.3, the camera was exposing a subframe at a breezy 25 fps but even at much longer exposures, there are clear differences in the sensitivity to seeing. Fig.4 compares the seeing noise with exposures of 0.5, 3 and 10 seconds. There is still a clear improvement between 3 and 10 seconds.

With longer exposures, however, the signal or the real tracking error is growing. In this case it has some way to go before the noise from seeing is reduced to the same level as that from the real tracking error. The tracking graphs in fig.4 give an indication. In this case, by my reckoning, it requires an exposure between 5 and 10 seconds to reduce the seeing noise to a level comparable to the PE error. Before we all start using 20-second guide exposures, we must recall that the whole purpose of autoguiding is to eliminate drift and PE. Long exposure times also have the potential to under-call the true tracking error, since, in the case of drift, the star moves during the exposure and the guider will work out a mid-position, rather than the end position of the star. Long exposures may also saturate a star and cause errors in the centroid calculation. (If the mount generally tracks well and has low drift, one can use a moderate guide exposure of say 5 seconds, with a 10-second delay or more between guider commands.) The question is, how long can we expose for and still maintain an acceptable tracking error?

If the seeing conditions effectively increase the star size to 3 arc seconds, one way to set the exposure time is to keep the underlying tracking error to say 10% of that figure, or 0.3 arc seconds. (The PHD guiding assistant computes an optimum value.) That is equivalent to 60 seconds of drift or 6 seconds of PE in my example. (The PE error rate is 10x greater than drift in this example and it caps the maximum exposure time.) To increase that exposure time, there are two choices; relax the tracking error specification or find a way to reduce the rate of PE in the mount. (This same EQ6 mount, after using the Periodic Error Correction feature in EQMOD, halves the maximum PE rate to 0.02 arc seconds / second.)

Assuming an otherwise perfect signal, if we simply take a single measurement every 6 seconds and correct 100% of the error, the maximum error will exceed 0.3 arc seconds due to the delays in the system. If we take 2 samples in 6 seconds and correct 50% of the residual error, there will be a slight lag, not exceeding 0.3 arc seconds. If we attempt to correct 70% of the measured error, the error settles at about 0.2 arc seconds. There is a clear trade-off between maximizing the exposure time and the real residual error. The 100%, 75% and 50% values above are often called the guider aggressiveness setting. The equivalent settings in Maxim DL use a 0–10 point scale, representing 0%–100% error correction each cycle. It is tempting to select 100%, but when we factor in the measurement noise caused by the seeing conditions, there is a danger of over-correcting the perceived error. In any system, a low aggressiveness value usually makes a system run smoother. The conclusions so far are:

• The effect of seeing is reduced by increasing the guide-camera exposure time.

- The unguided tracking error rate sets a cap on the maximum guider exposure time.
- The residual tracking error increases if the guider cycle time (exposure) is increased.
- A mount with a smaller PE *rate* is easier to guide, since it allows longer exposure times (or moderate exposures with a pause in between) to reduce the effect of seeing, without compromising actual tracking errors.

If the mount is polar aligned and has modest periodic error, it is unlikely that the guide camera exposure time will ever be long enough to reduce the effect of seeing to a level less than that of the true tracking error. Most systems operate with apparent tracking errors, caused by seeing, that are larger than the actual tracking error.

As a consequence of these and especially the last point, it makes sense that if our tracking corrections are still largely based on guesswork, with an underlying trend of reality, the best course of action is to do the minimum amount of correction. In other words we must not react to noise, add a further tracking error into the system and make matters worse.

Before we move on to discuss the mechanical system, there is another way to reduce the effect of localized seeing conditions. If a dozen stars are separately and randomly affected by seeing conditions, then if their individual apparent tracking errors are averaged, it should reduce the "noise" level up to about 3x. Most autoguider software works by sampling a single star but in recent years, plug-ins for Maxim DL and other advanced autoguiding routines have introduced multiple star sampling. Early results show that by sampling several stars the measurement error, induced by seeing, reduces by about 2x. The benefit is not as high as it might be, simply because air turbulence at one time may similarly affect more than one star and is therefore not locally random. It is also worth mentioning that there is a small benefit too to guiding through a red filter, since the longer red wavelengths are less affected by atmospheric refraction and hence seeing.

Periodic Error Control

Periodic error and its control have been mentioned a few times in passing but so far not in any particular detail. Unless a mount has a highly-accurate shaft encoder, with a resolution measured in sub-arc seconds, every mount, no matter how expensive, will have appreciable PE. There are two aspects of the nature of PE that cause concern:

- the rate of error change (affects guided accuracy)
- the peak to peak error (affects unguided accuracy)

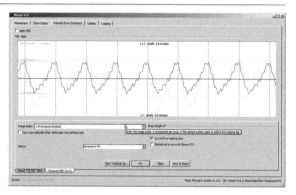

fig.5 The PEC utility in TheSkyX can analyze its own guider log (fig.6) and filter out high-frequency seeing noise, the effects of drift and other periodic error to leave behind the principal tracking error arising from worm anomalies. In this case the PE is 1.8 arc seconds peak to peak.

Most mount systems have a mechanism to store a set of PE correction values for each worm angle. The motor control system uses these values to alter the rate of the RA worm rotation, to compensate in real time for the major source of PE; the worm itself. This is called Periodic Error Correction or PEC and the values are either stored within the mount electronics or by the driver/application on the computer. For this to be successful requires an accurate tracking error assessment at each worm angle. (The "worm gear" is the large circular disk around the RA or DEC axis, the "worm" is the smaller gear resembling a screw.)

There are several methods to measure tracking errors. Most autoguider programs record a blow by blow account in a text log file. If the guider outputs are disabled, these values can be used for PEC analysis. There are also dedicated utilities that measure the tracking error using a video or high-speed camera. Some mounts, like iOptron, monitor guider corrections over a worm cycle

fig.6 A sample log file, generated by the TheSkyX autoguider for calculating Periodic Error. PHD2 will generate a similar log file for use by other programs, such as PEMPro and PECPrep.

fig.7 An example of a calculated Periodic Error Correction over a worm cycle for a Paramount MX mount, using TheSkyX.

and calculate their own PEC. All these tracking error logs, however, are also affected by the seeing noise. To isolate the tracking error in the presence of this noise uses a familiar technique that averages several measurements together. Well, almost. The standard practice is to measure the tracking error over four or more worm cycles and use a special program to average the errors together. It does this in a unique way that isolates those tracking errors that are caused by the worm cycle. In effect, the tracking error exhibits compound errors of different periodicity, which are caused by the rotations of gears, belts, pulleys and motors. Armed with the knowledge of the worm-cycle period, a mathematical technique known as the Fast Fourier Transform (FFT) can isolate the tracking errors that synchronize with the worm cycle. It is these errors that are averaged, as can be seen in fig.3 and 5. Crudely, this error signal is then inverted and stored as a correction signal, to be applied whilst the mount is tracking (figs.7, 8).

The second hurdle is to measure and deploy the error correction at the same precise worm angle. This requires a mechanical or electronic means of knowing the orientation of the worm (either continuously or relative to a reference position) and ensure the measurement and correction is applied without delay. To do this, most worms are either synchronized to a position-activated switch, have a rotary encoder or are manually aligned by the user and parked/un-parked with each use.

Although lengthy exposures are good at removing seeing noise, PE measurement normally uses an exposure duration of 1 second or less to minimize the measurement latency. (The FFT isolates the worm cycle effects and takes care of the high frequency seeing noise.) When applied, PEC is intelligently combined with autoguider commands using a technique generically called pulse guiding, rather than cause potentially conflicting commands through alternative interfaces.

fig.8 This screen shot from EQMOD shows the periodic error correction at work on the left and the guider settings for guide rate, along with the maximum and minimum movement times on the right-hand side. In this case, EQMOD is set up for pulse guiding, a technique that elegantly combines the RA guider correction inputs with the periodic error movement commands and sends an overall movement command to the mount. Other options are available, including using the traditional guide relays. This method may, at any one time, have conflicting inputs from the autoguider algorithm and the periodic error corrections.

Up to this point the discussion has concentrated on measuring the actual star location as accurately as possible. This is a compromise between sufficient exposure time to overcome noise sources and ensuring one keeps up with the real underlying tracking error. The level of compromise changes with the quality of the polar alignment and the mount's rate of periodic error. Successive measurements still show a high degree of randomness caused by seeing and this is before we send a control instruction into the great unknown; the mount. Even before we go there, we need to translate the star position error into RA and DEC corrections using a guider calibration.

Guider Calibration

The calibration process calculates how a star movement relates to a RA and DEC angle. The guide camera will have a certain pixel pitch and orientation, by which we mean angle, to the RA and DEC axis. If the guide camera is attached to an off-axis guider, or imaged via a mirror, the image will be flipped too. Guiding commands are specified in terms of method, duration and guiding rate (specified as a fraction or percentage of the sidereal tracking rate or a simple 1–10 value, depending on the

fig.9 This crop from a Maxim DL guider calibration screen shows the four completed movements, indicated by the red lines. The star should be centered on the apex. The fact that it does not indicates a degree of DEC backlash, in this case about 1 second's worth at the guiding rate. If this calibration is repeated (with a backlash value applied) the star position at the end of the calibration moves towards the apex.

fig.10 PHD2 has effectively superceded PHD and offers enhanced control options and interoperability with external imaging programs. A key feature is DEC compensation, allowing for a single calibration to apply for all the sky. This program is under active development and is being updated regularly to accommodate a growing range of needs and offers a number of alternative guiding algorithms to suit a range of hardware configurations.

application). Before guiding, it is necessary to calibrate your system, using the guider interface you will use in practice and with the same settings. This requires a knowledge beforehand of the best guider rate and physical method. As this may have not yet been determined, a few iterations may be necessary to trial different options. One has to start somewhere, however, so in the absence of any general consensus from a user-forum or the like, assume a 0.5x guide rate (50% of the sidereal rate of 15 arc seconds per second) and choose the ST4 interface as a starting point.

Calibration determines the pixels per second movement along RA and DEC axis, at the guiding rate and the sensor orientation. There are two principal methods of calibrating:

1 Deliberately move the mount back and forth in DEC and RA for a specified time and measure the star movement and angle.
2 Plate-solve the image from the guide camera and determine the guider angle and pixel scale in arc seconds per pixel.

PHD(2), TSX and Maxim DL employ the first method. These programs move the mount in both directions on each axis using the same control method employed for guiding and take exposures to determine the star movement. There are several control methods, including ST4 guider relays, various forms of pulse guiding, or direct mount commands; more on those later. In the case of Maxim DL, it moves the mount back and forth for a user-specified time. PHD2 moves the mount in about a dozen steps until the star has moved sufficiently to make a reliable measurement. From the relative positions of the star, the pixel / second movement (at the guide rate) is determined. There are a couple of points of note:

The first is the guide star needs to move several pixels to obtain a reliable measurement. Maxim DL rejects the calibration if the movement is less than 5 pixels. Ideally it should be more. If a low guide rate, say 0.1x, is specified, it will take a long time to move the guide camera sufficiently. (In Maxim DL, you can cheat by performing the calibration with a high guide rate setting and then reduce the guide rate and the x and y speed values by the same factor afterwards.) The second is that a basic RA guider calibration made at high declination is very different to one made at low declination. This is an important point that requires further discussion but for now, be sure to check your calibration declination and DEC compensation settings are as you intend them to be.

Returning to our two calibration methods, the second one is to use plate-solving. A plate-solve not only calculates the center of an image, it also reports the image scale, in arc seconds per pixel and its orientation. It only takes a

few seconds to generate a calibration. Since the sidereal tracking rate is 15 arc seconds / second, dividing the image scale into 15 gives the calibration value in pixels per second. If the guide rate is 0.5x, halve the calibration value and so on. This is very effective using stand-alone guide scopes but becomes more difficult in the restricted field of view of an off-axis guider image (The standard GSCII catalog used by PinPoint / Maxim 5 may have insufficient stars to plate-solve the few stars in say an off-axis guider image. The latest versions of Maxim and PinPoint can use the more detailed UCAC4 or USNO-A2.0 catalog, although they take considerable time to download their 8 GB multi-file structure.) Assuming one can plate-solve the guider image, a Maxim DL plug-in by John Winfield calculates the guider calibration with a few button presses.

There is a catch though: This method assumes a perfect system and may give the wrong results. Since it does not measure the actual star movement it can be caught out by system anomalies: I discovered pulse guiding with my EQ6 mount moves the mount further than it should, but moves correctly if I use the ST4 guide port. On my 10Micron mount, the pulse guide movement is accurate but the ST4 port is configured differently and one of the guiding directions is reversed. (As a result, I quickly discovered that far from being a single standard, the industry uses a number of ST4 pinouts that swap over connections for N<>S, E<>W and so on. If you do not believe me, just do an Internet search!) In the case of the 10Micron it is a simple matter to manually change the sign of one of the calibration values.

Calibration Declination

At high declinations, as a result of trigonometry, an image is less sensitive to periodic error and RA drift arising from polar misalignment. At first this seems confusing, when our field of view or pixel scale remains the same. To conceptualize, consider the logical extreme of a guide star at the celestial pole. It is immune to periodic error, or even if the mount stops tracking. In practical terms, a periodic error or RA drift of a few arc seconds at low declination moves the guide star position on the sensor by more pixels at low declination than at high. Conversely, a small pixel movement in RA at a high declination is more significant than at a low declination. The original PHD did not communicate with the mount and did not know the declination of the guide star. It was designed to be calibrated at the same declination as the imaging target for natural compensation.

Modern autoguiding algorithms automatically compensate for this, but only if they know the guide-star declination. These applications (including TheSkyX,

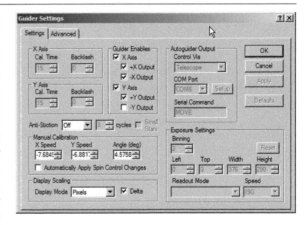

fig.11 Maxim DL's guider setting controls allow DEC corrections in one direction (shown) as well as stiction and backlash controls. The calibration values are shown as well as the physical guider method, communication port and exposure settings. Note the displayed calibration values are calculated for 1x1 binning and DEC=0, irrespective of the actual DEC and binning used for the calibration. Maxim uses these calibration values and the current DEC and guider binning to establish the actual calibration, allowing one to change binning and DEC without the need for a new calibration.

Maxim DL and PHD2) have the facility to connect to the mount and read its current DEC position and an option to change the RA calibration for alternative declinations: When connected to a telescope they read the declination telescope property and normalize the guider calibration values (the x and y speeds in pixels per second) to a declination of 0° (on the celestial equator). In this way these applications calculate new guiding parameters for any other declination, using the equation above, without repeating the entire calibration process. This is called DEC compensation and seems a savvy thing to do, but it has a sting in its tail. For now, the recommendation is to calibrate your autoguider at a low declination. This provides the most accurate reference.

Guider Setup

Guider Setup, like calibration, is an iterative process. It may be that a middle-of-the-road setting will be acceptable but it is more likely that tuning improves things further. Tuning broadly falls into two categories, optimization of exposure and tracking error determination and the most effective way to move the mount. There are two approaches to tuning, mindless experimentation and logical changes after system characterization. Both have their place if one is vigilant, for mindless experimentation, or what-if analysis, with extreme

values may often give valuable insights into how the mount responds to corrections. Tuning often centers around an appreciation and analysis of the tracking log and graph. A word of warning, however, remember that the real tracking error is masked by seeing noise and increasingly with short exposures, the real tracking error is more stable and smoother than the tracking log suggests. The infallible test is the image quality (star size and shape) from the main camera during autoguiding. Failing that, one can use a second guide camera system in place of the main imager, running with an alternative autoguider program, with 10-second exposures and set with its outputs disabled to simply monitor the underlying tracking error.

Control Method

In the beginning, there was ST4, and it survives to this day. It was ideally matched to the basic mounts at the time but today's modern mounts with their complex electronics, optical encoders and just as importantly, software, provide an opportunity for interesting alternatives. These are colloquially referred to as pulse guiding and are generally available through the ASCOM telescope device interface. Their concept is to introduce the RA and DEC corrections using software instructions rather than a direct hardware interface. It is easy to combine both guiding and PE corrections in software and issue one aggregate command to the motors. (Some mounts hijack the ST4 port, monitor it and combine with PEC in software.) The benefits are one less cable, diagnostic log files of every movement and smoother control, since the magnitude of the combined correction is potentially less than the two separate signals.

Pulse guiding implementations vary between mount models. Most rely upon modifying the tracking rate by the guiding rate for a specified duration. For example, a 100 ms 0.25x guide pulse to the RA axis would result in the RA moving either at 1.25x or 0.75x sidereal rate for 100 ms (depending on the polarity) and then would return to the sidereal rate. (Since the DEC axis is normally stationary, the rate and duration is simply applied directly.) Other implementations introduce an arc second equivalent positional error into the control software and let the existing control system accommodate it. My various mounts have displayed everything from severely over-damped (the mount takes several seconds to fully adjust its position) to virtually instantaneous. The former case is interesting; since even with a low aggression setting, if further guiding errors are measured and instructions issued before the mount has completed its initial movement, overshoot and oscillation occur very easily.

Clearly one chooses the method that performs best for your particular setup. When changing methods it is advisable to re-calibrate at the same time. Note too that guiding polarities before and after a meridian flip are sometimes treated differently and may require a change to the DEC reversal option in the autoguiding software. In practice, I find the performance differences between methods subtle and difficult to detect from an autoguiding trace or RMS error readout alone, especially in the presence of variable conditions. An alternative approach is to compare the mount's dynamic response to a single artificial correction (using a simple script or manual guide control) and look for tell-tale signs of delay, overshoot, consistency and crosstalk between the axis. Comparing this response at different guide rates and magnitudes provides valuable insights into the way the mount moves (or doesn't). This is not as artificial as it seems, as

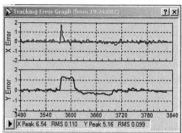

fig.12 *This small screen grab of a Maxim DL autoguider shows the (upper) RA error and (lower) DEC error traces. At about 3,570 seconds, the exposure ended and a dither command was sent to the mount. The dither command effectively moves the stars reference position and waits for the autoguider system to catch up and provides useful diagnostic information: The RA axis moves quickly to the new position in about 15 seconds but the DEC axis does not move for about 30 seconds, as its backlash is slowly removed by successive autoguider commands. It then overshoots slightly and takes another 90 seconds to finally center up (as a result of the corrections being less than the minimum move setting).*

this is precisely what an autoguider-implemented dither command does and in practice, the settling period after a dither command is very informative.

Min and Max Movement

Minimum and maximum movements limit the extent of an individual guiding correction and can be independently set for the RA and DEC axis (fig.10). In the prior example, a 50 ms minimum movement is equivalent to 15 x 0.05 x 0.5 = 0.37 arc seconds. That means that for any error less than 0.37 arc seconds, no mount correction is issued. The maximum movement sets a cap on the largest and although it reduces the likelihood of the mount responding to a rogue sample, it can also slow down the response to dither and centering. The minimum creates a threshold beneath which the seeing noise (and tracking error) is effectively ignored. The trick is to limit this range as much as possible and in doing the calculations, rationalize the guide rate for the RA axis:

1 Lower the maximum RA movement to say twice the highest possible PE error within a guide cycle. In the example used here, assuming a 2-second exposure and 3-second cycle, that is 0.3 arc seconds movement per cycle. That implies a time of moving time 40 ms at a guide rate of 0.5x, which is probably not feasible (Maxim's lowest value is 100 ms). If we assume a guide rate of 0.25x and a maximum movement of 100 ms, that gives 0.1 x 0.25 x 15 = 0.37 arc seconds.

2 Raise the minimum movement and set the error correction threshold to about 10% of the best likely seeing conditions. In my case this is about 0.2 arc seconds, or a minimum guide time of about 50 ms assuming the 0.25x guide rate. This can also be applied to the DEC axis setting.

DEC Compensation

As briefly mentioned, the declination of the guide star has an effect on the RA tracking error and although a sensor or pixel sees a fixed angle, this FOV is projected onto an imaginary equatorial grid. The FOV overlaps more RA grid lines as they get closer together and meet at the pole. In effect, the rate of star movement (in pixels) reduces at higher declinations and follows a simple rule:

rate at DEC = rate at celestial equator . cos(DEC)

If we take two points, one on the celestial equator (DEC= 0°) and another 10° from the celestial pole (DEC=80°), although the RA axis moves at a constant angular rate of 15 arc seconds per second, it sweeps out

more sky near the equator than near the pole. If the image scale is 2 arc seconds per pixel and the mount were to suddenly stop tracking, a star would move 7.5 pixels each second, for an object on the celestial equator but move just 1.3 pixels at DEC=80°. Similarly the effect of any PE is similarly scaled back. Happy days? Not necessarily; in an autoguiding system, the actual tracking error shrinks with higher DEC values (that is, the signal gets smaller). At the same time, the seeing conditions have the same effect on the star appearance and measured position, *in pixels*. In other words our signal to noise ratio is lowered, just by increasing the declination of the subject, and the system is more likely to react to seeing conditions. To make matters worse, some mount software and the guiding software's DEC compensation option mentioned earlier, compensate for the decreasing sensitivity of error detection at high declinations and increases the gain of the RA guider correction. (This correctly assumes the principle that the required physical angular corrections to compensate for periodic error, are the same, regardless of where it is pointing, but the measured RA tracking error appears smaller at higher declinations.) The intent is to ensure the degree of mount correction is not underestimated for correcting RA tracking issues.

This reasoning, however, completely ignores the effect of seeing conditions. Seeing conditions, in terms of measured pixel centroid error, are the same for any declination. Far from helping, DEC compensation can make the system more reactive to seeing conditions. For example, at DEC=0°, a pixel error of 0.1 pixels may translate to a guider movement of 0.3 arc seconds but at DEC=80°, after compensation, it translates to: 0.3 / cosine (80°) or 1.72 arc seconds.

If we pause to consider this for a moment, we quickly realize that DEC compensation acts precisely the same as if you calibrated the autoguider software at the target's DEC in the first place (the approach that was implicit in the original PHD guider calibration routine.) In the case of good seeing, the RA corrections will be automatically scaled and there will be no issue. Alternatively, in the case of less than ideal conditions and at high DEC, the errors caused by seeing conditions increasingly swamp your mount tracking errors and the autoguider has to work harder. In this case the autoguider software may try to chase seeing and the mount will receive continual, random corrections of quite high amplitude, limited by the maximum move parameter. A quick experiment will determine which case is prevalent; calibrate at low DEC and simply compare the guiding performance at high DEC with DEC compensation enabled and disabled.

The following, admittedly controversial suggestions, may help to reduce the sensitivity to seeing at high declinations and keep the mount under better control at high declinations:

1 increase exposure time for high declinations
2 calibrate at DEC=0 and disable DEC compensation
3 turn off guiding (in the case of a well-corrected mount)

In 1, the argument goes: Since the effect of drift and PE is less at high declinations, less guiding is needed and therefore a longer guide exposure time can be used to lower the influence of seeing conditions without compromising image appearance. In 2, we effectively lower our guide rate setting by cosine(DEC) and although the mount continues to react equally to seeing conditions, those movements at high declination have less effect on the image appearance as a result of the now familiar cosine relationship. Note: The original PHD user instruction notes the issue and suggests one uses its low-pass filter option, at high DEC settings, to reduce the effect of seeing noise.

In 3, it might be possible to disable guiding altogether at high DEC altogether. These recommendations are novel but the data-driven approach makes some sense, as long as you have an idea of the signal contribution from your mount and environment.

Guiding Algorithms

The simplest systems measure the tracking error and issue a guiding command to fix some of the error, determined by the aggression and guide rate settings. The more sophisticated offer a number of alternative algorithms for RA and DEC control. These are designed to minimize the number and magnitude of incorrect guiding corrections. Some are linear in design, combining and weighting prior errors with the current error to form an effective new value and others are non-linear, in so much that they uses math to generate a linear value but then switch behavior, based on preset conditions. The linear algorithms anticipate the kind of tracking error mechanisms we see with drift and seeing noise, namely an underlying error trend and randomness. For example, in PHD2, "LowPass" and "Hysteresis" algorithms statistically combine several recent tracking errors with the current error. They are subtly different; LowPass computes the median of recent errors and adjusts it in the presence of a underlying trend. Hysteresis is simpler and blends a user-defined proportion of the recent errors with the current one, allowing considerable flexibility. Predictive algorithms are also being developed to overcome latency and included in the latest PHD2 snapshot builds.

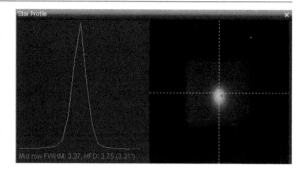

fig.13 *When choosing a guide star, make sure that the longest exposure you are likely to use does not clip. Here, the star is diffuse and the star profile shows a sharp peak. A flat top indicates the central pixels are saturated. (The latest version of PHD2 gives a clipping warning.)*

I typically start with the hysteresis method for both RA and DEC. If the mount shows signs of backlash, I evaluate one of the legacy PHD algorithms like, "resist switch". This non-linear filter is frequently used with mounts that have some DEC backlash (a non-linear problem). It avoids changes in DEC direction by statistically working out the underlying drift direction. This filter ignores tracking errors in the same direction as the same correction until the statistical likelihood of seeing noise being unidirectional compels it to change its mind. Not all mounts exhibit DEC backlash but it can also be useful when the DEC bearing has some lateral play (which translates into an apparent RA movement) that is triggered by a DEC reversal (fig.14). Choosing an optimum guiding algorithm usually starts by evaluating a default value and then, after some appreciation of the way the mount is drifting or reacting, making informed guesses and evaluating alternatives. (PHD2 usefully has a tool to measure DEC backlash.)

Star Mass

I often use PHD2 with SGP to do my guiding. On a few occasions the 'star lost' warning has come up whilst I'm sleeping and the system has shut down, fearing the worst. The cause is one of the PHD2 settings that is enabled by default. This is the Star Mass Detection option in the Guiding settings. This is designed to detect and prevent the guide star flipping between close stars of different magnitudes, most frequently found at shorter guiding focal lengths. It can also trip due to changes in transparency or a passing vapor trail. In practice, I disable this feature when using an off-axis guider.

Guide Exposure and Star Selection

Although we have discussed increasing the guider exposure duration to smooth out seeing noise and improve the

fig.14 *This is a 60-second image capture of a bright star, during which the mount has been successively moved N, S, E and W from a central position using manual guider commands (5 seconds at the guiding rate). The imaging sensor is aligned with the RA and DEC axis and you can see that when the DEC correction reversed, there is a small shift in RA too, shown by the double vertical trace and possibly caused by insufficient DEC bearing pre-load. In practice, however, it may not necessarily manifest itself unless one is heavy-handed with the guiding corrections. This mount routinely achieves sub 0.3 arc second RMS tracking accuracy with 2,000 mm focal length optics and on account of the highly accurate polar alignment, has frequent DEC reversals.*

signal to noise ratio, too much can be a problem if the combination of the guider exposure and the star intensity overloads the sensor well-depth. The centroid detection algorithms work best when the intensities are within the sensors range. Check your guide star choice with the longest likely guide exposure by sampling its peak value or reviewing its star profile, such as the one in PHD2, shown in fig.13 and which displays "Sat", for saturation.

The Mount

Given that we now have improved the star measurement as best we can and can translate this into RA and DEC corrections, what next? We have already established that the measured tracking errors still suffer from considerable noise. If we slavishly follow these values, the mount will try to follow in the seeing's footsteps, only several seconds later. This will simply move the mount around and the seeing, which after exposure integration is mostly a sub-second phenomena, will add further to the image blurriness and possibly double it. If we don't overreact but aim to reduce the apparent error by only 50% (aggressiveness = 5) we immediately reduce the influence of seeing on the actual mount tracking error by 50%. The trick is to set the *correction* as low as one can, yet still keep up with the underlying tracking error caused by drift and PE. The *correction* is an outcome of the aggressiveness setting and by the smoothing effect of any active filtering options that reduce the sensitivity to individual error measurements.

The guider input to the mount issues a discrete command that moves the mount at a guide rate and for a certain duration. The first of these two parameters is normally set by the mount control software or driver. The second is determined by the aggressiveness setting in the autoguiding program. There are two other parameters; the minimum and maximum move that set limits on movement. The guide rate / duration combination should be able to move the mount by the required angle

before the next guide cycle completes. If the guide rate is 0.5x, the error is 1 arc second and the aggressiveness is 7 (or 70%) the duration of the error correction t, is calculated by:

$$15 . 0.5 . t = 1 . 0.7$$

or $t = 93$ ms

These figures make interesting reading. A guide error of 1 arc second is 10x larger than the likely change in PE and drift between cycles, yet the duration is only twice the normal minimum mount move of 50 ms. (Although the default minimum move in Maxim DL's advanced guider settings is 10 ms, few mounts can reliably react to such a short relay command unless they use variable tracking rates with pulse guiding.) It also indicates our guide rate or aggressiveness is probably set too high to correct for actual tracking errors and this guider setting is likely to just react to seeing conditions. The probability is that these reactions will change direction after each cycle and the tracking will oscillate back and forth, adding to the seeing error. This suggests the following:

- If the signal to noise ratio is bad (there is little drift & PE or the seeing is bad), expose for as long as you can and set the aggressiveness and guide rate low, to stop the mount overreacting to seeing conditions but still keep up with any actual tracking error.
- If the signal to noise ratio is good (that is the mount needs taming, or you are on the top of a mountain) use a shorter exposure and set the aggressiveness and guide rate higher to keep up with mount tracking issues. This also is an excuse for a new mount or better alignment.

Unique DEC Axis Issues

Both the RA and DEC motor and gear assemblies have tolerance issues that manifest themselves as periodic error, backlash, play and static friction. These do not

equally apply: Since the RA system is continuously moving in the tracking direction, it should never encounter backlash or stiction (the one exception is in an unbalanced configuration when the OTA tips over). The DEC motor on the other hand is basically stationary and potentially has backlash and stiction but does not encounter periodic error. Play, however, sometimes the effect of insufficient bearing pre-load, can cause either axis to wobble and cause an apparent shift on the other axis (fig.14). A few microns of play can cause several arc seconds of movement. So far though we have generalized on issues common to both axes and we should additionally consider the special cases of backlash and stiction on the DEC axis. These are non-linear effects and require a non-linear treatment.

Static friction and dynamic friction are the terms given to the force required to move a body from rest and keep it moving. Static friction is always higher; the force to move your computer mouse is less than that to keep it moving. In a mount, the label stiction is given to that initial force to get things moving. For a small movement, the applied forces by the motor and gear assembly may be insufficient to overcome stiction, or worse still if you are changing direction, the energy stored in the flex within the bearing and gear assemblies may temporarily reverse the intended movement. After further movement commands are issued, the forces in the system are overcome, the full motor torque is applied to the head and things start to move (and in the right direction). If the mount does not move, it simply introduces a further lag. Since the input signal is mostly noise, the mount will either catch up on the second cycle, or the error nulled out by subsequent random commands in the opposite direction. If the mount temporarily moves in the wrong direction, it creates the potential for over-correction on successive guider cycles. One solution is to disable any DEC corrections in the direction of drift; this can either be done manually (fig.11) or alternatively PHD2 and Maxim DL have a facility to detect the drift direction and minimize DEC commands that add to it. With the right telescope fore-aft balance, this can be very effective but may falter when the telescope is pointing near the zenith, as there is no angular moment and the scope is "floating", for want of a better word.

Backlash is another non-linear affect and occurs when the DEC gears try to change direction. Unlike the RA gear, which is constantly tracking in one direction, the DEC motor is mostly stationary and gear backlash cause guiding commands in a reverse direction to have less than the desired effect. The guider calibration image in fig.9 actually shows it up: The red line traces the

star position at the end of the four calibration moves. If you look closely, the star does not return back to its initial position. The backlash is the small remaining distance. Judging from the length of the red lines and the calibration time, the backlash in this case is just under 1 second (at the guiding rate). This number may be useful later on. PHD2 has a more sophisticated method of measuring backlash within its calibration tools. The same unidirectional movement strategy used for stiction can help here too. Again we can selectively disable certain directional commands. This might be the end of the story until you execute a meridian flip or use dither. In the case of a meridian flip, the guider software must reverse the RA commands and swap over any disabled settings. (It is explained elsewhere but briefly, dither is a small deliberate image shift between exposures. Each exposure is in a slightly different position and after they are aligned and combined, the random distribution of hot pixels facilitate their removal during image processing.) In Maxim DL, when guiding, the dither movement is executed via guider commands. If it happens to request a movement in the DEC drift direction it can take an age for the mount to move by the correct amount. In effect, the drift has to catch up with the dither amount. You can prevent the main exposure starting until the tracking is back on target (within an error threshold) or after an elapsed time. PHD2 has an option to dither only in RA, to avoid this potential hang-up.

In these circumstances, one alternative is to enable backlash compensation. This is a feature of Maxim DL, PHD2 and some telescope mount drivers. If mount-based backlash is available it is usually a single parameter hysteresis value designed for visual observation purposes and if set too high, will cause DEC oscillation. PHD2 backlash compensation is more sophisticated, not only does it measure the backlash, it also dynamically adjusts the required amount based on real-time guiding performance.

Backlash creates a dead band with DEC reversal. In my SkyWatcher mount, DEC backlash was apparent during its calibration (fig.9) at about 10 arc seconds, or 1 second at a guiding rate of 0.7x. If the mount had both DEC movements enabled, it potentially set a rather large lower limit on tracking error. It is a bit like setting a minimum movement value of 1 second. The backlash compensation feature essentially skips over the dead band by adding additional guider movement time if, and only if, its direction is opposing the last.

The backlash value is measured in time (at the guider rate) and should be set to a value less than the actual backlash. The remaining backlash value is effectively the

difference. If you set its value too high, the mount will oscillate in DEC and the guider graph will show alternating large positive and negative tracking errors. Backlash compensation is tricky to get right and its avoidance is better than its cure. With backlash compensation, less is more. Lastly, if it is available, the "resist switch" or equivalent guiding algorithm, which requires several tracking errors to occur in the same direction as the last correction before electing to change the DEC correction polarity, will reduce the number of reversal instances.

Guider Settings

Autoguiding is not a trivial matter to get right and creates numerous practical compromises. The autoguiding programs go a long way to solve most issues but it still requires some work on the part of the astrophotographer to understand their system and set exposure times, guide rate, movement limits and establish if stiction and/or backlash compensation is required. If the inherent mount tracking errors are small to begin with, it allows longer guider exposures and a gentle touch to keep any remaining errors in check. As tracking errors become larger, a careful balance of correction versus over-correction is required. The autoguider tracking graphs give a clue if the mount is over-reacting to seeing conditions or if drift and PE are creeping in.

Good RA guiding results in a tracking graph that does not produce successive large corrections in opposite directions and only makes a few corrections in one direction before doing nothing (until the PE accumulates above the minimum movement value). If the autoguider requires many corrections in the same direction, especially with a high aggression setting, it is likely the system is not catching up. It is unlikely to be the guide rate or the maximum movement setting; even at their minimum settings they should keep up with all but the worse mount PE. It is more likely that the minimum movement is set too high or a result of excessive measurement latency (the centroid measurement of a 10-second exposure is 5 seconds old already). Since successive corrections in the same direction are an indication that seeing noise is not dominant; it should be safe to lower the minimum movement and exposure.

On the DEC axis, the guiding should only correct for drift and ideally, send out commands in one direction (and the opposing direction after a meridian flip). This behavior can be forced, by disabling corrections in the direction of the prevailing drift, or through long exposure and minimum movement settings. (This, however, does not allow you to dither between exposures on the DEC axis.) In general I disable the DEC compensation feature in the guider controls and calibrate

the autoguider at a low declination. In practice I find this gives greater stability when the seeing conditions are poor. Before I rationalized my guider parameters, my first attempt to image M82 at 70° DEC produced a tracking graph that resembled the Swiss Alps!

One other thing to watch out for is the combination of low aggressiveness, low guide rate and a large minimum movement that can prevent guider corrections and lock in an error threshold, calculated by the following equation:

$$error\ threshold = \frac{guide\text{-}rate \cdot min\ movement(sec) \cdot 15}{aggressiveness}$$

A 50 ms minimum move at 0.5x guide rate and 50% aggression setting locks in a ±0.75 arc second error guiding dead band, within which there are no corrections. (This is twice as large as the RMS tracking error of my Paramount.) On the other hand, a maximum move of 50 ms in PHD2 for DEC at 0.5x guide rate will keep up with the drift caused by a large polar alignment error of 15 arc minutes.

Case Study: Avalon Linear

It is useful to lay out the evaluation of the guiding parameters for a new mount. As we have seen, there are many variables and experimentation is always necessary. The trick is to narrow the range down using information about the mount's construction, conventional wisdom and intuition. The Avalon Instrument mounts are unique in that they use toothed belts to transmit and reduce the drive ratio from the motors to both axis. The belts are very durable and due to the large contact area around the various pulleys, do not exhibit a classical short-term periodic error. There are tracking errors, however, but they are hard to characterize (fig.16). With no gears, there is effectively no backlash but being a belt, which bends, there has to be a little elasticity. Some mount designs exhibit obvious play in worm drives or reducing gears. In this case, the drive yields elastically to an externally applied force. An Internet search from user forums is always a good place to start and in this case indicate a range of user-recommendations ranging from 100% aggression, 1-second exposures to 10-second exposures with less aggression. They all agree on using a slow guide rate and a small minimum movement value (presumably on the basis that lots of small, slow adjustments are better than a large fast one). This unique mount design should therefore make an interesting case study.

The first step with any mount is to analyze the underlying tracking error (without any guiding). This gives an indication of the polar alignment, the peak to peak error

and most importantly the tracking error's maximum rate of change. After setting up an accurate polar alignment of less than 1 arc-minute, I measured the tracking error over a 10-minute period. To reduce false measurements arising from seeing noise, the exposure was extended to 3 seconds. The all important parameter is not the peak to peak tracking error, but the rate of change of tracking error. In this case, the worse-case rate measured 0.32 arc seconds/second, suggesting that short guider exposures (or more accurately guide intervals) of 4 seconds or less were required to minimize the peak guided tracking error. Short-exposure, high-aggression guide settings are unusual and traditionally lead to erratic mount movement as the system tries to chase seeing noise. On the other hand, a low aggression value would be insufficient to keep up with the maximum rate of tracking error change, especially if used with longer guider intervals.

Using an autoguiding program to measure tracking error is very useful but becomes less accurate with short guider exposures in the presence of seeing noise. Anything less than a few seconds is likely to be give an overly pessimistic indication of tracking performance. The ultimate measure are the star's appearance in the image. The FWHM and the eccentricity are excellent measures to get the very best out of the system. A software utility like CCDInspector can monitor a folder and plot these attributes in real time, say for a sequence of 5-minute exposures using a range of guide exposure, hysteresis and aggression settings.

I also wondered if the mount would "bounce" with an impulsive movement. I visualized the mechanical behavior by considering a ball suspended from an elastic string and how I might lift and lower the ball without making it behave like a yo-yo. The answer is to use small moves, with low acceleration and in a time frame that does not reinforce any natural oscillation. I realized too, that the guiding parameters will be particular to the imaging system, since the mass affects any oscillation period.

In guiding terms, this empathetic approach suggests a slow guide rate (< 0.25x) and small minimum move (to prevent a dead-band). To avoid unnecessary movements from chasing seeing, it suggests guider exposures in the range 1.0–4.0 seconds, with no delay, and high aggressions setting of 75% or higher, with some hysteresis for filtering. Within these confines, there are several combinations that trade exposure time with aggressiveness and

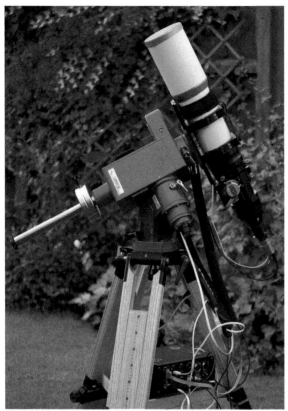

fig.15 *The test rig for establishing the Avalon Linear autoguider parameters. A medium refractor was fitted to the mount along with a high-speed guide camera and polar aligned with a QHY PoleMaster. The counterweight position indicates this is a lightweight imaging system and it may be necessary to additionally tune the autoguider parameters when using a heavier scope.*

fig.16 *The unguided tracking graph for the Avalon shows the level of tracking error, its magnitude and most importantly, the rate of change, which is a function of the slope or the tracking error characteristic. This sets an expectation for the maximum guider interval. If the slope changes rapidly, this can catch out guider parameters that rely on heavy filtering to remove seeing noise. These important characteristics correspond to the first and second derivatives of the tracking error. Newton would be proud.*

hysteresis, providing an opportunity to avoid oscillation over a range of equipment masses. It also occurred to me that in a system with allegedly no backlash and a compliant drive, symmetrical guider responses would benefit from precise equipment balance, a view supported by several recommendations from user forums.

Before trying these out, I tried an unusual experiment to understand the dynamics of the mount. Movement around DEC and RA axis can be quite different on account of the angular momentums involved. Any RA move swings the considerable counterweight and telescope masses about its axis but a DEC moves rotates the counterweight and telescope tube on-axis.

To get a feeling for how the mount would respond to a stimulus, I mounted a digital SLR to a 600-mm focal length lens and took a 10-second exposure of a bright star as the mount slewed in RA. During the exposure, I tapped the telescope lightly in the DEC movement direction and then examined the image. If the mount was going to "ring" in DEC, this would be seen as a wiggle in the star trail. Assessing this in RA required repeating the experiment, only this time, with the mount slewing about the DEC axis during the exposure (using the handset) and tapping the end of the telescope about the RA axis. In practice, the best conditions for this experiment were when the stimulus was confined to one axis. This is most easily achieved when DEC is close to zero and pointing at the meridian. The results can be seen in fig.17 and fig.18. In both cases the ringing decayed to negligible levels within 1 second, with the additional mass of the RA axis extending the decay period. The results suggest guider exposures of less than about half a second should be avoided as it might cause oscillation.

After a little experimentation, the final result proved the initial hunch was not far off (fig.19). The trick was to put as little energy transfer into the mount as possible and the guider responded with respectable guiding errors over indefinite periods, achieving a respectable RMS tracking error of 0.44" RMS in good seeing conditions.

The current SkyWatcher ASCOM driver permits guide-rate settings down to 0.1x. The new Avalon StarGo controller goes down to 0.05x. (This can be retro-fitted as an upgrade accessory.) There is room for further improvement and if the ASCOM driver is similarly updated, I will try 0.05x and zero the minimum move settings. As mentioned before, using the PHD2 graph to measure tracking performance with short exposures is undermined by poor seeing and my next step will be to do the final fine-tune by comparing star FWHM and eccentricity from using 2-minute imager exposures taken at different guider settings (or wait for excellent seeing conditions).

fig.17 This star trail of 2 seconds, taken with the mount slewing in RA, shows the effect of a light tap on the telescope about the DEC axis of rotation. It gives an indication of how the mount might respond to DEC guider pulses.

fig.18 As fig.17 but this time evaluating how the mount might react to a RA guider input. In this case, the mount is being slewed in DEC (using the handset over a 2 second period). The light tap is this time aimed about the RA axis.

fig.19 The guided tracking graph for the Avalon, close to its optimum setting and confirmed by checking the FWHM and eccentricity in CCDInspector. The RMS tracking error is 0.44", using the hysteresis algorithm, set to 15% with 2.5 second exposures, small minimum move and an aggression of 75%. The Lowpass2 algorithm works well too, using shorter exposures and zero min. move.

Pointing and Tracking Models

New technologies to make pixel-perfect object location and unguided long-duration exposures a reality.

The latest trend in mount design is to add modern electronic and software components into the system to deliver precise pointing and tracking abilities to accommodate all manner of mechanical limitations and atmospheric effects. A telescope mount on its own is a dumb pair of motors, that is, until it is connected to a computer that models the mechanical, astronomical and optical properties of its environment. A "model" in this instance refers to a complex multi-variable equation that correlates the mechanical properties of the mount and telescope with an aligned star database and the optical characteristics of the Earth's atmosphere. There are two types; a pointing model and a tracking model.

Pointing Models

The purpose of the prior chapter is to improve tracking performance during exposure. When the subject of models is introduced we only need to touch upon pointing models, clarify the distinction and move on. Programs such as Maxim's MaxPoint or the TPoint add-on for TheSkyX reside on a PC and create a model that enables the user to accurately point to objects in the sky and at the same time, report the polar alignment error. The 10Micron mounts have the same ability within their Linux-based controller. These are a step on from the multi-star alignment routines found in many GoTo mount handsets. Here, the model translates a database object position to a set of mount coordinates that account for various mechanical alignment, refractive and time-base errors. In practice, after simply sending the modified slew command to the mount, it then leaves the mount to track on its RA axis and at the sidereal rate.

This is useful but not mandatory for astrophotography: In a permanent setup, model generation is an infrequent event and it is convenient to use a prior model to center objects within several arc seconds, prior to an imaging run. In the case of a portable setup, the time taken generating the model each night is arguably better spent on refining polar alignment, since many acquisition programs now have closed-loop slew features.

These achieve remarkable pointing accuracy in under a minute. In practice, the software slews to the target, exposes, plate-solves, and corrects the mount position to the plate-solved position and repeats the slew command.

If there is backlash in the system another iteration often improves things to a single-digit pixel error. I routinely use this approach in a portable setup using Sequence Generator Pro (which automates the cycle) to point within a few pixels of the target in a single go. If I did use have an extensive pointing model for the pier-mounted scope, I would continue to sync to target at the start of a target sequence or after a meridian flip. This closed-loop system either makes use of the a telescope sync command, or calculates its own offset to issue a slew correction. One thing to take note of; if the mount already has a pointing model, a further sync command on another occasion can cause a hiccup (on account of different atmospheric refraction or a small clock error). To prevent this occurring, some telescope ASCOM drivers have a sync inhibit option, which either blocks the sync command entirely, or instructs the mount to sync outside of the model and not refine it.

Tracking Models

The second type of model is typically deployed within the motor control system of the mount and changes the way the mount moves across the sky. This is a tracking model and is typified by the system in the 10Micron mounts, Paramount's ProTrack system and the latest AstroPhysics designs. A significant difference between the two model types is a mount using a pointing model tracks with the RA axis only and to eliminate drift during an unguided exposure it is necessary to accurately polar align the mount. A tracking model uses both RA and DEC motors and will effectively eliminate drift and periodic error during tracking. The 10Micron mount employs shaft encoders and a control loop to effectively eradicate all mount mechanical tolerances. The Software Bisque mounts do not have shaft encoders but use a sophisticated model to tackle the residual tracking errors after PEC. In both cases, the model also accounts for mechanical anomalies, such as flexure, in the entire system. It is sometimes claimed that a tracking model can account for less than perfect polar alignment. Even so, it is not good practice to make the tracking model work hard on account of gross polar misalignment in any system, as it places unnecessary demands on the tracking corrections and, even perfect tracking with poor polar alignment, may show up in the form of star rotation in the outer image field over a long exposure.

If the optical configuration is changed, a new model is required to account for the different flexure, collimation and alignment errors. A model is a mathematical equation that relates a set of assumed and actual coordinates for multiple points in the sky and any points in between. The data that is used to calculate the model is generated by slewing the telescope to many different points in the sky and recording the assumed position and the actual position. This is either done by manually aligning a well-defined star on the CCD (using the slew controls) or more conveniently by taking a photograph, plate-solving the center of the image and syncing. To make a robust model, there should be data points on both sides of the meridian and at different altitudes. In this way the model will incorporate the mechanical flexures in the system and misalignments between the motors and the optical axis. To make a successful model it is essential that you address the mechanical, astrometric and the optical properties of the environment with equal care.

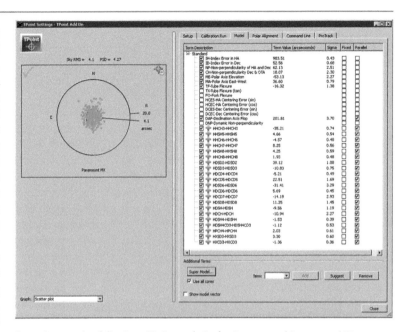

fig.1 *A screen shot following a TPoint analysis of a pier-mounted Paramount MX and a 10-inch RC telescope. The RMS pointing accuracy is just 4 arc seconds. The list on the right hand side show the various terms and factors that make up the complex modeling equation for pointing (and later on, tracking).*

Reality Check

Tracking models are very alluring. For some, the ability to make unguided exposures is the holy grail. It is not a panacea for everyone though and it is important to decide whether or not it is entirely necessary or effective in your own particular circumstances. The performance of tracking models is hotly contested and very dependent on your imaging requirements and standards. Please keep in mind that those imaging at short 400-mm focal length have a considerably less demanding requirement than those at 2,000+ mm and that reports of success in less than ideal circumstances may be a consequence of this, imaging at high declination, or a fortunate one-off.

Having direct experience of several dual-axis tracking systems in both permanent and fixed sites and over several years, I have reached a personal conclusion; a mobile setup is not ideal for the purpose of unguided dual-axis tracking. It is not ideal for a number of reasons: In a portable setup it is necessary to generate the model each time you set up. A good model takes time and care to get right and uses up precious imaging time. In comparison, those with a permanent setup can re-use an existing model up until the day they change the imaging hardware. A tracking model relies upon a set of repeatable errors. If not, the tracking is compromised. A tripod support is less rigid than a concrete-mounted pier and made worse if it is on a compliant footing. We have already seen how the smallest movement of a single tripod leg translates into a significant and unexpected drift. In addition, the generally lighter-weight components and exposed nature of a portable rig create their own challenges. I often use the 80–20 engineering paradigm, here with the thought to achieve the 80% with pragmatic polar alignment and a basic tracking model and the remaining 20% with gentle autoguiding to accommodate the residual or variable errors. In theory, this makes a lot of sense, but only if the dual-axis tracking and autoguider systems play together nicely. This is not always the case and something to look out for in your own system. In a permanent setup, the model and hardware can be optimized over time so, even with long focal lengths, unguided operation is an achievable goal. My goal here, however, is to achieve good tracking and if one achieves low RMS errors simply with PEC, accurate polar alignment and autoguiding, happy days. For those who do not have such luck, a mount that features a tracking model may be the answer. To get it to work needs an appreciation of the entire mechanical, software and environment system and how it affects tracking accuracy and repeatability.

fig.2 *Following on from fig.1, the TPoint model in TheSkyX*
can be used for dual-axis tracking (given there are
enough samples). Here, as a precaution, it is autoguiding
every 10 seconds using PHD2 and an off-axis guider.
The seeing was not great but the RMS tracking error is
0.3 arc seconds, well within the imaging resolution.

Mechanical Model Properties

As we have already realized, a telescope and camera fixed on a mount is a complex mechanical system. There are many physical properties that make it deviate away from perfection. Perfection requires the two motor axes to be perfectly orthogonal, a telescope that is perfectly collimated with the right ascension axis and an optical support system that has no flexibility or play when orientated at different angles. Perfection is an unobtainable goal and the next best thing is to minimize the errors and ensure the imperfections are consistent. In this way they can be measured and corrected for by the model. In practical terms this means that you should collimate the telescope as accurately as possible and ensure that the mount and optical support is rigid. It may be necessary to lock the focus, or in the long term, upgrade the focuser assembly, as these systems often are the largest potential source of flexure.

Another source of mechanical error is the positioning system itself. Gear systems are not perfect and various periodic errors introduce positional errors, possibly up over 30 arc seconds. The better mounts, using periodic error correction, reduce this to 1–4 arc seconds or less. Better still, as in the case of the 10Micron mounts, is to use an optical encoder in a feedback control system and effectively eliminate mount gear variation. Gear variation is otherwise difficult to model as it is a compound of multiple mechanical interfaces and is why tracking models work best with mounts using precision shaft encoders as part of their motor control system. The next best thing

is to use a belt-driven precision worm gear. For example, the SuperModel and ProTrack parameters in a TheSky X model correct for numerous mechanical alignment and refraction errors on a Paramount (fig.1, 2).

In the case of a shaft encoder system, the rotational angle of both axis are reported to fractions of an arc second. This information is used to send corrections to the motors to align the system. There are some challenges though: The encoder system has the same resolution as a good autoguider, without the seeing noise, at about 0.1 arc seconds. Unlike an autoguider, the position feedback is almost immediate and without noise. It still has to be integrated into a control loop that moves a motor quickly and without overshoot. The dynamics of the system do not make this a trivial task, especially if the control loop has to additionally cope with external dither and autoguider inputs too. In classical dynamic control theory, designing a responsive yet stable system with nested feedback loops is a challenge.

Astrometric Model Properties

Obviously stars appear to rotate as the Earth spins on its axis and we know we need the precise time to locate them on their endless cycle. In addition to this, the tilt of the Earth's axis, in astronomical terms, changes quickly (rotation and nutation) and on top of this, stars are not fixed in their relationship to one another as they circle around overhead (proper motion). As such, aligning reality with a catalog's static star database involves a number of different considerations and adjustments. The most obvious of these is the telescope's position on the Earth's surface, in terms of altitude, longitude and latitude as well as the precise time. Less obvious is ensuring that the coordinate system used by the catalog and the telescope mount are aligned. This last point causes some confusion and requires an understanding of Epochs and conversions: Catalogs have millions of star references and it is a mammoth task to update them. The result is they are static and standardized to a certain historical point in time (Epoch). In use, a star coordinate can be adjusted by a software calculation to any other point in time. Many applications including the common plate-solving programs use catalogs that define star astrometry in the J2000 Epoch. This defines the position of an object in RA and DEC as it was on midnight of 1st January 2000. Conversely, JNow is the RA and DEC coordinate at the current point in time. The difference can be calculated between the two providing you know your precise position and the precise time of the observation.

Telescope mount systems assume either JNow or J2000 coordinates and conversions happen between

software and hardware as required, providing that the different parts of the system are well defined. Maxim DL for instance can work in either J2000 or JNow and in the 10Micron controller, the software works solely in JNow coordinates. If J2000 coordinates are to be used with a mount that assumes JNow, either the driver or the mount software must make a conversion. If not, it will introduce errors into the model, measured today, in the region of a few arc minutes.

Many amateur telescopes use JNow (also called local topocentric coordinates). More sophisticated telescopes use one of the standard reference systems established by professional astronomers of which the most common is the Julian Epoch 2000 (J2000). These instruments require corrections for precession, nutation, aberration, etcetera to adjust the coordinates from the standard system to the pointing direction for the current time and location.

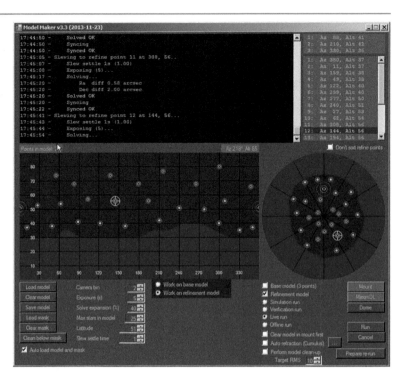

fig.3 The above screen capture is from a piece of donationware by the late Per Frejvall of Stockholm. His utility automates the data acquisition for the 10Micron mount model-building function. Interfacing to PinPoint and Maxim DL, it can acquire 25 sync points in about 10 minutes. With the right attention to detail in the imaging system setup, the resulting model effectively tracks unguided in both axis, without any apparent star elongation.

Time-Bases

Plate solving is the most expedient method to compare the apparent and actual position of sync points with which to calculate a pointing or tracking model. Plate solving is carried out in the PC. Establishing the coordinate pairs using a PC, rather than using the mount's hand controller to align stars, introduces a further source of error: Consider two identical telescope mounts whose clocks are one hour apart. If each is directed to the same RA and DEC coordinate, they will point to very different parts of the sky. If they are asked to point to the same Alt and Az coordinate, however, they will be aligned. Similarly, any calculations in the PC and the mount itself must assume the same precise time if there are any RA/DEC–Alt/Az coordinate conversions used in the internal calculations. The Earth rotates at 15 arc seconds per second and if the mount thinks it is midnight and the ASCOM driver and PC clock thinks it is 23:59:59, well, you get the picture. There are often several time-bases in play within the computer and the mount hardware. Ideally, they all must be perfectly accurate. That is not easy when one introduces a PC into the mix. They are not designed for this purpose and can drift several seconds over a week. A mount on the other hand, typically has a temperature-compensated crystal at its heart. In reality, there will be an absolute and relative time-base error that, depending on the what is going on at the time, will have a different impact: If both time-bases track perfectly but are 1 second out, the RA pointing accuracy will be out by 15 arc seconds but the tracking and model building process will usually work perfectly, accounting for the offset in the first sync. If there is a difference between the time-bases used for determining the actual and theoretical positions during model building, it translates to an error in the tracking model, especially if the time difference changes during the model building process. If the time-base used for tracking drifts, or is updated during an exposure, the tracking will similarly drift or jump in RA. The latter can happen if the mount (or PC) has been set up to update its time-base from a GPS source.

Ultimately, one needs to decide which device tracks time most accurately (normally the mount) and then set that up directly via a GPS unit or Network Time Server using the network time protocol (NTP) and ensure any

other time-bases are synced to this. This sets a baseline for the initial pointing accuracy. During the process of modeling, which may last all night, the time-bases usually free-run or at most, they are synced to the master in-between exposures. This ensures there are no discontinuities in the time-base that can be misinterpreted by the model calculations.

In practice, I set the time-base to the GPS clock or use an NTP utility, such as Dimension 4, at the beginning of the imaging session to improve the initial pointing accuracy. This is not as essential as one might think, since if the time-base is wrong, a single image sync offset will correct any offset. If there are any updates to the tracking time-base (or to the environmental parameters either) make sure these occur in-between exposures to preventing streaking during the exposures. (A simple time update may cause a sudden tracking correction and for that reason some applications low-pass filter environmental and time updates to make them less obvious.)

Plate-solving accuracy is the key to effective automated modeling. It is not perfect, however, and false matches do occur, especially if the pixel scale is incorrect. By way of example PinPoint commonly uses the GSCII catalog (a compilation of catalogs from different Epochs, converted to J2000) and reports the position of the image center in RA/DEC coordinates in J2000. If you are using Maxim

DL to acquire images, the pixel scale is reported in the FITS header of the image and is calculated from the Site and Optics settings for focal length and instrument in Maxim's settings dialog. If you have several telescope and field-flattener combinations, as I do, save specific Maxim DL configurations and load the correct one for the imaging session. After measuring the position at each sample point, it is important to review the individual pointing errors and delete the obvious outliers. The SuperModel option in TheSkyX does this automatically and other applications progressively delete the worst offenders above a threshold error value between the sample and the model.

Optical Model Properties

The last major consideration is the refraction caused by the atmosphere. There is no image shift at the zenith but progressively more towards the horizon. The ultra-precise polar alignment finders forget to mention that the apparent position of the North Celestial Pole and its actual position are different! Refraction effects can be modeled comparatively easily. Many PC applications (planetariums and applications such as MaxPoint) make allowances for refraction when they issue a slew command. This helps with pointing accuracy but does nothing to improve tracking. When the mount controller calculates the effect of atmospheric refraction on a star's apparent position, it not only improves pointing accuracy but makes it easier to model the remaining mechanical attributes more accurately and improve tracking accuracy.

To calculate the correct amount of atmospheric bending, we need the altitude of the object (coordinates), the ambient pressure and the ambient temperature, both measured on-site. The formula below, devised from Garfinkel in the 1960s for calculating the refraction based on the true altitude is accurate to 4 arc seconds (assuming 10°C and 101 kPa):

$$R\ (arcmins) = 1.02 \cdot \cot\left(alt + \frac{10.3}{alt + 5.11}\right)$$

At 40° altitude, an unguided 5 minute exposure can have up to 3 arc second apparent drift in RA. For other temperatures and pressures (in °C and kPa) it is multiplied by the following factor:

$$\frac{P}{101} \cdot \frac{283}{273 + T}$$

This formula is used in many applications and is in ASCOM's astrometric function library. It makes a big difference; at 25° it is 130 arc seconds and even at 40°, the shift is 73 arc seconds. Compared to a 5 arc second

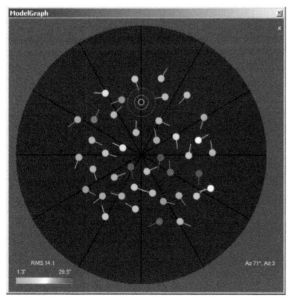

fig.4 This screen capture of ModelMaker for the 10Micron mount shows the reported sync point errors in the model and their direction. This model was generated in less than ideal conditions or settings and required a re-run after going through the checklist.

RMS (root mean square) target error, this is significant as a star changes its altitude during tracking. The refractive index relates to the air density and depth, which in turn is determined by air pressure, temperature and altitude. One could theoretically calculate it all in the model, along with all the mechanical considerations. Mathematically speaking, if the parameters are well understood and the refraction model is robust, it is better to deploy this model up front and load the refraction parameters into the mount before measuring points for a model. Refraction parameters can be entered directly into the mount via the handset or PC software. Refraction is particularly sensitive to temperature changes and the refraction increases as the temperature drops. Some ASCOM drivers and utilities also allow for the automatic updating of these parameters at the start of the run or during tracking. Others use the standardized text format files produced by some electronic weather stations. Paramount mounts have an internal temperature sensor which tracks ambient trends and the latest ASCOM environmental definitions will likely lead to full parameter update from external sensors in due course.

Effective Model Making

As an example, the tracking model for a 10Micron mount can deliver unguided 10-minute exposures, with an aspect ratio of less than 15%, even with modest polar misalignment. It is not a free ride; with all that has been said, generating an accurate tracking model requires attention to detail and optimization.

The following are the basics prerequisites. In no particular order:

- ensure the mechanical system is stable
- careful balance on both axis (reduces flexure)
- tighten the RA and DEC clutches
- set accurate location and altitude in the mount
- set correct epoch ASCOM driver settings
- set and synchronize time between the plate-solving system (PC) and mount with an accurate time source
- set air temp for refraction calculation
- set air pressure for refraction calculation (in the case of the 10Micron mount you should either enter the air pressure at sea level and have enable auto altitude in the mount or supply the surface air pressure and disable the auto altitude function)
- enable refraction
- set correct focal length in Maxim DL in Settings, Site and Optics for plate solving
- check camera sensor pixel pitch is set (modern astro CCDs communicate this automatically)

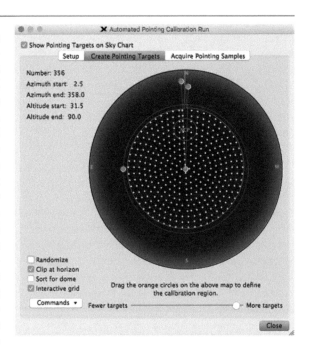

fig.5 *This screen capture from TheSkyX is the equivalent to the one in fig.3. Sample placement can be automated and constrained by horizon, altitude and either evenly-spaced or randomized. The sample order minimizes the number of meridian flips and all samples are considered in the determination of the polar alignment and model parameters.*

In the case of the 10Micron modeling software, you should additionally check the following:

- mount is set to treat 'syncs' to refine model
- set the PC clock with a NTP server or GPS
- one-time sync the mount clock to the PC clock (or use the Clock Sync utility)
- set exposure, binning and mount settle times for reliable plate-solving
- remember to clear the existing model in the mount before beginning a new model, or after polar adjustment
- enable dual tracking in the mount

If you are solely using the handset for model making, the Epoch parameters take care of themselves and it is only necessary to make sure that time, location (say with an external GPS) and environment parameters are set in the mount. You also need to check that the sync setting is set to "sync refines", rather than treat the sync as an offset, so that all your patient work adds further data points. (Before Per passed away, he added a facility for continual environmental updates to the 10Micron model.)

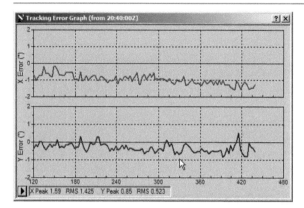

fig.6　This screen capture shows the tracking graph from Maxim DL (with the guider output disabled) for the imperfect model in fig.4. In context, the vertical axis is just ± 2 arc seconds. A very slight drift in RA can be seen over the full exposure. The actual exposures were perfectly usable, however, as seeing conditions were the limiting factor.

Running and Checking the Model

The first part of a 10Micron model is usually a three-point synchronization to determine the assumed celestial pole position. This can be done manually with an application like Maxim DL or a model making utility. The accuracy of these are fundamental to the final model accuracy and require special attention. These three points should be about 120 degrees apart in azimuth, about 40 degrees in altitude and avoid points on the meridian. It is good practice to use a longer exposure, say 15 seconds, no binning and a generous settling time to ensure an accurate plate-solve. It is important to check the errors for these first three points using the virtual handset or model making utility and redo them until they have single digit arc second errors. This may involve going through the checklist again and updating refraction settings.

The initial physical alignment of the mount requires a position that ideally is within the field of view of the camera for the plate-solve to work. Use your favorite method to polar align. One alternative is to slew to and center a named star, using the Alt and Az knobs, before starting the three-point calibration. In the case of the 10Micron mount, the polar alignment error report includes turn instructions for the Altitude and Azimuth adjustment knobs. If you follow the recommendations, turn the knobs by the required amount and re-run Model Maker (remembering to clear the model first) and you should be within 5 arc minutes. This may not be sufficiently accurate for unguided operation and may require further calibration. In a permanent setup, there is no reason why one should not aim for sub arc minute polar alignment error.

After the initial calibration any subsequent syncs are treated as "refine points". As more refine points are collected in the model, it becomes more sophisticated with potentially more equation terms in the model to map the theoretical and actual coordinates. Theoretically the error between reality and the model should decrease with more points but that is not always the case; it all depends upon the data. The mount alignment report displays how many terms it is using in its modeling equation and the error between each measurement point and the model. More points or terms do not always equate to better tracking accuracy. Errors do happen and it is better to have fewer, good points than many points with large errors. The better systems report the error of each sync point and have the ability to delete the worst point and resubmit the remainder of the data points to generate a new model. This is usually done to achieve a target RMS error. A rule of thumb is that no point should be over 10 arc seconds and an RMS error of 5 arc seconds or lower is a good result. A combination of a low RMS and a low term count implies a simpler and "smoother" model, with fewer anomalies.

The Software Bisque mounts are supplied with TheSkyX and their modeling software TPoint®. The intelligence for the mount and the modeling software reside on the same PC, bypassing time conflicts. The TPoint add-on is highly integrated with TheSkyX, making use of its planetarium, plate-solving and camera functions. Although these mounts are built to exacting standards the current Paramount models do not employ shaft encoders and so their residual tracking errors (after PEC) are higher than the 10Micron mounts. TPoint is very easy to use, however, and automates the image acquisition, plate solving, filtering and modeling terms (fig.1, 5). In practice my Paramount MX closes-in on the 10Micron accuracy with approximately double the number of sync points. The Model Maker software tops out at 100 points, whereas TPoint can exceed 500. TPoint requires about 20 sync points to nail Polar alignment error and 50 suffices for very accurate pointing. Each point has equal weighting in the model calculation and hence there is no need to make special efforts to define polar alignment error at the beginning of the process. The TPoint software also realizes that it obtains better results with fewer meridian flips during calibration. It can create random or regularly spaced sample points over the imaging horizon and organizes them into an optimum sequence. Although the tracking model accounts for atmospheric refraction, flexure and a multitude of mechanical errors, a TPoint requires more points for accurate unguided tracking. Moving along, and ideally after acquiring a few hundred data points,

their Super Model feature automatically deletes outlier points and adjusts and adds model terms to reduce the RMS pointing error further and to generate a tracking model (ProTrack™) for unguided exposures. The Paramount has negligible backlash and stiction and guides well via ST4 or pulse guiding interfaces. I typically run unguided with focal lengths less than 500 mm and use gentle autoguiding with the longer refractors and the 250 mm f/8 RCT.

One can check the tracking performance of any mount by calibrating and running your autoguider application, disabling the guider outputs and viewing its tracking graph. To distinguish tracking errors from seeing, use an exposure time of 5 seconds or more. Tracking performance is still affected by the mount's mechanical properties. Non-linear effects, such as backlash and stiction have to be addressed by the motor control feedback system. This is most likely to have an effect on the accuracy of the DEC axis tracking.

Summary

Tracking models (and encoders) appear to be a simple panacea for those who dislike autoguiding. They are not, since the system requires considerable diligence for it to be effective. In particular, a portable setup still requires optimized balance, alignment, live environment parameters, system rigidity and imaging time to generate an effective tracking model. Ground stability is not guaranteed and wet and dry seasons may require a new model. To my mind, a quality mount (polar aligned to 2 arc minutes or better) that is responsive to guider commands and whose motor axis exhibit little backlash is consistently easier to set up and a more effective use of a clear night. In a permanent setup, it is worth spending an entire night or more refining a multi-point model to improve tracking performance. Although some may shudder at the heresy, with a reasonable tracking model autoguiding is easier to implement, using a long exposure and a low aggression setting, to correct tracking drift and the repercussions of atmospheric refraction changes.

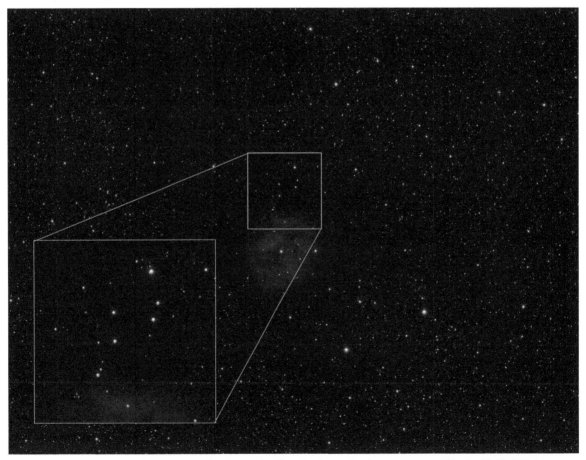

fig.7 This is a 10-minute unguided exposure with a 924-mm focal length refractor fitted to a Paramount MX, using TheSkyX TPoint modelling and ProTrack. The eccentricity of 10% is very difficult to detect and indistinguishable from the guided exposure.

Sequencing, Automation and Scripting

The power of automation extends one's ability to image for longer and adapt to changing conditions, with an immediate benefit on image quality and sleep.

In the beginning, film cameras were operated with a mechanical cable release and later, as electronic cameras evolved, using an electronic release or intervalometer. With the introduction of USB communications, more sophisticated computer control became possible including full remote control. The advent of digital SLRs refined the interface further and make image download a possibility too. The same evolutionary forces play out across many other astronomy devices and, with the advent of the Internet, remote control from virtually anywhere is not only a possibility but a reality for many astronomers. Without automation, however, all of this control still requires human monitoring and intervention and little sleep.

Sequencing and Automation

The mainstream image acquisition applications have varying degrees of automation, of which simple sequencing is the backbone. This, like an intervalometer, takes a series of exposures, adding various options of filter selection, binning, exposure length and camera angle. From here things start to get interesting; other activities are needed for extended sequences in real conditions including autofocusing, dithering, guiding and meridian flips. Very soon, what started off as a simple set of exposures becomes a complex interaction of multiple device controls and conditional activities and intelligent logic.

At this point, the acquisition applications take two different paths: The long established ones have mostly side-stepped advanced automation by offering an application interface (API) that allows third-party developers to manage the logic and the image acquisition application for basic equipment control. A combination of Maxim DL or TheSkyX with CCDAutopilot, CCDCommander or ACP offer programmable control options within the logic boundaries set by the application and use scripting to extend them. ACP also offers a controlled remote control environmental via a web application. This is useful to prevent inadvertent issues caused by the more intrusive operating system access offered by Microsoft Remote Desktop, TeamViewer and the like. Some remote imaging companies use a modified version of ACP to provide the user interface to their customers. SGP, which originally started as an automation front end to Nebulosity, has developed into an image acquisition suite in its own right, but uniquely offers a high level of intelligent automation within the application that is ideally suited for modest amateur observatories. It too has an expanding API, allowing access to camera and mount controls.

Each of these applications require updates to keep abreast of hardware and ASCOM developments. In the heavyweight external applications the user has extensive controls at their disposal, including the ability to further customize functionality through scripting. In the case of Sequence Generator Pro, the automation logic within the application is a careful trade-off between feature content and user interface complexity. In any sophisticated application, it is a fine balance between ease of use and providing multiple options, not all of which will be relevant for any particular user.

Drawing direct comparisons between the applications is difficult. The automation features are broadly similar and mostly differ in their detailed implementation and the user experience. These differences are further blurred by the possibilities brought about by scripting. Automation features basically fall into several categories:

- target planning
- acquisition automation
- observatory control
- remote control

Some go further and additionally do image calibration and stacking. Although convenient, these are crucial stages of linear imaging processing and ones that benefit from dedicated tools, judgement and discrimination.

Planning

At its simplest level, planning involves selecting an object, ensuring it is visible during the imaging window and setting its coordinates. Most planning tools can selectively choose objects from a catalog, based on type, visibility and so on and export into a proprietary file format. The nearest thing to a standard is the OpenAstronomyLog XML format. From here things quickly become more exciting: The advanced planning tools that work with planetariums help one to compare the object outline with the sensor field of view, determine the optimum angle and check for an available guide

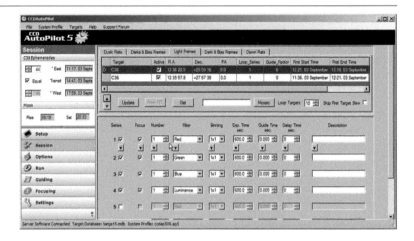

fig.1 *CCDAutopilot, showing a two-target sequence, acquires focus, guiding and images through either Maxim DL or TheSkyX applications. It optionally allows focusing with FocusMax (which CCDWare recently acquired and now offers as a commercial product). For the full effectiveness of FocusMax to be realized, telescope control is required to slew to stars of sufficient magnitude for short autofocus exposures.*

star. A catalog's object RA/DEC coordinates are a useful starting point but this may not be the optimum position for image composition. When the object extent reaches beyond the field of view, mosaic-planning is required. Graphical tools that overlay image Field Of Views (FOVs) over the image are invaluable in these cases. It is overkill for a single imaging object that takes several sessions to complete, as the setup time in an application such as SGP only takes a minute to adjust the framing and then plate-solve and record the coordinates. It becomes more useful though as things become more complicated; an object with limited visibility, may be partnered with a secondary object in an imaging sequence to make the most of a clear night. At the extreme, this is essential for supernova hunters who image hundreds of objects (typically galaxies) each night using a single exposure for each. The better planning software sorts the targets to maximize the number that are visible during any one night.

Acquisition

With the target(s) defined, image acquisition takes over. Here automation goes beyond a simple sequence of exposure times and filters to include:

- model building to reduce pointing errors and polar misalignment
- closed loop target centering, using plate solving to issue small corrections to the mount
- slew, solving and re-centering target to within a few pixels
- camera rotation (manual and motorized)
- handling meridian flips, including camera flipping and re-centering.
- exposure determination for each filter, based on sky noise and read noise

- image acquisition using time and/or altitude attributes to choose between multiple targets
- complex exposure sequencing for each target
- autofocus, automation logic and adjustment for each filter
- autoguider automation, including calibration, settling parameters and selective disabling during certain non-imaging activities
- automated calibration file acquisition (for example, sky flats)
- managing equipment and sequence configurations
- logging
- error and poor imaging condition recovery protocols

These are the mainstream activities that allow an exposure sequence to progress without constant intervention. They are variously described elsewhere in the book with a few exceptions:

Most planning programs can instigate a sequence at a certain time. Some, like CCDCommander additionally have the option to commence or abort a target sequence when it crosses a certain altitude. Automated calibrations (typically flats) are of particular interest to open reflector telescope users, since dust can find its way down to the optical surfaces close to the sensor between imaging sessions. The planning programs can insert a series of flat exposures at twilight (sky flats) or position the telescope or flat panel to capture a set of flats for the session. Refractor owners have an easier time and should not need to do this as frequently. I find that dark and bias frame exposures do not change appreciably over time and take many hours to expose sufficient frames to generate high quality master files for the common exposure times. For this reason, I update my library every six months. Recovery protocols are particularly useful: For example, SGP enters a recovery mode if the guider system has difficulty

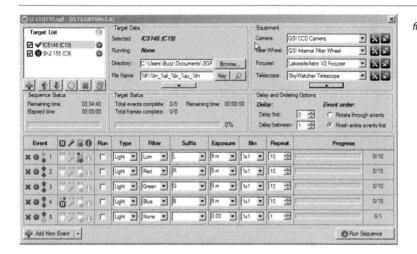

fig.2 The sequence window from
Sequence Generator Pro controls the
basic exposure automation, filter
event and target order. It can do
various activities at the beginning
or end of each event as well as
the overall end of the sequence. It
records the progress for each as it
goes along and can be changed
dynamically when the sequence
is progressing. It is normally
minimized during sequencing, to
display the equipment controls and
various performance monitors.

finding a star or settling. The recovery mode attempts to start the guider and image acquisition several times over a specified period. Similarly, if the autoguider reports a large tracking error, the exposure is automatically restarted. If unsuccessful, or if the ASCOM safety monitor trips, the sequence terminates. With a few simple options, termination also warms the camera up to ambient, parks the mount and closes the observatory roof. The other applications have similar protocols.

Observatory Control

Observatory control is becoming increasingly relevant to many amateurs. Here the observatory is defined as the immediate environment outside the mount and telescope and includes such things as environmental measurements. For a physical observatory, it also includes dome and roof operation in harmony with the mount. The recent inclusion of environmental sensing within ASCOM set the scene for automatic update of sky refraction models for improved mount pointing and tracking accuracy. The automation and intelligence applies to specific circumstances, for instance detecting poor weather and shutting down the system in a controlled manner.

Part of the appeal of the automation programs is their tight control over the various applications. In some cases separate specialist applications perform at a higher level and although there is a good amount of interoperability between applications in general, there is always the danger that they do not work harmoniously with each other, or become incompatible as one or the other is updated. For that reason, the companies collaborate by publishing an application interface (API). For instance the three main automation programs, CCDCommander, ACP and CCDAutopilot all work with TheSkyX and Maxim DL as the camera and mount interface. Although these

imaging applications have basic autofocus capabilities, FocusMax continues to thrive as a third-party application that again works through the imaging application's API to optimize the process. These APIs are the enabler for all this interaction. They make use of the way that modern operating systems work and in a sense, ASCOM can be thought of as a generic API. In Windows for instance, what we traditionally called program subroutines and variables have become COM objects, methods and properties. When these are made available to outside programs (public) they can be called, read and written to by other programs and usefully, scripts.

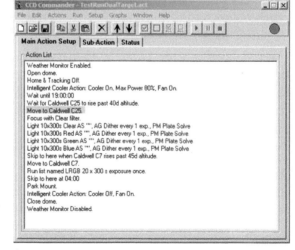

fig.3 CCDCommander is another sequencing utility which
relies upon a third-party imaging program. It has
a simple functional interface that is easy to use yet
has some useful features for starting and moving
between targets. It has a convenient feature that
imports targets from the planetarium program.

Remote Control

There are several levels of remote control sophistication: At its simplest, it is the simple remote operation of the imaging computer, by conveniently using a cable, Microsoft Remote Desktop or a similar program via an Internet link. If one is truly remote, further controls are needed, including power control and reset capabilities for all the observatory hardware. Lastly, you need eyes, or remote sensing. It is reassuring to see exactly what the telescope is doing and the environment. The increasingly popular IP cameras, which broadcast video over WiFi, are not only good as a security deterrent but provide key information on the relation of the roof and mount before something goes crunch or for an all-sky view for imaging conditions.

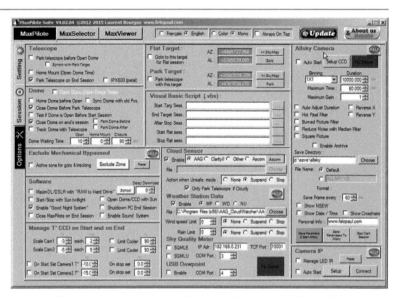

fig.4 MaxPilote is a freeware application that originally automated Maxim DL and now also can control TheSkyX and PHD2. It has three main screens. This one is the setup screen. It is busy, but all the information is there in one place.

These software applications manage environmental sensing. In the case of remote electrical control, there are two aspects: the user interface and the hardware. Remote power control and USB resetting is a must for an unmanned observatory. Software does crash for any number of reasons and sometimes the only solution is to selectively or globally reset the USB or power system. An increasing number of USB switches, partnered with suitable drivers make this a reality, especially when tied into the observatory control applications. Ethernet-controlled power switches and video relays exist today and connect directly to the Internet router and operate via web-based applications using TCP or UDP (protocols). They are unlikely be integrated into the host PC applications as they need to be able to, among other things, forcibly reboot power to all the electronics in some circumstances.

Scripting Commands

Scripts are a simple way of automating repetitive tasks with ease. They make use of the public methods and properties made available by the various applications and the operating system. When you run a sequence, some automation programs build and run a script derived from the user settings.

There are various flavors, VBScript and JScript being the two one is most likely to encounter. In essence, they are mini programs, accessing and linking a vast library of code that already exists on your computer. As such, a few lines can accomplish something very complicated by accessing the ASCOM methods and properties referenced on the ASCOM.org website. An Internet search for "ASCOM telescope methods" locates them. Scripts can be really simple; here is a fragment to unpark a SkyWatcher telescope and set it tracking, written in Visual Basic Script:

```
set mount = CreateObject("ASCOM.SkyWatcher.Telescope")
mount.Connected = true        'connect to the mount
mount.Unpark                  'unpark the mount
mount.Tracking = true         'start tracking
```

It could go on to set the guide rate to 0.2x :

```
'check mount can change guide rates
if scope.CanSetGuideRates then xrate = 0.2
        'guiderate is in degrees / second
        guiderate = 0.00417 * xrate
        'set RA guiderate
        mount.GuideRateRightAscension = guiderate
        'set DEC guiderate
        mount.GuideRateDeclination = guiderate
end if
```

In this manner, a script can access any public ASCOM object's properties or methods, or those of any published API. Common scripts set up the mount device (ASCOM confusingly calls them telescope devices) without having to use the handset to park the mount or run a simple exposure sequence and close the roof. They do not need a development environment to generate; the Windows

FilterWheel	Position	Names	FocusOffsets		
Telescope (Mount)	Park	FindHome	FindHome	AbortSlew	SlewToTarget
	SyncToTarget	UnPark	Tracking	PulseGuide	SlewToCoordinates
	MoveAxis	AxisRates	CanSetTracking	Declination	RightAscension
	Azimuth	TrackingRate	Slewing	AtHome	GuideRateDeclination
	AtPark	Altitude	SlewSettleTime	UTCDate	SideOfPier
Focuser	Halt	Move	Position	Temperature	StepSize
Dome	OpenShutter	CloseShutter	ShutterStatus	Slaved	Park

fig.5 A selection of ASCOM methods and properties for four device types. This is in no way an exhaustive list, but does represent some of the many telescope controls compared to, say a filter wheel. These names will typically pass or return a parameter, for example a true/false or a coordinate. The ASCOM.org website lists all the methods and properties and their parameters. Other program APIs have similar lists, all of the public ones can be accessed by scripting or a third-party automation program. In recent months, environmental sensing was added, which provides useful information for atmospheric refraction modelling and weather warnings.

operating system provides the simple text editor and compiles these mini programs automatically when you run them. Scripts are functional and not pretty. They work in a linear way, one thing at a time with basic user input and output using simple dialog boxes. They do, however, have full access to the file and network system. If you want to have something more permanent with multiple possible functions and an on-screen presence, you will need to move on to fully-featured Visual Basic, C++ or C# programs. These in turn can generate more COM or .NET objects for other applications to access. Imagination is the practical limit.

A script can be run directly by a mouse click action on a file or referenced by a program. For instance, a VBScript can be placed in the Windows startup folder so it runs as the computer boots. In this way, my weather system powers up with the PC and starts to record the cloud cover. Similarly, all the applications, including Maxim DL and Sequence Generator Pro offer the option to call a script at selected events (often before or after an exposure). For instance, it may be to check the altitude of the mount and decide if it is getting close to the horizon limit or send a notification that the sequence has completed.

Scripting is fun and not necessarily difficult. I started by studying some examples, a bit of bedtime reading with a book on VBScript (some recommendations are in the bibliography) and printed off the ASCOM methods and properties and those of my imaging applications. In a short while various patterns emerged and in a day or two, I could control my mount, filter wheel and so on. Although I was familiar with ASCOM programming after my observatory roof design, scripting appeared

as another black hole. I was inspired to write my own after examining a few examples kindly provided by the ASCOM developer, Chris Rowland.

There are a few things to watch out for: Not all devices implement all methods and properties. (In general terms methods do something and the properties are a value that can be read or set. The lines blur, however, when the value of a property changes the behavior of a device.)

In the prior example, it tests to see whether the AS-COM telescope driver accepts guide rate commands before trying to change them. That is sound practice but managing errors is something else you will have to look into if you are going to do anything complicated. VBScript has no notion of throwing or catching exceptions like C#, but it has a global Err property that contains the results of the last operation performed. The line *on error resume next* will skip over the offending line and set the error property:

```
On Error Resume Next
Dodgy_telescope_mount_operation
If err Then
  WScript.Stderr.Writeline "don't do that again "
  WScript.Quit 1        'quits script
End If
go on to do something more sensible
```

The math is sometimes confusing too; RA is typically quoted in hour angle and DEC in degrees. When one uses either to compute a move, you have to think about how the angle wraps around (e.g. 15 - 23 degrees = 352 degrees). It is easy to overlook and sometimes things like this catch out professional software developers.

One of the useful aspects of ASCOM is that all the devices have simulators. You can play to your heart's content with telescope and dome simulators without causing physical damage, during the day and in the comfort of the home. In fact some professional developers who do not have access to the equipment they are supporting, use simulators for proof of concept of device drivers and applications. In terms of what to use scripting for, there is not much point in trying to recreate the imaging applications but it is useful to augment your application's capabilities. For instance, start-up and shut-down sequences that park the mount in a precise home position and avoids the telescope and the roof system becoming intimate.

In such a manner, I largely ignore the Synscan handset on my Avalon mount and use scripting to remotely set it up and automate the slews to deliver a polar alignment in under 5 minutes. (The mosquitos will go hungry again.) Simple message boxes and dialogs ask a series of questions and prompt for settings, allowing me to select the changes I require.

For example, if there is no GPS unit attached to a SkyWatcher mount, one has to use the SynScan hand control to enter in the time manually (and not particularly accurately at that). Using a utility like Dimension 4 to access a timer server on boot up, my PC clock is only 100 ms out or better. The script in fig.6, sets up the mount's clock and date so it matches the PC.

Further example scripts are on the supporting website. One script tests a telescope mount's response to guider pulses. In practice, setting up an autoguider is always a random affair as seeing noise and tracking issues mask the effectiveness of the settings. Running the autoguider with its guider outputs disabled provides a handy tracking log. The script independently sends alternating and long and slow guider commands and short and fast bipolar commands to see if there is appreciable lag, overshoot, backlash or stiction with a particular axis, guide rate and movement amplitude.

```
' script to set Skywatcher mount time to PC time

' set up the dialog Yes / No / Cancel constants
Dim vbYes: vbYes=6
Dim vbNo: vbNo=7
Dim vbCancel: vbCancel=2

'create instance of your telescope...
Set Avalon = CreateObject("ASCOM.SkyWatcher.Telescope")
Avalon.Connected = True          '... and connect to it

' set up mount time to PC time GMT or BST
       (your timezone will differ)
Decision = MsgBox ("Is it British Summer Time?", vbYesNoCancel)
If decision = vbYes Then
       'adjust for daylight saving
       Avalon.UTCDate = Now - 1.0/24.0
       'show the time
       MsgBox "UTCDate set to " & Avalon.UTCDate

ElseIf  decision = vbNo Then
       'now provide the PC's date & time
       Avalon.UTCDate = Now
       'confirm it worked
       MsgBox "UTCDate set to " & Avalon.UTCDate

Else
   MsgBox "No Change"
End If

'dispense with the Avalon
Avalon.Connected = Nothing
```

fig.6 This example Visual Basic script sets the mount's clock to match that of the PC, with a prompt to the user to confirm if the PC clock is using daylight savings. This script, although intended for a SynScan-based mount (as my Avalon Linear is) can easily be adapted to connect to any ASCOM-compliant mount and accomplish the same thing.

Mosaics

Sometimes, imaging the very big is more impressive than the very small.

It is not uncommon for non-astronomers to believe that astrophotography requires a long telescope with considerable magnification and it is quite a shock when they realize just how big some deep-sky objects really are. Even then, astronomers are sometimes dismayed when their shiny new telescope has insufficient field of view to capture the entirety of a large galaxy or nebula. At the extremes, the shortest viable telescope focal lengths are around 350 mm and even with a full-frame sensor, may be too narrow to capture the largest views. In these circumstances most astronomers are aware of mosaics, where side by side image tiles are seamlessly joined to extend the visible field. For the widest views it is not unreasonable to question the need for this complexity, when a normal camera lens might be used from say 12–200 mm focal length. The rationale highlights a secondary benefit of mosaics; that of increasing detail, since a larger aperture instrument captures more light, with higher resolution and at the same time is capturing the image over more imaging pixels at a smaller pixel scale. A third benefit of the underlying mosaic process is its ability to combine images from different instruments, often at different scales and sometimes operating outside the visible electromagnetic spectrum too. There are four main challenges during the execution of a mosaic image prior to image processing:

fig.1 *A simple 2-tile mosaic of the Veil Nebula in The Sky X. Here it uses the field of views (FOV) that you have previously saved in an equipment profile to set up the image boundaries. Utilities such as ACP Planner can use this information to generate automated acquisition sequences.*

- acquisition planning
- tile alignment
- tile registration
- blending the image

Acquisition Planning

At first glance, acquisition planning appears to be a set of image targets that generate overlapping tiles, acquired in sequence. In some cases, this is not far wrong. As usual though, there are some nuances hiding in the detail that may catch you out, in particular when imaging with short focal lengths. The risk of unintentional gaps between tiles increases as the camera field of view increases. Although there are several planning aids that project an orthogonal mosaic grid onto a planetarium or photographic background, their ease of use can be deceptive. Depending on the projection method, although the tiles appear to have a consistent overlap, in reality the top of an image (closest to celestial pole) has a greater angular width in RA than the bottom, closer to the celestial horizon. The orthogonal grid may cause a generous overlap at the top and a thinner overlap or even a gap between tiles at the bottom. This is rarely a practical concern using typical telescope focal lengths but is an increasing consideration with wide angle lenses, if one is trying to minimize the overlap or imaging close to the celestial pole, where the RA lines converge rapidly. One solution is to slightly change the camera angle with target RA, another is to keep the camera angle constant and increase the tile overlap percentage.

Another practical consideration is the overall imaging time required to capture sufficient exposure for each tile, with narrowband mosaic images being the most

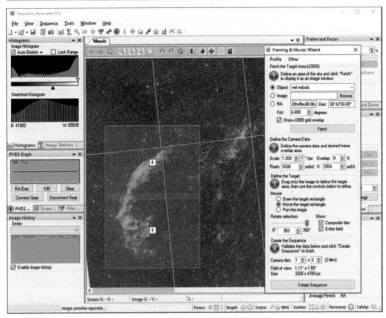

fig.2 As fig.1, only this time using the mosaic add-on within Sequence Generator Pro.
Here it uses downloaded image data from the Deep Sky Survey as the backdrop.

fig.3 Following on from fig.2, SGP can
then automatically generate a
set of targets (fig.4) for each tile
and set up global options for
accurate centering, depending on
the mount's pointing accuracy.

demanding. When imaging time is in short supply, a fast aperture refractor (with reducer/ field flattener) and a one-shot color (OSC) camera make an ideal pairing for natural-color images.

Planning Aids

The mainstream applications, including TheSkyX and Maxim DL have mosaic planning tools built in to create orthogonal mosaic grids. The free ACP planner tool interfaces to these applications and creates a multi-target imaging plan too, for use by ACP and other programs. Asimoplan is a stand alone low-cost mosaic planning tool that helps construct an imaging grid over a sky atlas (for example C2A, Stellarium, Cartes du Ciel or Virtual Moon Atlas) and then exports target coordinates in a text-based format (CSV). The later versions export in a format that can be read directly by the APT image capture application. Not to be left out, the mosaic add-on for Sequence Generator Pro generates complex mosaic arrangements over a Digital Sky Survey (DSS) image and automatically populates the multiple targets into an imaging sequence (figs.2–4). At a simpler level, the

SkyWatcher ASCOM driver EQMod has an associate utility EQMosaic that creates a grid of coordinates assuming the camera axis are orthogonal to RA and DEC.

Each of these planning aids allow the user to set the degree of overlap. Typical values range from 10–20%. If the value is too low, there is a risk of gaps and the small overlap makes tile registration more challenging. At the same time, those based on planetariums, and that show the field of view of the autoguider, allow the user to check the availability of suitable guide stars. It

fig.4 Here, the two-tile mosaic is set up as a two-target sequence. It is only necessary
to set up the filter and exposure details for one target. Right-clicking the target
name, provides an option to copy the exposure settings to the other targets.

may be that some tiles only have dim stars and require a longer autoguider exposure or a 180° camera flip.

Armed with a set of target positions (and possibly rotations too) and an exposure requirement, the exposure order may also need some refinement. At a low altitude, sky gradients are more apparent and it helps if the adjoining tiles are exposed similarly, or experience a similar range of imaging conditions. One simple way to achieve this is to take each target over a single night, starting at a particular altitude and ordering the filters in the same sequence. At the same time, watch out for differences in sky conditions between targets, most notably caused by changes in the Moon's phase.

Tile Alignment

Everything conspires to erode the tile overlap down to nothing: dither, drift, camera rotation and general mount alignment errors all eat into the margins. Those with portable systems or mounts with mediocre alignment will require a more generous tile overlap to avoid disappointment and a careful check of the camera angle before each imaging session. One convenient way to do this is to rotate the counterweight and telescope tube to the horizontal and hold a digital level held against a convenient flat surface on the camera to set an angle.

Target alignment is considerably easier in a permanent setup using a pointing model or from using a slew and closed-loop centering process. SGP and other imaging applications accomplish this with telescope sync commands or by maintaining an offset and issuing a small corrective slew command. By using plate solving, these applications can align the mount position very accurately. In SGP, the tight integration of mosaic planning, target sequence generation and its centering process makes image acquisition particularly easy. If there is no powered rotator, SGP has an option to use the plate-solve information to instruct the user of the necessary manual rotation.

Tile Registration and Blending

The general principle of mosaic image processing is to combine the images while they are still linear, to form supersize integrated image stacks for each filter, which

fig.5 Here, a more complex 4-tile mosaic around IC59 is set up in Sequence Generator Pro for the purpose of generating the sample images for this chapter. The bright star Navi straddles tiles 1 and 2 and makes life interesting during matching and blending. Its extended diffuse halo requires careful background calibration using the DynamicBackgroundExtractiontool (taking care to not sample the extended diffuse halo).

are then processed as normal LRGB or RGB images. If one stretches the stacks before combining them, this causes a world of pain and it is an almost impossible task to create an invisible join.

Processing mosaic tiles taken by wide-angle lenses are particular challenging; the optical design of a wide-angle lens trades distortion with vignetting. While distortion is not an overriding consideration in a single image, it is more critical when one wants to overlap two neighboring tiles. The distortion increases towards the margins in the same critical region where you wish to overlap and register stars. In these cases it is unlikely that a simple scale, angle and position transformation will produce a satisfactory result. A high-quality result requires a more advanced tile registration that effectively removes the distortion before alignment. The process described in a short while uses a surrogate star field to do just that. At the same time, image vignetting (and sky gradients) conspire to make the tile boundaries more obvious. Not only does one require careful flat calibration, but at key points in the image processing, the differences between the overlapping tiles require very careful matching. The very last thing one wants are opposing image gradients or background densities in the vicinity of a join.

The two challenges of registration and blending are addressed in stages, intertwined in a fairly complex linear image processing workflow. I use PixInsight

tools and scripts and although an Internet browse will identify a number of subtle alternative approaches, the general principles are the same:

1 calibrate and integrate images for each tile / filter
2 crop ragged margins after integration
3 equalize backgrounds
4 create overall star canvas for entire field of view
5 register tiles to the canvas
6 crop ragged margins
7 match tile intensity
8 combine tiles and blend overlap

The first two steps introduce familiar concepts. It assumes the calibration process uses bias, dark and flat calibration files. The initial cropping process improves the subsequent background equalization outcome. The equalization can use the DynamicBackgroundExtraction-tool or AutomaticBackgroundExtractor, that suits simpler subjects without complex faint nebulosity. Although both these tools are powerful, some residual differences remain and are addressed later on. The next step, however, is new and requires some more detailed explanation.

Star Canvas

I think of a star canvas as the printed image on the lid of the jigsaw box. It is possible to make a jigsaw by joining random tiles and building up the picture slowly but much easier if there is a frame of reference. In mosaic terms, one can register one tile to another and trust the matching algorithm has sufficient stars in the overlap to decide which sides are common and the precise registration of each. (How many times have you had two jigsaw pieces of featureless sky and you have tried each side in turn?) In PixInsight, this is accomplished using the Resister/Union - Mosaic working mode option in the StarAlignment tool with Distortion correction and Frame adaptation enabled. In the case of a two-tile mosaic, this may be sufficient, but with multiple tiles, the growing jigsaw image requires building up by matching to the next frame in turn and so on. This is tedious with large mosaics and potentially stores up issues if the registration is trying to accommodate image distortion.

An alternative way is to create a synthetic starfield (like a sketch of our Jigsaw image) and align the individual tiles to it. In this way, the entire starfield of each tile can be robustly registered to the master and at the same time, correct its distortion. A synthetic starfield is surprisingly easy to generate from a standard star catalog using the PixInsight Catalog Star Generator script (fig.8). All one requires are the coordinates of the middle, the image

fig.6 *The ImageSolver Script usefully not only calculates the center coordinates but the corners too in the console window (fig.7). Here, it is using a hint from a single frame's FITS header since after integration, the target coordinates are discarded during image calibration and integration.*

```
Referentiation Matrix (Gnomonic projection = Matrix * Coords[x,y]):
      -0.000332454      +1.57653e-05      +0.533185
      -1.57434e-05      -0.000332469      +0.442501
              +0                +0                +1
Projection origin.. [1663.167915 1252.197324]pix -> [RA:+00 56 12.99 Dec:
+61 07 21.40]
Resolution ........ 1.198 arcsec/pix
Rotation .......... -2.714 deg
Focal ............. 929.58 mm
Pixel size ........ 5.40 um
Field of view ..... 1d 6' 25.2" x 50' 0.3"
Image center ...... RA: 00 56 13.020   Dec: +61 07 21.64
Image bounds:
    top-left ....... RA: 01 00 41.695   Dec: +61 33 37.88
    top-right ...... RA: 00 51 24.942   Dec: +61 30 26.90
    bottom-left .... RA: 01 00 54.075   Dec: +60 43 39.03
    bottom-right ... RA: 00 51 51.764   Dec: +60 40 33.02
```

fig.7 *The output of the ImageSolver script in the console window shows the corner coordinates, scale and image rotation.*

scale, image rotation and a generous estimate of the height and width of the mosaic in pixels. The ImageSolver tool in PixInsight plate-solves the image and uniquely gives coordinates for the image corners. It is fairly straightforward to measure the top left of the top left image and the bottom right of the bottom right image and calculate a mid point (figs.6, 7). The synthetic starfield is then used as the reference registration image for the StarAlignment tool and is distortion free.

Registration

Registering the individual tiles against the canvas is easier than trying to align on their slim margins. Here

fig.9 *The settings above register the mosaic tiles against the master star image, generated by the Catalog Star Generator script, and surround it by blank canvas (fig.10)*

fig.10 *The Union-Separate working mode in the StarAlignment tool places the mosaic tile into a blank canvas, aligned to the stars in the catalog-generated star field.*

fig.8 *With the center coordinates of the entire mosaic, rotation angle, scale and canvas size, the Catalog Star Generator script produces a master background upon which to align the matrix tiles.*

the StarAlignment tool uses the canvas as the registration image and then places the individual tiles in their own unique black canvas. This is done with the settings shown in fig.9, which correct for distortion and create separate registered images, rather than a combination. With a dense starfield, it may be necessary to experiment with the star detection settings to deselect faint stars. A registered tile is shown in fig.10.

Matching and Cropping

Jumping ahead of ourselves for a moment, the Gradient-MergeMosaic (GMM) tool does not match the intensity of separate tiles but merely blends the join to disguise any remaining minor intensity differences. Even though the tiles have had a degree of matching using one of the background equalization tools, there will still be minor differences in intensity between adjacent tile edges. There are two tools that work on linear images, LinearFit and the PixInsight utility script DNA Linear Fit, written by David Ault, which is available from his website *www.trappedphotons.com*. Of the two, Dave's script is the more sophisticated and overcomes an issue when using LinearFit on the full canvas. The GMM tool relies upon black canvas to determine the boundaries of each tile. Unfortunately, applying LinearFit to an image, such as the one in fig.10, lifts the background level. Dave's tool overcomes that and, after selecting a master tile, is applied to each of the others in turn (fig.11).

If all is well, the individual tiles are now closely matched and are ready for combination. If you prefer to use the LinearFit tool to equalize tiles, try applying the equalization to the image files after background equalization and before using the StarAlignment tool to place in the wider the canvas.

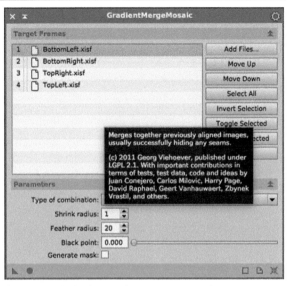

fig.11 One of the beauties of PixInsight is its ability to
be customized by scripts. This one by David Ault
skillfully navigates the LinearFit equalization
on a tile, such as the one in fig.10, to ensure the
black canvas does not skew the end result.

To improve GMM's performance, crop off the extraneous black borders before using the tool. To do this, create a basic mosaic, use DynamicCrop to set the canvas limit and then crop each of the tiles. It is easy to create a basic mosaic, using a PixelMath equation of the form: *max(tile1, tile2, tile3,…tilen)* to generate a new image.

Combination and Blending

The moment has finally arrived to combine our images and blend the margins to create invisible joins. For this the GradientMergeMosaic tool is in its element. This works on files rather than views, so before its use, save all the equalized mosaic canvases. The principal control is the feathering option, which determines the distance over which the two tiles are blended. If the two tiles have a very minor registration issue, a gradual blend may create some unusually shaped stars. The trick is to experiment with the settings around its default value and inspect the boundary area for defects. If the odd star is affected, one simple remedy is to selectively crop it out of one tile and try GMM again. For this I use the CloneStamp tool and clone a circular patch of black canvas over the offending star.

The full mosaic image is shown in fig.13. In this case I did not crop the individual tiles before merging, so I could judge the mount's native pointing accuracy without plate solving or a pointing model.

fig.12 GMM looks deceptively easy to use to combine
tiles to form the final linear mosaic image. If there
are some blending issues between tiles, a little
experimentation with the order of the files and the
feather and shrink radius often fixes the problem.

fig.13 The full mosaic canvas, still in linear mode, with an automatic screen stretch to
reveal differences. At this scale, it is easy to see any unevenness of the joins (though
the inclusion of the ragged edge can fool the brain and it is better to crop before
inspection). It requires closer inspection to check on individual stars shapes in the
overlap regions. I am particularly pleased with how the star Navi blended over the
join. (The excessive diffusion concerned me and I traced it to mild condensation
on the front optic. I discovered the refractor's dew shield had partially retracted,
pushing the dew heater tape away from the optical cell. I would normally
discard these images but in this case, it makes the example more challenging.)

Image Calibration and Processing

C49 or Rosette Nebula using narrowband filters (Hubble palette)

Post Exposure

*To me, the magic of monochrome photography occurs in the dark. The same
is true of astrophotography, except the lights are turned on.*

The glamorous part of astrophotography is the bit we see and touch. An enormous amount of energy and attention is spent (and not a little money) on cameras, telescopes, mounts and their location. It is always enjoyable to compare equipment, problem-solve system issues and capture images. Just like a photographic negative, these fuzzy frames are only half the story. Indeed, astrophotography has a great deal in common with traditional monochrome photography; it is easy to become diverted by camera and lens choice and ignore the magic that goes on in the darkroom. It is, in effect, a world apart but a crucial part of the end result.

On reflection, these two hobbies are very similar indeed: Just as the darkroom techniques that I developed over many years transform a plain negative into a glowing print, so the journey begins to transform our deep sky exposures into a thing of beauty. There is no single interpretation of a negative that is "right" and the same is true of deep sky images. These are distorted in color and tonality in ways to purely satisfy an aesthetic requirement or scientific analysis. In both hobbies, the steps taken to enhance an image require technical knowledge applied with artistic sensitivity. There is seldom a fix for a poorly executed negative and it is easy to spend a whole day in the darkroom perfecting a print. The demands of image processing in astrophotography deserve no less. It takes many hours of patient experimentation to become proficient at image processing. As our skills will undoubtedly improve over time, an archive of our original files gives the opportunity to try again with better tools and techniques.

There are many ways to achieve a certain look on a print (beyond the basics) and the same is true with image processing. After a little research you quickly realize this and that there is no "right way". In many cases, the image dictates what will work or not. In the end, the proof of the pudding is in the eating. In fine art circles, monochrome photographers practice exposure, development and printing controls, carefully translating subject tonalities to the print. Some of those concepts are relevant to astrophotography too but the analogy is wearing thin. Certainly, the most successful images apply different adjustments to the highlights, mid tones and shadows and importantly distinguish between subtleties in nebulous areas and true deep sky nothingness.

What Makes a Good Astrophotograph?

It is a good question and perhaps one that should have been addressed at the very beginning of the book. Art is certainly in the eye of the beholder and although astrophotography is essentially record-taking, there is still room for interpretation to turn multiple sub-exposures into photographic art. These include both technical and aesthetic attributes. Most can agree on some general guidelines but it is important to note more original interpretations that break rules can also work pictorially. A good part of photography is knowing what you want to achieve before you press the button. It certainly is the discipline that was adopted by photographers in the last century. They had no other choice; with roll film or sheet film and no Photoshop to correct their errors, the photographic artist had to be very particular about the craft of exposing; the composition, lighting, focus, filtration and exposure had to be just right. That was before they got into the darkroom to develop and print the negative. As an aside, although digital cameras have made astrophotography what it is today, I believe their immediacy and the ability of image manipulation to correct mistakes, encourages a culture to neglect the craft of composition and exposure. I feel something has been lost. For instance, I would use a Rolleiflex 6008 to take wedding pictures and would expose about a 100 frames to cover the entire event, with a few throwaways. My friend's wedding was a digital affair. The official photographer took 1,500 frames. I was a guest and took a single roll of Agfa APX100; suffice to say, a 12-inch square monochrome silver gelatin print has pride of place over their fireplace.

Technical Considerations

The technical aspects are probably the easiest to cover as there is less room for interpretation. If we first consider stars, they should be tightly focused and round, all the way into the corners of the image. Stars come in different colors from red through to blue, and a well exposed and processed image should retain star color. Bright stars always appear larger in an image and the exposures required to reveal faint nebulosity often render bright stars as a diffuse white blob. Poor image processing will cause further star bloat and wash out the color in stars of lesser magnitude. As we know what a star should look like, a star image ruthlessly

reveals poor focusing, tracking and optical aberrations. The quality of a star's image also reveal any image registration issues between sub-exposures or RGB frames. Although there are some processing techniques that reduce star bloat and elongation, these do not cure the problem. It is always preferable to avoid these issues in the first place.

The sky background is another area of image presentation with a general consensus on best practice. It should be neutral and very dark grey but not black. Ignoring nebulosity for the moment, it should be evenly illuminated throughout and also have low noise. By now we know that image processing increases the visual appearance of noise in the darker areas. There are some very clever algorithms that can minimize noise. If these are taken too far it the image takes on a plastic look. There is a degree of subjectivity here and just like film grain, a little noise adds a touch of reality to images. (At the same time there is a steady demand for film emulation plug-ins for Photoshop that add grain-like noise to an otherwise smooth digital image.) The "right amount" is something that can only be determined by the display medium, scale and your own viewpoint. In addition, green is not a color that appears naturally in deep sky and should be removed from images. (The exception to this is false color-mapping of narrowband imaging to red, green and blue channels.)

Sharpness, resolution and contrast are interrelated in a complex tangle of visual trickery. A high contrast image can give the appearance of sharpness and conversely a high resolution image may not look sharp. For a long while it was a long-running debate between the small format film and digital photographers. Fine grain monochrome film has over 3x the spatial resolution of a 12 Megapixel DSLR, yet the digital images look "sharper". The sharpening tools in general imaging programs are not optimized for astrophotography; a well-processed image needs careful sharpening at different scales to tighten stars without creating "Panda eyes" as well as to emphasize structures within galaxies and nebulosity without creating other unwanted artefacts. (Sometimes gas structures are also enhanced by using narrow band images assigned to complimentary colors.)

Image resolution is most often limited by seeing conditions and imaging technique rather than optics. Good image processing makes the most of what you have, with local contrast enhancement techniques and in the case of under sampled images, using drizzle techniques to actually increase spatial resolution. The trick to successful imaging is to trade-off sharpness for noise and resolution to arrive at an outcome that does not shout "look at me, I have been manipulated". It is easier said than done.

Aesthetics

Photographers and artists often have an innate ability to compose images. The choices they make consider orientation, scale, framing, position of the center of interest, balance and directing or confining the view. In this regard, astrophotography is no different to any other form of art and the guidelines are broadly common. The main difference between them is that the objects in space are less well behaved; you have no control over their relative positioning and the images are two-dimensional in so much that everything is in focus and there is no foreground or background. Good photographs often obey these guidelines but they do not have to. When I used to judge photographic competitions I would sometimes find a compelling image that would deliberately break the mold. If the image is strong, deliberately breaking composition rules will generate a strong emotional response.

Scale, framing and orientation are something that should be considered before exposure (figs.1, 2). This is particularly difficult for the astrophotographer since a short exposure reveals little detail other than galaxy cores and bright stars. Most camera systems can be rotated by 90° but at the same time, you need to consider if the image is more compelling reflected about a vertical or horizontal axis. During the planning phase, look up others' images on the Internet and use these fully-processed images to determine the framing. There are many guidelines in general photography, some of which are the rule of thirds, avoiding distractions on the image periphery and image dynamics.

The rule of thirds is a common guideline for rectangular images. For reasons that are unclear, placing an object of interest on the intersection of thirds has a pleasing effect, especially if there is some balance in the image to offset the main attraction. This does not always work for an image with a single object (a cluster or galaxy) and sometimes a square image with a centered object, is more powerful. I think the Rosette Nebula is a good example.

Distracting objects near the edge of an image draw the eye away from the center of attention and can be particularly troublesome in astrophotographs. The brain seeks out bright areas and areas of high contrast. (One trick to identify distractions in a normal photograph is to turn the image upside down. The brain disengages from the subject matter and it is much easier to identify offending areas.) Crop images to exclude a particular bright star on the periphery and to ensure the border does not bisect a small galaxy or bright star. In normal darkroom work, we print in a distracting highlight by "burning in" or clone out in the case of a digital image. To some, this is painting and not photography and considered "impure". It is still art though.

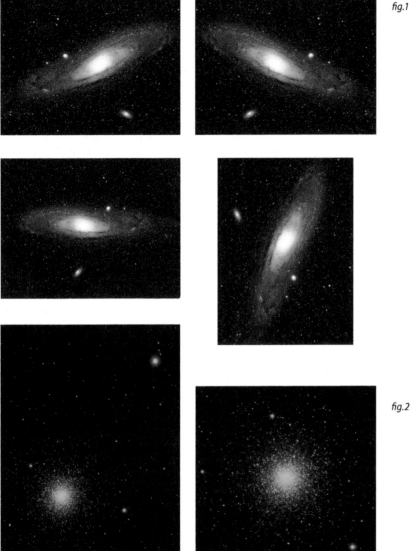

fig.1 (M31) The orientation of an image produces a very different dynamic. For many, the image top left has the most pleasing look and that is how the galaxy was framed in-camera. The strong diagonal element has a convenient small galaxy in the bottom right corner to fill the space and provide some balance. It feels like we are looking down on top of the galaxy when in reality we do not know. Convention puts the darker edge to the underside. The horizontal version is not as successful. The vertical shot is unusual; it feels like it is tipping over and I think the image is more unsettling. In general, landscape-orientated images are more passive than portrait ones.

fig.2 (M3) A cluster often works well centralized in a square frame. The vertical shot works too, by placing the cluster on the thirds and balancing with a bright star in the opposite corner. It also gives an impression of its isolation in space from surrounding stars, reinforcing the notion of a globular cluster. The same composition would also work in landscape form too.

Image dynamics is an interesting subject. Some orientations and placements feel better than others. To begin with, a landscape orientation is considered passive compared with a portrait orientation. There are very few portrait-orientated astrophotographs. The few that exist convey power of which the famous Hubble Space Telescope's vertical image of the "pillars of creation" is a notable example. An object's orientation also generates different emotions and mirrors some portraiture tricks of the trade: If you consider two similar portraits, in one the eyes are level and in the other the eyes are tilted, they provoke a different reaction. The angle and direction of the tilt also has a surprising effect. If an object has an axis,

in so much that it is not an amorphous blob or perfectly symmetrical, tilting that feature improves the image's dynamic. For example, try reversing the angle; it has a surprising effect. In the West, it is said, our brains "read" an image from left to right like a book; and in addition, a swooping diagonal from the bottom left corner to the top right feels more natural than the opposite.

All these guidelines are purely subjective. The intent here is to draw your attention to them and to improve an image through conscious decisions and experimentation. An experiment with a single familiar image in different crops and orientations is very informative. The trick is to realize this with the faint image during image capture.

What is Image Processing?

In loose terms, image processing is everything that happens to your image captures. It is a very broad term and divides into three more manageable activities:

1 calibration
2 sorting and stacking
3 image manipulation

Calibration, sorting and stacking are mechanistic in nature and are in effect an automated precursor to manipulation. Sorting removes the sub-standard exposures before image stacking and can be semi-automated based on a set of criteria or from a simple visual evaluation and rejection of poor exposures. In some references these actions are referred to as pre-processing or even processing. The outcome is a color image file, or a set of monochrome ones, ready for image manipulation. Image manipulation (sometimes also called processing or post processing) is itself a substantial activity to accomplish various aesthetic needs. These activities enhance the calibrated and stacked image. In no particular order they:

• remove unwanted background color and gradient
• enhance star shape and color
• repair cosmetic defects and improve composition
• reduce image noise
• sharpen and enhance structures
• enhance faint details and increase their contrast
• manage color hue and saturation
• combine images (mosaics or from multiple sources)

Software

Astrophotographers use an array of tools for image processing. Thankfully there is a good deal of file compatibility and an image may use multiple applications before completion. Calibration and stacking are best achieved with specialist astronomy programs. Image manipulation software include speciality programs (Maxim DL, Nebulosity, AstroArt and PixInsight are prime examples) as well as general purpose image programs such as Photoshop and GIMP. The use of Photoshop over dedicated imaging programs divides the community somewhat. Some purists believe that all processing should be done by mathematics and regard manual manipulations in Photoshop as "painting". Others are cool, so long as the final result is good.

Astrophotography has very distinct requirements that are optimally met with specific imaging controls. General imaging programs may deliver instant gratification but require elaborate techniques to produce a high-quality image. Even so, these may still have need for specialist techniques and this is where a dedicated program will help. These applications are daunting at first; the terminology is unfamiliar and there are numerous controls. It is not always obvious what to do, when and by how much. With care, however, these achieve high-quality images; reducing noise, improving color and refining detail. Having said that, many astrophotographers use Photoshop almost exclusively for their manipulation and it is amazing to see how some have adapted its layer and blending modes to their needs. The more recent versions have extensive 16-bit image support but at the time of writing 32-bit processing options are limited. PixInsight's default is 32-bit and can work in 64-bit too, making the most of the enhanced dynamic range created by image integration and processing. Enterprising photographers sell or share bundles of Photoshop actions, recorded sequences of manipulations that automate common processes to improve astrophotographs.

Adobe products are revised every few years and are expensive. The latest versions offer some 32-bit operations. A free alternative is GIMP, which has 32-bit image support. This may be sufficient for your needs. I prefer to use my existing imaging programs and increasingly use dedicated applications and support their ongoing development. After all, an investment in equipment and acquisition experience is wasted if the final output does not receive similar attention to detail.

Image Processing Order (Workflow)

There is a general consensus on the initial processing steps, after which the content of each image normally requires tailored enhancements. After a while one develops a sense of what might work, try out an informed guess and then let your eyes decide whether it is an improvement or not. Image processing requires patience and takes many separate actions to improve an image, regardless of application. There are many alternative paths and significantly, tools and processes may be applied globally or selectively. On this last point, selective application is perhaps one of the most significant differences between general imaging applications. Selective manipulation is important; many processes, when globally applied, fix some issues and at the same time create new problems. Three of these are star bloat, lost star color and increased background noise. We instinctively know what we want to achieve, as our brains can discriminate the information on the screen. This is often based on color, intensity, texture and contrast. Our brains know what noise looks like, but how do we tell a computer? Most programs can apply image manipulations to a selection based on image

color or intensity. Some allow manual input (painting) say with a graphics tablet. Finally and perhaps most significantly, selection based on image scale or local contrast is very useful. These allow a tool to discriminate stars based upon their size, shape and contrast, or larger structures such as dust lanes or galaxy details from the background. They use complex mathematics behind the scenes to work out the selection. Programs such as PixInsight are in their element with such computations, standard imaging programs require more ingenuity to accomplish the same. If you can get past the technical names and pretentious acronyms, PixInsight will apply the changes to the right pixels by the right amount and avoid those areas that would degrade from modification. Alternatively, some Photoshop functions, such as HDR, have fortunate unexpected side-effects that achieve remarkable manipulations.

Experimentation is the key to success and it is essential to save work at various stages of completion. Not all programs have a multiple undo feature and it may be necessary to back-track and try a different approach. The wise save their stacked files before manipulation, after background, gradient and color balancing and then after the first major non-linear stretch. There are a few truths in image processing, some of which might be the following:

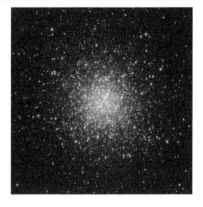

fig.3 A single 5-minute luminance frame of M13, with automatic stretching. The noise level practically restricts the extent of the outer star field.

- it is much easier (and better) to process an image with a good signal to noise ratio
- different parts of the image will have different signal to noise ratios and will almost certainly benefit from selective processing
- there are no magic bullets to overcome poor acquisition technique
- each image requires a different approach, based on content, contrast and the exposure quality
- many small adjustments are better than a single big one
- some manipulations solve one problem and create another
- with each step, consider if a manipulation is better applied globally or selectively, to the entire image, or just luminance or color information
- small errors before image stretching become big errors afterwards and are more difficult to fix
- be ruthless and throw away poor exposures (focus, tracking etc.)
- keep original exposures as they may have a second life
- store partially processed images along the way
- keep notes on the steps and settings
- there is more than one way to achieve a certain look
- if it looks right then it probably is right
- there are no rules!

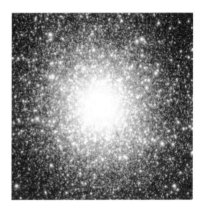

fig.4 The same image, but with 40 combined luminance frames, again with auto stretch. The lower noise floor allows a greater number of faint stars to appear out of the background light pollution. The key message is that while image processing is remarkable in what it can achieve, it cannot make up for a frugal set of exposures.

As such, the processing section in this book is a guide through some typical workflows and tools. The increased space in this edition expands on the available techniques and suggest references for further reading from more expert practitioners. The practical chapters deliberately use a variety of programs and techniques to give an idea of the available range and a feeling for practical experimentation, good and bad. Constructive criticism helps drive improvement. My own image capture and processing techniques are slowly getting better all the time and I thought it might be interesting to compare recent results with those from three years ago. One of the case studies does just that and revisits the same subject, to see just how far image capture and processing techniques have moved on.

Getting Started in PixInsight
Proving that quick (or easy) is seldom best.

This program is like no other and to some extent divides the astrophotography community. It presents a dilemma, since its powerful image manipulation algorithms are able to deliver the very best results but the user interface is unusual and at odds with the conventions of standard imaging programs, both photographic and astrophotographic. PixInsight (PI) is available for multiple platforms; Windows, OSX, FreeBSD and Linux, though it does require a 64-bit operating system. Most programs have a user guide but presently PixInsight has selected pop-up tools, partial documentation, tutorials and forum posts. Some tools have no documentation. A few experienced users have stepped in and helpfully publish free on-line tutorials, the most notable of which are Harry's at *www.harrysastroshed.com*. PI is evolving rapidly and Harry updates his tutorials to keep up with the changes. An Internet search will find other resources, including streamed and DVD media. Personally, I like Harry's down-to-earth style and found his videos and the notes from James Morse on the PI forum helped enormously with my "initiation" into the inner circle.

Many users will try PI without learning about it first but it is not particularly intuitive. For that reason I have singled out this imaging program for a closer look. Since writing the first edition, Warren Keller published a 380-page reference book. This chapter and the PI content in the following process and practical chapters take things further, with more of a practical application approach:

- help the new user overcome the initial mental hurdles
- understand the general processing workflow
- understand the tools, their purpose and context
- provide insights into alternative techniques
- provide an insight to common tool settings

Although I have a long experience with many programming languages and systems, dating back to CP/M, the user interface took me by surprise and it took a few weeks of head banging before I was able to make some progress. I am by no means an experienced user; there are few that truly can say they are, but this experience allows me to relate to the first-time user.

PI, unlike Photoshop, does not make sole use of a graphical user interface. Its roots are the powerful statistical and mathematical modelling equations that extract the faintest information from an image, reject unwanted information and remain true to the image intent. There is a philosophy behind PI that avoids manual manipulations of the image or "painting" as they call it, which is more prevalent in the digital imaging programs like Photoshop. PI, like Photoshop, has full color management, something that is lacking in some other astrophotography programs. The visual nature of Photoshop encourages experimentation with immediate feedback of a particular setting or adjustment. This immediacy often hides the fact that there are often many individual steps required to complete a task and the challenge is to remember the sequence rather than the individual actions. For some reason this makes us more comfortable, but it cannot be called "easy" to interpret a multi-layered Photoshop file with multiple blending modes, masks, and channels. I guess as Photoshop has evolved, our early successes and familiarity with the basic commands help us to cope with the latest advanced tools or simply accept "good enough". At a few points in the first few weeks I questioned whether the effort of understanding PI was worth the result. My first results confirmed it was and although we live in a world that demands instant results, it is all the more rewarding to accomplish something worthwhile after a little effort. This mantra is mirrored by the PI development team who are rapidly evolving the program and addressing the needs of the amateur community. Regular updates with improved tools, incremental documentation and new scripts are provided free of charge.

As I see it there are three obstacles to using PI effectively; the user interface, the language and the detailed settings of each tool. If you can overcome the first two, you will be able to use PI selectively in combination with other image manipulation programs. As experience grows and you learn from the practical examples on the Internet, further tool settings will become more familiar and find a place in your image processing sequence. Each image and the challenges it presents are unique and one soon learns that for a particular telescope and sensor there may be ball-park settings for a particular tool but the best setting can only be arrived at by experimentation. In some cases particular tool settings are closely linked

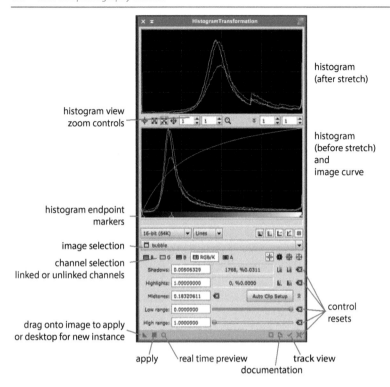

histogram
(after stretch)

histogram view
zoom controls

histogram
(before stretch)
and
image curve

histogram endpoint
markers

image selection

channel selection
linked or unlinked channels

control
resets

drag onto image to apply
or desktop for new instance

apply real time preview track view
documentation

fig.1 A very important function is the HistogramTransformation tool. It is responsible
 for the non-linear stretches that reveal the detail in deep sky images. It has zoom
 controls that facilitate precise location of black points and expands its view.
 It usefully tells you if you are clipping pixels and how many. The blue control
 icons along the bottom are found in many other process dialog boxes.

to image statistics, such as background levels, median absolute deviation (MAD) and noise levels.

The User Interface

This is perhaps the most striking immediate characteristic of PI (fig.2). There is a drop-down menu, tool bar, a sidebar and a bottom bar and yet few things are familiar or similar to any other image processing program. This can be quite daunting at first. The foundation of PI is a set of powerful mathematical processes that are applied to an image. They are treated like subroutines in a DOS program. Indeed they can actually be used in a command line interface, similar to the old typed commands in MS-DOS but more conveniently using a scripting language. To make them more useful and to avoid having to type a command and parameter string, the processes (aka tools) have graphical dialog boxes that offer a modern method of selecting files, settings and options. Some of the simpler tools have a real-time preview option; it all depends on the mathematical algorithm being used. (Similarly, other astronomy programs such as Maxim DL do not offer real-time previews on all of their image processing

commands.) The key word here is "real-time". Some of the algorithms are just too processor intensive for instant results. PI treats the image as sacrosanct and it will not apply or save any image manipulation without an explicit command. For this reason it uses image previews that facilitate a quick evaluation of a tool setting without affecting the main image. When the setting is just right, the tool and its settings can be applied to one or more images or stored for later use. This is a very useful feature. In this way it is possible to have multiple tools, say the HistogramTransformation tool, each with a different setting, saved to the desktop as an icon, stored in a different workspace for convenience and saved in a project for later recall. To save time, tools can be combined into a processing sequence to run as a batch and equally, image files can be grouped together and a tool (or tools) applied to all of them. Indeed it is possible to run a batch of processing steps to a batch of files for the ultimate in automation.

When you think about it, this approach allows you to customize your tools to give precisely the effect you want and store them for immediate use or apply later on similar images. The trick is to work out what the tools do, their sequence and what settings give the desired result. This is the part where other users' recommendations may establish a starting point for further experimentation, to adapt to your image's quirks.

The dialog boxes have some unusual features too. They have a number of buttons on their margins which have a special purpose. Fig.1 shows the most common of these and what they do. Depending on which button you use, a tool is applied to an image, all open images or a batch of images listed in the tool.

Image file windows also have buttons on their margins for quick access to common zoom tools (fig.2). The tab at the side of the window has special powers too. For instance, if you drag the tab to the desktop a duplicate image is formed. Drag the tab back onto the side bar of the first image and the image is used as a mask. (The image tab changes color to remind you that there is an active mask on the image.)

menus / toolbars (duplicate processes in Process Explorer)

process console and log

processes (tools) favorites and grouped by type

file information manager

image processing history

close / iconize / minimize / maximize

image tab

preview tab

image bar

preview box

image zoom tools

projects

area for iconized images and processes

fig.2 *The main imaging window of PixInsight has the customary menus and customized toolbars and additional tabs on the left-hand side that give access to process, file and history information and an alternative way of selecting processes (tools). An image window has some unique controls around its edges to control the zoom and size of the window and a left-hand border that acts as an active area for dropping in images for masking or creating previews.*

The four "explorer" tabs on the left hand side give quick access to the file system, tools, processing history and view information of an image. The PI "File Explorer" is designed for image files and gives unique image analysis information that is not available in a normal OS file browser and includes image analysis statistics. The View Explorer shows detailed information on the selected image file. This comes into its own when you have a lot of images to work with. The History Explorer (fig.3) is a useful extension of the

History Palette in Photoshop. PI goes further though; the listed processes store their settings and it is easy to apply them to another image or batch of images, simply by dragging the line item over to an image, icon, desktop and so on. This may be of particular interest when you process one image of an RGB set and then wish to apply the same tools and settings on the other two images. I guess the same is true when processing a mosaic and you require all the image files to seamlessly match in color and tone.

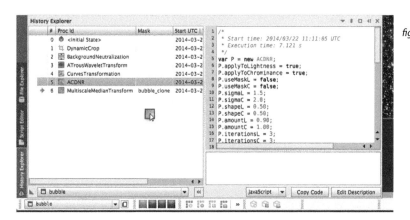

fig.3 *The History Explorer uniquely lists all the things you have done to an image and allows you to drag (as seen here) a highlighted process to apply it elsewhere or store it for later use. When you save a project, the history state of the image files are preserved. The process settings are shown on the right in script form, so that they can be copied and edited for sharing and use elsewhere. This is intimidating and powerful at the same time.*

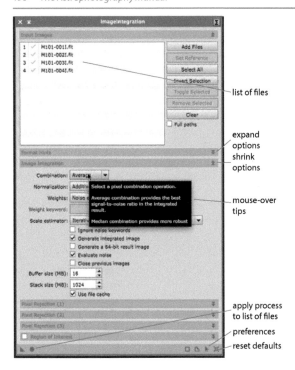

list of files

expand
options
shrink
options

mouse-over
tips

apply process
to list of files

preferences

reset defaults

fig.4 *A example of a batch process dialog, in this case the statistical combination of files. The file list is at the top and the various controls can be expanded, altered and shrunk back. This is a very powerful tool with many options optimized for darks, bias, flat and light exposures. It can use separate parameters for normalization, rejecting pixels and also for statistically combining the remaining ones.*

The Language

I have some issues with the unnecessary academic nomenclature. I am not averse to scientific language but in this case I think it is a barrier to useful and logical user experimentation. The most immediate are a number of tool names and especially their acronyms that offer little clue of their function, especially to a new user. Their icons are no better. That is true of many programs but PI seems to revel in being different and academic. In addition there are other unique peculiarities: there are processes, icons, containers, scripts, workspaces, projects, objects and previews.

Processes, Objects and Scripts

In the simplest terms, processes are equivalent to tools and objects are typically image files. A script is a small program, often provided by a third party that can provide a utility function, combine existing tools into a more usable form and simplify batch processing. A script editor is also provided in PI to create your own, or modify

existing ones. With a little knowledge you can read a script and work out what it does (that is if you have a few cloudy nights). As each tool is applied to an image, the "Process Console" tracks progress with a text-like record. This may appear redundant but it can be useful to scroll back to ensure everything worked on every file and that the various actions were performed according to plan.

Icons are minimized files or tools, floating on the desktop. In a program like Photoshop, the tools are anchored to the tool bars as small icons and a more detailed dialog is expanded when required. In PI, a process is selected from a menu and if the process (tool) is minimized to an icon on the desktop, it keeps its settings and can be renamed to something useful. Its icon form occupies very little space on the desktop and it can be recalled or stored for repeated use or arranged with others to remind you of a processing sequence. An image can be minimized to an icon too. It is handy to keep a partially processed image file close at hand for use later on, say for generating masks or alignment. These unique features allow one to build upon early successes.

Containers, Workspaces and Projects

For the more confident user, "Containers" is a posh word for a collection of image or tools. This is a software device to group together image files for batch processing and assemble a sequence of processes (tools) to apply to one or more images.

Workspaces are just a method to de-clutter the desktop and organize those images and tools that belong together and recall them as a group with a touch of a button. Files and tools are just dragged to the workspace buttons as required.

Projects are a lifesaver. They store all your work, tool settings, work in progress (and each image's processing history) for a particular session. When you next turn on the computer, run PI and load the project, these are recalled and allow one to carry on with transparent continuity. The workspaces are preserved, and if you organize your work, implicitly record tool settings, workflow and image states. This is not only extremely powerful, a project also serves as a reference for subsequent images. Projects are unbelievably useful, as image processing is often an ongoing activity spanning several sessions.

Previews

Previews may seem obvious enough but PI has a unique slant. One can click on a make preview button and a small outline will appear on your image file. Pulling the edges re-sizes and moves it about. It has its own tab in the image too. You can apply a tool to the preview

and get a good idea of what it is going to do. One first trick is to create multiple previews and quickly compare settings. The second is to combine several previews as a single entity, say, tiled around a central galaxy or nebula. This selection facilitates background or color calibration without being distracted by the higher luminance and color of the subject. Third, the preview has its own processing history. These settings can be copied for later use.

None of the above seem too strange or illogical in their own right. It is just, for a new user, little appears to be familiar or obvious. After a week or two, you will have it figured out and be on the learning curve of how to use the tools themselves. This is when the fun really starts.

PixInsight Workflows

A workflow is a defined processing sequence. You may have come across the term to describe the camera-to-print color management process in digital imaging. In astrophotography it is theoretically possible to adjust color, noise, sharpness and tonal distribution in any order. In practice, there is a preferred sequence that yields the best quality, or put another way, there are certain processing sequences that create issues that are difficult to fix later on. Here is the problem: The initial images start off as a few bright points of light for the brightest stars and everything else appears featureless, or simply black on the screen. All the interesting stuff occupies a tiny tonal range in the shadows. There is nothing else to see in the image, or more importantly, judge processing options with. This detail magically appears with an applied curve, HistogramTransformation or some kind of image stretch. With PI or any other program, do not permanently stretch an image to see the faint details before correcting the basic faults in the image. It is OK to stretch an image preview or view with a temporary screen stretch, so long as the image data is unaltered. A stretched image magnifies all the good and bad points at the same time. Stretching functions change the tone distribution of an image, typified by a curved transfer function between the input and output pixel values, that boost the shadow contrast and compress the highlights. (Altering the end points, with a linear characteristic in-between still has a linear transfer function.) Images that have not been stretched are called linear and after stretching, non-linear. Certain processes are optimized to work on linear images and once an image is non-linear, there is no return. The reason for this is simple; the mathematical algorithms behind these processes are designed for the typical parameters of a linear image in terms of signal level, contrast and noise. For instance, most noise reduction algorithms are optimized for linear or non-linear images as they work on statistical variations that are affected by the image stretching process.

It is possible to classify many PI processes into linear and non-linear camps and in simple terms, the linear processes are applied first, before image stretching. The equivalent processes in the other specialist astrophotography programs generally exhibit similar behavior. Normal photo editing programs are less specific, as they are purposed for general imaging in a non-linear gamma space to improve noise, sharpness and the like. A typical PI workflow is shown in fig.5.

PixInsight Processes

The following chapters step through a typical workflow and draw upon the alternative methods in Photoshop, Maxim DL, Nebulosity and PI. A table of the more common PI processes with a description of what they do and their practical application is shown in fig.6.

When you start using PixInsight, the individual settings in each tool will be just that, individual. Some tools have many controls, so many in fact that it is daunting. My approach is, if in doubt, leave them at their default setting. There are many Internet resources that offer practical examples and good starting points. Further experimentation will give you a feel for what works for your particular image conditions. The mouse-over help windows provide useful information for many tool settings.

After a while, especially with a common camera system, quite a few of the settings become second nature. PI still requires considerable catch-up on documentation, especially considering it is a commercial program. This quick appreciation gives an overview of the kind of tools that are at your disposal and unravels some of the acronyms. Enterprising users continually find new ways to use them for clever effect and in addition, new improved tools replace established ones from time to time. An active and friendly community continues to push the boundaries and share their insights.

There is no denying PI rewards patience and perseverance and it is not to everyone's taste. It does offer some unique processing tools that make the most of painstakingly acquired images, including high bit-depth processing, multiscale processing to enhance and suppress detail and optimized mask generation. I only started to use PI after the original book's market research identified the need for PI content. It was my intention to use PI to process a few images in the first light section, along with Nebulosity and Maxim DL. After trying it on a few images, however, I quickly noticed a significant jump in image quality, as a result of the complex mathematics that lie at its heart, and have to force myself to use anything else.

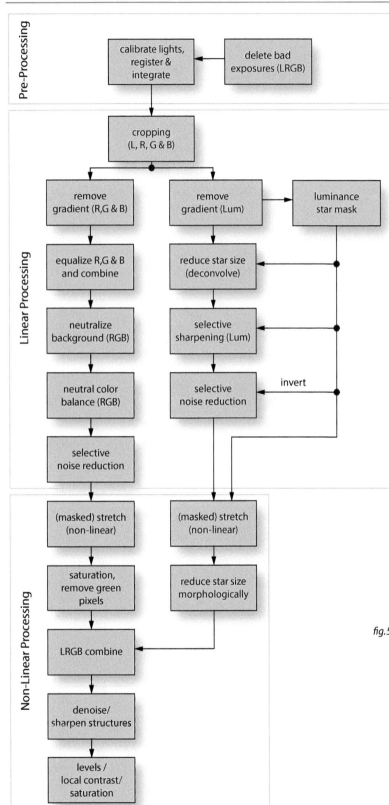

fig.5 A simplified PixInsight LRGB workflow from separate monochrome exposures through to the final image. There are many variations according to taste, for narrow band imaging, one-shot color imaging and also the nature of the deep sky object itself. The processes are generic and in many cases this workflow applies to other imaging software too. In PI, there is often a choice of tools to accomplish a similar function, each optimized for a certain situation. It is finding out what for, how much and when to, that is the fun part.

image calibration tools

Blink and SubFrameSelector utilities (batch process)

These two utilities are useful for selecting, ranking and discarding image exposures before stacking (integration). These tools allow you to rank and select frames based on a range of image quality parameters.

ImageIntegration (batch process)

This tool stacks images and can be applied to bias, dark and flat calibration frames and calibrated and registered image frames. It combines images and conditionally excludes statistical outliers. It has many powerful options that allow it to optimize the process for calibration master frames and image integration. Some options allow it to normalize frames before averaging them and can also be used to generate a luminance frame from RGB files.

ImageCalibration (batch process)

Processes dark and flat frames from dark, bias and flat exposures as well as calibrating light frames. It works on monochrome images and RGB one shot color images, also called colored filter array (CFA)

StarAlignment (batch process)

After choosing a reference image with the smallest FWHM star value, this generates a new set of registered image files. This also supports aligning files into a mosaic with minimal overlap.

BatchPreProcessing (script / batch process)

The above tools can be used individually to integrate, reject, calibrate and combine registered image pixels. It becomes quite laborious. This script automates the task and creates master calibration files and calibrates, registers image files. It can also integrate the calibrated and registered image files for quick evaluation. Many do this final step using the ImageIntegration tool for finer control.

CosmeticCorrection

This tool is a handy way to remove hot pixels from an image. It allows you to use a master dark file to identify which pixels to remove and replace with interpolated values of the surrounding image pixels.

sharpening tools

HDRMT (High Dynamic Range Multiscale Transformation)

used on non-linear images

This tool enhances contrast and structure of the image. We perceive it as more detail and dynamic range. The effect can be controlled and directed at objects of different scale. It is normally used with an inverted luminance mask to protect the background.

Morphological Transform

used on linear / non-linear images

This tool is useful for reducing excessive star sizes. It can also make slightly elongated stars round again. It in effect distorts a local area. One useful byproduct is that it reduces star peripheral intensity.

MLT (Multiscale Linear Transformation)

used on linear / non-linear images

This splits the image into its wavelet (size) layers and allows you to process separately. The tool can be used for analysis but also selective noise reduction or detail enhancement at different scales depending on the bias setting for the wavelet size. Effectively supersedes ATWT.

stretch preparation tools

DynamicCrop

It is important to crop the image to the extent of good data before doing image combination or manipulation. This tool allows you to crop several registered images to the same precise image frame. The best way to see the ragged edges is to apply a screen stretch. The history state can be applied to further images.

LinearFit

normally used on linear images

This tool is useful to linearize the fit between RGB&L channels. It effectively removes the extreme (often red) color cast in the background of a RGB image and achieves approximate balance between the channels. It takes a reference image and linearly scales other images so that their pixels (in a certain range) match background and signal levels. The images must be aligned for this to work.

BN (Background Neutralization)

normally used on linear images

After removing background gradients and the red cast, this tool makes the background a neutral tone. It does this by sampling background image pixels from the entire image or an image preview, within a specified value certain range.

Deconvolution

used on linear images

This tool models the effect of seeing conditions and applies the opposite effect to stars and structures, making them less blurred and more distinct. Uses a Point Spreading Function (PSF) to define how much blur to counteract. The PSF can be generated by measuring stars in the image with the PSF tool. The settings on this tool are very sensitive and it takes many attempts to find one that does not make things worse!

StarMask

It is a good idea to create a star mask before stretching an image, for later use. This tool creates a star mask from an image, using luminance and scale information. It can be adjusted to select big/small stars, bright /dim and extend or blur the mask boundaries. It can be combined with a range mask using PixelMath for use with noise reductions tools.

ColorCalibration

normally used on linear images

Whilst not really a background tool, following background neutralization, the color calibration tool balances the image colors by integrating stars, galaxies or the entire image to obtain a white reference. This allows for maximum color separation but is not technically accurate.

background tools

ABE (Automatic Background Extraction)

used on linear images

Automatically (or manually) arranges a grid of sample points over image to remove background. Removes background gradients and creates background image to confirm you are not over correcting for deep sky objects.

DBE (Dynamic Background Extraction)

used on linear images

This tool works similarly to ABE but allows the user to place their own sample points to avoid bright stars, nebulosity or faint details.

fig.6 Common PixInsight tool descriptions (continued on next page).

noise reduction tools

ACDNR (Adaptive Contrast Driven Noise Reduction)

used on non-linear images

Noise reduction tool with a low pass filter and a built in luminance mask to protect lighter areas. It can apply separate levels of noise reduction to color and luminance channels.

TGV Denoise (Total Generalized Variation Denoise)

used on linear / non-linear images

This tool basically replaces the older tool ACDNR. Use with a stretched luminance mask and experiment with strength and edge protection to get the right look.

ATWT (ATrous Wavelet Transformation) (also see MLT)

used on linear / non-linear images

This multi scale tool can be used for noise reduction on linear images, especially at small-scale. When used on linear images, some users only remove noise in the first wavelet layer and use a luminance mask to protect other areas. This sometimes works better on RGBs than TGVDenoise.

MMT (Multiscale Median Transformation)

used on linear / non-linear images

This noise reduction tool is often used with a mask to protect high SNR areas. TGVDenoise is often preferred. Recent enhancements, include differentiation of high contrast structures and a linear mask feature that greatly reduces noise when applied to linear (RAW) images.

SCNR (Selective Color Noise Reduction)

used on linear / non-linear images

This is the preferred method to remove green pixels. Green is not a native color in the sky and the green pixels can be eliminated by this tool and neutralized.

color tools

ChannelCombination

This tool can be used to replace the color components or channels of an existing image, or to generate a new image from existing channels or components. It supports several color spaces and for instance it can be used to replace the luminance channel in a LAB color space

ChannelExtraction

This tool is the opposite of the one above. This can be useful when assembling composite channels from wide and narrow band filtered exposures and for generating separate masks for RGB images.

LRGBCombination

This tool allows an LRGB image to be assembled out of its constituents, either as separate files or RGB with L. It allows for channel weightings and has built in tools to reduce color noise and boost saturation.

ColorSaturation

This tool allows you to selectively change the saturation and hue of an image. It has a live preview function that helps you fine tune the results. The data input uses a curve, the points of which can be edited and deleted.

ColorCalibration

Described in the stretch preparation tools section.

image stretching tools

STF (Screen Transfer Function)

This tool gives the appearance of a stretch function but it only does this to the screen image. The auto setting is very useful for a quick appreciation of the image and individual color channels can be tweaked. The settings can be copied over to the histogram tool to apply to an image.

HT (Histogram Transformation)

This tool can alter endpoints but more importantly stretches the tonal range using a gamma-like slider. It appears to be similar to the levels dialog in Photoshop but offers more precise control. This is the primary tool to convert a linear image into a non-linear one. There is no going back! This tool has a live preview function and some functions and readouts to identify clipped pixels. It is often a good idea to do the stretch in two stages, coarse and fine. This is often used with a mask to protect star bloat or alternatively some use the MaskedStretch tool.

AdaptiveStretch

This is a general contrast and brightness manipulation tool. Some prefer to use this to perform the initial stretch to a linear image. It measures the noise level in an image and adjusts the transfer function to maximize contrast but not intensify image noise.

MaskedStretch (Process and Script)

As the name implies, this applies a stretch function and masks off structures. It does this iteratively to achieve a better result. This prevents star bloat and desaturation. With the right settings, this gives a better result than a HT with a star mask.

CurvesTransformation

Often used with a luminance mask, this tool not only allows subtle control over the tonality of an image (like the curves tool in Photoshop) but also has a saturation and hue modes that allow adjustment based on color. This is very useful for tuning narrowband image color.

Rescale

The rescale function resets the black and white points of an image without clipping pixels. This is done linearly and does not stretch the image with any curve. It can be useful to quickly set endpoints and also clean up after some processes which generate out of limit data.

miscellany

FastRotation

A tool to rotate images in 90° increments and or mirror transformations. Unlike any other rotation value, these occur without interpolation.

PixelMath

This tool can create an image from a mathematical derivation on one or more images. It can be very simple; adding an offset to all pixels, combining images together or emulating Photoshop blending modes.

ProcessContainer

This enables one to create a sequence of processes, assembled by dragging process icons from the desktop or from the history state of another image.

HDRComposition

This tool blends Linear data of different intensity to extend the dynamic range of the image. It also can be used to replace the centers of burned out stars using a shorter exposure starfield image.

Image Calibration and Stacking

Two strategies that go hand-in-hand to remove mean errors
and reduce the noise level in the final image.

If a deep sky image was like a conventional photograph and did not require extensive image processing to enhance its details, calibration would be unnecessary. Unfortunately this is not the case and calibration is required to keep images at their best, even with extensive manipulation. The calibration process measures the consistent errors in an image and removes their effect. These errors are corrected by subtracting an offset and adjusting the gain for each image exposure. No two sensor pixels are precisely the same and the process of calibration applies unique corrections to each pixel in each image. Thankfully the image processing applications automate the calibration adjustment process and it is just left to the astrophotographer to provide the calibration data.

Calibration Overview

The calibration process starts by measuring your system and then, during the processing stage, applies a set of corrections to each individual image file. These calibrations are given the names of the exposure types that measure them: bias, darks and flats. Unfortunately, these very names give the impression that they remove all the problems associated with bias or read noise, dark noise and non-uniform gain. Unfortunately they do not; calibration only removes the constant (average or mean) error in a system and does nothing to fix the random errors. The process to calculate the mean offset error and gain adjustment for each pixel uses the same methods employed to reduce random noise, that is by averaging many exposures – the more the better. It takes a while to establish a good set of calibration values, but once defined, these only require updating if the camera ages or the optical system changes in some way.

Calibration, the Naming of Parts

Fig.1 shows the elements of a single image exposure. The bias, dark current and general light pollution all add to the image make-up, each with an unknown mean and random value. On top of this is a slight variation in system gain for each pixel, caused by sensor and optical effects. If we take a sneak peek at fig.3, which shows the calibration process for each image frame, we can see that the calculations are a little involved. The complication is driven by the equation used to normalize the gain of

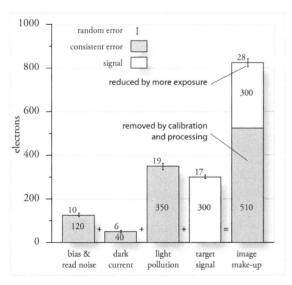

fig.1 *This shows the make-up of an image pixel value;*
from the bias, dark current, light pollution and target
image and the associated noise in each case. The
trick is to identify each element and remove it.

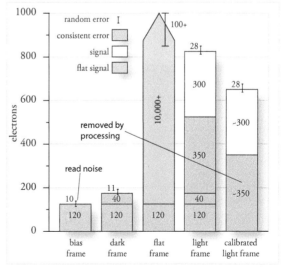

fig.2 *This relates to fig.1 and shows the constituents of*
the three types of calibration exposure; bias, dark
and flat. The right two right hand columns show
the image pixel before and after calibration.

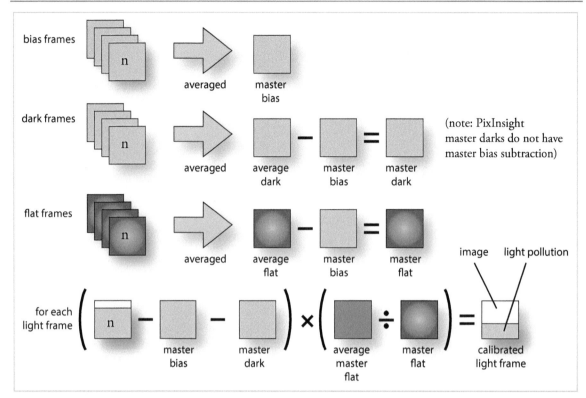

fig.3 Thankfully the calibration process is mostly automated by the image processing programs. This diagram shows the sequence of events to create the master dark, bias and flat files. Each light frame is calibrated separately and then the calibrated frames are statistically combined during the stacking (alignment and integration) process to reduce the image noise. This calibrated and stacked image will still carry the mean level of light pollution, which is removed by image levels and gradient tools.

each image. To understand why, we have to circle back to what we can directly and indirectly measure through the bias, dark and flat frame calibration exposures. Taking the exposure values from fig.1, fig.2 shows the make-up of the calibration exposures in a little more detail. The actual image exposure is called a "light frame" for consistency.

Bias Frames

The signal bias is present in every sensor image, irrespective of its temperature, exposure time or light level. It is easy enough to exclude all light sources from the image but even so, dark current accumulates with time and temperature. For that reason, bias is measured by taking a zero time or very brief exposure in the dark. In our example, each bias frame has a mean bias level (120) and noise (10). Taking 100 bias frames and averaging them reduces the image noise to around 1 electron, to form a master bias file (fig.4). If you typically acquire images at 1x1 binning for luminance frames and use 2x2 binning for RGB frames, you will need to derive two sets of bias frames at 1x1 and 2x2 binning levels. (If you use a modern photographic camera, it is likely that it performs its own

approximate bias subtraction but it still requires a master bias frame for flat computations.)

Dark Frames

The purpose of a dark frame is to generate the same amount of dark current as is present in the light frame. For this to be accurate, the exposure has to be taken on the same sensor and have:

- no light
- same sensor temperature as the light frame
- same exposure duration as the light frame
- same binning level as the light frame

Each dark frame exposure captures the dark current, bias and associated random noise. The random noise is reduced by combining many dark frame exposures to form an average dark file. (This process is called integration by some applications. In its simplest form it is a computed average value but can also be a median or a more advanced statistical evaluation of the corresponding pixel values.) The dark current is isolated by subtracting

the master bias pixel values from the average dark pixel values. The result is saved as the master dark file (fig.4) Take note that some applications, like PixInsight, do not subtract the master bias at this stage.

In practice several sets of dark frames are taken, for different combinations of exposure time and temperature and the software calculates intermediate values by scaling for temperature and exposure duration.

Simple Calibration

The dark frame consists of dark current and bias current, as does the light frame or image exposure. At its simplest level, a calibration process subtracts the average dark frame exposure from every flat frame exposure, leaving behind the signal, image noise and the general light pollution. In fig.2, we can see that a dark frame consists of bias (120), dark current (40) and its associated random noise (11). If many dark frames are averaged together, the noise level is reduced. If the average value (160) is subtracted from each light frame exposure, it leaves behind the light induced signal (650) and its shot noise (28). This still has the effect of light pollution (and its shot noise) embedded in each frame. Light pollution, as the sky background is aesthetically removed during image manipulation.

Full Calibration with Flat Frames

That might be the end of the story, but if we wish to normalize the exposure gain for every pixel, we need to do more work. This gain adjustment not only corrects for tiny inconsistencies between each pixel's quantum efficiency and amplifier gain but usefully corrects for light fall-off at the corners of an image due to the optical system, as well as dark spots created in the shade of dust particles on the optical surfaces. The calculation to do this works out a correction factor for each pixel, derived from an exposure of a uniformly lit subject, or flat frame. These flat frame exposures capture enough light to reliably measure the intensity, typically at a level around 50% of the maximum pixel value. As before, there is shot noise in this exposure too and as before, many flat frames are averaged to establish mean pixel values (typically 50+). These exposures are brief (a few seconds) and of a brightly lit diffuse image. This not only speeds the whole process up but also reduces dark current to negligible levels, sufficient for it to be ignored. In fig.2, a flat frame typically comprises just bias noise and about 10,000 electrons. As with bias and dark frames, the flat frame exposures must have the same binning level as the light frames that they are applied to. Some programs (like Nebulosity) provide options to blur the master flat file to lower its noise level or even the different sensitivities of adjacent color pixels in a photographic camera image or one-shot color CCD. As you can see in fig.3, flat frames are calculated from flat, bias and dark exposures. Each flat frame is individually calibrated and then averaged using powerful statistical methods that equalize fluxes between exposures.

Master Calibration Files

We are ready to take another look at fig.3. In the first two lines it establishes the master bias and master dark files. In the third line, we subtract the master bias from the averaged flat frames to establish the master flat file. The master flat file now shows the variation in gain and light fall-off across the whole image, without any noise

fig.4 From left to right, these three images show the master bias, dark (300-second exposure) and flat for a refractor system. To show the information in each, their contrast has been greatly exaggerated. In the bias exposure, fine vertical lines can be seen, corresponding to some clocking issues on the sensor (fixed later on by a firmware upgrade). Remember, this image is the average of about 50 separate bias exposures and the read noise is 1/7th of what it would be normally. This sensor has a very good dark current characteristic and has a fine spattering of pixels with a little more thermal current than others. There are no hot pixels to speak of. The image of the flat field has been stretched to show the light fall-off towards the corners and a few dust shadows (judging from their size, on the sensor cover slip) near the edges. As long as these dust spots do not change, the effect of dust in the system will be effectively removed during the calibration process.

or offsets. If we take an average of all its pixel values, it provides an average master flat pixel value. The gain normalization for each pixel in every image requires a correction factor of (average master flat pixel value / master flat pixel value). This is applied to each light frame, after the offsets from dark current and bias have been removed (in our simple calibration example above).

$$pixel\ value = \frac{(image-(dark+bias)).\ average\ flat\ pixel\ value}{master\ flat\ pixel\ value}$$

We now have a set of fully calibrated image (light) frames. Each will comprise an image made up of the photons from the exposure, corrected for dust spots and light fall-off but will still have all the random noise.

Wrinkles

Life is never quite that simple. There are always a few things going on to complicate matters. In the case of the dark frames, there may be an imperfect match between the dark frame and image exposure time and sensor temperature. This is often the case when using regular photographic cameras without temperature control, accident or your CCD cooling is insufficient on a particularly hot night. Murphy's law applies too: You may have standardized on 2-, 5- and 10-minute dark frame exposures only to use 3 minutes and 6 minutes on the night. In this case all is not lost as the process for generating dark current is proportional to temperature and time. To some extent a small adjustment to the master dark value can be achieved by scaling the available master dark files. This is done by the image processing software, providing that the sensor temperature was recorded in the file download. This adjustment is more effective with astronomical CCD cameras than digital SLRs since many DSLRs internally process their raw files and confuse this calculation. The other gremlin is caused by cosmic ray hits. These ionizing particles create tiny white squiggles on the image. The longer the exposure, the more likely you will get a hit. Since their effect is always to lighten the image, they can be statistically removed during the averaging or integration process by excluding "bright" noise more than "dark" noise with an asymmetrical probability (SD) mask. PixInsight has the ability to set individual rejection levels for high and low values and to scale dark frame subtraction by optimizing the image noise.

Generating master flat files is not without problems either since each optical system needs to be characterized. If you are using separate filters, this requires a master flat file for each combination of telescope, sensor, filter and field-flattener. In the case of dust, if dust changes over a

period of time, the calibrated light frames will not only show dark areas where the dust has now settled but light areas from its prior location. The size and intensity of dust shadows on the image change with their distance from the sensor. Dust that is close to the sensor has a smaller but more prominent effect and conversely away from the sensor it is larger and less well-defined.

In my system I keep my filters scrupulously clean and make sure that I keep lens caps on my sensor and filter wheel when not in use. I still have master flat files for each filter, since the light fall-off through the complicated coatings changes with incident angle. Another wrinkle is if your particular camera has a high dark current. In this case you need to change the calibration routine for your flat files and not only subtract the master bias but also a master dark file (set at the flat frame exposure time). These are sometimes named flat-darks. There may also be a lower limit on the flat frame exposure time. Those sensors that use a physical shutter, driven by small solenoids are primitive and slow compared to those in digital SLRs. Exposures less than 1 second should be avoided

fig.5 This screen grab from Maxim DL shows the calibration files for a set of biases, darks and flats at different binning levels. The flats, for each of the filters, are further down the list. The "Replace with Master" option will average all your calibration frames and compute them into master frames for future use. Maxim DL uses the sensor, telescope, binning and sensor temperature information in the FITS header to ensure the right files are processed together. This is one reason why it pays to set up Maxim DL properly before imaging. (The actual image calibration is performed during the stacking process.)

as the slow shutter movement will produce a noticeable light fall-off pattern across the sensor.

Lastly and most importantly, the outcome of the calibration process is a set of calibrated light frames, each of which still has light pollution, shot noise and read noise. The next step in the process is called stacking (a combination of registration and integration) that aligns and combines these calibrated light frames in a way that reduces the noise level. After stacking, the image file still includes the average level of light pollution. This may be even, or vary across the frame. The background light level is removed as one of the first steps of image manipulation, to achieve the right aesthetic appearance.

In Practice

Acquiring calibration images is a fairly straightforward process that does not mandate the telescope to be mounted. Bias and dark frame images just require the sensor, fitted with a lens cap (that blocks infrared) and a large capacity disk drive to accept all the image files. It does not pay to be frugal with the number of exposures that you take; most texts recommend a minimum of 20 exposures of each but I recommend 50 or more dark and flat frames and 100 or more bias frames. For dark frames, this may take several days to complete and if you are using a normal photographic camera, an external power

fig.7 *This 6-inch electroluminescent flat panel is a convenient way of creating a uniformly lit target for taking flat-frames. The neutral density gels are in ND2, 3 and 4 strengths, to regulate the output to achieve convenient sub 10-second exposures.*

supply adaptor is a great help. If the dark frames require cool conditions, to simulate the temperatures at night, place the camera in a fridge and pass the cables through the seal. In this way when the images are combined to form master files, the dark current is about right and the read noise level is acceptably low.

Flat frames are the most technically challenging to take. You need a set for each optical configuration and that includes the telescope, field-flattener, filters and sensor (and angle). If the configuration is repeatable (including the ability to prevent further dust) the flat frames can be reused. This is not always the case. Some telescope designs are open to the elements and it is particularly difficult to keep dust out. It is feasible to keep filters and field flatteners clean but some sensors have a shutter. These moving parts can deposit dust on the sensor within the sealed sensor housing. My original CCD had this issue and I had to redo my light frames several times and have the CCD professionally cleaned when the dust became too severe.

A flat frame requires an image of a uniformly lit target. Some use an artificial light source, or light box in front of the telescope lens; others cover the telescope with a diffuser and point it at the night sky during twilight or dusk (sky-flats). A scour of the Internet provides a number of projects to make custom-built diffuser light panels for their particular scope aperture. This normally involves sheets of foam core (a strong and light card and polystyrene sandwich board) and the now common white LEDs. White LEDs typically have a peak intensity at 450 nm but the intensity drops off sharply at longer wavelengths and is 10% or lower for Hydrogen alpha and Sulfur II wavelengths. Another alternative is to use an electroluminescent flat panel. These occupy little space and automatically provide a uniformly lit surface. I use an A2-size panel and hang it to a wall or use a 6-inch

fig.6 *As fig.5, only this time in Nebulosity 3. It is easier to see here what is going on and shows the options for when a full set of calibration images are not available. Here it performs the averaging and then applies them to the image files.*

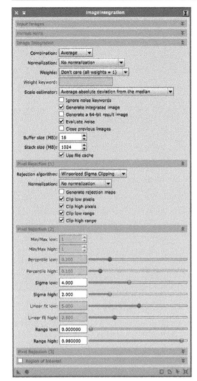

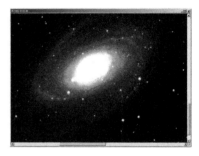

fig.8 These two screen grabs from PixInsight show their rather detailed approach to combining and calibrating images. On the left, there are specialist combination methods, with and without normalization and rejection criteria for creating master calibration files. On the right, these master files are used to calibrate three exposure files. Image registration is carried out in another dialog.

electroluminescent panel (fig.7). Its light output reduces at the longer wavelengths but is still usable. These panels are too bright for luminance images, just right for RGB exposures and not really bright enough for narrowband red filters. It is not feasible to dim an electroluminescent light output electrically and I insert neutral density gel lighting filters over the panel to reduce the light output. If narrowband red exposures are too long, a third alternative is to use a diffuse tungsten halogen lamp behind a diffuser.

Fig.4 shows some typical master calibration files from a ICX694 camera, coupled to a refractor with a field-flattener. The contrast of each image has been increased to show you the detailed appearance, otherwise they would show up simply as black, black and grey. The master bias shows vertical lines, indicated the small differences between alternate lines on the sensor. The master dark does not have any hot pixels (pure white) but does have "warm" ones. In the master flat, the light fall-off of the field-flattener is obvious. It is not symmetrical and I suspect that my flat frame target or the sensor has a slight fall-off. The flat frames show a few small dust spots. The size increases with distance from the sensor by the following equation, where p is the sensor pitch, f is the focal ratio and d is the diameter of the spot in pixels:

$$distance \ (mm) = \frac{p \cdot f \cdot d}{1000}$$

fig.9 From the top, these enlarged images of M81 (Bode's Galaxy) are of an un-calibrated light frame, calibrated light frame and stack of aligned and calibrated light frames. These show the effect of calibration and stacking on noise and detail. (The screen levels are deliberately set to high contrast to show the faint detail in the spiral arms and the background noise. This setting makes the core of the galaxy appear white but in reality the peak pixel value is less than 50,000.) These images were taken with an 8 megapixel Kodak KAF8300 sensor and have considerably higher dark current per pixel than the Sony sensor used for fig.4. The dust spots in the un-calibrated frame are removed during the calibration process.

(The dust spots take on the shape of the aperture; if the dust spots on the flat frames are rings rather than spots, it indicates the telescope has a central obstruction.)

Image Calibration

Figs.5 and 6 show the main calibration windows for Maxim DL and Nebulosity. They do the same thing but differ slightly in the approach. Maxim uses the FITS file header to intelligently combine images and calibration files that relate to one another. In Nebulosity, you have to match up the files manually by selecting individual files or folders for the bias, dark and flat frames. It has the ability to process and mix'n'match different sets of these depending on how you captured your images. You can also see the flat frame blurring option, in this case set to 2x2 mean, where each pixel is replaced by the mean of 4 pixels. (This is not quite the same as 2x2 binning, which reduces the number of pixels.) Other flat frame calibration options including normalization to the mean pixel value in the image, particularly useful if your flat frames are taken in natural light.

After this intense math, what is the result? Fig.9 shows three images: as single light frame, calibrated light frame and, as a precursor to the next chapter, a stack of 20 aligned light frames. The dust spots and hot pixels disappear in the calibrated frame and the stacked frame has less noise, especially noticeable in the galaxy spiral. These images are screen stretched but not processed. After processing, the differences will be exaggerated by the tonal manipulation and be very obvious.

Processing Options

So far we have assumed that the master files are produced by simply averaging the pixel values. There are a few further "averaging" options that help in special cases; median, sigma clip, SD mask and bad pixel mapping.

The median value of a data set is the middle value of the ordered data set. (The median of 1,2,3,5 and 12 is 3). It can be useful for suppressing random special causes, such as cosmic ray hits, at the expense of a little more general noise. Alternatively some programs allow an asymmetrical sigma clip, say 4 low and 3 high. This rejects positive excursions more than negative ones and eliminates cosmic ray hits, which are more likely to occur during long exposures. Sigma clip establishes, for each pixel, which frames, when averaged, have all their values within a specified number of standard deviations. It rejects the other frames and averages what is left. (For image frames, this is a great way to lose a Boeing 747.) The SD mask does a similar task and is particularly effective with small sample sets. It uses a computation that

either averages the pixel values or uses their median value, depending on whether there is just general Gaussian noise or some special event. In this way, the noise level is optimized. There are many other variations on a theme and PixInsight has most of them in its armory.

In addition to combining techniques, there are other options that optimize light frame calibrations: Ideally the light frames and dark frames are exposed with similar sensor temperatures and times. This is not always the case, especially with those images from cameras that are not temperature regulated. Since the dark current increases with exposure time at a linear rate, the dark frame subtraction can be scaled so it compensates for the difference in exposure time. To some extent the same applies to differences between the light frame and dark frame temperatures. Most CCD cameras are linear and some astrophotographers take a single set of long dark frame exposures and use the compensation option in the calibration program to scale them to match the conditions of the light frame.

Bad Pixel Mapping

Bad pixel mapping is not an averaging technique per se, but is used to substitute hot pixels in an image with an average of the surrounding pixels. It is an alternative to calibrating light frames by dark frame subtraction. Maxim DL and Nebulosity provide the option to identify hot pixels (and rows) in a master dark frame. The detection threshold is defined by the user, with a numeric value or slider. The positions of these pixels are stored in a hot or bad-pixel map. In practice, one might have a separate hot pixel map for a 1,200-, 600-, 300- and 150-second exposures.

During the light frame calibration setup, the user selects the "remove bad pixels" option. Instead of subtracting the master dark frame from each light frame, the image pixels that occur at the hot pixel positions are substituted by the average of their neighbors. (Bad pixel mapping can only be applied to camera RAW files or monochrome image frames.)

PixInsight has its own version, CosmeticCorrection, that will identify hot and cold pixels and substitute them with the average value of neighboring pixels in the image. Cold pixels are not usually a sensor defect but are the result of over correction of bias and dark noise. If this becomes a problem, it may help to disable the auto scaling dark subtraction option during image calibration.

Stacking Image Frames

Image stacking is essentially two activities: registration and integration. Although a few images can be registered

fig.10 PixInsight does require some perseverance at first. The process of calibration and stacking can be done in many individual
stages or using a script, which automates master calibration file generation and calibrates and registers light frames. It also
allows for automatic cosmetic defect removal (hot and cold pixels). It can also integrate the registered images too, for a quick
image evaluation. The dedicated integration tool provides additional options for optimized pixel rejection and averaging.

and blended in Photoshop, astrophotography demands advanced tools for accurate registration and statistical combination. These tools included the widely used (and free) DeepSkyStacker as well as CCDStack, Maxim DL and PixInsight. Both registration and combining (some programs call this integration) are carried out

fig.11 Maxim DL can automatically reject frames based
on certain parameters. Rejected images are not
combined. It is also possible to override these
selections and manually evaluate the images.

on calibrated light frames. In Maxim DL, the image calibration is done behind the scenes, using individual calibration files (or master calibration files) identified in the calibration dialog. As the image files are added into the stacking process they are calibrated. The stacking process also importantly offers quality checks on roundness, contrast and star size prior to alignment (registration) and combining. PixInsight individualizes these as separate processes, again less automated than some programs but offering greater control over the final result. (PixInsight has a powerful scripting capability that sequences these calibration commands; fig.10 shows a batch process to create master calibration files and stacked images, similar to Maxim DL.) Image assessment in PixInsight is carried out with a utility script called SubframeSelector or visually, using the Blink tool.

Checking the individual quality of calibrated image frames is an important step before combining images and should not be overlooked. Even though localized transient events such as airplanes and cosmic ray hits can be removed by statistical methods, the best-controlled system has the occasional glitch that affects the entire image; a gust of wind, a passing cloud or, as occurred to me last week, an inquisitive cat. These frames should be discarded. Maxim DL allows manual intervention and also has the option to eliminate frames automatically based on parameters such as roundness, contrast and star size.

Registration

At its simplest level, registration is just an alignment of calibrated image frames on orthogonal axes. This approach may work on a series of images taken at the same time in a continuous sequence but many real-world effects make it insufficiently accurate for quality work including:

- images before and after a meridian flip
- images from different sessions or camera angle
- images from different sources
- focal length differences between red, green and blue
- mosaics
- images taken at different binning settings

In increasing complexity, registration routines either translate, translate and rotate, or translate, rotate and scale images... and even distort! The registration data is either stored as separate file or as new images with aligned positions. The process of aligning stars can also be manual, by clicking on the same star or star pair in each image, computed automatically using mathematical modelling or by plate solving each image and using the solved image center, scale and rotation to align the frames. Mathematical models need to carefully calculate star centroids and also use several manipulations to distinguish stars from galaxies, noise or cosmic ray hits.

Imprecise alignment within an exposure group blurs star outlines or worse, between color groups, creates colored fringes around bright stars. The better registration programs can adjust for deliberate dither between image frames and binning, recognize an inverted image after a meridian flip and still align the images. Once these aligned frames are combined there will be an untidy border of partial overlap. To maximize the usable image area it is important to check the alignment after a meridian flip or between sessions. During the acquisition phase, some programs use plate solving to compare the original image and the latest one and calculate the telescope move to align the image centers. This is often labelled as a sync option in the acquisition or planetarium program. With the centers aligned, compare the two images side by side and check the camera angle is the same.

One of the more nifty features of the registration process is its ability to align different scaled frames of the same image, for instance 1x1 binned luminance frames with 2x2 binned red, green and blue frames. In the registration setup, the master frame is identified and the remaining frames are aligned to it. (In some programs, such as Nebulosity, the 2x2 binned frames require re-sampling by 2x before registration for this to work.)

fig.12 Nebulosity (top) and Maxim DL have very different alignment mechanisms. Nebulosity allows for manual star selection (identified by the small red circle) and Maxim DL can use PinPoint plate solving to establish position, scale and rotation of each image in a few seconds.

Drizzle

In the case of under-sampled images, the registration process in PixInsight additionally has the option to enhance resolution from dithered images by using the drizzle algorithm. This algorithm works by projecting image pixels onto a higher resolution grid of output pixels. When it is followed by a special application of the ImageIntegration and DrizzleIntegration tools, the effective resolution can be almost doubled. It relies upon the image of a star being slightly blurred and randomly lying across two or more pixels, even though, if it were perfectly centered on a pixel, the surrounding pixels would not see it.

Combining Image Frames (Integration)

By now we are aware of the various methods of averaging calibration frames using various statistical rejection techniques. The critical stage of image stacking adds a few more. Unlike calibration frames, image frames are taken in real-world conditions and may vary in intensity and noise for a number of reasons. Statistical integration generally rejects outlier pixel values and works well with images that share the same mean values. It becomes increasingly difficult if the images themselves are different. This may occur due to a change of sky condition, exposure time or sensor temperature.

To compensate for this, the stacking processes have a number of normalization options. Depending on the nature of the issue, these generally either add or delete a fixed value to each pixel in the image (add or subtract) and / or scale (multiply or divide) the image pixel values. These algorithms extract statistical information from each calibrated image exposure to work out the necessary adjustment. Having made these adjustments, the pixel rejection algorithms work more effectively to reject random hot pixels, cosmic rays and other transient issues. PixInsight employs two normalization phases. The first phase applies a temporary normalization to the image frames to determine which pixels to reject. The second phase normalizes the remaining pixels prior to integration. The two normalization criteria are usually the same (for bias or dark calibration frames) or subtly different (for flat frames and image frames).

The outcome of the integration process can be a single RGB image, or a set of monochrome images, representing luminance and the individual color channels. Some programs also produce a combined RGB image, with or without color balance weighting on each channel. PixInsight additionally provides two further images to show the rejected pixels, a handy means to ensure that the pixel rejection criteria were set correctly. The image files are ideally 32-bit, recalling that although a camera may only have a 25,000 electron well capacity, once many frames have been calibrated and averaged, the tonal resolution will increase and exceed 65,536 and the capability of a 16-bit file.

As an example, consider 16 image files that have a faint dust cloud that occupy a 10 ADU range. Individually, each file will have a range of pixel values due to the image noise but ultimately can have no more than 10 ADU steps of real signal data. If the images are simply averaged and stored back again as a 16-bit value, the individual pixel values will have less noise but the tonal signal resolution

will still occupy 10 steps. If, however, the averaging is done in a 32-bit space, the noise levels of the individual pixels average to intermediate values over the 10 ADU range and provides the potential for finer tonal resolution. Since $16 = 2^4$, the final combined image can potentially have up to 160 image values, or equivalent to a 20-bit image. During extreme image stretching, the benefit becomes apparent. Since this is only required in astrophotography, the dedicated image processing programs are fully compatible with 32-bit and sometimes 64-bit processing. In comparison all Photoshop's tools work on 8-bit files and each successive version progressively supports more functionality for 16-bit and 32-bit images.

Image integration is a crucial stage in image processing and in this second edition it has its own in-depth chapter, centered on the exhaustive settings in PixInsight.

One last point: These stacked files are a key step in the processing sequence and should be stored for future reference, before any manipulations are carried out.

Mixing Programs

During the research for this book and numerous experiments I quickly realized that not all programs can read each other's files. The FITS file data format has many settings: It can be saved in 8-, 16- or 32-bit as a signed or unsigned integer or alternatively as a 32- or 64-bit IEEE 754 floating point value. For instance, at the time of writing, the PixInsight calibration routines have trouble with 32-bit FITS file output from Maxim DL, whereas it has no difficulty with 16-bit files or its own 32-bit float FITS file. Nebulosity also has issues with reading some PixInsight files. Nebulosity and Maxim DL are not always on the same page either.

Capture programs such as Maxim DL and Sequence Generator Pro usefully label each file with essential exposure about the exposure conditions and equipment. These "tags" enable programs such as Maxim DL and PixInsight to segregate files by exposure length, binning and filter type. In some programs, the process of creating master files strips this important data out and it is necessary to add keywords to the FITS header with an editing program to ensure it is used correctly in subsequent operations. Alternatively, one can store these master files in unambiguous folders for later retrieval. Over time these nuances will be ironed out and effective interoperability between programs will echo the same that has occurred with JPEG and TIFF formats in the mainstream photographic world. If only the same could be said of camera RAW files!

Linear Image Processing

It easy to forget that sensor data is inherently linear and that some image processing algorithms, to be effective, depend on unadulterated sensor data.

The title for this chapter is a reminder that certain image processing tools are better suited to image files before they are stretched. Indeed, the typical workflow shown in fig.1 can equally be called "basic processing". As mentioned earlier, stretching causes a linear image to become non-linear and certain specialist image manipulation tools are optimized for linear images. These generally fix problems in the original files such as background gradients, color balance and convolution (blurring). If these issues are not fixed early on, subsequent image stretching exaggerates these problems and they become increasingly difficult to remove. General image processing programs like Photoshop work implicitly on mildly stretched (non-linear) images. An in-camera JPEG file is already stretched and similarly a RAW file converted and tagged with Adobe RGB assumes a gamma stretch of 2.2. A linear image in Photoshop would have a gamma setting of 1. For that reason I prefer dedicated astronomy imaging programs for the linear processing leading up to image stretching.

This distinction is not widely publicized and I was blissfully unaware up to the point that I researched image processing for this book; I now know why some of my early attempts failed or produced unexpected results. My early images have bloated white stars, complex color crossovers and excessive background noise. The key is to not stretch the image too early in the process (to reveal faint deep sky details) even though it is very tempting. Tools like Digital Development Processing (DDP) in Maxim and Nebulosity give an instant result. This early gratification yields to less heavy-handed processing over time. This is the problem; it is impossible to judge imaging controls without a stretched image.

Luckily astro imaging programs have a screen stretch function (Photoshop can use a temporary adjustment layer) that gives the impression of the final result without affecting the imaging data.

Color Management and Image Output

Color management is a science in its own right. In simple terms, color management defines what a certain pixel RGB value looks like. A color profile defines the color range (gamut) of an RGB image and its color temperature (the color of white). Some device profiles go further and define a transfer function too, akin to a set of curves

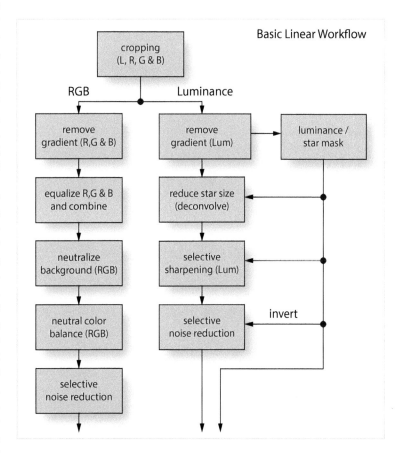

fig.1 An outline of a typical linear processing workflow assuming separate Red, Green, Blue and Luminance exposures. Careful adjustment of background and color, at this stage in particular, pay dividends later on.

in RGB that help programs convert color rendition accurately between physical devices. Significantly, several astro imaging programs do not have explicit color management or default to a common consumer color profile (sRGB) designed for portable electronics and web use. Seasoned photographers know that Adobe RGB (1998) has a wider color gamut and is preferred as an editing space. Both PixInsight and Photoshop have robust color management options that define color image appearance and convert between profiles if necessary.

Image Output

When it comes to image output, the target media determines the format and color profile. TIFF and JPEG image files are both common formats. For web use, 8-bit sRGB tagged JPEG files are preferred. Take care though; JPEG files are compressed and a medium or low-quality setting may shrink an image to a small file size, but it will not render dark skies with a smooth gradation.

For printing, 16-bit Adobe RGB TIFF files maintain the full quality of the original. Printing is another science in its own right and uses Cyan, Magenta, Yellow and blacK inks (CMYK) to selectively absorb light, whereas a monitor emits red, green and blue light. For that reason, the color gamut of a print will not match that of a monitor. The issue is we edit using a RGB monitor to decide the final output. When it comes to printing, the output may be quite different. Some desktop printers add additional red, green and blue inks to extend the color gamut of the output but standard book publishing uses CMYK and photo materials just use CMY. The translation of natural tones from RGB<->CMY(K) is normally without incident. Bright garish colors on a monitor, similar to those that many prefer in narrowband images, are likely to be muted in the final print. To anticipate these changes, check if your imaging program has a soft-proof option to display a facsimile of what the final print will look like on screen. If it does, enable it and select the destination as your printer profile. Some photographers edit in this mode if the output is for print-use only. The colors at most risk of being muted are saturated primary colors.

Monitor Calibration

Up to this point, the image processing has been mechanical and does not require an accurate visualization of the image on screen. Before starting any image manipulation, it is essential to calibrate the computer monitor to ensure that it is accurately representing color and tone. The best way of doing this is to use one of the many monitor calibrators: Macbeth, X-Rite, Datacolor and Pantone have similar models. These rest on the LCD

fig.2 An unusual feature of PixInsight is the ability to drag an operation from the image's processing history onto another file. In this case, the luminance image in the background was cropped and the same cropping is being applied to one of the color channels. (These files were previously aligned with each other during the calibration phase.)

screen and measure the brightness, tonality and color of the monitor. The outcome is a monitor color ICC/ICM profile that ensures some correlation to a standard and between computers.

The starting point for linear processing is a stacked set of registered and calibrated image files. This may be a single file in the case of one-shot color cameras (for instance a typical digital SLR or an astronomical CCD camera fitted with a Bayer array). Alternatively it may require separate image stacks for red green and blue, as well as luminance and narrowband images. The image processing of one-shot color and separate files broadly follows the same path but may deviate in a few places.

Getting Started

The worked example is a challenging arrangement of the loose cluster M52 and the bubble nebula, containing bright stars and dim nebulosity. Our set of stacked images, or in the case of one-shot color, a single stack, is the result of the selection, registration and integration of calibrated image files, or "lights". These stacks represent a critical stage in image processing and I recommend you archive for later reference. The registration process will

fig.4 *As fig.3 but the offending points have been deleted and additional points near the corners more accurately map slight gradients in the image. (The contrast of the background map is greatly exaggerated to show the effect.)*

fig.3 *One of the powerful features of PI is its DynamicBackgroundExtraction tool that eliminates gradient backgrounds. In this case I have deliberately chosen points close to nebulosity or bright stars and the background mapping in the bottom left corner shows a complex patchwork. This is a sign that something is wrong.*

likely have created a ragged border as a result of deliberate or accidental misalignments between individual light frames. Several imaging processes examine the contents of the image to determine their correction parameters and assume the image(s) only contain good data. The extent of the good data is easily seen by applying an extreme screen stretch or temporary curve adjustment layer to highlight the small differences at the frame edges. The cropping tool snips these off.

Image Cropping
In PI, the dynamic crop tool is able to mimic the precise crop parameters to previously registered files and crop each image so that the outcome is a fully aligned set of individual images. This is done by determining the crop settings on one image file and then applying the same settings to the others, either by dragging an instance onto an open file, or dragging the dynamic crop entry in an image's history to another image. In the case of Maxim DL, the outcome of the stacking process creates aligned files and these are similarly cropped using the crop tool. Check the crop trims off all the waste on the most affected image. Open the other images one at a time and crop these without altering the crop tool settings. Nebulosity 3 only allows a single file to be loaded at a time. The crop tool resets each time and is a simple dialog based on the number of pixels to discard off each edge. Write these

four numbers down and re-use them on the other images. Thankfully, in Photoshop, if the images are all aligned and in layers, an image crop affects all the layers equally.

Background Gradient Removal
Even though the images may have had the background adjusted for light fall-off in the calibration phase, there will still be light gradients across the image, mostly as a result of the actual sky background and light pollution near the horizon. It is important to remove these background

fig.5 *Maxim DL has a simpler interface for flattening backgrounds. This is an automatic tool but it does allow manual placement of background samples. Unlike PI, there is no indication if the placement is good or bad and it is reliant on the user magnifying the view and ensuring each sample misses stars and nebula.*

gradients, not only in the luminance channel but also in the individual red, green and blue color information. This is especially important to remove these gradients before stretching the image, color calibration or background neutralization. There are a number of powerful tools in PI, Maxim DL (and Photoshop) to sample the background levels and either subtract or divide the image with a correction to compensate for light gradients or vignetting respectively (figs.3–4). The more powerful tools automatically sample parts of the image that do not contain stars or bright nebula or ask the user to make that selection for them. The latter is often the better choice in the case of densely packed star fields as it allows one to avoid areas of pale nebulosity or the proximity of bright stars. In PI and Maxim DL there are two choices for background equalization: automatic and dynamic. It is important to note that these tools do not neutralize the background or correct color, they merely even out the background level. The color calibration happens afterwards. A good set of samples selects points in the background (avoiding stars, nebulosity or galaxies) over the entire image, including areas near the corners and edges of the field. If you prefer to use Photoshop, there are ways of extracting background information and creating complex curves, but a more convenient and reliable solution is the highly regarded GradientXTerminator plug-in, by Russel Croman, which costs about $50.

In practice, to identify the best sample areas of the background, apply a severe screen stretch to show the faintest detail in your stacked images. If the gradient removal program has a preview function of the correction, take a close look. It should be very smooth with gentle gradients. If it is complex and uneven, that indicates that some of the background samples are contaminated by faint nebulosity or light scatter from bright objects. In this case, look for where the anomalies lie and check the samples in this region and delete or move them.

Image processing is a journey. We make discoveries along the way that change the way we do things. In the beginning, most of us (myself included) will process a full color image (the combination of RGB and L) with global adjustments. The result is a compromise between bloated white stars, weak color, background color and sharpness. Depending on circumstances, the first revelation makes a distinction between luminance and color processing and the second between stars, bright details and the background.

After each image stack has been cropped and their gradients removed, the luminance and RGB images follow similar but distinct workflows before coming together for non-linear processing. In essence, the luminance image records the brightness, resolution and detail and the RGB data is used to supply color information. Similarly the processing places a different emphasis on the two types of data. In one case, the processing emphasizes detail without amplifying noise and in the other, maximizes color saturation and differentiation at the structure level but not at a pixel level.

Luminance Processing

Where this is most apparent is in the processing of the image detail. Increasing detail requires two things to fool the brain, an increase in local contrast and an overall brightness level that brings the details out of the shadows so that our eyes can detect them. It is really important to realize that increasing the luminance of an image affects color saturation: No matter how colorful the image is, as the luminance increases, the final image color becomes less saturated and ultimately, white. Good star color is an indicator of careful luminance processing.

Not everyone exposes through a filter wheel and so there may be no conveniently available luminance data per se. If you use a one-shot color camera, conventional digital camera or have joined the increasing number of astrophotographers that use R, G & B images binned 1x1 (in lieu of the conventional L binned 1x1 with RGB binned 2x2), the answer is to create an synthetic luminance image from the RGB information. Providing the images are registered, this is a simple average of the three separate stacks (if the noise level is about the same) or averaged in proportion to their signal to noise ratio,

fig.6 *This luminance mask on a small preview is protecting the background (red) but leaves the bright nebulosity and stars unprotected for modification. The final setting is applied to the entire image.*

which yields the cleanest signal. PixelMath in PI can apply a formula of the form (R+G+B)/3 or the standard stacking tools that integrate frames are another method, using the simplest average function, or one can use the ImageIntegration tool.

Different strategies are used to improve the resolution of small singular objects (stars), resolve details in mid tones (galaxies and bright nebula), enhance the details of dim nebula and at the same time suppress noise in the background. Some imaging tools automatically distinguish between these entities; others need a little help in the form of a mask. Masks are incredibly useful and vary slightly depending upon their application. Understanding how to generate them is an essential skill to improve your imagery.

Star Mask and Masking

A star mask is a special image file that is used selectively to protect parts of the image from being affected by the imaging tool. It is either binary or, more usefully, has varying degrees of protection with smooth boundaries between different protected and unprotected areas to disguise its application. (The best image edits are those that are undetectable.) Photoshop masks vary from white (transparent) through to black (obscure); other programs resort to the retro Rubylith look from the lithography industry. The general luminance mask is generated from a clone of the image itself. At its most basic, it uses a copy of the image, normally with an applied curve and blurred to create a distinct and smooth mask. The more sophisticated algorithms analyze the image spatially, as we do instinctively, as well as the general luminance to just select stars (a star mask). This is particularly useful when stars overlap bright galaxies and nebula. A further option is to combine masks. In PixInsight, the two masks are mathematically combined, using a tool called PixelMath. Photoshop can combine two masks by the "apply image" function.

Mask generation, often by default, protects the dark areas of a print and allows the brighter areas to be manipulated. Inverting the mask does the opposite. Inverted masks are commonly used to protect bright stars during the image-stretching process. If the extreme stretch necessary to show faint detail is equally applied to bright stars, they become whiter, brighter and grow in size.

As an aside, in practice a star mask is just one way to selectively apply imaging tools. Those using Photoshop have another option that removes the stars altogether from an image using repeated application of the dust and scratches filter. This tool fills in the voids with an average of local pixel values to create a starless version of the

fig.7 Maxim has simpler controls for doing deconvolution. It is particularly difficult to get a good result if there are very bright stars in the image. These acquire dark halos and some users simply resort to retouching these in later using Photoshop. By reducing the PSF radius by 50% and with fewer iterations, the dark halos disappeared but the larger stars can bloat easily.

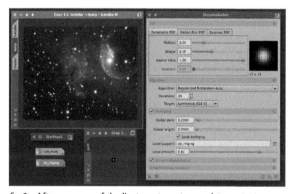

fig.8 After some careful adjustments, a star mask to protect the brightest stars from dark rings, a luminance mask to protect the deep background and using a PSF from suitable stars in the image, the deconvolution worked its magic. The PSF was generated by sampling medium brightness stars in the luminance image using the DynamicPSF tool. The result is very sensitive to the deringing dark control.

original image. (In short, create a duplicate layer of the original image and apply the dust and scratches filter several times to remove the stars. Save this starless imaging for later use. Now change the blend mode to "difference" to create a star-only image for separate processing.) Once the star and background layers are fully processed, they are combined as layers using the "screen" blend mode.

(The need for masks occurs many times during the imaging manipulation process and now is an ideal time to generate a mask, save it for later and for the next step, deconvolution.) The various applications all have

slightly different tool adjustments but since they show a visual representation of the mask, their various effects soon become intuitive. In PixInsight, the essential mask parameters are the scale, structure growth and smoothness. This determines what the tool identifies as a star, how much of the star core's surroundings is included and the smoothness of the transition. A mask should extend slightly beyond the boundaries of the star and fade off gently. It is not uncommon to discover during processing that a star mask's parameters need an adjustment and often requires several attempts to achieve Goldilocks perfection.

Deconvolution

If there is one tool that begs the question "why do I exist?", this is it. I wonder how many have abandoned it after a few hours of frustration. Everyone would agree that deconvolution is particularly difficult to apply in practice. We are just going to touch on the process here since it has its own in-depth chapter later on. Deconvolution is extremely sensitive to small changes in its settings and at the same time these are dependent upon the individual image. What it is meant to do is slightly sharpen up image details and compensate for the mild diffraction caused by the optical system and the seeing conditions, commonly referred to as the Point Spread Function (PSF). The PSF is a mathematical model of the blurring of a focused point light source. The final image is the convolution of the star and the PSF. Deconvolution, as the name implies, is an inverse transformation that compensates for the effect. The tool is designed to work with well- or over-sampled images; that is, stars spanning several pixels. It is also designed to work on linear images, before they have been stretched.

When it is used effectively, dim stars become more distinct, brighter stars appear more tightly focused and details in bright galaxies and nebula are improved. When the settings are wrong, the background becomes "curdled" and ugly black halos appear around bright stars. To prevent these issues, strong deconvolution is best only applied where needed. In PixInsight, this is achieved by protecting the background and bright stars with masks. In the case of the background, a luminance mask excludes the dark tones. This particular mask is created by stretching and slightly clipping the shadows of a duplicate image and applying a small blur. This makes the background obscure and the stars and nebula see-through. To stop black halos around the brightest stars, a special star mask that obscures these plus their immediate surroundings is created with the StarMask tool. This mask is selected as "local support" within

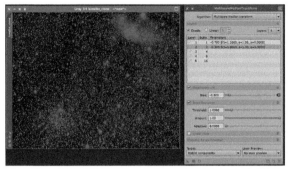

fig.9 The MultiscaleMedianTransform tool has multiple uses and it can be used to selectively reduce noise (blur) at selected image scales as well as lower contrast. In this example it is reducing noise at a scale of 1 and 2 pixels. In this image, the noise reduction is only being applied to the background and a luminance mask is protecting the brighter areas. The mask has been made visible in this image to confirm it is protecting the right areas.

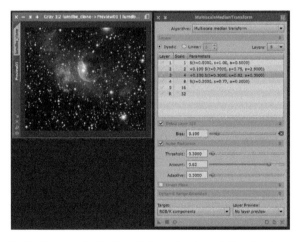

fig.10 The same tool set to reducing noise at a scale from 1 to 8 pixels and increasing the bias (detail) at the 2- and 4-pixel levels. A structure can be de-emphasized by making the bias level for that scale less than 0. Noise parameters can also be set for each scale. The mouse-overs explain the individual controls. Thankfully this tool has a real-time preview (the blue donut) that enables quick evaluation. The brown coloring of the image tabs indicates that a mask has been applied to the image and its preview.

the PixInsight deringing section of the deconvolution tool. This is our first application of a star mask, with holes in the mask for the stars and feathering off at the edges. A typical set of PixInsight settings are shown in fig. 8. Maxim DL's implementation (fig.7) is similar, but essentially, it is applied to the entire image. If there are unpleasant artefacts, try using a smaller PSF radius or fewer iterations to tame the problem. Additionally, if a

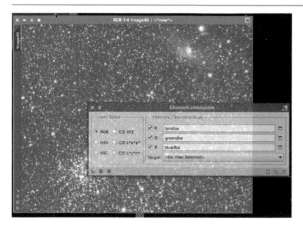

fig.11 *A quick look at the combined RGB image, either direct from the camera or after combining the separate files, reveals the extent of light pollution. The green and blue filters used in front of the CCD exclude the main 589-nm light pollution wavelength emitted from low-pressure sodium lamps. Even so, in this case, the light pollution level is still problematic (though I have seen worse) and the three files need some preliminary adjustment before using the more precise background and general color calibrations tools. Help is at hand with PI's LinearFit tool that does the brute work of equalizing the channels.*

fig.12 *The image in fig.11 is constructed from separate red, green and blue files. Here, these have been resurrected and the LinearFit tool applied to the green and blue channels using the red file as a reference and with the tool set to default parameters. To show the difference, these three files are combined once again with equal weight to show the difference using the ChannelCombination tool. This image is now ready for a fine tweak to neutralize the background and calibrate the overall color balance.*

PixInsight deconvolution increases noise levels (curdles), enable and increase "Wavelet Regularization" to just counter the effect. Less is often more! After an hour of experimentation, the final result does leave a smile on your face and a sense that you have overcome physics!

Luminance Sharpening and Noise Reduction

The luminance information provides the bite to an image. In our retina the color insensitive rods do the same; they are more numerous and have more sensitivity. In the pursuit of better clarity, deconvolution can only go so far and to emphasis further detail, we need different sharpening tools. Sharpening is most effective when applied to the luminance information; if we were to sharpen the RGB color information it would decrease color saturation and increase unsightly color (chrominance) noise. Sharpening the luminance information sharpens the final image. At the same time, sharpening noise emphasizes it further and so the two processes go head to head. Many of the tools which are based on analyzing the image in a spatial sense can equally sharpen or blur by emphasizing or de-emphasizing that particular scale. In its armory, Maxim has Kernel and Fast Fourier Transform (FFT) filters. They have several modes, two of which are low pass and high pass. When set to "low pass", these filters soften the image and the opposite for "high pass". The Kernel filters are applied globally but more usefully, their FFT filter implementation has a further control that restricts its application to a pixel value range. In practice, if you were sharpening an image, this pixel range would exclude the background values and conversely, noise reduction would exclude nebulosity and stars luminance values.

Standing back from the problem, our brain detects noise on a pixel scale. It compares the pixels in close proximity to each other and if they are not part of a recognized pattern, rejects the information as noise. Simply put, it is the differences that call attention to themselves. Effective sharpening works at a macro level. The earliest sharpening algorithms are a digital version of the analog process unsharp masking: In the darkroom, a low contrast, slightly blurred positive image is precisely registered and sandwiched with the original negative and the combination is used to make the print. This print is brimming with micro detail, at a scale determined by the degree of blurring. Unsharp masking has two problems if applied without great care; they leave tell-tale halos around objects and the brightness and distribution of tones is altered and can easily clip. In the early days of digital photography it was common to see prints that had a universal application. It is more effective when it is only applied where needed.

The latest algorithms identify differences between groups of pixels at different scales (termed "structures") and increase their apparent contrast without increasing general pixel-to-pixel differences. This concept is increasingly used for sharpening photographic images and I suspect is the concept behind the Nik® Photoshop plug-ins used for enhancing structures at various scales. The most advanced programs use something called wavelet transforms to identify structures. This technology is used in the communications industry, and like Fourier transforms, expresses a linear-based data set into a frequency-based set. In effect it is an electronic filter. In an audio context a wavelet filter is conceptualized by a graphics equalizer. When the same principles are applied to an image, it can boost or suppress details at a certain spatial scale. PixInsight and Maxim both have wavelet-based filter tools. Wavelet technology forms the basis of many PixInsight tools to enable selective manipulations and can uniquely reduce noise and sharpen structures at the same time. Photoshop users are not to be left out; the High Pass Filter tool performs a broadly similar task. When it is applied to a duplicate image, with its blend mode set to overlay or soft light, it enhances structures at a scale determined by the tool's radius setting.

Unfortunately all sharpening tools create problems of one kind or another. Different image structures will work best with certain algorithms but all create other artefacts as part of their process. The goal is to find the best combination and settings that reduce these to acceptable levels. As with deconvolution, an excellent way to direct the action to the right areas is to use a star mask to protect the background and / or very bright stars.

RGB Processing

RGB Combination

RGB or color processing deviates from luminance processing in two ways; color calibration and sharpening. After running a gradient removal tool on the individual filtered image files, you are ready to combine the images into a single color image. Maxim, Nebulosity and PI all have similar tools that combine separate monochrome files into a color image. They each prompt for the three files for the RGB channels. Some also have the ability to combine the luminance too at this stage but resist the temptation for a little longer. Most offer controls on channel weighting too. This can be useful to achieve a particular predetermined color setting. Some photograph a white surface in diffuse sunlight and determine what values give equivalent R, G and B values. PI has the ChannelCombination tool and Maxim has its Combine

fig.13 Maxim DL's channel combine tool can either assemble RGB or LRGB files. It provides further options for scaling and luminosity weighting during LRGB combination. In this example, I am using a predetermined RGB weighting and checked the background auto equalize to achieve a good color balance in the background.

Color tool, which is able to perform a number of alternative combinations from monochrome files.

Coarse Color Calibration

If you have low light pollution in your area, all may go well, but it is more likely the first attempt will look something like fig.11. Here, heavy light pollution dominates the red and green channels, even though the red and green filters exclude low-pressure sodium lamp emissions. PixInsight and other programs do have tools to remove color casts although these may struggle in an extreme case and leave behind a residual orange or red bias. One tool in PI that can assist, by balancing the channels, is LinearFit. It balances the channel histograms and is perhaps best thought of as determining a compatible setting of end points and gains for each

fig.14 In PI, the BackgroundNeutralization tool is simple and effective. In this case, the reference background is a preview, taken from a small area of background and unaffected by nebulosity. If one chose the entire image as a reference, the tool might compensate for the Hα emissions and turn the background green. The upper limit is carefully selected so as to exclude pixels associated with dim stars.

of the channels. (Note, the images are still linear.) To do this manually would require some dexterity between changing the shadow point in a traditional levels tool and channel gain. The more convenient LinearFit tool operates on separate files rather than the channels within the RGB file. So, back up to before the ChannelCombination action, or, if the image is from a one-shot color camera, use the PI ChannelExtraction tool to separate the RGB channels into its constituent files. Select a reference image (normally the channel with the best signal) and apply the tool to the other two files, thereby equalizing them. The result is remarkably neutral and any residual color issues are easily handled with PI's BackgroundNeutralization and ColorCalibration tools or their equivalents in Nebulosity and Maxim DL.

Neutralize the Background

Color calibration occurs in two distinct steps, the first of which is to neutralize the background. The second step is then to change the gain of the separate color channels so that a pleasing result is obtained. In this particular case we are color calibrating for aesthetics rather than for scientific purposes.

It makes life considerably easier if the background is neutral before image stretching. Any slight color bias will be amplified by the extreme tonal manipulation during stretching. The sequence of gradient removal and background neutralization should give the best chance of a convincing deep sky background. It only takes very small adjustments and it best done in a high bit depth (16-bit is a minimum). The mainstream astro imaging programs have similar tools that analyze the darkest tones in the RGB image and adjust their level setting so that red, green and blue occur in equal measure. The best tools do this from a select portion of the image that contains an area of uncontaminated background. There is often a setting that discriminates between background levels and faint nebulosity. In the ongoing example for this chapter, a small area away from the nebulosity and bright stars is selected as a preview. The tool's upper limit level is set to just above the background value and the scale option selected. In this case the BackgroundNeutralization tool made a very small change to the image following the LinearFit application. Maxim DL and Nebulosity have simpler tools for removing background color. Nebulosity initiates with automatic values that are easily overridden and have convenient sliders for altering shadow values. Although it shows the histograms for the RGB channels these would benefit from a zoom function to show precise shadow values for the three channels.

fig.15 In Maxim DL, there are two key parameters that set the background neutralization, the threshold of what "background" is and a smoothing function that softens the transition between the background and surrounding objects. The threshold can be entered in manually (after evaluating a range of background values over the entire image) or with the mouse, using the sampling cursor of the information tool.

fig.16 Not be left out, Nebulosity has a similar control for neutralizing the background. The screen stretch in the top right corner is deliberately set to show faint details and the tool has manual sliders for each channel. The effect is shown directly on the image and in their histograms. When the tool is opened up, it is loaded with its own assessment.

Neutral Color Balance

The right color balance is a matter of some debate. There are two schools of thought on color calibration: to achieve accurate color by calibrating on stars of known spectral class, or to maximize the visual impact of an image by selecting a color balance that allows for the greatest diversity in color. My images are for visual impact and I choose the second way to calibrate my color. In PI, I

fig.17 Again in PixInsight, the ColorCalibration tool makes
small adjustments to the image. Two previews are used
to sample a group of stars whose overall light level will be
neutralized and a reference background level. In this case it
is using stars as light references and the tool is set to detect
structures. The two monochrome images at the bottom
confirm what the tool is using for computing the white point
and background references within the preview selections.
This image just needs a little noise reduction and then it
is ready for the world of non-linear image processing.

fig.18 The latest noise reduction tool in PixInsight is TGVDenoise.
It can be used on linear and non-linear images. The
default settings are a good starting point for a stretched
(non-linear) image but are too aggressive for this
linear image. By backing off the strength by an order
of magnitude and increasing the edge protection (the
slider is counter-intuitive) the result is much better.
As with most tools, it is quickly evaluated on a small
preview before applying it to the full image.
This is not the last time noise reduction is applied.
Next time it will be to the stretched LRGB image. The
non-linear stretching changes the noise mode and
requires different noise reduction parameters.
Following the noise reduction, the green pixels in
the background are removed with the simple SCNR
tool, set to green and with default settings.

essentially choose two regions of the image with which
to calibrate color; one being a portion of background (for
instance the preview used for the background calibration
task) and a second area that contains some bright objects.
These objects can be realized by a number of unsaturated
stars or maybe a large bright object such as a galaxy. The
idea behind this is that these objects contain a range
of colors that average to a neutral color balance. In the
example opposite, I chose an area containing many stars
in the region of the loose cluster for white balance and a
second preview for background levels.

A third alternative is to determine the RGB weight-
ing independently by imaging a neutral reference (for
instance a Kodak grey card) in daylight and noting the
relative signal levels of the three channels. The weighting
factors are calculated to ensure that all three channels
have similar values. With a strong signal, around half
the well depth, an approximate channel weighting is the
reciprocal of its average pixel value ratio to the value in
the brightest of the three channels.

Noise Reduction on Color Images

One of the most unpleasant forms of noise is color noise
or to use the right nomenclature, chrominance noise. If
the screen stretched RGB image looks noisy, it can help to
apply a little noise reduction at the pixel level to smooth
things out before image stretching. In this particular im-
age, there is an obvious bias pattern noise present in the

image that the calibration process has not entirely removed.
(It was later traced to a fault in the camera firmware and
was fixed with a software update.) A small amount of noise
reduction was traded off with definition to disguise the
issue. Depending on the quality of the data, some RGB
images may not require noise reduction at this stage and
is entirely a case of experience and judgement.

Removing Green Pixels

Astrophotographers have a thing about green. As a color
it is rarely seen in deep sky. As such, it should not appear
in images either. The eye is very sensitive to green and
strong green pixels should be removed from the image
and replaced with a neutral pixel color. Photoshop users
have the Color Range tool to select a family of green
pixels, followed by a curves adjustment to reduce the
green content. PixInsight users have the Selective Color
Noise Reduction or SCNR tool. This is very simple to
use and depending on the selected color, identifies noise
of that color and neutralizes it.

Non-Linear Image Processing

These are the rules:
There are no rules, but if it looks right, it probably is.

We have reached a critical point; our images are ready for initiation into the non-linear world. Their backgrounds are flat and neutral, deconvolved, color balanced and separated into separate color and luminance channels. The next step is to apply permanent tonal manipulations to reveal the details that lie within. Up until now many of the adjustments have been determined more by process than judgement, but from this point onwards, individual interpretation takes over to determine the look and feel of the final image.

To recap, the starting point for non-linear processing is a set of fully calibrated, registered images with even backgrounds. The luminance image is carefully sharpened; emphasizing detail, reducing star size and minimizing background noise. The color image has a neutral background and an overall color balance that gives maximum latitude for color saturation on all channels. At this point many astrophotographers choose to abandon specialist imaging programs and adopt conventional Photoshop, GIMP and other photo editing suites. There are many existing resources that describe non-linear processing using Photoshop software and for that reason, it makes sense to continue the workflow in PixInsight and its unique method of working, highlighting substitute methods where appropriate. Other alternative workflows and unique processing techniques are explored at the end of the chapter and also occur in the practical sections.

During the linear processing phase a temporary stretch function is often applied to an image to indicate an effect, rather than to permanently alter an image. This is about to change with the HistogramTransformation and the CurvesTransformation tool in PixInsight.

Stretching

Histogram Stretching
Presently we have at least two image files, the monochrome luminance file and an RGB color file, and we stretch these non-linearly and independently before combining them. Non-linear stretching involves some form of tonal distortion. Changing the range of a file, via an endpoint adjustment, still results in a linear file. In PixInsight, stretching is achieved most conveniently with the HistogramTransformation tool (fig.1). In essence the mid tones

fig.1 *The HistogramTransformation tool in PixInsight is the mainstay stretching function. The real-time preview and the ability to zoom into the histogram allow accurate settings for end and mid points. It is not a good idea to clip pixels. The tool reports the number and percentage of pixels that will be clipped with the histogram setting. When the settings are right, apply the tool by dragging the blue triangle to the main image.*

slider is dragged to the extreme left-hand side creating a large increase in shadow contrast. It is important to not change the right-hand highlight slider. This ensures the transformation does not clip bright pixels. Drag the left-hand slider, which controls the black point very carefully to the extreme left-hand side of the image histogram, just before the readout shows clipped pixels. (This is shown along with the percentage of clipped pixels in the tool dialog box.) Putting aside clipped pixels, this manipulation is a purely subjective adjustment, judged from the screen appearance. For that reason it is essential to disable the screen transfer function (STF) to accurately assess the effect. The HistogramTransformation tool is one of those that has a real-time preview to assess the adjustment. It is also easier to obtain the desired effect by making the image stretch in two passes, with the first making about 80% of the total adjustment. Now reset the histogram tool and perform a second lesser stretch with greater finesse and finer control. To precisely place the sliders, home into the shadow foot of the histogram with the toolbox's zoom buttons. Repeat this exercise for both the color image and the luminance image, noting that they may need a different level of

adjustment to obtain the desired result. Like many other users you may find the screen transfer function automatically provides a very good approximation to the required image stretch. A simple trick is to copy its settings across to the histogram transfer tool, by simply dragging the blue triangle from the STF dialog across to the bottom of the histogram dialog box. Voilà!

This is just one way to perform a non-linear stretch in one application. If you prefer, one can achieve similar results using repeated curve adjustments in Photoshop, Nebulosity, Astroart or Maxim DL. Maxim DL also has a histogram remapping tool which you may find useful. In any every case, one thing is essential; the image must have 16-bit or preferably 32-bit depth to survive extreme stretching without tone separation (posterization). PI defaults to 32-bit floating point images during the stacking and integration process. If an image is exported to another application, it may require conversion to 16-bit or 32-bit integer files for compatibility.

When I started astrophotography I tried doing everything on my existing Mac OSX platform. My early images were processed in Nebulosity and I used the Curves tool, DDP and the Levels / Power Stretch to tease the detail out of my first images. To achieve the necessary stretch, the Bezier Curves and the Power Stretch tool were repeatedly applied to build up the result. Without masks to protect the background and stars, many of my early images featured big white stars and noisy backgrounds, which then required extensive work to make then acceptable.

Digital Development Process

No discussion on stretching can ignore this tool. DDP is an interesting dilemma. It is a combination of a sharpening and stretch tool originally designed to mimic the appearance and sensitivity of photographic film. When applied to a linear image, it gives an instant result, and for many, the allure of this initially agreeable image dissuades the astronomer from further experimentation. There are versions of this tool in Nebulosity, Maxim and PixInsight to name a few. It is very useful to quickly evaluate an image's potential. The results, though, are very sensitive to the background threshold and sharpening settings and the result often lacks refinement. This includes excessive background noise and star bloat. The sharpening algorithms that sometimes accompany this tool are also prone to produce black halos around bright stars. With a little patience and experimentation superior results are obtained by more sensitive methods. It is interesting to note that PixInsight have relegated their implementation of the tool to its obsolete section.

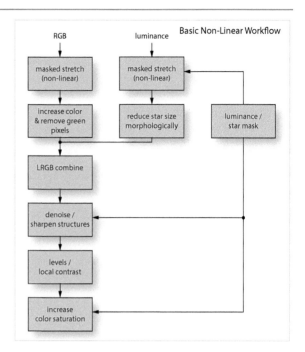

fig.2 The basic building blocks of the non-linear workflow for an LRGB image. It follows on from the workflow in the previous chapter on Linear Processing and assumes separate luminance and color exposures. This general process applies equally to many applications, with a little variation.

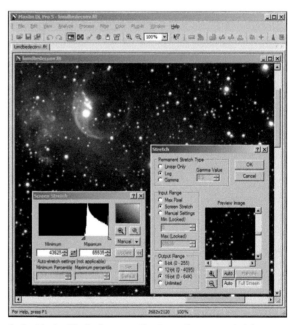

fig.3 Maxim DL also has an option to use the screen stretch settings to set the endpoints on a logarithmic or non-linear gamma curve. This has produced a good initial stretch to the entire image, in this instance, on the luminance file.

Masked Stretching

Some images do not take kindly to a global image stretch. In particular, those with faint nebulosity and bright stars are particularly troublesome. The same manipulation that boosts the faint nebulosity emphasizes the diffuse bright star glow and increases their size. Any form of image stretching will enlarge bright stars and their diffuse halo to some extent. It is an aesthetic choice but most agree that excessive star size detracts from an image. Some star growth is perfectly acceptable but if left unchecked, it alters the visual balance between stars and the intended deep sky object. Some workflows tackle star size later on in the imaging process with a transform tool, for example the MorphologicalTransformation tool in PI or, one at a time, using the Spherize filter in Photoshop. An alternative method preferred by some is to stretch a starless image, either by masking the stars before applying the stretching tool or by removing them altogether. These advanced techniques take some practice and early attempts will likely produce strange artefacts around bright stars.

Not all applications have the ability to selectively stretch an image. Maxim DL 5 (fig.3) and Nebulosity presently only support global application and for instance would require an external manipulation to remove stars from the image prior to stretching. PixInsight and Adobe processes support selective application with masks. The latest version of PI introduces the new MaskedStretch tool. In our example image, it produces artefacts on bright

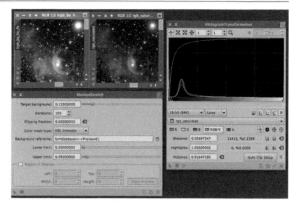

fig.5 *A combination of a medium HistogramTransformation and a MaskedStretch produces a pleasing balance of detail in the nebulosity and with less star bloat. In the two previews above, the result of a standard stretch is on the left and the masked stretch on the right.*

stars, regardless of setting, and is more effective, however, when used on a partially stretched luminance file. In this case, apply a medium strength HistogramTransformation curve to the luminance channel and then follow with a masked stretch. Altering the balance between the two stretches gives a range of effects. Applied to our ongoing example gives better definition in faint details and less star bloat than the same luminance file simply processed using the HistogramTransformation tool in combination with a star mask. The results are subtly different in other ways too: I prefer the balance between the nebulosity and the star field in the luminance file with masked stretching. Initial trials show an improvement in the nebulosity definition at the expense of a little noise.

Star Reduction and Removal

Even a simple star field requires stretching to make the low-magnitude stars visible. It is likely that even with masked stretching, bright stars require taming. There are several tools that identify and shrink singular bright objects: In PI this is the MorphologicalTransformation tool. Used in conjunction with a star mask and set to erode, it shrinks stars by a set number of pixels. Star removal is effected by applying the MultiscaleMedianTransform tool with the first 4–5 layers disabled with the same star mask. (Star processing is covered in detail later on in its own chapter.)

Star Removal

One extreme approach is to remove the stars from the image, stretch what remains and then put the stars back. This is particularly useful with images that are exposed through narrowband filters. The extreme stretches involved to tease details out of SII and OIII wavelengths

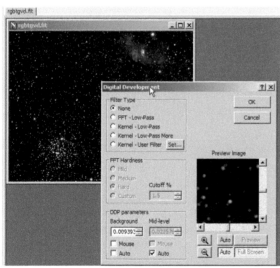

fig.4 *Maxim DL, in common with other astro imaging programs, has a digital development process tool. This stretches the image, with options for smoothing and sharpening. In the case of Nebulosity 3 and Maxim DL 5, there is no mask support.*

create ugly stars at the same time, often with unusual colors. In fact, some practitioners permanently remove stars from their narrowband files and, in addition to the many hours of narrow band exposures, they expose a few RGB files specifically for the star content. The RGB files are processed to optimize star shape and color and the stars are extracted from the file and added to the rainbow colors of the processed narrow band image.

To remove the stars temporarily there are several means to erode stars until they disappear. In Photoshop this is the dust and scratches filter, applied globally. Its original purpose is to fill in small anomalies with an average of the surrounding pixels. Luckily for us it treats stars as "dust" and in simplistic terms, if used iteratively, with different radii, diminishes star size until they disappear. The process is a little more involved than that and some process workflows have dozens of individual steps. This is a prime candidate for a Photoshop action and indeed, J-P Metsävainio at *www.astroanarchy.blogspot.de* has a sophisticated Photoshop plugin to do just that (donate ware). Another Photoshop method is to try the minimum filter. After creating a star mask using the Color Range's dropper on progressively dimmer stars, expand the selection by one pixel and feather by two. To finish off, apply the Minimum Filter with its radius set to 1 pixel.

In PI, the MorphologicalTransformation tool mentioned earlier has a lesser effect than the dust and scratches tool, even after repeated application. A third alternative is a low cost utility called Straton (fig.7), available from the website *www.zipproth.com*. This is very effective and convenient to use. With the stars removed, a star-only image is created from the difference of the original image and the starless one. With two images, stretching and enhancement is easily tailored to the subject matter in each case, with less need for finessed masking. Once completed, the two images are added back together. Combining images is not that difficult: To add or subtract images, simply select the linear dodge or subtract blending modes between Photoshop layers containing the star and starless images. Alternatively, image combination is easily achieved with the PixelMath tool in PI or Maxim DL either to combine the two images or generate their difference. In this case a simple equation adds or subtracts pixel values from each other to create a third image.

Enhancing Structures

Some tools for enhancing structures work better with non-linear images. This is a good time to improve their definition and if needed, reduce background noise at the same time. In PI the tool of choice is the

fig.6 Stretching causes stars to increase in apparent size. All images have to be stretched to some extent to show dim structures and stars. In the example above, an application of the MorphologicalTransformation tool shrinks the star size. The example shows the star field before and after. The highlighted brown preview tabs indicate a mask is in use; in this case, a simple star mask.

fig.7 The Straton star removal utility has a simple user interface with few adjustments. In practice, the application identifies what it believes are stars and when the cursor is placed over the image, it highlights this with a green coloring in the magnified pixel view. If the program believes it is a nebula, the bright pixels are white or grey in the pixel view. The default nebula detection setting considered the brighter parts of the bubble nebula a star. This was fixed with a small adjustment. Straton can currently accept up to 16-bit FITS and TIFF files.

HighDynamicRangeMultiscaleTransform tool or HDRMT for short. (After a mouthful like that, the acronym is not so bad after all.) Like many other PI tools, the HDRMT tool is able to operate at different imaging scales. The user has complete control over the enhancement or suppression of image structures of a particular size. This may be a unique treatment to the spiral arms of the galaxy, emphasizing detail in a dust lane or increasing the contrast of large swathes of nebulosity. Enhancement also increases noise and the HDRMT tool is optimally deployed in association with a luminance mask to protect sensitive areas. It is a good time to recall that it is the luminance file that provides the definition in an image and to go easy when improving the definition of the RGB file. Since each scale has its own unique combination of noise reduction, emphasis and iterations, there are a great many possible combinations. It takes multiple quick trials to achieve the right result. Some users apply HDRMT after the luminance channel has been combined with the RGB information, others before. (If it is only applied to the lightness information in the LRGB file, the effect is similar.) Once established, the tool settings are excellent starting points for further images from the same camera and only require minor adjustment. This is one of those times when a saved project that records tool settings (or a large notebook) is particularly useful for the second time around with a new image from the same setup.

fig.9 Enhancing structures and sharpening both increase local contrast. In the case of the new MultiscaleLinearTransform tool, it makes a distinct difference in this example. As the name implies, it can work at different imaging structure scales and has the option to increase (or decrease) the emphasis of a particular image scale and apply selective noise reduction at that scale too. This is a multipurpose tool and there are many further options including deringing and linear masking to improve noise reduction when this tool is applied to linear images.

Increasing Saturation

When an RGB image is combined with a luminance file to make an LRGB combination, it will likely reduce the color saturation at the same time. Boosting color saturation is an ongoing activity at various stages during non-linear processing and another case of little and often. As the luminance of an image increases, the differences between the R,G & B values diminish and the saturation decreases as a result. Once color information is lost, lowering the brightness of say a white star only turns it grey. For that reason it is essential to maintain good color saturation throughout your workflow. It is easy to be caught out though; it is not just the stretching tools that increase star brightness, it is a by-product of any tool that sharpens or alters local contrast. The brightened areas have lower saturation as a result of contrast enhancement. (Noel Carboni sells a suite of Photoshop actions designed for astrophotography. One of these actions boosts star color by using the color information on unsaturated star perimeters to color the bleached core.)

In practice, boost the color saturation a little before combining it with the luminance information. Although

fig.8 The HDRMultiscaleTransform tool changes the dynamic range of an image and creates what appears to be a flat image with lots of local detail. When used in combination with a subtle adjustment curve, the glowing blob of a galaxy or nebula is changed into a delicate structural form. This detailed but flat image is easily enhanced with a locally-applied contrast increase.

fig.10 It is a good idea to boost the saturation of the color image
a little prior to combination with the luminance channel.
Here, the RGB and Luminance previews are at the top
and a CurvesTransformation, set to saturation, is applied
to the preview at the bottom, using a gentle curve.

there is a saturation tool in PI, the CurvesTransformation tool, with the saturation option enabled, provides more control over the end result. Increasing color saturation also increases chrominance noise and this tool is best used together with a luminance mask that protects the background. When used in this manner, the tool's graph is a plot of input versus output saturation. Placing the cursor on the image indicates the level of saturation at that point on the curve. It is equally important to ensure that the individual red, green and blue channels do not clip (as well as the overall luminance value). If they do, the image loses color differentiation and has an unnatural "blotchy" appearance. If in doubt, click on the image to reveal the RGB values at that point. In the case of the CurvesTransformation tool, it additionally indicates its position on the tool's graph.

Photoshop Techniques for Increasing Color Saturation

Photoshop is at home with color images and has many interesting methods to improve color saturation. They make use of the color blending mode and layers to enhance image color. Many of these techniques follow the simple principle of blending a slightly blurred boosted color image with itself, using the color blending mode. The blurring reduces the risk of introducing color noise into the underlying image. The differences between the methods lie in the method to achieve the boosted color image.

One subtle solution is to use a property of the soft light blending mode. When two identical images are combined with a soft light blending mode, the image takes on a higher apparent contrast, similar to the effect of applying a traditional S-curve. At the same time as the contrast change, the colors intensify. If the result of this intensified color is gently blurred and combined with another copy of the image using the color blend mode, the result is an image with more intense colors but the same tonal distribution. In practice, duplicate the image twice, change the top layer blending mode to soft light and merge with the middle layer. Slightly blur this new colorful and contrasty image to deter color noise and change its blending mode to color. Merge this with the background image to give a gentle boost to color saturation and repeat the process to intensify the effect. Alternatively, for an intense color boost, substitute the soft light blending mode used on the top layer for the color burn blending mode. If that result is little too intense, lower the opacity of the color layer before merging the layers.

The other variations use the same trick of blending a slightly blurred boosted color image with itself. At its simplest, duplicate the image, apply the vibrance tool (introduced into Photoshop several years ago), blur and blend as before using the color mode. Another more involved technique, referred to as blurred saturation layering, works on separate luminance and color files using the saturation tool. The color saturation tool on its own can be a bit heavy-handed and will introduce color noise. This technique slightly lowers the luminance of the RGB file before increasing its saturation and then combining it with an unadulterated luminance file. In practice, with the RGB file as the background image, create two new layers with the luminance image file. Set the blending mode of each monochrome image to luminosity, blur the middle layer by about a pixel and reduce its opacity to 40%. Merge this layer with the RGB layer beneath it and boost its color saturation to taste.

Both PixInsight and Photoshop exploit the LAB color mode and its unique way of breaking an image into luminosity and two color difference channels. Simply put, if the equal and symmetrical S-curves are applied to the two color difference channels a and b, the effect is to amplify the color difference and keep the overall color balance. PixInsight flits between color modes and uses this technique behind the scenes to increase color saturation. Photoshop users have to use a procedure: In practice, convert the image mode to LAB, duplicate it and select the top layer. As before, change the blending mode to color and apply

a small Gaussian blur to it. Open its channel dialog and select the a channel. Apply a gentle s-curve adjustment to it. (Use the readout box in the Curves dialog to make equal and opposite adjustments on each side of the center point.) Save the curve as a preset and apply it to the b channel as well. As before, the trick is to blend a slightly blurred saturated image, using the color blend mode, with the original image. With the LAB technique, the steeper the curve as it crosses the middle peak of the a and b histograms, the greater the color differentiation.

Combining Luminance with Color

Once the files are fully stretched it is time to combine the color information with the sharpened and deconvoluted luminance data. In the particular case of separate L and RGB files, since the luminance and color information have been separately processed and stretched, as well as using different exposures, the general image intensity may be quite different. For best results, the luminance data in both should be balanced before combining the images. For instance, if the luminance signal is substantially stronger than the inherent luminance in the RGB file, the combination has weak colors. If the ScreenTransferFunction settings are used in each case to stretch both L and RGB images, the two images should have similar balance. If not, the distributions require equalizing with an adjustment to the endpoints and gain. Alternatively, the LRGBCombination tool in PixInsight has two controls that adjust the lightness contribution and the color saturation of the image. Moving these controls to the left increases the lightness contribution and saturation respectively. PI's LRGBCombination tool's default settings may produce a bland result. A boost in saturation and slight decrease in lightness bring the image to life. In practice, the luminance file is selected as the source image for L and the R,G and B boxes are unchecked. The tool is then applied to the RGB image. This has the effect of replacing its luminance information with a combination of the inherent luminance of the RGB image and the separate luminance file.

An alternative method is to deconstruct the RGB file, extract and balance its luminance to the stand-alone luminance file, assemble it back into the color file and then combine the separate luminance file with the RGB file. Thankfully this is easier than it sounds and uses the LinearFit tool and the color mode conversions in PI. In practice, extract the luminance channel from the RGB file with the tool of the same name and open the LinearFit tool. Select the original luminance file as the reference image and apply to the extracted luminance

fig.11 *After boosting saturation, the LRGBCombination tool applies the separate luminance image to the RGB image. The lightness and saturation slider positions are nominally 0.5. In this example, the saturation is slightly increased and the lightness contribution decreased to achieve a better balance between color and detail in the final image. (This was necessary as the luminance values in the RGB and luminance files had been separately stretched and were not balanced beforehand. The text explains how to avoid this and balance the two, before combination and achieve a better result with more finesse.) To apply, after selecting the luminance file and deselecting the R, G and B check-boxes drag the blue triangle of the tool to the RGB image.*

channel. This balances the two luminance histograms. The "RGB" file is now essentially treated as the a and b color difference channels of a LAB file. We repatriate it with its new balanced luminance information.

To do this open the ChannelCombination tool (the same one used to assemble the RGB file in the first place) but this time select the CIE L*a*b* color space. Deselect the a and b check-boxes, select the now adjusted luminance file as the L source image and apply it to the RGB file. This effectively re-assembles the color information with a newly balanced luminance file. This luminance file is the original RGB luminance information that is balanced tonally to the separate luminance file (the one that was acquired through a luminance filter and that contains all the deconvolved and sharpened information). Returning to the LRGBCombination tool, select the separate luminance file and as before combine it with the RGB

fig.12 In the continuing example, vertical 1-pixel-wide striations caused by a problem in the camera were noticeable in the LRGB image. To remove these, the ACDNR tool set to a scale of 1 is applied iteratively to the luminance information. The noise reduction is set by the standard deviation, amount and iterations values. A background threshold value is used in the bright sides edge protection section to prevent faint stars becoming blurred. Experimentation is again the key to success and the real-time preview helps enormously to find the Goldilocks value.

file. The result, even with default LRGBCombination tool settings, is much improved. If an increase in color saturation is required, drag the saturation slider slightly to the left in the LRGBCombination tool's dialog. This marks another key point in the image processing workflow and it is a good idea to save this file with "LRGB" in its name before moving on to the final tuning stages.

Noise Reduction and Sharpening

Noise Reduction
The example image suffers from excessive bias pattern noise, most noticeable in areas of faint nebulosity, even after calibration. In PixInsight, the ACDNR tool is an effective tool for reducing noise in non-linear images, as is the MultiscaleLinearTransform tool, both of which can work at a defined structure size. (PixInsight is a dynamic program with constant enhancements and developments; a year ago the ATrousWaveletTransform tool would have been the tool of choice.) In this example, the sensor pattern noise occurs between alternating pixel columns, that is, the smallest scale. It is selected with the structure size set to 1 and the noise

reduced by averaging the values over a 3x3 pixel area with a weighted average. With many noise reduction algorithms, little and often is better than a single coarse setting. This tool has a dual purpose: It can emphasize structure and reduce noise at the same spatial scale. With so many choices, the real-time preview comes into its own and is invaluable when you experiment with different settings and scales to see how the image reacts. In the case of ACDNR tool, there are further options: It can remove luminance noise (the lightness tab) or color noise (chrominance tab). It also has settings that prevent star edges from being blurred into the background (Bright Sides Edge Protection).

A good starting point for selective noise reduction, say with the MultiscaleLinearTransform (MLT) tool, is to progressively reduce the noise level at each scale. One suggestion is to set noise reduction levels of 3, 2, 1 and 0.5 for scales 1 to 4 and experiment with reducing the noise reduction amount and increasing the number of iterations at each scale.

fig.13 A repeat of fig.9, the MLT tool can be used for noise reduction and for emphasizing structures at the same time. Here a combination of mild sharpening and a boost of medium size structures emphasize the nebulosity structure and sharpens up the stars at the same time. The first three layers have a decreasing level of noise reduction. Layers 2, 3 and 4 have a subtle boost to their structures. The tool also has options for deringing and noise sensitive settings that discriminate between good and bad signal differences. For even more control, it can be applied to an image in combination with a mask, to prevent unwanted side effects.

fig.14 *The HDRMultiscaleTransform can also be applied to the LRGB image to enhance structure. In this case, it has been applied to the luminance information in the combined LRGB image with deringing and a lightness mask enabled to avoid unwanted artefacts.*

Finally, if green pixels have crept back into the image, apply the SCNR tool to fix the issue, or the Photoshop process described in the last chapter, by using the color range tool and a curve adjustment.

Sharpening

Noise reduction and sharpening go hand in hand, and in PixInsight, they are increasingly applied in combination within the same tool. The MLT tool can not only be used for progressive noise reduction at different scales, but also to boost local contrast at a scale level, giving the impression of image sharpening. As with other multi-scale tools, each successive scale is double the last, that is 1, 2, 4, 8 pixels and so on. (There is also a residual scale, R, that selects the remaining items that make up the large scale structures within the image.) In the MLT tool, the bias and noise reduction level is individually set at each image scale. When the bias is set to zero, the structures at that scale are not emphasized. The noise settings on the other hand potentially blur structures at that scale and de-emphasize. There is a real-time preview to quickly evaluate the effect of a setting. I often prefer to apply it to a small preview at 50% zoom level and directly compare it with a clone preview. I have no doubt you will quickly discover the undo / redo preview button and its shortcut (cmd-Z or ctrl-Z, depending on platform).

A second tool that is used to create the impression of sharpening is the HDRMultiscaleTransform tool. This is applied either to the luminance file or to the luminance

information in the LRGB image. In the running example it was applied to the luminance image (fig.8) and by way of comparison to the LRGB image (fig.14).

Curve Shaping and Local Contrast

The HistogramTransformation tool is not the last word in image stretching but it gets close. Curve adjustments, well known to Photoshop users, are the ultimate way to fine tune the local contrast in an image. Judicious use of a S-curve can bring an image to life and boost faint nebulosity without increasing background noise. This adjustment is used with or without a mask, depending on need. These curve tools have many options, including selective adjustments to one or more color or luminance channels, saturation and hue. These adjustments are often subtle and it is good practice to have an unadjusted duplicate image and a neutral desktop background to compare against. This calls for a properly calibrated monitor and accurate image color profiling. Curve tools exist in most imaging programs. Photoshop has the advantage of applying curves in an adjustment layer together with a mask. Nebulosity creates its curve shapes with a Bezier function, not unlike the drawing tool in Adobe Illustrator. By dragging the two "handles", a wide variety of shapes are possible.

PixInsight has a further tool called LocalHistogramEqualization (you guessed it, LHE) that enhances

fig.15 *The LocalHistogramEqualization tool creates micro contrast over a defined scale. In this example it has been applied twice, at a small and medium scale to bring out the tracery within the bubble and the larger gas cloud structures around it.*

fig.16 *A selection of curve dialogs from Maxim DL (top left), Photoshop (above) and Nebulosity (left). Nebulosity uses Bezier curves which have the advantage of creating strong curve manipulations with a smooth transfer function.*

structures in low contrast regions of the image (fig.15). In effect, it makes a histogram stretch but localizes the result. It is useful for enhancing faint structures in nebulosity and galaxies, although as mentioned before, it potentially reduces the saturation of the brighter parts of the enhanced image. It can be deployed at different kernel radii to select different structure sizes and at different strengths. No one setting may bring about the precise end result and multiple applications at different settings. The local adaptive filter in Maxim DL has a similar function but is prone to amplify noise.

Enhancing Structures with Photoshop

Whilst on the subject of local contrast enhancement, Photoshop users have a number of unique tools at their disposal, the first of which is the HDR Toning tool. This tool works on 32-bit images and is very effective. Indeed, it is a surprise to find out it was not designed for astrophotography in the first place. It is one of those things that you discover through patient experimentation and exploit for a purpose it was not designed for.

Real High Dynamic Range processing combines multiple exposures of different lengths into a single file. To compress all the tones into one image requires some extreme tonal manipulation. The obvious method simply compresses the image tonally between the endpoints of the extreme exposures. That produces a very dull result. More usefully, the HDR Toning tool in Photoshop can apply local histogram transformations to different areas of the image to increase contrast and then blend these together. On conventional images this creates a peculiar ghostly appearance that is not to everyone's taste. In astrophotography, it is particularly effective since the groups of image elements are often separated by a swathe of dark sky that disguises the manipulation. Just as with the multi-scale operations in PixInsight, local contrast is applied at a certain user-selectable scale. In the example in fig.17 and fig.18, the scale was selected to emphasize the detail with the bubble and outer clouds. The vibrance setting increases color saturation without clipping.

The second Photoshop technique used for enhancing structures uses the high pass filter and layer blending modes. This method is able to emphasize contrast at different scales in a broadly similar manner to the multi-scale processing in PixInsight. At its heart is the high pass filter. When applied to an image on its own, it produces a very unpromising grey image. When you look in closer, you can just make out the boundaries of objects, picked

fig.17 *When you first open the HDR Toning tool with a*
32-bit image, set the method to Local Adaptation
and reset the tone, detail and advanced sliders to
their mid positions and the edge glow settings at a
minimum. The tone curve should be a straight line.
The tool settings interact and at first, just play with
small changes to get a feel for the effects. The edge
glow settings are particularly sensitive and define what
image scales benefit from the contrast enhancement.

fig.18 *After 10 minutes of experimentation a combination of a*
subtle tone curve, increased color vibrancy and increased
detail make the image pop. A subtle amount of edge glow
gives the nebula's cloud fronts a 3D quality. In this example,
the histogram starts at the midpoint as the TIFF output
from PixInsight converts into an unsigned 32-bit integer.

out in paler and darker shades of grey. The radius setting in the high pass filter dialog determines what is picked out. The "a-ha" moment comes when you blend it with the original image using the overlay blending mode. Normality is resumed but the image structures are now generally crisper, with enhanced local contrast where there were faint lines of pale and darker grey in the high pass filter output. This enhancement is normally applied in conjunction with a luminosity mask, to protect the background. Just as with multi-scale processing, it is sometimes necessary to repeat the treatment at different pixel radii to show up multiple structures.

Alternative Processing Options

One-Shot Color (OSC) / RGB

In the case where the image is formed of RGB data only, either from a sensor sandwiched to a Bayer filter (i.e. any conventional digital camera) or through separate RGB filters, there is no separate luminance channel to process. The same guidelines apply though; it is the luminance data that requires sharpening and deconvolution. In this case, extract the luminance information from the stacked RGB file and treat as a separate luminance file through the remainder of the process. (Each of the astro imaging programs have a dedicated tool for this and if you are a Photoshop user, you can accomplish the same by changing the image mode to Lab and extracting the luminance (L) channel from the channels dialog.)

Compared to straightforward RGB processing, image quality improves when a synthetic luminance channel is extracted, processed and combined later on. This is good advice for a color camera user. Those who use a filter wheel might be wondering, why not shoot luminance exposures too? After all, many texts confirm that it is only necessary to take full definition luminance files and that lower resolution color information is sufficient and the binning gives the added bonus of shorter exposures / improved signal to noise ratio. There is a school of thought, however, that believes that LRGB imaging (where the RGB data is binned 2x2) in a typical country town environment with some light pollution, may be improved upon by using RGB imaging alone and without binning. Unlike the RGB Bayer array on a color camera, separate RGB filter sets for filter wheels are designed to exclude the principal light pollution wavelengths. The yellow sodium emission wavelength falls neatly between the red and green filter responses. The argument proposes that for *any given overall imaging time*, a better result is obtained by using RGB at 1x1 binning than L (1x1) and RGB (2x2). It reasons that the exposures through the luminance filter include a good deal of light

pollution and its associated shot noise. This shot noise exceeds that of the shot noise associated with faint deep sky objects. Over the same overall imaging time, the separate RGB exposures have a better combined signal to noise ratio and if binned 1x1, have the spatial information to provide a detailed image. At the same time, their narrower bandwidth is less likely to clip highlights on bright stars, as so frequently occurs in luminance exposures.

I have tried both approaches from my back yard and believe that separate RGB images processed with synthetic luminance (channel combination weighted by their noise level) certainly give excellent results with rich star fields and clusters. The star definition and color was excellent. This interesting idea requires more research and two successive clear nights for a proper back to back comparison. This is not a frequent occurrence in the UK!

Tips and Tricks

Image Repairs

If things have gone well, image repairs should not be necessary. If some problems remain Photoshop is in its element with its extensive cosmetic correction tools. In

fig.19 *The high pass filter in Photoshop can act as a multi-scale enhancement tool. From the top, the original file. Next, the background layer is duplicated twice and the high pass filter (filter>other>high pass) with a radius setting of 4 is applied to the top layer. The blending mode is set to overlay and the whole image sharpens up. In the third box, the two top layers are merged and a luminance layer mask is added. To do this, the background image is copied (cmd-A, cmd-C) and the mask is selected with alt-click. This image is pasted in with cmd-v. (These are Mac OSX keyboard shortcuts. The Windows shortcuts usually use ctrl instead of cmd.) This mask image is slightly stretched to ensure the background area is protected by black in the mask. Clicking on the image shows the final result. In the final image, the stars and nebula details are both sharpened to some degree. In practice, some use a star mask to protect the stars from being affected or remove the stars altogether before applying this technique.*

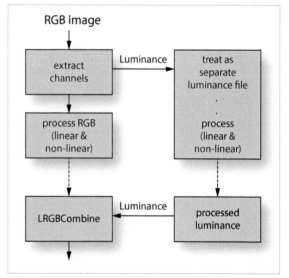

fig.20 *If there is no separate luminance exposure, the trick is to create one. After processing the color information, up to the point of non-linear stretching, extract the luminance information and process it separately as a luminance file as in fig.2. (For users of one-shot color cameras, extract the luminance information just before non-linear stretching.) The quality improvement is substantial over RGB-only processing.*

the latest versions it has intelligent cloning tools that replace a selection with chameleon-like camouflage. One such tool uses the new "content aware" option in the fill tool. The problem area is simply lassoed and filled, ticking the content aware box. The result is remarkable. A similar tool, particularly useful for small round blemishes, is the spot healing brush. In practice, select a brush radius to match the problem area and select the "proximity match" option before clicking on the problem. These tools were originally designed for fixing blemishes, particularly on portraits. As the T-shirt slogan says, "Photoshop, helping the ugly since 1988"!

Correcting Elongated Stars

In addition to the MorphologicalTransformation tool in PixInsight (one of its options identifies and distorts stars back into shape) Photoshop users have a few options of their own to correct slight star elongation. If the image is just a star field, you may find the following is sufficient: Duplicate the image into a new layer, set its blending mode to darken and move the image 1 pixel at a time. This will only work up to a few pixels and may create unwanted artefacts in galaxies or nebulosity. Another similar technique is more selective: In the "pixel offset technique", rotate the image so the elongation is parallel to one axis, duplicate it into another layer and select the darken blend mode. Using the color range tool, select bright stars in the duplicated layer and add to the selection, until most of the stars are identified. Modify the selection by enlarging by 1 or 2 pixels and feather by a few pixels to create a soft edged selection of all the stars. Now choose the offset filter (filter>other>offset) and nudge by 1 or 2 pixels. Once the desired effect is achieved, flatten the layers and de-rotate.

Big oblong stars pose a unique problem. One way to fix these is to individually blur them into a circle with the radial blur tool (filter>blur>radial blur)and then reduce their size with the spherize filter (filter>distort>spherize). In Adobe CS6, the image has to be in 8-bit mode for this tool to become available and for that reason, this cosmetic fix should be one of the last operations on an image. This tool will likely distort neighboring stars or move them. If you duplicate the image and apply the filter to the duplicate, you can paste the offending stars back into their correct positions from the background image.

Correcting Colored Star Fringing

Even though the RGB frames are matched and registered, color fringes may occur on stars as a result of focusing issues and small amounts of chromatic distortion. This is a common occurrence on narrowband

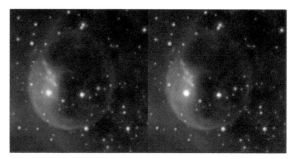

fig.21 *Photoshop has several cosmetic defect tools. Here is an evaluation of a content-aware fill and a spot healing brush set to "proximity match". The grey halo around a prominent star in the middle of the bubble is selected by two circular marquees and feathered by a few pixels. The image on the right shows the result of a content aware fill and the one on the left, the spot healing brush. Note the spot healing brush has also pasted in several small stars that can be seen at the 10 o'clock position.*

images too, caused by the significant differences in stretching required to balance each channel. Photoshop users have a few tools with which to tackle these, depending on the rest of the image content.

If the color of the fringe is unique, one can select it with the color range tool and neutralize it by adjusting the selection by adding the opposing color. If the stars are mixed up with nebulosity of the same color, this technique will also drain the color from the nebulosity. In this case, a star mask may not work, as each star may end up with a small grey halo around it. An alternate solution is to try the chromatic aberration tools in Photoshop (filter>lens correction>custom>chromatic aberration) and adjust the sliders to remove the offending color. Be careful not to go too far, or it will actually introduce fringes.

Extending Faint Nebulosity

When an image has an extended faint signal it is useful to boost this without affecting the brighter elements of the image. The PI tool of choice for emphasizing faint details is the LocalHistogramEqualization process. If set to a large radius, it will emphasize the contrast between large structures rather than at a pixel level and emphasize

noise. The trick is to apply the LHE to the image through a mask that excludes stars and brighter areas of the image. This is accomplished by a compound mask, made up of a star mask and one that excludes bright values. The combination of these two images breaks the ice with the PixelMath tool (figs.22, 23). In the ongoing example of the Bubble Nebula, we first check the settings in a small preview and then apply to the full image to see the overall effect (fig.24).

In the first instance, we use the StarMask tool to make a normal star mask. It should be distinct and tight; there is no need to grow the selection by much and select a moderate smoothness. If it is set too high, especially in a dense star field, the soften edges of the mask join up and there is too much protection of the intervening dark sky. Set the scale to ensure the largest stars are included. Having done that and checked that the resulting mask file, minimize it for later use. Now open the RangeSelection tool and click on the real-time preview. Increase the lower limit until the brighter areas of nebulosity show up in white. Apply a little smoothness to remove the hard edges and apply this tool to the image. We now have two separate masks and these are combined with PixelMath. You can see in fig.23 that combining the images in this case is a simple sum (or max) of the two images. Ensure the output is not re-scaled so the result combines both masks and clips them to black and white. (If the output was re-scaled, the mask would be tri-tone, white, black and grey.)

This mask is now applied to the image and inverted, to protect the light areas. With it in place, the subtle red nebulosity is boosted with the LocalHistogramEqualization tool, with a kernel radius set around

fig.22 *The StarMask and RangeSelection tools are adjusted to select stars and bright areas of nebulosity. The critical area is the vicinity of the bubble and the preview is used to quickly check the mask extent.*

fig.23 *The two masks generated in fig.22 are combined using PixelMath. Click on the Expression Editor and select the filenames from the drop down list. Open up the Destination settings and check create new file and deselect re-scale output. Apply this mask to the image by dragging its tab to the image left hand border. Invert the mask to protect the highlights.*

fig.24 *With the mask in place, check the LHE tool settings using the real-time preview and then apply to the image. In this example, the original image is on the left for comparison. The right hand image shows lighter wispy detail in the star field.*

fig.25 *The best time to remove bad pixels is during image calibration. Sometimes a few slip through and may be obtrusive in lighter areas. The two tools opposite will detect a dark pixel and replace it with a lighter value. The CosmeticCorrection tool has a simple slider that sets the threshold limit for cold pixels. The real-time preview identifies which pixels will be filled in. Alternatively, PixelMath can do the same thing with a simple equation and give a little more control. Here, if a pixel is lower than 0.1, it is replaced with a blend of the pixel value and the median pixel value of the entire image (which is typically a similar value to the average background value). A little experimentation on a preview window determines the detection threshold and the degree of blending. If a dark pixel has spread, try slightly under-correcting the problem but repeat with two passes and with a slightly higher threshold on the second pass.*

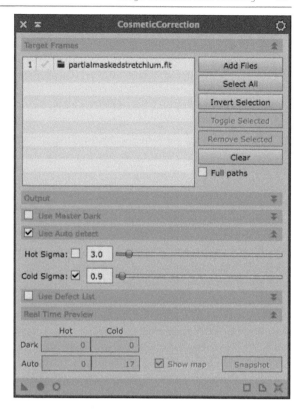

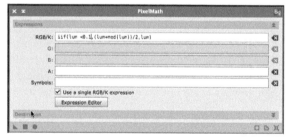

100–300 (to emphasize large cloud structures) and the contrast limit between 1 and 3. After checking the settings in a preview window, it is applied to the main image. Side by side, the effect is subtle and may not read well off the printed page. In this example, the faint wispy areas of nebulosity are more prominent in relation to the dark sky and the image has an overall less-processed look. This particular example uses a color image but it is equally effective when applied to the luminance file.

Removing Dark Pixels

Image calibration sometimes introduces black pixels into an image, or they occur with later image manipulation that creates an increase in local contrast. Even without dark frame auto-scaling, the image calibration in PixInsight or Maxim may over-compensate and conflict with the camera's own dark processing. This introduces random dark pixels. While these are not noticeable in the background, they detract from the image when they occur in brighter areas or after stretching. Isolated black pixels also seem to resist noise-reduction algorithms. The solution is to replace these cold pixels with an average of their surroundings. The CosmeticCorrection tool has the ability to detect cold and hot pixels and has the convenience of generating a preview of the defect map. Dragging the Cold Sigma slider to the left increases the selection threshold and the number of pixels. These pixels are replaced with a blend of surrounding pixels.

An alternative is a simple conditional statement using PixInsight's PixelMath tool. This selects pixels with a value lower than a defined threshold and substitutes them with an average background value. The sensitivity is determined by the threshold value in the equation. In this case it is 0.1. Both of these have no blending effect and so they literally substitute pixel values. For this reason, defects are best removed before the cold pixel boundary has blurred into neighboring pixels, or the fixed pixels may retain a small dark halo. Alternative blending equations can be used to combine the current pixel value with another. The tool can also be applied iteratively to great effect.

Narrowband Image Processing

For astrophotographers living in light-polluted areas, narrowband imaging is a savior and a thing of wonder to everyone else.

Following along the same lines as the previous chapter on CFA imaging, a whole new world opens up with the introduction of processing images taken through narrowband filters. These filters select a precise emission wavelength and almost completely reject light pollution (and moonlight) with the potential for lowering sky noise and hence deliver a better signal to noise ratio. This permits many astrophotographers to successfully image from light polluted urban areas. Images taken with narrowband filters are quite distinct; their raison d'être are gloriously colored nebulous clouds, punctuated by small richly colored stars. These particular goals require a unique approach and flexibility to image acquisition and processing. For starters, the exposures required to collect sufficient pixels are much longer than RGB imaging and will likely demand an entire night's imaging to each filter. Even so, the relative signal strengths for the common emission wavelengths are quite different and are dominated by the deep red of hydrogen alpha (Hα). Another anomaly is the commonly imaged wavelengths do not correspond to red, green and blue and encourage individual interpretation. Image "color" is whatever you choose it to be. Typically exposures are made with two or more filters and the image files are assigned and / or combined to the individual channels of an RGB file.

The assignment of each image to a color channel is arbitrary. There are six possible combinations and swapping this assignment completely alters the hue of the end result. Two of the most famous assignments are the Hubble Color Palette (HCP) that maps SII to red, Hα to green and OIII to blue and the Canada France Hawaii Telescope palette (CFHT) that maps Hα to red, OIII to green and SII to blue. A simple assignment will likely produce an almost monochromatic red image and a larger part of the processing workflow balances the relative signal strengths to boost the color gamut. Without care, the more extreme image stretches required to boost the weaker OIII and SII signals can cause unusual star color and magenta fringes around bright stars. Some imagers additionally expose a few hours of standard RGB images to create a natural color star field. They neutralize and shrink or remove the stars altogether in the narrowband image and substitute the RGB stars, typically by using the RGB star layer set to color blend mode (Photoshop).

In practice, there are many options and alternative workflows. Some of the most common are shown in fig.1, with 2- or 3-channel images, with and without separate luminance and RGB star image workflows. The first light assignments highlight some additional twists. The cosmos is your oyster!

Color Differentiation

The most striking images maximize the visible differences between the common emission wavelengths. With two reds and a turquoise, assigning these to the three primary colors on the color wheel already has a big visual impact. Of course, these assigned colors channels are just a starting point. One can alter selective hues of the image to increase the visual impact (color contrast) between overlapping gas clouds. These amazing opportunities and challenges are well met with Photoshop blending modes and re-mapping selective color hues to emphasize subtle differences. PixInsight tackles the challenges with different tools, which although they are broadly equivalent, may steer the final image to a slightly different conclusion. There is no "right" way and once you understand the tools at your disposal, the only obstacle is one's own imagination and time.

Narrowband and RGB

Before diving into the detail it is worth mentioning further options that combine narrowband exposures with RGB information in the main image. For those astrophotographers unlucky enough to image from light-polluted areas, the subtle colored details of the heavens are often masked by the overall background light level and accompanying shot noise. One way of injecting some more detail into these images is to enhance the RGB channels with narrowband information. A popular combination is Hα (deep red) with red and OIII (turquoise) with green and blue. In each case, the narrowband information has greater micro contrast and it is this that adds more bite to the RGB image and at the same time without adding much shot noise from light pollution. This is not quite as easy as it sounds. Hα emissions are far more abundant than OIII and unless this is taken into account during the image channel balancing, the Hα/red channel dominates the final image and an almost monochromatic red image will result.

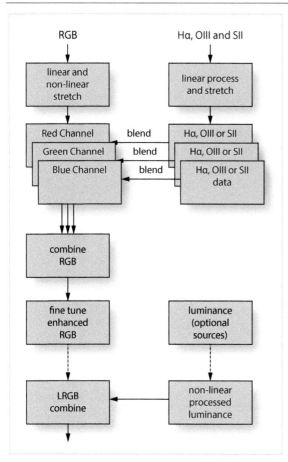

fig.1 *The first steps in narrowband imaging often begin with introducing narrowband exposures into existing LRGB data that has got to the stage of being non-linearly stretched. Here, the narrowband data is used to enhance the RGB data using a selected blend mode. Most commonly, abundant Hα data is combined with the red channel to enhance faint nebulosity but OIII and SII data can be used too, if available. The particular method of blending is a matter of personal preference and experimentation.*

Processing Fundamentals

In many ways processing a narrowband image follows the same path as a conventional RGB image, with and without luminance information. The main differences lie in the treatment and balance of the color channels, and additionally, the choices concerning luminance generation and processing. In some cases the luminance information is sourced from the narrowband data itself, or it may come from additional exposures using a clear filter. Narrowband imaging still follows the same calibration and linear processing paths up to a point. The challenges lie in the comparative strengths of the common narrowband signals and the fact that the colors associated with these narrowband emissions do not fall conveniently into red, green and blue wavelengths. This chapter concentrates on the unique processing steps and assumes the reader is familiar with the concepts outlined in the previous linear and non-linear processing chapters.

Combining RGB and Narrowband Data

Let us start by introducing narrowband data into an RGB image. The unique processing step here is to enhance the RGB data with another data source. This occurs after the separate images have been stretched non-linearly. The individual R, G and B filters typically have a broad pass-band of about 100 nm each, and even if the red and green filters exclude the dominant yellow sodium vapor lamp wavelength they will still pass considerable light pollution from broadband light sources and shot noise. The narrow filter passbands are typically 7–3 nm and pass more than 90% of the signal and at the same time blocks about 90% of the light pollution bandwidth of a normal color filter with an associated 4x reduction in shot noise. (This is significant, to achieve a similar improvement in SNR would require 16x the number or length of exposures.)

The key processing step is to blend the narrowband and RGB data together. Most commonly this involves blending Hα data with the red channel, although there is no limitation here and if you have the sky time, OIII and SII image data can be blended with the other color channels too. There are a number of options on how to combine the data, principally around the Hα data. Again, there is no right way and you will need to experiment with different options and decide which gives you the desired effect. In increasing sophistication, three common methods are used to combine the channels in proportion to their noise level, use the narrowband to increase local contrast or employ the lighten blending mode. The formulas below respond well to PixelMath in PixInsight. In each case, the channel names are substituted for the open image filenames.

Lighten Blend Mode

The first of the three example combining modes is adopted from a popular Photoshop action. In Photoshop, the red layer has the Hα layer placed above it and the blending mode set to lighten. In this blending mode, after flattening the layers, each red pixel R is replaced by the maximum of the corresponding pixels in the red and Hα images. In mathematical terms:

$$R = max\ (R,\ H\alpha)$$

One issue that arises from the lighten blend mode is that it also picks up on noise in the red channel's

background. A common temptation is to over-stretch the Hα data before combining it with the red channel. Although its contribution to the red channel is controlled by the opacity or scaling factors in the above equations, it is better to go easy on the non-linear stretch and use similar factors for all the narrowband inputs.

Proportional Combine

This concept combines the Hα and R channels with an equivalent light pollution weighting. In mathematical terms, the contributions of the Hα and R channels are inversely proportional to their approximate filter bandwidths. In the following example, a Hα filter has a 7-nm bandwidth and an R filter is 100 nm. Here, we use the "*" symbol to denote multiply, as used in PixInsight's PixelMath equation editor. Some simplify this to:

$$R = q*R + (1-q)*H\alpha \quad (q \approx 7\ nm/100\ nm)$$

Although this approach has some logic, it ultimately discounts a large proportion of the red channel's data and it is easy for small stars in the R channel to disappear.

Hα Contrast Enhancement

An alternate scheme enhances the R channel contrast by adding in a weighted Hα contrast value. The Hα contrast value is calculated by subtracting the median value from each pixel, where f is a factor, typically about 0.5:

$$R = R + (H\alpha - med(H\alpha))*f$$

This is often used in conjunction with a star mask and additionally can be used with a mask made up of the inverted image. The effect emphasizes the differences in the dim parts of the image and I think improves upon the two techniques above. A mask is effectively a multiplier of the contrast adjustment. The operator "~" inverts an image, so ~R is the same as (1-R) in the equation:

$$R = R + ((H\alpha - med(H\alpha))*(\sim R))$$

In PixInsight, there is a script that can do this for you and not surprisingly, it is called the NarrowBandRGB script or NBRGB for short. This does the pixel math for you and has a facility to evaluate different combination factors and filter bandwidths. In each case it allows you to enhance a color RGB file with narrowband data. In the case of OIII data, since it lies within the blue and green filter bandwidths, it is often used to bolster each. It uses a complex and non-linear algorithm that takes into account filter bandwidths, beyond the scope of this discussion.

Photoshop blending mode	PixelMath equivalent (assumes Hα layer on top or R layer)
Lighten	max(R,Hα)
Darken	min(R, Hα)
Screen	~(~R * ~Hα)
Overlay	iif(R>0.5, ~(~(2 * (R-0.5)) * ~Hα), 2 * R * Hα)
Soft Light	iif (Hα>0.5, ~(~R * ~(Hα-0.5)), R*(Hα+0.5))
Multiply	(R * Hα)
Linear Burn	R+Hα-1
Difference	R- -Hα

fig.2 Most of Photoshop's blending modes have a direct equivalent PixelMath equivalent, or at least a close approximation. These equations are using PixelMath notation. The "~" symbol denotes the inverse of an image (1-image) and the "- -" symbol is the magnitude operator.

PixInsight Iterative Workflow

Never one to be complacent, the folks at Pleiades Astrophoto have devised yet another approach that captures the best of both worlds. This revised workflow keeps control over the image and retains accurate color representation of both line emission and broadband emission objects. At the same time, it minimizes the SNR degradation to narrowband data. The workflow can be automated and it is planned for release in a future PixInsight update. In essence the process has three steps, which are repeated to keep the finer stellar detail from the broadband red image:

1) intermediate image, C = R / Hα
2) apply strong noise reduction to intermediate image
3) new R = C * Hα
4) repeat 1–3 for the desired effect

This is a good example of where a process container can store the three steps and repeatedly applied to an image.

Blending Modes and PixelMath

At this point it is worth taking a short detour to discuss Photoshop blending modes. For me, PS blending modes have always had a certain mystery. In reality, blending modes simply combine layers with a mathematical relationship between pixels in the image. The opacity setting proportionally mixes the global result with the underlying

layer and a mask does the same but at a pixel level. The same end result can be achieved in PixelMath using simple operators, once you know the equivalent equation for the Photoshop blending mode. Using PixelMath may take a few more grey cells at first, but crucially offers more extensive control. For instance, PixelMath can also use global image statistics (like median and mean) in its equations as well as work on combining more than two images at a time.

The two equations for combining R and Hα above blend the two channels together using simple additive math and some statistics. For Photoshop users, there is no simple equivalent to the two equations above but I dare say it could be done with a combination of layer commands if one feels so inclined. More frequently, a simple blending mode is used to similar effect. Of these, the lighten blending mode is perhaps the most popular choice to combine narrowband and color images. Several Internet resources specify the corresponding mathematical formula for the Photoshop blending modes and it is possible to replicate these using the PixelMath tool. Some of the more common ones used in astrophotography are shown in fig.2, using R and Hα as examples.

Narrowband Imaging

It is almost impossible to impart a regime on full narrowband imaging. The only limitation is time and imagination. Many of the tools for non-linear RGB processing equally apply, as well as the principles of little and often and delicacy, rather than searching for the magic wand. The unique challenges arise with the combination of weak and strong signals and the balancing and manipulation of color. After orientating ourselves with the general process, these will be the focus of attention.

Luminance Processing

The basic processing follows two paths as before; one for the color information and the other for the luminance. The luminance processing is identical to that in RGB imaging with one exception: the source of the luminance information. This may be a separate luminance exposure or more likely luminance information extracted from the narrowband data. When you examine the image stacks for the narrowband wavelengths, it is immediately apparent that the Hα has the cleanest signal by far. This makes it ideal for providing a strong signal with which to deconvolve and sharpen. The downside is that it will favor the Hα channel information if the Hα signal is also used solely as the information source for a color channel. Mixing the narrowband images together into the RGB channels overcomes this problem. Alternatively, if the

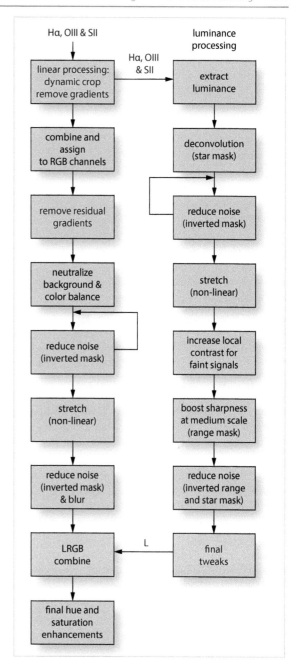

fig.3 *An example of a narrowband processing workflow. After preparing the linear images, a copy of the Hα (SII, OIII) is put aside for luminance processing (uniquely, deconvolution and sharpening). The narrowband channels are blended together, or simply assigned to the RGB channels and the resulting color image is processed to maximize saturation and color differential. Noise reduction on both the chrominance and luminance is repeated at various stages. Just before combining the stretched images, the RGB data is blurred slightly.*

intention is to assign one image to each RGB channel, extracting the luminance from a combination of all the images (preferably in proportion to their noise level to give the smoothest result) will produce a pseudo broadband luminance that boosts all the bright signals in the RGB image. Sometimes the star color arising from these machinations is rather peculiar and one technique for a more natural look is to shrink and de-saturate the stars in the narrowband image and replace their color information with that from some short RGB images, processed for star color, as depicted in fig.4.

Color Processing

The broad concepts of color processing are similar to RGB processing with the exception that, as previously mentioned, the SII and to some extent the OIII signals are much weaker than the Hα. The separate images still require careful gradient removal and when combined, the RGB image requires background neutralization and white point (color balance) before non-linear stretching. The OIII and SII data requires a more aggressive stretch to achieve a good image balance with Hα, with the result that their thermal and bias noise becomes intrusive. To combat this, apply noise reduction at key stages in the image processing, iteratively and selectively by using a mask to protect the areas with a stronger signal. As with broadband imaging, once the separate RGB and luminance images have been separately processed and stretched, combine them using the familiar principles used in LRGB imaging, to provide a fully colored image with fine detail. In many instances though, the narrowband data will be binned 1x1 as it will also be the source of the luminance information.

Fortunately spatial resolution is not as critical in the color information and the RGB image can withstand stronger noise reduction. Even so, strict adherence to a one image, one channel application may still produce an unbalanced colored result. To some extent the degree of this problem is dependent upon the deep sky target, and in each case, only careful experimentation will determine what suits your taste. As a fine-art photographer for 30 years I have evolved an individual style; to me the initial impact of over-saturated colored narrowband images wanes after a while and I prefer subtlety and detail that draw the viewer in. You may prefer something with more oomph. The two approaches are equally valid and how you combine the narrowband image data into each RGB channel is the key to useful experimentation and differentiation. With the basic palette defined, subsequent subtler selective hue shifts emphasize cloud boundaries and details. The narrowband first light assignments have some good examples of that subtlety.

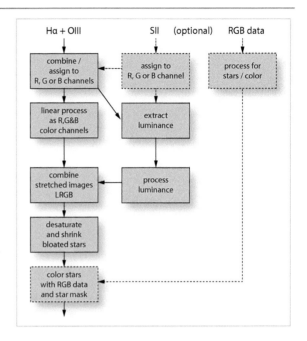

fig.4 *This shows a simplified workflow for narrowband exposures, with the added option of star color correction from a separate RGB exposure set. If using Photoshop, place the RGB image above the narrowband image, with a star mask, and select the color blending mode.*

Color Palettes

Just as with an artist's color palette, mixing colors is a complex and highly satisfying process. The unique aim of narrowband imaging is to combine image data from the narrowband images and assign them to each color channel. The remainder of this chapter looks at the unique techniques used to accomplish this.

Photoshop users' main tool is the Channel Mixer. This replaces one of the color channels with a mixture of all three channels levels. By default, each of the R, G and B channels is set to 100% R, G or B with the other channels set to zero contribution. Unlike an artist's palette, it can add or subtract channel data. The result is instantaneous and even if Photoshop is not part of your normal workflow, the channel mixer is a remarkably quick way of evaluating blending options. This freedom of expression has a gotcha, however. Photoshop has no means to auto-scale the end result and it is easy to oversaturate the end result by clipping the highlights of one of the color channels. Fortunately there is a warning flag, a histogram display and a manual gain control. Check the histogram does not have a peak at the far right, as it does in fig.5. Even so, the histogram tool is only an indicator. The most accurate way to determine clipping is to use the info box and run the cursor over the brightly colored parts of the

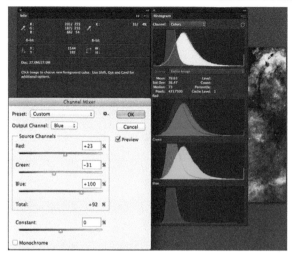

fig.5 Photoshop's Channel Mixer is an effective way to mix and match the narrowband images to the RGB channels. It is good practice to check for saturation with the histogram and eyedropper tools. If a channel starts to clip, reduce the overall level by dragging the constant slider to the left.

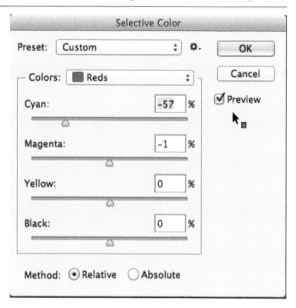

fig.6 The Selective Color tool in Photoshop, as the name suggests, is designed to selectively change colors. The color selection in this case is red and the slider setting of -57 cyan reduces the cyan content of strong reds in the image, shifting them towards orange and yellow. To avoid clipping issues, ensure the method is set to "Relative". When a primary color is selected, an imbalance between the two neighboring secondary colors in the color wheel will shift the hue.

nebula and ensure all values are below 255. Mixing it up not only changes the color but it also changes the noise level of the image. For most of us with limited imaging time, blending some of the stronger Hα signal with the OIII and SII may dilute the color separation but it will improve the signal to noise ratio. It is all about trade-offs.

This is only the start; once the basic separation and color is established, the Selective Color tool in Photoshop provides a mechanism for fine tuning the hue of the different colors in the image (fig.6). The Selective Color tool selects image content based on one of six primary or secondary colors and the color sliders alter the contribution of the secondary colors in that selection. In this way, a particular hue is moved around the color wheel without affecting the others in the image. In one direction, a red changes to orange and yellow, in the other, it moves to magenta and blue. Additionally, the Hue/Saturation tool has the ability to select image content based on a color range and alter is hue and saturation. With the preview button enabled, Photoshop is in its element and there is no limit to your creativity.

PixInsight has equivalent controls, but without the convenience of a live preview in all cases. In the first instance, PixelMath provides a simple solution to effect a precise blending of the three narrowband images into a color channel. Having used both programs, I confess to exporting a simply-assigned HαSIIOIII image to a RGB JPEG file and played with Photoshop's Channel Mixer settings to establish a good starting point for PixInsight. If you transfer the slider percentage settings back to a

fig.7 The ColorSaturation tool in PixInsight can alter an image's color saturation based on overall color. Here, the yellows and blues have a small saturation boost and the greens are lowered. It is important to ensure the curves are smooth to prevent unwanted artefacts.

fig.8 The PixInsight CurvesTransformation tool is very versatile. Here it is set to hue (H) and the curve is adjusted to alter pixel colors in the image. In this instance, yellows and blues are shifted towards green and turquoise respectively. This has an equivalent effect to the Selective Color tool in Photoshop but in graphical form.

fig.9 By selecting the saturation button (S), the CurvesTransformation tool maps input and output saturation. This S-curve boosts low saturation areas and lowers mid saturation areas. This manipulation may increase chrominance noise and should be done carefully in conjunction with a mask to exclude the sky background.

PixelMath equation to generate the initial red, green and blue channels. Having done that, the CurvesTransformation tool, unlike its cousin in Photoshop, provides the means to selective change hue and saturation based on an image color and saturation. The ColorSaturation tool additionally changes the image saturation based on image color. I think the graphical representations of the PixInsight tools are more intuitive than simple sliders and fortunately both these tools have a live preview function. The examples in figs.7, 8 and 9 show some sample manipulations. Although a simple curve adjustment is required in each case, behind the scenes PixInsight computes the complex math for each color channel. The key here is to experiment with different settings. Having tuned the color, the luminance information is replaced by the processed luminance data; in the case of PixInsight, using the LRGBCombination tool or in Photoshop, placing the luminance image in a layer above the RGB image and

changing the blending mode to "luminosity". (This has the same effect of placing a RGB file over a monochromatic RGB file and selecting the "color" blending mode.)

So, what kind of image colors can you get? All this theory is all well and good. The following page has a range of variations by altering the assignment and the mix between the channels. My planned narrowband sessions were kicked into touch by equipment issues and so this example uses data generously supplied by my friend Sam Anahory. The images were captured on a Takahashi FSQ85 refractor on an EQ6 mount using a QSI683 CCD camera from the suburbs of London. These images are not fully processed; they don't need to be at this scale, but they show you the kind of color variation that is possible. Each of the narrowband images was registered and auto stretched in PixInsight before combining and assigning to the RGB channels using PixelMath. A small saturation boost was applied for reproduction purposes.

fig.10 Canada France Hawaii palette: R=Hα, G=OIII,
 B= SII, a classic but not to my taste.

fig.11 Classic Hubble palette: R=SII, G=Hα, B=OII (note the stars'
 fringes are magenta due to stretched OIII & SII data).

fig.12 R=OIII, G=Hα, B=SII; swapping the OIII and SII around
 makes a subtle difference (note the stars' fringes
 are magenta due to stretched OIII & SII data).

fig.13 R=Hα +(SII-median(SII)), G=OIII+(Hα/20), B=OIII-(SII/4);
 the result of just playing around occasionally produces
 an interesting result which can be developed further.
 Star colors look realistic without obvious fringes.

IC1318 © 2014 Image capture by S. Anahory

fig.14 R=SII+Hα, G=80%OIII+10%Hα, B=OIII; SII and Hα
 are both red, so mixing together is realistic; OIII is
 given a little boost from Hα to make the green; OIII is
 used on its own for blue; stars' colors are neutral.

fig.15 R=SII+Hα, G=OIII+Hα, B=SII+OIII; each channel is a mixture
 of two narrowband images and produces a subtle result
 with less differentiation between the areas of nebulosity.

PixInsight Narrowband Tools

A single 10-minute Hα exposure can differentiate more object detail than an hour of conventional luminance. This will, however, favor red structures if used as a straight substitute. As such, astrophotographers are continually experimenting with ways of combining narrowband and wideband images to have the best of both worlds. The NBRGB script described earlier enhances an existing RGB image with narrowband data. Several astrophotographers have gone further and evaluated more radical blending parameters and developed their own PixInsight scripts to conveniently assess them. These are now included in the PixInsight script group "Multichannel Synthesis". Of these I frequently use the SHO-AIP script. (Just to note, the references to RVP are equivalent to RGB, since the French word for "Green" is "Vert".) The script uses normal RGBCombination and LRGBCombination tools along with simple PixelMath blending equations. It also uses ACDNR to reduce noise for the AIP mixing option, which as a noise reduction tool, has largely been replaced by TGVDenoise.

This is a playground for the curious and there are a number of tips that make it more effective:

- The files should preferably be non-linear but can be linear, provided the individual files have similar background levels and histogram distributions (LinearFit or MaskedStretch operations are recommended).
- The star sizes should be similar in appearance to avoid color halos. This may require Deconvolution or MorphologicalTransformation to tune first.
- When mixing the luminance, either using the Mixing Luminance tab or by some other means, avoid using strong contributions from weaker signals as it will increase image noise (e.g. SII).
- Process the luminance as required and set to one side.
- Find the right color using the Mixing SHONRVB button.
- When supporting a narrowband exposures with RGB data, start with proportions that add up to 100% and are in proportion to their respective SNR level.
- When satisfied, try the Mixing L-SHONRVB button to add in the processed luminance.
- If you enable AIP mixing, noise reduction is applied to the image in between progressive LRGBCombination applications, but the processing takes longer.
- Avoid using STF options.
- Extract the luminance from the outcome and combine with a RGB star field image. Use a simple PixelMath equation and a close-fitting star mask, to replace the star's color with that of the RGB star field.

The output of the script should have good color and tonal separation. If one wishes to selectively tune the color further within PixInsight, the ColorMask utility script creates a hue-specific mask. Applying this mask to the image then allows indefinite RGB channel, hue and saturation tuning with CurvesTransformation. With care, a color can be shifted and intensified to a neighboring point on the color wheel.

Narrowband imaging in false color is liberating. There is no "right" way. It does, however, require plenty of image exposure (for many objects, especially in SII and OIII) to facilitate expressive manipulation, as well as some judgement. Some examples resemble cartoons to my mind and lack subtlety and depth.

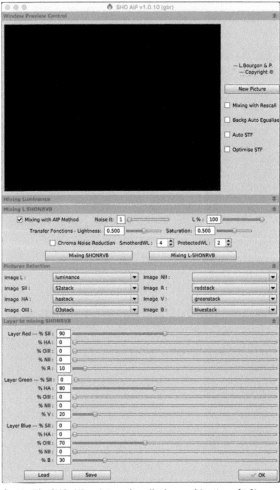

fig.16 *The SHO-AIP script can handle the combination of 8 files in a classic RGBCombination mix, LRGBCombination mix or using the AIP method, that progressively combines Luminance with the generated RGB image, with noise reduction in between each step. In practice, this sacrifices some star color in return for a smoother image.*

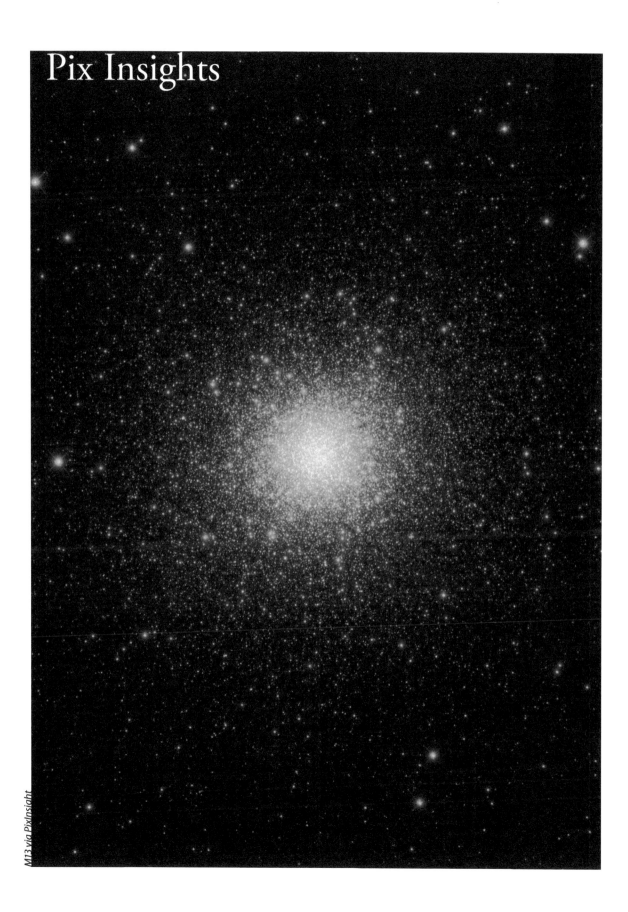

Pix Insights

M13 via PixInsight

Pre-Processing

This set of tasks is often automated for convenience but a little extra effort often improves image quality.

This chapter and the four that follow are new to edition two. Their inclusion is designed to push the quality envelope of your image processing using PixInsight. These five chapters discuss selected processes in more detail, the first of which looks at the often overlooked and highly automated process of image pre-processing. Pre-processing is a key step that is often taken for granted, on account that powerful tools can automate the process. Pre-processing consists of four main steps:

1 selection
2 calibration
3 registration
4 integration

Careless use of automation may fail to discriminate between good and bad images and choose sub-optimum strategies to minimize image noise, register images and reject bad pixels.

Selection (1)

The saying "you have got to be cruel to be kind" applies to astrophotography. After all the effort of honing your skills, ensuring your equipment is reliable and after patient hours of acquisition and tuning focusing and autoguiding parameters, it is often with some reluctance that we accept that some of our precious subframes are best discarded. This is really tough, especially when the pickings are meagre. These images are not necessarily the ones with aircraft or light trails, since these can be removed statistically, but those where the focus and tracking issues spoil star shapes and the image has excessive noise. It is important to select images prior to calibration rather than afterwards, since the data from these bad boys influences the statistical analysis of the good frames.

PixInsight has several tools that help identify those images for relegation of which the SubframeSelector and the Blink tool are the most useful. The three main indicators of a poor image are the star size (FWHM), eccentricity and signal to noise ratio. These measures are not unique to PixInsight; CCDInspector and other tools, such as Main Sequence's free FITS Image Grader have simpler versions. In each case the images are loaded into the tool and sorted according to the selected discriminating parameter. As

fig.1 Sometimes, a simple monitor during image capture will detect oddballs or worsening trends (e.g. star count and HFR).

you might expect, PixInsight, which revels in statistical detail, has many adjustable parameters behind the simple default tool settings.

Let us initially back up and start at a simpler level, to the business of image acquisition. Problem images, arising from special causes do happen from time to time but more often than not, an indication that something has gone off the boil is apparent during image acquisition. Prevention is always better than cure and it is possible to detect focus drift or tracking issues in real time. This provides an opportunity to pause and fix things, discard obvious duds and add further sub-frames to the sequence to make up for the loss. I use Sequence Generator Pro for image acquisition and one of its panels provides a simple image history graph, with HFR and star-count metrics for each exposure (fig.1). An adverse trend or special issue are easily spotted and uniquely, in SGP, a dud image can be marked as "bad" during a sequence and the event count is automatically compensated. If the HFR suddenly reduces after a temperature-triggered autofocus run, it may be a sign that the temperature trigger point is too large. Not everyone uses SGP and it is useful to know that CCDInspector can be set running and watching your image folder. As the images roll in, it measures FWHM, eccentricity, background and other parameters and can equally plot them on a graph to identify trends or outliers.

Blink Tool

The PixInsight blink tool has a number of uses, including the ability to generate a movie file from separate images. In this instance, it is used to initially visual compare and assess images. In practice, load all the files for a

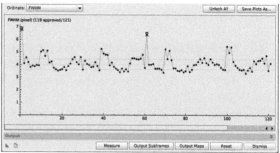

fig.3 The output of the SubframeSelector Tool is a
 table and a set of useful graphs. Here is the
 one for FWHM, showing a few outliers.

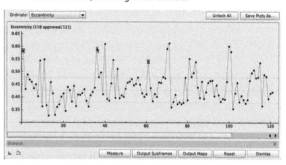

fig.2 The blink tool in operation on M3. The frames are displayed
 in stretched form onto the main screen and quickly updated
 from one image to another, making differences obvious.

fig.4 As fig.3 but this time measuring star eccentricity
 or elongation, normally as a result of tracking
 issues caused by autoguider issues.

target image and hit the histogram button. This applies
an automatic histogram transformation (similar to the
screen stretch function) to all images. The subsequent
comparison is then much easier, since the images from
all the filter sets have the same general appearance on
screen. (This does not change the image data, only its ap-
pearance on screen.) I then set the time-scale to 1 second
and "play" the images to the screen. Although simple in
concept, the quick overlay of successive images is surpris-
ingly effective at weeding out a few strays. The blink tool
also provides a data comparison for each image that has
some diagnostic use, for instance, correlating particular
imaging conditions with poor performance.

SubframeSelector Tool

This tool is considerably more sophisticated and discrimi-
nating. It calculates useful image data to sort and identify
rogue images. This is a script that uses several PixInsight
tools in a convenient way. After loading the images, open
the system parameters and enter the camera gain and an-
gular resolution. The tool analyzes stars and uses further
parameters to optimize star-detection and exclusion. The
pop-up dialogs show how the various sliders can be used
to exclude highly distorted stars, hot pixels, saturated
stars and characterize the point spreading function (PSF)
for star detection and measurement. The aim is to detect
about 200–1,000 stars, avoiding saturated ones and hot
pixels. If in doubt, just add a few images and experiment
with some settings before loading the entire image folder.
Finally, click measure and put the kettle on.

The result is a considerable amount of quantitative data
and the next step is to make some sense of it. The Sub-
frameSelector tool produces a table of results with all kinds
of information. This generally consists of data in two forms:

its absolute value and its deviation from its mean value.
The same data is also presented in graphical form, one for
each parameter. Principally, I use star size (FWHM), star
shape (eccentricity) and a general noise weighting factor.
At a simple level, outlier points in the plots section (fig.3
and fig.4) are clicked on to exclude them (shown with an
x). In this case, those with high eccentricity and FWHM.
The output section of the tool has the ability to copy or
move approved and rejected image files to a folder and add
an appropriate suffix to identify its status.

If you prefer a single balanced assessment of a number
or criteria, one can enter in an expression, which combines
attributes and weighting factors, to provide an overall
goodness indicator. In the "goodness" expression below, it
is set to a combination of three performance parameters,
whose contribution is weighted and scaled within a range:

$$(25*(1- (FWHM-1)/(5-1)) + 15*(1- (Eccentricity - 0.2)$$
$$/(0.5 - 0.2)) + 10*(1- (Noise - 25)/(70-25))) + 50$$

where:

FWHM	1–5	- weighted 50%
Eccentricity	0.2–0.5	- weighted 30%
Noise	25–70	- weighted 20%

In the example I rejected about 10% of the sub-frames, mostly due to guiding and focus issues, and noted the image with the best parameters as a reference for later on.

Calibration (2)

The science of calibration has its own extensive chapter, explaining how and why we calibrate images and including best practices and techniques. All the image processing tools have semi-automatic methods to do this, removing the boring bits. This includes PixInsight too, in which its standard tools have been incorporated into a script to generate master bias, flat and dark files and calibrate light frames. I often use the BatchPreprocessing script for convenience to generate the master calibration files, calibrate and register subframes, but leave out the final integration. Here, we lift the lid off these processes to see if there is some further quality improvement we can eke out using the individual standard tools.

Manual calibration processing is formed by two main steps: generating master calibration files and applying them to the individual light subframes, using the ImageIntegration and ImageCalibration tools in turn. (Another, the Superbias tool, is a specialized filter that improves the master bias file, especially with small data sets, by extracting column and/or row artefacts in the presence of random noise.) With refractors, and providing one is scrupulous about cleanliness, the dull task of generating master calibration files is an infrequent event. One might not be so lucky with open-design reflectors though, as both mirrors attract dust in addition to the camera filter. In this case, master flat files may be required for each imaging session.

Master Bias and Darks

The master bias and dark files are generated using the ImageIntegration tool. This tool has many uses and it has a range of options that selectively apply to the task in hand. In this case it is important to disable some of the features that we are accustomed to using on image subframes. The key parameters are shown in (fig.5).

- Do not normalize the images, either in the Image-Integration or Pixel Rejection (1) settings.
- Disable the image weighting feature, as we want to average a large number of frames and reject obvious outliers.
- Choose Winsorized Sigma Clipping option to reject outliers, with a 3–4 Sigma clipping point or, if you know your sensor characteristics, try the CCD Noise Model option.

fig.5 The typical settings for creating a master bias or dark file. Note, there is no normalization or weighting.

In each case, select the files according to the filter, binning and exposure setting and generate an overall average master file for each combination. These files should be good for a while, though most CCD cameras develop additional hot pixels over time. It takes three days to acquire all my dark frames, but they generally last a year.

Superbias

This unique PixInsight tool improves image calibration beyond a straight integration of bias frames. A bias frame has very faint pattern noise that is obscured by read noise

and it requires a large number of integrated frames to reveal it. The Superbias tool uses multiscale processing to extract this pattern noise from a master bias file that has been made with a modest number of images. In practice, the default settings work well with 20 bias frames or less (fig.6). Fig.7 and fig.8 show the dramatic reduction in noise in a master bias file. With every doubling of the count, it may be possible to lower the layer count by 1. Noisier CCD sensors and CMOS sensors require more bias frames for the same quality outcome. CMOS sensors present some unique issues; the Superbias tool is optimized for column or row-oriented sensors like a CCD camera and most CMOS cameras have both row and column patterns causing a combination of orthogonal variations. It is still possible to establish a good Superbias for a CMOS sensor, but it requires a few more steps:

fig.6 The default settings for the Superbias tool, to improve master bias generation.

- run Superbias on the master bias image using the Column mode
- using PixelMath, subtract the superbias from the master bias and add an offset of 0.1
- run Superbias on this new image using Row mode
- using PixelMath, add the first and second superbias images and subtract the offset of 0.1

fig.7 A master bias of 100 integrated frames from a KAF8300 CCD sensor.

The resulting Superbias should have both column and row patterns. The comparison in fig.9 and fig.10 show a master bias from an EOS 60Da and after the application of Superbias. If you look carefully, there are faint horizontal bands in the Superbias image.

fig.8 The master bias in fig.7, after application of the the Superbias tool.

Master Flats

The master flat frames are treated differently, to account for the fact that each flat subframe has bias and dark noise in it. This is a two-step process; first we calibrate each subframe (fig.11) and then we integrate them (fig.12). Open up the ImageCalibration tool and select the master bias and dark frame. The master dark frame will have a different exposure (typically longer) to the flat's and check the optimize option to ensure it is appropriately scaled to optimize the signal to noise ratio. After the tool has done its work on all the frames, we move on to combining them. In this case, the images are normalized multiplicatively (especially with sky-flats) and with equal weighting. Pixel rejection has a few alternative approaches, depending on how one took the flat frames. Fig.12 shows a typical setting for a limited number of sky-flats. In this case the recommended rejection algorithm is Percentile Clipping, with very low clipping points (under 0.02). Some experimentation may be required to determine the optimum value to reject outliers. I use a electroluminescent panel and take 10–50 flat subframes for each filter position, allowing me to use Winsorized Sigma Clipping for the rejection algorithm. Pixel rejection benefits from normalized frames. For flat frames choose the Equalize fluxes option for the normalization method.

fig.9 The master bias from 100 EOS frames.

After applying the tool, the outcome is a series of master flat files on your desktop. As these master files are created outside of the BatchPreprocessing script, give each file a meaningful title and then use the FITSHeader tool to add the filter name and binning level to each master file. This is useful for later on, for instance, the BatchPreProcessing script uses the information in the FITS headers to match up filter and binning with light frames during the image calibration process.

fig.10 Superbias, run in separate column and row modes on the data in fig.9.

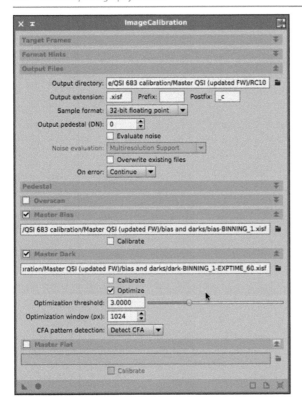

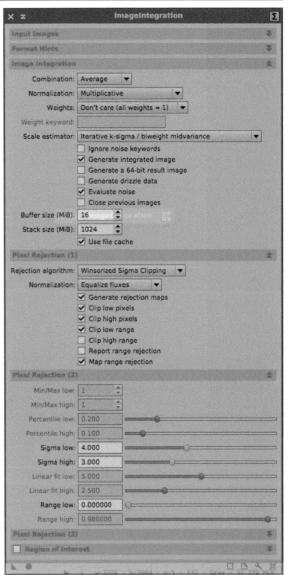

fig.11 *The typical settings for creating calibrated flat files, using the previously generated master bias and dark files.*

Calibrating Lights

Lights are our precious image subframes. Before registering these they require individual calibration. The ImageCalibration tool is swung into action once more, but with some additional settings: We replace the individual flat files in the Target Frame box with our light frames (for a particular filter, binning and exposure time) and identify the matching master bias, dark and flat files in their respective choosers. In the Master Flat section, remember to un-check the calibrate box (since we have already calibrated the flat files) but leave the Optimize option enabled. Repeat for all the various combinations of exposure, filter and binning, using the matching dark, bias and flat masters in each case.

Note: In the ImageCalibration tool the Optimize option scales the master dark frame, before subtraction, to maximize the calibrated image's signal to noise ratio (as before during flat file calibration). In some instances this may not fully eliminate hot pixels, or if new hot pixels have developed since the dark frames were taken, miss them altogether. This is especially noticeable in the normally darker image exposures after stretching (fig.13). There are a number of strategies to remove these; if you dither between exposures, the hot pixels move around

fig.12 *The typical settings for integrating calibrated flat files. Note the weighting and normalization settings are different to calibrating lights in both cases.*

the image and with the right pixel rejection settings, the final integration process removes them. At the same time, these settings may be overly aggressive on normal image pixels, reducing the overall image SNR. A better way is to remove them from the calibrated images before registration (this also reduces the possibility of false matches) using DefectMap or CosmeticCorrection.

Fixing Residual Defect Pixels

The principle is to identify and replace defect pixels with an average of the surrounding pixels before registration

and integration. The DefectMap and CosmeticCorrection tools do similar jobs. In both cases they are applied to the individual calibrated lights. To use the simpler DefectMap, load all your calibrated images into an image container. Load the master dark image and open the Binarize tool. Look at the image at full scale and move the threshold slider to find a setting that just picks up the hot pixels (typically 0.01). Close the preview and apply to the master dark image. Now choose Image/Invert from the PI menu to form a white image with black specks and then select this file in the DefectMap tool dialog. Drag the blue triangle from ImageContainer onto the DefectMap bottom bar to apply the correction to each image in the container.

The second tool, CosmeticCorrection is more powerful and is a combination of DefectMap and statistical corrections. Again, it is applied to calibrated images before registration. Its setup parameters include a simple threshold (to identify hot pixels from a master dark file in a similar manner to DefectMap) in addition to statistically comparing neighboring pixels. Most CCDs develop additional hot pixels over time and in practice the CosmeticCorrection can fix those pixels that escape the calibration process (fig.13). The benefits are two-fold; not only are there fewer outlier pixels but these in turn improve the accuracy of the registration algorithm by reducing false matches. The benefits extend to image

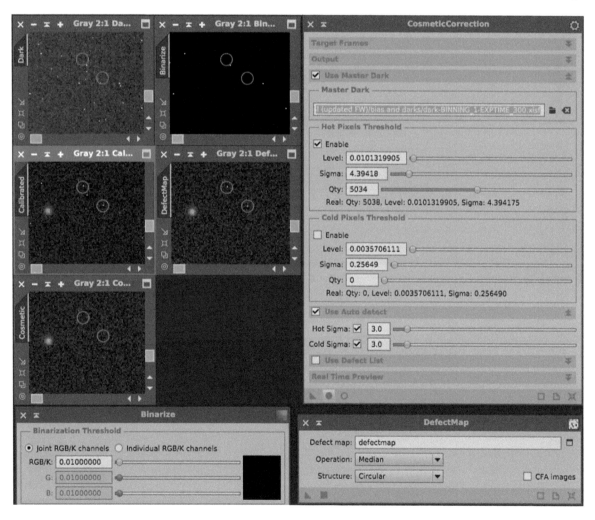

fig.13 *This screen shot shows a selection of image pixel correction tools and results using DefectMap and CosmeticCorrection. The array of images are shown at 200%, starting top left with a 2015 master dark and its binarized version alongside. Beneath these are the calibrated light frame (taken in 2016) and after DefectMap has been applied. The bottom image shows the calibrated light frame after CosmeticCorrection has been applied. Note the absence of hot pixels in the old dark file, which are then missed in the DefectMap application. It is the Auto detect method in Cosmetic correction that fixes them.*

integration too, since there is less need for extensive pixel rejection and hence the integrated result benefits from a mildly improved signal to noise ratio. In the example in fig.13, the registration errors in the normal integrated image (with hot pixels) are 4x higher than the same files using CosmeticCorrection. The default hot and cold settings of 3 Sigma work well in many cases but as always, a little experimentation on a sample image, using the live preview at different settings, may achieve a better result.

A cosmetic correction option also appears in the BatchPreprocessing script. In practice, use the real time preview of the CosmeticCorrection tool on an uncalibrated image file and select the matching dark file in the dialog. Zoom in (or use a preview of the image file) to see what hot and cold thresholds are needed to identify the hot and cold pixels. One can additionally use the auto settings too, adjusting the hot and cold sigma sliders, to remove the ones that refuse to disappear. Once you have the right settings, close the preview and drag the blue triangle onto the desktop to produce a new process instance icon and give it a useful name. It is this process icon that is selected in the BatchPreprocessing script to apply CosmeticCorrection to all the light frames.

Registration (3)

Image registration is also integrated into the Batch-Preprocessing Script and, using its default parameters is often perfectly adequate for the job. It utilizes the StarAlignment tool with a set of basic settings. As with the other tools, however, one can perform registration independently, using the StarAlignment tool in all its glory. This may be a requirement in tricky situations, for instance when aligning tiled images (with minimal overlap) for a mosaic. It can also be used to align stars to astrometry data, to form a solid reference.

Image registration for deep sky objects uses image features to align subframes; in our case we have plenty of them, namely stars. (Image registration for planetary images uses other techniques that match images in the frequency or spatial domains.) Simple star alignment is called a rigid transformation, in so much that it only shifts, rotates and scales an image uniformly to make a match. The more advanced algorithms stretch and distort images to match one another, a handy feature for accurate star-matching towards the edge of an image. The StarAlignment tool has a number of settings and fortunately the best starting point are its defaults. It can automatically register a group of images, or a single image. During mosaic panel alignments, it can not only create the separate mosaic components but also merge them and

adapt frames to make them seamless. Mosaics pose the biggest challenge and the StarAlignment tool can restrict the star matching to selected areas and use other mathematical techniques (FFT-based intersection estimation) to improve alignments. Just before going into the clever workings behind the scenes, it is important to note that the choice of reference image is critical. If you noted the best image during subframe selection, this is the one that is best suited for use as the reference for the others, typically the one with the smallest FWHM and eccentricity.

Star Detection

The Working mode is set to Register/Match Images by default, used for normal single-pane images. For mosaics, the Register/Union-Mosaic and Register/Union -Separate generate a new combined mosaic image and separate ones on a full canvas. This latter setting allows one to use powerful tools like GradientMergeMosaic that hides the joins between panes. (An example of this is used to combine a 5-tile mosaic of the California Nebula in one of the first light assignment chapters.)

After several dialogs on file input and output we come to the Star Detection section. Although we can instinctively identify stars in an image, computers need a little help to discriminate between star sizes, hot pixels, nebula, cosmic rays and noise. The default values work well but a few may be worth experimenting with. The Detection scale is normally set to 5; a higher number favors bigger stars and a smaller value will include many more smaller stars. If the default value has difficulty finding enough stars, a setting of 4 or 3 may fix the issue. The following parameters refer to noise rejection; the default Noise scale value of 1 removes the first layer (the one with most of the noise) prior to star detection. I have never had the need to change this value and the PixInsight documentation suggests that a value of zero may help with wide-field shots where stars may be one pixel, or larger, in the case of very dim stars. Similarly the Hot pixel removal setting changes the degree of blurring before structure detection. This uses a median filter, which is particularly effective at removing hot pixels.

Two further settings affect the sensitivity of star detection, Log(sensitivity) and Peak response. A lower Log(sensitivity) setting favors dimmer stars. Again, the default value works well and including more stars with a lower value may be counter-productive. The Peak response parameter is a clever way to avoid using stars with several saturated pixels at their core. This setting is a compromise like the others; too small and it will not detect less pronounced stars, too high and it will be overly sensitive and potentially choose saturated stars.

Star Matching

Now that the star detection settings are confirmed, the next section looks at the matching process parameters. Here, there are some freaky terms that refer to RANSAC or RANdom SAmple Consensus. The tolerance term sets the number of pixels between allegedly matched stars. A larger value will be more tolerant of distortion but too high and one may get some false matches. The Overlapping, Regularity and RMS error parameters should be left at their default values in all but the trickiest mosaics. The Descriptor type changes the number of stars in the matching process. The default Pentagons settings works well on standard images, but on mirrored sets of images, change it to Triangles similarity. Lastly, the Use scale differences and its tolerance parameter constrict the allowable scale range between images, useful to prevent false matches on mosaics.

Interpolation

The last section worth discussing is Interpolation. This is where things become interesting. Why do we need interpolation? We know that autoguider algorithms can detect the centroid of a star to $1/10^{th}$ pixel. The alignment algorithms are no different in that they can register an image with sub-pixel accuracy, added to which, there may also be an overall scaling factor required during the registration process. If the mode is set to auto, Lanczos-4 is employed for stacks of images of the same scale, and for down-scaling, Mitchell-Netravali and Cubic B-spline. The default value of 0.3 for the clamping threshold is normally sufficient to stop dark pixels appearing around high-contrast objects. This works similarly to the deringing controls in deconvolution and sharpening tools. Lowering the value softens the edges further. Since these dark pixels are random, one can also remove isolated dark pixels using statistics during image integration.

Integration (4)

The last of the four processing steps is the one in which user-input plays the biggest part in the outcome and where the default settings may be some way off optimum. Integration is about combining your calibrated and registered images in a way that keeps good data and rejects the poor. Keeping and rejecting are relative terms: It can physically mean that certain pixels from a subframe are totally ignored and at the same time that the remaining pixels contribute to the final image in proportion to the subframe quality. This selection and weighting process assumes that the computer can compare subframes with some certainty. Subjectively, our brains can determine a hot pixel in an image as it sees things in context to its surroundings, but consider a program trying to compare images of different brightness.

The ImageIntegration tool (fig.12) takes things in its stride and the statistical methods that underpin its workings are not for the faint hearted. We can conceptualize what the tool needs to do and the settings it requires to make the best judgements. At its heart are two processes; statistical combination (in its simplest form, averaging) and pixel rejection. The tool identifies which pixels to reject in each image and statistically combines the remainder. Pixel rejection is very important and is done by comparing a pixel value in a particular subframe to the corresponding pixels in the others and a fixed reference. To do this reliably it needs to make an adjustment to each subframe (normalization) so that it can directly compare images statistically to identify reject pixels. Normalization is also required prior to the image combination process, to adjust the images so that they are similar. To explain this last point, which is not necessarily obvious, if we consider the case of a set of near identical images, a simple statistical average may suffice, but in the case where the background illumination, exposure or camera gain changes between sub-frames, the brightest images will dominate the overall average and these may be brighter due to mist and reflected light pollution! Remember, scaling an image does not change its signal to noise ratio.

Normalization takes several forms and the precise setting is optimized for its purpose; rejection or combination. Given that we have two sets of normalized images, the user now has to choose the statistical method to correspondingly identify reject and combine pixels. Finally, during the combination stage, one has the choice to favor (weight) some subframes more than others based on a particular criteria, for example, subframe signal to noise ratio (SNR).

With a broad understanding on what is going on under the hood, it is easier to review the principal options in each of the tool sections:

Input Images

This section looks familiar with many other tools but there is a gotcha that requires a little explanation. In addition to the standard image add, clear and selection buttons, there are a few concerning drizzle that we can disregard for the moment and another, named Set Reference. The referenced file is a registered subframe that is used as the template for registering and matching the other images to and from which the quality and image weighting is judged. By default, it is set to the first file in the list but for best results, choose it carefully. This image should ideally have the best SNR of the group

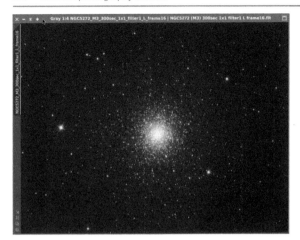
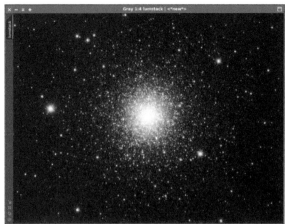

fig.14 *These two images show the effect of image integration on an image stack. (Both images have had an automatic screen stretch.) On the left is a single uncalibrated sub-frame and on the right, the final integrated stack of the best of 30 images. The background noise has diminished slightly but more importantly, the signal level had been boosted enormously.*

and at the same time have the most even illumination and have the least defects, such as plane trails etc. I often start imaging low in the east and track across the meridian until I run out of night, horizon or weather. As a result, my first image always has the worst sky gradient and poorest seeing and is a long way from being the optimum reference image. To select the best reference, identify the top ten images using the report from the SubframeSelector tool (using SNR as a guideline) and examine them for gradients and defects. Then choose the best of these as the reference file.

Image Integration

In the main Image integration section, we have the combination, image normalization, weighting and scale options. For image combination the Average (mean) or Median options are preferred. Of the two, Average has better noise performance. In one of the practical chapters in edition 1, I used median combination to eliminate an aircraft trail. I have since realized that I can do that with average combination, which achieves a better overall signal to noise ratio, and tune the rejection settings to remove the pesky pixels. The image weighting is normally left at the default setting of Noise evaluation, which provides automatic image weighting based on image data. (The Average signal strength option uses the image data too. It may not provide such a good result though if there are illumination variations, for instance due to a changing sky gradient.)

As mentioned earlier, the ImageIntegration tool has two distinct settings for normalization: one for image integration and another for pixel rejection, as the needs of each process are slightly different. Many statistical tools work well with symmetrical distributions, like pure Gaussian noise. In practice, however, other alternatives often work better with real data. In the case of image integration, since we are trying to match the main histogram peaks and dispersion of each images, choose the Additive with scaling option for normalizing the light frames.

There are a number of methods to calculate the normalization parameters. These are selected in the Scale estimator option box. Several of these statistical methods analyze an image using its median pixel value to locate the hump of its histogram (to identify the additive bit) and then work out the data distribution (to calculate the scale bit). The exception is the Iterative K-sigma / biweight mid variance scheme, or IKSS for short. This default value is the preferred safe choice, since it accepts real data with skewed distributions and is less sensitive to random pixel values (that have not been rejected).

Lastly, before leaving the Image integration section, check the Evaluate noise and Generate integrated image options (that create your image stack). All these myriad settings are wonderful but at first the selections are guided by science and faith. Help is at hand. The evaluate noise option is useful since it generates a report with numerical values for the image noise level (and improvement) of the final image and hence, is an ideal way to directly compare the performance of the various integration options. In the final report out (shown in the process console window after the ImageIntegration tool has completed) the goal is to maximize the median noise reduction figure. Every situation is unique and it is likely that each will benefit from a unique deviation from the default settings to maximize its SNR.

Pixel Rejection –1

Pixel rejection removes individual pixels from an image that arise from special causes (cosmic ray hits, satellites, meteors, airplanes) and common causes (tracking issues, focusing issues, excessive noise). After normalization, the pixels are statistically identified and removed. If the rejection settings are too aggressive, there will be no spurious pixels but the signal to noise ratio will suffer as a result of less combined data. The opposite is true and obviously the aim is to find a setting that just removes the unwanted pixels. The rejection algorithm itself is an interesting dilemma: No one algorithm works in all cases and hitting the tool's reset button changes it to No rejection, encouraging experimentation. Although trying out different techniques is illuminating, broadly speaking, the selection principally depends upon the number of sub-frames and to a lesser extent the image conditions. The following are useful starting points:

3–6 images	Percentile Clipping
8–10 images	Averaged Sigma Clipping
> 10 images	Sigma Clipping
> 15 images	Winsorized Sigma Clipping
> 15 images	Linear Fit Clipping (see text)

The Linear Fit Clipping algorithm is subtly different to the others: Rather than use a static mid-point about which to set rejection limits, it can adapt to a changing set of pixel values over time, for instance, a changing sky gradient. Although overall mean background values are normalized in the rejection process, subframes at low altitude will have a more extreme gradient to those at high altitude. Linear fit clipping works best with a large number of images.

We have already discussed that normalization occurs before the algorithms are set to work and in this case there are two main methods: Scale + zero offset and Equalize fluxes. The first is used for calibrated subframes and the second is the better choice for flat frames, uncalibrated subframes or images with severe changes in illumination across the frame (for example, sky gradients before and after a meridian flip).

The Generate rejection maps option instructs the tool to produce two images that indicate the positions of all the rejected (high and low pixels) from all the frames. These are useful to check the rejection settings. In practice, apply a screen stretch to them and compare these to those images with known issues (for instance satellite trails). Beneath these options are the ones for clipping: The Clip low and high pixels options enable the statistical rejection of dark and bright pixels identified by the chosen algorithm. The Clip low and high range options exclude pixels outside an absolute value range (independent of the algorithm). The Clip low range option can be quite useful: On one occasion I had to rotate my camera after a meridian flip to find a suitable guide star. The image frame overlap was poor and I used this option to reject all the empty border space in the registered files. Without that, I created a patchwork quilt!

Pixel Rejection –2

There are quite a few alternative rejection algorithms. Once chosen, the irrelevant slider settings are greyed-out. Each algorithm has a low and high setting permitting asymmetrical clipping. This is particularly useful in astrophotography since most special causes only add electrons to a CCD well and in practice "high" clipping values are typically more aggressive than their "low" cousins. For those algorithms that use standard deviation (sigma) settings, the default values of 4 and 2 will almost certainly need some modification to find a value that is just sufficient to remove the unwanted pixels. In both cases, a higher value excludes fewer pixels. For the low setting, I find the point where I start to have very dark pixels and on the high setting, since I invariably have a plane trail in one of my subframes, I gradually decrease the Sigma high value until it disappears. The other thing

fig.15 The two image crops above show the difference between the default rejection settings and optimized settings (using a linear fit algorithm with tuned clipping parameters). The left image, using default settings, shows the integration of 30 images and has some spurious pixels from cosmic ray hits. The image on the right has been optimized and is a much cleaner result, but with very slightly more noise as a result of more rejected pixels (although this may not be visible in print).

to note is that optimum settings may well be different for luminance, color and narrowband filters. The Clip low and high range settings are here too and populated by the default values 0 and 0.98 respectively.

Region of Interest

Experimentation is the key here but it is time consuming. In common with many other PixInsight tools, to speed up the evaluation, it helps to try different settings on a portion of the image, defined in the Region of Interest section. Conveniently, one can open a registered frame and choose an image preview, that ideally covers a representative range of background and objects. PixInsight usefully has an image buffer and different rejection settings are quickly re-evaluated from the calculations in memory. The golden rule to PixInsight is to experiment and find the right compromise between improvement and destruction. As the figures show, integration always improves the depth of an image and it is principally the rejection criteria that strike a balance between random noise increase and the eradication of spurious pixels.

LRGB Luminance Enhancement

There is a further consideration in the image integration process. We know that high-quality imaging processes the luminance and color information follow two distinct workflows, optimized for enhancing detail and color information respectively. For instance, if one takes images with a DSLR, the DeBayered color image contains both color and luminance information and although some image processing tools can restrict application to the luminance information (for instance some noise reduction ones) an easier method is to extract the luminance information from the color image and process through a separate workflow. The "aha" moment is to realize an RGB image has both color and luminance information and when one considers image capture through separate filters, the LRGB processing workflow discards this luminance information with the LRGBCombination tool. This is a lost opportunity; the luminance information from those exposures taken through colored filters can be combined with the dedicated luminance channel to produce a result with improved SNR (the impact is dependent upon the quality of the color data). It also improves potential color separation too, since the luminance information from the color images is tuned to those

wavelengths, as in the case of enhancing red separation by combining it with Hα data and assuming that the RGB images are taken with the same binning level as the luminance too, to preserve the luminance resolution.

There are many potential ways of combining the data and one has to sit back and consider the integration process and likely outcomes. The data from each channel is quite different; each has a different bandwidth and object color as well as potentially having a different exposure duration and quantity. Each noise level, signal level and distribution will be distinct from the other channels. A simple integration of all image subframes would have difficulty rejecting pixels reliably (the rejection criteria assumes a single signal statistical distribution and potentially, in this case, there would be multiple distributions).

A more reliable method is to integrate the discrete luminance and color information as normal, optimizing each in their own right and then combine these stacks. A simple average with scaling, using the noise level as a scaling parameter and with no pixel rejection, produces a substantial noise reduction. Note: the ImageIntegration tool can only work on 3 or more images. This is not an issue when working with LRGB or LRGBHα information but in the case of combining the luminance information from a color image with separate luminance data, you will need to first extract the separate RGB channels from the color image using the ChannelExtraction tool.

When it comes to LRGBCombination, there is a further trick to help with the predictability and quality of the outcome. When the luminance of the RGB image and Luminance image are very different, LRGBCombination struggles. I found this useful trick from the PixInsight forum to make the process more robust:

1 Apply the ChannelExtraction tool to the RGB image (set to CIE L*a*b* mode).
2 Use LinearFit to match the L* channel to the Luminance image.
3 Reassemble the L*a*b* channels using the ChannelCombination tool.
4 Apply LRGBCombination

The outcome of introducing these extra steps makes the image much easier to tune with the LRGBCombination tool's brightness and saturation sliders.

Seeing Stars

Stars are "just" points of light.
Tricky little devils. They show up every slip we make.

It is easy to take stars for granted and yet they pose some of the most difficult objects to process. The problem is that we instinctively know what a star should look like... or do we? Theoretically, all stars should be a single illuminated pixel on account of their distance and yet we accept the concept that brighter stars appear larger than dimmer ones. The question remains, how much is enough? Pictorially, stars can visually get in the way of the purpose of an image: consider a dim nebula in the Milky Way, the eye is distracted by the numerous bright punctuations and as a result it is harder to distinguish the gaseous clouds within. In this case, some photographers go to the extreme of removing the stars altogether while others leave them to bloat naturally with image stretching. I aim somewhere in the middle, keeping true to nature but trying to avoid them detracting from the image. In other images they are the "star" of the show and processing is optimized to show their individuality: color, size, definition and symmetry.

Star processing then is a complex matter, designed for the purpose in mind. The tools at our disposal can reduce star sizes, improve star shape, increase color, accentuate faint stars, remove stars altogether or blend star images with nebulosity image data from parallel workflows. This chapter looks at complex techniques such as deconvolution, other star-shrinking techniques, removing stars (to assist image processing), restoring star color and look at the essential supporting act of creating and using star masks. In a typical processing sequence, deconvolution is the first challenge and is probably the trickiest to get just right.

Deconvolution

This process is surrounded by some considerable mystique. This mathematical function is used both in signal processing and imaging in many disciplines. For astrophotographers, its aim is to undo the effects of the optical limitations set by the laws of diffraction, refraction, dispersion and minor tracking errors. These limitations convolve light, or in simple terms, blur it, reducing local contrast and resolution. The aim of deconvolution is to reverse these (in the case of the initial Hubble Space Telescope, it was used to compensate for its initial flawed mirror alignment). Although it is instinctive to think about the benefit to

stars, deconvolution's magical properties equally apply to all fine structures. Deconvolution is not a panacea though; it is most effective on over-sampled images, that is, those taken with long focal lengths and small pixel sizes. This is because the math requires the optical smearing to occur across a block of pixels.

Deconvolution is applied to linear luminance image data. In the case of an LRGB image, to the unprocessed, integrated luminance channel, or in the case of a CFA RGB image, to the luminance information contained within. (In the case of deconvolving color images, PixInsight requires implicit instruction that the image is linear, since RGB camera image data is assumed to have a gamma setting of 2.2. This is done with the RGBWorkingSpace tool. Make sure the settings are the same as those in fig.1, with equal weights for the RGB channels and in particular, a linear gamma setting of 1.0.)

fig.1 For those of you who wish to deconvolve an RGB image, PI assumes it has a gamma of 2.2 until told otherwise. The settings above ensure the deconvolution works as predicted.

In the PixInsight implementation, as multiple variables affect the outcome, it can be quite tricky to find the best settings. That being said, my best results have been using the PI version, since it offers extensive facilities to tune or selectively apply deconvolution to different deep sky image types. In addition to my normal scouring of

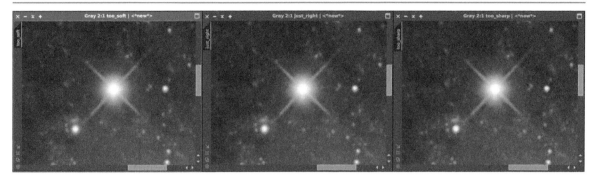

fig.2–4 The Goldilocks dilemma: what is too soft, too sharp or just right? You may come to a different conclusion by viewing the page at different distances. These images differ in the deringing global dark setting, found in the deconvolution tool.

existing resources, I have approached this by considering several image scenarios and with a methodical approach; I have found an efficient way to deconvolve an image without extensive and cyclical experimentation. The clues lie in some forum tutorials and the layout of the tool itself.

Deconvolution Process Flow

The deconvolution tool has a number of settings laid out in the normal vertical arrangement. In practice, I found I could establish the settings in each section before proceeding to the next, with only the smallest amount of tweaking at the end. The trick is to know what to look for in the image at each stage to establish the correct setting. In essence the setting flow is:

1 Set aside a duplicate luminance image and apply a medium stretch for use with the mask generation tools.
2 Measure the convolution effect with the point spreading function tool (DynamicPSF).
3 Disable Deringing and Wavelet Regularization options.
4 Establish a preview window that encompasses a range of image areas (background, different star brightness and nebulosity / galaxy).
5 Use this preview to experiment with tool settings, in this case, choose a value for Iterations to optimize appearance of small dim stars, ignoring dark halos for the moment.
6 Enable Deringing and experiment with Global dark settings to almost entirely remove dark rings around dim stars.
7 Experiment with small values of Global bright (if necessary, to remove light artefacts around dark objects).
8 Create a mask for use with the Local deringing option.
9 Enable Local deringing, identify the Local deringing support file and experiment with Local amount to improve the appearance of bright stars and stars in bright regions.

10 Enable Wavelet Regularization and tune settings to establish the minimum noise reduction setting which removes the "curdling" of bright areas, such as bright nebula or galaxy cores.
11 Create a mask that protects stars and bright areas, invert it and apply to the main image.
12 Apply the Deconvolution tool to the main image and check the key areas of background noise, dim stars, bright stars and nebula/galaxy detail. Make small adjustments for fine-tuning.

Before starting, one needs to know what success looks like. Deconvolution is an imperfect process; it cannot reconstruct a perfect image but it can go a long way to improving it. In doing so, it will create other issues, increasing image noise, creating artefacts and unwanted halos around bright and dark objects. The settings are a compromise and although we may all agree on the more obvious issues, individual preferences define a wide selection of "acceptable" results that in addition, are also dependent upon the final reproduction scale and application. A range of potential candidates is shown in figs.2–4.

Preparation (1)

Before using the deconvolution function itself, it is necessary to complete some preparatory work for the deconvolution process, starting with the image. We stated at the beginning the deconvolution process is a benefit to stellar and non-stellar images. That being said, it is sometimes necessary to exclude it from operating on particular areas of the image that are otherwise featureless, but exhibit noise. Applying a deconvolution function to these areas makes matters worse. In other areas, differing amounts of deringing are required. Both cases require selectivity and these are achieved through the applications of masks at various points in the process. Forming a mask directly from

an unprocessed linear image (star or range mask) is not an easy task. In both cases a mild image stretch increases local contrast where it is most needed by the mask tools. There are some additional ways to improve the robustness of star mask generation but for now, create two clones of the luminance image by dragging its tab onto the desktop. Next, open the HistogramTransformation tool and apply a mild stretch to both luminance clones, sufficient to see more stars and perhaps the first traces of a galaxy core or bright nebula. Give each clone a meaningful name; it helps when there are dozens of images on the desktop later on!

Point Spread Function (2)

The deconvolution process starts in earnest with the supporting process of describing a Point Spread Function (PSF). This is a model of the effect of all those imperfections on a perfect point light source. Deconvolution is also used in microscopy and determining a PSF in this discipline is partly guesswork; astrophotographers on the other hand have the good fortune to routinely work with perfect light sources, stars, from which they can precisely measure the optical path characteristics rather than make educated guesses. PixInsight provides a specific tool, DynamicPSF, with which to measure selected stars to form a model.

The DynamicPSF process starts with a cropped linear image (before stretching) and before noise reduction too. After opening the DynamicPSF tool, apply a screen stretch to your image to show up the stars. Select up to 100 stars from all areas of the image, although it helps to avoid those in the extreme corners, where excessive field curvature may distort the results. At the same time, avoid saturated stars and the very tiny dim ones that just occupy a pixel or two. As you click on each star the tool analyses it for symmetry, amplitude and compares them statistically. Theoretically each star should have the same PSF. Of course, this does not happen in practice and so the next step is to find a PSF that best describes them as a group. This is achieved with the Export synthetic PSF button (the little camera icon at the bottom).

Before hitting this button though, it is necessary to weed out those samples that do not fit in. To do this sort the DynamicPSF table using a few of the many criteria and remove those star entries that appear to be non-conforming. The table uses unusual acronyms for each criterion and the most useful are explained in fig.5. In turn select the Mean Absolute Deviation (MAD), Amplitude (A) and then eccentricity or aspect ratio (r). In the first case remove those stars that seem to have an excessively high MAD value and then remove the outliers for amplitude. I have seen some tutorials that propose to keep stars in the region 0.2–0.8. I found I had better results using dimmer stars and rejecting anything above 0.2. It is certainly worth trying out both approaches. Finally, remove any stars whose eccentricity is very different to the norm (which may be the result of double stars). If your tracking is known to be good, reject anything that shows poor eccentricity (for example r<0.80). Select the remaining stars and hit the Export synthetic PSF button. The result is an image of a blob, named PSF (fig.6). Although this appears particularly under whelming, this blob describes what a singular point light source transforms into after it has passed through countless light years of interstellar matter, our atmosphere, your optics and triggered electrons on the CCD. It is pretty blurry… which explains a lot! Keep this image and close the DynamicPSF tool.

Table Parameter	Description
A	Amplitude of centroid, (0–1) Reject stars with A > 0.2 or A < 0.005
MAD	Mean Absolute Difference. Smaller is better. Reject those stars with big values.
r	Aspect ratio. A perfect circle = 1 Reject stars that have poor aspect ratio
theta	Angle of eccentric star axis. Check out the outliers and delete as required

fig.5 The DynamicPSF tool classifies stars with various parameters. The above parameters are the most useful to determine which of the sampled stars most reliably represent a PSF form.

fig.6 The point spreading function describes the outcome of a point light source through the atmosphere, optics and sensor. It puts things into perspective, doesn't it?

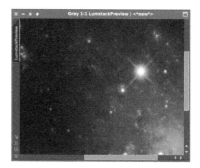

fig.7 A close up of the image preview showing a selection of stars for reference (with respect to the subsequent processing settings).

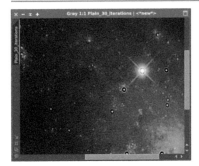

fig.8–10 From left to right, these three close-ups show the characteristic dark halos of a plain deconvolution, with dark side deringing and lastly deringing with local support. Note the background is "curdled" with respect to the starting image (fig.7)

First Iteration (3–5)

Perform an automatic screen stretch to the luminance image and drag a preview that covers a range of sins, including background, faint stars, bright stars and brighter areas (preferably with some bright stars too). The initial trial runs will be on this preview. Some of the deconvolution processes use image properties to alter their behavior and if the preview is not representative of the image as a whole, the final application to the full image will produce a different result. Open the Deconvolution tool and disable the Deringing and Wavelet Regularization options. Choose External PSF and select the PSF file created earlier. For the algorithm, choose Regularized Richardson-Lucy and start with the default 20 iterations. Apply Deconvolution to the preview and compare the results for 10–50 iterations.

As the iterations accumulate so does the sharpening affect increase and the accumulation of artefacts. In addition to the halos around bright stars, those areas with the lowest SNR start to "curdle" and then progressively the brighter regions with better SNRs do to. This curdling is objectionable and requires further treatment (simply put, blurring) to remove the effect. That is fine when it is an area of blank sky, but is a problem when it is a galaxy core in which one wants to preserve detail. I normally increase the number of iterations to the onset of this curdling in the bright areas (fig.8). At the same time, check the Process Console for warning messages on divergence (going the wrong way). This may be indicative of a poor PSF description or too many iterations.

The results are messy at first but for the moment the aim is to improve the smaller stars, checking they are tighter and more distinct (even if they have a dark halo) and in addition, that any small-scale patterns within bright areas are more distinct. At this point in the process, it establishes a general setting that can be revisited later on in the final round-up.

Deringing (6–7)

Almost inevitably, dark rings, as shown in the fig.8 will surround most stars. These artefacts are an unavoidable consequence of the sharpening process. Fortunately they can be removed by progressively replacing ringing artefacts with original pixel values. These artefacts are associated with dark and bright object boundaries and are tuned out by changing the values for Global dark and light in the Deconvolution tool. The sliders are sensitive and I type in the values I need, to two significant figures. Of the two artefacts, dark rings are the most obvious and many images may only require an adjustment to the Global dark setting. Each image is unique, however, but I often find optimum values in the range of 0.02–0.06. For the Global light setting, I may use an even smaller amount, if at all, around 0.01, to remove bright artefacts.

To decide upon the setting, change the dark setting so that small stars just lose their dark halo, as in fig.9, or can just be perceived (to improve apparent sharpness). If you overdo the Global light setting, it negates out the effect of the deconvolution. Flip the preview back and forth to check the overall change. In some cases, this level of deringing will suffice for the entire image. Bright stars and stars over brighter areas may need more help though. You can see from the figures that they have a hard core and alternating rings. These are addressed by using the Local deringing option in the tool and for this it needs to be selective, using a form of mask.

Local Deringing and Star Masks (8–9)

The Local deringing option addresses the ringing around the brighter stars (fig.10). It does this by limiting the growth of artefacts at each iteration of the deconvolution algorithm. In the case of a deep sky image, it does this selectively using something resembling an optimized star mask for Local support. Mask generation appears straightforward enough but generating a good Local support file requires care. There is no one do-it-all star

fig.11 *The above settings in the HDRMT tool do a good job of evening out background levels to help with reliable star detection.*

fig.12 *The entire preview image after HDRMT application on the non-linear (stretched) image effectively removes background levels to improve threshold star detection.*

mask and since there are a number of ways of creating a star mask it is worth comparing some common methods:

Star Masks (An Aside)

There is a world beyond the StarMask tool to produce a decent star mask. By itself it can be tricky to use on some images, on account of altering background levels and a wide difference in star intensity and sizes. Mask-building skills are worth acquiring though; they come in handy during many processes as well as deconvolution. Although the tool can be used on unmolested linear and non-linear images, in practice, it is easier to use on a stretched image. Some were produced earlier in step 1 and there is nothing to prevent one applying the StarMask tool to these images. There are some things, however, that help the StarMask tool achieve a better result. Star images are small blobs that are lighter than their surroundings. Two techniques help discriminate stars, even-out fluctuating background levels and distinguish star-sized objects from noise (at a smaller scale) and bright objects (at a larger scale). There are several ways to do this; two common techniques use the HDRMultiscaleTransform (HDRMT) or Multiscale-MedianTransform (MMT) tools.

In the first case, apply a HDRMT to the stretched clone image to flatten the background (large scale areas) and leave the stars alone. For this, start with the default settings and experiment with it set to several layers and iterations (fig.11–12). Carefully measure the background level and use this for the StarMask tool's Noise threshold value.

In the second, the stars are isolated by using scale rather than brightness as the key, by applying the MMT tool to the stretched duplicate image. In this case, from the default setting, increase the layers value to 5 or 6 and disable the first and residual scales (fig.13–14).

Both isolate star-like objects and yet in both cases the resulting image may contain elements of non-stellar material that can be interpreted as stars. In most cases

a slight adjustment to the black levels with the HistogramTransformation tool will clip faint traces and as a last resort, the CloneStamp tool may be applied too. (Sometimes this is the most expedient way to deal with a bright galaxy or comet core.)

The StarMask tool has a number of parameters that require some explanation. The simplest is the Noise threshold. This defines a baseline between the background level and the faintest stars you wish to mask. If this is set too high, some stars will not be detected, too low and noise may be interpreted as stars. Select a dim star with the mouse and press the left mouse button. A magnified cursor appears with a convenient readout. The working mode is normally left at the default (Star Mask) and the Scale parameter set to an upper star-size limit. Too small and it will miss the big bright stars altogether, too large and it may include non-stellar objects. There are cases when one scale does not fit all and it is then necessary to create several star masks, using different Scale and Noise threshold settings optimized for small stars and heavyweight ones, and then combine the masks with PixelMath using an equation of the form:

max(mask1,mask2)

The output of the StarMask tool is a non-linear stretched image and it is often the case that it appears to have missed many of the smaller stars at first glance. This may not be the case; it is just they are not white in the mask but dark grey. Jumping ahead, the Mask Preprocessing section has a series of mask stretch and clipping tools. The Mid-tones slider performs a basic non-linear stretch.

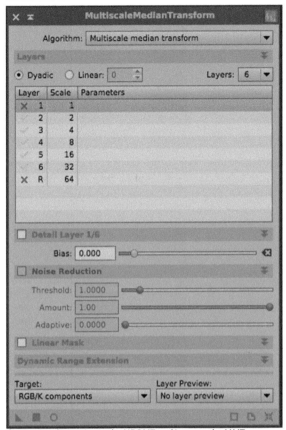

fig.14 *The resulting image from the MMT application prior to using the StarMask tool on it, shown here with a mild stretch and shadow clipping for printing purposes.*

fig.13 *An alternative to the HDRMT tool is to use the MMT tool, to remove noise and large scale objects, to help the StarMask tool to discriminate more effectively.*

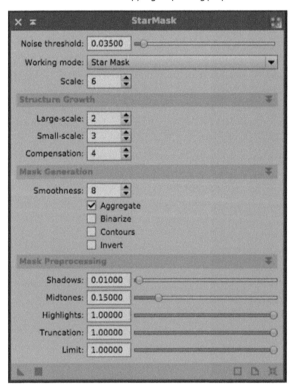

fig.15 *These StarMask settings were used on the HDRMT processed image to form the Local support file (fig.16).*

Decreasing its value boosts faint detail in the mask. Values around 0.01–0.1 will significantly boost protection on the fainter stars.

The Structure Growth section can be confusing at first, since it appears to have two controls for small stars and interact with the Mask Generation settings too. There are several benefits to growing structures; the first being one often needs to process a star as well as its diffuse periphery beyond its distinct core. Growing a structure extends the boundary to encompass more star flux. Another reason is to do with the smoothness option; this blurs the mask and lowers protection on the star side of the mask boundary. A growth of the mask before smoothing ensures this erosion does not encroach into the star flux. The two top controls change the mask boundaries for Large and Small stars and in practice I use the Compensation setting as a fine tune to the Small-scale adjustment.

In the Mask generation section there are four controls that alter the mask appearance: Aggregate's pop-up description is not the easiest to work out. When it is enabled, big bright stars do not appear in the mask as a uniform mid grey blob but with less intensity and shading towards the edges. This gives a natural feathering of the mask and can be useful during the deconvolution process on big bright stars. The Binarize option is the opposite and creates a black and white mask, with hard

fig.16 *The Local support file. Note that the largest stars in this*
 case are only partially masked. That can be changed by
 enabling the Binarize option in the StarMask settings.

edges, no mid-tones and is not suitable. It has its uses though in other processes but can throw unexpected results. If the Noise threshold is set too low every noisy pixel turns white in the mask. To avoid this, increase the Noise threshold (to about 10x the background value) and optimize the mask with small adjustments to the Noise threshold. When Aggregate and Binarize are used together, fewer "stars" are detected and the larger stars are rendered smaller in the mask, on account of the shading. If I do enable Binarize, I enable Aggregate too as I find the combination is less susceptible to small-scale noise.

After a little experimentation on the preview I chose the settings in fig.15, which produced my Local support image (fig.16). Select this file in the deconvolution Deringing settings and move the Local amount slider fine to tune the correction. This slider blends the original image with the deconvoluted one. Choose a setting that leaves behind the faintest dark ring around bright stars (fig.10) as the next step also reduces ringing to some extent.

Wavelet Regularization (10)
The controls in this section of the deconvolution tool look suspiciously like those in the noise reduction tools, and for good reason; their inclusion is to counter the curdling effect caused by the deconvolution process trying its best on noisy pixels. The noise reduction level for each scale is set by a noise threshold and reduction amount and just as with noise reduction settings, the strongest settings are at the lowest scale. The Wavelet layers setting determines the number of scales. I normally set it to 3 or 4 and proportionally scale back the larger scale noise

thresholds and reduction amount. I choose a setting that restores the appearance of the brighter areas of the image, in this example, the main part of the galaxy.

The brighter areas of the image have a high signal to noise ratio and the wavelet regularization settings required to remedy these areas are less severe than those required to smooth the dark sky background. Conversely, I find that the noise reduction settings to fix the background appearance soften the appearance of the brighter areas. For this reason, I optimize for the bright areas and mask off the darkest regions of the image before applying the final deconvolution settings.

Background Combination Masking (11)
The mask for the background is a combination of a range and star mask. In this example, I experimented using the same star-based mask used for Local support and some other derivations. I increased the scale one notch to identify the biggest stars and stretched the mask to boost small star protection.

The range mask tool seems easy enough with its preview tool. Well, yes and no. If the background has a sky gradient, it may prove troublesome. In this case, duplicate the luminance channel and use the DynamicBackgroundExtraction tool to flatten the background before using the RangeSelection tool. Deselect Invert and choose a threshold that excludes featureless background but leaves behind interesting structures. You can feather and smooth the selection too, to alter the boundaries. Feather and smooth have different effects; with both at zero, a simple black/white mask is generated according to the limit sliders. Increasing the feather slider selects pixels proportionally based on their value, whereas the smooth slider blurs the mask. Even so, this mask will exclude some stars that reside in otherwise featureless sky and it is necessary to unprotect these areas. The common method is to create a star mask and then combine it with the range mask to create a mask that protects the background, using a simple PixelMath equation in the form:

max(rangemask, starmask)

Ironically, the very brightest stars may not appreciate being deconvoluted and may exhibit weird artefacts. In these cases, it may be necessary to further alter this combination mask by creating a unique star mask with a very high noise threshold that just selects the clipped stars and then subtract this from the combination mask using Pixelmath. The combination mask will look peculiar but it will do its job.

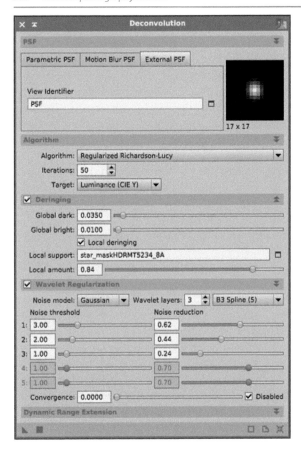

fig.17 *The final deconvolution settings that were applied to fig.18, in combination with a mask protecting empty background, produced the final result in fig.19.*

Final Tuning (12)

Generate the range mask and Local support image from the full frame image using the settings you settled upon in the preview trials. Generate the full frame star mask and combination mask too and apply this to the luminance image. Select your full frame Local support image in the Deconvolution tool and keeping all the other settings as they were, apply to the full frame. The result may differ from that of the preview (depending on how well you chose the preview area) and so a small amount of tuning is in order. Knowing what each tool setting does makes it much easier to make those small adjustments. I found my deringing tools and noise reduction settings were still good and I just increased the number of iterations to see how far I could go. In this case I increased the iterations from 20 to 50. This control has diminishing returns and with 50 iterations only mild further sharpening was apparent and without any artefacts.

Life After Deconvolution

Deconvolution is not the last word in star processing; although it yields a modest effect on small structures it struggles with large bloated stars and even nicely sharpened stars can be mutilated by extreme stretching (for example, those encountered during narrowband image processing). In these cases there are techniques that can shrink all star sizes, even large ones, or remove them altogether. In the latter case, some find it helpful to process nebulous clouds in the absence of stars and then add them back in later on. The star processing is done separately and has a less aggressive non-linear stretch. This avoids highlight clipping and preserves color saturation.

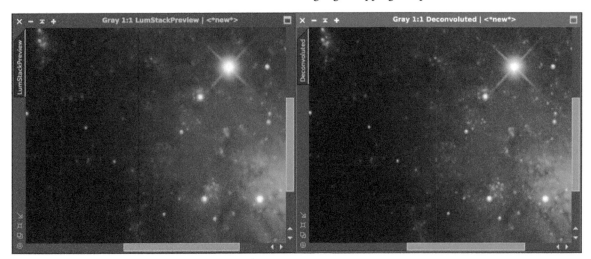

figs.18, 19 *The original image stack is shown on the left (magnified) and the deconvoluted version on the right. The differences are subtle and not "obvious", which is a sign of good editing judgement. A more heavy-handed approach can cause unsightly artefacts that outweigh the benefits of deconvolution.*

Morphological Transformation

An alternative to deconvolution is morphological transformation (MT). This tool can appear to change the size and emphasis of stars within an image or remove them altogether. Its tool settings alter the amount and shape of the transformation by iteratively replacing pixels with a statistical combination of its neighbors and blending them with the original image. (The tool is very flexible and it can potentially make an asymmetrical transformation to compensate for elongated stars.) The tool is applied to an image in combination with a mask to confine the effect. To remove stars altogether, apply iteratively until the stars have shrunk to a few pixels and then blend these pixels with its neighbors within the star mask's holes. I use this tool on the stretched (non-linear) image and after it has received some noise reduction. Excessive noise interferes with star mask generation and reacts to any image sharpening too.

Reducing Star Sizes with MT

Star masks have already been discussed at some length. As before, use HDRMultiscaleTransform on a duplicate stretched image to even out the background. In the Star-Mask tool, set the background level so it only identifies stars and the scale to identify the stars you wish to shrink. The MT tool blends each pixel with the median of the pixels within its defined boundary (the Structuring Element). If one uses a simple star mask, this will also cause the central core pixel value to lower too. To just shrink the star edges select the star peripheries with the mask, using the StarMask tool, but this time, with very different settings. In fig.20 the Structure Growth is reduced to minimal levels, as is the Smoothness parameter. This confines the mask and prevents even small stars being fully selected. In the Mask Generation section select the Contours option. Finally, change the Mid-tones setting to about 0.1 to boost the mask's contrast. When applied to our prepared image, it produces the star mask shown in Fig.21. On closer inspection each star mask is a tiny donut that marks the stars diffuse boundary. If during this process it is impossible to create a perfect mask from one application, create a range of star masks, optimized for stars of different scales and intensities and then combine these using a simple PixelMath equation (as above) to generate a single mask. Apply the final star mask to the image.

The MT tool has a number of modes (operations): erosion shrinks a star, dilation expands a star and Morphological Selection combines both erosion and dilation. This last mode produces a smoother overall result than erosion on its own. The Selection parameter defines the

fig.20 These StarMask settings identify a star's periphery, rather than the whole. The low growth settings ensure a thin annulus mask is generated around each (fig.21). Higher growth settings would "fill-in" the donuts, with the risk of star removal during the MT application.

fig.21 This star mask, using the Contours option in StarMask (as shown in fig.20), protects star cores and restricts manipulations to the diffuse star boundaries.

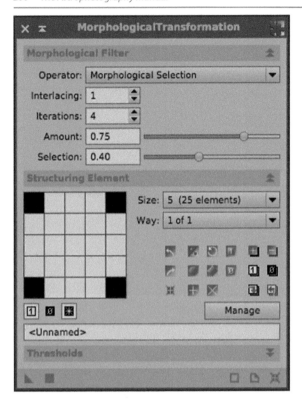

fig.22 Typical MorphologicalTransformation (MT) tool settings for reducing star sizes, identified using the star mask in fig.21.

ratio of the two operations. Low values (<0.5) shrink the star and high values (>0.5) enlarge it. The Amount parameter blends the transformed image with the original image; when set to 1 there is no blending and for a more natural result try a modest blend in the region of 30–10% (0.7–0.9). The MT tool is more effective when a mild setting is applied iteratively; try 2–5 iterations with a mild erosion setting. The last group of settings concerns the Structuring element. This defines the scope of the median calculation for each pixel. In this case, for small and medium stars, choose a circular pattern with 3x3 or 5x5 elements.

Apply the MT tool to the image or preview and evaluate the result. If the mask and settings are correct, the smallest stars are unaffected but the larger stars are smaller and less intense. In an image of a diffuse nebula, this may be desirable as it places more emphasis on the cloud structure. If, however, you only wish to reduce star sizes and not their intensity, applying some image sharpening restores normality. This again employs a mask to select the image's small-scale structures and then these are emphasized by applying the Multiscale-MedianTransform (MMT) tool.

In practice, take the prepared stretched image that has HDRMT applied to it and use it to create star mask (with the scale set to 2 or 3) or apply the MMT tool to it, (disable all but the two smallest scales). With the mask in place, emphasize the star intensity by applying the MMT tool, only this time using its default settings and with an increase in the Bias setting of the two smallest scales. Use the real-time preview function to try out different bias settings; depending on the mask intensity, it may require a large bias value to make a noticeable difference. Watch out for noise; increasing the bias of small scales is the opposite of noise reduction. If the mask does not obscure hot pixels and high noise levels, the MMT application will create havoc. The net outcome of all this, using the

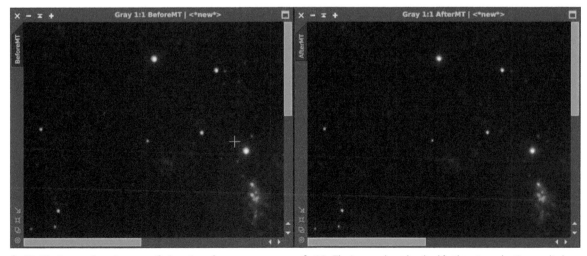

fig.23 The image above is a magnified portion of the stretched deconvoluted image.

fig.24 The image above has had further star reduction applied to it, using the MT tool and some mild sharpening (using the MMT tool) to recover the peak star values.

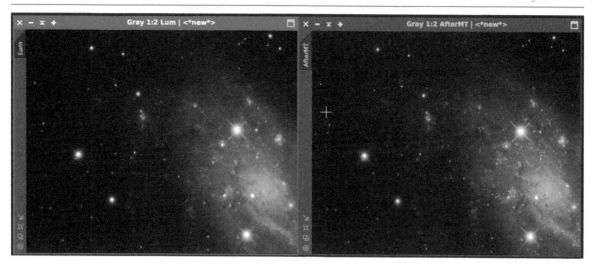

MT tool and some mild sharpening, is shown in fig.22 and fig.23. The deconvoluted image on the left has had a standard non-linear stretch applied to it and the one on the right has had further star size reduction with MT and MMT treatment.

Removing Stars with MT

The same set of tools can be used to shrink stars to oblivion (the Vogans would be impressed). In this case the MT tool is repeatedly applied until the stars disappear, though with different settings. In the first step, ensure the star mask is only selecting stars and remove any remaining large-scale elements from the preliminary star mask. One effective method applies the MultiscaleMedianTransform tool to the star mask, with its residual layer setting disabled. Stretch the mask using the HistogramTransformation tool and at the same time, gently clip the shadow slider to remove faint traces of non-stellar imagery. Repeat to discriminate and boost the mask in favor of the stars.

To remove rather than shrink stars uses more brutal settings in the MT tool. Select the erosion operation with the Iterations and Amount set to 1. Even so, it will take several applications to remove the stars and even then, it may leave behind curious diffuse blobs. In the case of working on colored images, the process sometimes produces colored artefacts too. If this occurs, undo the last MT application, apply a modest MT dose of dilation and then try the MT tool (set to erosion) once more. Even so, some stars may stubbornly refuse to be scrubbed out, even after several applications of the MT tool. One method to disguise the remaining blip is to smooth the image (with the star mask still in place) using the MMT tool, only this time, enable the residual and larger scales and disable the smaller ones. The largest stars will still leave their mark, however,

fig.25 A final comparison of a stretched luminance image with that of one that has been deconvoluted and had further star-size reduction. The difference is subtle but worthwhile.

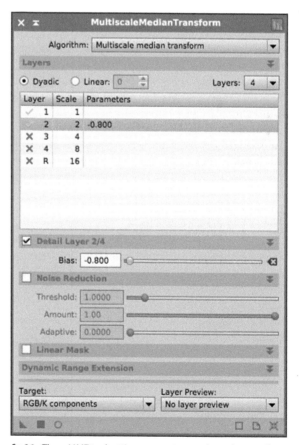

fig.26 These MMT tool settings generate a mask to select small structures and is an alternative to using the StarMask tool to select small stars for sharpening after shrinking.

especially if they have diffraction spikes and as a last resort, even though it is heresy, use the CloneStamp tool to blend out the offending blobs.

Improving Star Color

Generating good star color is deceptively simple and in reality is a significant challenge in its own right. It appears that almost every action conspires to destroy it and to create and keep it requires special attention from image capture through to both luminance and RGB image processing. It can evaporate in a single step; for instance, if one has a pure red star and mix it with a high luminance value (>90%), the result is a white star. Similarly, if the RGB channel values are at maximum and mixed with a mid-tone luminance, you will get grey. Good color therefore requires two things: differentiation between the RGB values, coupled with a modest luminance value.

Image Capture Strategies for Star Color

Sub-frame exposures try to satisfy two opposing demands: sufficiently long to achieve a good SNR and capture faint detail, yet short enough to avoid clipping highlight values. It is rare to find a single setting that satisfies both. The solution is most easily met by taking a long and short exposure set; each optimized for a singular purpose and then combine the integrated images later on. This is easily done in the acquisition software's sequence settings by creating two distinct image subframe events for a filter. I normally create a LRGB sequence with long and short luminance exposures designed for nebulous clouds and bright stars / galaxy cores respectively. I choose a subframe exposure for the color channels that does not clip the bright stars, or a few at most. Some subjects will never cooperate; Alnitak close to the Horsehead nebula is a beast that will not be tamed.

The concept of exposing a unique set of color subframes will also put natural star color into a narrowband image; a narrowband sequence typically consists of 10–20 minute subframe exposures and on their own produce oddly colored or clipped white stars. By including a few hours of RGB data into the imaging sequence (using short subframe exposures) the separate colorful star image is overlaid to good effect. This technique is explained in the C27 Crescent Nebula practical assignment.

These are all excellent starting points but even so, a few stars may still clip. Really bright stars become large diffuse blobs when stretched, on account of diffusion and diffraction along the optical path. It does not really help to combine subframes of different exposure length either, as the lower-intensity diffuse boundary picks up color but the central core stubbornly remains

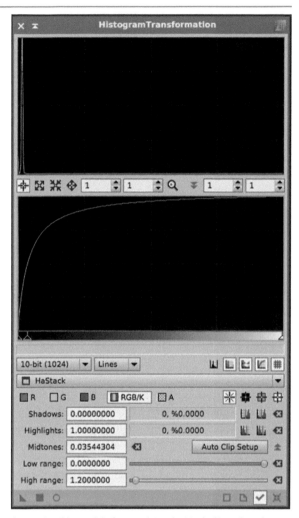

fig.27 A mild stretch before applying the MaskedStretch tool, using an extended high range setting, helps keep star peak intensities in the range of 0.8–0.95 and looking natural.

near-white. This remaining obstacle, creating a realistic appearance to really bright stars, is possibly the largest challenge in an image and more drastic means are needed during image processing to tame these bloaters. (You didn't hear me say it, but Photoshop or Gimp is also quite useful for isolated edits, post PI editing.)

Image Processing Strategies for Star Color

Our two mantras during image processing are to stretch the image without clipping and to maintain RGB differentiation. The first applies to both luminance and color processing work-streams and the second solely to RGB processes. If one considers a deconvoluted linear luminance image, the next step after a little selective noise reduction is to stretch the image. By its very nature, everything becomes brighter. A couple of medium stretches

using the traditional HistogramTransformation HT) tool soon boosts the brighter star cores into the danger zone and at the same time, extends their diffuse boundary.

The idea of a variable strength stretch, based on image intensity comes to mind; a simple image mask that protects the brightest areas may be a partial solution. The Masked-Stretch tool does precisely this but in a more sophisticated progressive way. This tool stretches stars to form a small but pronounced central peak with an extended faint periphery. Used on its own it can cause stars to take on a surreal appearance. If you apply it to an image that has already received a modest non-linear stretch, the effect is more acceptable. First apply a medium stretch to the image, using typical settings as the ones in fig.27, followed by the MaskedStretch tool, set to 1,000 iterations and a clipping point set as a compromise between background noise and feature brightness. To avoid either stretching operation proliferating clipped highlights, the highlight slider on the HT tool is increased to 1.2–1.3, which provides some headroom for the stretching outcome (fig.27).

Another technique for retrospectively reducing star intensity during processing is to use the star shrinking properties of the MorphologicalTransformation tool. As seen before, the act of shrinking stars also dims them as it replaces each pixel with the median of its neighbors. In this case, create a star mask solely for the bright stars and apply an erosion or morphological selection to the bloaters. The same logic applies to the various blurring techniques, that blend a sharp centrally and clipped peak with its immediate surroundings. To blend the clipped star core apply a tight star mask and apply the convolution tool, or one of the multi-scale tools, with its bias setting reduced for the first two scales. A good non-linear luminance channel may have peak intensities below 0.95 and most star peak intensities below 0.8. If the image looks dull, one visual trick is to increase the apparent contrast by lowering the background level from the nominal 0.125 and mounting the image with a dark surroundings and with no nearby white reference. It is amazing how much you can fool the brain with simple visual tricks such as these.

Having processed the luminance channel, it is now the turn of the color channels. It is important to remember that this only concerns the color information. Stretching a color image has two effects on saturation. It accentuates the differences (increases saturation) between color channels in the area of maximum local contrast increase (typically shadow areas) and conversely decreases the differences in the highlight regions (reducing saturation). At the extreme, if a color image is stretched too far, the individual RGB levels clip and

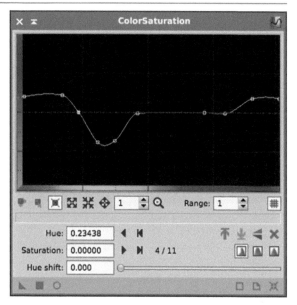

fig.28 The ColorSaturation tool applies selective boosts and reductions to various colors. Here, reducing green saturation and boosting yellow–magenta.

once more bright stars become white blobs. (Once this occurs, there is no method to recover the original color information and an inverse intensity transform simply creates grey blobs.)

There are a few more tools at our disposal to improve color differentiation: The ColorSaturation tool selectively increases color saturation. I often use this to balance red and blue star saturation in an image and at the same time, suppress anything green (fig.28). Overall color saturation appears as one of the settings in the CurvesTransformation tool. Select the "S" for saturation and drag the curve to boost color saturation. This changes the color saturation as a function of its present saturation (not color or brightness). A typical curve predominantly boosts areas of low saturation (and for that reason my require a mask to protect featureless sky, to avoid increasing chroma noise).

Lastly, the color balance tools, or individual RGB channels in the HistogramTransformation tool manipulate individual color intensity, to alter the color differentiation but at the same time, change the overall color balance. These color saturation tools are often more effective if they are applied to the linear (un-stretched) RGB image. In that way, the following non-linear stretching further accentuates the differences between the RGB values. Conversely, increasing the color saturation of an over-stretched image is mostly futile and will not add significant color to bright stars.

Noise Reduction and Sharpening

Astrophotography requires specialized techniques to reduce image noise and improve definition, without each destroying the other.

On our journey through critical PixInsight processes, noise reduction and sharpening are the next stop. These are two sides of the same coin; sharpening often makes image noise more obvious and noise reduction often reduces the apparent sharpness. Considering them both at the same time makes sense, as the optimum adjustment is always a balance between the two.

Both processes employ unique tools but share some too. They are often deployed a little during linear and non-linear processing for best effect. These are uniquely applied to different parts of the image to achieve the right balance between sharpening and noise reduction, rather than to the image as a whole, and as a result both noise reduction and sharpening are usually applied through a mask of some sort. Interestingly, a search of the PI forum for advice on which to apply first, suggests that there are few rules. One thing is true though, stretching and sharpening make image noise more obvious and more difficult to remove. The trick, as always, is to apply manipulations that do not create more issues than they solve.

Both noise reduction and sharpening techniques affect the variation between neighboring pixels. These can be direct neighbors or pixels in the wider neighborhood, depending on the type and scale of the operation. Noise can be measured mathematically but sharpness is more difficult to assess and relies upon judgement. Some texts suggest that the Modulation Transfer Function (MTF) of a low resolution target is a good indicator of sharpness, in photographic terms using the 10 line-pairs/mm transfer function (whereas resolution is indicted by the contrast level of 40 line-pairs/mm). In practice, however, there is no precise boundary between improving the appearance of smaller structures and enhancing the contrast of larger ones. As such there is some overlap between sharpening and general local contrast enhancing (stretching) tools, which are the subject of the next chapter.

Typically noise reduction concepts include:

- blurring; reducing local contrast by averaging a group of neighboring pixels, affecting all pixels
- selective substitution; by replacing outlier pixels with an aggregate (for example, median) of its surroundings

Sharpening includes these concepts:

- deconvolution (explained in its own chapter)
- increasing the contrast of small-scale features
- enhancing edge contrasts (the equivalent of acutance in film development)
- more edge effects such as unsharp mask (again, originating from the traditional photographic era)

The marriage of the two processes is cemented by the fact that, in some cases, the same tool can sharpen and reduce noise. In both processes we also rely upon the quirks of human vision to convince oneself that we have increased sharpness and reduced noise. Our ability to discern small changes in luminosity diminishes with intensity and as a result, if we were to compare similar levels of noise in shadow and mid-tone areas, we would perceive more noise in the mid-tone area. Our color discrimination is not uniform either and we are more sensitive to subtle changes in green coloration, which explains why color cameras have two green-filtered photosites for each red and blue in the Bayer array. There are a few other things to keep in mind:

- Noise and signal to noise ratio are different: Amplifying an image does not change the signal to noise ratio but it does increase the noise level. Noise is more apparent if the overall signal level is increased from a shadow level to a mid-tone.
- Non-linear stretches may affect the signal to noise ratio slightly, as the amplification (gain) is not applied uniformly across different image intensities.
- Noise levels in an image are often dominated by read noise and sky noise – both of which have uniform levels. The signal to noise ratio, however, will be very different between bright and dark areas in the image. Brighter areas can withstand more sharpening and require less noise reduction.
- The eye is adept in detecting adjacent differences in brightness. As a consequence, sharpening is mostly applied to the luminance data.
- Sharpening increases contrast and may cause clipping and/or artefacts.
- Some objects do not have distinct boundaries and sometimes, as a consequence, less is more.

- The stretching process accentuates problems, so be careful and do not introduce subtle artefacts when sharpening or reducing noise in a linear image.

Noise Reduction

The available tools in PixInsight have changed over the last few years and as they been updated, a few have fallen by the wayside. It is a tough old world and image processing is no exception. So, if you are looking for instruction on using AdaptiveContrast-DrivenNoise Reduction (ACDNR) or AtrousWaveletTransform (ATWT), there is good and bad news; they have been moved to the obsolete category but have more effective replacements in the form of MultiscaleLinearTransform (MLT), MultiscaleMedianTransform (MMT), TGVDenoise and some very clever scripts. Before looking at each in turn, we need to consider a few more things:

- Where in the workflow should we reduce noise and by how much (and at what scale) ?
- How do we protect stars?
- How do we preserve image detail?
- How do we treat color (chroma) noise?

As usual, there are no hard and fast rules but only general recommendations; the latest noise reduction techniques are best applied before any image sharpening (including deconvolution) and yet, it is also often the case that a small dose of sharpening and noise reduction prior to publication is required to tune the final image. The blurring effect of noise reduction potentially robs essential detail from an image and it is essential to ensure that either the tool itself, or a protection mask directs the noise reduction to the lowest SNR areas and equally does not soften star boundaries. Excessive application can make backgrounds look plastic and the best practice is to acquire sufficient exposure in the first place and apply the minimum amount of noise reduction on the linear, integrated image before any sharpening process.

MureDenoise Script

This tool has evaded many for some time as it is hidden in the PixInsight script menu. It works exclusively on linear monochrome images (or averaged combinations) corrupted by shot, dark current and read noise. Its acronym is a tenuous contrivance of a "interscale wavelet Mixed noise Unbiased Risk Estimator". Thankfully it works brilliantly on image stacks, especially before any sharpening, including deconvolution. One of its attractions is that it is based on sensor parameters and does not require extensive tweaking. The nearest performing

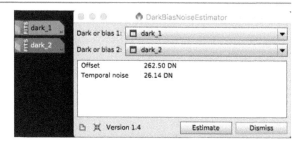

fig.1 A good estimate of Gaussian noise for the MureDenoise script is to use the Temporal noise assessment from two dark or bias frames in the DarkBiasNoiseEstimator script.

equivalent, and only after extensive trial and error, is the Multiscale Linear Transformation tool.

In use, the tool requires a minimum of information (fig.2) with which to calculate and remove the noise. This includes the number of images in the stack, the interpolation method used by image registration and the camera gain and noise. The last two are normally available from the manufacturer but can be measured by running the FlatSNREstimator and DarkBiasNoiseEstimator scripts respectively on a couple of representative flat and dark frames. An example of using the DarkBiasNoiseEstimator script to calculate noise is shown in fig.1. The unit DN, refers to a 16-bit data number (aka ADU), so, in the case of a camera with 8e read (Gaussian) noise and a gain of 0.5e / ADU, the Gaussian noise is 16 DN. If your image

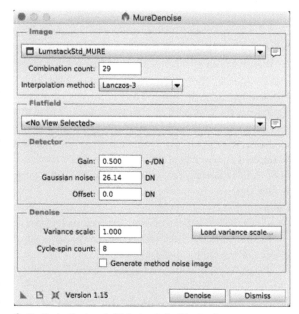

fig.2 Under the hood of this simple-looking tool is a sophisticated noise reduction algorithm that is hard to beat on linear images. Its few settings are well documented within the tool. It is easy to use too.

has significant vignetting or fall-off, the shot noise level changes over the image and there is an option to include a flat frame reference. The script is well documented and provides just two adjustments; Variance scale and Cyclespin count. The former changes the aggression of the noise reduction and the latter sets a trade-off between quality and processing time. The Variance scale is nominally 1, with smaller values reducing the aggression. Its value (and the combination count) can also be loaded from the information provided by the ImageIntegration tool; simply cut and paste the Process Console output from the image integration routine into a standard text file and load it with the Load variance scale button. In practice, the transformation is remarkable and preferred against the other noise reduction tools (fig.4), providing it is used as intended, on linear images. It works best when applied to an image stack, rather than separate images which are subsequently stacked. It also assumes the images in the stack have similar exposures.

Multiscale Transforms

MLT and MMT are two multiscale tools that can sharpen and soften content at a specific image scale. We first consider their noise reduction properties and return to them later for their sharpening prowess. Both work with linear and non-linear image data and are most effective when applied through a linear mask that protects the brighter areas with a higher SNR. Unlike MureDenoise, they work on the image data rather than using an estimate of sensor characteristics. In both cases the normal approach is to reduce noise over the first 3 or 5 image scales. Typically there is less noise at larger scales and it is normal to decreasingly apply their noise reduction parameters at larger scales. Both MLT and MMT are able to reduce noise and sharpen at the same time. I used this approach for some time and for several case studies. After further research, I discovered this approach is only recommended with high SNR images (normal photographic images) and is not optimum for astrophotography. It is better to apply noise reduction and sharpening as distinct process steps, at the optimum point in the workflow. In the same manner, both tools have real-time previews and the trick is to examine the results at different noise reduction settings, one scale at a time. I also examine and compare the noise level at each scale using the ExtractWaveletLayers Script. It is a good way to check before and after results too. In doing so one can detect any trade-off, at any particular scale, between noise reduction and unwanted side-effects.

The two tools work in a complementary fashion and although there have many similarities, it is worth noting their differences:

MultiscaleLinearTransform

MLT works well with linear images and with its robust settings can achieve a smooth reduction to either color or luminance noise. It is more effective than MMT at reducing heavy noise. If it is overdone it can blur edges, especially if used without a mask, and at the same time aggressive use may create single black pixels too. It has a number of controls that provide considerable control over the outcome. At the top is the often overlooked Algorithm selection. The Starlet and Multiscale linear algorithms are different forms of multiscale analysis and are optimized for isolating and detecting structures. Both are isotropic,

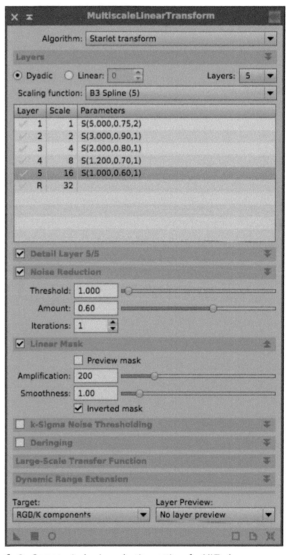

fig.3 *Some typical noise reduction settings for MLT when operating on a linear image. This tool comes close to the performance of the MureDenoise script but has the advantage of being more selective and tunable.*

in that they modify the image exactly the same way in all directions, perfect for astrophotography. The differences are subtle; in most cases the scales form a geometric (dyadic) sequence (1, 2, 4, 8, 16 etc.) but it is also possible to have any arbitrary set of image scales (linear). In the latter case, use the multiscale linear algorithm for greater control at large scales. I use the Starlet algorithm for noise reduction on linear images.

The degree of noise reduction is set by three parameters: Threshold, Amount and Iterations. The Threshold is in Mean Absolute Deviation units (MAD), with larger values being more aggressive. Values of 3–5 for the first scale are not uncommon, with something like a 30–50% reduction at each successive scale. An Amount value of 1 removes all the noise at that scale and again, is reduced for larger scales. Uniquely, the MLT tool also has an Iterations control. In some cases, applying several iterations with a small Amount value is more effective and worth evaluating. The last control is the Linear Mask feature. This is similar to the RangeSelection tool, with a preview and an invert option. In practice, with Real-Time Preview on, check the Preview mask box and Inverted mask box. Now increase the Amplification value (around 200) to create a black mask over the bright areas and soften the edges with the Smoothness setting. The four tool sections that follow

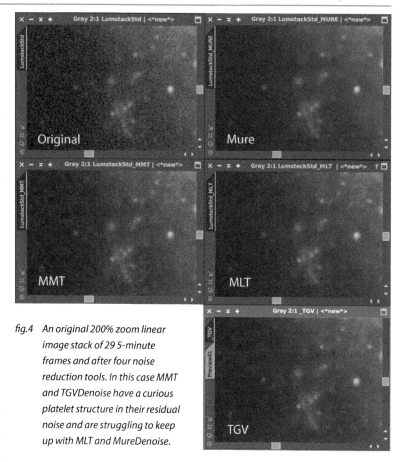

fig.4 An original 200% zoom linear image stack of 29 5-minute frames and after four noise reduction tools. In this case MMT and TGVDenoise have a curious platelet structure in their residual noise and are struggling to keep up with MLT and MureDenoise.

(k-Sigma Noise Thresholding, Deringing, Large-Scale Transfer Function and Dynamic Range Extension) are not required for noise reduction and left disabled. The combinations are endless and a set of typical settings for a linear image is shown in fig.3. With the mask just so, clear the Preview mask box and either apply to a preview or the entire image to assess the effect.

noise reduction tool	linear	non-linear	small scale	medium scale	retain detail	chroma noise	artifacts	comment
MUREDenoise	+++	+	+++	++	+++	mono only	+++	use before any sharpening, best for linear images, easy to adjust
MLT	++	+++	+++	++	+	option	+	use with linear mask, use starlet transform and tune with amount
MMT	+	+++	++	+++	++	option	++	use with linear mask and median wavelet transformation
TGVDenoise	++	++	++	++	+++	option	+	use statistics to set edge protection level, very sensitive!

fig.5 This table is a broad and generalized assessment of the popular noise reduction techniques that looks at what they are best applied to, whether they work well with small and medium scale noise, retain essential detail, color options and potential side-effects.

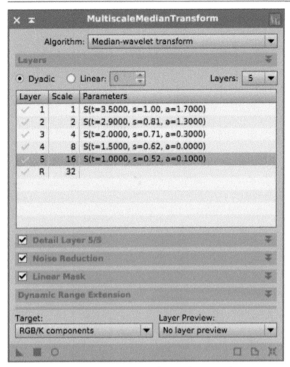

fig.6 *These MMT settings were used to produce its noise reduction comparison in fig.7. Note an Adaptive setting >1.0 is required at several scales, to (just) remove the black pixels that appear in the real-time preview.*

MultiscaleMedianTransformation

MMT works with linear and non-linear images. It is less aggressive than MLT and a setting gives broadly reproducible results across images. It delivers a smooth result but has a tendency to leave behind black pixels. Like MLT, it is best used in conjunction with a Linear mask. It is more at home with non-linear images and its structure detection algorithms are more effective than MLT and protect those areas from softening. In particular the Median Wavelet Algorithm adapts to the image structures and directs the noise reduction where it is most needed. The noise controls look familiar but the Iteration setting is replaced by an Adaptive setting (fig.6). Adjust this setting to remove black pixel artefacts. In this tool the degree of noise reduction is mostly controlled by Amount and Threshold. It is typically less aggressive than MLT and can withstand higher Threshold values. In fig.4, which assesses the four tools on a linear image, it struggles. The second comparison in fig.7, on a stretched image, puts it in a much better light.

TGVDenoise

This tool uses another form of algorithm to detect and reduce noise. The settings for linear and non-linear images are very different and it is tricky to get right. Unlike the prior three tools, this one can simultaneously work on luminance and chroma noise with different settings. The most critical is the Edge protection setting, get it wrong and the tool appears broken. Fortunately its value can be set by image data statistics: Run the Statistics tool on a preview of blank sky. In the options, enable Standard Deviation and set the readings to Normalized Real [0,1]. Transfer this value to the Edge protection setting and experiment with 250-500 iterations and the strength value. If small structures are becoming affected, reduce the Smoothness setting slightly from its default value of 2.0.

Just as with MMT and MLT, this is best applied selectively to an image. Here the mask is labelled Local support, in much the same way as that used in deconvolution. It is especially useful with linear images and reducing the noise in RGB images. The local support image can be tuned with the three sliders (histogram sliders)

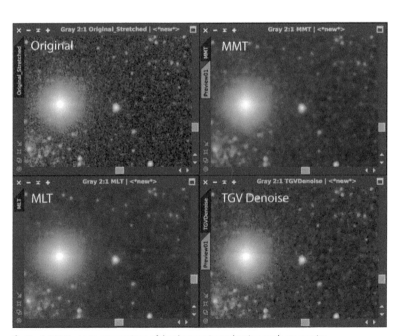

fig.7 *A 200% zoom comparison of the three noise reduction tools on a noisy non-linear image after an hour of experimentation. MLT performed well, followed by MMT and TGVDenoise. In brighter parts of the image, MMT edges ahead. TGVDenoise preserves edges better, but it is easy to overdo.*

that change the endpoint and midpoint values. The default number of iterations is 100. It is worth experimenting with higher values and enabling Automatic convergence, set in the region 0.002–0.005. If TGVDenoise is set to CIE L*a*b* mode, the Chrominance tab becomes active, allowing a unique settings to reduce chrominance noise. Though tricky to master, TGVDenoise potentially produces the smoothest results, think Botox.

Sharpening and Increasing Detail

If noise reduction was all about lowering ones awareness to unwelcome detail, sharpening is all about drawing attention to it, in essence by increasing its contrast. In most cases this happens with a selective, non-linear transform of some kind. As such there is an inevitable overlap with general non-linear stretching transformations. To make the distinction, we consider deconvolution and small-scale feature / edge enhancement as sharpening actions (using MLT, MMT and HDRMultiscaleTransform). In doing so, we are principally concerned with enhancing star appearance and the details of galaxies and nebulae. Deconvolution and star appearance are special cases covered in their own chapter, which leaves small-scale / edge enhancement. (Masked Stretch and LocalHistogramEqualization equally increase local contrast, but typically at a large scale and are covered in the chapter on image stretching.) Sharpening is more effective and considerably more controllable on a stretched non-linear image. Yes, it can be applied to linear images but if you consider the stretching process to follow, the slightest issue is magnified into something unmanageable.

Beyond UnsharpMask

When looking at the tools at our disposal, Photoshop users will immediately notice that one is noticeable by its absence from most processing workflows. UnsharpMask is included in PI but it is rarely used in preference to deconvolution and the multiscale tools. It creates the illusion of sharpness by deliberately creating alternating dark and light rings around feature boundaries and in doing so destroys image information. Deconvolution on the other hand attempts to recover data. UnsharpMask does have its uses, mostly as a final step prior to publication to gently add sparkle to an image. The trick is to view the preview at the right size to assess the impact on the final print or screen.

The multiscale tools include our old friends MLT and MMT but here we use them in a different way to give the appearance of sharpening by changing local contrast at a particular scale. As before, they are best used selectively through a mask. This time, however,

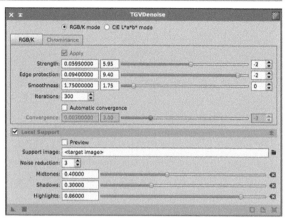

fig.8 These settings were used to produce the noise reduction comparison in fig.7. A small increase in the strength caused unsightly platelets to appear in the background.

the linear mask is non-inverted, to protect background areas of low SNR. To sharpen an image, the Bias setting in either tool is increased for a particular layer, corresponding to a different image scale. Visualizing scale is daunting for the novice and it is useful to run the ExtractWaveletLayers image analysis script on the target image. The multiple previews, each extracting the information at a different image scale, provide a useful insight into the image detail at each.

fig.9 This image was generated by the ExtractWaveletLayers script. This one is for scale 5 and shows the broad swirls of the galaxy arms. Increasing the bias of this layer, increases its contrast and its emphasis in the combination of all the scales and the residual layer.

These images are typically a mid grey, with faint detail etched in dark and light grey (fig.9). From these one can determine where the detail and noise lay and target these layers with noise reduction and sharpening. These images also give a clue on how the tool sharpens and the likely appearance: When these images are combined with equal weight, they recreate the normal image. The bias control amplifies the contrast at a particular scale, so that when it is combined, the local contrast for that scale is emphasized in the final image. For that reason, it is easy to see that the general tone of the image is retained but the tonal extremes are broadened.

As an aside, the same bias control can be used to de-emphasize structures too, by reducing its value to a negative number. It is not unusual to see the first layer (corresponding to a scale of 1) completely disabled in an RGB image to remove chroma noise. It has other potential uses too: A globular cluster technically has no large-scale structures but some of the brighter stars will bloat with image stretching. Applying MLT (or MMT) with the bias level slightly reduced for layers 4–5, reduces the halo around the largest stars.

The other common characteristic of these two sharpening algorithms is their tendency to clip highlights. This is inevitable since sharpening increases contrast. Both multiscale tools have a Dynamic Range Extension option that facilitates more headroom for the tonal extremes. I start with a High range value of 0.1 and tune so the brightest highlights are in the range 0.9–0.95. Both tools have a real-time preview facility and, in conjunction with a representative sample preview, enable almost instantaneous evaluation of a setting.

Sharpening with MLT

MLT can be used on linear and non-linear images. In common with all other linear sharpening tools, it can produce ringing around stars, especially on linear images. For that reason, it has a deringing algorithm option to improve the appearance. In a number of tutorials MLT is commonly used with its linear mask to exclude stars and background, with a little noise reduction on the first layer and a small bias increase at the larger scales to make these more pronounced. Compared with MMT, MLT works best at medium and large scales. As usual, ensure one has a screen transfer applied to the image before activating the real time preview, to assess the likely impact on the final image. Some typical settings in fig.10 were applied to a stretched image of M81 (fig.14). The MLT tool did the best job of showing the delicate larger structures in the outer galaxy arms. It was less suited for enhancing fine detail.

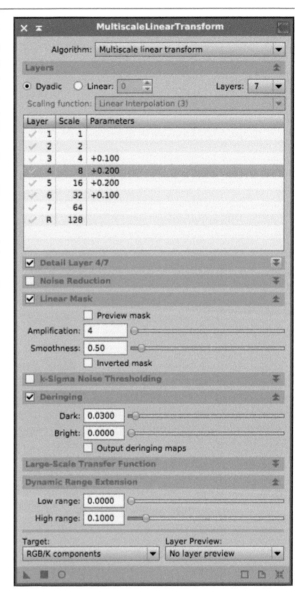

fig.10 *These settings were used to produce the sharpening comparison in fig.14. Note the bias settings are working on the larger scales and a small amount of deringing keeps artefacts in check. Sharpening increases dynamic range and here it is extended by 10% to avoid clipping.*

Sharpening with MMT

MMT improves upon MLT in a number of ways. MMT does not create rings and sharpens well at smaller scales. The multiscale median algorithm is not as effective at larger scales, though the median-wavelet transform algorithm setting blends the linear and median algorithms for general use at all scales.

MMT can produce other artefacts, which is usually an indication of over-application. Again, it is best to

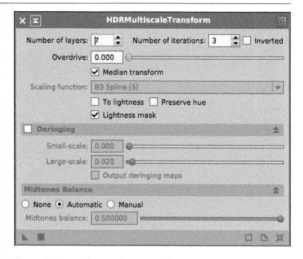

MultiscaleMedianTransform

Algorithm: Median-wavelet transform

Layers

⦿ Dyadic ○ Linear: 0 Layers: 5

Layer	Scale	Parameters
✓ 1	1	
✓ 2	2	+0.050
✓ 3	4	+0.100
✓ 4	8	+0.300
✓ 5	16	+0.100
✓ R	32	

☑ Detail Layer 3/5

Bias: 0.100

☐ Noise Reduction

Threshold: 1.0000
Amount: 1.00
Adaptive: 0.0000

☑ Linear Mask

☐ Preview mask
Amplification: 10
Smoothness: 3.20
☐ Inverted mask

Dynamic Range Extension

Target: RGB/K components
Layer Preview: No layer preview

fig.11 *These settings were used to produce the noise reduction comparison in fig.14. The bias settings here have an emphasis on smaller scales and deringing is not an option or required. Sharpening increases dynamic range and here it is extended by 10% to avoid clipping.*

HDRMultiscaleTransform

Number of layers: 7 Number of iterations: 3 ☐ Inverted
Overdrive: 0.000
☑ Median transform
Scaling function: B3 Spline (5)
☐ To lightness ☐ Preserve hue
☑ Lightness mask

☐ Deringing
Small-scale: 0.000
Large-scale: 0.020
☐ Output deringing maps

Midtones Balance
○ None ⦿ Automatic ○ Manual
Midtones balance: 0.500000

fig.12 *Likewise, the simpler settings for HDRMT create a wealth of detail where there apparently is none. The scale factor changes what is emphasized, from subtle swathes in brightness to highlight local changes from dust lanes.*

examine the extracted layer information to decide what to sharpen and by how much.

Sharpening with HDRMT

This tool is simpler to operate than the other two multiscale tools. It works in a very different way and as the name implies, it is used with images of high dynamic range. It has the ability to create spectacular detail from a seemingly bright, diffuse galaxy core. I usually apply this selectively to a non-linear image to enhance nebula or galaxy detail, using the median transform option. Changing the layer value generates diverse alternatives. One does not have to choose between them, however, simply combine these with PixelMath. In common with other tools, it has an in-built lightness mask and deringing option, if required. The Overdrive setting changes

sharpening tool	linear	non linear	small scale	medium scale	ringing	artifacts	local support	comment
HDRMT	+	+++	+++	+++	++	+	+++	use to enhance bright structures
MLT	+	++	++	+++	+	+	+++	use the starlet algorithm for medium scales
MMT	++	+++	+++	++	+++	++	+++	use median wavelet algorithm for best results over range of scales

fig.13 *As fig.5, but this time a comparison of sharpening tools. This is generalized assessment of the performance of these tools on linear and non-linear images, optimum scale and likely side-effects, based on personal experience and the tutorials from the PI development team. At the end of the day, further experimentation is the key to successful deployment.*

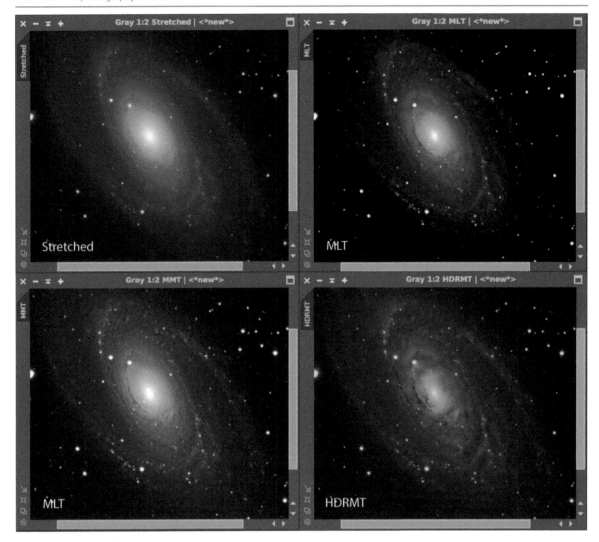

fig.14 A comparison of sharpening techniques on the delicate spirals of M81 (shown at a 50% zoom level to see the effect on the
larger scales at which sharpening operates). These are not the last word in sharpening but give an appreciation of the very
different results that each of the tools can bring. MLT and MMT are subtly different in output, with MMT being more adaptable.
HDRMT is particularly dynamic. The result here is quite tame compared to some that can occur. The trick
is to realize that HDRMT is not a silver bullet, just a step on the journey and the result can be subsequently
stretched or blended to balance the galaxy's overall brilliance with the surrounding sky.

the amount of tonal compression and, with the iterations setting, provides opportunity for fine tuning.

Combining Strengths

Some of these tools are quite aggressive or dramatically change the image balance. Subsequent processing, for example CurvesTransformation, can recover this. Another possibility is to create a number of sharpened versions, optimize for different effect and then blend them. The most convenient way to do this is to simply add them using a simple PixelMath equation, which additionally provides endless possibilities to weight their contribution in the final image. For example, one of the drawbacks of sharpening tools is their clipping effect on stars. Even with additional headroom, stars become too dominant. One method is to apply the HDRMT tool to a stretched image and then blend this image with another optimized for star processing, with a similar median background level. For example, apply the MaskedStretch tool to a linear version of the same file for star appearance and blend the large scale features created by the HDRMT tool with the small scale structures from the MaskedStretch version.

Image Stretching

Just as when a print emerges from a tray of developer, this is the magical moment when you find out if your patience has been rewarded.

Following on from the chapter on noise and sharpening, stretching is the logical step into the non-linear workflow. This is the magical moment when faint details are made permanently visible and the fruits or your labor become apparent. The familiar automatic screen stretch that we use for assessing manipulations on linear images can be applied to an image but rarely gives optimum results. The golden rule is to not over-stretch. Although global stretching is frequently required to set a baseline, it is often the case that further manipulation requires selective application. Stretching alters contrast and depending on the tool, localizes the effect based on brightness or scale. As such, some enhancements overlap with sharpening effects to some degree. To distinguish between the two, I consider image stretching operates at a scale of 32 pixels or more.

Stretching an image not only brings about a miraculous change in the image, it also causes issues too, apparent noise in dark areas and loss of saturation being the most obvious. To keep both in check requires selective manipulation and at the same time, start with a quality image, in so much that it has sufficient overall exposure to have a high signal to noise ratio and not individually too long to cause clipped pixels in the first place.

As usual, there are a number of image stretching tools in PixInsight, optimized for specific situations. Their application is not automatic and tool choice and settings are heavily dependent upon the challenges set by the individual image. The most popular are;

- LinearFit
- HistogramTransformation
- LocalHistogramEqualization
- CurvesTransformation
- MaskedStretch
- AutoHistogram

LinearFit (LF)

This tool is unique in that it produces a linear stretch on an image by simply changing the black and white end points. This has been used before, during the first manipulations of the RGB channels, prior to combination into a color image. As such it is usually applied to the entire image.

The tool is automatic in operation and applies a linear equation to the image in the form:

$$y = m \cdot x + c$$

Its purpose is to minimize the distribution of the image intensities between two images. Since only the endpoints are moved, the output is still linear and in the case of

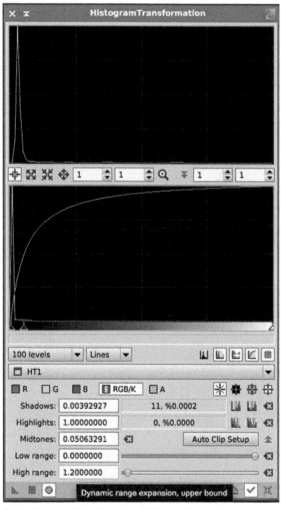

fig.1 *HistogramTransformation (HT) normally requires several passes to achieve the right level of stretch. Here, very mild shadow clipping is also being applied, along with a 20% dynamic range highlight expansion.*

applying one channel of an RGB set to the other channels, it has the useful outcome of broadly matching the channels, producing an approximate color-balanced result and with a neutral background. It also has uses when scaling and matching narrowband channels, when the Hα signal is typically considerably stronger than the OIII and SII signals, as well as equalizing mosaic images before combining. There are a couple of instances where matching two images helps during advanced processing; for instance when matching the intensity of a narrowband color image and a RGB starfield, prior to combination. There are variations of the LinearFit tool, using scripts, that are specific to mosaic images, where an image is placed within a black canvas. These disregard the black canvas in the matching algorithm and are described in more detail in the chapter on mosaic processing.

HistogramTransformation (HT)

This is the standard non-linear stretching tool. It can adjust both highlight and shadow endpoints, mimicking the actions of LinearFit and also adjust the midpoint too, creating the non-linear stretch element. It usefully has a real time preview function and displays the histograms of the target image, before and after stretching. There are also histogram zoom controls that facilitate careful placement of the three adjustments with respect to the image values. Each pixel value is independently calculated from the transfer function and its original value.

With this tool, it is possible to adjust the color channels independently in a RGB image and / or the luminance values. Since stretching an image pushes brighter areas close to peak values, this tool has a facility to extend the dynamic range using the highlight range control (fig.1). This allows any highlights to be brought into the safe region of say 0.8–0.9. The shadow range slider does the same for the other end of the scale. One wonders why that might be useful; so this is a good time to remember that sharpening and local contrast controls amplify pixel differences and an image sometimes requires a small range extension to ensure pixel values do not hit the limits later on. It does not hurt; a 32-bit image has enough tonal resolution to afford some waste and it is a simple task to trim it off any excess range later on. During the initial stretch it is more likely that the image will require deliberate trimming of the shadow region to remove offsets and light pollution (fig.1). Here, it is important to go carefully and not clip image pixels. Fortunately there are readouts next to the shadows slider that provide vital information on clipping, in terms of pixels and percentage. Ideally, if your image is cropped and properly calibrated, there should be no black pixels.

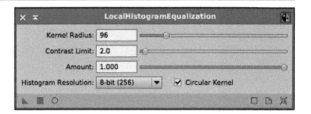

fig.2 LHE is very useful at enhancing contrast at large scales. At a high radius (above 150) it helps to increase the Histogram Resolution to 10- or 12-bit. Apply it in several passes, at different Kernel Radii and with the contrast limit set around 1.5 and a blending amount of ~0.7 (70%).

LocalHistogramEqualization (LHE)

This tool is fantastic at pulling out swathes of nebulosity from seemingly bland images without over-cooking the highlights in non-linear images. As the name implies, it attempts to equalize contrast over the image, so that areas with low contrast have their contrast increased. As such LHE implements a conditional modification of pixel values. The concept of localized histogram equalization is not new and is an established algorithm. In the PixInsight implementation, a few further controls improve the visual result. As the name implies, the Contrast Limit control limits the contrast enhancement. Typically values are in the range of 1.5–2.5, above which, image noise becomes noticeable. The Kernel radius control sets the evaluation area and has the practical effect that a larger radius enhances larger structures.

In practice, use this tool after the initial non-linear stretch or later on, if the general structures need a gentle boost. It helps to apply it in several passes; building up contrast in small, medium and larger structures. If the image has a featureless background or prominent stars, it is better to selectively apply LHE and protect these areas with a mask. If the effect is too aggressive, scale back the Amount setting to proportionally blend with the original image. This may appear remarkably similar to the multi-scale sharpening algorithms. In one sense, they are doing similar things, but the LHE tool is operating at much larger scales (typically 32–300). At the very largest scales, increase the Histogram resolution setting to 10- or 12-bit. If the application of LHE causes excessive brightness in highlight regions (over 0.9), back up and apply a simple linear HistogramTransformation highlight extension of say 10% (0.1) to effectively compress the image tonality before proceeding with LHE once more.

Masked Stretch (MS)

This is another tool which, when applied correctly, has a miraculous effect on a deep sky image and for many,

fig.3 *The MaskedStretch tool has few options. The clipping*
function has a very profound effect on the output
(fig.4). Try values between 0 and the default, 0.0005

is the go-to tool for the initial non-linear stretch. The tool effectively applies many weak, non-linear stretches to the image, but crucially masks the highlight areas of the image between each iteration, using the intermediate result of the last micro-stretch to form a mask. The practical upshot of all this is that the masking process prevents the image highlights from saturating. This also benefits star color too. Stars take on a fainter periphery, with a sharp central peak, rather than a circular, sharply defined circle and extended diffuse boundary. This appearance takes some getting used to. Logically though, it makes more sense to have a point source and a diffuse boundary. The images that this tool creates are more subtle in appearance that those using a standard histogram stretch. It is important to realize this is just one step on a path. Crucially the highlights are restrained and a bolder appearance is a single mild stretch away (fig.4).

This tool has few controls but even so, they create some confusion, not helped by the sensitivity of some. As usual there is no magic one-size-fits-all setting but the settings in fig.3 are a good starting point for further experimentation. From the top, the target background sets the general background level in the final image. Values in the range of 0.85 to 1.25 are typical. The default value of 100 for the Iterations setting works well, though it is worth trying 500 and 1,000 too. The Clipping fraction causes dramatic changes to the image manipulation and defines the proportion of pixels that are clipped prior to the stretch. Many use the default value of 0.0005, though it is worthwhile to compare the results using values between this and 0.0. With zero, the result can look pasty, but nothing that cannot be fixed later on (fig.4). The Background reference selects a target image, normally a small image preview that represents the darkest sky area and the two limit settings below restrict the range of values used in the background calculation.

MaskedStretch and HistogramTransformation complement one another in many ways. Some of the best results occur when they work together, either in sequence or in parallel. In sequence, try applying MaskedStretch followed by a mild HistogramTransformation, or the other way around. In parallel, some prefer the appearance of stars with MS and the nebula/galaxies with HT (figs.4–5). Start by cloning the un-stretched image and stretch one with HistogramTransformation and note the median image value (using the Statistics tool). Open the MaskedStretch tool and set the Target background value to this median value. Apply MaskedStretch to the other image. On can now combine the stars from the MaskedStretch image with the nebula of the HistogramTransformation image through a star mask. The possibilities are endless.

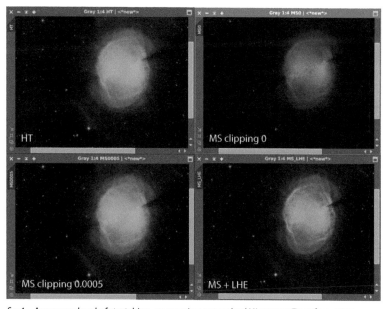

fig.4 *A smorgasbord of stretching, comparing a standard HistogramTransformation*
(HT) stretch versus Masked Stretch (MS) at 0 and 0.0005 clipping levels. Finally
in the bottom right, is a combination of a Masked Stretch followed by Local
Histogram Equalization at a medium scale. The MS images show better separation
in the highlights and yet retain the faint nebulosity at the same time.

fig.5 *Up close, one can see the effect of HT (right) and MS (left) on star appearance on this luminance stack. The saturation is limited in the MS version to a few pixels and hence the star will be more colorful in the MS version, especially if the Morphological Transform tool is selectively applied to lower star intensity too.*

CurvesTransformation (CT)

If anyone has used the curves tool in Photoshop, this tool will look immediately familiar. Look a little deeper and you soon realize it goes much further. Unlike its Photoshop cousin, this tool can also change saturation, hue and the channels in CIE color-space. This is not a tool for extreme manipulations but a fine-tune tool, typically used towards the end of the imaging workflow. In particular it is useful to apply a gentle S-curve to an image to lower the shadow values and contrast, especially useful if the background is a bit noisy, and increase the mid-band contrast. This is often a better option than simply changing the shadow endpoint in the HT tool and clipping dark pixels.

It is also useful to boost general color saturation. In this case, selecting the "S" transforms input and output color saturation. A gentle curve boosts areas of lower saturation and restrains the already colorful areas from clipping one of the color channels. To avoid adding chroma noise to shadow areas, selectively apply a saturation boost in conjunction with a range mask, or if it is only star color that needs enhancing, a star mask.

If one needs to selectively boost or suppress saturation based on color, for instance, boost red and reduce green, one might use a mask to select a prominent color and use the CT tool. Practically, however, the ColorSaturation tool is a better choice.

AutoHistogram (AH)

I am not a huge fan of automatic adjustments; each image is different and I prefer to use my eyes and judge each manipulation on its own merit. Having said that there are occasions when a quick fix is required and it can be quite effective. This tool works using an assumption that the sky background is dominant in the image and aims to non-linearly stretch the image to achieve a target median value. There are only a few controls; clipping levels, target median value and stretch method. The clipping levels are sometimes useful to constrain the stretch to the image dynamic range. The readout is expressed in percentage clipping. It is not advisable to clip the highlights though a little clipping on the shadow end can be useful. Since the tool is automatic, is requires that any image borders are cropped to avoid unexpected results.

While the target median value sets the degree of stretch, the three stretch methods (gamma, logarithmic and mid tone transfer function) alter the shape of the non-linear stretch function. An explanation of the various algorithms is not as useful as trying each and judging their effectiveness for oneself. It is easy to try each in turn and assess the results (fig.6).

fig.6 *The AutoHistogram tool has three stretching algorithms: logarithmic, gamma and mid-tone transfer function. These produce very different results. The mid-tone transfer function has a very similar effect to the standard HT tool. Remember that these initial stretches are the first step on a long road. One is generally looking for boosting faint nebulosity and good definition of brighter areas. The overall brightness can always be increased later on.*

Color Filter Array (CFA) Processing

Color cameras do not require filter wheels to produce color but
require some unique image processing techniques.

An observation made of the first edition was its lack of emphasis on using conventional digital (color) cameras. It is easy to get hung up on these things but the camera is just one part of a vast array of other equipment, software and processes that are common, regardless of the choice. Whether or not a camera is a DSLR (or mirror-less model) or a dedicated CCD, it is still connected to a telescope, power and a USB cable. There are some differences though; some snobbery and also misleading claims about the inefficiency of color cameras: For an object that is not monochromatic, there is little difference in the received photon count via a color camera or a sensor behind a filter wheel for any given session. Unfortunately, conventional digital cameras alter the RAW image data and the (CMOS) output is not as linear as that from an dedicated CCD camera. Monochrome sensors do have other advantages; there is a slight increase in image resolution, the external red and green filters reject Sodium-yellow light pollution and more efficient for narrowband use. As a rule, dedicated cameras are more easily cooled too. These are the principal reasons both book editions major on monochrome CCD cameras, using an external filter wheel to create colored images and unmolested linear sensor data. This chapter addresses the important omissions concerning linearity and color formation in conventional color cameras.

Both one shot color (OSC) CCDs and conventional digital cameras have a Color Filter Array (CFA) directly in front of the sensor that require unique processing steps. In addition, photographic camera's RAW formats are not an unprocessed representation of the sensor's photosite values and require attention during image calibration and linear processing. The most common CFA is the Bayer Filter Array, with two green, one red and one blue-filtered sensor element in any 2x2 area, but there are others, notably those sensors from Fuji and Sigma. Consumer cameras suitable for astrophotography output RAW files, but this moniker is misleading. These cameras manipulate sensor data by various undocumented means before outputting a RAW file. For instance, it is apparent from conventional dark frame analysis, at different exposure conditions, that some form of dark current adjustment kicks in. At some point a long dark frame has lower minium pixel values than a bias frame. Each RAW file format is potentially different: In some cases the output is not linear, especially at the tonal extremes, which affects conventional calibration, rejection and integration processes. In others, most notably older Nikon DSLRs, the RAW file had noise reduction applied to it, potentially confusing stars for hot pixels.

The traditional workstreams that transfer a RAW camera file to say Photoshop, go through a number of translation, interpolation and non-linear stretching operations behind the scenes to make the image appear "right". This is a problem to astrophotographers who are mostly interested in the darkest image tones. These are at most risk from well-meaning manipulation designed for traditional imaging. So how do we meet the two principal challenges posed by non-linearity on image calibration and color conversion, using PixInsight tools?

Image Calibration

First, why does it matter? Well, all the math behind calibration, integration and deconvolution assume an image is linear. If it is not, these do not operate at their best. It is important that we calibrate an image before it is converted into a non-linear form for an RGB color image. Second, it is never going to be perfect: RAW file specifications are seldom published and are deliberately the intellectual property of the camera manufacturers. To some extent we are working blind during these initial processing steps. For instance, if you measure RAW file dark current at different temperatures and exposure lengths, you will discover the relationship is not linear (as in a dedicated CCD camera) but the calibration process assumes they are. In addition, as soon as a RAW file is put into another program, the programs themselves make assumptions on the linearity of the image data during color profile translations. Many applications (including PixInsight) employ the open-source utility DCRAW to translate a RAW file into a manipulatable image format when it is opened. Over the years, this utility has accumulated considerable insight into the unique RAW file formats. In the case of most photo editing programs, these additionally automatically stretch the RAW image so it looks natural.

Each of the various popular image file formats, JPEG, TIFF, FITS, PSD and the new XISF, have a number of options: bit depth, signed / unsigned integers, floating point, with and without color profiles and so on. When PixInsight loads one of the myriad RAW file formats, it

fig.1 *It is essential to set the right output options in the RAW*
 Format Preferences for DSLR_RAW (found in the Format
 Explorer tab). Here it is set to convert to a monochrome CFA
 image (Pure Raw) without any interpolation (DeBayering).

converts it into an internal format called DSLR_RAW. This has several flavors too, under full control in the Format Explorer tab. The options allow one to retain the individual pixel values or convert into a conventional color image. A third option falls in-between and produces a colored matrix of individual pixel values (fig.2).

These options do not, however, change the tonality of the image mid tones (gamma adjustment). For example, if you compare an original scene with any of the DSLR_RAW image versions, it is immediately apparent the image is very dark. This is more than a standard 2.2 gamma adjustment can correct. (2.2 is the gamma setting of sRGB and Adobe 1998 color profiles.) The reason is that the sensor data is a 14-bit value in a 16-bit format. This is confirmed by a little experimentation; if one opens a raw file with the HistogramTransformation tool and moves the highlight point to about 0.25, to render a clipped highlight as white, and adjusts the gamma from 1.0 to 2.2 it restores normality in the RAW files's mid-tones and the image looks natural (similar to if you had imported it into Photoshop).

Calibration Woes

When you look up close at a RAW file (fig.2) and consider the calibration process, one quickly realizes that calibration is a pixel by pixel process, in so much that the bias, lights and darks are compared and manipulated on the same pixel position in each image. To create a color image it is necessary to interpolate (also called de-mosaic or DeBayer) an image, which replaces each pixel in the image file by a combination of the surrounding pixels, affecting color and resolution (fig.2). Interpolation ruins the opportunity to calibrate each pixel position and is the reason to keep the pixels discrete during the bias, dark and flat calibration processes. To do this we avoid the interpolated formats and choose either the Bayer CFA format or Bayer RGB option in the DSLR_RAW settings (fig.1). These settings are used by any PI tool that opens a RAW file. The Bayer RGB version, however, occupies three times more file space and separates the color information into three channels. This has some minor quality advantages during image calibration but is computationally more demanding. (You might also find some older workflows use 16-bit monochrome TIFF to store calibration files. When the Debayer tool is applied to them, they magically become color images.)

fig.2 *From the left are three highly magnified (and screen-stretched) output formats (see fig.1) of the same Canon CR2 RAW file; raw Bayer*
 RGB, Bayer CFA and DeBayered RGB file (using the VNG option). You can see how the DeBayer interpolation has smeared the effect
 of the bright pixel. The green cast is removed later on, after registration and integration, during the color calibration processes.

The latest calibration tools in PixInsight work equally well with image formats that preserve the CFA values, as does the BatchPreprocessing (BPP) Script, providing the tool knows these are not de-mosaiced RGB color images. It is important to note that image capture programs store camera files in different formats. Sequence Generator Pro gives the option to save in Bayer CFA or in the original camera RAW format (as one would have on the memory card). Nebulosity stores in Bayer CFA too, but crops slightly, which then requires the user to take all their calibration and image files with Nebulosity. After a little consideration one also realizes that binning exposures is not a good idea. The binning occurs in the camera, on the RAW image before it is DeBayered and the process corrupts the bayer pattern.

When the file has a RAW file extension, for instance .CR2 for Canon EOS, PI knows to convert it using the DSLR_RAW settings. When the file is already in a Bayer CFA format, PI tools need to be told. To do this, in the BPP Script, check the CFA images box in the Global Options and in the case of the separate calibration tools, enter "RAW CFA" as the input hint in the Format Hints section of the tool. When dark and light frames are taken at different temperatures and / or exposure times, a dark frame is traditionally linearly-scaled during the calibration process, as it assumes a linear dark current. Any non-linearity degrades the outcome of a conventional calibration. Fortunately, the dark frame subtraction feature of PixInsight's ImageCalibration tool optimizes the image noise by using the image data itself, rather than the exposure data in the image header, to determine the best scaling factor. As mentioned earlier, while both CFA formats calibrate well, of the two, the Bayer RGB format is potentially more flexible with manual calibration. The BPP script produces the exact same noise standard deviation per channel (with the same calibration settings) but when the color information is split into three channels and using separate tools, it is possible to optimize the settings for each to maximize image quality.

Color Conversion

The CFA formats from either photographic cameras or one shot color CCDs retain the individual adjacent sensor element values, each individually filtered by red, green or blue filters. In contrast, a conventional RGB color image has three channels, with red, green and blue values for a single pixel position in the image. The conversion between the two is generically called de-mosaicing or more typically DeBayering and the next step, registration, in our linear processing workflow requires DeBayered images. (Integration uses registered light frames in the same vein but note the ImageIntegration tool can also integrate Bayer RGB/CFA files, for instance, to generate master calibration files.)

The BPP Script DeBayers automatically prior to registration when its CFA option is checked. If you are registering your images with the StarAlignment tool, however, you need to apply the BatchDebayer or BatchFormatConversion script to your calibrated image files

fig.3 The Batch Preprocessing Script set up to work with CFA files. In this specific case, rather than use a DeBayer interpolation to generate RGB color files, it has been set up for Bayer Drizzle. As well as the normal directories with calibrated and registered images, it additionally generates drizzle data that are used by the ImageIntegration and DrizzleIntegration tools, to generate color files at a higher resolution and approaching the optical limitation. Make sure to use the same file format for bias, dark, flat and light.

before registering and integrating them. One thing to note; when using the BPP script, if the Export Calibration File option is enabled, the calibration master files and calibrated images are always saved in the mono Bayer CFA format but when integrating calibration files with the ImageIntegration tool, the final image is only displayed on screen and can be saved in any format, including Bayer CFA or Bayer RGB. The trick is to make a note of the settings that work for you.

Debayering is a form of interpolation and combines adjacent pixels into one pixel, degrading both color and resolution (fig.2). Since the original Bryce Bayer patent in 1976, there have been several alternative pixel patterns and ways to combine pixels to different effect. PixInsight offers several, of which SuperPixel, Bilinear and VNG are the most common and that interpolate 2x2, 3x3 or 5x5 spatially-separate sensor elements into a single color "pixel". These various methods have different pros and cons that are also more or less suited to different image types. Most choose VNG over the Bilinear option for astrophotography since it is better at preserving edges, exhibits less color artefacts and has less noise. The SuperPixel method is included too for those images that are significantly over-sampled. This speedy option halves the angular resolution and reduces artefacts. I stress the word over-sampled, since the effective resolution for any particular color is less than the sensor resolution. For images that are under-sampled (and which have 20+ frames) there is also an interesting alternative to DeBayering called Bayer Drizzle with some useful properties.

Registration and Integration
Star alignment works on an RGB color image, in which each pixel is an interpolated value of its neighbors. After registration, integration does likewise, outputting a RGB file. During integration, some users disable pixel rejection if the file originates from a photographic camera but otherwise enable them for dedicated OSC cameras. That of course leaves the door open to cosmic ray hits, satellites and aircraft trails. It certainly is worth experimenting with both approaches and compare the output rejection maps to tune the settings.

Bayer Drizzle
As the name implies, this uses the resolution-enhancing drizzle process on Bayer CFA images to produce color images. Drizzle is a technique famously used to enhance the resolution of the Hubble Space Telescope's images, by combining many under-sampled images taken at slightly different target positions. This technique can recover much of an optical system's resolution that is lost by a sensor with coarse pixel spacing. For drizzle to be effective, however, it requires a small image shift between exposures (by a non-integer number of pixels too) that is normally achieved using dither. Most autoguiding programs have a dither option and many users already use it to assist in the statistical removal of hot pixels during integration.

Bayer Drizzle cleverly avoids employing a DeBayer interpolation since, for any position in the object, a slight change in camera position between exposures enables an image to be formed from a blend of signals from different sensor elements (and that are differently filtered). In this case, the resolution recovery is not compensating for lost optical resolution but the loss in spatial resolution that occurs due to the non-adjacent spacing of individual colors in the Bayer array. Thinking this through, one can see how wide-field shots may benefit from this technique as the angular resolution of the sensor is considerably less than the optical resolution.

As with image calibration and integration, one can either use several tools consecutively to achieve the final image stack, or rely on the BPP Script to accomplish the task more conveniently, by enabling the Bayer drizzle option in the DeBayer section and the Drizzle option in the Image Registration section. With these settings the BPP script generates calibrated and registered files, as normal, in a folder of the same name. In addition it generates drizzle data in a subdirectory of the registered folder, using a special drizzle file format (.drz). Bayer drizzle requires a two-stage image registration and integration process:

1 Add the **registered** fits images into the ImageIntegration tool (using Add files button).
2 Add the drizzle .drz files in the **registered/bayer** subfolder using Add Drizzle Files button. This should automatically enable the Generate Drizzle data option.
3 Perform image integration as normal, maximizing the SNR improvement and at the same time just excluding image defects.
4 In the DrizzleIntegration tool select the updated .drz files in the **registered/bayer** folder. Set the scale and drop shrink to 1.0.

If you have many images, say 40 or more, it may be possible to increase the scale beyond 1.0. Considering the actual distribution of colored filters in the Bayer array, a scale of 1.0 is already a significant improvement on the effective resolution of any particular color. In this process the initial ImageIntegration does not actually integrate the images but simply uses the registered files to work out the normalization and rejection parameters and updates the

fig.4 *This 2:1 magnified comparison of DeBayered registration and Bayer Drizzle process on 40 under-sampled subframes. The Bayer Drizzle process produces marginally tighter stars with more saturated color (and chroma noise). You have to look hard though!*

drizzle (.drz) files with these values. The DrizzleIntegration tool uses these updated drizzle files to complete the image integration. The proof of the pudding is in the eating and fig.4 compares the result of 40 registered and integrated wide-field exposures, taken with a 135 mm f/2.8 lens on the EOS through a standard DeBayered workflow and through the bayer drizzle process. To compare the results, we need the sensor to be the limiting factor, or the lens resolution and seeing conditions may mask the outcome. In this case, the wide angle lens has a theoretical diffraction limited resolution of approximately 2.6 arc second and appears poor until one realizes that the sensor resolution is over 6.5 arc seconds / pixel and under-sampled to use for comparison purposes. (In practice, seeing noise and tracking errors probably put the effective resolution on a par with the sensor resolution.)

Post Integration Workflow

The practical workflows in the First Light Assignment section assume a common starting point using separate stacked images for each color filter. In these, the luminance and color information are processed separately before being combined later on. In the case of CFA images, we have just one RGB image. These workflows are still perfectly valid though. The luminance information (L) is extracted from the RGB file using the ChannelExtraction tool or the Extract CIE L* component toolbar button and follows its normal course. For the color file, the various background equalization, background neutralization and color calibration are simply applied to the RGB file. Once the RGB file has been processed to improve color saturation, noise and is lightly stretched, it is mated with its now deconvoluted, sharpened, stretched and generally enhanced luminance information using LRGBCombination (fig.5).

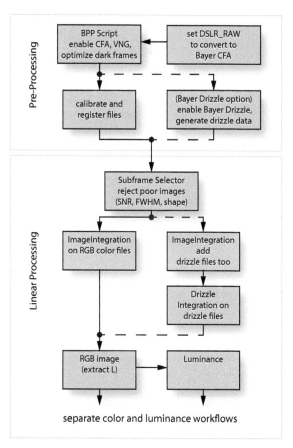

fig.5 *The CFA workflow using standard DeBayered registration or Bayer Drizzle process, through to the start of the separate processing of the color and luminance data (the starting point for many of the practical workflows throughout the book). The BPP Script can be replaced by the separate integration (of bias, darks and lights), calibration and registration tools if one feels the urge.*

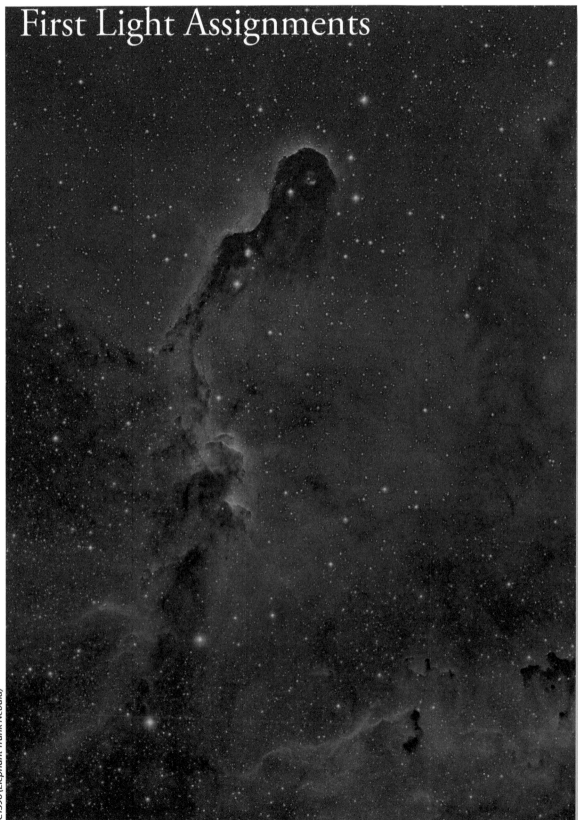

First Light Assignments

IC1396 (Elephant Trunk Nebula)

Practical Examples

An extensive range of worked examples; with acquisition and processing notes, warts and all.

Following the technical chapters, this section concentrates on some practical examples that illustrate alternative techniques. These are deliberately chosen to use a selection of different capture and processing programs and to cover a range of imaging problems and solutions. In each case the unique or significant aspects are highlighted rather than a full blow-by-blow account. In particular these examples consider techniques to capture and process objects with a high dynamic range, nebulosity, star fields and in narrowband wavelengths. These images were taken with a variety of cameras and telescopes, all on equatorial mounts. These are presented in chronological order and show a deliberate evolution in technique that will resonate with newcomers to the hobby and more experienced practitioners alike.

This is a deliberate journey, the path of which, to quote Rowan Atkinson as Blackadder, "is strewn with cow pats from the devil's own satanic herd!" To avoid stepping on some, these case studies do not paint a rosy picture of perfection but present a warts-and-all view that highlight issues, mistakes, improvements and lessons learned. Some of these are experiments in alternative techniques and others highlight gotchas that are less well documented. Collectively they are a fascinating insight into the variety of challenges that face the astrophotographer and provide useful information with which to improve your imaging.

General Capture Setup

Polar Alignment

Until recently, I assembled and disassembled my imaging rig each night. This and the uncertainty of the British weather made image capture challenging. To make the most of these brief opportunities, system reliability and quick setup times were essential. In the early days my polar alignment followed the 80–20 rule: to quickly align within 10 arc minutes and accommodate any drift or periodic error using an off-axis autoguider. On the SkyWatcher NEQ6 mount, a calibrated polar scope and the polar alignment routine in EQMOD delivered the results. In this setup, EQMOD moved the mount to a position where Polaris was at transit (6 o'clock in the eyepiece) and then moved to its current hour angle. (Since an EQ6 can rotate full circle, snags and leg-clashes are a possibility and I stood by the mount during these slews.) After upgrading the mount, using ground spikes (detailed in the chapter *Summer Projects*) close-tolerance mount fixings and a locked azimuth reference I consistently achieved 1 arc minute alignment. A hernia forced a more permanent pier-mounted system that achieves better than 20 arc seconds after using TPoint modelling software. My most recent portable (sub-10 kg) mount is polar aligned using the QHY PoleMaster camera and achieves the same accuracy.

Hardware Evolution

My first system comprised an 8-inch Meade LX200 GPS with a piggy-back refractor as a guide scope, both fitted with early Meade CCD cameras. Whilst very impressive on the driveway, I soon realized it was not best suited to my imaging needs or physical strength. I now use three refractors of different focal lengths with two field-flattener options, to match the subject to the sensor, in addition to a 250 mm f/8 reflector. With the camera at its focus position, the balance point is marked on the dovetail for each assembly. These are color coded according to the field-flattener in use and enable swift repositioning of the dovetail in the clamp. Cables are either routed through a plastic clip positioned close to this mark to reduce cable induced imbalances or through the mount. The autoguider system employs a Starlight Xpress Lodestar fitted to an off-axis guider, parfocal with the main imaging camera. The entire imaging chain is screw-coupled for rigidity; 2- or 1.25-inch eyepiece couplings are banished. The two larger refractors were fitted with a Feather Touch® focuser and MicroTouch motor to improve rigidity and absolute positioning. The MicroTouch® motors and controller have since been replaced by Lakeside units, so that a single module can be used across all my focus mechanisms. The cameras used in these examples include Starlight Xpress and QSI models fitted with the Kodak KAF8300 sensor and the smaller but less noisy Sony ICX694AL. My mount has changed several times: Early images were taken on the popular SkyWatcher NEQ6 running with EQMOD. This was replaced by a 10Micron GM1000HPS and then a Paramount MX. The load capacity of all these mounts is sufficient for my largest telescope but the high-end mounts

have considerably less periodic error and backlash, are intrinsically stronger and have better pointing accuracy. The belt-drive systems in the high end mounts crucially have less DEC backlash too, ideal for autoguiding. A previously-owned Avalon mount is used for travelling.

Each system uses remote control; in the early days over a USB extender over Cat 5 module and later, using a miniature host PC, controlled over WiFi with Microsoft's Remote Desktop application. All USB connections were optimized for lead length and daisy-chain hubs kept to a minimum. The back yard setup used a dual 13-volt linear regulated DC bench power supply (one for the camera and USB system, the other for the dew heater, focuser and mount) carried through 2.5 mm² copper speaker cables. The observatory system uses permanent high-quality switched mode power supply units mounted in a water-proof enclosure.

Software Evolution

My preferred software solution has equally evolved: After a brief flirtation with Meade's own image capture software and after switching to the NEQ6 mount I moved to Nebulosity, PHD and Equinox Pro running in Mac OSX. I quickly realized the importance of accurate computer-controlled focus and moved to Starry Night Pro, Maxim DL 5 and FocusMax in Windows 7, using Maxim for both acquisition and processing. This system sufficed for several years but not without issue; the hardware and software system was not robust and difficult to fully diagnose. When I changed camera systems I skipped Maxim DL 6, that had just been released at that time, and decided to try something different. The software market is rapidly evolving with new competitively-priced offerings, delivering intelligent and simplified automation and advanced image-processing capabilities. In particular, two applications radically changed my enjoyment, system's performance and improved image quality.

The first was Sequence Generator Pro (SGP). This achieved my goal to let the entire system start up, align, focus and run autonomously and reliably without resorting to an external automation program, many of which, with the exception of MaxPilote, are more expensive than SGP. At the same time, the popular guiding program PHD transformed itself into PHD2, adding further refinements and seamless integration with SGP.

The second was PixInsight (PI). The quality improvements brought about by sophisticated image processing tools, including masking and multi-scale processing, addressed the shortcomings of the simpler global manipulations of the earlier systems and bettered complex Photoshop techniques too. The combination of SGP, PHD2 and PI is ideally pitched for my needs, dependable and good value. These core applications are now augmented with my own observatory automation software, controller and drivers.

Setting Up

In the case of a portable setup, after the physical assembly, I confirm the polar alignment at dusk with a polar scope or QHY PoleMaster. In the case of the Paramount MX, the tripod's ground spikes and optimized mounting plate have very little play and in most cases this mount requires no further adjustment. When the MX is permanently mounted, I simply home the mount and load the pointing model that corresponds to the equipment configuration. At dusk, I synchronize the PC clock using a NTP server and if required, set the altitude, temperature, pressure and humidity refraction parameters. I then set the focus position to its last used position for that imaging combination. With either setup, and allowing for the system to acclimatize to the ambient conditions, I open AAG CloudWatcher (to supply the ASCOM safety monitor) and run the imaging sequence in SGP, which automatically slews and centers on the target, fine tunes the focus and waits for the camera to cool down or a start time. SGP fires up PHD2 and starts capturing images once the guider calibration has completed and the tracking has settled. If this is part of an imaging run, I ensure the camera orientation is the same as before and reuse a stored calibration for the autoguider (measured near the celestial equator). The 10Micron mount, MaxPoint and its equivalent, TPoint (TSX), are all capable of building a sophisticated pointing model, capable of sub 20-arc second accuracy, from the synchronization of 50–100 data points. Using SGP's slew and center automation, it is not mandatory to have that level of pointing precision and I employ autoguiding to fix any residual centering or tracking issues. (In Maxim DL5, a similar level of pointing accuracy is achieved by manually pointing, plate-solving, synching and pointing again.)

Most astronomical equipment is nominally rated at 12 volts but often accepts a range of 11.5–15 volts. (If in doubt, consult the device's specification sheet.) Lead acid cells vary from about 13.8–11.0 volts over a full discharge, depending on load current and temperature. In practice, 11.5 volts is a working minimum, since discharging a battery below that level reduces its life and is for some mounts a minimum requirement too, to guarantee correct motor operation.

Exposure Sequencing

Setting the exposure is a juggling act: Too much and colorful stars become white blobs, too short and vital deep sky nebulosity or galaxy periphery is lost in read noise. Typically with LRGB filters I use an exposure range of 3–5 minutes, extending to 10 minutes if the conditions are favorable. Narrowband exposures require and can cope with considerably longer exposures of 10 minutes or more without saturation. The brightest stars will always clip but that does not have to be the case for the more abundant dimmer ones. If the subject is a galaxy, however, I check the maximum pixel value at the core of the galaxy with a test exposure. I typically use the same exposure for each RGB filter and in the early days cycled through LRGB to slowly build up exposure sets. I now complete the exposures one filter at a time, over several nights, to accumulate enough data for higher quality images. (The one exception being when imaging comets.) If the seeing is poor, I will organize the exposures over one night to expose in the order RGBL (red is the least affected by turbulence at low altitude) and move the focuser at each filter change by a predetermined focus offset. After each exposure the ambient temperature is sampled and SGP's autofocus routine kicks in if there has been a significant change since the last autofocus run (0.5–1 °C).

I used to dither between exposures (using PHD2) to aid rogue-pixel rejection during processing. I rarely do this now since I discovered PixInsight's CosmeticCorrection tool, which does not require dithered images to eliminate hot pixels during image integration.

The equipment and exposure settings are set and stored in a SGP sequence and equipment profile. Now that I have designed a permanent automated observatory, at the end of the session or, if the weather turns, the mount parks, the roof closes automatically and the sequence is updated, allowing it to be recalled for future use and quickly continue from where it left off, with a couple of button presses.

fig.1 For the beginner, it is rather disconcerting when, even after a 20-minute exposure, the image is just an empty black space with a few white pinpricks corresponding to the very brightest stars. This is not very helpful or encouraging to say the least! All the image capture programs that I have used have the facility to automatically apply a temporary histogram stretch to the image for display purposes only. This confirms the faint details of the galaxy or nebula and a sense of orientation and framing. The example above shows one of the 20-minute Hα frames of the Heart Nebula, after a strong image stretch, in which the white point is set to just 5% of full-well capacity. In all the imaging examples that follow, the un-stretched images are almost entirely featureless black. Only the very brightest galaxies may reveal some details at this stage.

fig.2 This "mobile" setup, made neater with full module integration within my Mk2 master interface box, has through-the-mount cabling for USB, focus and power. It is fully operational in 20–25 minutes with PHD2 and Sequence Generator Pro. It is now pier-mounted in a roll-off-roof observatory for almost instant operation, and just as important, swift protection from inclement weather.

M51a/b (Whirlpool Galaxy)

A reminder of how it used to be ...

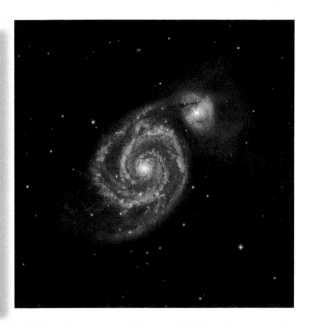

Equipment:
Refractor, 132 mm aperture, 928 mm focal length
TMB Flattener 68
Starlight Xpress SXVR-H18 (Kodak KAF8300 sensor)
Starlight Xpress 2" Filter Wheel (Baader filters)
Starlight Xpress Lodestar off-axis guider
Skywatcher NEQ6 mount

Software: (Windows 7)
Maxim DL 5.24, ASCOM drivers
EQMOD
PixInsight (Mac OSX), Photoshop CS6

Exposure: (LRGB)
L bin 1; 23 x 300 seconds, RGB bin 2; 20 x 200 seconds each

The Whirlpool Galaxy is a popular target for astronomers. It is a perfect jewel in the sky; measuring only about 10 arc minutes square, it is especially intriguing due to the neighboring galaxy with which it appears to be interacting. The beautiful spiral structure was the first to be observed in a "nebula". It is amazing to think that this occurred in 1845, by the Earl of Rosse, using a 72-inch telescope. The term "galaxy", however, did not replace the term "nebula" for these small, deep-sky objects until the 1920s. Armed with a small refractor and a digital sensor, it is easy for us to underestimate the extraordinary efforts that past astronomers made to further science.

Acquisition

This early example is a reminder of what it is like to start imaging and took place over three nights, at the end of each, the equipment was packed away. The camera remained on the telescope for repeatability and simple repositioning (in the absence of plate solving) placed the galaxy in the middle of the frame. The Starlight Xpress camera was screw-thread coupled to my longest focal length refractor and for this small galaxy used a non-reducing field-flattener. The KAF8300 sensor has obvious thermal noise and warm pixels. A small amount of dither was introduced between each exposure to help

with their later statistical removal. After adjustment, the NEQ6 mount still had a small amount of residual DEC backlash and a deliberate slight imbalance about the DEC axis minimized its effect on tracking. Very few of the exposures were rejected.

Image Calibration

This is one of the last images I took with my original imaging setup. I sold the camera and mount shortly afterwards and before I had completed the image processing. Although I retained the Maxim DL master calibration files, I foolishly discarded the unprocessed exposures. The masters comprised of sets of 50 files each and with hindsight really required a larger sample set to improve the bias frame quality. As we shall see later on, this was not the only issue with the master files to surface, when they were used by PixInsight for the image processing.

Linear Processing

The eighty or so light frames and the Maxim master calibration files were loaded into the PixInsight batch preprocessing script for what I thought would be a straightforward step. After cropping, the background was equalized using the DynamicBackgroundExtraction tool, making sure not to place sample points near the

galaxy or its faint perimeter. Viewing the four files with a temporary screen stretch showed immediate problems; the background noise was blotchy and, surprisingly, dust spots were still apparent in the image. Undeterred, I carried on with the standard dual processing approach on the luminance and color information, following the steps summarized in fig.1. Of note, the luminance information required two passes of the noise-reducing ATWT tool, using a mask to protect galaxy and stars (fig.2). To increase the detail within the galaxy I employed the HDRMT tool; also applied in two passes at different layer settings to emphasize the galaxy structure at different scales. Color processing was more conventional, with the standard combination of neutralizing the background, color calibration and removing green pixels. Finally, these were combined into a single RGB file for non-linear processing.

Issues

A temporary screen stretch of the RGB file showed some worrying color gradients that for some reason had escaped the color calibration tools. Zooming into the image showed high levels of chroma noise too. Cropping removed the worst gradients and the background noise levels were improved and neutralized with noise reduction at a scale of one and two pixels (with a mask) followed by another background neutralization. Even so, I was not entirely happy with the quality of the background although I knew that its appearance would improve when I adjusted the shadow clipping point during non-linear stretching.

Non-Linear Processing

All four files were stretched with the HistogramTransformation tool in two passes, with mask support for the second stretch to limit amplification of background noise. The shadow clipping point was carefully selected in the second pass to clip no more than a few hundred pixels and to set the background level. After stretching, the background noise was subdued a little more with an application of the ACDNR tool (now effectively superceded by MLT/MMT/TGVDenoise).

Prior to combining the RGB and L files, the color saturation of the RGB file was increased using the ColorSaturation tool (fig.3). This particular setting accentuates the saturation of yellows, reds and blues but suppresses greens. Finally, the luminance in the RGB file and master luminance were balanced using the now familiar LinearFit process: In this process, the extracted RGB luminance channel is balanced with the processed luminance file using LinearFit tool. It is then combined back into the RGB file using ChannelCombination using

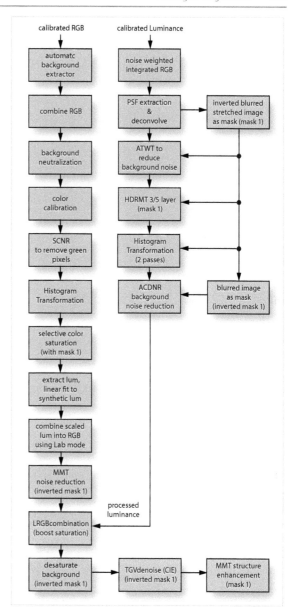

fig.1 The processing sequence for M51, using the PixInsight calibration and registration scripts, required considerable effort to improve the noisy background and prevent the image manipulation from making it worse. Soft-edged masks in normal and inverted forms were employed in almost every step to selectively increase detail and contrast in the galaxy and reduce it in the background. After the realization that the dark frames had double bias subtraction and using Maxim calibrated and registered files, the image processing was considerably easier. Several noise reduction steps were no longer required. (It is easy to over-do the background noise reduction and produce a plastic look.)

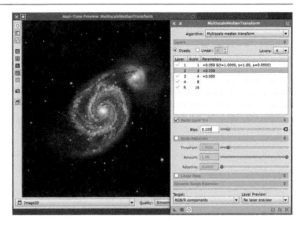

fig.4 *The MultiscaleMedianTransform tool, like many of the multiscale tools in PixInsight, can work to suppress or enhance images based on image structure scale. Here the first three dyadic layers (1, 2 and 4) are gently emphasized to show the dust lane and nebulosity in the spiral galaxy. The background was protected by a soft-edged mask.*

fig.2 *The ATWT tool, set up here to reduce noise in the first three scales of the luminance file. A good starting point is to halve the noise reduction setting for each successive scale. It is applied selectively using a soft-edged mask to protect the galaxy and stars.*

the CIE L*a*b* setting and then the processed luminance is applied using the LRGBCombination tool on the RGB file, with fine adjustments to saturation and lightness.

Final Tuning

After applying LRGBCombination, the galaxy looked promising but the background still needed more work. This came in the form of a masked desaturation and a soft edged mask, tuned to remove some of the chroma noise in

the background and the faint tails of the galaxy. As there were still several dust spots in the cropped image, I used the PixInsight clone tool (fig.5) to carefully blend them away before increasing the saturation of the galaxy with the saturation option of the CurvesTransformation tool (with mask support). The background had another dose of smoothing, this time with the TGVDenoise tool, set to CIE mode, to reduce luminance and chroma noise. Finally a fruitful half hour was spent using the MMT tool to enhance small and medium structures a little, protecting the background with a mask. The settings were perfected on an active preview (fig.4).

Revelation

There was something bothering me about this image and the quality of the original files. They required considerable noise reduction, more than usual. I went back to my very first efforts using Maxim DL for the entire processing

fig.3 *The ColorSaturation tool is able to selectively increase or decrease saturation based on hue. Here it is set up to boost the dust lanes and bright nebulosity without accentuating green noise.*

fig.5 *Abandoning the PixInsight ethos, the CloneStamp tool, similar to that in Photoshop, is used to blend away the dust spots, left behind after the imperfect image calibration.*

sequence only to find that the background noise was considerably lower and the dust spots were almost invisible. As an experiment I repeated the entire processing sequence, only this time using Maxim DL to generate the calibrated and registered RGB and luminance files. Bingo! There was something clearly wrong with the combination of Maxim master calibration files and the PixInsight batch preprocessing script. A web search established the reason why: Master darks are created differently by Maxim DL and PixInsight. I had in effect introduced bias noise and clipping by subtracting the master bias from the master dark frames twice.

A little more research established key differences between PixInsight and Maxim DL (fig. 6). This outlines the assumptions used for Maxim's default calibration settings and PixInsight best practice, as embedded in their BatchPreProcessing script. The differences between the calibrated and stretched files can be seen in fig.7. These files are the result of calibrated and stacked frames, with a similar histogram stretch and a black clipping point set to exactly 100 pixels. These images also indicate that the PixInsight registration algorithm is more accurate than the plate solving technique that Maxim used. The final image using the Maxim stacks were less noisy and flat.

My processing and acquisition techniques have moved on considerably since this early image. This example is retained, however, as it provides useful diagnostic insights and a healthy realism of working with less than perfect data. Its challenges will resonate with newcomers to the hobby. In this case it is easy to add the bias back onto the Maxim master darks, using PixelMath, before processing in PixInsight. Better still, was to keep the original calibration files and regenerate the masters in an optimized all-PixInsight workflow. Hindsight is a wonderful thing.

type	PixInsight (batch preprocessing)	Maxim DL5 (default setting)
master bias	master bias is simple average: output normalization = none rejection normalization = none scale estimator = median absolute deviation from the median (MAD)	master bias is simple average, sigma clipped
master darks	master darks are a simple scaled average and do not have bias subtracted: output normalization = none rejection normalization = none scale estimator = median absolute deviation from the median (MAD)	master dark is a simple average of sigma clipped values and has master bias subtracted normalization options include scale according to exposure time or RMS noise, useful for when the exposure time is not in the FITS file header
master flats	flat frames are an average of scaled values, with bias and dark subtracted: output normalization = multiplicative rejection normalization = equalize fluxes scale estimator = iterative k-sigma / biweight midvariance (IKSS)	master flat is a simple average, of sigma clipped values and has master bias and dark subtracted (dark is often ignored for short flat exposures)
calibrated lights	calibrated light = (light - dark) / flat these are normalized using additive and scaling, estimated by iterative k-sigma / biweight mid variance	calibrated light = (light - dark - bias) / flat there are several normalization options, including scale and offset for exposure and changing background levels

fig.6 A search of the forums and Internet resources establishes the differences between Maxim DL and PixInsight's handling of master calibration files and how to apply them to image (light) frames. It is easy to subtract the bias twice from dark frames.

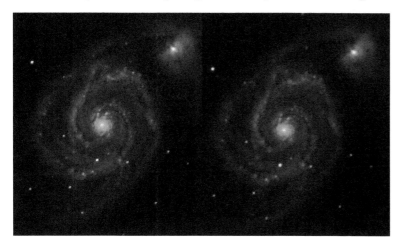

fig.7 These calibrated luminance frames show the effect of the corrupted master dark frame. The image on the left was calibrated in PixInsight with Maxim masters, the one on the right was fully calibrated in Maxim. The background noise in this case is much lower and the more accurate flat calibration addressed the dust spots too on the original exposures. The PixInsight image on the left has better definition though from better image weighting, rejection and registration.

M45 (Pleiades Open Cluster)

What it takes; when "OK" is not quite good enough.

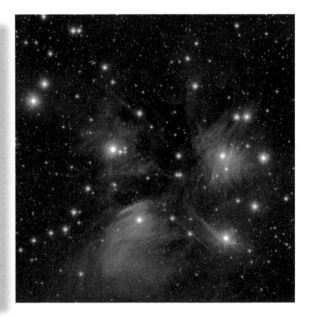

Equipment:
Refractor, 98 mm aperture, 618 mm focal length
Reducer / flattener (0.8x)
Starlight Xpress SXVR-H18 (Kodak KAF8300 sensor)
Starlight Xpress Filter Wheel (Baader filters)
Starlight Xpress Lodestar off-axis guider
SkyWatcher NEQ6 mount, Berlebach tripod
USB to serial TTL cable for mount, USB hub etc.

Software: (Windows 7)
Maxim DL 5.24, ASCOM drivers, FocusMax
PixInsight (Mac OSX)

Exposure: (LRGB)
L bin 1; 11 x 300 seconds
R:G:B bin 2; 5 x 300 : 5 x 300 : 10 x 300 seconds

It is tempting to only choose the best images to showcase one's prowess and hide the heroic failures away. In a how-to-do book, it is more useful to use less-than-perfect images and use them to highlight the lessons learned and techniques to make the best of it. The Pleiades open cluster M45 is a challenging subject at the best of times on account of its enormous dynamic range between the bright stars in the cluster and the faint reflection nebulosity. In this case, those issues were compounded by sub-optimal calibration files. To demonstrate what difference it makes, I repeated the calibration and acquisition with my latest CCD camera, using the same Kodak 8.3 megapixel chip (fig.6). The techniques that one uses to overcome the image deficiencies are useful to know as rescue techniques, however, and provide an opportunity to use further processing tools in PixInsight.

These images were taken with a Starlight Xpress SXVR H18, with the same archived calibration that plagued the images

It is quite likely that halos may appear around the blue-filtered exposures of bright stars of about 30–50 pixels diameter. This is on account of some CCDs having a propensity to reflect blue light from the sensor surface, which in turn reflects back off the CCD cover glass and back onto the sensor. A strong non-linear stretch reveals the haloes around the bright central stars. Fortunately this is minimized by using a luminance channel in LRGB imaging in which the blue light is only a contribution to overall lightness.

of M51. This time, however, I corrected the dark files to create PI-compatible dark frames. As a result, the background noise is better and with less exposure too than the M51 images. The salutary lesson is; that it does not pay to be miserly in the acquisition of bias, dark, flat and light frames, since the image almost certainly suffers as a result. On a bright object such as this, it is just possible to extract a satisfactory image, but the same could not be said of a dim galaxy or nebula.

Acquisition

M45 is a large subject and to fit the main cluster into the field of view requires a short focal length, in this case using a 98 mm APO refractor fitted with a reducer/flattener, producing a 510 mm focal length at f/5. The supplied Crayford focuser with this refractor was replaced by a Starlight Instruments' Feather Touch focuser and motor drive. Focusing is always important and in this unusually blue-rich

subject is particularly sensitive. Acquiring blue light onto a CCD requires careful attention since in some refractive optics, it is often blue light that has the largest focus offset from the white-light optimum. At the same time CCD sensitivity is about 25% lower than the peak green response. For the very best focusing, I used the (then) free FocusMax utility in conjunction with Maxim DL to establish an optimum focus position for each color filter. The camera was rotated to frame the main cluster and the off-axis autoguider calibrated for the new angle.

Exposure choice is a dilemma for this image. The bright stars in this cluster will clip in all but the briefest exposure, so unlike imaging a globular cluster, where the stars themselves are center stage, the emphasis here is on the nebulosity and the fainter stars. I tried 10- and 5-minute test exposures and chose the shorter duration. This had less star bloat on the bright stars and the magnitude 10 stars were still within the sensor range. The color images were acquired using 2x2 binning and the luminance frames without binning for the same 300-second exposure time. Poor weather curtailed proceedings and it was only much later that I had to reject 40% of the sub frames for tracking issues, leaving behind perilously few good exposures. (As a result I now check my exposures soon after acquisition, before moving on to the next subject, in case an additional session is required to secure sufficient good exposures.)

Image Calibration

As in the case of the M51 image, after selling the CCD camera, I only had Maxim's master calibration files for image processing. To use these with PixInsight's more advanced calibration, alignment and integration tools, I used Maxim DL one last time to add together the master bias and dark files, using its Pixel Math tool to generate PI-compatible master dark files (fig.1). These new master darks are suitable for the BatchPreProcessing script tool to calibrate and register with the images. The final combination was separately managed with the ImageIntegration tool so that the rejection criteria could be tailored for the best image quality. The luminance channel showed promise, with good background detail of the faint nebulosity. The sparse RGB files were barely passable. All files had suspicious random dark pixels that suggested further calibration issues. These would require attention during processing. In this case, they were almost certainly caused by insufficient calibration files. (Dark pixels sometimes also occur in DSLR images, after calibration, if the sensor temperature is unregulated and dark frame subtraction is scaled incorrectly.)

fig.1 This shows the Pixel Math tool in Maxim DI at work to add the master bias to its master dark to create a file suitable for use in PixInsight calibration.

Image Processing

Luminance

Before imaging processing I searched for M45 images on the Internet for inspiration. The displayed images covered a vast range of interpretation, from glowing neon blue blobs through to delicate silvery-grey mist to an isolated blue nebula in a sea of red swirling dust. In this image I set out to enhance the blue, but not to the extent that it was saturated, so that the different hues showed through and at the same time I also wanted to retain star color. The luminance channel follows a modified standard processing sequence to reduce star bloat (fig.4). Following a deconvolution step, with a supporting star mask (fig.2), the background was carefully sampled (away from the

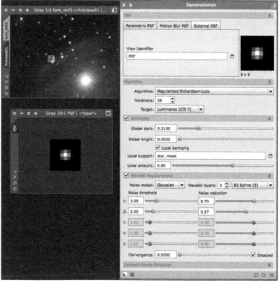

fig.2 Deconvolution parameters require adjustment for every scenario. Here a PSF model has been extracted from the stars in the image itself, and with the support of masking and noise reduction, improves apparent definition.

nebulosity) to ensure the background extraction was a smooth uncomplicated gradient. This was achieved using the DynamicBackgroundExtraction (DBE) tool, manually placing the background samples, checking the background extraction and then modifying the sample points until DBE generated a smooth symmetrical gradient. Only then was this subtracted from the linear image. Before stretching, the dark pixels caused by the problematic calibration were sampled to establish the threshold and filled with a blend of the median image value and the image pixel using a PixelMath equation (fig.3). This also had the bonus of disguising a few new dust spots at the same time. Image stretching was accomplished in two passes, first with a medium stretch using the HistogramTransformation tool and followed by another with the MaskedStretch tool. It took a few tries to find the right balance between the two stretches: On their own, the HistogramTransformation tool bloats the bright stars and the Masked Stretch tool reduces star bloat but with an unnatural hard-edged core. Then, using a combination of a star and range mask to protect the brighter areas (fig.5), the background noise was improved with the ACDNR tool. Finally, using the same mask but in an inverted form enabled the LocalHistogramEqualization tool to emphasize the cloud texture without accentuating background irregularities.

Color

The color processing follows the now-familiar path of combination, background neutralization and stretching, with a few minor alterations: Prior to stretching, the dark pixels were filled in and color calibration was omitted. (It was difficult to find a sample of stars colors without the pervading blue nebulosity and this would have skewed the color balance to yellow.) Green pixels were then removed with the SCNR tool and the ATWT tool used to blur the image at a small scale before applying a medium stretch with the

fig.3 PixelMath once more in action. In this case, it is selectively replacing dark pixels in the image with a blend of their value and the median image value, improving the appearance of calibration issues. It disguises black pixels and, if the background level is correctly set, fills in dust donuts too.

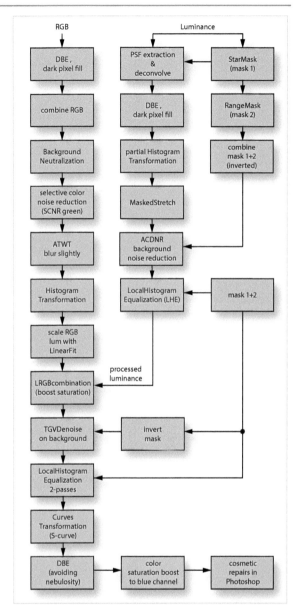

fig.4 An outline of the PixInsight processing sequence. With improved calibration files and more exposure, the details of the nebulosity and dust clouds withstand a further boost, without requiring aggressive levels of noise reduction.

HistogramTransformation tool. The non-linear color and luminance files were then combined using the LRGB combine tool (after testing a few trial settings on a preview). In this case, with the frugal exposure count, further noise reduction was required. Background luminance and chrominance noise were reduced, using the TGVDenoise tool in CIE L*a*b* mode and with the help of a mask. To improve the details within the nebulosity, the LocalHistogramEqualization tool was

fig.5 *A range mask and star mask are combined in PixInsight's PixelMath to support several processing steps including noise reduction and local contrast changes. The range mask needs to be inverted before combining with the star mask so that they are both in the same "sense".*

applied at medium strength and at two different scales. This emphasized the striations in the nebulosity and at the same time deepened the background a little. The background was still too bright, however, and had annoying irregularities. Rather than clip the shadow point, I chose to lower and reduce shadow brightness and contrast with a small S-curve adjustment using the CurvesTransformation tool.

M45's immediate surroundings have dark red clouds of ionized gas and dust. In a tightly cropped image, they only occur in the margins and resemble poor calibration. In this case, another pass with the DynamicBackgroundExtraction tool created a neutral aesthetic and a good foundation for small boost in saturation. (In a wide-field shot of M45, the red clouds have more structure, become part of the scene and explain the color variations in the background.)

Alternatives

M45 is a particularly popular object and there are many stunning interpretations on the web. I particularly like those that do not oversaturate the blue color and set it in context to the extensive cloud structure in the surrounding area. Some imagers combine blue and luminance to make a super luminance. When combined with the RGB data, this shows extended structure detail in the blue nebulosity, and as a result, emphasizes details in that color in preference to the others. The wide-field shots that depict M45 as an isolated cluster and blue nebulosity in a sea of red dust require considerable exposure and dark skies to achieve. Fortunately, at my latitude M45 has an extended imaging season and armed with new extensive calibration files, more exposures, I gave it another go. The result is shown in fig.6, with greater subtlety and a deeper rendition in the surrounding space. Two luminance sets were combined with HDRComposition followed by a MaskedStretch to reduce the bright star blooming.

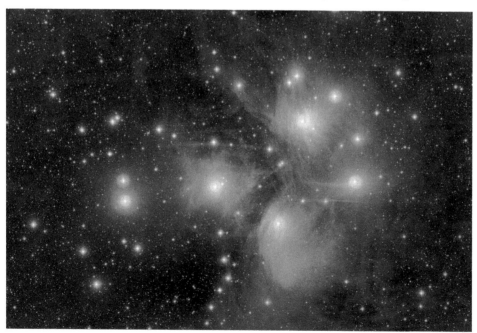

fig.6 *Second time around and taking account of the lessons learned from before, with better calibration files and considerably more exposure, the difference in background detail and noise is significant, especially without any moonlight. At the same time, it also shows just how powerful the image processing tools are to tease out the information from less-than-perfect data. Exposure in this case comprised LRGB 40 x 2 minutes (each) for the nebulosity and shorter L exposures at 15 x 30 seconds for the bright star cores.*

C27 (Crescent Nebula) in Narrowband

A first-light experience of an incredible nebula, using new imaging equipment and software.

Equipment:
Refractor, 132 mm aperture, 928 mm focal length
TMB Flattener 68
QSI683 (Kodak KAF8300 sensor)
QSI 8-position filter wheel and off-axis guider
Starlight Xpress Lodestar (guide camera)
Paramount MX mount, Berlebach tripod
USB over Cat5 cable extender and interface box

Software: (Windows 7)
Sequence Generator Pro, PHD2, TheSkyX, AstroPlanner
PixInsight (Mac OSX)

Exposure: (Ha OIII, RGB)
Ha, OIII bin 1; 12 x 1,200 seconds each
RGB bin 1; 10 x 300 seconds each

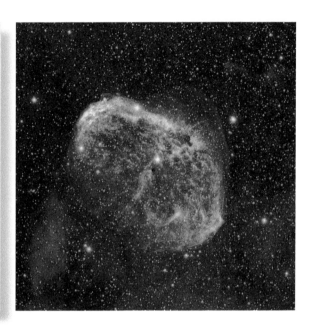

This faint nebula was my real first-light experience of my upgraded imaging equipment and software, using Sequence Generator Pro (SGP) as the image capture program, TheSkyX for the telescope control, PHD2 for guiding and PinPoint 6 for plate solving. (SGP can also use Elbrus and PlateSolve 2 for astrometry as well as astrometry.net, for free.) Plate solving is used for automatic accurate target centering, at the beginning of the sequence and after a meridian flip.

The nebula itself is believed to be formed by the stellar wind from a Wolf-Rayet star catching up and energizing a slower ejection that occurred when the star became a red giant. The nebula has a number of alternative colloquial names. To me, the delicate ribbed patterns of glowing gas resemble a cosmic brain. It has endless interpretations and I wanted to show the delicacy of this huge structure.

This fascinating object is largely comprised of Hα and OIII. There is some SII content but it is very faint and only the most patient imagers spend valuable imaging time recording it. Even so, this subject deserves a minimum of three nights for the narrowband exposures and a few hours to capture RGB data to enhance star color. The image processing here does not attempt to make a false color Hubble palette image but creates realistic colors from the red and blue-green narrowband wavelengths.

Equipment Setup

This small object is surrounded by interesting gaseous clouds and the William Optics FLT132 and the APS-C sized sensor of the QSI683 were a good match for the subject. The 1.2" / pixel resolution and the long duration exposures demanded accurate guiding and good seeing conditions. Sequence Generator Pro does not have an in-built autoguiding capability but interfaces intelligently to PHD2. PHD2 emerged during the writing of the first edition and continues to improve through open source collaboration. It works with the majority of imaging programs that do not have their own autoguiding capability.

The mount and telescope setup is not permanent and was simply assembled into position. Prior tests demonstrated my mounting system and ground locators achieve repeatability of ~1 arc minute and maintain polar alignment within 2 arc minutes. Guiding parameters are always an interesting dilemma with a new mount since the mechanical properties dictate the optimum settings, especially for the DEC axis. Fortunately the Paramount MX mount has no appreciable DEC backlash, and guided well using PHD2's guiding algorithm set to "hysteresis" for RA and "resist switching" for DEC (fig.3). To ensure there were no cable snags to spoil tracking, the camera connections were routed through the mount and used

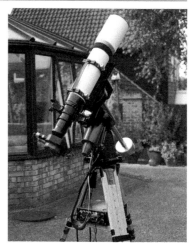

fig.1 Having bought Sequence Generator Pro a year ago, I had continued to persevere with Maxim DL 5. With the new camera and mount, I decided to use SGP for this chapter. It is powerful yet easy to learn. In the above screen, it is in the middle of the imaging sequence. It is set up here to autofocus if the temperature changes and automatically center the target after a meridian flip, which it fully orchestrates.

fig.2 This setup is the outcome of several upgrades and successive optimizations, using the techniques and precautions indicated throughout the book. The cabling is bundled for reliability and ease of assembly into my interface box. This event was a first for me. After three successive nights of imaging, just three little words come to mind ... It Just Works.

short interconnecting looms. The only trailing cable was the one going to the dew heater tape, on account of its potential for cross-coupling electrical interference. At the beginning of the imaging session, the nebula was 1 hour from the meridian and 2 hours from the mount limit. Although the Paramount does not have an automatic meridian flip, SGP manages the sequence of commands to flip the mount, re-center the image, flip the guider calibration and find a suitable guide star. It even establishes if there is insufficient time before flipping for the next exposure in the sequence and provides the option to flip early. If it was not for the uncertainty of the English weather, this automation would suffice for unsupervised operation with the exception of a cloud detector.

Acquisition

When focusing, I normally use the luminance filter for convenience. This is not necessarily the same focus setting for other filters. To achieve the best possible focus, the exposures were captured one filter event at a time, focusing for each filter change and between exposures for every 1°C temperature change. This marks a change in my approach. Previously, my hardware and software were not sufficiently reliable for extended imaging sessions, and

fig.3 PHD2, the successor to the original, has been extensively upgraded. Its feature set now includes alternative display information, equipment configurations, DEC compensation and a more advanced interface with other programs. One of the contributors to this project is also responsible for Sequence Generator Pro. A marriage made for the heavens.

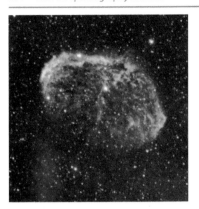

fig.4 *The Hα signal shows the brain-like structure of the inner shock wave as well as general background clouds.*

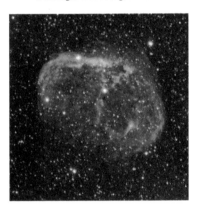

fig.5 *The OIII signal appears as a wispy outer veil. The levels were balanced to the Hα channel, before non-linear stretching, using the LinearFit tool in PixInsight. This helps with the later emphasis of the OIII details in the color image.*

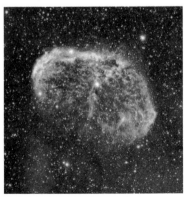

fig.6 *The synthetic luminance file picks out the prominent details of both narrowband images.*

that encouraged a round-robin approach to ensure an LRGB image from the briefest of sessions. (If you establish the focus offsets for each filter, cycling through filters has little time penalty.)

Exposure

A theoretical exposure calculation based on the background level versus the sensor bias noise suggests a 60-minute exposure, rather than the 5-minute norm for a luminance filter (such is the effectiveness of narrowband filters to block light pollution). That exposure, however, causes clipping in too many stars and the possibility of wasted exposures from unforeseen issues. I settled on 20-minute exposures in common with many excellent images of C27 on the Internet. I set up SGP to introduce a small amount of dither between exposures, executed through the autoguider interface. This assists in hot pixel removal during image processing. After the narrowband acquisition was complete, three hours of basic RGB exposures rounded off the third night, in shorter 5-minute exposures, sufficient to generate a colored star image without clipping.

Image Calibration

Taking no chances with image calibration this time, calibration consisted of 150 bias frames and 50 darks and flats for each time and filter combination. Previous concerns of dust build up with a shuttered sensor were unfounded. After hundreds of shutter activations I was pleased to see one solitary spot in a corner of the flat frame. QSI cleverly house the sensor in a sealed cavity and place the shutter immediately outside. With care, these flat frames will be reusable for some time to come with a refractor system. The light frames were analyzed for tracking and focus issues and amazingly there were no rejects. I used the BatchPreProcessing script in PixInsight to create master calibration files and calibrate and register the light frames. The light integration settings of the script sometimes need tuning for optimum results and I integrated the light frames using the ImageIntegration tool but with altered rejection criteria tuned to the narrowband and RGB images. The end result was 5 stacked and aligned 32-bit images; Hα, OIII, red, green and blue. (With the very faint signals, a 16-bit image has insufficient tonal resolution to withstand extreme stretching. For instance, the integration of eight 16-bit noisy images potentially increases the bit depth to 19-bit.) These images were inspected with a screen stretch and then identically cropped to remove the small angle variations introduced between the imaging sessions.

Image Processing Options

The Psychology of Processing

Confidence is sometimes misplaced and it is tempting to plunge into image processing, following a well-trodden path that just happens to be the wrong one. I did just that at first before I realized the image lacked finesse. Even then it was only apparent after returning from a break.

An important consideration for processing is to review the options and assess the available interpretations before committing to an imaging path. When one is up close and personal to an image on the screen for many hours (or in the darkroom with a wet print) it is also easy to lose perspective. One simple tip is to check the image still looks good in the morning or have a

reference image to compare against (and do not discard the intermediate files and save as a PixInsight project).

In this particular case, we assume the final image will be made up of a narrowband image combined with stars substituted from a standard RGB image. Astrophotography is no different to any other art form in that there are several subliminal messages that we may wish to convey: power, majesty, scale, isolation, beauty, delicacy, bizarre, to name a few. Echoing an Ansel Adams quote, if the exposure is the score, the image processing is the performance.

In this particular case, the goal is to show the nebula with its two distinct shock waves, the brain-like Hα structure and the surrounding blue-green veil. The two narrowband image stacks in fig.4 and fig.5 target these specific features. Combining these to make a color image and a synthetic luminance file is the key to the image. Not only do different combinations affect the image color, but the balance of these in the luminance file controls the dominance of that color in the final LRGB image. This point is worth repeating; even if the RGB combination reproduce both features in equal measure, if the Hα channel dominates the luminance file, the OIII veil will be less evident.

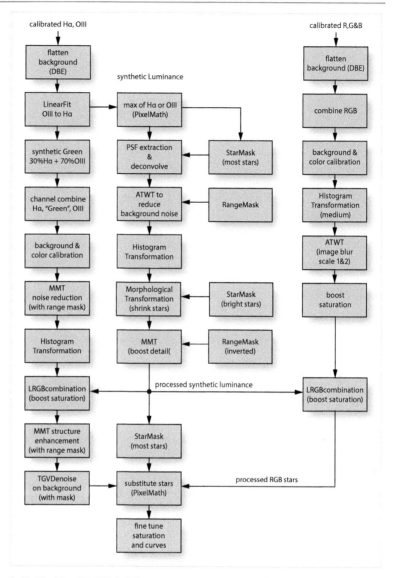

fig.7 The "simplified" PixInsight processing sequence. (ATWT has now been superseded.)

Alternative Paths

We can break this down into two conceptual decisions: the color balance of the RGB image, through the mixing of the two narrowband signals over the three color channels, and the contribution of each to the luminance channel, to emphasize one color or more. The balance equation for both does not have to be the same. In the case of image color, a Hubble palette did not seem appropriate since Hα and OIII are naturally aligned to red and blue for a realistic rendition. The green channel is the open question. I evaluated a number of options, including leaving it blank and using simple PixelMath equations and ChannelCombination to assess a simple 50:50 blend of Hα and OIII and OIII on its own (since OIII is a turquoise color). To emphasize the fainter OIII signal and to prevent the entire

nebula turning yellow, I selected a blend of 30% Hα and 70% OIII for the green channel.

The synthetic luminance channel needs to pick out the dominant features of both channels. After a similar number of blending experiments, I hit upon a novel solution to select the brighter pixel of either the Hα or OIII channel in each case, using a simple PixelMath equation:

$$iif(H\alpha>OIII, H\alpha, OIII)$$

When this image (fig.6) was combined later on with the processed color image, the blue veil sprang to life, without diminishing the dominant Hα signal in other areas. Since the two narrowband channels were balanced

with the LinearFit tool, the synthetic green channel had similar levels too, which ensured the star color avoided the magenta hue often seen in Hubble palette images. To improve the star color further, one of the last steps of the process was to substitute their color information with that from an ordinary RGB star image.

Image Processing

The image processing in fig.7 follows three distinct paths: the main narrowband color image that forms the nebula and background; a synthetic luminance channel used to emphasize details; and a second color image route, made with the RGB filters and processed for strong star color. These three paths make extensive use of different masks, optimized for the applied tool. Generating these masks is another task that requires several iterations to tune the selection, size, brightness and feathering for the optimum result.

Narrowband Processing

After deciding upon the blend for the green channel, the narrowband processing followed a standard workflow. After carefully flattening the background (easier said than done on the Hα channel, on account of the copious nebulosity), the blue channel (OIII) was balanced to the red channel (Hα) by applying the LinearFit tool. The two channels were added together with the PixelMath formula below to form the synthetic green channel, before combining the three channels with the RGBCombination tool.

*(0.3*Hα)+(0.7*OIII)*

This still-linear RGB image has a small clear section of sky, free of nebulosity and this was used as the background reference for the BackgroundNeutralization tool. Similarly, a preview window dragged over a selection of bright stars of varying hue was then used as the white reference for the ColorCalibration tool. Before stretching, a small amount of noise reduction was applied to the entire image and then again, using a range mask to protect the brighter areas of nebulosity. Stretching was applied in two rounds with the HistogramTransformation tool, using the live preview to ensure the highlights were not over-brightened and hence desaturated. This image was put aside for later combination with the luminance data.

Luminance Processing

Linear Processing

A new file for luminance processing was synthesized by PixelMath using the earlier equation. A temporary screen

stretch shows an extensive star field that pervades the image and in this case I decided to only deconvolve the stars to prevent any tell-tale artefacts in the nebula. To do this I needed a star mask that excluded the nebulosity. After some experimentation with the noise threshold and growth settings in the StarMask tool, I was able to select nearly all the stars. About 20 stars were selected for the DynamicPSF tool to generate a point spreading function (PSF) image. This in turn was used by the Deconvolution tool to give better star definition. Deconvolution can be a fiddle at the best of times. To prevent black halos, the image requires de-ringing. The result is very sensitive to the Global Dark setting. I started with a value of 0.02 and made small changes. Once optimized for the stars, this setting will almost certainly affect the background. The application of the star mask prevents the tool affecting the background. It took a few tries with modified star masks (using different Smoothness and Growth parameters) to ensure there was no residual effect from the Deconvolution tool to surrounding dark sky and nebula.

Having sharpened the stars, noise reduction was applied to the background with the ATWT tool (now superceded) using a simple range mask. This mask is created with the RangeSelection tool: First a duplicate luminance image was stretched non-linearly and the upper limit tool slider adjusted to select the nebulosity and stars. I then used the fuzziness and smoothness settings to feather and smooth the selection. This range mask was put aside for later use.

Non-Linear Processing

This image has many small stars and just a few very bright ones. In this case, I chose to stretch the image non-linearly

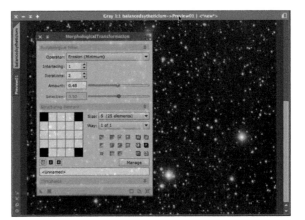

fig.8 I selected the brightest stars with a star mask and applied the MorphologicalTransformation tool to them. This tamed the star bloat to some extent and lowered the luminance values. These lower luminance values also help later on with color saturation in the LRGB composite.

with two passes of the HistogramTransformation tool, taking care not to clip the nebulosity luminance. To address the inflated bright stars I used the MorphologicalTransformation tool, set to Erosion mode. This shrinks big stars and reduces their intensity, which allows them to be colorful. At the same time, small stars disappear. After establishing a setting that realistically shrank the inflated stars, I generated a star mask that only revealed the bright stars. This was done by carefully selecting a high noise threshold value in the StarMask tool (but not the bright nebulosity) and a larger scale setting that identifies the largest stars. With an inverted mask in place, the MT tool tames the excess blooming on the brightest stars. The last luminance processing step was to enhance the detail in the nebulosity using the MMT tool. Sharpening a linear image is difficult and may create artefacts. The MMT tool, working on a non-linear image, does not. In this case, a mild bias increase on layer 2 and 3 improved the detail in the nebulosity. This fully processed image was then used as the luminance channel for both RGB images, the narrowband image *and* the star image. In this way, when the two LRGB images were finally combined, they blended seamlessly.

RGB Star Processing

After the complex processing of the narrowband images, the RGB star image processing was light relief. The separate images had their backgrounds flattened with the DBE tool before being combined into an RGB file. The background was neutralized and the image color calibrated as normal. The transformation to non-linear

used a medium histogram stretch. This image is all about star color, and over-stretching clips the color channels and reduces color saturation. The star sharpness was supplied by the previously processed luminance file and so the ATWT tool was used to blur the first two image scales of the RGB file to ensure low chrominance noise before its color saturation was boosted a little.

Image Combination

Bringing it all together was very satisfying. The narrowband color image and the luminance were combined as normal using the LRGBCombination tool; by checking the L channel, selecting the Luminance file and applying the tool to the color image by dragging the blue triangle across. This image was subtly finessed with the MMT tool to improve the definition of the nebula structure and further noise reduction on the background using TGVDenoise, both using a suitable mask support to direct the effect. (In both cases these tools' live preview gives convenient swift feedback of its settings, especially when they are tried out first on a smaller preview window.)

Similarly, the RGB star image was combined with the same luminance file with LRGBCombination to form the adopted star image. Bringing the two LRGB files together was relatively easy, provided I used a good star mask. This mask selected most if not all the stars, with minimal structure growth. This mask was then inverted and applied to the narrowband image, protecting everything apart from the stars. Combining the color images was surprisingly easy with a simple PixelMath equation that just called out the RGB star image. The mask did the work of selectively replacing the color information. (As the luminance information was the same in both files, it was only the color information that changed.) Clicking the undo/redo button had the satisfying effect of instantly changing the star colors back and forth.

After examining the final result, although technically accurate, the combination of OIII and Hα luminosity in the image margins resembled poor calibration. Using the CurvesTransformation tool, I applied a very slight S-curve to the entire image luminance and then, using the ColorSaturation tool, in combination with a range mask, increased the relative color saturation of the reds slightly in the background nebulosity.

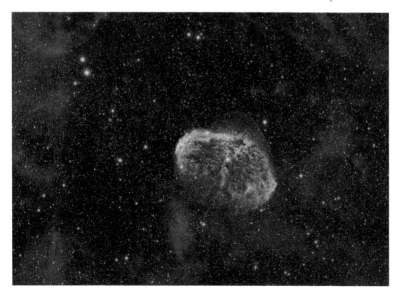

fig.9 *The wide-field shot, showing the nebula in context of its surroundings; the red nebulosity in the background and the myriad stars of the Milky Way.*

M31 (Andromeda Galaxy)

Sensitivity and novel techniques to get the best from a classic subject.

Equipment:
Refractor, 98 mm aperture, 618 mm focal length
Reducer / flattener (0.8x)
QSI683 CCD (Kodak KAF8300 sensor)
QSI integrated Filter Wheel (1.25" Baader filters)
QSI integrated off-axis guider with Lodestar CCD
Paramount MX, Berlebach tripod

Software: (Windows 7)
Sequence Generator Pro, ASCOM drivers
PHD2 autoguider software
PixInsight (Mac OSX)

Exposure: (LRGBHa)
L bin 1; 10 x 120, 15 x 300, 15 x 600 seconds
RGB bin 2; 15 x 300 seconds, Ha bin 1; 15 x 600 seconds

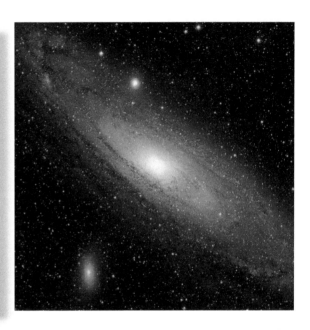

There are a few popular images that appear in everyone's portfolio but at the same time present technical difficulties that require special measures to make the very best image. One of these is the great Andromeda Galaxy. It is often one of the first to be attempted and is within the reach of a digital SLR fitted with a modest telephoto lens. At the same time, it is particularly difficult to render the faint outer reaches and keep the bright central core from clipping and losing detail. The temptation with such a bright object is to take insufficient exposures that – although they show up the impressive dust lanes, glowing core and neighboring galaxies – are individually too long to see the faint detail in the galaxy core and insufficient in duration to capture the outer margins. To compensate, the image requires considerable stretching and a great number of early attempts often show clipped white stars. This subject then deserves a little respect and sensitivity using some novel techniques to do it justice.

One of the most impressive versions of M31 is that by Robert Gendler, editor of *Lessons from the Masters*, who produced a 1-GB image mosaic using a remotely operated 20-inch RC telescope located in New Mexico. I think his beautiful image is the benchmark for those of us on terra firma. By comparison, my modest portable system in my back yard, 30 miles from London, feels somewhat

inadequate and my final image is all the more satisfying for the same reason.

M31, is one of the few galaxies that exhibits a blueshift as it hurtles towards us on a collision course (in approximately 3.75 billion years). This object is about 3° wide (about six times wider than the Moon) and requires a short focal length. Using an APS-C sized CCD with a 618 mm focal length refractor, fitted with a 0.8 x reducer, it just squeezes its extent across the sensor diagonal. The lack of a margin did cause some issues during the background equalization process, since the background samples near two of the corners affected the rendering of the galaxy itself. After realizing this, I repeated the entire workflow with fewer background samples and this provided an even better image, with extended fine tracery.

Setting Up

The equipment setup is remarkably simple, a medium-sized refractor fitted with a reducing field-flattener screwed to a CCD camera, filter wheel and an off-axis guider. For precise focus control, a Feather Touch focus upgrade to the telescope was fitted with a digital stepper motor and USB controller. At this short focal length the demands on the telescope mount are slight and in this instance the Paramount MX hardly noticed the load. The mount was

quickly aligned using its polar scope and confirmed with a 15-point TPoint model to within one arc minute.

Acquisition

Imaging occurred over four nights during Andromeda's early season in September. Image acquisition started at an altitude of 35° and ideally, had deadlines permitted, I would have waited a few months to image from 45° and above, away from the light pollution gradient near the horizon. To minimize its effect on each night, I started with a binned color filter exposure set and followed with luminance, by which time, M31 had risen to a respectable altitude and the local street lamps had turned off. The exposures were captured with Sequence Generator Pro using PHD2 to guide via a Lodestar's ST4 interface. SGP remembers the sequence progress when it shuts down and picks up again where it left off on each subsequent session. The filename and FITS header in each file were clearly labelled so that the different luminance sub exposures could be grouped together during calibration. Early autumn in the UK is a damp affair and the dew heater was set to half power to ensure the front optic remained clear in the high humidity.

Guiding performance on this occasion was a further improvement from previous sessions. For the DEC axis I changed PHD2's DEC guiding algorithm from "resist switching" to "low pass". RMS tracking errors with 5-second exposures were around 0.3 arc seconds. PHD2 mimics PHD guiding algorithms and I experimented with different control algorithms including hysteresis, resist switching and the low pass option. The hysteresis function, with hysteresis set to 0, behaves similarly to Maxim DL's guiding algorithm.

fig.1 *This simplified workflow is designed for use with PixInsight. Most of the imaging steps can be accomplished in other packages or combinations too.*

Calibration and Channel Integration

The 1.25-inch filters in the QSI683 are a tight crop, and when used with a fast aperture scope, the extreme corners vignette sharply. Flat calibration does not entirely remedy this and in practice, if these corners are crucial, they are remedied in Photoshop as a final manual manipulation. For this case study, the calibration process generated seven sets of calibrated and registered files; three Luminance sets of different exposure duration, RGB and Hα. The individual calibrated files were registered to the Hα file with the smallest half flux density. These file sets were separately integrated to form seven master image files, weighted by noise and using Winsorized Sigma Clipping to ensure the plane trails and cosmic ray hits were removed.

Processing

Channel Combinations

One of the first "tricks" with this image is the combination of image channels to form a set of LRGB master files. In the case of the luminance images, we have three sets, two of which have progressively more clipping at the galaxy's core. PixInsight has an effective high dynamic range combination tool, named HDRComposition, that blends two or more images together using a certain threshold for the 50:50 point. This is great but in this case, several hours of shorter exposures do nothing to assist the noise level of the 600-second exposures. Recall I took three luminance exposure sets? The ImageIntegration tool can weight-average three exposures or more. The first trick is to simply average the 120-, 300- and 600-second exposure sets according to their exposure duration (fig.2) and then finally, to improve the galaxy core, use the HDRComposition tool to substitute in the 300- and 120-second exposure information. Since the image is already an average of three files, the core is not clipped, but upon closer inspection it is posterized, at an image level threshold of about 0.2. Using 0.15 as the threshold in HDRComposition, the smoother, detailed cores from the shorter exposure blend into the core as well as the brighter stars (fig.3). (In fact, using HDRComposition on a starfield image, taken with a shorter exposure, is a nifty method to reduce bright star intensity in images.)

In practice, the luminance files have considerable light pollution in them. Before integrating the three exposure stacks (with no pixel rejection), I used the DynamicBackgroundExtraction (DBE) tool to remove the sky pedestal and even out the background. In that way, the ImageIntegration tool only took account of the

fig.2 The evaluate noise feature of the ImageIntegration tool provides a measure of the final noise level. This allows one to optimize the settings. In this case, an "exposure time" weighting outperformed the "noise" weighting.

image signal rather than the image plus light pollution. (To confirm my assumptions were correct I compared the image noise and noise weighting using the SubframeSelector script on the separate luminance files, the HDRComposition file and the hybrid combination.)

The other departure from standard LRGB imaging is to combine the Hα and red channels. Comparing the red and Hα images, the Hα exposures pick out the nebulosity along the spiral arms and do not exhibit a gradient. Again, after carefully applying the DBE tool to each stack, they were combined using PixelMath using a simple ratio: Several values were tried, including:

*Red+Hα, (0.2*Red)+(0.8*Hα) and (0.4*Red)+(0.6*Hα)*

*fig.3 The integrated image (top) seemingly looks fine. On closer
inspection there are two concentric halos, corresponding to
the clipping boundary of the two longer exposure sets. Using
HDRComposition, this is blended away, substituting the
shorter exposure set data for the higher image intensities,
leaving just a few saturated pixels in the very middle.*

Since the red channel contained a prominent image
gradation (before applying DBE) it was evident that it
was detecting light pollution and I chose to favor the Hα
channel 9:1 using the PixelMath equation:

$$(H\alpha*0.9)+(Red*0.1)$$

Linear Processing

Some of the linear processing steps (DBE) had already
been completed to assist with the unique image channel

combinations. The remaining green and blue channels
were similarly processed, removing background gradi-
ents. In all cases applying DBE was particularly difficult
as the galaxy extended to the extreme corners of the im-
age. In hindsight, my sampling points were too close to
the faintest periphery and if I had "retreated", the subtle
subtraction would have been less severe, preserving the
outer glow. The master luminance file also required
further standard processing steps including deconvolu-
tion, using an extracted point spreading function (PSF),
deringing with the support of a purpose-made mask, and
combining a star and range mask to exclude the back-
ground. The deringing option was adjusted precisely to
remove tell-tale halos, especially those stars overlapping
the bright galaxy core. This improved star and dust lane
definition at the same time.

To complete the luminance linear processing, noise
reduction was applied using the TGVDenoise tool, with
local support carefully set to proportionally protect those
areas with a high SNR, and with a range mask to be on
the safe side. The settings were practiced on a preview
before applying to the full image.

For the color channels, having equalized their back-
grounds, the separate image stacks were inspected for
overall levels. Using the green channel as a reference,
the LinearFit tool was applied in turn to the red and
blue images to equalize them, prior to using the Chan-
nelCombination tool to create the initial RGB color
image. To neutralize the background I created several
small previews on areas of dark sky and combined them
for use as a reference for the tool of the same name (fig.5).
This was additionally used as the background reference

*fig.4 The TGVDenoise has an extended option for "Local Support" that progressively protects areas with a high signal to noise ratio.
The settings for mid, shadow and highlight tones are set to the image parameters. Fortunately the ScreenTransferFunction
supplies the data, by clicking on the wrench symbol. Note the numbers are in a different order between the two tools.*

fig.5 *Background neutralization is quite difficult on this image on account of the sky gradient. Multiple previews were created to cover the background. These were combined using the PreviewAggregator script and this preview used as the background reference.*

for the ColorCalibration tool, in combination with a preview window drawn over the galaxy area, to set the color balance. After several attempts using different white references, a pleasing color balance was established, with a range of warm and cool tones in the galaxy.

Non-Linear Luminance Processing

Although non-linear processing followed a well-trodden path, it was not the easiest of journeys. Starting with the luminance, a careful set of iterative HistogramTransformation applications ensured that the histogram did not clip at either end and there was sufficient image headroom to allow for the brightening effect of sharpening tools. The details in the galaxy were teased out using the LocalHistogramEqualization tool, applied at different scales and with different range masks; first to the galaxy to improve the definition of the spiral arms and again, using a more selective mask, revealing only the central core to tease out the innermost dust lanes. By this stage some star intensities had started to clip and, unless they were reduced in intensity, would be rendered white in the final color image. I used the Morphological tool, with a

supporting star mask, to slightly shrink the stars and at the same time, reduce their overall intensity. This useful trick ensures that, providing the non-linear RGB file is not over-stretched, the star color is preserved. (Another method is to substitute stars in from a duplicate linear image that has had masked stretch applied.) Using a general luminance mask to reveal the background and faint parts of the galaxy, a little more noise reduction was applied to the background, using TGVDenoise, careful to avoid a "plastic" look. (It is easy to over-do noise reduction.)

Non-Linear Color Processing

The aim of the color file is to just provide supporting color information for the luminance file. As such, it has to be colorful, yet with low chrominance noise. At the same time, the background must be neutral and even. Since bright images by their very nature have low color saturation, the non-linear stretch should be moderate, to avoid clipping pixels color values. The non-linear stretch was carried out in two passes to form a slightly low-key result (fig.6). Troublesome green pixels were removed with the SCNR tool and after a mild saturation boost, noise reduction was applied to the background using TGVDenoise (with a supporting mask). The stars were then slightly blurred too, to remove some colorful hot pixels on their margins (through a supporting star mask). This evened out a few colored fringes and gave a more natural look. Satisfied I had a smooth and colorful image, the luminance file was applied to it using the LRGBCombination tool, adjusting the saturation and lightness settings to suit

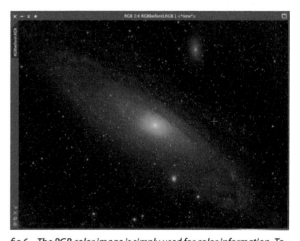

fig.6 *The RGB color image is simply used for color information. To preserve color saturation, it is important not to over-stretch it or create excessive chrominance noise. For that reason the entire image was blurred slightly and noise reduction applied to selective areas. Star saturation was increased slightly using the CurvesTransformation tool and a star mask.*

my taste. To preserve color, the image brightness was kept on the darker side of the default settings.

Now that the general color, saturation and brightness were established, the structures in the galaxy core and margins were emphasized using the MultiscaleMedian-Transform tool and the LocalHistogramEqualization tool, with supporting masks to concentrate their effect. On screen, I could see the faint tracery of the dust lanes spiral into the very center of the galaxy core. After some minor boosts to the saturation, using the CurvesTransfor-mation tool, a final course of noise reduction was applied to those areas that needed it, of course, using masks to direct the effect to those areas where it was most needed. (By the end of this exercise I had about 10 different masks, each optimized to select particular objects based on brightness, scale or both.)

Improvements

This impressive subject is hard to resist. I had to use several novel techniques to overcome the difficulties presented by its high dynamic range to lift it above the average interpretation. There was still room for improve-ment; having compared the final result with other notable examples, I realized that I had inadvertently lowered the intensity of the outer margins with over-zealous use of the DynamicBackgroundExtraction tool and missed an opportunity to boost a ring of bright blue nebulosity around the margins. (The fault of a range mask that was too restrictive to the brighter parts of the galaxy.) Putting these corrections back into the beginning of the image workflow yielded a small but worthwhile improvement, many hours later.

At the same time, I also realized another trick to im-prove the appearance of the red and blue nebulosity in the margins: I used CurvesTransformation's saturation curve to boost the red color and the blue and RGB/K curves to emphasize and lighten the blue luminosity. The trick was to select the content using a stretched version of the Hα and blue-image stacks as a mask. The final re-processed image appears below (fig.7). Phew!

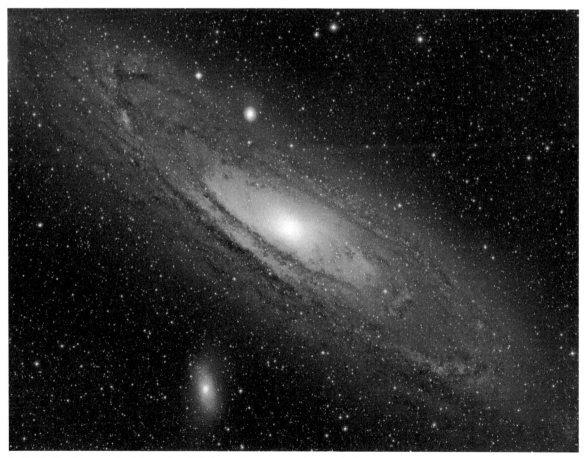

fig.7 The final image makes full use of the APS-C sensor in more ways than one. In this particular image tiny dust clouds in the companion galaxy M110 can be seen. At first I thought it was noise, until an Internet search confirmed it to be the case.

IC1805 (Heart Nebula) in False Color

Synthetic colors, synthetic luminance and real stars.

Equipment:
Refractor, 71 mm aperture, 350 mm focal length
Reducer (none, 5-element astrograph)
QSI683 CCD (Kodak KAF8300 sensor)
QSI integrated Filter Wheel (1.25" Baader filters)
QSI integrated off-axis guider with Lodestar CCD
Paramount MX, Berlebach tripod

Software: (Windows 7)
Sequence Generator Pro, ASCOM drivers
PHD2 autoguider software
PixInsight (Mac OSX)

Exposure: (Ha, SII, OIII, RGB)
Ha, SII, OIII bin 1; 15 x 1,200 seconds each
RGB bin 1; 10 x 200 seconds each

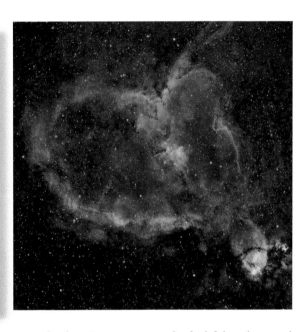

IC1805 is a large emission nebula, mostly formed from ionized hydrogen plasma, powered by the radiation from the star cluster (Melotte 15) at its center. Its shape resembles a heart with two ventricles, suggesting its common name. Having said that, a search for "The Heart Nebula" in several planetarium and planning programs surprisingly draws a blank. This object requires a wide field of view of about 3 x 2.5 degrees to comfortably frame it, mandating a short focal length and a larger sensor. This object was my first with a new William Optics Star 71, a 5-element astrograph. Unlike a traditional 3-element APO and 2-element field-flattener (with the associated issues of defining sensor distances) the 5 optical elements are in a fixed relationship to each other and are simply focused on the sensor, in the same way that manual focus camera lenses have done for the last century, with no tricky sensor spacing. Although short focal lengths are less sensitive to tracking errors, they require precise focus and image registration to ensure a high-quality result.

In this example, similar to the image of the Crescent Nebula, the main exposures are taken through narrowband filters. Although this required many long 20-minute exposures over several nights, they did block the light pollution gradient and were largely unaffected by the sky glow from the gibbous Moon. Unlike the earlier example, there is no attempt to be faithful to the actual object color, and the image uses the classic Hubble Space Telescope palette, assigning SII to red, Hα to green and OIII to the blue channel. The novel processing workflow also includes star removal in the color image, prior to stretching the faint nebulosity and later substitution with RGB star color.

Acquisition

This William Optics refractor is tiny, and although it uses a rack and pinion focuser, the QSI camera is a heavy load for such a small mechanism. As can be seen in fig.1, the camera and filter wheel assembly dwarf the telescope tube. In common with many mass-produced telescopes, a small degree of fine-tuning of the focus mechanism was necessary to minimize focus-tube flexure. I tensioned the two brass bolts on the top of the focuser to reduce play but not too tight to prevent motorized operation. To be sure, the scope was auto focused in Sequence Generator Pro and the first few frames analyzed with CCDInspector. This analysis program confirmed an image tilt of a few arc seconds and a reassuringly flat frame. After some further adjustment, the tilt halved to a respectable arc second.

Another practical difficulty of using a light telescope and a heavy camera is achieving fore-aft telescope balance,

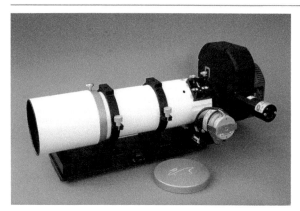

fig.1 *The diminutive William Optics Star 71 is a high-quality 5-element astrograph. Here it is fitted with a Lakeside focus motor. The long Losmandy dovetail plate is fitted in a forward position and a painted steel rod is attached to its end to offset the weight of the QSI camera assembly.*

especially if you need to rotate the camera body for framing. The solution in this case was to attach the telescope tube rings to an overly long Losmandy plate extending out the front and to add further weight at the front end, in the form of a steel bar. In this way, when the assembly was balanced, it facilitated a few millimeters' clearance between the camera and mounting plate for rotation.

Image exposure for narrowband images is subtly different to that with RGB filters. Only a few emission nebulas are sufficiently bright to saturate a sensor using exposures under 20 minutes, and in most instances exposure is a simple balance between exposure length and the probability of a ruined exposure from some special cause. In this case, 20-minute exposures were used with all three narrowband filters, managing four hours per night in late October. In common with the Crescent Nebula, ionized hydrogen dominates the image, and balancing the contribution of the three narrowband exposures is the challenge. The severe stretching required to balance the channels is known to produce magenta-colored stars. For that reason

additional shorter RGB binned exposures were taken to record realistic star colors for later inclusion. On the final night, having exposed the remaining OIII frames, once the nebula had risen away from the light pollution three hours of RGB were captured in the darker region of the sky. In this wide-field shot, since the pixel resolution was already greater than 3 arc seconds/pixel, the RGB exposures were also taken unbinned, to avoid undersampling.

These exposures were taken over 5 nights, and at the end of each session, the equipment was dismantled. Even with the short focal length and large(ish) sensor, the framing was tight and I could not afford to lose peripheral data from misalignment between sessions. Thankfully, the slew and center commands in Sequence Generator Pro, using the first image as a plate-solved reference, relocated center within 1 pixel in less than a minute and gave directions for manual rotation adjustments too.

Image Calibration

Each of the file sets was calibrated using the PixInsight BatchPreprocessing script using the master bias, darks and flats that I had previously created for this telescope and camera combination. I then registered these to the Hα file with the smallest star size (HFD). In the BatchPreprocessing script, the image integration box was left unchecked, as this essential processing step always benefits from some individual experimentation with its combination and rejection settings.

With 15 images in each set, I lowered the SD setting in the all-important ImageIntegration process, trying out different values to just eliminate 3 plane trails running through the image. I started off with the image integration mode set to "Average" but the plane trails remained; after some research, I changed the integration mode to "Median" and they disappeared with these settings. (Things move on and further study has established that it is preferable to persevere with the average mode settings as the median mode has a poorer noise performance.)

 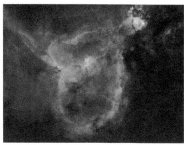

fig.2 *The three stacked images, without stars; L-R, SII, Hα and OIII before processing. The SII and OIII (red and blue) will require more stretching to match the intensity of the Hα (green). This will not only emphasize the image noise level but create magenta stars too.*

The three narrowband images are shown in fig.2, after basic linear processing and with their stars removed and auto-stretched. The significant difference in signal level for the three emissions is evident and highlights the need for careful manipulation in the non-linear processing stages.

Manipulation Strategies

For a colorful and interesting image we need contrast; both color and luminance. These in turn require careful linear and non-linear processing for the color information in the LRGB combination as well as the luminance data. Considering the luminance first, this data not only sets the details for the structures and stars, it also determines the luminance of a particular color. If the luminance data favors one channel more than another, that color will dominate the final image at the point of LRGB combination. The first trick then is to construct a luminance channel that reflects the "interesting" bits of the three monochrome images. Once these files are combined, there is no way to determine whether the luminance is associated with Hα, OIII or SII. Structure enhancement certainly adds bite to the image but does not necessarily add color contrast. Color processing, especially in the non-linear domain, requires some out-of-the-box thinking to make the most of what we have. One powerful way of achieving color contrast is to manipulate the a* and b* channels of

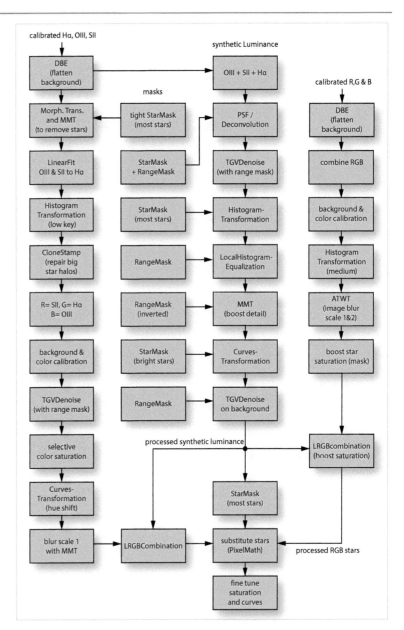

fig.3 *The emphasis of the processing is to make the most of the weak SII and OIII signals and remove stars before stretching. As with the Crescent Nebula example, a separate processing workflow, using RGB frames, generates color information for the stars.*

a CIE L*a*b* file; as is selective color manipulation and hue adjustments. I tried a number of alternative ideas that produced very different interpretations. Three of these, in unfinished form, are shown in figs.4–6. Of course, a more literal rendering would be almost entirely red since Hα and SII are deep red and the turquoise blue OIII signal is weak. It is also tempting to overdo the coloration. The result has impact but if taken too far, is cartoon-like. I prefer something with more subtlety.

Linear Processing

The three workstreams for the linear processing are shown in fig.2. These process the narrowband color, artificial luminance and the RGB star image. Narrowband exposures typically do not have a significant light-pollution gradient and in this case only required the minimum of equalization. It was a necessary step, however, since the process also sets the general background level. The trick was to find a sample of the true background level without

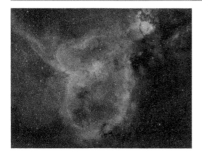

figs.4, 5, 6 (Left): With poor channel equalization, the combined image is dominated by the green channel, as it is assigned to the Hα data.
(Middle): After applying LinearFit to the starless images, the color balance improves significantly.
(Right): After using the full image as a reference for color calibration, the balance changes dramatically.

faint nebulosity. (In the case of the star exposures taken through standard RGB filters, since the background is discarded when it is combined with the narrowband image, accurate background equalization is not essential.) The artificial luminance file, however, requires a little more thought and attention, due to the variations in general signal level. The Hα signal is very much stronger than the other two and has considerably less noise. Rather than introduce noise into the luminance file, I combined the signals in proportion to their signal to noise ratio using the ImageIntegration tool. The end result closely resembled the original Hα image.

Star Removal

As mentioned before, a common issue arising in HST-palette images are magenta-fringed stars; an outcome of the unequal channel stretches. In this example, the stars were removed in the narrowband images to ease subsequent processing and then added back in later on. I used PixInsight rather than the Straton application, so I could continue using 32-bit FITS files. Using a star mask to isolate the stars, I first shrunk them with the Morphological Transformation tool and then blended them in with their surroundings by applying the MultiscaleMedianTransformation tool, with scales 1–5 disabled. The starless images are shown in fig.2. It required some novel techniques to make the most of the faint SII and OIII data; this is, after all, a false color image, so anything goes, so long as the outcome is picturesque. With the stars removed, balancing the channels was considerably easier and, before stretching, the three channels were equalized with the LinearFit tool by applying the Hα channel in turn to boost the SII and OIII. This performed a linear translation that broadly matched the histogram distributions of the three channels.

Non-Linear Processing

Image stretching is also much easier without stars and removes the risk of star bloat. I applied two gentle stretches with the HistogramTransformation tool, to yield a low-key result. (This allows for some processing headroom for sharpening tools and preserves color saturation.) Careful examination of the images revealed a few tell-tale colored haloes around the brightest star positions. These were cloned out using the CloneStamp tool in PixInsight, blending them with the adjacent colors. The three images were then combined into an RGB file using the ChannelCombination tool and had the customary color calibration; a simple background neutralization and a color calibration that employed the entire image as the white reference. Figs.5 and 6 show the image before and after color calibration. Although both interpretations vary enormously, they both work and the choice is a personal one. In this case, I decided to fully process both versions. The color image does not have to be sharp and I applied a generous dose of noise reduction using the handy TGVDenoise tool, using a range mask to protect the brightest areas. To complete the color processing, I increased the saturation of the nebulosity and adjusted the hues to emphasize the blue tones (fig.7). I removed some chroma noise with the MultiscaleMedianTransformation tool by disabling the first scale and lowering second scale's bias to -0.1.

Luminance Processing

The linear luminance file, chiefly made from H data, was processed in a standard manner: First, I sampled 30 stars and formed a PSF image to support the Deconvolution tool. I then combined a soft-edged range and star mask and experimented with the deconvolution settings to improve details in the stars and bright nebulosity. I then stretched the image in several stages: After applying a modest stretch with the HistogramTransformation tool, I applied the LocalHistogramEqualization tool to emphasize the cloud structure and the MultiscaleMedianTransformation tool again, this time to boost scales 2 and 3. A slight S-curve in the CurvesTransformation

tool improved image "snap". Finally, using a range mask to protect clean areas, TGVDenoise was then applied to reduce the encroaching background noise.

Assembly and Final Touches

The files were then assembled, starting with the fully processed luminance file, which was applied to the narrowband file using the LRGBCombination tool. Finally, the RGB star images were combined and mildly stretched to show good star color throughout a range of star intensities. To soften the star outlines and blend their color, noise reduction was applied in the form of a mild blur, using the convolution tool, followed by a saturation boost. This image was then LRGB combined with the processed luminance file and added to the narrowband image. This was achieved by creating a close fitting star mask, applying it to the narrowband image and then using a PixelMath equation to substitute in the star colors through the mask. After a few attempts, each time tuning the mask with the Morphological Transformation tool, the stars blended in without tell-tale halos. Abandoning the image overnight, the final adjustments were made on the following day with the CurvesTransformation tool to saturation, hue and balance. After a final check at a 100% zoom level, additional chrominance noise reduction was applied to the background and fainter luminosity data, with the support of a soft-edged range mask. It was tempting to continue editing since false-color images provide endless interpretations, up to the point that the image data starts to degrade with artefacts or clipping.

Conclusions

Even after 20 hours of exposure, the image would have benefitted with more, especially for the OIII and SII channels. Accurate plate solving and rotational alignment make it easy to add further data, if the weather permits. For a meaningful improvement however, I would need twice the exposure. Thankfully the processing of a false color image abandons the more standard workflows and as a result there is no "right" interpretation. With care, the poor signal to noise ratio of the faint OIII and SII data can be disguised by making the most of the stronger H signal. Alternative interpretations have even more saturated colors. Anything goes, so long as one pays attention to the image quality at each stage.

Another interesting possibility with this nebula is to form a mosaic that stretches to its aptly named neighboring "Soul" nebula. I am eager to try this in Sequence Generator Pro as it has a very powerful mosaic planning tool which calculates the positional translations to create accurate panoramas for a given wide-field reference image.

fig.7 *The CurvesTransformation tool has many uses. In this case, this hue curve shifts the hues of the object (horizontal axis) to the target (vertical axis). Here the turquoise and magenta is shifted to blue and the yellows are shifted to red. This is a similar function to Photoshop's selective color tool.*

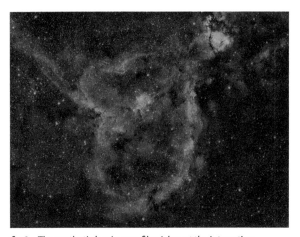

fig.8 *The synthetic luminance file picks out the interesting detail from each of the narrowband images, not just their luminance. In that way it emphasizes the differences between relative signal levels more and changes the feel of the image to something that is more delicate.*

Horsehead and Flame Nebula

A popular, yet challenging image to capture and process.

Equipment:
Refractor, 71 mm aperture, 350 mm focal length
QSI683 CCD (Kodak KAF8300 sensor)
QSI integrated Filter Wheel (1.25" Baader filters)
QSI integrated off-axis guider with Lodestar CCD
Paramount MX, Berlebach tripod

Software: (Windows 7)
Sequence Generator Pro, ASCOM drivers
PHD2 autoguider software
PixInsight (Mac OSX)

Exposure: (LRGBHa)
L bin 1; 35 x 300 seconds, 15 x 30 seconds
RGB bin 2; 130 x 300 seconds each
Ha bin 1; 15 x 1200 seconds

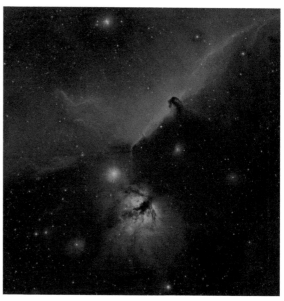

The first edition has a facer image of this nebula pair, a true first-light experience of this famous part of the Orion nebula complex. At the time of image capture I was using a portable setup and the acquisition took several months of cloud dodging to complete. Although a common subject, the image processing presents several interesting challenges, including the dominance of the bright star Alnitak (and its artefacts) as well as achieving the right color balance and achieving extended nebulosity. It is probably my most challenging image to process to date. The initial attempt followed a familiar route, using the Hα to enhance the red channel in an otherwise classic LRGB processing workflow. In the intervening time, my image processing skills have moved on and make better use of the plentiful options provided by the generous L, RGB and Hα exposures. These include MURE noise reduction, combined luminance information, optimized deconvolution, non-linear stretching and enhancement techniques.

Acquisition

The images were acquired with the diminutive William Optics Star 71 5-element astrograph. It was almost comic fixing this to the substantial Paramount MX mount. The heavy QSI camera is a significant load for the focus

mechanism, however, and it took some time to find the best focuser clamp force to reduce flexure and still allow the focuser's stepper motor to work. The outcome was a compromise and the asymmetrical reflections are evidence of some remaining focuser sag. The bright star Alnitak (the left-most star of Orion's belt) challenges most refractor optics and this little scope was no different. In this case, a complex diffraction pattern around this star is the consequence of minute irregularities in the optical aperture and blue reflections from the sensor glass cover.

Astrophotography is a continual learning experience; it is all too easy to plough in and follow established, familiar processing workflows. Hindsight is a wonderful thing too. Having calibrated, registered and integrated the separate channels, it was questionable that the time spent acquiring luminance may have been better spent on Hα exposures. If one compares the two grey-scale images in fig.1, it is clear that the Hα image has better red nebulosity definition and a tighter star appearance too. Nebulosity of other colors though is more muted but Alnitak has a much improved appearance.

The binned RGB color exposures show some blooming on bright stars and they require extra care during the registration process to avoid ringing artefacts. The outcome repeats some of the lessons from the Dumbbell Nebula

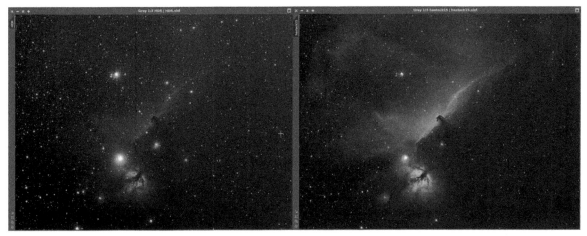

fig.1 *The image on the left is a processed luminance stack taken through a clear filter. The image on the right was taken with a Hα*
filter. In the presence of mild light pollution the Hα image is superior in almost every way for defining stars and nebulosity.

example, where the wideband luminance information was similarly challenged in favor of narrowband luminance data. The key takeaway is to expose an image through each filter, apply a screen stretch and examine each carefully for its likely contribution to the final image before deciding on the final image acquisition plan. That is easier said than done, since it is difficult to predict how subsequent processing will play out, but it is better than following a standard acquisition plan that completely disregards the contribution of each channel to the final image.

Linear Processing

After checking the individual L,RGB and Hα frames for duds, they were calibrated and registered. In the case of the binned RGB exposures, the standard registration parameters using an Auto interpolation method typically default to Lanczos 3 and a Clamping threshold of 0.3, which produces ringing artefacts. For these channels, I

switched the interpolation method to Bicubic Spline and reduced the clamping threshold of 0.1. The lower clamping threshold reduced ringing artefacts but degrades fine detail. This was not an issue as the RGB data was principally used for low-resolution color information. Image integration followed, using Winsorized Sigma algorithms and Sigma thresholds set to just remove cosmic ray hits and various spurious trails for satellites, meteorites and aircraft. The individual image stacks, while in their linear state, had MureDenoise applied to them, with the settings adjusted to the individual interpolation method, gain and noise for each binning level and image count.

Luminance Strategy

As mentioned earlier, the screen-stretched Luminance and Hα images in fig.1 play out an interesting story. The light pollution clearly washes out the faint red nebulosity in the broadband luminance image and at the same time,

fig.2 *The LRGB image above uses the processed luminance*
channel taken through a clear filter. The larger star
sizes hide the blue halos in all but the largest stars.

fig.3 *In this HαRGB image, the smaller stars are surrounded*
by blue halos (these are not deconvolution artefacts
and are not present in the luminance channel).

the brightest stars are bloated and ugly. The Hα channel looks considerably better but using it for luminance data causes subtle issues around bright stars later on. Using Hα for luminance naturally favors its own and often leads to a red-dominated picture. Although red nebulosity is abundant in this image, it gives the flame nebula a red hue too and in addition, diminishes the appearance of several blue reflection nebula close to the familiar horse head.

The image in the first edition used a blend of luminance with a little Hα, to form a master luminance file. This image has obvious diffraction artefacts around Alnitak and the other bright stars. The next attempt used the Hα channel for luminance. At first glance, the stretched Hα channel looked very promising, not particularly surprising considering the overall red color of the nebula, although it lacks some definition in NGC2023. Further down the road, however, there is a bigger issue when it is combined with the RGB image: The star sizes in the images taken with narrowband filters are considerably smaller than those through broadband filters and, after applying deconvolution and masked stretch, become smaller still. This is normally good news but after LRGB combination, many small bright stars are surrounded by a blue halo (fig.3).

This highlights a tricky issue and makes this image an interesting case study. It is easy to "plug in" stars against a dark background but in order to do so over a lighter background requires a close structure match between the luminance and color data to yield a natural appearance. In this image many stars are surrounded by bright red nebulosity and hence high luminance values. In the RGB file, these areas are dominated by diffuse blue reflections around the brighter stars. This causes the blue coloration around the brightest stars, overriding the red background. The range of issues experienced with the LRGB blends is shown in fig.2 and fig.3. One bookend using Hα for luminance has tight stars with blue halos, the other uses standard luminance exposures has larger stars and diffraction artefacts. In a perfect world, we need to retain the star information from the Hα channel but minimize the blue halos around stars. This requires some subtle trade-offs; several alternative strategies come to mind, including:

- experiment with different combinations of Luminance and Hα to create luminance channel
- shrink the stars (and halation) in the RGB channels
- histogram stretch the Hα channel (rather than MaskedStretch) to avoid star erosion
- separately process the RGB images for small (star) structures and larger general coloration

There is seldom a silver bullet for these kinds of issues and all the above strategies were tried in various combinations. The outcome is an optimized compromise. As channel blending and linear fit algorithms are confused by general background levels and the background of broadband and narrowband images are very different, the background levels were subtracted by applying the DynamicBackgroundExtraction tool to each integrated stack. A clumsy use of DBE also removes faint nebulosity and hence the background samples were placed very carefully to avoid any such areas. A "superlum" image was built up by first combining the short and long luminance exposures using the HDRComposition tool. This blends the clipped stars in the 5-minute exposures with the unsaturated pixels from the shorter exposures. The final "superlum" file was created by combining L and Hα files, allowing their contributions to be scaled according to their noise levels. This produces the lowest noise level for the general image background and a

fig.4 *Deconvolution on this image requires progressive deringing settings for stars in dark regions, local support for stars in bright nebulosity and regularization to avoid artefacts in bright regions. A range mask also protected dark regions.*

compromise between star sizes and artefacts. Deconvolution was carefully set to reduce star sizes a little and give better definition to the brighter nebulosity (fig.4). (In this study, the RGB exposures were binned and showed some blooming on the brightest stars. Since registration scales these images it is technically possible to integrate with the 1x1 binned files. The result is not pleasing and in this instance I did not use them to contribute to the "superlum". I now take unbinned RGB exposures for maximum flexibility during processing.)

Linear RGB Processing

RGB processing followed a similar path of blending. The Hα and Red channels were equalized using the LinearFit tool and then blended 1:2, on account of the stronger Hα signal. This ratio produced star sizes exceeding that of the Hα channel and yet retained the fainter cloud detail. This file was then in turn equalized with LinearFit to the Green and Blue channels before combining all three with ChannelCombination. A standard color calibration, with BackgroundNeutralization and ColorCalibration followed, carefully sampling blank sky and a range of stars respectively, to set the end points.

Non-Linear Processing

Both luminance and color images were stretched in the same manner to maintain, as much as possible, the same star sizes. This comprised of an initial, medium HistogramTransformation, which boosted the brighter stars and produced a faint image, followed by Masked-Stretch. This departure from an all HT non-linear stretch, prevented the brighter stars clipping and kept their size under control.

The bright star sizes in the color image were reduced further, using a star mask and the MorphologicalTransformation tool. The StarMask noise threshold was set to detect the brightest stars, with sufficient structure growth to encompass their immediate surroundings. Some convolution was applied to the star mask to soften and extend the boundaries. This also had the effect to draw in the red surroundings around the medium bright stars to replace their blue halos. In the case of the few super-bright stars, the extent of their blue halo was too large to remove and remains in the image. Not ideal I admit, but a quick Internet image search suggests I'm not alone! As usual, star color was enhanced using the color saturation tool in conjunction with a star mask. The tool was set to enhance the yellow and red stars and to decrease the blue color saturation (fig.6). In preparation for LRGBCombination, a small amount of convolution was applied to the image (with the star mask

in place) followed by a healthy dose of noise reduction, using TGVDenoise, to remove chromatic noise.

The stretched "superlum" channel had its structures enhanced and sharpened with successive applications of LocalHistogramEqualization (LHE) at different large scales and sharpened with MultiscaleMedianTransform (fig.5). In between applications, the dynamic range was extended slightly (to avoid clipped highlights) by applying a plain HistogramTransformation with a 10% highlight extension. After tuning the brightness distribution with a S-curve CurvesTransformation, I applied selective noise reduction, using MultiscaleLinearTransform and

fig.5 After gentle boosts to nebulosity from repeated applications of the LocalHistogramEqualization tool (at different large scales) I used MMT to sharpen up smaller structures. A linear mask protected dark areas.

fig.6 *Star color saturation was selectively adjusted with the ColorSaturation tool (blue/green saturation is reduced).*

replaced green pixels with neutral ones, using Selective-ColorNoiseReduction (SCNR).

As usual, the color and luminance channels are combined using the LRGBCombination tool. Before using this tool, however, I followed a suggestion from the PixInsight forum. In this process, the luminance values in the RGB and master luminance are equalized before the application of the LRGBCombination tool. To do this, I first decomposed the RGB file using the ChannelExtraction tool set to CIE L*a*b* mode. I then applied the LinearFit tool to the L channel, using the "superlum" as the reference image. After using the ChannelCombination tool to put them back together I followed up with the LRGBCombination tool as normal. After doing this extra step, the result is more predictable and easier to tune with small slider changes.

In the final image, slightly larger star sizes are the sacrifice for fewer small blue haloes. The MaskedStretch certainly reduces the visual dominance of the brightest stars and the blending process records both the blue and red nebulosity. I noticed, however, that the dominance of the Hα signal in both the luminance and color files caused the flame nebula to turn pink. In one-shot color images, this is more orange in appearance and for the final image, the color was gently adjusted in Photoshop using a soft-edged lasso and the hue tools. I did contemplate using the spherical blur tool on Alnitak to remove the diffraction artefacts but ultimately resisted the temptation; if it were that easy to remove the effects of subtle optical anomalies, I would not have an excuse to upgrade my refractor.

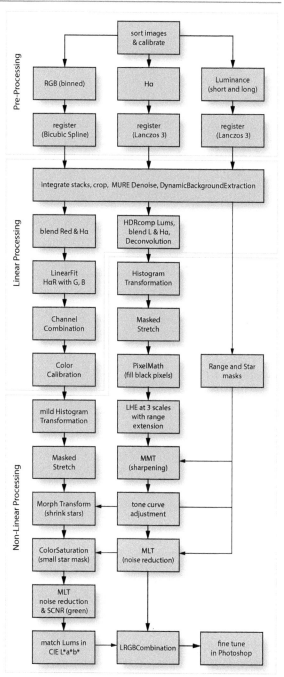

fig.7 *This is the simplified workflow of the separate color, luminance and narrowband channels and combinations. By now, you will appreciate that the difference between good and also-ran images lies in the subtlety of the various tool settings as well as the tool selection and order. Patient experimentation is the key ingredient for many deep sky images. Frequent breaks during image processing help calibrate perception. Returning to an image helps overcome the tendency to over-process.*

Comet C/2014 Q2

I find it ironic that Messier's catalog was created with the purpose to identify "non-comets".

Equipment:
Refractor, 71 mm aperture, 350 mm focal length
Reducer (none, 5-element astrograph)
QSI683 CCD (Kodak KAF8300 sensor)
QSI integrated Filter Wheel (1.25" Baader filters)
QSI integrated off-axis guider with Lodestar CCD
Paramount MX, Berlebach tripod

Software: (Windows 7)
Sequence Generator Pro, ASCOM drivers
PHD2 autoguider software
PixInsight (Mac OSX)

Exposure: (LRGB)
LRGB bin 2; 4 x 120 seconds each

C/2014 Q2 (Lovejoy) is a long-period comet of about 10,000 years that was discovered in August 2014 by Terry Lovejoy. It continued to brighten to magnitude 4 in January 2015, making it one of the brightest comets since Hale-Bopp in 1997. I almost missed it. At the time I was totally engrossed in acquiring sufficient imaging hours of a dim nebula and it was by chance that a visitor asked me about it. In less than an hour, I had captured enough frames to make an image before cloud stopped play (more would have been useful to improve image quality). This comet is big and bright and in some respects not particularly difficult to acquire or process. The biggest challenge arises from the fact that the stars and comet are moving in different directions and each exposure has a unique alignment. A simple combination of the frames would produce a smeared image.

My first challenge though was finding it. Each night a comet is in a different position in relation to the stars and I had not yet loaded the comet database in to TheSkyX. Fortunately, SkySafari on an iPad updates regularly and connected via TCP to TheSkyX. In a few moments the mount was slewing and a minute later a 30-second exposure filled the screen. It was difficult to miss! After a few minor adjustments to make a more pleasing composition, I tested a 5-minute exposure through the luminance filter.

At this exposure the bright comet core was already clipping and I settled on 2-minute exposures for all LRGB filters. At this duration, the relative comet movement would be minor during each exposure.

Acquisition and Processing Overview

This subject requires a back-to-front approach that considers processing before acquisition. The final image is a composite of the star background and a comet image. To do this, the captured images are processed in two workstreams; one with a set of images registered to the stars and the other aligned to the comet head. In the first, the stars are eliminated and in the second, the stars are isolated. The new PixInsight Comet Alignment module accomplishes both the registration and, after integrating the comet image, the isolation of the stars by subtracting the comet-only image. From here, each is processed before combining them into the final image.

Removing the stars from the comet image is much easier if the exposures are made in a specific manner; the trick being to image each of the LRGB exposures in such a way that when the images are aligned to the comet head, the stars form a string of non-overlapping pearls. The image integration process rejection algorithm naturally rejects the pixels relating to the stars, leaving

fig.1 *With insufficient intervals between exposures, an integrated image of the luminance exposures, aligned on the comet's head, does not entirely remove the stars... oops!*

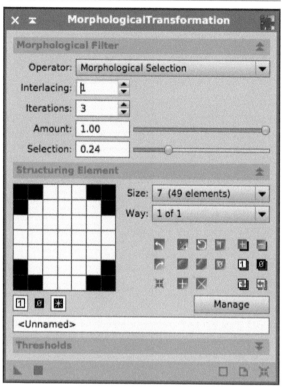

fig.2 *Several applications of these MT settings removed most stars without leaving obvious tell-tale marks. The remaining blemishes were blended with the convolution tool or cloned with an area of matching featureless background. The clone tool was set to a soft-edged circle, with 30% transparency, to disguise its application.*

behind the comet and its tail. That is the theory anyway. In a dense starfield, however, this may not be perfect and even in a sparse one, there may be a few artefacts left behind that need attention. There are various ways of removing these blemishes, including a small scale DynamicBackgroundExtraction, the clone tool and the MorphologicalTransformation tool in combination with a star mask. For effective star rejection, the exposure sequence (for a monochrome camera using a filter wheel) should ideally have the following pattern:

1 luminance, delay
2 red, delay
3 green, delay
4 blue, delay
5 repeat 1–4

(In the case of a CFA camera, there should ideally be several minutes delay between images to avoid any overlap.)The star-only image can be created in at least two ways; by subtracting the comet image from each exposure (using the Comet Alignment module) or simply using a star mask to isolate them during the final combination.

After fully processing both images to produce a colorful comet and a starfield (which excludes the comet head), the two are combined to make the final image. My preference is to apply a star mask to the comet image and use a PixelMath equation to substitute in the stars from the star field. As long as the starfield background is darker than the comet background, it works a treat, especially if the admittedly distorted comet image is left in the star field image, as it helps restore stars in the bright coma periphery.

Processing in Practice

By cycling through the LRGB filters and with a modest delay in between each exposure, there is less chance of star overlap between successive exposures through the same filter (when these are aligned to the comet head). Unfortunately, in my haste, I completed all the exposures for each filter before moving onto the next. As a result, when the images are aligned to the comet head, the brighter stars partially overlap and are not removed by the image integration step (fig.1). The weather closed in for the next few weeks and I had to make the best of what I had.

This assignment then also explains the rescue mission. The overall workflow shown in fig.3 outlines how the color and luminance information are separately manipulated and combined for both the comet and the star images. My acquisition sequence error forced an additional step to remove the rogue stars in the integrated comet images, although in all likelihood, that step would have been required anyway to remove fainter residuals remaining after image integration.

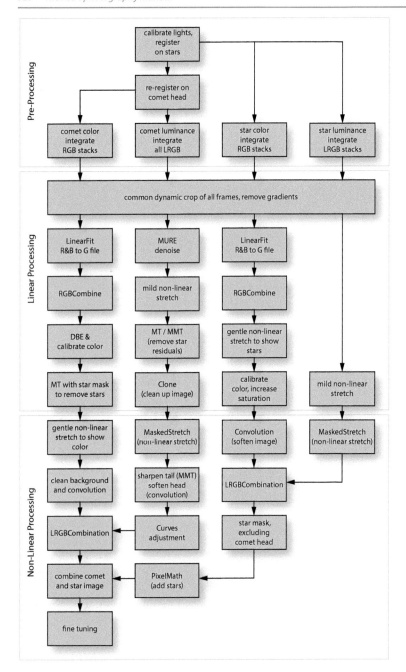

fig.3 The image processing flow follows four workstreams, to separately process comet and star's luminance and color. In the star image, the starmask effectively isolates the stars from the comet. In the comet image, repeated applications of morphological transformation shrink stars prior to integration and blend in remaining pixels. Here, the number of images is small and the luminance channel integrates all LRGB images to keep image noise to a minimum. At various times, range masks and star masks were used to protect the image during sharpening and noise reduction. I used the clone stamp tool on the image mask to clear the area of the comet head in which the core is confused as a star. The next time a comet appears close to Earth I will be better prepared and take more exposures, unbinned and with a decent interval between the exposures. It is unfortunate that Comet ISON disintegrated in November 2013 due to the Sun's heat and tidal forces.

Comet Processing

All the registered images were loaded into the Comet Alignment module and re-registered to the comet head. These images were integrated to form luminance and RGB linear files. In the ImageIntegration tool I set a low rejection value for the highlights to improve star rejection but at the same time this makes the already noisy image grainy. I settled on a value around 1–1.5 as the best compromise. To reduce the noise in the all-important luminance frame, I combined all LRGB exposures and applied MURE noise reduction. The R, G & B images were combined and calibrated as normal and the remaining stars traces in the RGB file and luminance file were removed using a star mask and several applications of the MorphologicalTransformation tool (fig.2) to form the comet RGB and L images. In this wide field image, there was a distinct gradient and both image backgrounds were equalized with the DBE tool, with about 25 samples

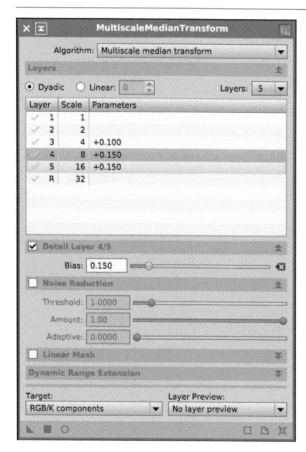

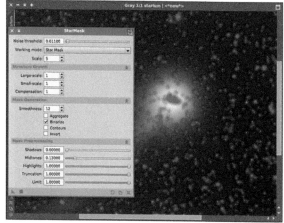

fig.5 *When the star mask is applied to the luminance file and inverted, it is easy to check that the mask is effective and locating all the stars. Here it is also locating several comet cores too. These were cloned out to prevent accidental substitution during the final image combination.*

fig.4 *The faint comet tail structures were emphasized with the MMT tool, with increased Bias levels on medium scales.*

per row. In the critical luminance channel, the last star remnants were removed by blurring and cloning to produce an even and smooth background.

Once the backgrounds were clean, I applied a mild stretch with HistogramTransformation, followed by a further sharpening on the luminance image (fig.4) using MultiscaleMedianTransformation. In both cases, a mild highlight extension was applied to prevent clipping. The bright comet head had a few minor blemishes in its outer margins and these were gently blurred using Convolution (with a mask). It then required a few iterations of the LRG-BCombination tool to find the right setting to combine the color and luminance data to produce the comet image.

Star Processing

The star processing was more conventional, similar to any RGB star image. The trick was to not over-stretch the image and maintain star color. The RGB image was softened slightly and the luminance data was sharpened using MaskedStretch. (The image was under sampled and not ideal for using deconvolution.) With a pleasing image

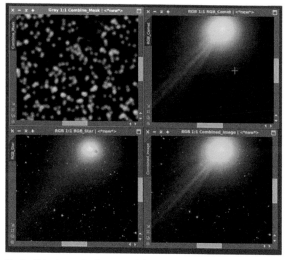

fig.6 *This shows the four panels laid up together, the star mask, comet image, star image and the final combination.*

of the stars but still showing a blurred comet, I created a tight star mask, using low growth parameters. In the final marriage, this star mask is applied to the comet image and the stars added with a PixelMath equation of the form:

$$iff\ (star_image > comet_image,\ star_image,\ comet_image)$$

This substitutes the star pixel values into the comet image, if they are brighter, and only in areas that are not protected by the mask. (The comet color is very green and some color hue shifts towards cyan were necessary to optimize the CMYK conversion for publication purposes.)

M27 (Dumbbell Nebula)

A lesson in observation and ruthless editing to improve definition.

Equipment:
250 mm f/8 RCT (2,000 mm focal length)
QSI 683 (Kodak KAF8300 sensor)
QSI filter wheel (Astrodon filters)
Starlight Xpress Lodestar off-axis guider
Paramount MX mount

Software: (Windows 10)
Sequence Generator Pro, ASCOM drivers
TheSkyX Professional , PHD2
PixInsight (Mac OSX), Photoshop CS6

Exposure: (HOLRGB)
Hα,OIII bin 1; 25 x 1,200 seconds,
L bin 1; 50 x 300 seconds, RGB bin 2; 25 x 300 seconds each

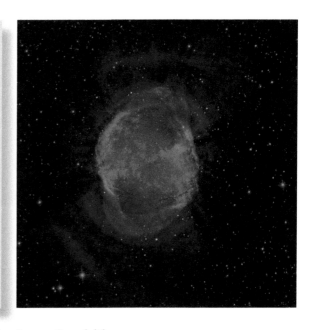

Planetary nebula, formed by an expanding glowing shell of ionized gas radiating from an old red giant, are fascinating subjects to image. Rather than form an amorphous blob, many take on amazing shapes as they grow. M27 is a big, bright object and was the first planetary nebula to be discovered and an ideal target for my first attempt. The object size fitted nicely into the field of view of a 10-inch Ritchey-Chrétien telescope. Ionized gases immediately suggest using narrowband filters and a quick perusal of other M27 images on the Internet confirmed it is largely formed from Hα and OIII and with subtle SII content. This assignment then also became a good subject to show how to process a bi-color narrowband image.

Lumination Rumination

The acquisition occurred during an unusually clear spell in July, and aimed to capture many hours of L, Hα and OIII, as well as a few hours of RGB for star color correction. As it turned out, this object provided a useful learning experience in exposure planning, for as I later discovered during image processing, the extensive luminance frames were hardly used in the final image and the clear skies would have been better spent on acquiring further OIII frames. It was a lesson in gainful luminance-data capture.

Image Acquisition

The main exposure plan was based on 1x1 binned exposures. Although this is slightly over-sampled for the effective resolution of the RCT at 0.5 arc seconds / pixel, I found that binning 2x2 caused bright stars (not clipped) to bloom slightly and look like tear-drops. The plan delivered 25 x 20-minute exposures of Hα and OIII and 50 x 5-minute luminances, along with 6 hours worth of 2x2 binned RGB exposures to provide low resolution color information. During the all-important thrifting process (using the PixInsight SubframeSelector script) I discarded a short sequence of blue exposures, caused by a single rogue autofocus cycle coincident with passing thin cloud. (I set Sequence Generator Pro's autofocus to automatically run with each 1°C ambient change. With the loss of half a dozen consecutive frames, I have changed that to also trigger autofocus based on time or frame count.)

During the image acquisition, it was evident from a simple screen stretch that both the Hα and OIII emissions were strong (fig.1). This is quite unusual; the OIII signal is usually much weaker and requires considerably more exposures to achieve a satisfactory signal to noise ratio. At the start of one evening I evaluated a few 20-minute SII exposures. These showed faint and subtle detailing in the core of M27 (fig.1) but for now, I disabled the event in

fig.1 *Visual inspection of the luminance candidates shows a remarkable difference in detail and depth. The Hα and OIII images both show extensive detail structures within the nebula and peripheral tendrils too. The SII data is faint by comparison and the luminance file, itself an integration of over 4 hours, admittedly shows more stars but lacks the definition within the core and misses the external peripheral plumes altogether. This suggests creating a luminance image by combining Hα and OIII.*

Sequence Generator Pro. At the same time, I should have looked more carefully at the luminance information: When you compare the definition of the three narrowband images with the luminance image in fig.1, it is quite obvious that the luminance does not really provide the necessary detail or pick up on the faint peripheral nebulosity over the light pollution. This is in contrast to imaging galaxies, in which the luminance data is often used to define the broadband light output of the galaxy and any narrowband exposures are used to accentuate fine nebulosity.

Linear Processing

I used the BatchPreprocessing script to calibrate and register all frames. Just beforehand, I defined a CosmeticCorrection process on an Hα frame to remove some outlier pixels and selected its process instance in the batch script. The narrow field of view had less incidences of aircraft or meteor trails and the image integration used comparatively high settings for pixel rejection. The MURE noise reduction script was applied to all the image stacks using the camera gain and noise settings

determined from the analysis of two light and dark frames at the same binning level. (This is described in detail in the chapter on noise reduction.) This algorithm has the almost remarkable property of attacking noise without destroying faint detail and is now a feature of all my non-linear processing, prior to deconvolution.

In normal LRGB imaging, it is the luminance that receives the deconvolution treatment. In this instance, the narrowband images are used for color and luminance information and the Hα and OIII image stacks went through the same treatment, with individual PSF functions and optimized settings for ringing and artefact softening. This improved both the star sizes and delineated fine detail in the nebula at the same time.

Non-Linear Processing

M27 lies within the star-rich band of the Milky Way and the sheer number of stars can easily compete and can obscure faint nebulosity in an image. To keep the right visual emphasis, a masked stretch was used as the initial non-linear transformation on the three "luminance"

files, followed by several applications of LocalHistogramEqualization applied at scales between 60 and 300 to emphasize the structures within the nebula. This combination reduced star bloat. The RGB files, intended for low-resolution color support and star color were gently stretched using the MaskedStretch tool and put to one side. One useful by-product of this tool is that it also sets a target background level that makes image combination initially balanced, similar in a way to the LinearFit tool.

Creating the Luminance File

A little background reading uncovered the useful Multichannel Synthesis SHO-AIP script. The SHO stands for SulfurHydrogenOxygen and it is from the French association of Astro Images Processing. The script by Bourgon and Bernhard allows one to try out different combinations of narrowband and broadband files, in different strengths and with different blending modes, similar to those found in Photoshop. In practice I applied it in two stages; the first to establish a blended luminance file and the second to mix the files into the RGB channels and automatic LRGB combination.

It is also worth experimenting by bypassing LRGB combination with the luminance channel if your RGB channels are already deconvoluted and have better

fig.2 *After some experimentation, I formed a luminance channel by just combining Hα and OIII. As soon as I included luminance information, the stars became bloated and the fine detail in the sky was washed out.*

fig.3 *Bubble, bubble, toil and trouble. This is the mixing pot for endless experimentation. On the advice of others, I did not enable the STF (Screen Transform Function) options. Altering the balance of the OIII contribution between the G and B channels alters the color of the nebula to a representative turquoise.*

definition. In this case manipulate the color file using its native luminance. This works quite well if the channels are first separately deconvoluted and had MaskedStretch applied to make them non-linear.

In the first instance I tried different weighting of narrowband and luminance to form an overall luminance file. The aim was to capture the detail from both narrowband stacks. There are various blending modes, which will be familiar to Photoshop users. I chose the lighten mode, in which the final image reflects the maximum signal from the weighted files (fig.2). The final combination had a very minor contribution from luminance (to just add more stars in the background) and was almost

entirely a blend of Hα and OIII (after than had been LinearFitted to each other). This concerned me for some time until I realized that a luminance file is all about definition and depth. In future, when I am planning an image acquisition, I will examine the luminance and narrowband files for these attributes and decide whether luminance acquisition through a clear filter is a good use of imaging time. When imaging dim nebula, I increasingly use the luminance filter for autofocus / plate-solving and use a light pollution filter for broadband luminance and combine with narrow band data to manufacture a master luminance file.

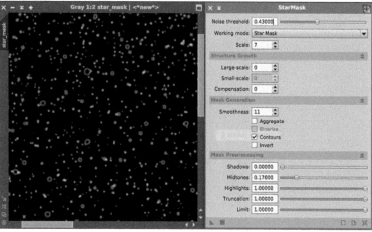

fig.4 *The myriad stars in the image can detract from the nebula. Here, I made a star contour mask, characterized by small donut mask elements. When applied to the image and the Morphological Transformation tool is set to erode, the star sizes shrink without their cores fading too much.*

Creating the RGB File

The second stage is the melting pot of color. Here I blended the OIII data into both Green and Blue channels (Green is Vert in French, hence the "V") along with some of the RGB data too (fig.3). After setting the OIII contribution to Green and Blue channels, I balanced the background with Green and Blue broadband data to keep the background neutral. This script does not have a live preview but hitting either of the two mixing buttons refreshes an evaluation image. The other options on the tool perform noise reduction and LRGB combination using existing PixInsight tools. Some typical settings are shown in fig.3.

Fine Tuning

The image still required further improvement to star color, background levels, sharpening, color saturation, noise reduction, and star size. The RGB channels were combined and tuned for star color before being linear-fitted to the nebula RGB image. This matching of intensities makes the combination process seamless. With a simple star mask and a PixelMath equation the star color in the nebula was quickly replaced with something more realistic.

The main image background was then treated with DynamicBackgroundExtractionand with the help of a range mask, the nebula sharpened using the MultiscaleMedianTransform tool (fig.5). Saturation was increased slightly and background noise reduced using TGVDenoise in combination with a mask. The star sizes were then reduced by making a star contour mask (fig.4) and applying a reducing Morphological Transform to the image. A gentle "S-curve" was then applied to the image to make it pop and as the image still had some

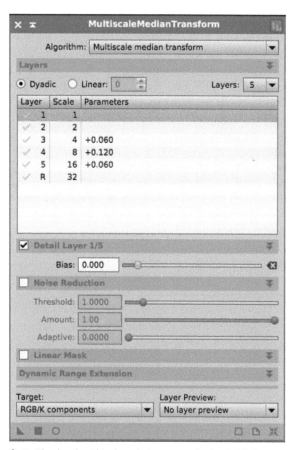

fig.5 *The details within the nebula were emphasized with the MMT tool, increasing the bias to medium-sized scales. Here, I used it with an external range mask that was fitted to the nebula and also excluded the brightest stars.*

intrusive background noise, further noise reduction, in the form of the MMT tool was carefully applied to dark areas. The resulting workflow is outlined in fig.6.

Summary

This is an interesting case study, that has encouraged me to think more carefully about image capture, taught me new tools and the subtleties of balancing truthful rendition with aesthetics. A key part of this was the re-alization that I had to optimize and process the separate narrowband files prior to combining them. There is no perfect interpretation and I explored some interesting variations before settling on the final image. For this ver-sion I simply used MaskedStretch to transform the linear images and after using the Multichannel Synthesis script to product the color image, I used HighDynamicRange-MultiscaleTransform (HDRMT) to enhance the details. This produced excellent definition in the nebula without resorting to multiple applications of LHE (interspersed with small range extensions with HT to avoid clipping). The image just needed a small amount of sharpening, a gentle S-curve to emphasize the faint peripheral nebulos-ity, a subtle increase in saturation and some gentle noise reduction in the background.

It may sound easy but the various processing attempts took many hours, so one should expect to try things out several times before being satisfied with the end result. If you have not already realized, the trick here is to save each major processing attempt as a PixInsight project, which makes it possible pick it up again on another day, or duplicate and try out different parallel paths from an established starting point. This may be useful if, in the future, I decide to dedicate a few nights to record SII exposures and create a tri-color image version.

fig.6 *The image processing workflow is deceptively simple here and hides a number of subtleties. First, all the files are de-noised with MURE immediately following integration and before any manipulation. The narrowband files are also treated schizophrenically, both as color files and also as the source of the luminance detail. Unlike many other examples in the book, the left hand workflow handles both the luminance and color information simultaneously. In the workflow opposite I have included the original luminance file for completeness, though in this case it was not actually used, but it may be of service with a different subject. The RGB broadband files were principally used for star color but were useful in balancing the background color by including them in the SHO-AIP script (fig.3).*

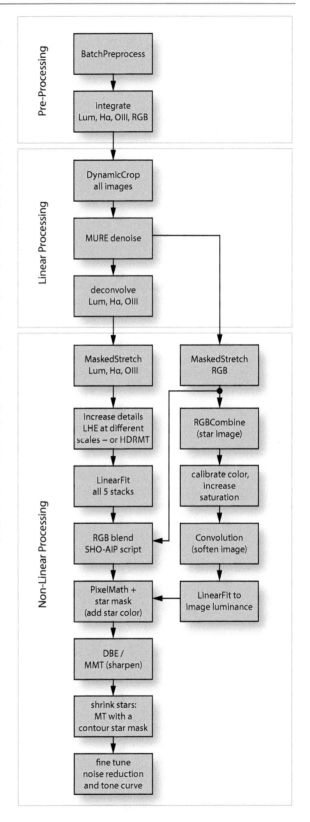

M3 (Globular Cluster), revisited

The journey continues; the outcome of 3 years of continual refinement.

Equipment:

250 mm f/8 RCT (2,000 mm focal length)

QSI 680 wsg-8 (KAF8300 sensor) Astrodon Filters

Starlight Xpress Lodestar guide camera

Paramount MX mount, on pier

Mk2 interface box, remote-controlled NUC

AAG Cloudwatcher, Lakeside Focuser

Software:

Sequence Generator Pro (Windows 10)

PHD2 autoguiding software (Windows 10)

TheSkyX Pro (Windows 10)

PixInsight (OSX)

Exposure: (LRGB)

L bin 1; 33 x 300 seconds, RGB bin 1; 33 x 300 seconds each

I think I said somewhere in Edition 1 that astrophotography was a journey and a continual learning process. Like many hobbies it has a diminishing return on expenditure and effort and I thought it worthwhile to compare and contrast the incremental improvements brought about by "stuff" and knowledge over the last three years.

Globular clusters appear simple but they ruthlessly reveal poor technique. If the exposure, tracking, focus and processing are all not just so, the result is an indistinct mush with overblown highlights. Moving on, nearly everything has changed: the camera, filters, mount, telescope, acquisition and processing software and most importantly, technique. In the original, I was keen to show that not everything goes to plan and suggested various remedies. Those issues are addressed at source in this new version, and some. It is still not perfect by any means but it certainly does convey more of the serene beauty of a large globular cluster. I had been using a tripod-mounted telescope and although I had optimized the setup times to under 20 minutes, with the vagaries of the English weather I was not confident to leave the equipment out in the open and go to bed. This placed a practical limit on the imaging time for each night.

This version of M3 was the first image from a pier-mounted Paramount MX in my fully automated observatory. The new setup enables generous exposures and at the same time M3 is an ideal target to test out the collimation of the 10-inch Ritchey Chrétien telescope. At my latitude M3 is available earlier in the summer season than the larger M13 cluster and provides a more convenient target for extended imaging.

Acquisition (Tracking)

The Paramount is a "dumb" mount in so much that it depends upon TheSkyX application for its intelligence. This software appears as a full planetarium, complete with catalogs. Under the surface of the PC and Mac versions, it controls mounts too and in the case of their own Paramount models adds additional tracking, PEC and advanced model capabilities. TheSkyX is also a fully-fledged image acquisition program, with imaging, focusing, guiding and plate solving. It has an application interface or API that allows external control too. The ASCOM telescope driver for TheSkyX uses this API to enable external programs to control any telescope connected to TheSkyX. In my configuration, I connect PHD2, Sequence Generator Pro (SGP) and my observatory application to this ASCOM driver.

The MX's permanent installation makes developing an extensive pointing and tracking model a good use of a night with a full moon. With the telescope aligned within 1 arc minute of the pole, it created a 200-point TPoint model. TheSkyX makes this a trivial exercise as the software does everything; from determining the sync points to acquiring images, plate solving, slewing the mount and creating and optimizing the models. Although the resulting unguided tracking is excellent it is not 100% reliable for a long focal length during periods of rapid atmospheric cooling.

Some consider unguided operation as a crusade; I prefer to use clear nights for imaging and I use the improved tracking as an opportunity to enhance autoguiding performance, using a low-aggression setting or

long 10-second exposures. The Paramount has negligible backlash and low inherent periodic error and is a significant step up in performance (and in price) from the popular SkyWatcher NEQ6. It responds well to guiding and when this is all put together, the net effect effectively eliminates the residual tracking errors and the random

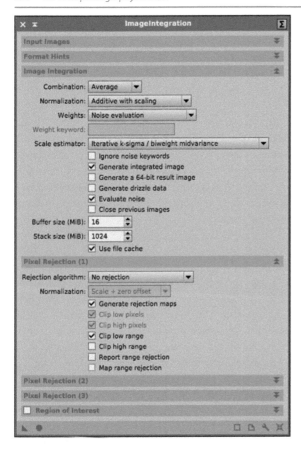

fig.1 *A worthwhile improvement in noise level is achieved by combining the luminance information from all four image stacks, weighted by their image noise level.*

effects of atmospheric seeing. In practice PHD2's RMS tracking error is typically less than 0.3 arc seconds during acquisition and well within the pixel resolution.

Acquisition (Exposure)

By this time a QSI camera replaced my original Starlight Xpress H18 camera system, combining the off-axis guider tube, sensor and a 8-position filter wheel in one sealed unit. Although both camera systems use the stalwart KAF8300 sensor, the QSI's image noise is better, though its download times are noticeably longer. More significantly, the sensor is housed in a sealed cavity, filled with dry Argon gas and the shutter is external, eliminating the possibility of shutter-disturbed dust contaminating the sensor surface over time.

For image acquisition I used SGP, testing its use in unattended operation, including its ability to start and finish automatically, manage image centering, meridian flips and the inclusion of an intelligent recovery mode for all of life's gremlins. In this case, after selecting a previously defined RCT equipment profile and selecting the

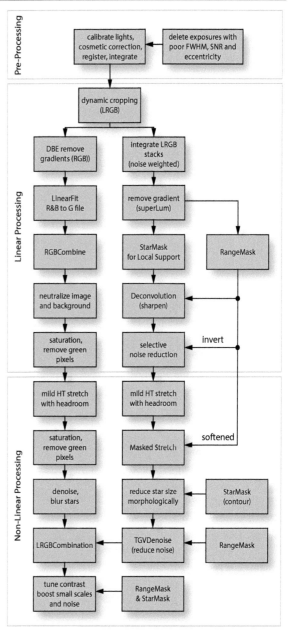

fig.2 *The overall image processing workflow for this new version of M3 is extensive and makes best use of the available data. It features a combination of all the image stacks to create a deeper "superLum" with lower noise and, during the image stretching process, ensures that the highlight range is extended to give some headroom and avoid clipping. This image also benefits from a more exhaustive deconvolution treatment, optimized for star size and definition. RGB color saturation is also enhanced by adding saturation processes before mild stretching and blending star cores to improve even color before combining with the luminance data.*

LRGB exposure parameters, I queued up the system to run during the hours of darkness and left it to its own devices. The ASCOM safety monitor and additional rain sensors were then set up to intervene if necessary and once the sequence had run out of night, set to save the sequence progress, park the mount and shut the roof. I monitored the first few subframes to satisfy myself that PHD2 had a good calibration and a clear guide star, good focus and to check over the sequence options one more time. (Most sequence options can be changed on the fly during sequence execution.) The next morning, to my relief, my own roof controller had done its stuff and the mount was safely parked, roof closed and the camera cooling turned off. On the next clear night, I simply double-clicked the saved sequence and hit "run" to continue.

The subframe exposures were determined (as before) to just clip the very brightest star cores. This required doubling the exposures to 300 seconds to account for the slower f/8 aperture. I also decided to take all the exposures with 1x1 binning, partly as an experiment and partly because the KAF8300 sensor has a habit of blooming on bright stars along one axis in its binned modes. The overall integration time, taking into account the aperture changes was 3.5x longer, which approximately doubled the signal to noise ratio. The sub-exposures were taken one filter at a time and without dither between exposures, both of which ensured an efficient use of sky time. In this manner I collected 11 hours of data over a few weeks and with little loss of sleep.

Acquisition (Focus)

It is critical with this image to nail the focus for every exposure. I quickly established that if the collimation is not perfect, an RCT is difficult to focus using HFD measurements. During the image acquisition period there were several beta releases of SGP trialling new autofocus algorithms. These improved HFD calculation accuracy, especially for out-of-focus images from centrally-obstructed telescopes. These new algorithms are more robust to "donuts" and exclude hot pixels in the aggregate HFD calculation. To ensure the focus was consistent between frames, I set the autofocus option to run after each filter change and for an ambient temperature change of 1°C or more since the last autofocus event. Of the 132 subframes I discarded a few with large FWHM values which, from their appearance, were caused by poor guiding conditions.

Image Calibration

During the image calibration process I discovered that my camera had developed additional hot pixels since creating an extensive master bias and dark library. I also became more familiar with the PixInsight calibration process, which does not necessarily simply subtract matching dark frames from subframes of the same exposure and temperature. The optimize option in the Master Dark section of the ImageCalibration tool instructs PI to scale the darks before subtraction to minimize the overall noise level. This sometimes has the effect of leaving behind lukewarm pixels. For those, and the few new hot pixels, I applied the CosmeticCorrection tool. Its useful real-time preview allows one to vary the Sigma sliders in the Auto Detect section to a level that just eliminates the defects. (An instance of this tool can also be used as a template in the BatchPreprocessing script to similar and convenient effect.) The master flat frames for this target used my new rotating A2 electroluminescent panel, mounted to the observatory wall (described in Summer Projects). Although the RCT has a even illumination over the sensor, its open design does attract dust over time. I used to expose my flat frames indoors using a white wall and a diffuse tungsten halogen lamp. Moving the heavy RCT potentially degrades its collimation and the pointing/tracking model and I now take all flat frames in situ.

These calibrated and registered frames were then integrated carefully, following the processes described in the Pre-Processing chapter and using the noise improvement readout at the end of the integration process to optimize rejection settings. The resulting four image stacks were then combined using the ImageIntegration tool once more to form a "superLum". The tool settings in this case perform a simple average of the scaled images, weighted by their noise level but with no further pixel rejection (fig.1). This superLum and the RGB linear data then passed into the image processing workflow laid out in fig.2.

Image Processing Highlights

By now, I am assuming your familiarity with PixInsight excuses the need to explain every step of the workflow. There are some novel twists though, to ensure that stars are as colorful as possible and the star field is extensive and delicate. In the luminance processing workflow, after careful deconvolution (using the methods described in the Seeing Stars chapter) the non-linear stretching is divided between HistogramTransformation and MaskedStretch tools, with additional highlight headroom introduced during the first mild stretch. Stars are further reduced in size using the MorphologicalTransformation tool through a contour star mask. This shrinking process also dims some small stars and their intensity is recovered using the MMT tool, to selectively boost small-scale bias (using a tight star mask). These techniques are also

described, in detail, in the "Seeing Stars" chapter. At each stage, the aim was to keep peak intensities below 0.9. A few bright stars still had a distinctive plateau at their center and these were selected with a star mask and gently blurred for a more realistic appearance.

The RGB processing followed more familiar lines, calibrating the color and removing green pixels. Noise reduction on the background and a light convolution (blur) was applied to the entire image followed by a more aggressive blur, through a star mask, to evenly blend star color and intensity.

The LRGBCombination process has the ability to change brightness and color saturation. It always takes a few goes to reach the desired balance. After LRGBCombination, the contrast was tuned with CurvesTransformation, using a subtle S-shaped luminance curve. The relative color saturation of the blue and red stars were balanced using the ColorSaturation tool. Finally, a blend of noise reduction and bias changes in the MultiscaleMedianTransform balanced the image clarity and noise levels.

fig.3 The original image from 2013, taken with a 132 mm f/7 refractor, 1.5 hours exposure, KAF8300 sensor, NEQ6 mount, processed in Maxim DL and Photoshop.

If you compare the images in fig.3 and fig.4, you will notice a big difference in resolution and depth. One might think this is a result of the larger aperture and longer focal length of the RCT. In practice, the resolution of the 250-mm RCT is not *significantly* better than the excellent 132-mm William Optics refractor, on account of the diffraction introduced by the significant central obstruction and the limits imposed by seeing conditions. What is significant, however, is the generous 11-hour exposure, accurate focus, better tracking and the sensitive treatment of the image processing to prevent the core of the cluster blowing out.

Those imagers who have the benefit of dark skies will certainly be able to achieve similar results with considerably less exposure. My semi-rural position still has appreciable light pollution. The associated sky noise adds to the dark and bias noise and necessitates extended exposures to average out. I also need to have a word with a neighbor, who turns on their 1 kW insecurity light so their dog can see where it is relieving itself!

fig.4 The revisited image from 2016, taken with a 10-inch truss model RCT, 11 hours exposure, KAF8300 sensor, Paramount MX mount, automated acquisition in Sequence Generator Pro and processed in PixInsight.

Exoplanet and Transit Photometry *– by Sam Anahory*

If you thought astrophotography was demanding, think again.

There has been a lot of interest recently on the idea of finding a "replacement Earth" planet, around a different star, to offer us the opportunity to begin exploring space in the widest possible context. Surprisingly, many amateur astronomers have proven that they can contribute to this search, and even engage in finding their own exoplanets. Sadly, unlike comets, international naming conventions mean that you cannot name a planet after yourself but still, the excitement of finding a new candidate exoplanet is hard to beat. Even better, you can do it from your back yard. The main advance in technology that has made this possible is the availability of CCD cameras, that have virtually no noise and use small pixels. Before we consider what hardware is required in detail, it is important to understand how one goes about discovering exoplanets.

There are a number of scientific methods used to discover and/or monitor new exoplanets. Given that most of us would struggle to take a decent photograph of Neptune or Pluto, even when they are within our own solar system, it would be unrealistic to attempt to photograph exoplanets directly. Even the HST at its best would struggle to take a direct image of a "hot Jupiter" in a star close to us, unless it was very lucky and various strict conditions were met.

The basic challenge is that the brightness of the host star swamps out the reflected light of any exoplanet in its orbit. This forces us to think outside the box and identify exoplanets by implication, rather than by direct viewing. There are two main methods of doing so, only one of which it is feasible for amateurs to carry out.

The Transit Photometry Method

This is by far the most effective method to find new exoplanets, and the majority of newly discovered exoplanets (particularly by space programs like Kepler) have been discovered this way.

Rather than look for the reflected light from an exoplanet, it relies on the fact that as an exoplanet orbits their host star, at some point, and if they are in the direct line-of-sight, the exoplanet obscures a small part of the host star as it transits. This causes a measurable drop in the light output, or flux, of the star, which cannot be explained by other means. In effect, as the exoplanet crosses in front of the host star, a "transit dip" occurs that continues for the life of the transit. At the end of the transit period, the host star's flux rapidly increases back to its normal value.

After discounting other causes (stars can vary in flux for a host of other reasons) the shape of the flux-curve indicates whether an exoplanet has crossed in front of its star. A typical transit curve looks like that in fig.1. It is characterized by a very fast small drop in flux as the planet crosses in front of the star, that extends for the period of time that the exoplanet partially occludes the host star. As the exoplanet exits occlusion, the flux returns quickly to its prior steady-state value.

The shape of the transit dip is the biggest indicator that an exoplanet has crossed in front of a star. If the shape is "messy", it may indicate that more than one exoplanet is crossing the host star at roughly the same time, or it could be the dip in flux is being caused by other means. Other explanations include binary or variable stars.

The second element that is an exoplanet give-away, is the period at which these dips occur. For example, if we see this distinctive dip on a regular basis, it indicates that the probable reason why a star's flux is being reduced, is because an exoplanet is regularly orbiting in front of it. If the period between dips is not regular, it becomes less clear that an exoplanet is responsible for that dip, since it becomes difficult to imagine a solar orbit that would cause an irregular dip in flux (although it could happen if an exoplanet had an erratic orbit).

For these reasons, most obvious exoplanets are identified by a clear, regular dip in flux at predictable intervals. This matches to the regular orbit of a large exoplanet that is orbiting very close to its host star; i.e. closer than the orbit of Mercury to the Sun. Invariably, such large exoplanets are called "super Jupiters" (likely having similar characteristics as Jupiter, but larger).

These exoplanets, collectively known as "hot Jupiters", are by far the most common exoplanet found so far. Unfortunately, many exoplanets are neither conveniently close to their host star or are very large in size, making it difficult to detect them (the dip in flux is extremely small and infrequent). For these exoplanets, the technology you use and the quality of the observations are critical for robust detection.

This means that as amateurs, although it is possible to identify exoplanets smaller than hot Jupiters, it becomes increasingly difficult to do so, since the relative drop in flux is much smaller and more difficult to measure precisely.

The Wobble Method

The second method to observe exoplanets, commonly known as the "Wobble Method", requires such detailed observations that at this time, it is mostly the domain of a space telescope system. It requires precise spectrographic data to measure minute changes in the velocity of the star, caused by the gravitational pull of its orbiting exoplanet.

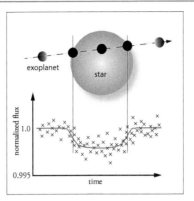

fig.1 This shows a "large" exoplanet transiting across its host star. As it passes in front of the star, the total light output (flux) dips sharply, plateaus and then increases sharply again to its prior level, as the exoplanet passes out the line of sight. The flux reduction is tiny compared to the measurement variation between individual samples (shown with x).

Differential Photometry

Before setting out to find hot Jupiters, one needs to understand how to go about it in some detail. It may seem easy enough but there are several pitfalls that catch out the unprepared. To accurately measure the amount of flux generated by a host star, we use a technique called differential photometry. If you have never done photometry before, do not worry, it is fairly straightforward; being realistic though, if you are not a proficient imager it is likely you will struggle to achieve reliable results.

This process also places high demands on equipment and before starting, one should check that you have the right calibre to make effective measurements. By and large, in order to observe and/or find new exoplanets, you ideally need the following, over and above regular imaging equipment:

- a high quality robotic mount, camera rotator and an auto-focus system
- a large aperture, quality optic (e.g. 14-inch+ Ritchey-Chrétien or Dall-Kirkham, or 6-inch refractor)
- quiet, small pixel CCD, (e.g. based on Sony HAD ICX834, ICX814 sensors)
- photometric filters (e.g. Johnson-Cousins V, B and Sloan g', r' i; Astrodon filters are recommended, since they are used by many NASA programs.)
- access to an exoplanet data reduction analysis tool: (e.g. one recommended by either the AAVSO or the BAA/RAS)

These will allow you to observe most exoplanets currently discovered (seeing-conditions permitting). If you do not have this level of equipment, however, one can still successfully observe known exoplanet transits, but only for the very brightest host stars.

Theory

This process consists of taking many, relatively short exposures using a low-noise CCD, ideally with very small pixels, before, during and ideally after the exoplanet transit. Although the general use of differential photometry does not necessarily require these CCD attributes, it makes life much easier if you do have them. At the same time, you need to be capable of taking exposures with minimal/zero drift, accurate tracking and be well-versed with plate solving, calibration and spreadsheets. As long as a single exposure does not over-expose a star, we can define a circle around each star, called an "aperture", that we use to measure the flux that it generated for each exposure.

In practice, each star is surrounded by a common-sized aperture, that defines the area of the star (or in fact the precise pixels within the star) that are used to calculate the star's flux measurement. Each star, at a near infinite imaging distance, should theoretically be a point of light. Optical effects (convolution) cause each star profile to be represented as a Gaussian blur (also called the point spreading function or PSF). The peak of the distribution represents the center of the star at its brightest point and as we move away from the center, the intensity rapidly drops. This continues until the star's flux is indistinguishable from the background sky flux and the star merges into the background, as shown in fig.2.

This aperture defines the common area around each star that we define "is part of the star". That is, we define a threshold and deem that everything above is part of the star, and everything below is not, and is part of the background sky. This may not be 100% accurate from a Physics standpoint, but it is accurate enough to enable us to perform the correct math.

To create a transit curve, similar to the one in fig.1, we measure the flux of the host star accurately in each image, allowing for any atmospheric differences that may occur at the time. The easiest way to do this is not by measuring an absolute flux of a host star (target star) but the relative change, or flux delta, from one image to another.

To do this, we measure the total flux of all pixels deemed to be part of a star, and compare it to the flux generated in a different *comparison star*, which we know to be stable and invariant. For example:

- If most stars dim by 0.01% from one image to another, the dimming is probably caused by atmospheric changes.
- If only the host star dims by 0.01% from one image to another, then it is more likely that the dimming is caused by an exoplanet transit.

The comparison star's flux is used as the baseline measurement from one image to the next. If we always adjust the flux of the host star to make it relative to the comparison star, then it automatically compensates for changes in flux caused by other environmental factors. In this way, it can produce a numeric value of the flux generated by the host star from image to image, that excludes all factors, other than the host star dimming due to an exoplanet passing in front of it. This logic holds true as long as the comparison star is close to the host star, of similar surface temperature and of the same spectral type. In plain English, this only works if we compare apples with apples. So for example, if you use a comparison star that has a different color temperature, you will introduce an unknown variable into the comparison process, rendering the results unreliable and invalid for submission.

Acquiring Images

Let us assume you have decided to try this exciting pursuit by testing your observing skills on a known exoplanet. Unlike long-exposure imaging, or even regular variable-star photometric observations, exoplanet photometry is more challenging because the flux variation from the bottom to the top of a transit curve is usually 0.2% or less. In fact, since it requires multiple images across the transit period, it is potentially measuring milli-magnitude values; tiny changes in flux from one image to another, which are difficult to differentiate from the background noise generated by the camera and sky noise.

Having said that, if one follows the following process, you can achieve clear and value-adding exoplanet transit curves. It is essential to test your process on known exoplanets before trying to attempting to find new ones.

Once you can replicate the accuracy of the transit curves produced by professionals, you can then start searching on your own. The remainder of this chapter assumes you initially observe a known exoplanet.

Identify Which Exoplanet to Observe

It may seem trivial but you would be surprised at the number of amateurs who select an inappropriate exoplanet and then struggle. Most amateurs use the following websites to select (known) exoplanets: NASA, the Exoplanet Transit Database (ETD) and other more specific ones e.g. the AAVSO exoplanet database. Each database usually predicts when a transit will occur for a given latitude and longitude, the depth of the transit and its duration. Use this information to plan the observing session, allowing for any visual obstructions as you track the star and in particular, planning for meridian flips.

To correctly observe a transit, one not only needs to choose a host star with a known transit during your observing session, but also conform to the following conditions:

- The observing session captures the transit itself and a minimum of one hour on each side of the transit (two hours are better). This monitors the star when the flux-curve is flat and reveals when the flux-curve drops, making the transit curve more obvious.
- Select an exoplanet which has the largest delta in flux, i.e. has the deepest transit available to your location. This makes the measurement process easier, and since you are attempting to discover how the process of observing exoplanets operates, this significantly simplifies matters. Unless you have a 14-inch telescope (or larger) avoid selecting smaller "rocky Earths" sized exoplanets, where the corresponding dip in flux is closer to 0.06% or less.
- Select an exoplanet where the host star's magnitude is within the visible range of your optics. It is difficult to observe a host star of magnitude 8 or 9, with a 14-inch telescope, as the star is easily over-exposed. Conversely, the intensity of a magnitude 13 host star with a 6-inch refractor is too weak and requires a long exposure to achieve an acceptable SNR (8/10 or better). This reduces the number of image events during the transit. Determine the brightest star magnitude that does not over-expose the CCD after an exposure of 60 seconds or so.
- Set the exposure within sensible limits, ensuring it does not saturate the CCD. If a transit's elapsed time is 2 hours, 10-minute exposures are too long. Equally, short exposures of less than 5 seconds are not recommended either, due to exposure inconsistencies.

- Most CCDs become non-linear before they reach their maximum ADU. If a target or comparison star flux measurement becomes non-linear, a comparison is no longer valid. Fine-tune the exposure to keep all within the linear region; a rule of thumb assumes Sony HAD CCDs are linear up to about 85% of their ADU range and Kodak CCDs up to about 40–50%.

Setup Equipment for Photometry

Unlike long-exposure imaging, photometry requires one to be very careful about the quality of the captured data. In essence, whereas a galaxy or nebula is unlikely to change from night-to-night (unless there is a super-nova of course), an exoplanet transit will be changing every minute, so the tricks of the trade you might use to image deep sky objects, are not valid for imaging exoplanets.

Optimize Signal to Noise Ratio (SNR)

An image of a galaxy or nebula can be enhanced by taking many hours of images, to increase the SNR to 8/10 or better. Although it is possible to observe exoplanet transits with an SNR of 7/10, it is not recommended, since it is very close to the noise level of current CCD technology.

The process that calibrates, registers and integrates multiple images to produce a single image with a high SNR is not appropriate for exoplanet observing, as the host star's flux will be varying second by second. The act of integrating multiple images averages the flux and introduces an approximation error that is virtually impossible to deconstruct later.

The aim is, however, to achieve a SNR of 8/10 or better, without integrating multiple images. This can be achieved partially by the use of low-noise CCDs, but also, through the use of calibration files taken in-situ.

Create Flats Before Session

It is good practice to take flats in advance of the session, with the rotator and camera in their observing session positions (angle and focus extension). Ideally, these flats can be used, together with a second set taken post meridian-flip, to calibrate the images from either side of the meridian.

Create Bias and Dark Frames Mid/Late Session

For normal imaging it is common practice to re-use bias and dark frames between sessions, for up to two or three months at a time or longer. It assumes the CCD does not vary significantly during this period. For exoplanet observing it is imperative to capture bias and dark frames, with conditions as close as possible to those when the data images were taken. This typically requires capturing calibration frames just before or after a transit observing session, so that the camera's electronic characteristics are identical to those during the data capture process.

It is critical that bias and dark frames are taken with the same duration and CCD temperature setting as the data images. As a consequence, this occurs after the exact exposure duration (that balances over-exposure and a decent SNR) has been established.

Select Photometric Filters

Although one can perform exoplanet observing with regular RGB filters (particularly R), in practice, it is much more valuable if you use photometric filters designed for scientific use. Many filter options exist, but it is useful to have what we refer to as the APASS photometric filter set. APASS is the most accurate photometric star survey carried out to date (by the AAVSO), with the aim to identify all stars that can be used as comparison stars across the entire sky.

APASS used a specific set of Astrodon filters, specified to be Johnson-Cousins V and B filters, and Sloan g', r' and i' filters. For ease of comparison, it makes sense to use the same filter set. The UCAC4 database contains highly accurate magnitude values through those filters, for the 56 million APASS stars, making the task of finding a reliable comparison star much easier. In practice, if one uses any filter other than blue, it will maximize the result of observing an exoplanet. (Blue light is absorbed by the atmosphere, so the flux data captured for a star can be compromised by atmospheric absorption.) This is why some amateurs use Johnson-Cousins R, or Sloan r' (red) photometric filters, or the Astrodon non-blue exoplanet filter.

Select the Correct Field of View

The selection of the correct comparison star is critical to the generation of accurate and reliable transit-curves. To this end, it is important that the CCD's Field of View (FOV) is positioned so that it allows one to simultaneously capture target star data as well as identifiable and appropriate comparison stars. In some cases, depending on the size of the FOV, it may require an off-center target host star, to include **nearby** comparison stars of a **similar surface temperature,** of the **same spectral type** and which are **not variable stars.** The transit period should also occur within the observing period.

Select the Correct Exposure Time

For the same reason as selecting the appropriate field of view (i.e. the inclusion of comparison stars), the exposure time is carefully optimized so that it maximizes the number of photons captured during each image, without

exceeding the linearity limit of the CCD. Assuming that your CCD's linearity-loss point (the ADU value, above which the sensor response is non-linear) has been correctly calculated, **the final exposure must not have any pixels, within a target or comparison star, that exceed this ADU value.** Since these stars may significantly vary in magnitude, select an exposure time that creates the correct balance between not over-exposing any star, and maximizing the number of photons captured per pixel for the target's host star.

For example, let us assume the target's host star magnitude is 13.2, there are several nearby comparison stars that range in magnitude from 12.0 to 13.0 and the full depth of a transit curve, results in a 0.2% magnitude change. The target star's pixel ADU, will similarly vary by 0.2%. Assuming the CCD's linearity will only allow you to measure ADU values up to 55,000, then in order to not over-expose *any* comparison star, the maximum target star ADU is:

$$55,000 / 2.5^{(13.2-12)} = 18,316$$

and the maximum transit depth ADU is:

$$18,316 \cdot (0.2/100) = 36$$

To continue the example, assuming an exposure duration of 30 seconds and a transit egress of 30 minutes would acquire 60 exposures over the transition period. The ADU variance is as low as 36/60 = 0.6 ADU between exposures. This value is below a point where it can be reliably measured since ADUs are integer numbers produced by measuring photons hitting the pixel surface.

In this example it is better to discard the brightest comparison stars, and keep those that are closer to the target's host star magnitude, to achieve a typical target star ADU count closer to 45,000. Applying the same equation gives us a measurable variance of 90/60 = 1.5 ADU between exposures. As a general guideline select an exposure time that produces a target host star ADU count per pixel in the range 40,000–50,000 (assuming CCD linearity continues to 55,000) and at the same time ensures the comparison star(s) are below 55,000 ADU.

Accurately Locate and Center on Target

Simply put, slew to the host star, plate-solve, re-position as required to capture the correct comparison stars, rotate the camera as necessary to bring the comparison stars and guide star into the FOV and autofocus. It is assumed that the guider is already calibrated and the telescope is auto-focused correctly to produce the sharpest possible

exposures, although it is not strictly necessary. (Some observers deliberately de-focus bright stars to avoid over-saturation of pixels, but this can introduce a unique set of variables that cause difficulties later on.)

Expose Images

Take many (500+) short star images (typically less than 60s) and manage the meridian flip. It is important to ensure the host star is in exactly the same position during the observing session (for each side of the meridian) and for that reason, disable any dither functions between exposures. Plate-solvers are common-place but they are not all created equal. Use the most accurate plate-solver available, and one that can use the UCAC4 catalog (it is the most accurate to date and it has the added benefit of including the 56 million-star APASS catalog in full).

Manage the Meridian Flip

If your acquisition program does not automatically flip, plate-solve, self-center and rotate the camera to pixel precision, trap the flip before it happens and manage the meridian flip manually. This includes optionally rotating the camera, plate solving and slewing the mount to an identical observing position and continuing the imaging sequence. If the observing session requires a meridian flip, remember to take additional flats with the camera at that position (e.g. dawn flats at the end of the observing session). Note that some practitioners rotate the camera back to the same orientation, post meridian flip, to remove the effect of any potential CCD variation across the sensor surface. It is something worth testing with an experiment.

Take Bias and Dark Frames

Allow 20 minutes or so to take a minimum of 16 bias and 16 dark frames (at the same time and temperature as the observing session). Clearly, it is not advisable to capture this data during the ingress or egress of the transiting exoplanet, but they can be taken while the exoplanet is fully occluding the host star, or just before/after the transit itself. Flat frames are not particularly temperature dependent (on account of the short exposure) and most analysis tools will produce dark-flats for your flat frames.

This is one reason why Sony HAD CCDs are preferred for observing exoplanets. They have a read noise of under 1.5 electrons (compared to a typical 8 or 9 electrons of a Kodak 8300 CCD) and a very low dark current. In practice, a slight camera temperature variation during the observing session should not be a concern. Typically, with Sony HAD cameras, once the camera is below -15°C, any temperature fluctuation produces negligible dark-noise variation.

Remember to take flat frames before and after the observing session, on each side of the meridian flip and with the camera at the precise orientation that it was at each stage in the observing session. Some practitioners have attempted to use artificial LED light sources in the middle of an observing session, with limited success. Its light output does not match the broadband spectrum of pure white light.

Analyzing the Data

The process of creating a transit curve from the captured data is relatively simple, as long as one consistently follows the process steps. Unlike imaging galaxies or nebula, the analysis of these exposures is working with very small variations in the flux of a star (or stars) and it is critical that any possible errors created by variations in the sky quality, the CCD and the optics are removed. Carefully follow the steps in order to generate an exoplanet transit curve (using photometric nomenclature, the exoplanet's host star as referred to as the target star).

Identify the Stars Against a Known Star Catalog

This first stage is necessary so that we identify the target stars as well as the comparison stars that we use as a baseline. As previously discussed, differential photometry is the process in which the flux of a target star is compared against that of a suitable comparison star. By measuring the difference in target star flux output between one image and another, we can produce a flux curve for that particular target star. Unless we are lucky enough to be using an orbiting telescope, however, the sky quality will vary slightly during the observing session. For example, if a small cloud passes across the FOV during an exposure, some or all of the stars in the image will appear less bright (and possibly with a brighter background too) than in the exposures where there was no obscuration.

To make matters worse, sky quality can additionally vary if there is turbulence or high levels of humidity in the upper atmosphere. These events are usually invisible to the naked eye, but are sufficient to partially obscure the stars in the image, creating a noticeable dimming effect. Since the target flux variances are very small (~0.2%) we must compensate for atmospheric and seeing changes. This is the purpose of differential photometry and requires the observer to determine the published magnitude of a comparison star, measured through specified photometric filter(s).

Most older star catalogs contain information on the brightness (or magnitude) of the star, measured using Johnson-Cousins filters (usually B and V). More recent star catalogs are comprised of sky surveys that used the more accurate modern photometric filters; usually the Sloan u', g', r', i' and z' filter set.

In practice, it is recommended that you utilize the UCAC4 star catalog, which contains sufficient detail to identify most stars in your field of view for telescopes up to 400–500 mm aperture, for photometric filters B, V, g', r' and i'.

As mentioned earlier, always use the most accurate star catalog and plate-solver. Although most plate-solvers work well in a dense starfield, choose one that also performs well with a handful of bright stars in an image. It is not uncommon for substantial errors to creep in, which result in the incorrect identification of stars that are in close proximity to one another.

Some applications attempt to simplify matters by allowing one to measure stars without identifying them first. More specifically, having identified the stars in the first image, its assumes that each star will remain at exactly the same position from one image to the next. Be wary of this, as it requires perfect mount tracking (no drift or PE) over the entire observing session. In practice, it is easier to allow the mount to drift slightly during the observing session, and then use an application that uses accurate plate-solving to correctly identify the stars in each image.

Identify the Target Stars

This activity is straightforward, providing one has executed an accurate plate-solve. First, look up the catalog number of the star in question and locate it on the plate-solved image. (You can alternatively compare a star map to the image in front of you, and determine which star is which.)

Simple photometric analysis tools can produce a flux curve, after manually selecting the stars you are interested in (by visual comparison to a star map), but they are not terribly accurate, and can be easily out-witted. In many cases, if you meridian flipped halfway through the observing session, the application will not realize that the stars are in completely different positions, and will produce some very peculiar-looking transit flux curves. When measuring exoplanet flux curves, it pays to be cautious, pedantic and thorough.

Identify the Comparison Star(s)

As discussed earlier, the way in which differential photometry negates any seeing or atmospheric effects, is by measuring the target star's difference in flux when compared to a specified comparison star, from one exposure to another. This assumes that if the seeing or atmospherics have changed from one exposure to another, all stars in

the field of view, or at least stars close together, will be affected in the same way. In fact, the equations for differential photometry can be proven mathematically to be highly robust, providing they follow these guidelines, repeated here for clarity:

- the comparison star is the same stellar type as the target star
- the comparison star has the same stellar surface temperature as the target star
- the comparison star is close to the target star

In practice, rather than comparing surface temperatures of each star, we measure and compare particular color intensities. Specifically, we measure the difference in star magnitude for the same star through two known photometric filters. A common metric used is the difference between the blue and green color measurements for a given star; which using Johnson-Cousins filters, equate to:

B - V = relative color ≈ relative surface temperature

If the target star has a very different B - V value to the comparison star, it indicates they have very different surface temperatures. In this situation, the normal differential flux comparison equation will fail, as it assumes that the target and comparison stars have similar surface temperatures, hence the recommendation to select comparison and target stars with a similar B - V value.

Similarly, measurement accuracy improves by selecting comparison stars that are close to the target stars. Close stars are more likely to vary similarly with atmospheric obstructions and transmission. An important element of the differential photometry equation is the altitude of each star, which is compromised if the comparison star has a substantially different altitude to the target star. Starlight is absorbed and scattered by the Earth's atmosphere and passes obliquely through more atmosphere at lower altitudes. At the same time select frequencies of light are progressively attenuated (this is why the Sun appears red near the horizon). It is important to avoid the situation where the flux from the target and comparison stars are dissimilarly affected by atmospheric affects.

In practice, it is a good idea to select more than one comparison star to use against a single target star. Using the flux data from multiple valid comparison stars improves the SNR measurement of the baseline flux, which in turn improves the target star's flux difference measurement robustness. In other words, the more the merrier!

Finally, do not forget to ensure that each comparison star has a valid star catalog magnitude value and is consistent with the photometric filters used during the observing session. If the tool has not correctly extracted the magnitude value from the catalog, find the value using an offline resource and enter the value manually. For our purposes, the precise magnitude of the exoplanet flux curve is less important than evidencing the characteristic transit dip in the magnitude measurement.

Identify the Check Stars

Check stars are treated in the same way as target stars, with one exception; you use them to check that the comparison stars are good enough to enable the production of a reliable flux curve. In theory, if the data capture process has been executed correctly, then applying the differential photometry algorithm and processes to the check stars should produce flux curves that match the expected flux curve and magnitude. In this way, you can confirm that all aspects of the data analysis process are working as they should.

Having analyzed all the exposures and confirmed the stated magnitude for each comparison star is accurately reflecting the catalog value, implies that your analysis and process is sound. Moving on, any exoplanet flux curves produced from the data reduction process are more likely to be accurate and reliable. As with comparison stars, select check stars that are similar to the target/comparison stars in terms of stellar type and color temperature and are not known variable stars. Choose those with a transit within the observing period for this analysis.

Determine the Star Flux Measurement Aperture

The final element is to determine how much of a star's area should be included in the calculation of star flux. We know the image of a star represents the visual description of a point light source (i.e. the stars are at optical infinity relative to Earth). It appears as a Gaussian blur; brightest at the center point, with surrounding pixels dropping off in brightness with their distance from the center. When the ADU value of each pixel drops to the background sky level, we visualize this as the boundary of the star. Bright stars appear "fatter" than faint ones, and occupy a larger number of pixels on the image.

For this reason, we utilize a mathematical calculation of how big a star is, to represent at what point do we distinguish between pixels being part of a star, and pixels being part of the background. Commonly, the Gaussian blur is assumed symmetrical and a slice through the middle produces an intensity profile resembling a Gaussian curve. (If you are looking at a stretched 16-bit image, the apparent

boundary of the star will vary, depending on the scale of the image stretch.) In practice, we use two common metrics to define the boundary of a star, those being:

- Full Width Half Max: the point at which the pixel ADU value is less than 50% of the maximum ADU value of any pixel in the star (i.e. the star center)
- Half Flux Diameter: the point at which the ADU sum of all the pixels inside the star, equal the ADU sum of all the pixels outside the star. It follows that this only works when you define an arbitrary outer boundary for the outside of the star.

We commonly use the FWHM value to indicate if a star is in focus or not (an out-of-focus star generates a larger FWHM value). Once a star is in focus, the FWHM value reduces to a minimum, set by the constraints of optics and the seeing quality of that location. Pin sharp stars will never be exactly one pixel in size and we will always see a fall-off from the center of the star in light intensity. Understanding what constitutes the boundary of a star is a critical factor in the analysis; without knowing where the star's boundary is, we do not know which pixels to include in the flux measurement.

As described earlier, most data reduction/photometric applications will ask you to define a circular boundary or "aperture" of the star; in which the ADU values of each pixel are measured. In order to compare robustly, we must select an aperture value that is applied identically to all the stars being measured. (Recall the target and comparison stars will be of similar magnitudes.) Many academics have analyzed at length what the optimum boundary point might be, for amateurs, a good starting point is:

aperture = 1.44 . FWHM (of largest measured star)

A critical element in the calculation, is the extent to which those pixels on the boundary are fully measured (partial pixels). This requirement is not supported by all analysis tools but is required to match the translation of a perfect circle into the orthogonal pixel grid on the CCD surface. (For example, a simple 9-pixel group is square, not a circle). Several photometric data reduction tools, used for detecting exoplanets, were originally designed for the analysis of variable stars. The common approximations made by these tools do not significantly affect the measurement of variable stars but introduce large errors into the more demanding analysis of exoplanet flux curves. It is a good idea to check that the data reduction tool you use properly accounts for partial pixels.

Determine the Background Sky Flux

The temperature of interplanetary vacuum is never at absolute zero and any pixels that represent the background sky (i.e. the space between stars), will by definition have a non-zero flux value (even in zero light pollution). For the differential photometry equation to be effective, it must calculate and allow for the element of a star's flux that is actually due to the background sky flux.

Differential photometry uses a circular area outside the star's aperture to measure the sky flux. This area is separated from the aperture by a thin annulus, a no-man's land in which the pixels are not used for any measurement. The outer circular boundary forms another annulus, the pixels of which are selected to measure the sky flux (fig.2). This is done by measuring the ADU values within the outer annulus and calculating the mean ADU value per pixel. This value is defined as the sky background radiation and is deducted from the calculated background ADU value from each pixel that makes up a star (i.e. the pixels within the aperture) before summing up the ADU values and comparing them to the adjusted ADU values in the comparison star. In practice, the tool does not actually compare star ADU values; they are all converted by a mathematical equation into star magnitude values. It is these magnitude values that are compared between the target and comparison stars. Having multiple comparison stars requires us to repeat the process for each comparison star, and calculate a mean magnitude to compare against the calculated magnitude of each target star.

In practice, the important thing to remember is that:

- Select an aperture that fully encloses the largest star that is being measured.
- Define a thin spacing between the aperture and the start of the annulus.
- Select an annulus that does NOT include pixels that form part of other stars.

Remember, these aperture values apply to *all* stars being measured and must be chosen with care. Most applications allow you to visualize what each aperture and annulus will look like on each star being measured; check that they do not inadvertently include partial elements of other stars within the annulus (this inflates the background sky flux value and will artificially reduce the flux calculation of that star). Conversely, avoid making the aperture too small as it may exclude flux elements of the star being measured. This is very easy to do if the stars are of substantially different size or area and will generate "static" star flux values between exposures, as

a significant percentage of a star's pixels are not being measured.

A careless selection at this point, that includes the wrong bits of stars, generates major discrepancies in the analysis. In practice, most amateurs will repeatedly recalculate exoplanet flux curves, by changing the values of the aperture and annulus. The difference in results, between a set of aperture and annulus values to another, has to be seen to be believed. This is why some more modern applications dispense with the definition of an annulus altogether, and apply complex mathematical equations to correctly deduct the flux value of all stars from the image (pixel by pixel). This technique is extensively used by professionals but can largely be ignored for our purposes, as long as the data reduction tool you use is capable of performing this function for you.

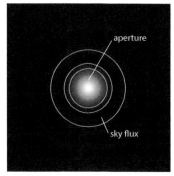

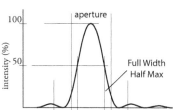

fig.2 This pictorial shows a typical star image and its intensity profile. Although technically the Airy pattern, the central profile is principally a Gaussian curve. Here the flux measurement aperture is set to 1.44x the FWHM value and an outer annulus used for the sky background flux measurement. The thin annulus between these is excluded from either measurement. As the circle becomes smaller, the measurement software needs to consider the orthogonal pixel approximation to a circle and compensate by using a proportion of the boundary pixel values, referred to as "partial pixels".

Measuring Flux of the Target Stars etc

Having done all the above, the last stage is repetitive and is best left to the automatic data reduction tool. Each exposure is analyzed as above, using the values set for star aperture and annulus. The ADU value per target and check star is converted into a magnitude value, and is compared against the mean magnitude value of the comparison stars. To compare exposures of differing duration (which will produce brighter/fainter stars) the flux values are converted into a flux value per second of exposure. This ensures a robust comparison (again, as long as none of the stars are over-exposed).

Once a calculated magnitude value is generated for each target and check star, based on the relative value of flux in the comparison stars, it is plotted on a time axis. The flux curve is then examined to see if one can spot the characteristic exoplanet dip, corresponding to the start of an exoplanet transit; the period when it is fully in front of the star, and the period when it is exiting the star.

In practice, it is common to run this analysis stage several times using the same data but differing selections for comparison and check stars. The investment in analyzing the data in various ways, improves the certainty that the flux curve has the highest degree of accuracy.

Best-Fit modeling

The final stage in the process, applies complex "best-fit" modeling techniques to predict if what appears to be an

exoplanet flux curve, is actually an exoplanet transit. This is also referred to as Procrustes modeling, named after the mythological Greek hotelier who used to chop off the extremities of any individual unlucky enough to overhang his deliberately small hotel bed. In other words, it "forces" the data to fit the constraints.

Modeling is a powerful technique that statistically correlates data against an assumed outcome or model. It is not cheating, as the output additionally indicates the probability of the data fit to the model. Different analysis tools do this differently, and it is best to familiarize yourself with how your specific tool operates. If in doubt follow the advice of the AAVSO or BAA/RAS exoplanet groups.

And Finally

If you have got this far, you will have produced one or more exoplanet flux curves to rival the results produced by the professionals. The surprising aspect to this activity, is the ease in which amateurs can produce complex astronomical analyses, purely using the equipment we have had for producing amazing astronomical pictures. Frame the flux curve; you are now one of a small number of amateur astronomers worldwide who can correctly identify exoplanets. Examples of professional data curves can be found on the NASA Exoplanet Archive website:

http://exoplanetarchive.ipac.caltech.edu

If you have overwhelmed your PC with data and your brain hurts, why not try astrophotography, it will now appear easy by comparison ;)

NGC1499 (California Nebula Mosaic)

My first mosaic, using special tools in Sequence Generator Pro and PixInsight.

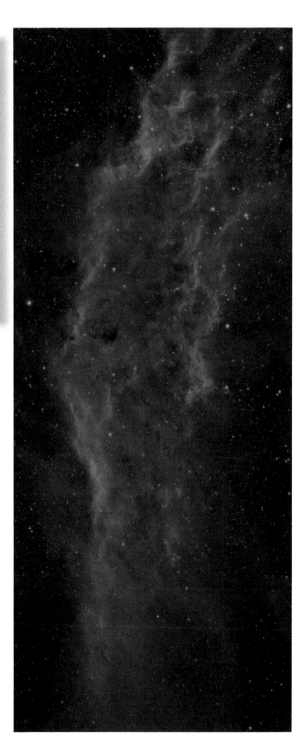

Equipment:
Refractor, 132 mm aperture, 928 mm focal length
TMB Flattener 68
QSI683wsg, 8-position filter wheel, Astrodon filters
Paramount MX
SX Lodestar guide camera (off-axis guider)

Software: (Windows 10)
Sequence Generator Pro, ASCOM drivers
TheSkyX pro
PHD2 autoguider software
PixInsight (Mac OSX)

Exposure (for each tile): (LRGBHα)
LPS P2 bin 1; 15 x 300 seconds, Ha bin1; 5 x 1,200 seconds
G&B bin 2; 10 x 300 seconds, R bin2; 15 x 300 seconds

It is one thing to take and process a simple mosaic, comprising of a few images, and quite another when the tile count grows and each is taken through 5 separate filters. Not only does the overall imaging time increase dramatically but so does the time taken to calibrate, register and process the images up to the point of a seamless linear image. This 5-tile mosaic image in LRGBHα had over 300 exposures and 25 integrated image stacks, all of which had to be prepared for joining. When you undertake this substantial task (which can only be partially automated) one quickly develops a healthy respect for those photographers, like Rogelio Bernal Andreo, who make amazing expansive vistas.

One reason for taking mosaics is to accomplish a wide-field view to give an alternative perspective, away from the piecemeal approach of a single entity. The blue nebulosity of M45 for instance is all the more striking when seen in context to its dusty surroundings of the Integrated Flux Nebula (IFN). In this assignment, I chose to do a mosaic to create an unorthodox framing, with 5 images in a line, following the form of the long thin California Nebula (NGC1499) some of which is shown opposite. With a range of star intensities and varying intensities of nebulosity, it is a good example to work through in order to explore mosaic image acquisition and processing in practice.

fig.1 This shows the outcome of the mosaic planning wizard in Sequence Generator Pro, shown here in its latest livery. After running the wizard, an option retains the mosaic overlay on a Deep Sky Survey (DSS) image, which SGP downloads for the region of interest. This image is kept with the sequence file for reference. This mosaic planning wizard makes target planning extremely easy, without resorting to external applications.

fig.2 Following on from fig.1, the mosaic planning wizard auto-populates a target sequence with the RA/DEC coordinates of each tile, allowing the options to slew and or center for each. It is an easy task to design the exposure plan for one target and use SGP's copy command to populate the others. In this example, I reversed the target order so as to maximize the imaging time, as the object rose and set over the horizon.

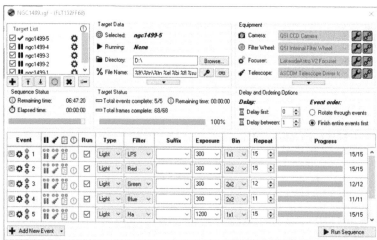

Image Acquisition

The images were taken with a 132-mm refractor, fitted with a non-reducing field flattener. Using the mosaic tool in SGP (fig.1) I planned the mosaic over a monochrome image from the Deep Sky Survey (DSS) using 5 overlapping tiles. SGP then proceeded to create a sequence with five targets. I chose to image through an IDAS LPS-P2 light pollution and Hα filters (unbinned) and added general coloration with binned RGB exposures (fig.2). The nebula emerges end-on over my neighbor's roof. By reversing the target order, it allowed me to maximize the imaging time; by starting each session with the emerging end and finish on the trailing one, as it disappeared over the western horizon. I used moonless nights for the LRGB images and switched to Hα when there was more light pollution. To ensure accurate framing to within a few pixels, I used the new sync offset feature in SGP. (SGP has always offered a synchronization feature that uses the ASCOM sync command. Some mounts, however, do not support this command, as it can interfere with pointing and tracking

models, and in common with some other acquisition packages, SGP now calculates the pointing error itself and issues a corrective slew to center the image to the target.)

Linear Processing

The overall process flow is shown in fig.9. It concentrates on the specific mosaic-related processes up to what I would consider are normal LRGB processing activities (starting with color calibration, deconvolution and stretching). Following the standardized workflow for merging images, outlined in the mosaic chapter, each image was calibrated, registered and integrated to form 25 individual traditional stacks. (The binned RGB images were registered using B-Spline interpolation to avoid ringing artefacts.) After applying MureDenoise to them (noting the image count, noise, gain and interpolation method in each case) I cropped each set and carefully calibrated the background levels using DynamicBackgroundExtraction. There were only a few background samples selected on each image on account of the

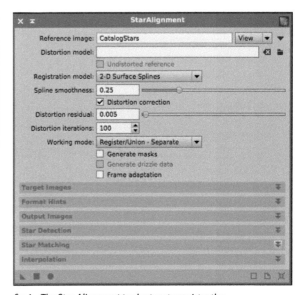

fig.3 *The Catalog Star Generator is used to create a starry image covering the mosaic extent. The benefit of this approach over generating one from combining image tiles is that image distortion is well controlled and it resolves any issues arising from minimal image overlaps.*

extensive nebulosity. I placed sample points near each image corner, on the assumption that sampling equivalent points in each tile helps with imaging blending during the mosaic assembly process.

There are a number of ways forward at this point. Mosaic images can be made with the individual image stacks for each filter, or a combination of stacks for simplicity. In this case I chose to have a luminance and color image for each tile. I used the Hα channel to enhance both. In one case, I created a "superRed" channel from a combination of Red and Hα (before using RGBCombination) and in the other a "superLum", from Hα and Luminance channels. In each case I used LinearFit to equalize images to the Hα channel before combination. This makes the combination more convenient to balance and allows simpler and more memorable ratios in PixelMath of the form:

*(Hα*0.6)+(Red*0.4)*

Image Registration

Image integration, removes the RA and DEC information from the FITS header. The ImageSolver script re-instates it. Using an approximate center and accurate image scale, it reports the center and corner coordinates as well as the image orientation. I ran the script on each of the image stacks assuming it helps with later registration. I then created a blank star canvas, using the Catalog Star Generator script, with dimensions slightly exceeding the 5 x 1 tile matrix and centered on tile 3 (fig.3). Tile registration to the canvas followed, in this case using the StarAlignment tool, with its working mode set to the Register/Union-Separate (fig.4). This produced two images per registration. The plain star canvas is discarded leaving behind a solitary tile on a blank canvas (fig.6).

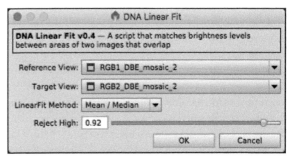

fig.4 *The Star Alignment tool set up to register the image tiles to the generated star image. The other settings were left at their default.*

fig.5 *This script, kindly developed by David Ault, carefully equalizes tiles using a variation of LinearFit that is not affected by black borders in an image (as in fig.6).*

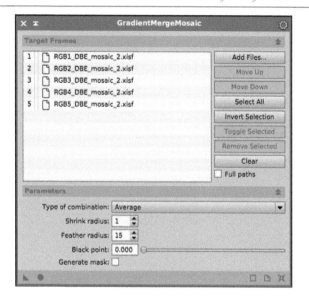

fig.6 *The (partially cropped) result of the Star Alignment tool creates a blank canvas with the image tile placed in the right location. Here, it is also equalized by the script tool in fig.5.*

fig.7 *This is when the magic occurs. The GradientMergeMosaic tool combines and blends the images. A scan of the process console shows it uses both Laplace and Fast Fourier transforms. I always wondered what they were good for, when I studied them at University!*

Before combination, the registered image tiles require further equalization. As described in the mosaic chapter, the LinearFit algorithm struggles with images that have black borders. To equalize the tiles, I used David Ault's DNA Linear Fit PixInsight script, which effectively matches tile intensity between two frames in the overlap region and ignores areas of blank canvas. This was progressively done tile to tile; 1 >> 2, 2 >> 3 and so on for the luminance views and then for the RGB views (fig.5).

To create both mosaic images one uses GradientMergeMosaic (GMM). It works best if there are no non-overlapping black areas. My oversize star canvas had a generous margin all round and I needed to crop all canvases down to the overall mosaic image area. This was done by creating a rough image using a simple PixelMath equation of the form:

max(image1, image2, image3, image5, image5)

I then used the DynamicCrop tool on this image to trim off the ragged edges and applied an instance of the tool to all 5 pairs of tiles.

The next stage was to create two mosaic images (one for luminance and one for color) using GradientMergeMosaic. I first saved the five pairs of tiles to disk as this tool works on files, rather than PixInsight views. The outcome from GMM looked remarkable, with no apparent tile intensity mismatches and good blending, but upon close examination, a few stars on the join required some tuning (fig.8). I fixed these by trying GMM again using an increased Feather radius. I had a single remaining telltale star and this was fixed by removing it from one of the overlapped images (by cloning a black circle over it) and running GMM once more. As far as registration was concerned, this refractor has good star shape and low distortion throughout the

fig.8 *Sometimes the magic is not quite good enough. Here a star on the join needs some refining. This issue was resolved by increasing the Feather radius from 10 to 15. Dense starfields can be quite demanding and it is not always possible to find a feather radius that fixes all. A few odd stars remained in the final mosaic. I cloned these out in one image (with blank canvas) and then GMM used the star from the other overlapping image without issue.*

image and the registration technique that matched the images to a star canvas ensured good alignment in the overlap regions.

In this particular image the nebulosity fades off at one end and the prior equalization processes had caused a gradual darkening too. This was quickly fixed with another application of DynamicBackgroundExtraction on both mosaic images, taking care to sample away from areas of nebulosity.

Image Processing

Armed with two supersized images, I carefully color-calibrated the RGB image, after removing green pixels with SCNR. I lightly stretched the image, reduced the noise and blurred it with the Convolution tool. (This also reduces the noise and improves star color information.) Colors were enhanced with the saturation control in the CurvesTransformation tool.

The luminance file was processed normally; first with Deconvolution and then stretched with a combination of HistogramTransformation and MaskedStretch. After a little noise reduction, the cloud details were enhanced with LHE and MMT tools. Between each stretching or sharpening action, the Histogram-Transformation tool was applied to extend the dynamic range by 10% to reduce the chance of image clipping.

It is sometimes difficult to find the right settings for LRGBCombination for color and luminosity. One way to make it more predictable is to balance the luminance information beforehand. To do this I first converted the RGB to CIE L*a*b*, using ChannelExtraction and applied LinearFit, to the L channel using the Luminance as the reference image. Using ChannelCombination, I recreated the RGB file and then used LRGBCombination to create the final image.

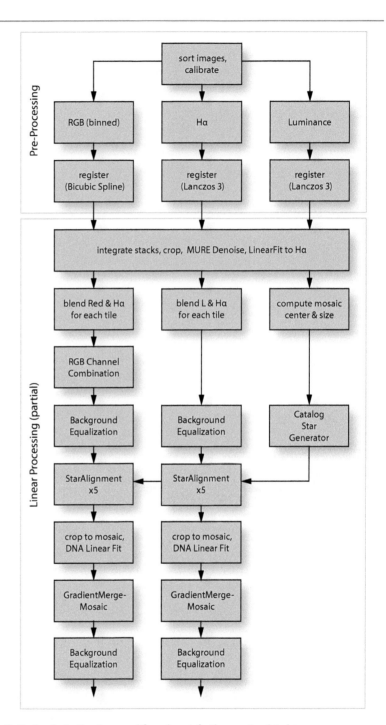

fig.9　For clarity, the above workflow above is for the mosaic-related steps leading up to classical LRGB processing. The output is two linear files, one for RGB and another for Luminance. These are submitted to the remaining linear processes (such as Deconvolution and ColorCalibration), non-linear stretches, sharpening, noise reduction and so on.

NGC2264 (Cone Nebula Region)

An experiment in wide-field portable imaging, using color cameras.

Equipment:

Refractor, 71 mm aperture, 350 mm focal length

Canon EOS60Da, QSI683 and Fuji X-T1

IDAS LPS-D1 filter, RGB filters

Avalon Linear Mount, T-Pod

SX Superstar guide camera, 60-mm guide scope

Software: (Windows 10)

Sequence Generator Pro, ASCOM drivers

PHD2 autoguider software

PixInsight (Mac OS) / Nebulosity 4

Exposure (color and RGB) 3.75 hours for each system:

(Canon / Fuji) 150 x 90 seconds @ ISO 800

(QSI) RGB filters bin 1; 15 x 300 seconds each

It is all to easy to be carried away with astrophotography by acquiring more equipment and generally becoming more sophisticated. This alone can be off-putting to those aspiring to try it out for the first time. This assignment was conceived as a more down-to-earth opportunity to practice imaging with modest equipment and compare camera performance. Rural vacations provide just the right opportunity to image under darker skies and use the constraints of travel to pare down equipment to the essentials (so that there is just enough room in the car for mundane things such as food, clothes and family). The results from such an approach may not rank with those from more exotic setups but it makes a refreshing change to keep things simple. Little did I know how spectacularly wrong it would go. The fresh challenges it threw in my path are worthy of discussion and prompted a complete re-think. In the end, although there were several clear nights during the vacation, the light pollution was only marginally better than my semi-rural home, once the street lamps switch off. The various issues prevented any successful imaging and the experimentation continued from the middle of my lawn during the following weeks.

Of course I didn't know this beforehand and since the likelihood of good weather in the winter is poor I spent the preceding month trying out the various system setups. To that end, I made several dry runs at home to familiarize myself with the new system and address any shortcomings. During these I improved the cable routing, the guide scope and camera mountings, tried out different lenses and balanced the power requirements. Even with simpler equipment, the initial morass of cables and modules reminded me of the need for simplicity and order. The solution was to assemble another, smaller master interface box to organize the modules, power, computing and electrical interfaces. These dry runs also established the very different equipment profiles for the imaging and guiding software, to allow sequences to be generated with ease from saved imaging configurations.

Hardware

If I have learned anything over the last five years, it is to not compromise on the mount. My Paramount has an exceptional tracking performance of 0.3 arc seconds RMS but it is too big and heavy for casual travel. For a mobile rig, I relaxed the tracking target to 1.2 arc seconds to guarantee performance up to 600-mm focal lengths. I had yet to achieve that with the iOptron iEQ30, when I had an unexpected opportunity to buy a used Avalon Linear mount. Although 6 kg heavier, it more than compensated by the improved tracking performance. I

fig.1 A little larger than some offerings, the Avalon Linear is easy to carry and is arguably one of the best performers in its weight class up to 12 kg. This is the original SynScan-based system but can be upgraded to the later StarGO controller.

fig.2 This screen grab is of a small Windows application generated by Visual Studio. This is a simple Windows form that executes ASCOM COM commands to the telescope. It is a convenient way to have access to basic telescope controls if there is no requirement for a planetarium.

fixed this to the solid, yet lightweight aluminum Avalon T-Pod. As a bonus, its red anodizing matched the finish of the Linear. (Color coordination is very important for karma.) This mount's tracking and load capability clearly exceeded the needs for this particular imaging assignment but was a better long term investment for use with more demanding optics in the future.

The T-Pod does not have an accessory tray and I balanced the interface box on the spreader. To stop it sliding about I fitted rubber pads on the three aluminum bars. The box uses the familiar Neutrik connectors for power, focusing, dew and USB, with an additional DC power connection for digital cameras, a 5-volt DC output for an Intel computing stick, a serial interface for the Avalon mount and a network connection for an external WiFi access point. The Avalon does not cater for internal wiring and to avoid cable snags, I bundled the wiring into a zipped nylon mesh sleeve and attached it to the center of the dovetail bar and to the top of the tripod leg to reduce drag.

This original version of the Linear uses the SkyWatcher SynScan motor control board and handset. It has a substantial and detachable stainless steel counterweight bar and a choice of Losmandy or Vixen clamps. My initial trials were with wide-field images using focal lengths under 100 mm. In the quest to reduce weight, I constructed a dual-saddle plate system from Ge-optik components. This comprised a Vixen clamp on one side and a Vixen/Losmandy clamp on the other, mounted at either end of a short Vixen bar, all in a fetching orange color. This solved one problem and created another, since the imaging and guider system was now too light for the smallest (1 kg) counterweight. For that reason I had a shorter counterweight bar turned from aluminum and to add a little extra weight to the imaging end, used a 170-mm Losmandy rather than Vixen dovetail plate for the camera system.

For late-night unattended operation, weather monitoring is essential in the UK. I purchased a 12-volt rain detector module. Its heated resistance sensor prevents dew formation and its relay output was connected to a buzzer to prompt pajama-clad attention. For quick polar alignment I used a calibrated SkyWatcher polar scope (the latest version that uses a clock reticle) and a PoleMaster camera, screwed to the saddle plate, for fine tuning. I also switched to a Starlight Xpress SuperStar guide camera. Its pixels are half the size of the ubiquitous Lodestar and better suited for a short, fast guide scope. To save time later on, I set up its focus on a distant object during the day and locked the focus mechanism. Guide scopes typically use simple doublets with considerable dispersion and to ensure good focus, I screwed a 1.25-inch dark red filter into the C-thread adaptor. This filter creates a virtually monochromatic image that not only has a smaller FWHM but is less affected by atmospheric seeing.

Dew prevention is challenging with small camera lenses since the natural place for the dew heater tape obscures the focus and aperture rings. The solution was to use a metal lens hood that screwed into the filter ring (rather than any plastic bayonet version). This provided a useful locating for the dew heater tape and it conducted heat back into the metal lens assembly.

I loaded the control and acquisition software on an Intel computing stick running Windows 10 Pro. In this setup I slung it beneath the mount and controlled it remotely using Microsoft Remote Desktop, running on an iPad and connected via WiFi to a static IP address. The solitary USB 3 port on the computing stick was expanded via a powered 7-way industrial USB 2 hub within the interface box to various modules and interfaces, all

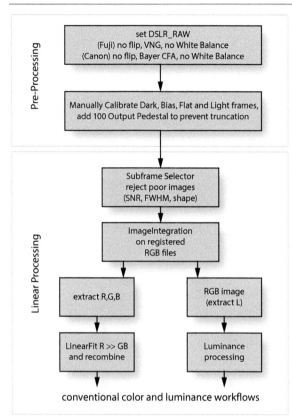

fig.3 This shows the unique pre-processing steps to change
 the RAW files into a form that can be processed normally.
 Here I have used different DSLR_RAW settings to cope
 with the very different Fuji and Canon file formats. After
 noting that both cameras were manipulating the RAW file
 levels, a pedestal was added to the dark frames to ensure
 the bias subtraction did not truncate the image values.

powered by two 24 Ah lead-acid batteries. These shared a common ground but powered different systems to match current consumption and at the same time, reduce power supply interference on sensitive circuits.

The SynScan unit loses its sense of time and place on power-down and requires manual initialization on each power-up. I do not use a GPS unit and rely upon the Dimension 4 application to set the PC's time from the Internet. To avoid repeated trips to the mount handset, I initialized the mount to the PC's time via ASCOM script commands (as described in the chapter *Sequencing, Automation and Scripting*). Later, I wrote a simple Windows program to do the same and added options to set guide rate, location and jog control (fig.2). This program (a copy of which is available from the support website) uses the standard ASCOM methods and should work with any compliant mount. Over the testing phase I tried a number of image capture applications, including

Backyard EOS, APT, Nebulosity and SGP, all of which are easy to use and great value. APT has some interesting features and integrates well with the free planetariums SkytechX, CdC and C2A as well as PHD2. Some of its unique features include a Bahtinov grabber and autofocus control of EOS lenses.

Trials and Tribulations

The initial trials used prime lenses fitted to a digital camera. I first tried a Fuji X-T1 as its prime lenses have an excellent reputation. This camera has reasonable deep-red sensitivity that extends up to 720 nm, is weather-sealed and has a provision for remote power through an adaptor in the vertical grip. It presents a few additional acquisition challenges over an EOS as it has no remote computer control facility (that work with long exposures) and there is no convenient place to fit a light-pollution filter. The solution was to simplify things further using an accessory intervalometer connected via a 2.5-mm jack plug cable and some Blu-Tak® to attach a 2-inch IDAS filter to the front of the lens. I decided to compare the performance of the Carl Zeiss Contax lenses with the Fujinon primes. Consumer lenses are often optimized to operate at about 20x the focal length and traditional testing typically uses a 30 x 40-inch test chart. The performance at infinity can be quite different and a range of distant pylons against pale cloud provided a better daytime test. Not surprisingly, given the use of aspherical elements, 20 years of optical development and optimization for digital sensors, the wide angle Contax lenses were outclassed by Fuji's own versions. For the short telephoto lengths, the differences were marginal and there was not much to choose between a 135-mm f/2.8 or 100-mm f/3.5 Carl Zeiss lens with the Fujinon 90-mm f/2. All of these had excellent resolution in the center and edge of field, with minimal chromatic aberration. The optimum performance in each case was around f/4. Focusing with wide angle lenses was not easy; the image from using a Bahtinov focus mask is too small to use and without the ability to download images dynamically and assess the star HFD, it required a visual assessment using the x10 manual focus aid display on the fold-out screen. While focusing on a bright star, it obviously gets smaller as it approaches focus but at the same time I crucially noticed that at the point of focus, some of the smaller stars disappeared as they shrunk to sub-pixel dimensions.

Wide Field Flop

The first trial was a tad too ambitious, in which I attempted to record Barnard's loop. It had been a long time since I had used a color camera for astrophotography and the

results were shocking. Even in a semi-rural environment, the in-camera previews from an initial test using a 35 mm f/1.4 lens showed extreme gradients from light pollution and flare from an off-axis street lamp, both beyond my abilities to process-out. Operating at f/2.8, there was also a noticeable reduction in the effectiveness of the IDAS filter as one moved from the image center. Exposing wide-field at low altitude was simply too demanding on the prevailing conditions. Aiming the camera at the zenith, I stopped down to f/4 and set up the intervalometer for 2 hours of 1-minute exposures onto the SD card. A quick calibration, registration and integration of these images in PixInsight generated a respectable dense star field. Although technically competent, it was not particularly interesting and needed some color to add vibrancy.

Returning to Orion and increasing the focal length to 100 mm, I aimed the mount at M42. The bright nebulosity was clearly visible in the electronic viewfinder but even with a light pollution filter wedged in the lens hood, the exposures still displayed significant gradient sky pollution and flare. I was still pushing my luck; at my 51° N latitude, Orion does not rise to a respectable altitude and it really needed a very dark sky for a high quality result. It was time to experiment further.

Swapping the Fuji for the EOS 60Da I inserted an IDAS light pollution filter into the camera throat and fitted it to a short refractor with a 350-mm focal length. I chose the Cone Nebula since this region has mild red and blue nebulosity with a range of star intensities. With the guide scope attached directly to the refractor, I set up SGP to handle two full nights exposure, with autofocus and meridian flips. The exposure preview appearance after a screen stretch was not encouraging and I hoped that 12 hours of integrated exposures would tease out the nebulosity. It did not. It was only then that I realized that the EOS was effectively taking a 1-second exposure every 2 minutes, due to a mismatch between the mirror lock-up custom function setting and the mirror settle setting in SGP. I had effectively taken 1 minute of exposure over two nights!

It was a humbling experience and I had no excuse; it was clearly documented in the instructions, which of course I had only skimmed. It also explained why the bias and dark frames looked alike. I thought the dark frames looked too good! During the later analysis, it was also apparent that the EOS RAW files are manipulated; the bias frames had a higher minimum ADU value than the dark frame exposures, even when they were a true 10 minutes in duration. A traditional calibration subtracts the bias from the dark frames, so in this case, it would clip pixels to black and degrade image calibration.

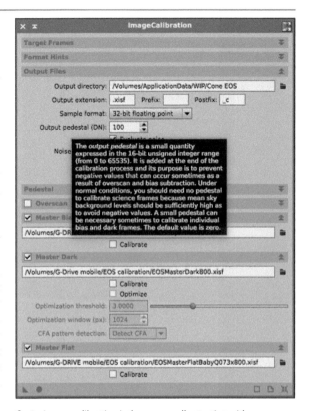

fig.4 *Image calibration is done manually, starting with integrating Bias and Darks and using a pedestal to prevent a situation where (Dark - Bias) < 0*

A different strategy was required to optimize calibration. There were a few alternatives to consider:

- calibrate with bias (or superbias) and flat frames and apply the cometic correction tool, selecting pixels from the master dark frame
- calibrate with dark and flat frames (ignore bias)
- add a small offset to the dark frames so the bias (or superbias) subtraction does not clip values

While waiting for the next clear sky I repeated all the calibration frames to keep the options open. Over the course of three nights I repeated the acquisition using the Canon EOS 60Da, Fuji X-T1 and the QSI683 with Astrodon filters. I thought it would be interesting to compare the results over the same integration time and although the QSI CCD was cooled to -5°C, the ambient temperature was also -5°C, so the benefit was marginal. With the longer focal length, I could focus the Fuji system using a Bahtinov mask and trusted the pointing accuracy of the mount, rather than use plate-solving to align after meridian flips. The comparison images from the QSI CCD and Fuji X-T1 are shown in figs.5 and 6.

fig.5 *The same target, captured over the same period with a mono CCD camera and filters. This image has the highest quality.*

fig.6 *This time, captured with the Fuji X-T1 camera. This has the most noise and nebulosity is subdued and more orange.*

Pre-Processing

The integrated master bias images from the Fuji and Canon showed obvious banding. Using the techniques described in the chapter on processing CFA images, the master bias was transformed into a superbias including both row and column structures. As dithering was disabled during acquisition and there were hot pixels in the dark frames, I needed to process a master dark file too. Since both photographic cameras manipulate dark levels over long exposures, it was necessary to add a pedestal to the result of the bias subtraction during calibration to avoid pixels clipping to black. The PixInsight Image-Calibration tool has two pedestal controls. In this case it required an **output** pedestal of 100 (fig.4). The flat frames were individually calibrated and integrated and then the three master files were used to calibrate the light frames, after which they were registered and integrated. The registration process requires DeBayered images and in the case of the Canon files, required an additional step to create RGB images. (The Fuji RAW files required a different DSLR_RAW setting and are DeBayered when they were read in, as the RAF RAW format does not translate well into Raw Bayer CFA format, due to the unique Fuji X-Trans bayer mosaic pattern).

In the case of the CFA images, after integrating the registered images, the luminance information was extracted into a separate file for conventional luminance processing and the RGB channels were separated, linear-fitted to each other and recombined. This takes care of the dominant green cast from the debayer process and makes it easier to judge background levels during background equalization. The QSI's images were formed into the usual RGB and Luminance images too, following well established workflows (but without deconvolution in this case as the images were not over-sampled).

Non-Linear Processing

The processing was kept simple and consistent to show up the image differences between the cameras. After carefully equalizing the backgrounds, the integrated images were initially stretched using MaskedStretch, followed by LocalHistogramEqualization to enhance cloud structures in the luminance channel. The RGB images had noise reduction applied, followed by a saturation boost and a convolution blur in preparation for combining with the enhanced luminance data. The background noise was carefully reduced in the luminance channel and a small degree of sharpening, in the form of MultiscaleMedianTransform, applied to give some definition to the structures.

Conclusion

These images are not going to win any awards but show interesting insights into the differing performance of conventional, modified and dedicated camera systems. The CCD system has less noise and its filter system is better able to detect faint nebulosity than either color camera fitted with a light pollution filter. Focusing was more precise too, without the encumbrance of a bayer filter array. It will be interesting to see how dedicated mono CMOS-based systems develop in the next few years.

3-D Video Imaging *– by Lawrence Dunn*

A great way to breathe new life into an iconic image.

3-D imaging is a niche activity that literally gives another dimension to our flat astro photographs. Motivated by the inspiring 2-D and 3-D astro art on J-P Metsävainio's AstroAnarchy web site, for me, 3-D imaging can use virtually any regular 2-D image. Once acquired and processed with the normal plethora of tools and methods at our disposal, a compositing program transforms the 2-D into a 3-D diorama within the computer, such that a software camera can move through the space to create an animation. It is worth a little effort to make the 3-D model as faithful as possible, to appreciate the structure of the space. After first using Adobe After Effects®, I switched to an alternative application from Blackmagic Design, called Fusion 8®. It has a unique nodal graphical interface to compositing which is both interesting and fun to use and very powerful. For instance, Fusion 8 allows one to deform the image planes in 3-D, which allows more engaging 3-D animations. What follows is my current workflow, which uses a mixture of PixInsight, Photoshop, Microsoft Excel and Fusion 8:

1 establish object distances in the 2-D image
2 isolate the objects into layers according to distance
3 prepare the image in Fusion 8
4 position layers along the z-axis according to distance
5 scale each layer according to distance
6 add a camera
7 create a camera path
8 render and save the animation

Establish Object Distances in 2-D Image (1)

To create the third dimension for our image requires the object distances from Earth. There are both semi-automatic and manual ways to achieve this. With the PixInsight ImageSolver and AnnotateImage scripts it is possible to automatically generate a spreadsheet of objects and correlate them to light year (ly) distances, obtained from the VisieR on-line catalog. It is also possible to identify the objects manually and create a spreadsheet of objects and distances for later reference. Here, for brevity, we use a simple example with a few image objects and assumed distances from Earth and a more sophisticated version, with automatic object calculations, is available from the website.

Isolate the Objects into Layers (2)

This task selectively pastes the objects into layers, according to their distance. This can be done in Fusion 8 or in Photoshop. Using Photoshop, start by isolating the main stars; drag a circular marquee around a star and use the Refine Edge tool to fine-tune the selection. Adjust feathering, smoothing, contrast and the Shift Edge value to eliminate the surrounding dark sky, leaving just the star. Take some time with the first star to establish values that work well and then use similar values with the other stars, fine-tuning the boundary with the Shift Edge setting.

Having isolated the star(s), Copy and be sure to use Paste Special>Paste in Place, to place it into a new layer at the same location as the star in the original image. You should now have the original image and a new layer with a star. Rename the new layer with its distance (in ly) and the star name or reference number, to identify it later (this data should be on your spreadsheet).

You now remove the star from the original image as if it was never there. To do this select the new layer containing just the star, click the Magic Wand selection tool on the blank canvas and then invert the selection. Switch to the original image and Fill this area, selecting Content-Aware, Normal blending mode and 100% opacity. Turn the star layer off and examine the area around where the star should be. If the fill action has resulted in a noticeable boundary or other artefacts, use the blur and smudge tools to blend the content-aware fill into the background (or at least to make it a little less obvious). Repeat this process for all the major stars. (For this reason, I would avoid globular clusters!). Next, it is the turn of the various nebula. The process is similar but uses the Lasso tool to roughly draw around parts of the nebula using an appropriate feather setting. At some point, the Fill action will create obvious artefacts and liberal use of smudge and blur is to be expected. Stars where distances are unknown can be put to good use later, so place them in their own layers too.

The repeated content-aware fills cause the background to become increasingly messy but it is eventually covered by the multiple layers and ends up as the extreme background. After much repetition one should have an image separated into many layers, determined by

fig.1 To help identify stars, after running the PixInsight ImageSolver script, the AnnotateImage script usefully creates a visual map of the object references, with an option to create a text file, listing the objects and their details too.

fig.2 A close-up of some of the Photoshop layers. Some of the layers have been excluded for clarity.

distance (fig.2) and with them all turned on, the image should still look very similar to the original 2-D image. Save this as a PSD file (without flattening).

Prepare the Image in Fusion 8 (3)

It has been mundane ground-work up to this point. The 3-D fun starts now and, to bring our multi-layered 2-D image to life, the PSD file is opened in compositing software. Compositing software is used in film and video production to combine multiple images and effects into a single image stream: This example uses Black Magic Design's Fusion 8 application, available for Mac OS, Windows and Linux platforms. Fortunately, the free download version is more than sufficient for our simple purposes.

Fusion 8 is in the same camp as PixInsight; powerful, but works in a totally different manner to any other software and has a steep learning curve. It uses a node-based graphical editing system rather than layers. Nodes can be images or tools that are linked together to perform operations and manipulations on images and 3-D objects. Multiple nodes can be joined together in complex and flexible ways. Fusion 8 has that rare factor that makes exploration fun, rather than frustrating. As ever, the Internet provides a rich training resource including online tutorial videos. We only scratch the surface of what Fusion 8 can do but it is worth covering a few basics first.

Fusion 8 Screen

The application screen has 4 main areas (fig.3); a control pane on the right, two node preview windows on the top and a node construction area underneath to create and link nodes. Each requires a little explanation:

The Node Construction Area

To add a node, right-click and select Add Tool from the submenu and the required tool or node type. A selected node is highlighted in yellow, whereas de-selected nodes have other colors, depending upon their type. When the mouse hovers over a node, a section extends at the bottom of the node that contains two dots, clicking on a dot displays the node output in one of the preview windows, or alternatively, dragging the node up to one of the preview windows displays the node in that window. Nodes also have small colored triangles and squares around their edge; anchor points used to link nodes together. To link two nodes together, hover and drag one node's small red square to extend a line out to another node. Releasing the mouse button snaps the line onto the second node. Nodes can be joined to multiple other nodes. When the nodes occupy more space than can be accommodated in the pane, an overview map will appear in the upper right of the node construction area to aid with navigation. In this case click and drag the box on the map to move the view on the main pane. A node is renamed by hovering over it, right-clicking and selecting Rename or alternatively, by selecting it and pressing F2.

The Preview Windows

The preview windows can show different views; the view type is shown in the lower corner. A right-click shows the options: Perspective, Top, Front, Left, Right and

Camera. A 3-D view is rotated by holding the Shift and right mouse button while dragging. Similarly, to shift the preview, hold Shift-Control and the left mouse button while dragging. The + and - keys perform zoom functions.

The Node Control Pane

The information in this control pane changes dynamically depending upon the selected node. There are usually multiple pages; the main ones being: Controls, Materials and a 3-axis icon (referred to as "3D page" from now on). There are five sections to the 3D page: Translation, Rotation, Pivot, Scale and Target, these are the main ways in which we can directly manipulate an ImagePlane.

The Time-Line

Running along the very bottom of the Fusion window is a time-line. It defaults to 1000 frames starting at 0. The number of frames that an animation runs over can be adjusted by changing the number in the time-line boxes. This area also controls forward, backward, play and render controls.

Getting Started

The layers in the PSD file are important and to keep them intact, import the PSD file via the top menu (File>Import>PSD). The individual layers from the Photoshop file are shown as separate nodes (as green boxes).

Hover over any node and click on either of the dots to show the contents of the layer in one of the preview panes. The green nodes (the Photoshop layers) are connected with a short line to grey rectangles (named Normals) to the right of each green node. In turn, these grey nodes are connected to the grey node below each of them. Hover over a grey node and click on one of the preview dots to see the output from these in the preview window.

By going down the list of grey nodes and previewing some of the lower ones, you will see that the Normal previews are additive and contain the contents of their connected green node, plus all the nodes above them. In effect, the green nodes correspond to viewing one layer only at a time in Photoshop, and the grey nodes are like turning on multiple layers progressively from top to bottom. Here, the layers are manipulated independently and one can ignore the grey Normal nodes. You can select the Normal nodes with the mouse and delete them if you want.

Position Layers along the Z-Axis (4)

To translate a 2-D image into 3-D requires it to be joined to a ImagePlane3D node. These nodes uniquely can be moved in a 3-D space so that in our case, its distance along the z-axis is set, according to its distance from Earth. To create a ImagePlane3D node,

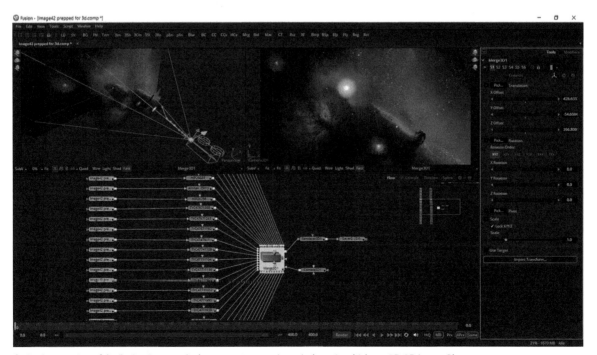

fig.3 An overview of the Fusion 8 screen. At the top are two preview windows, in which our 2D, 3D Image Plane, Camera or Render nodes are displayed. Beneath those is the node construction pane, where the layers and links are organized. Down the right hand side is the control pane, which allows node parameters to be edited.

right-click in the node construction area and select Add Tool>3D>Image Plane 3D from the pop-up. A new ImagePlane3D node appears in yellow. Now attach a green 2D layer image node to the ImagePlane3D node by dragging its small red square to the newly created node. The red square turns white and a white line should join the 2D image node (corresponding to a Photoshop layer) to the ImagePlane3D node. (To break a link, click on the white line.)

It is a good idea to rename the ImagePlane3D node for later reference. It is useful to name the object and include its distance in light years too. (As in PixInsight, names cannot contain spaces, but an underscore is allowed to break up multiple words.) This process is then repeated, linking each green 2D image node to *its own* ImagePlane3D node (fig.4). (It helps to use copy / paste or the keyboard shortcuts to speed things along.)

The ImagePlane3D nodes have to be joined before you can view them collectively. This employs another new node; right-click in the pane and select Add Tool>3D>Merge 3D. Now join all the ImagePlane3D nodes to the Merge3D node (dragging the small red square as before). Do this for all the ImagePlane3D nodes and then view the Merge3D node in one of the preview screens.

By default, all our newly created ImagePlane3D nodes are at located at x,y,z location 0,0,0 and require shifting in the z-axis to give the appearance of depth. To do this, select one of the ImagePlane3D nodes. The node controls appear in the right window pane. Click the 3D page icon and enter the number of light years (as a negative number) in the small box to the right of the Z Offset slider. This moves this image plane in 3-D space (in this case closer or further away to the viewer). Repeat this operation for all the ImagePlane3D nodes (this is where one appreciates having the ly value in the node name).

fig.4 This shows a part of the node pane, showing the linkages between the PSD layers, ImagePlane3D, Merge3D, Camera 3D and Render3D nodes. The final node in the chain is the node that saves the output in the designated format.

Scale Each Layer (5)

As an object is moved further away from a viewer, it is perceived as getting smaller. A 2-D photo, however captures the size of objects from different distances from a static vantage point. Separating out the objects into different image planes and moving those image planes in 3-D space loses their relative size from a fixed viewpoint.

To maintain the relative size of the objects in the 2-D photo, the ImagePlane3D nodes are scaled up, relative to their distance from the viewer. It is possible to manually scale each image plane empirically but there is a way to do this automatically (and yet still be able to manually fine-tune, in case one later decided to angle or rotate an image plane and need to compensate the scale slightly).

This requires a user control added to each Image-Plane3D node. To do this, click on the a node, right-click and select Edit Controls. In the dialog box click in the name box and change it (say "Plane Scale"). Click on the ID box and the ID name will change to the name you have just typed, less any spaces. Leave the Type on Number, change Page to 3D, Input Ctrl to SliderControl, Range to 0–2, Default to 1 and click OK to confirm. Conceptually, this is like adding a user-defined variable in computer program. This creates the new adjustment tool in the node control pane on the right (if it is needed later to scale the image independently of the auto scaling).

Selecting the 3D page icon in the node control window, should show the newly-created Plane Scale control. All of the tools on this page can be adjusted via the sliders, or by typing numbers directly into them. There is another, less obvious option, for entering in the result of a formula, which we now make use of, to auto-scale each image.

Click in the box for the Scale number (leave Lock XYZ checked). Type = and return. Drag the plus-sign to the left of the new box that appears up to the Z Offset field. This adds the z-axis translation into the formula field. Type *-1 to make it negative, * and the name of the node. The formula should read something like this:

Transform3-DOp.Translate.Z-1*DeepSpace.PlaneScale*

This formula automatically controls the Image-Plane3D node's scale, based upon the value you enter in the Translation Z Offset field. As the image plane moves away into the distance, it will get larger, to maintain its size from the camera's starting point of z=0. Yes, you guessed it, you now repeat this for all the other ImagePlane3D nodes.

If you do not have the distance data for all the stars, this is where a few layers of random stars, with a little creativity, fills in areas where there are large gaps in your z-axis. When

all the ImagePlane3D nodes are viewed directly head on, the overall image should resemble the original 2-D photo. If it does not, then something has gone terribly wrong!

Add a Camera (6)

The 3-D scene is now ready to fly through. To do this, add a Camera3D node (Add Tool>3D>Camera 3D) and join this **to** the Merge3D node. With the Camera3D node selected, its controls should be shown in the control pane. The type of camera and lens can be adjusted, as can its position and direction via the 3D page. By default the camera is at x=y=z=0, which is the position set for an observer on Earth.

Create a Camera Path (7)

Up to this point, there has been no regard for the 4th dimension, time. The time-line at the bottom of the window shows 0 to 1000 frames. With a video typically running at 25 frames per second (fps), 1000 frames creates 40 seconds of animation. To alter the video duration, change 1000 to a new value. A quick fly-through works well with 10–15 seconds or less, suggesting 250–400 frames as a good starting point.

Fusion 8 animation works using key frames. If you define the start and end points of your animation with them, the software will move the camera evenly between the two over the total time. Adding more key frames between the start and end points facilitates further control of the camera's movement path.

Key frames are added to the Camera3D node's 3D page for Translation, Rotation and Pivot groups. Adding key frames in Fusion is not particularly obvious: In the 3D page, right-click over the Translation heading and select Animate Translate Group (or Rotation/Pivot groups depending on needs). The Translate group changes green, indicating that it can be animated. Still hovering over the Translate heading, right-click again and select Set Key on Translate Group. This adds a key frame to the camera translate group at the current frame point indicated on the time-line. Now drag this indicator in the time-line to a new position, say to the end point of the animation. Now move the camera via the Translation group controls (XYZ) to a new camera position. Try starting with a z-axis value equivalent to the nearest object in your layers/ImagePlane3D nodes and make the figure negative, i.e. if the first layer/Image plane node is 300 ly. Move your camera -300 in Z which will move your camera into your scene. Now, right-click the Translation title again to add the key frame. Clicking the triangular play button under the time-line, moves the camera slowly between the start and end key frames, as it renders each frame.

fig.5 This perspective view shows the camera path between key frames, at which point the camera orientation changes.

To make the animation more interesting, as the camera moves through space, bank slightly with a change in direction (like a plane dipping its wing as it slowly stars to turn). Moving in X and Y and/or rotating the camera makes for a more engaging animation. It is worth spending some time experimenting with the path's key frame controls and adding key frames in-between the endpoints.

With the Perspective view in one of the previews, you may be able to see and modify the camera's animation path. Initially, the animation path is a straight line between each key frame but, by hovering over the joint between two lines in the animation path, the joint turns white. A right-click produces a popup menu and at the bottom is a submenu item for the 3D camera path. Within this, select smooth and one of the options. This changes the two angled straight lines of the animation into a flowing curved line joining the key frames (fig.5). Space animations look better with smoothed animation paths.

Render the Save the Animation (8)

To render the animation, one introduces another new node type (Add Tool>3D>3D Renderer) and connects the output of the Merge3D node **to** the input of the Render3D node (fig.4). (One can create multiple render nodes to create different resolution outputs.)

To save your rendered animation to a file, requires an input/output (I/O) node (Add Tool>I/O>Saver). The Save dialog window will open for the path and file name, file type and a suitable video format, like a Quicktime file. The Saver node's controls allow changes to these settings later on, if required. Connect the output from the Render3D node to the input of the Saver node. (As with Render3D nodes, one can set up multiple Saver nodes to save with different settings.) In the Saver node control page, you can also add a link to an audio file to accompany the video. Finally, clicking on the green render button at the bottom of the screen opens up the Render Settings window where the rendering is started.

With this, you should now have the makings of an animation from your 2-D astro image.

Enhancements

Depending on the subject, it is worth experimenting by reducing the opacity settings for those ImagePlane3D nodes that contain nebulosity. This allows the animation to partially look through the nebulosity; increased translucency reduces the feeling of flying through a solid object.

In addition, visually, some nebula may not be perpendicular to our view from Earth, i.e. one side of the nebula appears closer. To create this look, the image plane is angled. There is a small snag, however, when the camera views a plane at an angle it becomes relatively smaller. To recover the size, the ImagePlane3D node is increased in scale slightly. This is where the earlier-created user Plane Scale tool comes in handy. The ImagePlane3D nodes are initially scaled proportionally by their distance from the zero datum point. The newly-added manual Plane Scale tool allows one to increase the scale, taking care of any slight angling of the plane.

Angling image planes (rather than having them all parallel) to each other helps improve the look and feel of the video by making the animation more organic and less structured. It is worth experimenting with angles in the 1–10° range. (An angle of more than 10° may create undesirable effects.)

There are some other node types that distort an image plane that can work well with a nebula. For example, the Displace node and/or Bump Map node using a grey scale image or Fast Noise Texture to deform it from a flat plane into 3-dimensions, may give a better impression of a gas cloud. The possibilities are endless.

Once the animation is nearly done, it is time to consider special effects (in moderation of course). These include the Hot Spot node, to create a lens flare effect for bright light sources and the Highlight node, to create start spikes, as they sweep by in the animation.

Obviously the printed page has limitations and for this first light assignment, the Photoshop image, Fusion 8 file and example video are available from the book's support website, along with the technical details of creating automatic object and distance look-up tables.

Lunar Surface 3-D.

Since nebulae are popular 2-D targets, this chapter focuses on 3-D modeling a 2-D astro image with prominent nebulosity. With a little adaptation some of these techniques can be applied to galaxies too. Some of my earlier attempts of 3-D animations of galaxies used the luminance data as a grey scale displacement map, but it was only partially successful on account of the bright stars (though they could be removed). Grey scale displacement mapping, however, works well for lunar surface 3-D fly-overs and is a lot simpler than the previous nebula approach. Using the methods described earlier, the first step is to take your 2-D lunar image and create an ImagePlane3D node. It then requires a grey scale image to deform this flat plane to match the features in the 2-D lunar surface photo. Using the 2-D photo luminance as the displacement map, however, falls down due to side-lighting on the craters, causing some very odd-shaped surfaces (I know, I tried!). There is a much better approach that uses real, grey-scale elevation maps of the moon as the displacement map. These maps are available on line from the USGS Astrogeology website (the website is being redesigned and it is best to do an Internet search for the latest link).

After locating the moon elevation map, zoom in on the area of the elevation map that corresponds to your image, increase the resolution of the elevation map and copy-save the part of the map that you need.

The next step is to align the elevation data with your lunar photo. In Photoshop, open this and then grey scale elevation image, as a layer above the lunar photo. Set the top layer opacity to 50% (it may also help to temporarily colorize the layers red and blue to help with the aligning process). Using Photoshop's Free Transformation tools, size, rotate, skew and generally deform the elevation grey scale image until all the craters, mountain ranges and features are nicely aligned with those on the lunar photo. Crop the elevation image to the same size as the lunar photo and save the grey scale elevation image.

In Fusion 8, add a new node (Add Tool>I/O>Loader) and select your lunar image and then repeat for the elevation image. Now, create a ImagePlane3D node (Add Tool>3D>Image Plane 3D) and link the 2-D moon photo to this node. Add a Displace3D node, attach the 2-D image of the moon photo to the scene input (the triangle on the end) and connect the grey scale elevation image to the displacement input (the triangle in the middle) of the Displace3D node. This deforms the image plane in the third dimension relative to the grey scale elevation data (craters, mountains and valleys will look very realistic). The remaining steps follow a familiar route; the output of the Displace3D node is linked **to** a Merge3D node, as is a Camera3D node. The Merge3D node is linked **to** a Render3D node. Set up the camera key frames as before (tilted angles work well) and render the animation as per the nebula process and you should have a wonderful fly-by, or orbit, across your lunar surface.

IC1396A (Elephant's Trunk Nebula)

An astonishing image, from an initially uninspiring appearance.

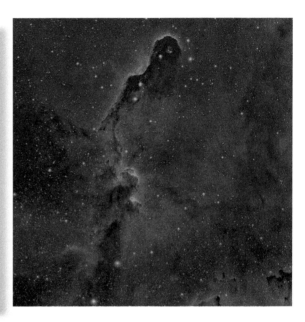

Equipment:
Refractor, 132 mm aperture, 928 mm focal length
TMB Flattener 68
QSI683wsg, 8-position filter wheel, Astrodon filters
Paramount MX
SX Lodestar guide camera (off-axis guider)

Software: (Windows 10)
Sequence Generator Pro, ASCOM drivers
TheSkyX Pro
PHD2 autoguider software
PixInsight (Mac OS)

Exposure: (RGB Hα, SII, OIII)
Hα, OIII, SII bin 1; 40 x 1200 seconds each
RGB bin 1; 20 x 300 seconds each

Just occasionally, everything falls into place. It does not happen very often but when it does, it gives enormous satisfaction. It is certainly a case of "fortune favors the prepared mind". This image is one of my favorites and is the result of substantive, careful acquisition coupled with the best practices during image calibration and processing. A follow-on attempt to image the NGC 2403 (Caldwell 7) galaxy challenged my acquisition and processing abilities to the point of waiting for another year to acquire more data, and with better tracking and focusing.

This nebula is part of the larger IC1396 nebula in Cepheus and its fanciful name describes the sinuous gas and dust feature, glowing as a result of intense ultraviolet radiation from the super-massive triple star system HD 206267A. For astrophotographers, it is a favorite subject for narrowband imaging as it has an abundance of Hα, OIII and SII nebulosity. The interesting thing is, however, when one looks at the individual Hα, OIII and SII acquisitions, only the Hα looks interesting. The other two are pretty dull after a standard screen stretch (fig.1). Surprisingly, when the files are matched to each other and combined using the standard HST palette, the outcome is the reverse; with clear opposing SII and OIII gradients, providing a rainbow-like background and with less obvious detail in the green channel (assigned to Hα).

Acquisition

This image received a total exposure of 45 hours, the combination of an unusual run of clear nights and all-night imaging with an automated observatory. The acquisition plan used 6 filters: R, G, B, Hα, SII and OIII. By this time I had learned to be more selective with exposure plans and this one did not waste imaging time on general wide-band luminance exposure. All exposures were acquired with a 132-mm refractor and field flattener, mounted on a Paramount MX. The observatory used my own Windows and Arduino applications and ASCOM dome driver and the images were acquired automatically with Sequence Generator Pro. It was cool to set it going, go to bed and find it had parked itself, shut down and closed up by morning. Guiding was ably provided with PHD2, using an off-axis guider on the KAF8300-based QSI camera. A previously acquired 300-point TPoint model and ProTrack made guiding easy, with long-duration guide exposures that delivered a tracking error of less than 0.4 arc seconds RMS. Only four light frames were rejected out of a total of 180.

In my semi-rural environment, a 45-hour integration time overcomes the image shot noise from light pollution. A darker site would achieve similar results in less time.

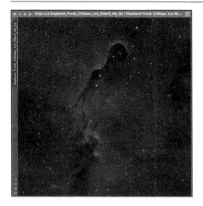

fig.1 During acquisition, a single screen-stretched Hα narrowband exposure looked promising, but the OII and SII looked dull in comparison (the light frames shown here are in PixInsight, before image calibration and with a simple screen stretch). The combination, however, provides stunning rainbow colors due to a subtle opposing gradation in the narrowband intensities.

Processing

The processing workflow (fig.8) used the best practices that have evolved over the last few years. Initially, all the individual lights were batch-preprocessed to generate calibrated and registered images and then integrated into a stack for each filter. These in turn were cropped with DynamicCrop and had noise reduction applied, in the form of MURE Denoise, according to the sensor gain, noise, integration count and interpolation algorithm during registration (in this case, Lanczos 3). These 6 files flowed into three processing streams for color, star and luminance processing.

Luminance Processing

As usual deconvolution, sharpening and enhancement is performed on luminance data. In this case, the luminance information is buried in all of the 6 exposure stacks. To extract that, the 6 stacks were integrated (without pixel rejection) using a simple scaling, based on MAD noise levels, to form an optimized luminance file. (This is one of the reasons I no longer bin RGB exposures, since interpolated binned RGB files do not combine well.) After deconvolution, the initial image stretch was carried out using MaskedStretch, set up to deliberately keep clipping to a minimum. On the subject of deconvolution, after fully processing this image, I noticed small dark halos around some stars and I returned to this step to increase the Deringing setting. Before rolling back the changes, I dragged those processing steps that followed deconvolution from the luminance's History Explorer tab into an empty ProcessContainer (fig.2). It was a simple matter to re-do the deconvolution and then apply the process container to the result to return to the prior status quo. (It is easy to see how this idea can equally be used to apply similar process sequences to several images.)

One of the key lessons from previous image processing is to avoid stretching too much or too early. Every sharpening or enhancement technique generally increases contrast and to that extent, push bright stars or nebulosity to brightness levels perilously close to clipping. When a bright luminance file is combined with a RGB file, no matter how saturated, the result is washed-out color. With that in mind, three passes of LocalHistogramEqualization (LHE) at scales of 350, 150 and 70 pixels were applied. Before each, I applied an application of HistogramTransformation (HT) with just the endpoints extended out by 10%. On first appearance, the result is lackluster, but it is

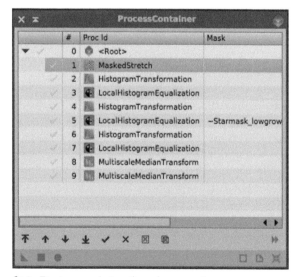

fig.2 To retrace one's steps through a processing sequence, drag the processes from the image's History Explorer tab into an empty ProcessContainer. Apply this to an image to automatically step through all the processes (including all the tool settings).

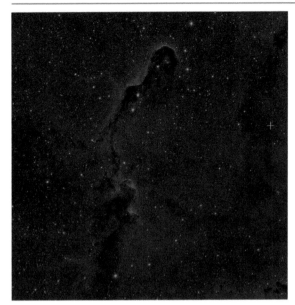

fig.3 *The fully processed luminance file, comprising data from all the 6 filters. It is deliberately subtle and none of the pixels are saturated, which helps to retain color saturation when applied to the RGB file.*

easy to expand the tonal range by changing the endpoints in HT back again at the end. These three passes of LHE emphasized the cloud structures in the nebulosity. To sharpen the features further, the first four scales were gently exaggerated using MultiscaleMedianTransform (MMT) in combination with a linear mask. With the same mask (inverted this time to protect the highlights) MMT was applied again, only this time, set to reduce the noise levels for the first 5 scales. The processed luminance is completely filled with nebulous clouds (fig.3) and so crucially, neither this or any of the color channels had its background equalized with DynamicBackgroundExtraction (DBE). This would have significantly removed these fascinating features. It is useful to note that MaskedStretch sets a target background level and if the same setting is kept constant between applications, the images will automatically have similar background median values after stretching.

Star Processing

The purpose of processing the RGB stacks was to generate a realistic color star field. To that extent, after each of the channels had been stretched, they were linear-fitted to each other and then combined into a RGB file. One thing I discovered along the way is to use the same stretch method for the color and luminance data. This helps achieve a neater fit when the two are combined later on. Linear-fitting the three files to each other before combining generally approximates a good color match.

I went further; with an application of BackgroundNeutralization and ColorCalibration to a group of stars to fine-tune the color fidelity. After removing green pixels with SCNR, the star color was boosted with a gentle saturation curve using the CurvesTransformation tool.

Color Processing

The basic color image was surprisingly easy to generate using the SHO-AIP script. This utility provides a convenient way to control the contribution of narrowband, luminance and color channels into a RGB image. In this case, I used the classic Hubble palette, assigning SII to red, Hα to green and OIII to blue. After checking the noise levels of the RGB files versus their narrowband

fig.4 *This script allows one to quickly evaluate a number of different channel mix and assignment options, allowing up to 8 files to be combined. Here, I blended a little of the RGB channels with their Hubble palette cousins to improve star rendition and color.*

counterparts, I added a 15% contribution from those into the final result (fig.4). This improves star appearance and color. There are endless combinations and it is easy to also blend image stacks across one or more RGB channels (as in the case of a bi-color image). There are two main options: to generate a file with just color information, or combine it with luminance data too. In the latter, the luminance file created earlier was used as the luminance reference during the script's internal LRGBCombination operation.

Backing up a bit, the relative signal strengths from three narrowband channels are often quite different. The same was true here and, although I did not equalize them in any explicit manner during their processing, another by-product of the MaskedStretch operation is to produce similar image value distributions.

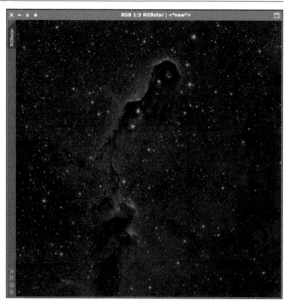

fig.5 The natural-color RGB file, processed to enhance star color, ready for combining with the final image, using PixelMath and a star mask. This image takes its color information from the RGB combination process and uses LRGBCombination to adjust it to the luminance from the master color image.

I viewed these stretched narrowband files and applied the SHO-AIP script without further modification. Pleased with the result, I saw no reason to alter the balance. The image showed promise but with intentional low contrast, on account of the subtle luminance data (fig.3). To bring the image to life I used CurvesTransformation to gently boost the overall saturation and applied a gentle S-curve, followed by selective saturation with the ColorSaturation tool. Finally, the HistogramTransformation tool was applied to adjust the endpoints to lift the midtones slightly for reproduction.

Star Substitution

At this point the stars had unusual coloring and needed replacing. The dodge here was to extract the luminance from the main RGB image and then use LRGBCombination to apply this to the RGB star image (fig.5). This matched the intensity of both files and it was then a simple matter to apply a star mask to the color nebulosity image and overwrite this file with RGB star data, using a simple PixelMath equation to effectively replace the star color. Well, almost. The crucial step here was the star mask. It needed to be tight to the stars, otherwise they had natural-colored dark boundaries over the false-color nebulosity. The solution was to generate the star mask with low growth settings and then generate a series of versions with progressive applications of

fig.6 After applying Morphological transformation to reduce star sizes, the overall image had some bite and twinkle added by a small dose of sharpening on the smaller scales.

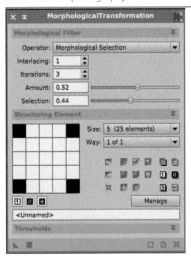

fig.7 The MorphologicalTransformation tool set to subtly shrink stars.

MorphologicalTransformation, set to erode. It was very quick to try each mask in turn and examine a few stars of different sizes at 100% zoom level.

After viewing the final image at different zoom levels I decided to alter the visual balance between the stars and nebulosity and blend the star's luminance and color boundary at the same time. With the aid of a normal star mask, an application of MorphologicalTransformation (set to Morphological Selection) drew in the star boundaries and lessened their dominance (fig.7). To put some twinkle back and add further crispness, I followed by boosting small-scale bias in the lighter regions using the Multiscale-MedianTranform tool together with a non-inverted linear mask (fig.6).

It normally takes two or three tries with an image data-set before I am satisfied with the result, or return later to try something I have learned, to push the quality envelope. Though this processing sequence looks involved, I accomplished it in a single afternoon. A rare case where everything just slotted into place and the base data was copious and of high quality. It is a good note to end the practical assignments section on.

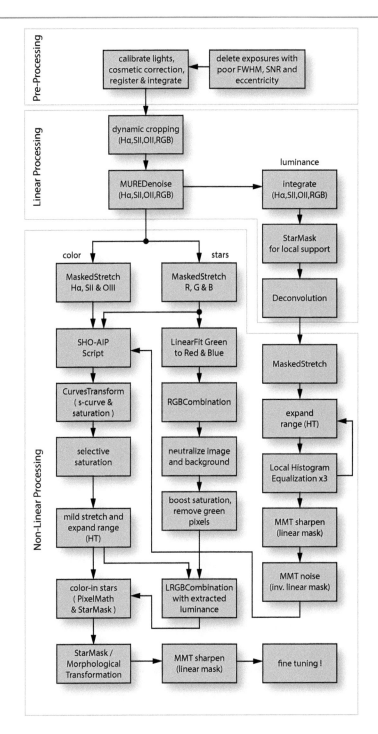

fig.8 The processing workflow for this image only uses data from colored filters and uniquely does not equalize background levels on account of the abundant nebulosity. The color information is shared across the three main branches that process the luminance, RGB star and the nebulosity data. This workflow also uniquely uses MaskedStretch rather than HistogramTransformation and S-Curves to reduce background levels (and apparent noise). It also keeps luminance levels low until the final fine-tuning.

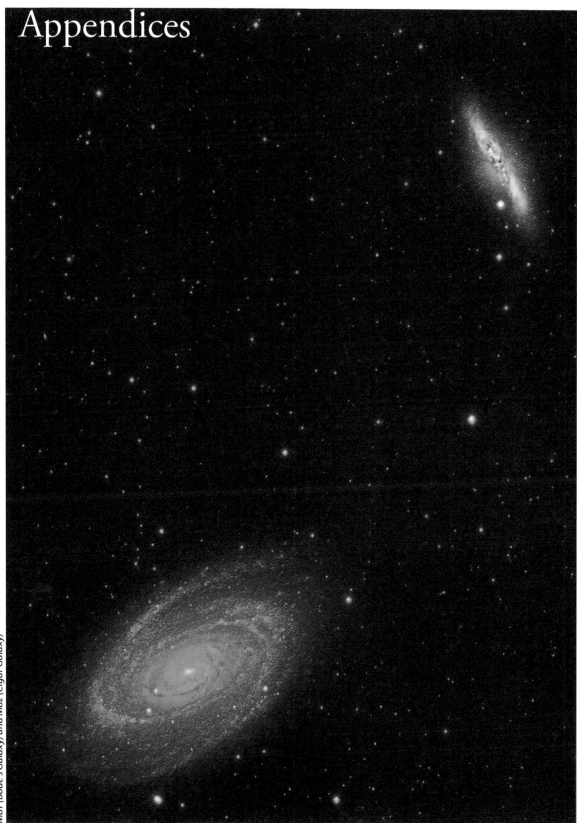

Appendices

M81 (Bode's Galaxy) and M82 (Cigar Galaxy)

Diagnostics and Problem Solving

Techniques and thought-starters to root out those gremlins that
turn an interesting challenge into a tiresome issue.

Many things can go wrong during setup, image capture and processing; some immediately obvious and others that occur later. Trying to establish what has gone wrong in a complex system can be particularly difficult. The traffic on the on-line forums bears witness to both extraordinarily obscure causes, as well as basic mistakes. This chapter goes some way to help you identify common issues in your own system using visual clues and suggests potential root causes and remedies.

General Principles

In the automotive industry a design or manufacturing fault can cost millions in warranty and lost sales. As a result it has a highly-developed root cause analysis process designed to find, verify and fix problems. Just as with a full imaging system, automotive systems are complex and trust me, some of the root causes are unbelievably obscure. One of the processes used by the automotive, medical and defense industries is called 8D. The principles behind this process are equally applicable to any problem solving effort. These can be simplified to:

1 Record the symptom with as much detail as possible; it is a common mistake to interpret the symptom. "I have flu" is not a symptom but "I have nausea and a temperature" are.

2 Record when the symptom occurs and when it does not; what distinguishes those times when the problem occurs? This may be time, a different sensor or software version or a change in the "environment" for example. If the software records log files, keep them safe for later diagnostics.

3 Brainstorm the possible root causes; this is where you need system knowledge. An Internet search or the information in the tables may help. In all likelihood someone, somewhere, has had the same issue.

4 Evaluate the root causes and potential fixes; this may take the form of substitution (i.e. change cables, driver version, power supply, revert back to a working configuration) or an experiment to isolate variables and a compatibility check with the symptom. This last point is very powerful. Engineers talk about special and common causes. If there is a sudden problem in a fixed configuration that has otherwise been behaving itself for months, the issue is unlikely to be a design issue, or software. A sudden problem must be caused by a sudden change, like a hardware failure, software corruption or an "environment" change.

5 Verify the root cause and the potential fixes; many issues are intermittent and it is very easy to make a change which seemingly fixes the problem. For instance, swapping an electronic module in a system may make the problem go away, when it is the cleaning action of breaking and making the connection that actually fixes the issue. The solution is very simple: turn the problem off, on and off again with your "fix". In the above example, plugging in the "broken" module also fixes the problem!

Problem solving is part of the hobby but it can be tiresome when you have the first clear night in a month and the system refuses to play nicely. Fixing a problem also provides an opportunity to prevent it happening again. This may take the form of regular mount maintenance, checking cables for connectivity and the old truism, "if it ain't broke, don't fix it"!

Hardware, Software and Customer Failures

So, which part of the system do you think is the most unreliable? Most likely you, or "customer error", and with the complexity of ever-changing technology it is not surprising. The most complex problems to identify and fix are interactions between hardware and software, caused by poor design robustness (the system works in ideal circumstances but is intolerant to small changes in its environment) or device driver issues. A common example are the many issues caused by inexpensive USB hubs. They all seem to work in an office environment but refuse to operate reliably in a cold observatory. In this case, not only are some chip-sets more fault-tolerant than others, the surrounding analog components change their properties in cold conditions and the electrical performance suffers. The same applies to the lubricants used in some telescope mounts. Apparently unrelated changes to other parts of the computer operating system, a longer USB cable or interruptions caused by scheduled operating system maintenance may also be the culprit. It is a wonder that anything ever works!

symptom	possible root cause	notes
USB device disconnects	cable too long	may work when warm but fail when cold
(often as it cools down)	dew on connectors	protect with cloth over connectors in dewy conditions
	too many daisy-chain hubs	restrict sequential USB hubs
	insufficient power	power overload on hub after initial connection
	chip-set or hardware clock frequency	some hardware is just not up to the job: look for hubs that use the NEC chip-set
	intermittent power during slew	use locking DC connectors where possible
device does not connect	also includes disconnect root causes above	try turning off / on or connect / disconnect cable
	ground offset (often seen with switch-mode DC power supplies)	check to see if floating DC supplies have ground reference and check system grounding
	insufficient power	check USB hub power supply and cable type and quality (some are lossy)
	ASCOM driver issue	reload / repair ASCOM drivers
	wrong COM port	use device manager to confirm COM ports
	wrong driver	check hardware driver is up to date
USB serial failure	adaptors are not all created equal!	try one with FTDI / Prolific chip-set / Keyspan
broad stripes on any image	slow or interrupted USB interface	often seen on slow netbook computers
fine stripes on any image	camera clock stability within CCD	potentially curable with a firmware update
interference pattern on image	power supply noise during image download	check to see if CCD cooling is disabled during image download
	radiated or conducted radio frequency interference	isolate power supply, apply ferrite clamps and shielding, check grounding and cable routing
dark frame evenness	CCD sensor issue	check with manufacturer what is considered normal, before claiming warranty repair
	light leak in hardware	confirm by exposing with lens cap on

fig.1 *The most annoying problems are those that occur during image acquisition. The following list of common issues and possible causes may be of some use, many of which I have experienced at some time. These are "starters for ten" and are best considered in context to the occurrence of the issue and in response to the question, "What has changed"? Processing issues are not listed here since, although they are equally annoying, time is on your side to re-process the data to overcome the issue. Some visual clues, seen in images and software graphs, are shown in figs.2–9. (fig.1 is continued on the next three pages.)*

symptom	possible root cause	notes
dark frame evenness	light leak (IR transparency)	use metal lens caps where possible
exposure evenness	light leaks	check around filter wheel and OAG housing
	blooming around edges	possible CCD issue, or uneven cooling
	flare from nearby light source	extend the dew shield, remove the light
	light pollution near horizon	use light pollution filter or narrowband exposure to confirm
stars vertically "fragmented"	progressive scan CCD line-order is wrong	check advanced driver settings to swap line order
elongated stars (RA axis)	wrong tracking rate	is the sidereal rate set?
	autoguider issues (see autoguiding)	
	periodic error (unguided)	check PE with utilities and use PEC
	refraction (at low altitude)	does mount support refraction compensation?
	exposure before post-dither settle	increase settle time or lower pixel error threshold
	poor polar alignment (unguided)	RA drift can also occur in specific cases
elongated stars (radial)	no field-flattener	insert a compatible field-flattener
	wrong sensor spacing to flattener	use a tool like CCDInspector to confirm optimum
elongated stars (tangential)	field rotation from polar misalignment	seen most during long exposures and at high DEC
elongated stars (DEC axis)	drift due to polar misalignment	check your alignment process / drift align
	autoguider issues (see autoguiding)	backlash, drift, stiction, min. move set too high
	exposure before post-dither settles	increase settle time or lower pixel error limit
elongated stars (any axis)	guider output disabled	check guider controls and ST4 cable connection
	guider locked onto hot pixel	use dark frame or bad PixelMath calibration
	temporary clouds	stop buying new equipment!
	tripod movement (soft ground)	place legs on broad platform or deep spikes
out of focus (center)	worse over time	possible focus drift with thermal contraction
	worse with some filters	adjust focus for each filter position
	all the time	use autofocus tool or HFD to confirm best focus
	focuser mechanism slip	consider motorized rack and pinion focuser
out of focus (gradient)	sensor not square on	use laser jig to confirm sensor alignment
	sensor not square on	check focuser tube for play / sag

symptom	possible root cause	notes
out of focus (corners)	field flatness	check sensor spacing to field-flattener
poor goto accuracy	poor polar alignment	
	inaccurate time and location setting	check time zones and daylight saving settings
	telescope not synced / homed	often required to set a known position
	axis clutches slipping	check DEC / RA clutches are tight
star distortion with guiding	overcorrection from instability	check guider graph to confirm
(seen in image and also in guider graph)	overcorrection from incorrect calibration	check guider calibration with theoretical value
	overcorrection from stiction	possible with DEC axis, when moving from stationary
	overcorrection from high aggression	lower aggression setting
	maximum move set too low	set maximum move to 1 second
	guide rate set too low	increase guide rate by 25% and try again
	guide output inaccurate (seeing)	try increasing exposure to 5 seconds
	guide output inaccurate (seeing)	try binning to increase sensor SNR
	guide output inaccurate (flexure)	use OAG, tighten fasteners, lock mirrors
	constant guide error (no corrections)	lower minimum move setting in guider software
	constant guide error (with corrections)	backlash (DEC)
	slow to correct error (on graph)	increase max move, aggression or guide rate
star trails (graph good)	differential flexure	check rigidity of both optical/camera systems
star trails (sudden)	mount stops moving	check mount slew limits
	mount stops moving	tracking set to "off" accidentally?
star trails (after flip)	autoguider has lost guide star	re-acquire guide star and restart sequence
	system is applying RA in wrong direction	confirm settings to change RA guider polarity after meridian flip
star trails (stuttered)	wind or disturbance	check the cat is not sitting on the telescope (yes really)
	cable snag	route cables in polyester mesh sleeving and look for snag points
dumbbell stars (DEC)	DEC backlash is causing two-positions	tune mechanical backlash or use backlash compensation in software
dumbbell stars (any axis)	autoguider locks onto adjacent star	select guide star that is isolated from nearby stars
dumbbell star (RA)	DEC axis bearing preload	occurs when DEC guider changes polarity

symptom	possible root cause	notes
small diffraction spikes	sometimes from lens spacers or micro-lens	seen on brighter stars, sorry, it's physics
halo around bright stars	internal filter reflections	often in range of 30–60 pixels
	internal sensor reflections	often in range of 70–140 pixels
plate-solve fails	insufficient exposure / stars	longer exposure or choose different RA / DEC
	pixel scale estimate is wrong	check estimate for binning level used for exposure
	estimated position is wrong	check estimate, expand search area
	no estimates is available	use blind solve or all-sky solve (astrometry.net)
autofocus fails	star is too bright or dim	locate better star / change autofocus exposure
	optical parameters incorrect	check focal ratio and step size
	autofocus locks onto hot pixel	use dark frame calibration or select star in sub-frame manually
	focus tube does not move	check mechanical and electrical systems
inaccurate autofocus	too few sampling points	need minimum of 3 points either side of focus position to establish V-curve
	over / under exposure	bright / dim stars are difficult to focus
	tracking issues during exposure	tracking problems distort HFD / FWHM measurement
	stars are too dim	try multi-star sampling to improve robustness of measurement
	focuser backlash	enable backlash compensation for moves that travel towards the ground
	autofocus through wrong filter	develop strategy for autofocus and filter changes
	bad seeing	increase sampling per position to reduce effect
guider calibration fails	insufficient movement, low rate	increase calibration time, move to smaller DEC
	does not move / output disabled	hardware or control failure, check cables
	locks onto hot pixel for calibration	calibrate guider exposures and use filter / binning / sub-frame / dark pixel map or dark frame
	star moves off image	choose guide star away from edge of frame
	small RA movement	try calibrating at lower DEC setting (see guiding chapter on compensation pros/cons)
	lost star (poor SNR)	increase exposure, check focus, check for guide scope condensation
	bad calibration accuracy	seen in some cases where PE is excessive (100")

 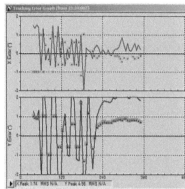 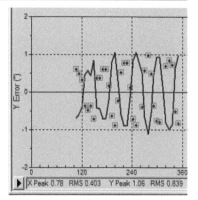

fig.2 Bias frame downloaded on a slow
 USB connection (with a medium
 stretch applied). In this case, it was
 a direct USB 2.0 connection on a
 Netbook computer. Changing to
 a faster laptop fixed this issue.

fig.3 Over-correction during autoguiding
 (the guide rate was accidentally
 doubled after calibration) causing
 oscillation. The guider output is
 disabled at 220 seconds and the
 oscillation immediately stops.

fig.4 Subtly different to fig.3, multiple
 (DEC) corrections within each
 oscillation rule out over-correction
 from autoguider. In this case, it
 is a complex interaction within
 the mount firmware between
 encoders and autoguider inputs.

 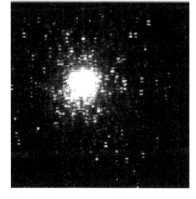

fig.5 Dumbbell stars, in this case caused
 by DEC backlash. (The camera
 is at 30° angle to DEC axis.)

fig.6 Field curvature in a crop from the
 top left corner. (Stars are perfectly
 round in center of image.)

fig.7 Lodestar image (unbinned),
 which has an incorrect line-order
 setting in its ASCOM driver.

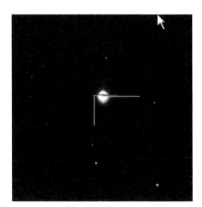

fig.8 Maxim autoguider calibration image
 reveals mount backlash issue, as star
 does not return to starting position.

fig.9 Stretched master bias. CCD internal
 clock issue, fixed with a firmware
 update. Very difficult to calibrate out.

fig.10 Tracking oscillation, not drift.
 (Short exposure and a small hot
 spot in the middle of each line.)

Summer Projects

A diverse range of practical daytime projects to make clear nights more productive.

The summer months are a challenge for astrophotographers; and at the higher latitudes, this extends a few either side. During these months, with their long evenings, it is a good time to do all those little projects that make your imaging more reliable and convenient. For those of you with a temporary setup, anything that reduces the setup time and makes it more robust is a good thing. What follows are a couple of ideas that make my portable setup in the back yard virtually as convenient as a pier system, improves alignment, reliability and simplifies my setup. I have also included some neat ideas for invisibly mounting a heater on a secondary mirror and a wall-mounted flat box with a novel twist that can be used in an observatory. The major project, to develop an observatory controller system, has its own chapter.

Ground Spikes

This simple idea came about from a "discussion" with my better half, on whether I could have a sundial on the lawn that could double-up as a telescope pier. Well, you have to ask the question, don't you? England had just had one of its wettest winters on record and my lawn was very soft underfoot. The tripod legs slowly sank into the ground, ruining polar alignment and worse. As a temporary measure I placed the tripod feet on three concrete paving slabs. This made a huge improvement, apart from a few things: my cat had a habit of jumping on them when I was imaging, they left marks on the grass and I had to haul them back into the shed each night.

My Berlebach Planet tripod has rubber- and spiked-feet options. The spikes are the better choice for outdoors, though as I mentioned, they sink into soft ground. My ground spikes overcome this issue by thinking big, yet at the same time, are lawn-friendly.

Design

The design is very simple; it is based on a long metal rod, with a point at one end and a tapped M8 hole or similar at the other. My first design is shown in fig.1, though clearly the dimensions can be altered to suit your own conditions. The spikes are hammered into the ground, so that the top is at, or slightly below, ground-level. Into each is screwed a stainless steel cap-head bolt. The end of the spike is easily lost in the grass, and to make it

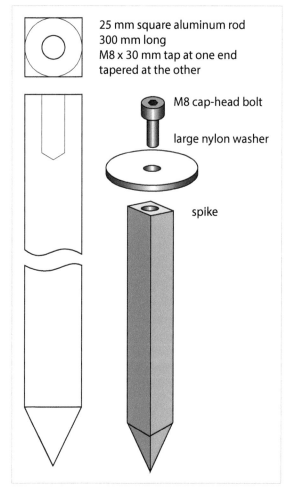

25 mm square aluminum rod
300 mm long
M8 x 30 mm tap at one end
tapered at the other

M8 cap-head bolt

large nylon washer

spike

fig.1 The basic design for the ground spikes, in this case using a square aluminum rod. It could also be round, longer, or shorter, depending on need.

easier to locate, a giant white nylon washer is added. The tapped hole serves two purposes: as a retrieval device and for perfect location. To retrieve the spikes, take a plank of wood and drill a 10-mm hole, about 1/3rd along its length. Insert a long M8 bolt through it and screw it into the spike. The plank now acts as a giant lever-corkscrew for effortless removal. In use, the Allen key hole in the top of the M8 bolt is also a perfect locator for the tripod leg spike. The top of the bolt lies just beneath grass level and is invisible from the house (fig.2).

Setting Up North and Level

For this to be at its most effective, you need to find a flat piece of ground, true north and extend the tripod legs to marked positions. In my case, the position in the back yard optimizes the horizon and is conveniently close to my control room at the back of the garage. I generally do not find compasses that reliable: first the magnetic declination is not always known and more importantly they are affected by nearby metalwork, even by some stainless steels. There is a better way, which is far more accurate, and requires three large nails, an accurate watch, about 4 feet of string and some astronomy know-how:

1 On a sunny mid morning, push one nail into the lawn where the north tripod leg will be.
2 Tie a second nail to the end of the string to make a plumb bob.
3 Using a planetarium, find the local transit time for the Sun (when it is on the meridian due south).
4 At precisely the transit time, hold up the plumb bob so the shadow of the string falls on the nail and mark the plumb bob position on the ground with the third nail, a few feet due south of the first nail.

With an accurate north-south reference line, it just requires the positioning of the three spikes. First, extend each tripod leg by the same amount and lock. Keep the extension modest (less than 6 inches if possible).

1 Hammer the north spike into the hole left by the first nail so its top is at ground level. (Use a club hammer and a hardwood block to prevent damage to the screw thread.) Screw in a M8 bolt and washer.
2 Place the north leg spike into the M8 bolt head and gently rest the southern legs on a couple of place mats in the approximate position on the lawn.
3 Swivel the tripod so the two southern legs are equidistant from the north-south line running from the third nail and the north leg. (I used two long rulers but two pieces of string will work too.) When it is in position, remove the beer mats and use the tripod leg indentations to mark the remaining spike positions.
4 Hammer in the two remaining spikes and screw in the M8 bolts and washers.
5 Place the tripod spikes into all three M8 bolt heads and check the level. At this point it is unlikely to be perfect. If it needs some adjustment, remove the M8 bolt from the elevated spike, hammer it in a bit further and try again. (I achieve a perfect level using minute leg adjustments rather than loosening the M8 bolt.)

fig.2 *The end result is discreet. The tripod spike sits in the bolt cap head and the white nylon washer makes it more obvious in long grass.*

Within 10 minutes I was able to obtain a level to within 0.03°. Although not strictly necessary for a GEM, this makes it much easier to detect any movement over the coming months. In a portable setup, this achieves consistent alignment within 1 arc minute, providing the tripod is not collapsed after use. I also use a lock nut on one bolt of the mount's azimuth control for reference.

Master Interface Box Mk2

At a different level, and requiring construction and soldering skills, is my master interface box. The idea behind this is to encapsulate several functions in one box. This makes system setup a breeze, since many common modules are permanently connected and secure. At the same time, it upgrades the power connector and fusing strategy: This reduces the number of external connections, equalizes the power consumption and sensibly divides the power supplies into clean and dirty to minimize CCD interference through its power feed. Wiring tags are soldered

fig.3 *The Mk2 master interface box, with its 16 pre-punched connector holes fully occupied. There is plenty of space inside for expansion and the rear panel can accommodate further connections if required. Male and female XLR connectors are used for 12-volt power. A unique Neutrik PowerCON® connector is used for the Paramount 48-volt supply and Neutrik USB and RJ45 connectors for communications. The fasteners are upgraded to stainless steel to prevent corrosion.*

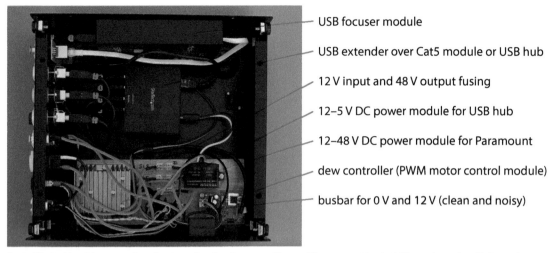

USB focuser module

USB extender over Cat5 module or USB hub

12 V input and 48 V output fusing

12–5 V DC power module for USB hub

12–48 V DC power module for Paramount

dew controller (PWM motor control module)

busbar for 0 V and 12 V (clean and noisy)

fig.4 The inside of the master interface box, showing the general layout. The power wiring is deliberately not bundled to reduce crosstalk. The power modules are screwed into a wooden plinth, which is then fastened to the base with self-adhesive Velcro. The 3 x 6-way bus bar sits next to the fuses, and offers the opportunity to redistribute power supplies and balance the load on the power feeds. Short USB cables are used to reduce signal latency and the power feed to the PWM controller is filtered with an inductive choke.

for low resistance and insulated with heat-shrink, rather than relying on crimps alone, which I find to be unreliable with small wire gauges. This was initially designed to make my portable setup a breeze but I use it now in a permanent setup too, mounted to the side of the metal pier using a purpose-built cradle.

Enclosure and Connector Strategy

The most difficult and time-consuming part of electronics design is typically the enclosure. Initially, I integrated battery and hub electronics into a pair of enclosures, as previously shown in the chapter on imaging equipment. It took several weekends to just drill, saw and file those box cutouts. They served well for 2 years, but over time several shortcomings became apparent:

- The crimped power connectors are difficult to make reliably, and mechanically / electrically fail.
- Automotive cigarette connectors are unreliable and it is easy for the plugs to lose pin contact, especially if the socket does not have a lock feature.
- The configuration is dedicated to a certain setup (which was forever changing) and limits the battery size.
- There were still too many boxes and a rat's nest of wires between them, all collecting dew.
- The current demand was not divided intelligently between the batteries.

Two enablers spurred an improved system: a wide range of chassis connectors with a XLR connector footprint and pre-punched audio project boxes in a wide range of sizes. XLR connectors are ideal for carrying 12-volt power and Neutrik DB9, RJ45, USB and PowerCON connectors also fit the standard 24-mm punch-out. I chose a 10.5-inch 2U audio project box, selecting front and back panels with XLR punch-outs. These boxes come in a range of standard sizes and this particular size fits neatly on the accessory tray of my Berlebach tripod. These boxes are typically made from powder-coated steel and to avoid corrosion I replaced the external fasteners with stainless steel equivalents. To allow simple repositioning and changes for future upgrades I fixed the modules in place with self-adhesive Velcro. I fitted blanking plates to the unused punch-outs. The Neutrik D range does not include phono connectors or switches. To overcome this, I fitted standard power switches within a Neutrik D plastic blanking-plate and similarly fitted the dew heater control and outputs into a piece of black plastic (in this case, cut from a plastic seed tray) aligning the connectors with the panel cutouts.

Electronic Design

The design intent houses all the common modules used during an imaging session in a single enclosure, including dew heater, USB extender / hub, power supply conversion / distribution and electronic focuser output. At the same time, the internal 3 x 6-way busbar module (a Land Rover spare part found on eBay) enables alternative power supply assignments, to balance demand and reduce electrical noise on the camera power lines.

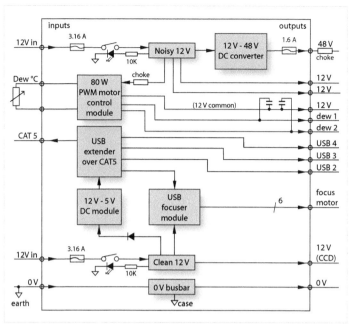

fig.6 *The dew heater controller calibration. (See the text for the calibration method.) The marker at 6 o'clock is the counter-clockwise limit. Towards the beginning and end of travel there is little change in output power. In the central part the calibration is approximately linear. In practice, a setting between 2 and 6 °C prevents dew forming in normal UK conditions.*

fig.5 *The schematic for the interface box. The active outputs are shown but obviously each of the power outputs are accompanied by a 0 volt feed from the 0 volt bus in each case. The dew heater output has a 12-volt common rail.*

The layout is shown in figs.4 and 5. I have two focuser systems and the precise DewBuster dew heater controller. My system has 2 free USB and power ports that allow these to be operate externally, if required. Both my initial Microtouch focus controller and the later Lakeside controller fit neatly on their side within the box and use EJ/DB9 connectors respectively. My existing dew heater controller was more of a challenge; I needed access to its control knob and opted to keep my DewBuster unmolested and investigate alternative solutions.

Dew Heater Controller

All dew controllers work by switching current on and off using a technique called Pulse Width Modulation (PWM). An Internet search for a dew controller circuit finds dozens of similar designs. An astronomy forum search also finds many threads that discuss using motor or LED light-control modules as dew heater controllers. Power switching is not without issue since a dew heater controller can abruptly switch an amp or more. This can cause conducted or radiated interference to other electronic components. The abruptness of the switching action on an inductive load also creates voltage spikes that potentially affect image quality and USB communications. Dew controllers typically operate at 1Hz. Motor and light PWM modules work at about 10 KHz and are a tenth of the price. The better PWM motor controllers have a clamping diode and

filter protection on their outputs, to cope with a motor's inductive load. After perusing the available modules on Amazon and eBay, I chose an 80-watt motor speed controller module whose picture clearly showed clamping diodes and a high power resistor near the output. These modules have two outputs: switched and 12 volts (not 0 volts). You need to ensure that any outer connector metalwork does not touch other surfaces that are likely to be 0 volts or ground. On the bench, this small module operates at 12 KHz. I checked for RFI by listening to an AM / LW radio close by, while powering the output at 50%. As a precaution, in the final box assembly, I wound the input power cable around a ferrite core, used a shielded cable for the PWM output and soldered 100 nF capacitors across the output connectors. To minimize crosstalk, one can route the heater cables away from the other cables, or in my setup, I used a flexible double-shielded microphone cable (with the outer shield grounded at one end) and routed it inside the Paramount MX mount body. Some mounts are *very* sensitive to interference and in those cases, one can alternatively use a 12-volt, 1-amp linear DC module using the LM317 voltage regulator chip. The voltage regulator chip requires a heatsink to keep cool.

The DewBuster controller has a unique feature that maintains a constant temperature differential between the ambient conditions and the surface of the telescope. My aim was to achieve the same temperature difference

but without using an external sensor. Assuming for any telescope and for each power level, there is a steady state temperature differential in still conditions, based on Newton's law of thermodynamics. I calibrated the system by setting the controller to a particular setting and after 10 minutes or so measured the steady-state temperature difference. To do this, I calibrated the controller using a simple internal / external thermometer and placed the external sensor under the dew heater tape. To avoid direct heating I insulated the sensor from the heater with a couple of 1-inch squares of thick card, so that it only sensed the telescope body temperature. After recording the temperature measurements at 30° knob increments, I plotted the temperature differences and worked out the angles for a 1–10°C scale. (The example label in fig.6 is conveniently made from a laminated inkjet print.)

This system is not as versatile as the DewBuster controller, but it was ideal for permanent incarceration and is the basis of most inexpensive commercial dew controllers. In these designs the power level is a function of a potentiometer setting; the DewBuster uniquely warms the telescope up to temperature more quickly, as its power level is proportional to the temperature offset error.

USB Considerations

The USB interface is generally responsible for more erratic equipment problems than anything else. One particular problem is the maximum cable distance over which it will work. Under normal conditions this is five meters, before the signal degradation by the cable causes issues. USB repeaters and daisy-chained hubs extend the range with diminishing effectiveness and also require power. Bus-powered extenders also eat into the power budget, leaving less for the peripherals. Extended USB networks cause other problems too. A USB interface requires a signal delivery in 380 nS. Each cable introduces a propagation delay and each active interface or hub typically introduces a 100 nS delay or more. It does not take long for USB communications to fail. Component quality plays a big role too: not all cables have the same build quality and USB hubs vary widely, many of which work perfectly under normal office conditions and fail in cool or freezing conditions. There are also performance differences between the USB hub chip sets. Those made by NEC are often cited as the best by users on the astronomy forums, preferably advertised as "industrial".

For the last few years I have used a USB extender over CAT 5 cable. These are expensive and require a power supply at the hub end, but they deliver a full bandwidth four-port hub up to 300-feet away from a computer. Apart

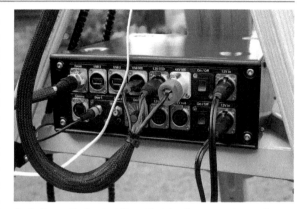

fig.7 *In use, the box just fits on the tripod accessory tray and greatly simplifies the cabling. The communication cable is all that is needed to complete the installation. The two battery feeds on the right hand side go to sealed lead-acid cells that sit beneath the tripod, or two speaker leads that go to a bench DC supply in the house.*

fig.8 *With a minimal re-arrangement of the USB connectors this box works well in the observatory too. I constructed a plywood cradle around the metal pier and the box just slips in. As it points upwards I took the precaution to seal the unused connectors and unused sockets against rain and dew. I use the rear facing connectors for inbound USB and external sensors, coming in along the floor.*

fig.9 The CCD alignment jig, here
 made from glued and screwed
 plywood. A low-power laser shines
 and reflects off the sensor and
 produces a diffraction pattern.

fig.10 From above, you can see the
 camera mounting plate is slightly
 angled to aim the reflected
 beam to the side of the laser.

fig.11 The reflected beam creates a grid of
 bright dots and reflections from the
 sensor, cover and housing windows.

fig.12 This Starlight Xpress CCD has three
 adjustment bolts and opposing
 locking grub-screws to angle its
 faceplate in relation to the sensor.

from the high-speed video camera, all of my peripherals work through this hub, even if they are connected via the built-in hub of the Paramount MX. With all that in mind, the trick with USB is to keep the cable lengths and daisy chains as short as possible, always use high-quality USB 2 cable and avoid hard-wire USB connections with unmatched impedance characteristics. Since then, after installing a NUC PC close by, the USB extender hub in the enclosure has been replaced by a single 7-port industrial USB hub. The Velcro mounting makes configuration changes very easy.

Power

The power system is first fused and then passes via switches to a busbar system that distributes it to the inside of the box. This ensures that if there are any errors, the fuse will take out the entire circuit, and the small indicator lamp on the switch will show that the fuse is broken. There are two power inputs: one for electrically noisy applications and the other for clean. The dew heater and mount's DC power module consume about 1 amp in total and make use of the noisy feed. The communications hub, focuser and camera consume a similar amount and are connected to the clean feed. (The focuser is inactive during image download and the USB is already connected to the camera system.) Most of the power connections use spade terminals. I prefer a bare terminal that is crimped and soldered to the wire and insulated with heat-shrink tubing. This provides a more reliable electrical connection than crimping alone.

In my particular system, the Paramount requires a 48-volt DC supply (10Micron and some other designs require 24 volts). The embedded 12–48 volt encapsulated DC-DC module is highly efficient, rejects noise and also regulates the supply. Even with twice the expected maximum load, the module remains cool. (To prevent accidental 48-volt connections to 12-volt equipment, I chose a unique Neutrik PowerCON® connector for the 48-volt output.)

Final Checks

Before connecting any peripherals, it is important to check for short-circuits between the power lines, signal cables and insure the polarity of every power connector is the correct way around. With the XLR connectors I assigned the long central pin to 0 volt, as it connects first during plug insertion. I also earthed the 0-volt line at the power supply end. The same attention to detail is required with the connecting cables. It is advisable to insulate each soldered connection with heat-shrink tubing to prevent accidental shorts.

The end result is a neat and reliable system that fits together in moments (figs.7 and 8) and provides a consistent interface for each imaging session.

CCD Alignment Jig

As we already know, astrophotographs reveal every minor defect in tracking, optical alignment and focus. In particular, if stars are in precise focus in one part of the image yet blurred or elongated in others, it becomes very obvious that things are not quite what they should be. Since the critical focus zone is so small, especially with shorter focal lengths, even the slightest tilt of the sensor away from the orthogonal will degrade image quality. Some CCD sensors are carefully aligned to be co-planar with their mounting flange before shipping, others provide the opportunity for customers to make their own

adjustments. In the case of Starlight Xpress cameras, this adjustment is facilitated by opposing bolts on the mounting flange (fig.12). Trying to align the camera manually on a telescope is particularly hit and miss. Fortunately, it can be adjusted on the bench, with a simple jig and a low-power laser pointer.

Construction

This particular jig makes use of some spare plywood but it can be made of metal if you prefer. As can be seen in fig.9, it is made up of two opposing walls, mounted on a base. One wall has a small hole through which a low power laser is inserted. This one was bought for a few dollars on the Internet and has two fly-leads that connect to a 3-volt camera battery. A piece of squared paper is attached to the inside of this wall to act as a projector screen. The opposing wall holds the camera. It is braced with two buttresses to ensure it is rigid under load. It is also slightly angled so that the reflected beam from the camera aims to the side of the laser (fig.10). A 2-inch hole is accurately cut through this wall to mount the camera, fitted with a 2-inch adaptor. In this case a 2-inch to C-thread adaptor is passed through. This is deliberately a snug fit and the adaptor is held in place with a plastic clip made from a piece of plastic plumbing pipe. In figs.9–11 I'm using a guider camera to produce the diffraction pattern, but in practice it will be the imaging camera.

Operation

When a laser is shone onto a sensor, a regular pattern of dots is diffracted back from the sensor surface. These form a rectangular pattern and the dots have similar intensity. Other reflections occur too; from the sensor cover glass and window in the sensor housing. The image in fig.11 shows the pattern reflected from the Lodestar camera. This camera has a bare sensor and you can see the reflection from the coverslip (B in fig.11) and a grid of dots, which I have emphasized with fine lines. Other cameras will show an additional strong reflection if there is a glass window on the camera housing.

As you rotate the camera, the dot pattern rotates too. The camera sensor is aligned if the central dot of the regular pattern (A in fig.11) does not move as the camera is rotated. The squared paper helps here, as it does to rotate and gently

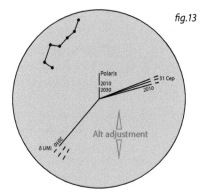

fig.13 This simplified MX polar scope schematic for the Northern Hemisphere relies on a 3-point star alignment. (The scope view is inverted.)

push the camera up against the wall at the same time. (The plastic clip is not strong enough to guarantee the camera rotates perfectly on its axis.)

It is a 10-minute job to align a sensor using this jig. In the case of the Starlight Xpress cameras, after alignment, I applied a thin strip of self-adhesive aluminum foil to seal the gap between the mounting flange and the camera body, to ensure a light-tight seal. (If your camera has a shutter or filter wheel, remove the filter from the light path, power up the camera and make a dummy exposure to open the shutter during the alignment process.)

Paramount MX RA Scale

This mount has an optional polar scope that is uncannily accurate (providing you center the reticle it correctly with its three grub screws). Unlike the popular SkyWatcher

fig.14 The RA scale fixed to the outer housing. The white arrow is opposite 0 HA when Polaris is at a 0- or 12-hour angle.

fig.15 The RA scale (reduced), showing the two scales, for when Polaris is calibrated to either a 6 or 12 o'clock reticle position. It is accurate when enlarged so the scale length is exactly 31.5 cm (a PDF file version is available at www.digitalastrophotography.co.uk).

NEQ6 mount however, there is no RA scale to facilitate the rotation of the mount to the correct Polaris hour angle. It relies instead on aligning three stars: Polaris, δ-UMi and 51-Cep to determine the Alt / Az setting of the mount (fig.13). This requires a few iterations of rotating the RA axis using the hand paddle and adjusting the mount bolts. Unfortunately δ-UMi and 51-Cep are about 7.5x dimmer than Polaris and very difficult to see in twilight or in light pollution. Fortunately, even with a mount of this standing there is a quick and easy way to improve on it. To overcome this limitation, we need to align the polar scope so that it is at the 6 or 12 o'clock position and make a simple RA scale.

Making the RA Scale

I drew this scale using Adobe Illustrator® but any graphics package will suffice. The MX's RA housing is exactly 20 cm in diameter and assuming 23.9356 hours per 360 degrees, a 12-hour scale is 31.5 cm long (fig.15). The scale is doubled up, with either 0 or 12 (HA) in the middle, corresponding to the two alternative Polaris calibration positions (fig.15). This scale just prints within an A4 paper diagonal. The print is laminated and fixed to one side of the outer casing with double-sided adhesive tape (fig.14). The white arrow is made from a slither of white electrical tape; it is positioned against the zero marker on this scale when Polaris is exactly at the 6 or 12 o'clock reticle position and is deliberately repositionable to facilitate accurate calibration.

Calibrating the Polar Scope

The RA axis on the MX only rotates through ~200° and the polar scope requires a 180° flip once a year. The polar scope is rotated by loosening its locking collar and turning gently. Since it is difficult to rotate precisely, any angular error is more easily fixed by moving the pointer. This neat trick makes things easy: with the mount in its park position (DEC=90, counterweight bar facing downwards), rotate the polar scope to place Polaris vertically above or below the crosshair and tighten the collar. Center Polaris by adjusting the mount and check the reticle is still accurately centered. Rotate the mount in RA and note if Polaris wanders off the crosshair. Make small adjustments to the three grub screws surrounding the polar scope eyepiece and repeat. The trick now is to place the white marker against 0 HA, when Polaris is *exactly* at the 6 or 12 o'clock reticle position. To locate this position, center Polaris (or a convenient daylight target) on the polar scope crosshair and change the mount's Altitude adjuster, moving it towards its reference line. To align the scale, I rotate the RA axis until Polaris lies on this line and then attach a sticky tape arrow on the mount housing, to point exactly at the 0/12 HA scale marker.

Polar Alignment in Practice

At twilight I determine the HA of Polaris using the PolarAlign app for the iPad (or similar), and after homing, rotate the RA axis using the hand paddle until the white arrow is at that HA scale marking. (The mount should be tracking too.) I then align Polaris in the polar scope using the Alt/Az mount adjusters. Halfway through the year I flip the polar scope 180°, re-center the reticle, re-calibrate the arrow position and use the other half of the RA scale for alignment. How good is it? A 100-point TPoint model confirms it consistently achieves an accuracy of about 1 arc minute and only bettered (in the same time) by using TPoint's Accurate Polar Alignment routine or a QHY PoleMaster.

Invisible Spider Cable

My 10-inch RCT was supplied with a secondary heater tape but it was left to the customer to fit it. This rubber-backed circular heater is easy enough to stick onto the back of the secondary mirror housing but the power cable

fig.16 A thin copper strip is stuck to both sides of a spider vane. A standard dew heater cable is gently soldered onto one end.

fig.17 At the other end, the cable from the dew heater is cropped, stripped, tinned and soldered to the strip.

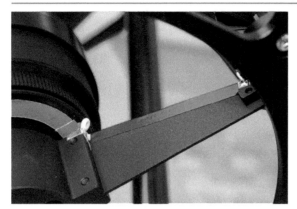

fig.18 *The copper strip is neatly covered by folding a piece of black electrical tape over the vane edge.*

fig.19 *The front view shows no additional image obscuration, as the wires are masked by the baffle.*

is a different matter. The four spider vanes that hold the secondary mirror in place create diffraction patterns that are instantly recognizable radiating from bright stars. I could not simply drag the cables to the outer flange, as this would create an additional diffraction spike and even taping them to a vane would create distracting asymmetries in the diffraction pattern. To ensure the system has no impact on image quality requires a low-profile cable attached to a spider vane.

The key words here are "low-profile cable". Many years ago during my engineering days at Marconi, I wrapped sensitive components in copper tape to reduce their susceptibility to electrical interference. I recalled this tape came in a self-adhesive version. A quick eBay search discovered it was still available, often sold as "guitar tape" and amusingly as slug and snail repellent too. For this project one needs the smallest quantity; a strip the length of a spider vane.

This is ideal for passing the current along the vane and does not short out as the adhesive layer and paint on the vane act as insulators. Carefully stick a 5-mm wide copper strip to both sides of the trailing edge of a vane. Then, gentle tin the ends of the strip with solder. Next, strip and tin the end of a standard coaxial dew heater cable and quickly tack on to the copper (fig.16) and secure to the outside of the truss with cable-ties. Position the dew tape and stick to the rear face of the secondary mirror so that the wires come out by the same vane. Then, trim, tin and solder to the ends of the copper tape (fig.17). (With both ends being independently tinned, it only requires the briefest dab of a soldering iron to bond the two conductors.)

Lastly, hide the copper foil under a length of black electrician's tape, folded over the edge of the vane and slightly overlapping the copper tape (fig.18). A final check from the front confirms the cable joins are obscured by existing metalwork (the secondary mirror shroud and the truss supports), as seen in figs.18 and 19.

Observatory Flat Panel

I have been fortunate enough to have a clean-room to store my equipment and conveniently produce flat-frames with either an illuminated white wall, or using a small electroluminescent panel held over the front of my refractors. By keeping things spotlessly clean, I can re-use these flat frames for an entire season. With the purchase of my reflector telescope and its permanent mounting in a drafty roll-off roof shed, the need for local and more frequent flat frames encouraged me to think of another solution. The shed walls are too close to illuminate evenly and I'm not a fan of sky flats since I typically average 50 exposures, using each filter, to remove shot noise. The answer is an illuminated panel. I experimented with white LEDs but found they had minimal deep-red output and it was difficult to achieve even illumination in a slim package. EL panels are better in this respect but are limited in their ability to adjust their brightness. They do have some deep red

fig.20 *The front view of the completed EL panel, with the opal glass secured in place by secondary glazing clips. This A2-sized panel is not heavy, as the glazing is made from plastic, and is securely held to the wall with a single magnet.*

output (but not to the same extent as a tungsten light source). Circular commercial electroluminescent panels for astronomy are formed by sandwiching an EL panel between two circular sheets of white plastic glass but are quite expensive.

I decided to make my own using standard-sized components. A circle is a convenient shape but wasteful, considering the sensor is a rectangle. An Internet search identified many suppliers, one of whom manufactured in standard European paper sizes. I chose an A2 panel (420 x 594 mm) with a power supply. At the same time eBay provided an inexpensive A2 wooden picture frame (with plastic glazing), a 200 x 200 x 0.6 mm piece of plastic coated steel, a 50-mm diameter magnet and an A2 piece of opal plastic glass. I found some left-over secondary glazing clips in the toolbox and a few hours later I had the completed assembly (fig.20).

The novel twist, literally, is the rotation feature. To ensure good and even illumination of the sensor with an economically-sized panel requires the panel to be orientated similarly to the sensor. The solution is to attach the panel to the shed wall using a strong magnet and rotate the panel on the axis of the magnet.

First, rotate the optical tube assembly so that is square-on to a wall and screw the magnet to the wall so that it is opposite the optics. Disassemble the picture frame and place the EL panel behind the safety glazing and cut a slot through the frame in one corner to allow the wires to pass through. Place an A2 piece of card on top as a spacer. Now cut a 50-mm hole in the middle of the hardboard back panel and stick the metal panel behind it (I stuck it down with strong adhesive tape along all four sides). Assemble the panel into the frame and secure (my frame has metal tabs that bend over to secure the back panel). That completes the basic panel; the circular magnet latches onto the metal plate through the hole in the back panel and the entire panel rotates with ease.

What of the A2 opal plastic? It occurred that I could attach the opal, or other less transparent media to the frame, to reduce the light output. In this case, I use some old secondary glazing clips to hold the plastic in place. These nylon clips simply twist round their fastener to grip the plastic. To apply this modification, place the plastic panel on top of the frame and screw in the clips around its periphery. (If the frame is made from wood drill a small pilot hole for each screw to prevent splitting.) When in use, the EL power supply is attached to the wall nearby, ensuring there is enough lead length to allow the frame to rotate ± 45°. This is a temporary fixing since the power supply is not waterproof; I simply hang it on a hook and remove when it is not required. To minimize the chance

fig.21 The front view of the completed EL panel, showing the pink EL panel (unpowered) behind the plastic glazing and the opal plastic diffuser resting on top.

fig.22 The rear view showing the magnet, the hole in the rear wooden panel and the steel plate showing through. The delicate cable from the EL panel exits bottom right and is given relief by carefully cutting away some of the wooden frame. The back panel is held in with metal clips. At a later stage, I may varnish the back panel and use a sealer around the frame to protect from damp.

of electrical interference with other electrical equipment I attached ferrite inductive clamps around the mains power lead and the output cable.

My current telescopes are in the f/8–f/5.6 aperture range and if in the future I have faster scopes, I may need to reduce the light output further. For under £10, I bought some A2-sized neutral-density lighting gels in 1-, 2- and 3-stop strengths. To mount them, I cut these to fit into the panel recess and can simply hold them in place with the opal plastic on top or with tiny Velcro tabs on the corners of the frame. For convenience I programmed a special park position opposite the frame and use Sequence Generator Pro to take a series of 50 flat exposures at each filter position.

Automating Observatory Control

An example of designing your own hardware, software,
ASCOM driver and Windows applications.

Sooner or later the idea of having an observatory looms. All the images from the first edition were accomplished without one but the start of a hernia made it more essential than just a convenience, though the quicker setup and shutdown times also provide an opportunity for making use of short spans of clear weather. There have been numerous articles on building an observatory; concreting-in supports, pier designs and the ingenious ways in which people have created articulated roofs and sides. Although it is very satisfying to design and build one and a useful project for the summer months, this is not one of them. Instead, this chapter describes the conception and implementation of an automatic roll-off roof controller in software and hardware. This serves mostly as an example; it is not my intention to design the definitive roof controller but rather to show what is involved in having a go at software and hardware development, that conforms to the current applicable standards, and whose processes apply equally well to other astro projects.

There are many astronomy-related programs written by retired professionals or gifted amateurs and I admit I have been looking for an excuse to do one of my own for some time. Many years ago I designed hardware and software for industrial gauging; this project requires those skills once more and a crash-course to bridge the technology advances of the last 30 years. Today, the advanced high-level tools that modern operating systems offer make complex software development considerably easier, so long as you know what to look for. A few lines of code and an extensive software library can accomplish what would have taken weeks of typing and debugging.

Since it was over-exertion in the first place that made the observatory a necessity, I decided to buy a commercial product; a roll-off roof shed (fig.1), complete with a basic motorized roof. The Home Observatory company in Norfolk (UK) receive excellent reviews and fortunately are local to me too. One of the build options is for them to supply and fit a roof motor control with a wireless remote. The supplied motor has a sophisticated module that accelerates and decelerates the roof between its end-stops. Although in its normal habitat, it is usually controlled with an RF remote, it can be additionally controlled with wired switch inputs to open/close and toggle the roof direction.

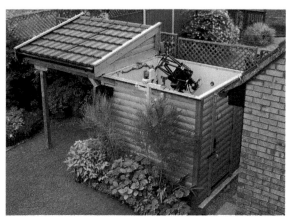

fig.1 *The finished roll-off roof observatory, complete with custom weather sensor array for detecting auto-close conditions. The mount is purposefully positioned as high as possible, to maximize the imaging horizon but has to be carefully parked for the roof to close.*

This project makes uses of these control inputs to extend its functionality, so that I can:

1 Turn on the computer each evening and it senses when it is safe to open the roof.
2 The roof opens when it is dry and without colliding with the telescope and then connects to the camera and mount system.
3 The image acquisition system waits for the clouds to part before starting an imaging sequence.
4 At the end of sequence, if the clouds return or rain stops play, the mount parks itself safely under the roof line and the roof closes.
5 When the roof is closed, it checks and stops illegal mount moves away from the park position.

The project starts with understanding the motor module's capabilities. It accepts an optical interrupter, since in its normal use, it is employed as a sliding gate mechanism. Just as an iron gate colliding with a car is an expensive mistake, so too is a roof colliding with a telescope. It makes sense to connect the relay inputs for "open" and "close" to my own controller and use proximity detectors to detect the roof position. Although a physical fail-safe is a robust way to avoid accidents, avoidance is better still, so

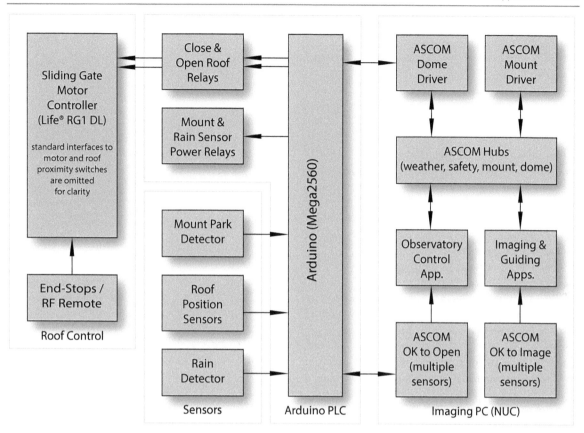

*fig.2 The logical and physical architecture of the roof automation system and its connectivity to the astronomy programs, using
ASCOM as the consistent device interface. What it really needs is an intelligent hub that manages weather, observatory and
mount commands (maybe for the next book). Here, there are two independent weather detection systems, one used by the
imaging program and an additional rain detector to confirm it is OK to open the roof or shut the system down in a downfall
(in case the imaging program is not running). The roof control is deceptively complicated and it needs careful consideration
of "what-if" scenarios. Barring a sensor failure, the Arduino code ensures all movements are safe and since it cannot control
mount movement, if it detects the mount is moving when the roof is closed, it has the ability to interrupt mount power.*

I prefer to physically check the mount is in a low-profile state before moving the roof. Reliable optical proximity sensors are common, as they are a mandatory requirement for perimeter sensing around industrial machinery. I use one that has a combined sender/receiver in a single compact housing and uses a reflector, similar to that used on a bicycle, that is easy to mount on the roof and telescope dovetail plate (fig.7).

There are several commercially available observatory dome and roll-off roof control systems. These are typically bespoke to a particular observatory design. Some offer web-based control too, ideal for remote operation. In this case, once I physically turn it on, I can access it through my PC or, with Microsoft Remote Desktop enabled, my home network. I can also operate remotely over the Internet, so long as the entire system is powered up and I enable a connection using VPN or through the router's

firewall. Again, this project is not the last word in programming perfection but it does employ several hardware and software good practices that are not implemented in some of the commercial astronomy control applications.

Design Architecture

Designing your own stuff is very rewarding (as well as frustrating). In this case it would be of little value to others to describe something entirely bespoke. Although the precise requirements will be slightly different for each user, by following established protocols and by using commonly available hardware, this chapter and the web-based support provide a framework and insights for like-minded practical astrophotographers to help them develop their own solutions. One of the first challenges is working out what you want it to do and designing the architecture; choosing where various functions

are logically and physically implemented. In this case, there is a need for intelligence, sensing and control. It is possible to put all the intelligence within a Windows program and extend the PC's Input/Output (I/O) capability with dumb USB or Ethernet controlled boards. I chose, however, to implement some of the intelligence in an Arduino board, in the form of a ruggedized Programmable Logic Controller, that already has multiple digital and analog interfaces and mounts in an IP65 (splash-proof) DIN rail enclosure. This communicates via a serial port to the imaging PC using a simple messaging structure, ideal for interfacing to the imaging program via its own ASCOM driver. A custom observatory control Windows application monitors the roof, environment and mount. Since ASCOM only allows one connection to a device type, in order for both the imaging program and observatory control application to park the mount, it feeds its controls via a telescope hub, designed to serve multiple application demands. The ASCOM definitions do cater for additional bespoke commands, that I use for rain and mount position detection. The general schematic is shown in fig.2 but, before we get into too much detail, it makes sense to familiarize ourselves with some of the building blocks.

Arduino

Arduino micro-controller boards have been around for over 10 years and designed to be highly extensible and affordable. Along with the slightly more powerful Raspberry Pi boards, they have become the go-to choice for small projects and robotics that require sensing and control. The original boards have a standardized connector arrangement that enables easy I/O expansion over parallel and serial interfaces. In Arduino parlance these expansion boards are called "shields". As these devices are optimized for new users, the Arduino website has extensive support for software and hardware development and an active support forum. Outside schools and universities, the architecture has also found applications in industry, in my case, a ruggedized Programmable Logic Controller (PLC) version (fig.3). To make them more accessible, they are supported by an Integrated Development Environment (IDE) and an active user community. A common feature is a bootloader on the board that allows them to be permanently programmed via a serial port (normally a "virtual" COM port, using a USB to serial adaptor). They have all kinds of interface capabilities including: I²C, RS232, USB, WiFi, Analog, Digital and Ethernet. Once programmed they work stand-alone. Looking over the forum, these little boards have been used for an amazing diversity of applications.

fig.3 *This Arduino is sold as a programmable logic controller (PLC) and conveniently has screw connectors for inputs and outputs, along with two serial ports. The analog inputs are an invitation to expand into weather sensing at a later stage.*

In comparison, my application is quite straightforward but requires some care to make it reliable. Arduino boards are typically programmed in the C or C++ language. (Incidentally, both Steve Jobs and Dennis Ritchie died in 2011. Ritchie, who created the C language and a large part of UNIX was largely overlooked but made an arguably more significant contribution to modern life, as these are the bedrock of modern computing, including Apple's.) The free Arduino development environment is quite basic but usefully, there is a plug-in (from the Visual Micro website) to the Microsoft Visual Studio application that allows the Arduino, driver and Windows applications to be developed in the same environment.

ASCOM

The ascom-standards.org site goes into great detail on the benefits of ASCOM. Fundamentally, it, or more precisely ASCOM drivers, present a consistent device interface for the mainstream software applications. These applications can command and talk to any ASCOM compliant astronomy device (physical or logical), without knowing how each and every device works. It achieves this by defining standardized commands and data for each class of device. The acronym stands for AStronomy Common Object Model and usefully the programming objects it creates are programming language independent, allowing a broad range of applications to access them. The standard extends beyond just an interface standard and it also offers tools to ensure reliable operation within a Windows operating system as well as mathematical conversions and utilities. ASCOM has been around for about 15 years

and is frequently refined to accommodate evolving requirements. It is not a commercial product and relies upon, in no small part, to the generosity of a handful of volunteers. It is not perfect and in some respects needs some modernization, for instance, to ensure ongoing Windows support; some of the utilities would benefit from being re-coded in C#. There are some competing alternatives too, such as the X2 driver standards from Software Bisque, used in TheSkyX.

Each class of device has a unique set of possible commands and variables, not all of which have to be implemented by a driver. In programming parlance, these are called "methods" and "properties". In the case of a roll-off roof (which is basically a sub-set of the more complicated requirements for a rotating dome) the useful ones include "OpenShutter", "CloseShutter" and "ShutterState". My ASCOM driver for my particular roof translates these generic requests into specific serial commands that are sent to the Arduino, that in turn, after confirming to itself that the mount is parked, moves the roof and detects its position. For mature devices, these definitions are rigorous but for emergent technologies, such as weather sensing, the ASCOM community work together to define a set of definitions for the more obvious items (temperature, humidity, pressure) and at the same time keep some definitions open for new developments. The way that the ASCOM drivers are compiled creates a number of library subroutines, that can be called by any application or script. For instance, for my Paramount mount, I can control it via its ASCOM driver with a Visual Basic Script (VBS) from a command line or access it from many programs including Java, JavaScript, Cobol, Python, C#.net, the list goes on.

To support software development, the ascom-standards.org site not only has downloads for the platform and distributed drivers but also has development tools and documentation. There are a couple of helpful videos on the website too from Tom How, that show a simple Arduino development, ASCOM driver and Windows application in VisualBasic. Additional links are provided for installer utilities that allow one to create your own Windows driver installer package.

Observatory Control

This is a Windows application and a nice-to-have addition. It provides all the information and controls in one place. The imaging applications may not always be running and it is useful to control the roof safely and potentially override the safety sensors too. I designed it to independently monitor rain and weather sensors too (fig.8).

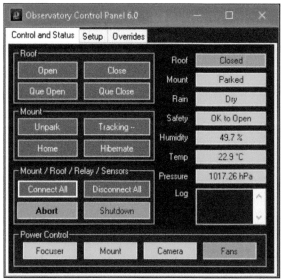

fig.4 This observatory Windows app provides a basic interface to the roof, its setup and allows simple controls of the mount position so that it is tucked out of the way of the roof aperture. The Windows form allows for various control customization and endless layouts. The 4 relay control buttons at the bottom are an expansion into power control, which helps with remote operation and system resets, using ASCOM Switch .COM methods.

There are several layers of command:

1 At the highest level it can monitor the weather conditions, automatically open and close the roof and at the same time ensure the mount is in a safe position. (At a later stage I may add functionality linked to light detectors too or a timer to enhance the intelligence.)

2 At a basic level, it will use the standard ASCOM commands to open and close the roof. These trigger fail-safe open and close commands in the Arduino code.

3 At the third level it uses unique commands (through ASCOM) that bypass the safety controls, for special situations. These trigger unique override commands in the Arduino code, or cause it to operate in a different mode that consistently ignores sensory information, say in the case of a small refractor that always clears the roof line.

In this implementation the application communicates to the dome and mount through a hub, an ASCOM compliant driver that allows multiple connections to a single device. In time, I might write my own, but for now the one sold by Optec® works very well for my purposes.

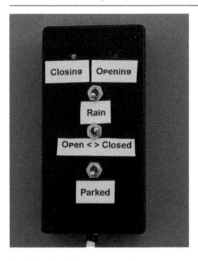

fig.5 *Rather than test my code out on the roof and mount hardware, this simple test jig emulates the optical sensors and allows for safe and intensive testing on the bench.*

fig.6 *Two plywood cradles support my existing Mk2 interface box around the pier, which houses the USB system, power control and serial communications.*

fig.7 *Two reflective detectors, used to confirm the roof in the closed, and here, the open position. They have adjustable sensitivity for a wide range of uses and conform to IP65.*

Development

In the early days, programs were written in a text editor, compiled by a separate utility and then burned into an EPROM device. If one wanted to start over, you had to erase the EPROM with UV light and re-program it. Thankfully, things have moved on and today, an integrated development environment is the norm, which brings together all these elements and includes debugging tools to test the software. Fortunately in the specific case of ASCOM and Arduino code, provided you load the developer components in the right order, the free Microsoft Visual Studio provides a seamless environment, in which you can directly access the ASCOM templates (in C# or Visual Basic) and Arduino library components in C++. As mentioned above, these tools avoid re-inventing code to navigate the Windows operating system to access files or communication ports and provide a handy framework that allows you to concentrate on the driver's functionality. ASCOM drivers are commonly coded in Visual C# or VisualBasic (VB). Although VB is easier for beginners, it is considered less future-proof. Since the Arduino is programmed in C++, it made sense to take the plunge and write the driver in C# as well. For larger projects, that require collaboration, Visual Studio additionally supports cloud-based developing environments, typically for a small fee.

Robust Programming

With something as simple as moving a roof, we conceptually know what we want to achieve. Writing the code for both the Arduino and ASCOM driver is relatively straightforward, once you have mastered the language, use the supplied templates and know what Windows library functions you can call upon. At the end of the day, the amount of typing is minimal. The tricky bit is knowing what to type and making it work in the real world! I openly admit that my books on C were hopelessly out of date (1978) and it took quite a bit of reading and scouring the Internet for examples, as well as some forum suggestions, before the light came on. Of the three books I purchased on C#, *The C# Player's Guide* by RB Whitaker was best suited for my needs, since it dealt with the C# language and Microsoft's Visual Studio developing environment.

We take a lot for granted; armed with a roof remote control and the mount software, our brains instantly compute and adjust our actions based upon the position of the roof and mount and their response, or lack thereof. We must translate that adaptive intelligence into the world of computer control. Our program requires robust strategies to cope with life's curve-balls. For example; the roof might not open fully, two programs access the roof with conflicting commands or a prolonged delay in responding to a command causes a hang-up in the calling application, the list goes on. At every stage in the programs, one needs to consider fail-safe options, error handling and an ordered exit when things go wrong. The best way of writing code is to anticipate the potential error states and design them into the flow from the start. This makes for a more elegant outcome, that is also easier to follow. Murphy's law rules; in the case of Three-Mile Island incident, the all-important switch for the pressure relief valve had an illuminated indicator. Unfortunately, that indicated the position of the switch rather than the position of the pressure relief valve, with disastrous results. I have seen some sophisticated drivers on the web that assume commands are followed-through. My engineering background makes me more cynical; I use roof position sensors for closed-loop feedback

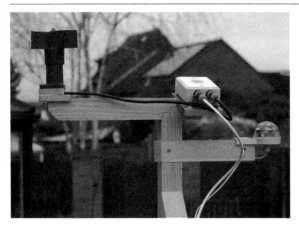

fig.8 *The weather sensor array consists of an anemometer, a cloud detector from AAG and a Hydreon RG-11 rain detector, that has programmable sensitivity and a simple relay output.*

to ensure that when the shutter state says it is open, it really is, rather than just should be.

Within C and its relatives, there are programming pitfalls too. The language is very compact, in that many commands have abbreviated forms and code sometimes resembles Egyptian hieroglyphics. It also relies upon precedence, which determine the order of computation in a mathematical expression. A single misplaced semi-colon can alter the entire operation. Thankfully the development environment tools often identify these mistakes before it even attempts to compile code, but not in every case. The trick is to build and test the code progressively, either from the lowest level subroutines up to the main loop or the vise versa. During the development phase, I did not wish to use the actual roof and mount hardware and in the case of a roll-off roof, it is easy enough to make a simple test jig with a few switches for the roof, rain and mount position sensors and a LED in series with a resistor to monitor the motor control outputs (fig.5). This emulates the roof hardware and the entire program can be checked for every possible combination and sequence of inputs, within the comfort of the office.

In addition to general good practice, ASCOM lays down some rules that reduce the likelihood of unexpected behavior or crashes. For instance, if an application starts to communicate to a particular focuser through its ASCOM driver, it normally locks out others from using the same focuser. When an application finishes with it, the code must release the driver for use by another. That seems to be quite a restriction but it has some logic behind it. If two applications try to communicate with the driver at the same time, it is entirely possible that the responses from the driver can get mixed up and directed to the wrong application.

It is quite tricky to manage; if two people ask you two separate questions at the same time and you answer both, with a "yes" and a "no", how do the interrogators know which answer is meant for them? In ASCOM, it is possible for multiple devices to communicate to a single device through a special ASCOM driver called a "hub". This is especially relevant with mount drivers, which often require logical connections to multiple applications. These hubs use a number of techniques to queue up the interrogations and ensure that each gets the intended response. Considering the project here, since I want the maximum imaging sky view, it is necessary to incorporate mount controls to move the mount to a safe park position, before the roof closes.

The C# language has a comprehensive error handling process that provides an opportunity to fix things before a major crash, or at least provide a useful warning message to the user. The most likely issues will be associated with serial communications and as these should not be fatal I intend to "catch" them with a warning dialog that asks the user to try again or check connections.

Communication Protocols

The ASCOM templates provided in the developer pack define the protocol between the mainstream applications and a device. When using C#, these typically involve passing and returning strings and logical parameters using predetermined methods of the device's class. On the other hand, the communication protocol between the Arduino and the PC is entirely the developer's choice, as is the communication medium. In this project the medium is good old RS232 from the 1960s and consists of a serial data stream using +/-12 volt signal levels at a pedestrian 9,600 baud (bits per second). By way of comparison USB 3.0 can transfer data up to 5,000,000,000 bits per second. RS232 though can happily transmit over 100 m at 9,600 baud and since the volume of traffic is minimal, robustness is more important than speed. There is a snag, however, in that the time for a message to transmit is slow in computing terms and it has the potential to tie up a PC while it is waiting for a response. With such an ancient interface too, there is sometimes a need to ensure the message got through. There are several ways around this, some of which make use of the multi-tasking capabilities of modern operating systems.

Two possible schemes are:

1 Commands to the Arduino do not require a response but it periodically transmits its status. The incoming status is detected by the driver and a recent copy is maintained for instant retrieval.

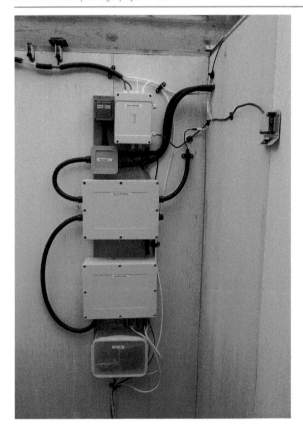

fig.9 The electrical systems are mounted in waterproof containers onto a plywood panel. From the top; power switches, Arduino controller, mains junction box, mains distribution box, DC power supplies and the NUC sits in a sealed food container at the bottom for easy access along with its external solid state drive. The three reflective sensors, two for the roof and one for the mount are mounted to the walls. Illumination is provided by an IP65 LED strip around the top of three walls.

2 Commands are echoed back to the PC, along with any additional status information. The PC monitors the responses, which confirm the communications are working and decodes the additional information on request.

In this particular case, I use scheme a), with the Arduino receiving commands in the form *xxxxx#*, where *xxxxx* is a command word. I have the Arduino transmit its sensor status once every 4 seconds in the form *$a,b,c,d,e,f,g#*, where a–g are status flags or sensor values. Presently I only make use of a–c, reserving d–f for potential expansion. The symbols # and $ are used as "framing" characters, which make it easy for the PC to isolate commands and status values. This makes some

sense with a roll-off roof, since an open or close operation takes about 20 seconds to complete and the Arduino does not wait for the command to complete before returning control to the PC. The ASCOM driver in this case nimbly responds to all commands and in the background, detects incoming serial data and updates the status.

Get Stuck In

There is no substitute for just giving it a go. If you, like me, are developing this on a computer that is already loaded with ASCOM and astronomy applications, you will need to load the following applications in the following order, irrespective of whether they are already loaded. In doing so, both the Arduino and ASCOM installers load resources into the Microsoft Visual Studio development environment that make life very much simpler:

1 Visual Studio Community (include Visual C# / VB / .NET options)
2 Visual Micro (loads Arduino resources into Visual Studio)
3 ASCOM Platform (in this case, Version 6.2)
4 ASCOM Developer Components (loads the essential driver templates and resources)
5 ASCOM Conformance Checker (for checking your driver)
6 Inno Setup (free installer builder)

Once you have done this, you will need to register with Microsoft to use Visual Studio. The community version, for which there should be no commercial use, is subscription-free. At this point I heartily recommend viewing Tim Long's videos a few times on the *www.ascom-standards.org* website. He covers an Arduino project in C++, an ASCOM driver in Visual Basic and a simple Windows application to control a filter wheel. The code has a similar structure to the C# version and although the code is not the same, the principles hold true for different devices and languages.

The next thing is to create a new project. In our example we have three: Arduino code, ASCOM driver and a Windows Application. These projects are created by:

1 File>New>Arduino Project,
2 File>New>Project>Visual C#>ASCOM6>ASCOM Device Driver (C#)
3 File>New>Project>Windows>Classic Desktop/Windows Forms Application

A collection of projects is called a solution. I compile and test the Arduino project separately to the Windows

projects, which I combine into a single solution for convenience. The permutations of the three programs are endless and a mature version of the projects for each, along with construction details, is provided in a zipped file on the book's support website. These have been reliable in operation over several years but are not commercial products. Their intent is to provide context and I accept no liability for loss or damage of whatever nature arising from your use.

Hints and Tips for the Arduino Code

There are no templates here to help you and one starts with a clean sheet. The Arduino development language is similar to C++ with a few exceptions and additions. The *www.arduino.cc* website has extensive learning resources, designed for a wide range of abilities. It is worth looking over the language reference since there are a number of simple high-level functions that greatly simplify communications, timers, string handling and input/output. The basic design for the code is shown in fig.10. This shows a simple loop that includes a serial port monitor, follows up on roof movement commands and periodically reads and transmits the sensor status every 4 seconds. Within this loop is a one-line lifeline called a watchdog. This is a simple timer that is reset every loop. If for whatever reason it does not and it times-out, it automatically resets the Arduino and it re-boots, which in this application has no adverse operational consequence.

There are two serial ports on the Comfile® Arduino module and I use one for programming and the other for operation with the PC. The Arduino uses the Data Terminal Ready (DTR) pin on one serial port to provoke a processor reset and for the bootloader to wake up. If the DTR pin is connected, an initial scan of the USB hub also wakes the bootloader. I found out the hard way that this can interfere with normal communications and in practice I switch serial cables over at the PC end between developing and testing code. (I'm assuming one can equally make up two cables, with and without DTR connections.) As mentioned before, the serial commands are terminated with a '#' character, that allow one to use high-level string commands such as *Serial.readStringUntil('#')*.

Many of my Arduino functions mimic the ASCOM commands, for example: OpenRoof(), CloseRoof() and ShutterStatus(). There are some others that provide additional functionality to the unit during the time in which the roof is moving. There are also non-standard ASCOM commands to interface to the safety sensors. These are allowed within the free-form ASCOM methods but are limited for use by those applications in the know, such as my observatory control application. These pass

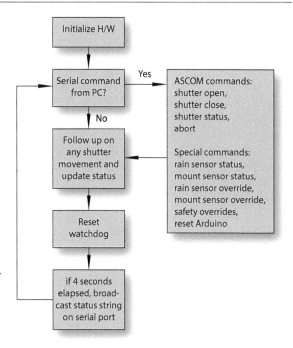

fig.10 The basic flow of the Arduino code is a simple loop.

unnoticed by the ASCOM Conformance checker but do not pass through either the Generic or POTH ASCOM hubs. OPTEC (*www.optecinc.com*) have developed an extensive multiple device hub, which they call an AS-COM server. This usefully passes all commands for all device types and additionally can cope with multiple devices of the same class. So, if you had two focusers, one for the guider and one for the main camera, this hub will allow both to operate at the same time.

Testing the Arduino code is fairly straightforward with the aid of two tools; the serial monitor and the test-jig described earlier. In practice, by keeping things simple, I did not find it necessary to use the debugging capabilities or breakpoint features of Visual Studio. The test-jig also allows for simulating unusual conditions and stress-testing the Arduino control logic. I also tested the actual roof operation using a toggle-switch connection to its module. Here, I discovered the motor controller required a short pulse to operate the roof and that, being designed for a driveway gate, responded differently to a change in direction command. The Arduino logic was suitably modified.

Hints and Tips for the ASCOM driver

On the advice of some of the other ASCOM developers, I chose Visual C# rather than Visual Basic (VB) for creating the ASCOM driver. When one creates the project, as directed earlier, what appears to be a fully-populated program is generated. This is not quite the case; scrolling

through you will soon notice some green comments that indicate where you need to put in your specific code to operate your particular device.

In C# terms, the ASCOM has a library of classes, each corresponding to a device type. These classes describe a device in the form of their allowable functions (methods) and variables (properties). The beauty of the ASCOM templates is they create an instance of the device's class that you then personalize for your hardware. This means that all the allowable methods and variables are already in place and you "just" need to put in the device-specific actions. These include ready-made support methods for choosing, selecting and storing the device settings and overall, save considerable effort and at the same time, encourage a tried and tested approach. It also includes the framework for writing a log-file with one-liners at different points in your driver code. This is a useful tool for debugging programs and looking at interactions between drivers and applications.

In the case of a roll-off roof, it only requires a few methods being fleshed out. Many of the commands are not required and you will notice that the template has already made that assumption and put in the appropriate exception, declaring the function as not supported. After personalizing the code to your driver name, the principal methods issue a text string command or retrieve and interpret a text string status from the device using the serial port. In this application, the tricky part is handling these serial communications. As mentioned earlier, I chose a protocol that had the Arduino continually broadcasting a simple status message every four seconds. The device driver uses an "event handler" that detects received characters on its serial port and reads them. The device driver software looks for a start-of message character and then builds up the text string until it detects an end-of message character. It then updates a few local variables with the roof status so that it can respond without delay to a status enquiry. A handful of characters every four seconds is not a burden and although this approach is acceptable with the slow cadence of roof movements or environment changes it is wasteful of processor resources if the refresh rate is set higher than necessary and may not be a suitable approach for other, faster device types.

The ASCOM device driver templates include several standard routines that store the device settings, such as the serial com port number and whether the diagnostic trace is active. It does not store, however, the chosen device. For this, my code includes two small functions that store and retrieve the device IDs for connected devices in a small text file to remember the last connection. (Later on, I use this to store power relay names too.)

Hints and Tips for the Observatory Application

My simple Windows application uses a C# form. Playing with the form design is easy and fun but it is better to start with a clear plan in mind and do the functional programming first. Using high-tech CAD tools (paper and pencil), I sketched out some form designs and controls. For each of the controls, there is a function in the program, which generally communicates to the ASCOM devices using the method and properties in their class. It made sense that separate connect / disconnect / setup device controls were useful for setting up and testing the system as well as connect- and disconnect-all functions for normal convenience.

In my application I connect to dome, mount, observing conditions, and safety devices to get an all round view of whether to open or close the roof. Rather than rely on a single sensor, my first implementation uses any one of high humidity, heavy cloud or rainy conditions to decide to shut-up shop. It also uses the mount device's reported park status and a park sensor to ensure the mount is truly parked. This may be a little too cautious and in doing so also requires some unique commands to the Arduino/ASCOM driver that for some, may get in the way of basic operation. (Not everyone may need or want roof and mount sensors.) To pare back this functionally requires a sensor override. I decided on two approaches: a single forced one-off roof operation command using a unique CommandBlind call to the ASCOM driver and a more generic one, that is stored in the Arduino's EEPROM memory, that disables the sensors for any application using the generic ASCOM commands. For this, the Arduino code includes the EEPROM library functions and simply stores two flags, for roof and mount sensors, in permanent memory. In that way, the code in the Arduino is configurable with a few unique commands from my observatory app. These are remembered when the power is off and allow the Arduino to play nicely with other programs such as Maxim DL or Sequence Generator Pro without the possibility of conflicting sensory conditions.

The main application form itself is generated by dragging various text and buttons from the Visual Studio toolbox to a blank form on the screen. Using just a mouse these can be manipulated to design the layout and align objects. In my application I also use tabbed boxes and groups, to make the layout more intuitive. These buttons are C# objects in themselves and have their own properties and methods. One is its "click" action that you point to a method you have previously prepared. Other properties can be set to change fonts or colors dynamically, to provide an instant visual warning. One less obvious object is the timer object. When added to the form and linked to a function it performs a periodic repeat method

call; in this case, the update of weather and equipment parameters. This timer is set to a few seconds, slightly faster than the Arduino broadcast rate. In this way, it is more nimble to a status change. You can also have more than one timer event, for instance if there is a need for both fast- and slow-response requirements.

Debugging and Compiling

When you "build" the project or solution, it normally is in one of two modes: debug or release. The compiler build options should be set up in each case for the processor and operating system settings. Although most operating systems are 64-bit, most astronomy applications are still 32-bit. In the build tab in the code's properties menu, I tick "prefer 32-bit" and "Any CPU" for the platform target and select .NET 4.0. In debug mode, when you run the program, the application and its driver are run dynamically so that breakpoints and crashes are managed dynamically and safely. The compiled files are stored in the debug folder. Diagnostic information is shown too, such as memory usage as well as instructive data on the cause of a crash (fig.11). If the memory usage slowly increases with time, it can be an indication of a memory leak issue in the program. This application is not particularly sophisticated but the debug features are useful during the first forays into the C# language.

I normally work on the driver and the application projects in the same solution and the compiler senses whether it needs to re-compile each project. In release mode, the ASCOM driver and observatory applications are stored by default into its release folder. The generated observatory app is a simple executable .exe file but the ASCOM driver requires installing. This is made trivial by the free application called Inno Setup. When you install the ASCOM developer components, it creates a folder called "Installer Generator" in which is placed a program that helps Inno Setup generate your own professional ASCOM driver installer. After filling out the form with the code information, run the compiler. The resulting .exe program can run from within Inno Setup and is stored in the Visual Studio project folder. This file is a standard Windows installer and is the file with which to install onto other computers. One of the installer features is that it usefully removes old driver versions before installing the new one. At the same time, the Inno Setup program generates a small file in your code folder with your driver name and with the file extension .iss. Double clicking this file loads Inno Setup with all the details of your source code, program locations and the compiler settings, facilitating a quick turnaround for another attempt.

After designing what you believe to be a working driver, run the ASCOM conformance checker on your driver code. With the test jig at the ready, hook up the Arduino and run the conformance program. After selecting the dome device and running the checker, it tests a number of features of the code. As it runs, watch what is

fig.11 *Visual Studio 2015 screen. Shown here running the application in debug mode. It is simpler than it looks!*

happening on screen and flip the status switches on the test jig within the allowed response times when the open and close commands are issued (normally between 20–60 seconds for a roof) . The conformance checker will of course only check for the standard commands. Others, specific to your hardware (like my mount and rain detectors) rely upon systematic manual testing.

Further Expansion

A project like this can go on to extend the software features further; for instance adding in scheduled open and close events (providing it is safe to do so). Moreover, the same design processes apply to other ASCOM devices. A much simpler and less expensive project is to add remote power control. In this case I embedded a serially controlled 4-way relay within my master interface box to switch DC power to the mount, camera, focuser and weather systems. This is useful to conserve power, if it is not needed during the day, and allows power toggling to reset devices, without being physically present. To be more universally useful, it requires its own ASCOM Switch driver and then it can be easily controlled by an ASCOM compliant application (fig.4). The Visual Studio project resources for this are also available on this book's Internet resource page (*www.digitalastrophotography.co.uk*).

There are a few hardware considerations: There are many small inexpensive relay boards, many of which are designed for Arduino projects. It is advisable to avoid those that use a FTDI parallel port (FT245R) chip-set, as they toggle the relays during power-up. The units that use the serial (FT232R) chip-set do not have this issue. Some relay modules store the state of the relays and resume that state on power-up. (My initial module did this but used the venerable MicroChip MCP2200 UART, which unfortunately did not have a 64-bit DLL driver to work with my ASCOM driver.) The one in fig.12 does not remember the relay states during power-off but gives access to both the normally open (NO) and normally closed (NC) pins of the relay. This gives the option of defining the un-powered connection state. In my case, I use the NC connections so that everything powers up together and is not dependent upon the presence of USB power. (The power control is principally used for toggling power to reset devices.)

This implementation assumes the PC and USB system are always powered. A further layer of power control, over the Internet, can switch either DC or mains power to the observatory as a whole or selectively. There are many to choose from: The simplest are connected-home devices and use a mobile application or browser to turn on a mains plug; I use a WiFi connected TP-Link device on my observatory de-humidifier. These are domestic devices and are housed in a plastic enclosure to keep it safe and dry. This simple control is OK if you are around (or awake) to switch things on and off, or the simple programmable timer events offer sufficient control.

A further level of control is implemented by Internet-controlled relay boards using device drivers, accessible from computing applications to allow intelligent operation. In the above example, switching the de-humidifier off when the roof is open. This level of control is most useful when the observatory is remote and a certain degree of autonomy is required. Some of these work from web-page interfaces (like a router's setup page) and others accept User Datagram Protocol (UDP) commands that facilitate embedding within applications. The supplied example programs are easy to use but require some network knowledge to operate securely from outside your home network.

fig.12 This 4-way relay from KMtronic has a USB interface but in practice, the built-in FTDI chip-set converts this to a virtual COM port. The board resides inside my master interface box. An ASCOM driver for a "Switch" binary device is one of the simplest to construct. This allows ASCOM commands to turn the relays on and off, enquire on their state and allow them to be individually named. The relays and circuitry on this board are powered from the USB connection. Although the relays can handle AC and DC, my preference is to not to mix these in close proximity and I use this on DC power lines. Mains connections demand respect and I keep all mains power control in an independent isolated IP65-rated enclosure.

Collimating a Ritchey Chrétien Telescope

*A deep dive into collimation techniques, the principles of which apply,
in part, to many other catadioptric and reflecting optics.*

After publishing the first edition, I purchased a new 10-inch Ritchey Chrétien telescope (RCT), to image smaller galaxies and planetary nebula. The price of RCTs has plummeted over recent years and is an increasingly popular choice for imagers. My assortment of refractors all arrived with perfectly aligned optics. In contrast, the delivered condition of an RCT (or SCT) is seldom perfect and aligning the two mirrors, or collimation, is not a trivial task and carries some risk. If you are not entirely comfortable taking a wrench and screwdriver to your scope then it is better to be honest with yourself and avoid adjustments, as you may do more harm than good. For those of you with a mechanical ability and a steady hand, find a comfortable chair and read on.

What started out as a short evaluation of the few collimation techniques that I was aware of (from manufacturers instructions and other users) quickly mushroomed during the research and testing. Over this time I became more acquainted with my RCT than I had intended. By comparing the results and carefully considering the various tolerances, this chapter hopefully puts things into focus, literally and covers most of the common collimation techniques. Many concepts, with a little lateral thinking, equally apply to other reflectors.

Uniquely, a RCT comprises two adjustable hyperbolic mirrors facing one another. In comparison, a Schmidt Cassegrain Telescope (SCT), typified by the models from Meade and Celestron, is collimated solely by a secondary mirror adjustment. Unfortunately, many of the collimation processes are optimized for the more common SCT designs and need a re-think when applied to a RCT and its additional adjustable primary mirror, especially when they rely upon arbitrary mechanical properties of the assembly. When you consider these assembly tolerances, compared to the surface tolerances of the mirrors, it is quite obvious that the likely issues that one will experience will be with the mechanical adjustment of the mirrors in relation to themselves and to the camera. As Harold Suiter explains in his book, *Star Testing Astronomical Telescopes*, if an 8-inch primary mirror is enlarged to 1 mile in diameter the wavelength of light would be 0.17 inches and at this scale, the required surface tolerance would be 0.02 inches or less! No such equivalent precision exists in the mechanical domain with tubes, trusses, CNC machining and castings.

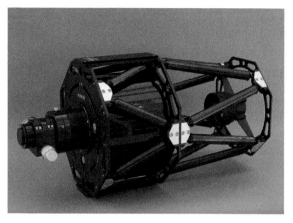

fig.1 *This 10-inch RCT is fitted with an adjustable collimating focuser tube. The accessory Moonlight Instruments focuser also has a collimating device that ensures collimation for all angles of its rotation feature.*

What becomes quickly apparent is that there is no guarantee that a telescope setup on the bench will perform in real life, either when it is moved to the mount or launched into space (sorry NASA). Whatever technique you use and whichever devices you employ in the process, perfect collimation cannot be guaranteed without optical testing. Those users who declare a particular bench technique was successful and did not require any further adjustment are either extremely lucky or the remaining aberrations in their system are masked by other issues such as binning, focusing, tracking and or seeing.

Successful collimation therefore mandates a two-pass approach; 90% through careful bench alignment and the remaining 10% by optical testing, using real or artificial stars. Optical testing is the ultimate judgement of an optical system. It is more sensitive to imperfections than most common artificial means and can detect minute errors in the optical surfaces' orientation and within the tolerances of bench testing (with some proviso).

A perfect RCT has two perfectly polished hyperbolic mirrors, set at the correct distance apart, on a common optical axis. This axis is aligned with the focus extension, focuser, rotator and camera system. That alignment must remain consistent over all temperatures, after mechanical and thermal shock and for any celestial target. Sounds simple, doesn't it? At first, that is what I thought too.

House of Cards or, Hide the Allen Keys

All calibrations and adjustments are built upon assumptions; if those assumptions (or initial alignments) are incorrect, the result is not optimum, possibly even after optical testing. In the case of the Hubble Space Telescope the null-corrector plate, used in the alignment checking process, was incorrect. The trick to a smooth collimation procedure is to be aware of the possible problems and measure, adjust and verify each before touching the mirrors. That also includes checking the accuracy of the collimation aids. As the aperture of the RCT increases, so does its sensitivity to error and, irrespective of any advertisement to the contrary, even if it leaves the factory in perfect alignment, there is a high probability it will arrive in a different state. Price is not a guarantee either; my friend's premium product arrived after it was hand-built and collimated. It bristled with QC stickers, but arrived with the opposing lock-screws loose, and required extensive collimation as a result. My unit arrived with the mirror spacing out by a few millimeters.

All is not lost if one takes a methodical view of things; although it looks intimidating, fig.2 shows the common sources of error in a typical RCT and those variables used to compensate for them. Some of these errors are static, some change with time, handling and temperature and the remaining ones, more worryingly, vary with the system's orientation. RCT models vary considerably in their facility for user adjustment. These differences force alternative collimation strategies and, since every variable is not necessarily adjustable, collimation is always a compromise (that is, two wrongs almost make a right). The correct approach is also unavoidably iterative, since most adjustments interact with one another. If one is methodical, however, and base each on sound principles and careful measurement, convergence to a good collimation is significantly quicker. In the following, admittedly extensive instructions to compare and contrast approaches, it is important to realize that basic collimation is usually a one-time affair, followed by occasional fine-tuning, using an optical test with real or artificial stars.

Hyperbolae and Trigonometry

Understanding the best compromise requires an appreciation of geometry and optics. A hyperbolic mirror follows a mathematical function which has a more aggressive curve near the middle. In other words, in the center, the angle of the surface changes rapidly. In practical terms, when you consider the two mirrors, the secondary is very sensitive to its center position in relation to its optical axis, whereas the primary has a big hole in the middle where the light baffle passes through. Although the center of the secondary mirror is not used for imaging, it *is* used for setting up its initial collimation.

The second observation concerns angles and angular sensitivity. A 2-mm deflection of a laser beam on the secondary mirror, over a 1,000-mm path length can be caused by a focuser coupling plate, of 100-mm diameter, being tilted by 0.2 mm at one edge (a 7 arc-minute angular error). The image displacement increases with distance, a fact that can be used to our advantage during

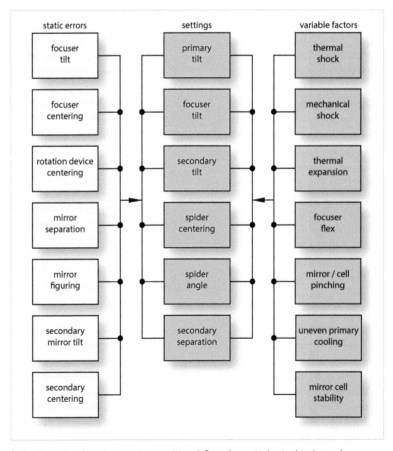

fig.2 Assuming the primary mirror position defines the optical axis, this shows the static errors, the available adjustments to the user and the factors that cause the collimation to change over time. Not every error has a matching adjustment.

several alignment techniques and to select the right compromises. It is worth noting in this case, as the laser beam passes through the hole in the primary mirror, it is only displaced by about 0.1 mm, since the coupling plate's pivot point is much closer to the primary mirror surface than it is to the secondary mirror surface. Flat surfaces can also be deceptive; what is flat anyway? Using a precision level I determined the back-plate of my 10-inch RCT, CNC-machined from 8-mm thick aluminum, is not perfectly flat and varies by a few arc minutes over its surface. Metal bends after all, and in addition to the usual machining tolerances and surface finish, I assume the stress of the truss and mirror attachments warp the metal too. The same holds true for the all-important mirror support inside the housing. When making adjustments with opposing set and lock screws, they should be torqued sufficiently to stop movement but not to the extent that they adversely deform the local metalwork.

fig.3 A Cheshire combination sight tube. It has a cross hair at one end and a small peep hole at the other. A polished aluminum wedge illuminates the view.

Breaking Convention

I said earlier that every collimation technique is built on assumptions. Unfortunately, a number of popular collimating techniques are based on unnecessarily optimistic ones. That is not to say they never work, only that, at best, they are taking a chance and at worse, potentially make the wrong one. For instance, the classic concentric circles alignment process, using the Takahashi Collimating Scope (Tak) shown in fig.4, with the center marking (donut) on the secondary mirror. This inserts an illuminated surface with a central hole into the focus tube. A magnified reflection of this surface from the secondary mirror is seen through the eyepiece. The secondary mirror is tilted until the reflected central hole of the Tak is centered with the donut marking on the secondary. It goes on to adjust the primary mirror to centralize the gap between primary and secondary baffle reflections (fig.6). For now, we are just going to consider the secondary mirror movements. This alignment technique is often cited, but it relies upon an assertion that the focuser tube assembly is aligned to the optical axis. (In some cases it is physically locked to the primary mirror support too.) It is most likely not aligned and easily demonstrated by using a laser. A good quality laser tool, accurately centered and inserted into the eyepiece tube identifies the axis of the focuser and camera. After making sure it is sitting squarely in the eyepiece tube (more on that later), the dot is visible on the secondary surface. More likely than not, it will not hit the center of the black donut. More interestingly, the reflection back to the source misses by several millimeters. At first this appears to be a head-scratcher; the reflection of the Tak is centralized but the laser is not? The difference is this; one is a simple reflection of an arbitrary surface and the other is a reflection of a directed collimated beam. Is the focuser aligned with the optical axis or is the donut not in the optical center of the mirror? Which do you trust?

fig.4 A Takahashi collimating scope. The Tak has a magnified image that can be selectively focused on the secondary mirror and reflections.

When it is put like that, it is more likely that a focuser adjustment plate or assembly is out by ~5 arc minutes (combined with the mirror's mechanical assembly error on the end of a long tube or truss) than the center spot of a mirror, polished to a 1/4 wavelength, is out by 2 mm. RC Optical systems correctly pick-up on this in their instructions and use a laser to align the mirror and focuser axes before using the Tak to set the secondary mirror tilt. (It is worth noting that some RCTs have the focuser assembly bolted rigidly to the primary mirror support and cannot be independently

fig.5 The Howie Glatter laser, fitted with the standard 1-mm aperture, is a very useful tool for the initial alignment of both the secondary mirror and the focuser axis.

fig.6 The view through the Cheshire, Tak and with a laser collimator. The Cheshire eyepiece is a simple viewing hole, reflective surface and crosshair but you need good eyesight to use it accurately. The Tak magnifies the view and has a focus tube, so that you can confirm the various circular elements are concentric. Aiming the laser at the secondary is easy (especially if you use a piece of polyethylene bag over the mirror to see the beam location, as shown here) but requires some careful ingenuity to see the reflected beam back onto the face of the laser. I can see down the central baffle and view the beam and wear polarizing sunglasses to see the dots more clearly. Alternatively, you can use a laser that has an angled target, outside the focus tube, such as those from Baader Planetarium.

collimated. All is well and good so long as they are aligned. If they are not, and you still have image tilt after collimation, it may be time to invest in an accessory collimating focus coupling plate.)

Interestingly, in dim lighting conditions, I discovered I did not need the Tak at all. The Howie Glatter laser (great name) is supplied with a 1-mm aperture, which generates faint but distinct diffraction rings around its central beam. These rings are reflected back to the white face of the laser module and can be seen circling the reflected beam. If you look carefully, there is a donut shaped shadow in the rings (my secondary's donut marking is not reflective) whose position corresponds exactly with the view through the Tak (fig.6). When the donut, rings and beam are all concentric with the emitted beam, we are ready for the next step (figs.7–9). The Tak confirms this to be the case too and, just in case you are still doubtful and you do not own a laser, wiggle the Tak in the eyepiece tube whilst looking though it. The image remains aligned, proving it is insensitive to the angle of the Tak and hence, the focus-tube angle.

Without laboring the point, why is this a problem? The only point of

fig.7 With the laser inserted into the focuser and reflected off the secondary, this shows the view on the white face of the laser collimator before secondary (or focuser) alignment. Neither the focuser axis or the secondary are pointing towards each other; the laser misses the secondary donut and its reflection misses the laser origin. The faint diffraction rings do not reflect off the donut and a shadow is seen on the face of the laser. This donut shadow corresponds exactly with the view through the Tak.

fig.8 This view is typical from a laser collimator after just using a Takahashi collimation scope to align the secondary. Although the reflection of the secondary donut falls onto the laser origin, the laser beam will not necessarily aim at the center of the donut and its reflection will miss the laser origin. The off-axis reflected beam indicates the focuser axis does not point towards the center of the secondary.

fig.9 When everything is lined up, the bright central laser is reflected back on itself and is surrounded by faint diffraction rings (these are not the rings from the accessory holographic attachment). The dimmer circular patch, arising from the reflection from the secondary mirror donut, is centered. The donut shadow position corresponds exactly with the view through the Tak.

reference in the entire system is the secondary donut. It may be a false premise, but it is normally possible to bench-set the secondary with more precision than the primary mirror. Since the secondary mirror is hyperbolic, both the incident beam and mirror angle are critical to its calibration. (If the secondary mirror was spherical, as in the case of SCTs, this would be less significant.) If there is a large error in both primary and secondary mirror attitudes, optical testing requires more iterations to converge on an optimum position. For example, it *is* possible to achieve good on-axis star collimation with two opposing mirror angle errors and convince oneself the *entire image* is good.

Euclid to the Rescue

The ancient Greeks knew a thing or two; not only did Euclid's conic sections define the principal mirror shapes used for reflector telescopes, his book on mathematics and geometry ruled until the late 19th century. I was pondering (as you do) on whether I should have bought an RCT with a fully adjustable secondary that allowed for centering. What if my truss was distorted (sounds painful) and the secondary was not on the center-line? It then hit me. It was virtually irrelevant; if both mirrors are tilted so that its optical axis passes through the optical center of its opposing neighbor, then the mirrors are perfectly aligned, irrespective of their relationship to the mechanical mounting. The outcome, however, generates an optical axis that is tilted, displaces the image on the CCD and creates a slight focus-plane tilt. This issue is largely tuned out if one has an adjustable focus coupler, as the latest GSO truss-models offer. A residual error, of say a whopping 4-mm displacement of the secondary has a net result that the focussed image at the CCD is off center by just 0.2 mm (thanks to geometry) but perfectly coplanar with the CCD surface. Even if the bench testing method accidentally tries to forcibly misalign the optics, the subsequent optical testing will eventually align the mirrors back again.

Sensor tilt will, in itself, confuse the optical testing, so it is better to address this at the start of the collimation process and minimize it as much as possible by aligning the focuser/camera assembly.

Collimation Process

So, having outlined the case for change, the collimation workflow is summarized as follows:

Bench Testing – Preliminary Checks

1 Check and calibrate your test equipment (laser, collimation scope and precision level).
2 Check and square the focus adjustment assembly to its fixing thread (if possible).
3 Check and ensure any camera rotation device is square at all angles (if possible).
4 Check and square the focuser coupling plate with the back-plate of the telescope (if possible).
5 Check and square the primary mirror (optional).
6 Check and adjust the mechanical centering of the secondary mirror housing in the spider.
7 Confirm that all the mirror adjustments are at a nominal position (some primaries are shipped with the push-bolts loose and pull-bolts fully tight).
8 Prepare your Allen keys (hex wrenches); attach to a wrist strap or use T-handled version to avoid dropping them onto mirror surfaces. If the adjustment bolts are jerky, carefully lubricate them first with a high quality grease.
9 Tape over one set of primary adjusters and if the secondary does not have a central bolt, tape one of the secondary adjusters to avoid mirror-separation creep through repeated adjustments.

Bench Testing – Precision Focuser Centering

10 Using a laser mounted in the focus tube, adjust the camera rotation or focuser mechanism collimation so that their operation does not affect the beam position on the secondary.

fig.10 *This precision level is designed for setting machine tools but has a useful calibrated bubble level in 0.03° increments.*

fig.11 *To align the focuser system without a laser, aim the telescope downwards and level the backplate (N–S and E–W) and the focuser assembly coupler. With care, you can set angles to 0.01°. I place a thin glass over the 2-inch eyepiece adaptor and rest the level on that. In this orientation, one can also check the distance to the primary mirror support by removing each **push-screw** and measure the depth with a Vernier caliper.*

fig.12 *The front of this truss RC shows three tilt adjusters, A, B & C with a central fixing bolt D. A, B and C tilt the assembly about the fixed central bolt; in this design, loosen one before tightening another.*

Bench Testing – Initial Secondary / Focuser Alignment

11 Use the laser in the eyepiece tube and center the beam on the donut, either by adjusting the spider or tilting the entire focuser assembly with the backplate mounting (fig.12, 13). Do not tilt the secondary to center the beam!

12 Adjust the secondary mirror tilt to reflect the beam back onto itself.

13 Repeat steps 11 and 12 to achieve initial focuser and mirror alignment.

Bench Testing – Initial Primary Adjustment

14 (Alternative 1) Using a rear view, adjust the primary mirror tilt so that the mirror boundaries are concentric, and depending upon the viewing distance, the spider reflections align or any intrusion of the outer vane brackets are symmetrical.

(Alternative 2) Use laser beam reflections to confirm primary mirror alignment with the secondary, either using a holographic projection or centered beams on the rear target of the Hotech Advanced CT laser.

Bench Testing – Tuning Alignment

15 Using a front view, fine tune the secondary mirror position with "Hall of Mirrors" test (described later), tuning as necessary to align reflections (or use the SCT instructions with a Hotech Advanced CT laser).

16 Repeat 14 and 15 to converge on a good mirror alignment, ready for optical testing. (An interesting alternative is to confirm the mirror axes are common, using reflections of a crossed wire, especially on large truss-based designs.)

17 Check alignment holds at different telescope angles.

Optical Testing – Star Testing / Diffraction Testing

18 Using a CCD camera, alter the primary mirror tilt so an outside-of-focus star image, in the center of the field, is an evenly lit circular symmetrical annulus.

19 Similarly, alter the secondary tilt to ensure any residual aberrations in the outer field are radially symmetrical (balanced), or diffraction mask spikes of a near-focused star image, in the center of the field, have perfectly intersecting lines.

20 Repeat 18–19 to converge on the two mirror positions.

21 Focus the image, plate-solve and use the image scale to calculate the effective focal length and compare with the telescope specification.

22 Adjust the mirror separation, if necessary, assuming a 10:1 ratio (a 1-mm increase in mirror separation effectively reduces the focal length by ~10 mm) either by adjusting the secondary mirror position (fig.15), or for small changes, moving the three adjusters on the primary mirror to the same degree (a M6 bolt conveniently has a 1-mm pitch) (fig.14).

23 Confirm alignment with another star test (steps 18–22).

Bench Testing

Preliminary Checks (1–9)

Everything has a tolerance and a RCT is a sensitive beast. Any collimation device that inserts into an eyepiece tube is required to be perfectly centered. Putting aside the vagaries of the eyepiece clamp for a moment, the quickest way to verify device centering is to rotate it in a V-block. In its crudest

form, a V-block is constructed from four three-inch nails, hammered into a piece of wood to form two V-shaped cradles. Lay the collimation scope, Cheshire eyepiece, laser or sighting tube body in the cradle and check its beam or image center is stationary as it is rotated. The greater the distance from the device to the convenient wall, the more obvious any error. The best lasers offer some means of adjustment, normally by three opposing grub screws. If yours does not and is not accurately centered, send it back. In the case of a precision level, the best devices have a bubble level with 0.03° markings which, with care, enable measurements to 0.01°, 10x more resolution than its digital readout. This is sensitive enough to detect a thin piece of paper placed under one end. To calibrate the level, place it on a smooth level surface, note the bubble position and ensure it is consistent when the device is turned around to face the other way. On the unit in fig.10 there are two tiny screws that tilt the phial. Armed with your calibrated devices, it is time to start checking and adjusting the mechanical system as much as possible.

fig.13 The secondary and baffle, showing the central donut. The donut is not silvered and appears black. Initial collimation relies upon the fact that the manufacturer, after polishing a glass surface to 100 nm, is able to locate the center within 1,000,000 nm (more likely than relying on the baffle and mirror being accurately centered).

The focuser system has a difficult job to remain orthogonal to its mounting. The nature of its construction translates microscopic errors in the draw tube into angular movement and, this is without swinging it around with a heavy camera on its end. All good models offer some form of tension adjustment that, at the same time, remove some flexure between the sliding parts. The better ones, like the large FeatherTouch and Moonlight Telescope Accessory models have collimating adjusters. In the absence of a laser, a precision level can be used to ensure the camera and focuser mounting flanges are parallel at all angles (figs.10, 11). This is most conveniently adjusted by placing the focuser assembly telescope-end down onto a flat horizontal surface. Place the level on the surface and adjust its level so that the bubble lies between the end-stops (within ±0.1° from horizontal) in both a conceptual E–W and N–S direction. Note the exact position in both instances. Then, place the focuser on the end of the focus draw-tube. Nominally assign one of the collimating screws to "North" and adjust the other two first, to achieve the same E–W level as the reading from the plate. Then, adjust the third one for N–S calibration. In this orientation, facing downwards, flexure is at a minimum and this adjustment represents the average position. If all is well and the focuser has a rotation feature, it will be consistent at all angles.

fig.14 On the back are the three primary push- and pull-bolts A, B & C. You can also see two focus-plate adjusters D & E and the focuser collimating adjusters F & G. I changed my primary push grub screws to pointed stainless steel versions.

If the back-plate of your RCT is a flat aluminum panel, rather than a complex casting, it is easy to go further and confirm the focusing coupling plate is parallel to the panel. In this case, with the telescope pointing downwards, mount the (calibrated) focuser onto the mounting plate and confirm the panel and the camera mounting flange are parallel in N–S and E–W directions (fig.11). It is very useful to have a collimation coupling plate on the back of the telescope, especially if there are no centering adjustments on the secondary spider. On my 10-inch truss model, I decided to square the primary mirror, or more correctly, its housing. I carefully rested the scope on its front face (or you can mount it and point it downwards). I removed the smaller **push-screws** on my truss model and measured the depth of the hole to the outside housing. For this I used the depth gauge end of a Vernier caliper. They were in the range of 10–10.5 mm. I adjusted the pull-screws until the distance to the back of the mirror housing was exactly 10 mm (the back-plate is 8-mm deep). This is not essential but a useful reference if things go wrong. In my case, the

fig.15 The secondary mirror flange A is fixed to the spider tilt-mechanism. The mirror and baffle assembly C can be unscrewed to set the mirror distance and is locked in place by the knurled ring B. The pitch of the lock ring is about 0.75 mm.

black push-screws were rather short and only engaged the back-plate through half its depth. I also discovered that their flat ends would "corkscrew" and displace the mirror laterally. With the pull-bolts in place, I rested the RCT on its front face and replaced these grub screws with a longer pointed stainless-steel version. Not only are these easier to spot in the dark, but the longer thread engagement is more stable between the soft aluminium and stainless steel. Usefully, each point creates a small conical indentation in the softer aluminum and minimizes lateral movement during adjustment.

High-end RCTs often have adjustable spiders. The current popular GSO derivatives have an assembly with no obvious method of centering the secondary mirror other than disassembly and experimentation. In my case, I used a Vernier caliper to confirm that the mounting boss was in the physical center of the front truss ring. It was within 0.1 mm of the physical center, but unfortunately one cannot infer that the front truss ring is aligned to the optical center of the primary mirror. If there is no easy way to adjust the secondary mirror position using the supporting spiders, it modifies the subsequent process used to align the optics.

Lastly, if your RCT has its mirror separation set up in the factory, tape over one of the primary mirror adjusters to prevent any accidental change to the mirror separation. Some larger RCTs have their primaries bolted down tight for transit and in these cases, follow the manufacturer's instructions to set the initial primary position, normally by unscrewing the pull-bolts bolts by one or two turns. Similarly, if your secondary mirror is only attached with three pairs of opposing bolts, tape over one set. The lower-cost RCTs have a secured central fixing bolt that is used to set the distance of the secondary mirror base, rather than three sets of opposing bolts. In these designs, you need to use all three tilt adjusters, by easing and tightening in pairs, in that order, to rock around the central sprung bolt. It is not immediately apparent but the GSO-based RCTs have a very useful precision mirror separation adjustment (fig.15). The black knurled ring and secondary baffle unscrew, leaving the bolted back-plate untouched. This thread on my RCT has a pitch of 0.75 mm, enabling precision adjustment. As it happens, my RCT required a mirror separation reduction of about 2.5 mm, to increase the focal length to 2,000 mm, accomplished by unscrewing the baffle by ~3.3 turns and screwing up the knurled ring to lock it into position. (The secondary mirror appeared to remain perfectly centered but I checked its collimation after the adjustment with a laser and fine-tuned it with a star test to be sure.)

Precision Focuser Centering (10)

To improve on the focuser assembly collimation requires a laser. (**Please remember to observe the safety instructions that accompany a laser.**) With the focuser fully assembled to the telescope, make adjustments to the focuser's collimation (if it has that facility) so the laser dot remains stationary on the secondary mirror, as the focuser is rotated. (If your secondary mirror has a lens cap, one can make a simple target by making a reference dot on a small piece of masking tape to assist the assessment.) After removing the cap, if the laser is not incident on the middle of the donut, it implies the focuser axis is not aligned to the secondary. Something has to move; if there is no obvious spider centering method, center the beam using the focus-tube coupling-plate adjusters. This is a compromise that is discussed later in more detail. (If you are unable to clearly see the laser on the mirror surface, place a piece of clean polyethylene bag on the mirror surface, as in fig.6. It scatters the laser beam, making it visible but at the same time, you can still see the donut too.) At this point, do **not** use the secondary tilt adjustments to try and center the laser on the donut! For enclosed RCTs, it is necessary to make the equivalent of a dentist's mirror and peak back at the **secondary mirror**.

To assess whether focuser sag is going to be an issue, push the focuser tube in different directions and notice if the beam moves about. If there is excessive play, the focuser mechanism may need a small adjustment, or more drastically, upgraded with a more robust unit.

Initial Secondary /Focuser Alignment (11–13)

The aim is to place the center of the secondary mirror on the main optical axis and set its tilt to align its optical axis using a laser in the focus tube. Once the laser beam is perfectly centered, initial alignment is complete when the beam reflects back on itself (figs.7–9).

That discussion on compromise is required here; the ideal solution is to align the focuser axis independently with the primary mirror's optical axis and shift the secondary mirror laterally to center the beam on the donut. Without that centering facility, the alternative is to angle the focuser assembly to aim the laser at the secondary donut. This tilt moves the focuser axis with respect to both mirror optical centers. Although this is a compromise, since the secondary mirror is about 30x further away from the focuser adjuster's tilt axis than the primary mirror, any de-centering with the primary mirror is minimal and the final alignment of both mirrors during *optical testing* reduces the error to a small (sub-millimeter) image displacement on the sensor.

In practice, carefully place the laser in the eyepiece tube, so it sits square, center the beam on the donut, either by adjusting one or more spiders (if your RCT has that facility) or by tilting the entire focuser assembly with its back-plate coupling. If your laser unit tips within the eyepiece coupling ring when the locking screws are tightened (a common issue with those units a single clamp or without a brass compression ring) point the telescope vertically downwards and let the laser unit simply rest on the eyepiece tube flange (assuming the flange is square). I achieve good alignment consistency by using a light touch on the clamp screws with metal-to-metal shoulder contact.

The next step is to adjust the secondary mirror tilt to reflect the beam back onto itself. (This involves minute adjustments. As delivered, the secondary mirror tilt-adjuster bolts on my RCT were stiff and jerky, making small adjustments impossible. I removed mine, one at a time, lubricated and replaced them before bench collimating.) On an RCT, this can be done by carefully peeking down the central baffle. (Since the laser is aimed at the secondary mirror, there is no risk of a direct incidence on your eye.) The outgoing and reflected beams can be quite bright and fuzzy and difficult to distinguish. I use a pair of polarizing sunglasses, and tilt my head to eliminate the glare, or reduce the power of the laser. This makes an accurate assessment considerably easier. Alternatively use a laser with an exposed target, like those from Baader Planetarium, or use the Tak in place of the laser and center the dot and donut, as in fig.6. These last two methods also work for those RCT derivatives, such as modified Dall-Kirkhams, that have refractive correction optics within the baffle. In the case of the RCT, the faint diffraction halo of the laser illuminates a considerable portion of the secondary mirror and is reflected back to the primary. If you look carefully at the white face of the laser, you will see a faint donut shadow on the laser's target surface. When the mirror is properly centered, the laser beam, reflected beam and donut shadow are concentric (see figs.7–9). Since a change in mirror tilt has a minor effect on the donut position, repeat the mirror centering and tilt adjustment one more time (if required). Lasers are wonderful things and the donut shadow on the laser face is something I have not seen mentioned before. It is the equivalent of the view through the Tak and is a viable alternative.

The Fifth Dimension

The proof of bench testing is that, after doing several extended star tests, the optics still pass the bench test. In my case, this was not always so. In a few instances, the final alignment was indistinguishable from the bench setup and notably different in others. Bizarrely though, in every case bench alignment always needed a reasonable adjustment during star testing to achieve collimation. At the same time I would sometimes hear a creaking noise during adjustments during star testing. The cause was the primary mirror cell shifting laterally on its three mounting-bolts during adjustment. This is a common issue in some of the lighter designs. (It also accounts for some of the variations between user-experiences, with one method or another, and the reason that some of the more confident users insert a stiff elastomer to provide lateral support to the mirror cage.) I realized that during star testing near the Zenith, the act of adjustment was equally to do with re-centering the mirror. As a consequence, although I may assess the alignment of the RCT in a horizontal aspect, **I always point to the zenith to make primary adjustments**. My unit is light enough to rest on a table or up-end. Heavier

fig.16 A classic Cheshire eyepiece, this one has a white rear face, typically used during Newtonian collimation process. This one is beautifully made and does not have an internal crosshair to obscure the view. Its color even matches the Paramount! A Takahashi scope extends the eyepiece outwards so that it can detect the thin gap between the mirror reflections. This eyepiece can do this too, if it is similarly extended with focuser extension tubes (providing the 200 mm or so extension does not introduce focuser tube sag).

fig.17 The view through the Cheshire, showing a marginal error, indicated by the spider clamp showing (A) and the slightly larger gap (B). As the eyepiece is moved further out, the gap (B) between the mirrors increases and it becomes considerably easier to perform the alignment. This image is taken at the normal focus position, but moving out another 200 mm with extension tubes and the focuser rack, makes it easier to see and equalize the thin annulus.

units will require to be mounted and swung on the DEC axis. The bottom line; a laser-based adjustment is only as good as the primary mirror centering with the focuser and sensor axis.

Initial Primary Adjustment

It is worth noting some of the variations between RCT models and their effect on the collimation process. The less expensive RCTs have the focuser assembly fixed directly to the primary mirror cell. Tilting this tilts the focuser assembly too. This is common on the smaller-aperture versions with closed tubes. This is not an issue if they are already accurately aligned but, judging from the recent flurry of accessory focuser collimation adaptors that attach between the RCT housing and the focuser assembly, this may not always be the case. In the case of the focuser assembly and primary-mirror cage being attached to a back-plate, mirror tilt and focuser tilt is independent. If the focuser assembly is rigidly attached to the mirror cell, any change in mirror tilt might need a subsequent focuser adjustment to square-up to the secondary mirror.

In my case, both the focuser and mirror cell are independently attached to an 8-mm deep aluminum backplate. This is a favorable design since I use the back-plate as an initial "nominal", from which I make adjustments. Setting up the primary is both critical and challenging, since there is no simple reference. If it is not aligned correctly, the other tests which fine-tune the secondary will not work. Some advanced products are designed for SCTs, in which the primary mirror is essentially already aligned and they are optimized for secondary adjustment. Some rely upon the centering of the baffles and those doubtful mechanical assembly tolerances, while others reflect a laser beam off a mirrored surface inserted into the focus tube. The simplest methods use the reflections between the mirrors, to ensure they are centered and coplanar and are insensitive to the focuser alignment. It is a case of the mirrors never lie! Two similar techniques line up the mirror reflections from the rear, at different operating distances. Both work on the premise that if the reflections between the mirrors line up in all axes, the mirrors are aligned. A third alternative employs a laser array and projects an image via two reflections:

Initial Primary Alignment (14) (sighting tube)

In this process I prefer to use an original Cheshire eyepiece (fig.16) or a simple viewing hole. I aim the RCT at an illuminated white wall (or you can place a diffuser over the end) to evenly illuminate the mirrors. I then look through the Cheshire and adjust the primary mirror so that the mirror and its reflections are concentric (fig.17).

fig.18 *The view from the rear, through a camera, showing the concentric mirror outlines and aligned spiders. The camera is precisely centered on the collimated secondary mirror and the primary mirror is adjusted to align the spiders. This should be confirmed by concentric mirror reflections too, from their outside edges rather than their baffles. It is often confusing to work out what you are seeing in the reflections. A is the outer edge of the secondary mirror, B is the reflection down the focus tube, C shows the outer part of the spider vane and its double reflection (aligned) and D is the outer edge of the primary mirror baffle.*

In particular, I look at the tiny gap between the inner and outer mirror reflections and at the same time, I also note the symmetry of the outer field. When my RCT primary is not aligned, I can just see the bulge of a spider's outer support bracket at the outer edge. When it is aligned, all four spider brackets are hidden, unless I move my eye about and view obliquely through the eyepiece.

Initial Primary Alignment (14) (camera)

This process is a variation of the above one, except for enhanced accuracy, I use a camera, fitted with a telephoto lens and mounted on a tripod and aimed squarely at the secondary mirror, so the center of the camera lens is seen reflected in a mirror. Any misalignment is more obvious at longer viewing distances and I typically do this from about 5 m (15 ft). The spider and its reflection can be seen in the viewfinder (fig.18) and usefully, my Fuji X-T1 camera has an option to magnify the focus point when the manual focus ring is moved. By making small adjustments to the primary mirror, I align all four spiders with their reflection. This works on the assumption that if the two mirrors are not aligned, one or more of the vane images and their reflections will be disjointed. At the same time the correct primary setting is confirmed by concentric images of the two mirrors' outer edges (not the baffles). In both processes, if one has already established

the mirror separation for the right focal length, only use two of the three primary adjusters.

Initial Primary Alignment (14) (laser)

Throwing technology at the problem introduces other interesting possibilities; for example using SCT laser alignment tools on a RCT. One can either shine a laser onto the primary (from the front, as the Hotech advanced CT collimator) or from the rear onto the secondary (as the Howie Glatter holographic projection method). Both products are principally marketed for SCT and Newtonian users but can be used for RCTs too. This is because in their simplest deployment, they are used to adjust the secondary mirror and crucially, assume the primary mirror is fixed (aligned) *and* the focus tube is aligned on the optical axis of the primary mirror.

The Howie Glatter laser has a number of alternative attachments, one of which beams concentric rings (fig.19). One alignment technique relies upon the mirrors being filled with light rings (and concentric to the mirror edges) and beams them onto a nearby wall for closer examination. Alignment is tuned and confirmed by checking the concentricity of the central shadow. In practice, this test is *very* sensitive to the laser alignment onto the secondary and the secondary tilt. My holographic attachment, as supplied, projects an uneven pattern and central spot, hampering assessment. I remedied this by leaving the standard 1-mm aperture screwed in place and taping the holographic attachment back-to-back. Some on-line methods suggest to ensure the circular rings are concentric on both mirrors. In my old darkroom and even after a period of acclimatization, my pristine mirrors do not reveal the concentric rings incident on their surface. There is a degree of mix'n'match between methods; one method is to set up the secondary mirror to a collimated focuser with a simple laser and then using the holographic attachment to fine tune the result to centralize the projected rings.

As mentioned earlier, the laser must be **precisely** centered onto the secondary (a 1-mm error here equates to a quarter-turn on a primary mirror adjuster) and the secondary aiming squarely at the primary, or it adversely affects the outcome. As such, this test is also very useful as an independent method to confirm system alignment prior to optical testing and is most easily accomplished indoors, projected against a light colored wall.

In the case of the Hotech device, it uses the reflective properties of the two mirrors to ensure that three laser beams, parallel and equidistant to the primary mirror axis, are reflected back on paths that are equidistant from the optical axis. To do this, one first squares the primary mirror to the target and then adjusts the

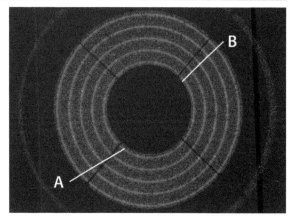

fig.19 *The projection from the RCT, fitted with a Howie Glatter laser and holographic attachment. Up close, the spacing between the ring at A and the central shadow is slightly larger than the spacing at B, indicating (assuming the laser is hitting the secondary square on and aligned to the optical center) that the secondary mirror is slightly misaligned. At the same time, the spacing between the outer ring and the edge of the diffuse background is equalized. It sometimes helps to attach a piece of paper to the wall and mark the positions, rather than judge by eye alone. As with other laser methods that rely upon the focuser alignment, if the primary mirror is not precisely centered with the focuser assembly, this will affect the accuracy of the final result.*

secondary. The reflections require an additional (semi-silvered) mirror to be inserted into the focus tube and the physics rely upon it being coplanar with the primary mirror (as assumed in the case of a SCT). Hotech have a unique 2-inch adaptor tube design with expanding rubber glands. These are designed to overcome de-centering issues in the simpler 2-inch eyepiece tubes. I am not enthusiastic about compliant rubber interfaces and in the case of the Moonlight focuser, with its close tolerance smooth bore, I achieved even better repeatability by pushing the attachment up against the metal collar and using minimum force on the three clamp screws.

The laser source and its circular target in effect ensure the mirrors are parallel using secondary adjustments (fig.20). With that accomplished, the rear target behind the semi-silvered mirror (inset) indicates if the primary mirror is tilted. When aligned, the three incident beams are symmetrically placed around the target crosshair. (As this target plane approaches the focus plane, the dots converge to a single bright dot.)

In fig.20, the Hotech unit is confirming RCT collimation, after classical star testing, back on the bench. In this case, it is very close to being fully aligned. The

smallest change to any setting throws off this bench alignment, indicating its sensitivity is considerably higher than a simple single beam reflection method and arguably as accurate as classical star testing in typical seeing conditions. Indeed, the results from using this device to set up the secondary mirror correlate perfectly with the "hall of mirrors" test described below.

As mentioned before, all these alignments work best if both focuser tilt *and* centering errors have been minimized. That is not always mechanically possible, so the next best thing is to collimate the focuser assembly as best as one can, assuming an optical axis that runs through the secondary donut. If a device such as the Hotech is not available, the next best thing is to tilt the secondary to reflect a simple laser beam back on itself (as explained in the earlier sections) and then proceed with the primary mirror centering, viewing from the front or rear, to fine tune both mirrors.

Tuning Alignment (15–17) (Visual)

With one or both mirrors in its rough position, we use a sighting test from the front, suggested by Jared Wilson on the Cloudy Nights forum, dubbed the "hall of mirrors" test. This is best done by eye alone and is very sensitive to the relationship between the two mirrors. This can be used for setting either the secondary or primary as, ultimately, it is only the relationship between the two mirrors that is being evaluated. Crucially, it is independent of the focuser assembly but only confirms the mirrors are parallel. (They might not be necessarily on the same optical axis.) As such, it is best to adjust the mirror that is assumed to be the most out-of-alignment. In my case, after star testing my RCT and then returning the telescope to the optical bench, I found the secondary mirror still reflected an incident laser beam back on itself and used this visual test to modify the primary position.

This test is conceptually simple: View down the end of the RCT from about 0.5 meters away, close to the center axis, so you can see the repeating reflections between the two mirrors. When the mirrors are parallel on that axis, the spider, its reflection and the reflection of your pupil in the primary mirror are aligned. At the same time, the repeating and diminishing reflections of the secondary baffle are symmetrical and the subsequent spider reflections are aligned too. After checking one axis, repeat for one of the adjacent spiders and confirm the collimation is true on that axis (see fig.21).

The multiple reflections make this test very sensitive to any misalignment and it can easily detect the smallest turn on a secondary or primary adjustment screw and obviously, is unaffected by seeing conditions. Usefully, it can be easily performed with the RCT in situ and does not require any equipment, though I do make the primary adjustments with the mirror in a horizontal position.

It does require a few tries to figure the relationship between the error and necessary adjustment. Again, it helps to take notes in case you need to retrace your steps and to become familiar with the effect of a push- or pull-adjustment.

I use the following process to rationalise the diagonal spider vanes with the two primary adjusters set 120° apart: First, I tilt a mirror left/right using equal and opposite adjustments to the two adjusters in the 4 and 8 o'clock positions, until the reflections (warts and all) of the two upper (or lower) spider vanes are mirror-images of each other. I then know that any remaining error is caused by an up or down misalignment. To correct this and to ensure that I do not introduce a lateral tilt I use all three secondary adjusters (or both primary adjusters) moving the two bottom adjusters by the same

fig.20 The Hotech Advanced CT laser is a very sensitive test due to the double reflections employed in its optical design. Excellent results are possible but only if close attention is paid to the initial setup; for instance, moving around on floorboards affects the laser trajectory. Conceptually, the front target confirms secondary alignment and the rear target confirms primary alignment.

amount. As mentioned earlier, this new mirror position ensures both mirrors are approximately square-on *but not necessarily aligned on the optical centers.*

So, there are two approaches using the same technique: If one is more confident on the initial primary mirror position, use this secondary tuning step a few times to converge on the optimum position, and align the primary by repeating the rear sight test. If the primary tilt is less likely to be correct (and assuming the focuser alignment is accurate) the order of these alignments is logically reversed; the secondary alignment is solely accomplished using a laser reflection and the primary mirror is setup using the hall of mirrors or a holographic projection.

So, a good collimation satisfies the hall of mirrors test (confirming parallel mirrors), a simple laser fired at the center of the secondary will reflect back on itself (confirming secondary alignment) and at the same time the Howie Glatter holographic projection should be symmetrical. There is no single answer here on which road to travel, since every experience may differ and, if the primary tilt is incorrect, the end result will likely not be optimum. Ultimately, however, all roads lead to Rome.

The good news is that with care, the combination of these visual techniques consistently achieve a good alignment and subsequent optical testing demands the smallest of corrections. The last step is to confirm the bench alignment holds true for different orientations; the easiest way being to rotate the RCT through different angles and repeat the hall of mirrors assessment.

A Novel Alternative for Mirror Collimation

As an interesting aside, a Harvard University Education paper 1969, by J Krugler, describes the collimation of a professional observatory RCT. This proposes a novel solution for aligning the optical axes, by introducing an independent reference point. In an open-truss construction, they stretched two thin wires across the truss to create a crosshair in-between the mirrors. All other things being equal, if the optical axes of the two mirrors are coincident, the crosshair reflection in the secondary coincides with the actual crosshair and the reflection of the secondary mirror in the primary is concentric. In the paper, they employ a theodolite to align the reflections but a tripod, digital camera and a telephoto lens, mounted on a sturdy tripod is a good alternative, with a little imagination.

In an attempt to recreate this, I fastened a small circular flat mirror, removed from a bicycle accessory, to the back-plate of the focuser tube with double-sided sticky tape. The mirror was prepared by finding the middle and drawing a cross on the glass surface to facilitate centering. In my case, I placed the telescope on a table

fig.21 The view from the front, though a camera, showing the concentric mirror reflections and aligned spiders. This is sometimes referred to as the "hall of mirrors" test. The test is repeated for a second spider at 90°. To perform this check, sight down the telescope from a few feet away so that the spider and its reflection coincide. If the mirrors are aligned on this axis, the receding reflections of the secondary baffle will be symmetrical about the spider vane. Any small misalignment causes subsequent reflections to deviate further off center. Having confirmed it is aligned on this spider, repeat for its neighbor. It can be used to align either mirror to the other.

and aimed an APS-C camera (fitted with a telephoto zoom lens and mounted on a sturdy tripod) at the mirror. I made small adjustments to the camera so that I had a perfectly-centered reflection of the lens in the mirror at the center-mark of the viewfinder. I then removed the 2-inch adaptor and knew I was looking down the middle of the focus tube. I stretched two thin enameled-copper wires across the truss joints, holding them in place with masking tape. Using the focus ring and confirming by taking photographs at f/22, I made small changes to the secondary so I had coincident cross-hairs. I chose to alter the primary so that the reflections of the spider were aligned, on the basis of human perception of the vernier effect. In the event, I achieved reasonable alignment on the bench but with sub-optimal centering of the mirrors (fig.22). As an experiment it was interesting but relied upon the focuser tube being aligned to the secondary's mechanical center, which in my case was not adjustable. The drawback of the original method on an amateur scope is one of scale; a minor displacement of the wire cross-hair in a small space introduces a large arbitrary optical axis angular error when its purpose is to define the optical axis to the secondary. Two other things came to mind; not everyone has an open-tube RCT and the focuser-mounted laser is a better way to

fig.22 This is the "theodolite" view from the back, with the fine crosshair and its reflection coincident in the secondary mirror. Here, you can see a small misalignment; although the spiders are aligned, the mirrors are not concentric. This arises due to a tiny displacement error on the crossed wires, which is more significant on a small RCT, such as this.

define an optical axis to the center of the secondary. It was a useful exercise, however, and some of its lessons are blended into my collimation plan and echoes those parts of other techniques that align spider reflections.

Validation

So how does each fare? To confirm the validity of each bench-testing technique, after optical testing I returned the collimated RCT to the bench and evaluated it with the various tests. Gratifyingly, they all confirmed collimation and did not suggest any significant "deviation", unless the mirror had shifted laterally. This indicates the collimation setting is within the usable tolerance of each method and confirms bench testing for coarse adjustment and star testing as the fine tune. The tolerances of each method are different, however, and after doing some sensitivity analysis, working backwards from a perfectly collimated RCT, I was able to make a simple comparison, summarized in fig.36, at the end of the chapter.

Optical Testing

Optical testing completes the collimation process using CCD images. These tests detect small residual aberrations in the system, which can then be carefully tuned out with micro-tilt adjustments of the two mirrors. There are two methods to identify these aberrations, star testing with de-focused stars and using optimized diffraction masks on a near-focus star, each of which detect coma and astigmatism. Both techniques require a bright star(s) but before evaluating either process, we must examine the optimum star-testing parameters for real and artificial stars.

Artificial Stars

The universal law of stargazing applies; three months of cloud follow any significant astronomical purchase and obviously our thoughts then turn to using artificial stars for alignment. With an artificial source, the device is placed tens or hundreds of meters away and the telescope aimed at it (with mount tracking disabled). There are advantages and disadvantages of this approach:

1 The telescope is stationary, so tracking issues are eliminated.
2 Testing can be done in daytime or at night, within reason, depending on air turbulence.
3 The telescope is normally in a horizontal attitude, which challenges the mirror-support system on large aperture instruments, and may lead to unexpected results when the tube is pointed skyward later on.
4 A horizontal aspect is susceptible to near-ground air turbulence.
5 An artificial star needs to subtend a smaller angle than the telescope's effective resolution.
6 The necessary small hole size (less than 0.5 mm) and long distances may be difficult to achieve in practice.
7 A starfield conveniently has many stars over the entire image, allowing simultaneous evaluation over the entire CCD image - something that is particularly useful for two-mirror systems. A single artificial star may take more time to evaluate for multiple positions.
8 Long focal length telescopes may not have sufficient focus extension to focus on a nearby artificial source and the additional focus extension may also change the focuser-tube alignment.
9 Reflecting telescope aberrations change at close focus distances and will impose a practical limit on the closest target placement. As such, an artificial source

fig.23 This commercial artificial star consists of a bright white-light LED behind a laser-cut pinhole. The pinhole is 0.1 mm diameter (100 micron) and is suitable for a range of popular RCTs, providing its distance is sufficient to create a pinhole angle that when subtended at the sensor, is less than the Airy disk **radius** of the telescope under test.

requires a little planning; its distance and size parameters are interlinked with the telescope specification and each user has to determine their own compromise.

Alternative Artificial Star Sources

Two main sources are in common use; an illuminated pinhole and a specular reflection of a bright light source in a small spherical mirror. Commercial illuminated pinhole sources typically use a bright white LED behind a laser-cut hole. Some have an assortment of pinhole diameters from 0.05–0.25 mm, others concentrate the entire beam behind a single 0.1-mm diameter hole (fig.23). I have been making pinholes for my other passion, monochrome photography and although it is possible to carefully "drill" a piece of brass or aluminum foil, it is easier said than done to make a smooth hole of that size. Classical star testing uses a single on-axis star. That's fine for some but only takes us so far when collimating a RCT. Multiple star positions are more convenient.

Another and perhaps more interesting idea is to bounce the Sun's image off a reflective sphere. Ball bearings and Xmas tree decorations (of the aluminized blown-glass variety) are both popular candidates. Xmas tree baubles are useful as they come in a wide range of sizes, creating a range of apparent star sizes. They are fragile, however, and I prefer stainless-steel ball bearings. The Sun is a good light source during the day for visual assessment through an eyepiece and is usefully a consistent 0.5° wide. Its reflection in a small sphere is much smaller and its equivalent pinhole size is approximately 1/300th of the sphere's diameter. When the Sun is close to the telescope axis and shining over your shoulder, this reduces to 1/450th. To create a 0.1 mm pinhole equivalent, requires a 30-mm diameter ball. The sun reflection is too bright for camera-based assessment, however, even with the facility to take sub 1-second exposures, a sensor is saturated by the reflection. For camera-based assessment I prefer to work at night and use a bright torch as the light source; there are fewer distractions and the illumination level supports exposures of several seconds. To ensure the effective "star" is small enough, I place the torch at a sufficient distance so its beam subtends 0.5 degrees or less. For a single star test, others use a laser to similar effect. I have, however, a practical solution in mind, in the form of a multiple ball tester that produces multiple reflections that does not require a laser.

Artificial Star Size and Distance

There are some other considerations to take into account, which we take for granted with real stars. If one considers distance first, there are two bookends; the closest focus distance that is achievable (governed by the available RCT focus extension and close-focus optical aberrations) and, at the other extreme, the furthest distance one can practically test over (determined by logistics and light intensity). Clearly, as the distance is doubled, the star's effective angular "size" halves. This size needs to be less than the angular resolution of the RCT but not so small that there is insufficient light with which to conduct the test. Suiter suggests that the minimum distance to the artificial star should be at least 20x the telescope's focal length to avoid optical aberrations affecting the outcome. For a multiplier of x, the focus extension is given by the equation:

$$\text{focus extension} = \frac{f_L}{x - 1}$$

In the case of a 10-inch f/8 RCT, it requires two of its four 25-mm extension rings to achieve focus at infinity onto the sensor (with minimal focuser-tube extension). Assuming we use the other 2 for the star test, we have up to 75 mm to play with. The equation above implies the artificial star can be no closer than 25x the focal length, at ~50 m (160 ft). A small grassy area with an unobstructed view for 50 m, is an ideal testing ground.

Size Is Important

The other unique aspect of an artificial star is its apparent size; the diameter of the artificial source should be no larger than the resolution of the RCT. Suiter suggests the maximum *diameter* of the pinhole should be set to the Airy disk *radius*, extended to the star's distance, which ensures this condition is met. This can be written:

$$\frac{\text{pinhole diameter}}{\text{distance multiplier}} = r_{airy} = \frac{1.22 . \lambda . f_L}{D}$$

So, in the continuing example, the Airy disk radius is 5.4 microns that, when extended by 25x focal lengths, enlarges to 134 microns, slightly more than the Astrozap 100-micron diameter artificial star. Even so, when it comes to testing the CCD periphery, one has to move the telescope slightly to place the star in different positions to evaluate the balance of aberrations. This is where my novel 9-ball tester may help.

9-Ball Tester

It occurred to construct a multiple-star target, using 8 balls mounted in a circle and with a central ball. In that way, these allow simultaneous assessment of central and peripheral aberrations with ease. At 25x the focal length, and with a KAF8300 APS-C CCD, it requires the target to be a little less than 350-mm (14-inches) square. In

fig.24 *My 9-ball star tester. The nice thing about this is its repeatability; there is no need to find a good patch of equally bright stars. Their placement allows one to quickly assess the balance of aberrations around the optical axis. Here the diameter of the array is about 300 mm, suitable for a APS-C sensor placed at a 25x focal-length distance.*

one of those scrap-heap-challenge moments, I found a black plastic seed tray, approximately 400 mm square and mounted nine ball bearings in a 300-mm diameter circle with bathroom sealant (fig.24). This size will suit a APS-C chip user at 25x the focal distance. Other assumptions facilitate other setups; one might add more balls inside the outer circle to work with a smaller chip size and so on. At night, I use a white LED torch, with a 50-mm diameter reflector. I diffuse its flat lens with a piece of tissue paper and point it towards the balls from about 6 m (18 feet) away, to subtend 0.5°, as the Sun does. I do get some weird looks from my neighbors, but they are used to me and my mad experiments now. An alternative to this Heath-Robinson method is to make use of any calibrated telescope jog commands in your telescope driver. I use TheSkyX Pro and apply a 10 arc-minute jog setting to move a central star to the cardinal points within the image frame. Since the Paramount has very little backlash, I am able to precisely move a single star around in a repeatable manner around the frame, without resorting to analog slew methods using sustained button-presses on a handset.

Classical Star Testing

Star testing lays bare the optical performance of any optical system. Used properly, it can distinguish minute aberrations in an out-of-focus image that would otherwise be visually indistinguishable in the diffuse blob of an in-focus image. Used properly it is very revealing; for instance, it is easy to fear the worst and believe one has pinched optics when focused stars are irregular in shape,

when in fact a de-focused image identifies it as coma, arising from misaligned mirrors.

In the case of a RCT, one prominent method consists of two cyclic events; removing coma on a central, de-focused star using primary mirror adjustments and subsequently balancing the astigmatism in the surrounding image area using small adjustments to the secondary mirror tilt. The two adjustments interact to some extent and a couple of iterations are normally required to create symmetrical aberrations. Star testing is very sensitive to any number of aberrations and is a substantial subject in its own right. The ultimate guide is the book *Star Testing Astronomical Telescopes* by Harold Suiter. Although RCTs are only mentioned in passing, there are many examples of other optical configurations with central obstructions, but not necessarily aligning dual, curved mirrors. The book has an excellent section on the use of artificial stars, either illuminated pinholes or reflections off shiny spheres as substitutes on a cloudy night. The prior parameters for star testing are derived from his recommendations. These involve a star test of a single star, which makes perfect sense for many optical configurations with a plane mirror or with few adjustments. In the case of the RCT, the primary mirror is often adjusted to optimize the appearance of a central star but in addition, uses multiple star positions to confirm the optical balance in the image periphery, largely determined by the secondary mirror alignment.

The following star-testing process is a slight adaptation of that suggested by Rich Simons of Deep Sky Instruments in their support documentation and uses the imaging CCD camera to confirm the results, rather than an eyepiece. In doing so, it avoids the complications of further focus extension, or the use of a diagonal, and follows the following iterative process applied after bench alignment:

1 Center a star and alter the primary mirror tilt so an outside-of-focus star is an evenly lit circular annulus (i.e. remove on-axis coma).

2 Balance the image, with small adjustments to the secondary mirror tilt, so that the aberrations in the image periphery (mostly astigmatism) are radially symmetrical.

3 (Optional) If the optimum mirror separation has not yet been established, before fine-tuning with a second iteration of 1 and 2, focus the image, plate-solve and use the image scale to calculate the effective focal length and compare with the telescope specification. At the same time, check for extreme field curvature and tilt with a program such as CCDInspector. (Field curvature is sometimes confused for aberrations in

the image corners. This can be a symptom of an incorrect mirror separation; as the mirrors become closer, the field has more spherical aberration correction). If these two test results correlate, adjust the mirror separation.

4 Repeat 1, 2 and 3 until you have an evenly lit circular annulus in the center of field, with a balanced outer field, such that any astigmatism is evenly distributed and astrometry confirms the correct focal length.

5 Give a gentle thump with the heel of your hand to the RCT back-plate, and flip the telescope, to relieve the stresses and check the collimation is still true. (If you have ever built or trued up a bicycle wheel, you bounce it to relieve the torsional stresses in the spokes.)

Just before we move on, now is the time to tape over one set of primary adjustment screws (and secondary adjusters, if there is no central bolt) to prevent mirror-separation creep.

Star Testing Parameters – De-focus

Successful star testing requires stable atmospheric conditions. The best target is a bundle of bright(ish) stars at high altitude that fill the CCD sensor, say a loose cluster, and on a night of good seeing. You need a good central star and ones around the periphery to conduct the full alignment. The star test is conducted outside of focus, in that, having focused the image, the CCD is moved outboard, or, if you employ a secondary focuser, the secondary is moved away from the primary mirror. With a large secondary obstruction, the focuser should be moved a distance of about 5–8 aberration wavelengths (n). To equate that to a stepper motor offset, requires the aperture ratio and the following equation from Suiter's book:

$$\text{focus movement} = 8 . F^2 n . \lambda$$

where F is the focal ratio, n is the number of aberration wavelengths and λ is the wavelength (assumed 550 nm). Fig.25 compares the out of focus star appearance for a range of aberration wavelength positions.

For n = 5, my f/8 RCT requires a 1.4-mm outboard movement. Its Lakeside focus motor has a step size of 3.7 μm, so evaluations take place after moving outwards by about 380 steps. Incidentally - this same equation gives an indication of the depth of focus, using n= ±0.25 wavelengths as the criteria. In the above example, the equation simplifies to:

$$\text{depth of focus} = 4 . F^2 \lambda$$

For the RCT used in the example above, the depth of focus is about 140 μm, or about ±15 steps.

fig.25 This series shows a bright central star that is progressively de-focused. In this case, the focuser was moved outwards by 100 ticks between each image. For this 10-inch f/8 RCT, 100 ticks represents about 1.3 aberration wavelengths. The dark hole is a feature of the central obstruction of the secondary mirror and as the star energy is spread over a wider number of pixels, the overall intensity reduces.
As you move further out, it is easier to see the slight on-axis coma. The ring is slightly fatter and dimmer in the lower left hand quadrant. The push adjuster nearest this position was screwed in by about 1/8th turn in this case. Typical evaluations take place for n = 5–8 aberration wavelengths.

Testing Times

It pays dividends to be patient and do star-testing when the conditions are optimum. At night, choose a high-altitude star, with the RCT pointing up, to avoid mirror shift issues and to minimize air turbulence. Use a red filter too, as long wavelengths are refracted less by the atmosphere (and hence by turbulence). For artificial stars, ground turbulence in daylight hours is best in the early morning and over grass rather than concrete. I have had success for a short time around sunset too, before night-time cooling accelerates ground turbulence.

Star-Testing Exposure Time

An optimum exposure renders the star annulus without distortion (from atmospheric seeing or tracking errors) and produces bright mid-tones, so any variations in illumination are easy to evaluate. My Paramount MX tracks well without autoguiding (PE is about 1" peak to peak) and I found exposures between 10 and 30 seconds were optimum. Over that time any effects of seeing conditions are averaged out, just as with autoguiding exposures. For exposures under a few seconds, non-ideal seeing conditions confuse the interpretation (which is easily confirmed by comparing repeated exposures). Some texts suggest to use Polaris (with an apparent magnitude 2), since it is immune to tracking issues. I find this to be too bright and, to avoid saturation, requires a 0.1-second exposure. Apart from seeing issues, not all CCDs can achieve short exposures, especially those with mechanical shutters. I suggest to accurately polar align, to avoid drift, locate a loose cluster with magnitude 5–6 stars and then one can image comfortably with 5- to 20-second exposures, without resorting to a severe screen-stretch to enhance their visibility.

Star-Testing Procedure

As outlined previously, in the case of a RCT, star testing consists of two cyclic events; removing coma on a central, de-focused star, using primary mirror adjustments and subsequently balancing the astigmatism in the surrounding image area, using small adjustments to the secondary mirror tilt. These two adjustments interact and a couple of iterations are normally sufficient to create symmetrical aberrations. For a small collimation error, it is almost impossible to distinguish between a primary or secondary misalignment and confusingly, a small adjustment in one will appear to cancel out the issues introduced by the other. Before you start, ensure your mount is aligned accurately to the Celestial Pole and choose a bright star near the Zenith. (Although the test exposures are short, poor tracking will hamper star evaluation.) Rotate your camera so that its horizontal axis is parallel to the dovetail bar (DEC axis) and focus and align the mount so the star is in the center of the image. De-focus by 5–8 aberration wavelengths by extending the focus tube. Next, establish an exposure that renders the star annulus clearly, with a mild screen stretch, and so the illumination levels are not clipped (like those in figs.25, 26). Depending on the star's magnitude and with a clear or red filter in place, an exposure of about 10 seconds is normally about right. Evaluate the image with a screen zoom level of 100–200%.

Fine Primary Adjustment (18)

To correct on-axis coma, make tiny adjustments (typically 1/8–1/32 turn) to the primary-mirror adjusters to even the illumination and thickness of the annulus of the de-focused star. This unevenness is caused by residual coma that causes the diffractions rings to lose concentricity (fig.26). On my RCT, the three primary adjusters are in the 12, 4 and 8

fig.26 On the left is a central star with bad coma. Its annulus is narrower and brighter on the left and the primary mirror requires pushing on the right and pulling on the left in equal measure. The middle image is an improvement. The image on the right is cropped from the center of a full-frame image of a loose cluster, de-focused by 10 aberration wavelengths, showing good out-of-focus symmetry.

fig.27 These three figures show a balanced set of aberrations, since all of the de-focused stars are radially symmetrical around the
middle of the image. Deep Sky Instruments, in their own collimation instructions for their RCTs, explain the process very well
and usefully classify the elongated star shapes: A "pointy" star has its major axis pointing towards the image center and a
"flat" star's major axis is tangential. The figure on the left shows under-correction (pointy stars) which is often an indication of
the mirrors being too far apart. The figure in the middle is a perfect scenario and the one on the right shows over-correction
(flat stars), normally as a result of the mirror separation being too small. There is always some field curvature with an RCT
and the likely outcome is mild under-correction in the corners of the image. For larger sensors, a field flattener is required.
The trick with collimation is to identify the dominant 'pointy' stars and make secondary mirror adjustments to make them
flatter, so that the degree of elongation is equal at all points in a circle, and at the same time, radially symmetrical.

o'clock position. I alter the 4 and 8 o'clock adjusters, in pairs. In that way I think of them logically as up/down and left/right controls; up/down by tightening or loosening them equally and left/right by loosening one and tightening the other in equal measure. There are other logical methods, but for me, I find thinking in an orthogonal sense is easier to relate to the CCD image.

To save time, the first thing one should do is to understand the relationship of the adjusters to the image, which is made easier from one session to the next if the camera angle is consistent. In my setup, with the off-axis guider port uppermost, I push the mirror on the "dim" side, to make the annulus thinner and brighter. I also follow an adjustment regime: The push- and pull-screws have different pitches, so I always use the push (grub) screw, with its finer thread, to set the primary mirror position and the coarser pull-screw to secure the mirror. This either means I back off the push-screw first and then tighten the pull screw, or in the case of pushing the mirror out, say by 1/4 turn, back off the pull-screw by half a turn, tighten the push-screw by 1/4 turn and then tighten the pull-screw to secure the mirror. This helps to achieve a consistent tension and is especially useful if you are trying to undo a prior change. Even so judging precise adjustments is tricky and if it helps, mark the wrench position with some sticky tape next for the two primary adjusters on the back-plate.

A change to the primary mirror tilt shifts the star position on the sensor and, for an accurate assessment, it needs to be close to the center. Re-center the star and repeat the process until you have an evenly lit and symmetrical annulus. TheSkyX and SGP have useful center commands to accomplish that in under a minute.

Since the two mirrors interact, it is a first-order simplification to suggest that each mirror only affects either on-axis or off axis aberrations. If the bench alignment was not accurate, the primary mirror had shifted laterally or the secondary was a long way off, it is difficult to achieve circular disks in the center of the image, or they may appear almost circular but with the Poisson spot (Argo spot) off-center. A central spot is another indicator that the primary mirror is in its optimum position. It may take a few iterations of adjusting primary and secondary mirrors to converge on an optimum adjustment. (In a perfectly collimated system, you might also discern the Airy disk of a focused bright star.)

Fine Secondary Adjustment (19–20)

Once this central star looks even, it is time to move onto tuning the secondary mirror. If the primary mirror is centered on the focuser assembly, a laser alignment of the secondary is often close to optimum and needs the tiniest of adjustment to achieve a good balance of aberrations around the image center. Good balance may not necessarily result in perfectly round donuts all over; looking at fig.27, one can see, dependent upon mirror separation, that the outer stars may be rendered as oblongs, indicating astigmatism. In fact, a RCT has field curvature and the star donuts will be slightly elongated towards the corners.

fig.28 *These three figures show various unbalanced aberrations, requiring secondary mirror adjustment. The image on the left shows distinct elongation (pointy stars) in the top left corner, requiring adjustment, the middle image is the same, in this case the pointy star is opposite the flat star in the bottom right, requiring a lesser adjustment to balance the aberrations in the same direction. The image on the right is almost there, with less distinct orientations requiring an even smaller adjustment.*

The trick is to make this elongation radially symmetrical about the center. (This is quite difficult to judge and I found myself increasingly relying upon the hall of mirrors test to adjust the secondary to the new primary position and then confirming collimation with a star test of a loose cluster.

These final adjustments need a steady hand and preferably a T-handled Allen key or hex wrench to apply small and precise movements. (If you are concerned about dropping a wrench onto the primary mirror, why not attach it to a wrist strap?) The best seeing conditions are near the Zenith and if you do not relish the prospect of balancing on a ladder in the dark, choose the highest altitude setting that still allows you to reach the secondary adjusters with one's feet on terra firma.

The process begins with an image of some bright stars; a loose cluster or the 9-ball tester is ideal. This image uses the same focus position used for the primary adjustment. The stars donuts will likely be a range of circles and oblongs as you scan around the image. The trick is to identify where they are most "pointy". This term is coined by Deep Sky Instruments in their on-line RCT collimation guideline. They define pointy stars as those whose major (long) axis point towards the image center, or in cases where there are none, opposite those oblongs stars whose minor (short) axis is pointing towards the center (fig.27), which they term "flat" stars. Again, in my setup, the adjustment convention is to "pull" or loosen the secondary bolt closest to the pointy star (as viewed from the rear of the scope) but please realize your orientation may differ. Having made a tiny adjustment, re-assess a new image and continue to tune out the imbalances. If the central stars show signs of elongation, repeat the primary adjustment process and then check the image balance once more. As you approach

collimation, the differences are subtle and may require several image downloads to be sure of the necessary (if any) adjustment. The example image in fig.29 is almost perfectly balanced. There are some slight asymmetries, that suggest a need to loosen the top adjuster a fraction, and tighten the other two.

Diffraction Mask Star-Testing

The most difficult aspect of classic star testing is assessing the balance of aberrations around the image periphery. The hall of mirrors test provides an excellent alternative or you can use a diffraction mask applied to a bright star. A Bahtinov mask can detect de-focus but the focus/collimation mask manufactured by GoldAstro is cleverly designed for a dual task. It has 9 groups of gratings (fig.30) orientated to provide 3-axis de-focus information that is analyzed by the accompanying software to imply focus and collimation errors in addition to their orientation. The software locates the diffraction line intersects in the CCD image and provides a numerical value for aberration in pixels (and focus) rather than a subjective assessment (fig.33). The software evaluates the geometry of these diffraction spikes and stacks successive images to reduce its susceptibility to seeing conditions and image noise. It can take several minutes to acquire enough exposures to generate a stable reading. It is a very sensitive test, however, that detects the compound errors of both mirrors and with the prescribed procedure can set both mirrors within two or three iterations. For best results, set the exposure so that it is just sufficient to saturate the core of the image (fig.31) and show bright "petals" in an un-stretched screen image. The software automatically detects the relative positions of the faint diffraction spikes which,

fig.29 *A full frame image of a loose cluster, after an initial star calibration. It is almost there but some of the de-focused stars are slightly*
elliptical and the yellow lines indicate their major axis. There is some field curvature in a RCT and one will not get perfect circular
disks in the corners. Their major axes are not quite radial though, although the central stars are very close to being perfectly
circular. In this case, the secondary mirror requires a miniscule downwards tilt to balance the image. A good indicator that you
are getting there, seen here in the brighter stars, is the presence of a Poisson spot (or Arago spot) at the precise center of the disk.

after some image stretching, appear as fig.32. These
signals are affected by seeing and image noise and I typi-
cally stack 10–15 frames to obtain an average reading.
Making adjustments to either mirror affects focus but
usefully, the collimation readout is largely unaffected
by a small amount of de-focus.

With perfect collimation, a central star's readout is
(0,0,0) and the readouts, at three symmetrical peripheral
positions, switch values and read (A,B,C), (B,A,C) and
(C,B,A). Due to the slight field curvature and off-axis
astigmatism of the RCT design, A = B = C = zero will
not occur. The preferred collimation procedure is not
something you would work out for yourself and is better
than using the collimation readouts as a direct substitute
for classical star testing (earlier). When one follows the
instructions, it takes about an hour to achieve excel-
lent collimation. For convenience and speed, it helps if

your imaging software can both download sub-frames
and has a repeatable jog command for the mount, as
TheSkyX does.

In essence, the calibration process kicks off after
a rough collimation from using star testing or bench
methods. A bright star is focused, centered and the
secondary mirror is adjusted to get close to a (0,0,0)
readout. The star is then jogged to three positions, say
10 arc minutes from center, along each of the mirror
adjustment axes (in my case 4, 8 and 12 o'clock posi-
tions). After more image downloads at each position,
use the Gold Focus software to analyze the collima-
tion errors at each of these positions and in particular
note the 4, 8 and 12 o'clock readout for the respective
positions. These (the "A" readings in fig.34) are used
to calculate the next adjustment. In the case of perfect
collimation, these readouts will be identical. If there is

fig.30 The GoldFocus focus and collimation mask, seen here fitted to the front of the RCT, is a novel variation of the Bahtinov mask principle. It requires a repeatable orientation as that creates a consistent relationship between readouts and adjustments.

fig.31 In the case of a RCT, for primary mirror adjustment, the brightest star should be placed in the middle of the image. The exposure should be sufficient to create a "daisy" with a bright center (with a few saturated pixels) and 6 petals that are not quite saturated.

fig.32 As fig.31 but with a moderate image stretch, showing the faint diffraction spikes. The dynamic range is huge and it requires several stacked exposures to minimize the effects of noise and achieve stable results, even with an exposure that potentially saturates the core.

a slight collimation error, these will all have different values but their mean will be similar to the "perfect" value. The axis with the biggest error from the mean is noted, along with its error value. For example, if the 12, 4 and 8 o'clock readouts are 1, 0.5 and 0.3 respectively, the mean is 0.6 and the biggest error is +0.4 at the 12 o'clock position. The star is then slewed to the center of the image and this "error" is added to the prior central readout value (in fig.34, A = 0). This becomes the target value for the second adjustment. Running the image acquisition program again and using just one adjuster, corresponding to the offending axis, the *primary* mirror is moved until the readout for that axis matches the target value of +0.4. After checking the star is still central, acquire more images again and adjust the *secondary* mirror once more until the center readings return to (0,0,0). (A perfect result is often difficult to obtain in the presence of normal seeing conditions and I aim to get them within the range -0.2 to +0.2.) At first glance this may not seem an intuitive process but when one appreciates the interaction of optical aberrations caused by small movements in either mirror, it does have a logic. I found one iteration produced an acceptable result, while a second iteration, starting with a second analysis of peripheral star readouts and ending with a final secondary adjustment on a central star improved things further. Using this collimation setting and producing an out of focus star image, as fig.29, it was just possible to detect a small imbalance in the donut illumination when the seeing conditions were good.

The benefit of this technique though is that it does not require a subjective assessment of star shapes and even illumination and the end result is more robust to the presence of atmospheric seeing. For best results, start off with a reasonable collimation, good polar alignment and carry out in steady conditions. Give yourself time to orient oneself with the test and adjustments (which change with mask orientation) and make notes for next time. In that way it is much easier to recall which way to move an adjuster to change the readout value. It is also a good idea to use a reference mark or locator for the mask, so it is easy to align precisely with the three adjustment axes.

The mask has a dual-purpose as a focus aid. The GoldFocus software also acts as an accurate "Bahtinov Grabber" and outputs a pixel error that correlates directly to a focus offset in motor steps via its calibration routine. The software can also control an ASCOM focuser and this calibrated "gain" setting enables a highly accurate single-step autofocus system. In my system, it can discriminate a few focuser steps (about 1/10th of the depth of focus). The focus module would be even more useful if it included a standard set of in and out controls, improved its ASCOM focuser handling and more significantly, added backlash control (currently V4.0.0.24). I have made these suggestions to the developer and it may be updated by the time of publishing. In a system that has automatic sequenced autofocus, the introduction of a mask is a manual intrusion, unless its deployment and program can be scripted and employ a mechanical means

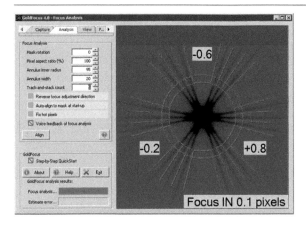

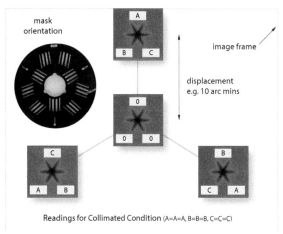

Readings for Collimated Condition (A=A=A, B=B=B, C=C=C)

fig.33 The GoldFocus software in action, here the autofocus routine has completed and the collimation errors are shown in the three boxes. The three readings around the circumference give an indication of the balance of aberrations. Ideally, the secondary should be adjusted so a centrally-placed star reads zero for all values. Away from the center, these will likely be non-zero and the trick is to ensure the readings are symmetrical about the center position (A=A=A in fig.34). If you follow the comprehensive collimation instructions, with stable conditions, excellent collimation is achievable within an hour.

fig.34 This shows what to look for when balancing aberrations with the GoldFocus system. Each of the red squares represents a GoldFocus readout as in fig.33, for each of four star positions, placed at 120° intervals (conveniently using a mount's jog commands from a center position).

to swing the mask in and out of place and temporarily slew to a lone bright star. Even so, in an otherwise automated imaging system, it is a useful tool if you wish to quickly and accurately assess the focus offsets for each filter or to determine the temperature / focus relationship of a RCT or any other type of telescope. GoldAstro also manufacture an alternative mask design that is optimized for even greater focus accuracy but this version does not support collimation measurements.

Image Scale and Mirror Separation (21–23)

Mirror separation is something that is often taken for granted. One authoritative text evaluated mirror separation by comparing Strehl ratios at different mirror separations. That measurement is an overall assessment and not the most critical assessment of stars in the image periphery. The distance, and hence the focal length, has a big effect on aberration on stars around the periphery. Thankfully, plate-solving not only returns the image center coordinates, but also the pixel scale, to three decimal places. If the pixel size is known too, an accurate assessment of the effective focal length is a short equation away:

$$f_L = \frac{\text{pixel size}}{\tan(\text{pixel scale})}$$

After initial star testing, I had what seemed to be poor field curvature (fig.35). The initial star test confirmed an image scale of 0.564"/pixel without binning, which with a 5.4 µm pixel size indicated a focal length of 1975 mm. The focal length *increases* with *reduced* mirror separation and the estimated separation error was about 2.5 mm too far apart. The stars in the image corners were obviously elongated along a radial axis, indicating under-correction. As mirror separation is reduced, the degree of spherical aberration correction is increased. The configuration is also very sensitive; when the mirror separation reduces by 1 mm the focal length increases by about 9 mm.

In theory one can move either mirror; but it is preferable to adjust the secondary position. (Extending the primary mirror fixing bolts makes it more vulnerable to lateral forces.) I unscrewed the secondary lock ring and baffle by about 3.5 turns and then gently tightened up the lock ring (fig.15). The flange between the lock ring and the secondary baffle facilitated an exact measurement using a Vernier caliper. After two successive adjustments, a plate-solve confirmed an image scale of 0.577"/pixel equating to a focal length of 2,000 mm (as per the optical design). This has a considerably flatter field, indicated on the right-hand image of fig.35. Remember, a RCT design has a curved field and some degree of off-axis astigmatism is to be expected. My 10-inch RCT has acceptable field curvature when used with an APS-C sensor but it is advisable to use a field flattener for high quality images when imaging onto larger sensors.

fig.35 *These CCDInspector plots show the field curvature of my RCT before and after an initial alignment. A test of the image
scale revealed the focal length was 1,975 mm. The image on the right shows the field curvature after the RCT was adjusted
to a focal length of 2,000 mm. The image has better correction but the RC design inherently has some field curvature.*

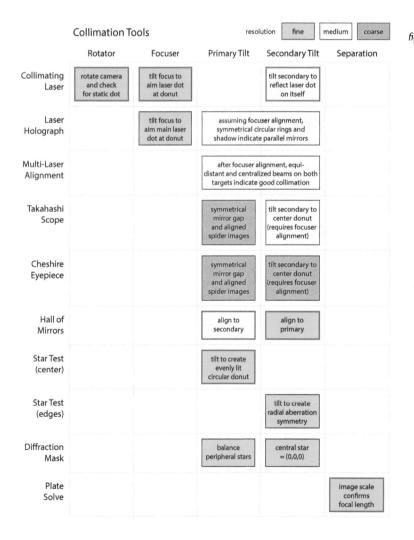

Collimation Tools

resolution fine medium coarse

	Rotator	Focuser	Primary Tilt	Secondary Tilt	Separation
Collimating Laser	rotate camera and check for static dot	tilt focus to aim laser dot at donut		tilt secondary to reflect laser dot on itself	
Laser Holograph		tilt focus to aim main laser dot at donut	assuming focuser alignment, symmetrical circular rings and shadow indicate parallel mirrors		
Multi-Laser Alignment			after focuser alignment, equi-distant and centralized beams on both targets indicate good collimation		
Takahashi Scope			symmetrical mirror gap and aligned spider images	tilt secondary to center donut (requires focuser alignment)	
Cheshire Eyepiece			symmetrical mirror gap and aligned spider images	tilt secondary to center donut (requires focuser alignment)	
Hall of Mirrors			align to secondary	align to primary	
Star Test (center)			tilt to create evenly lit circular donut		
Star Test (edges)				tilt to create radial aberration symmetry	
Diffraction Mask			balance peripheral stars	central star = (0,0,0)	
Plate Solve					image scale confirms focal length

fig.36 *This chapter deliberately evaluates
many alternative techniques, some
of which overlap on purpose. To
summarize, this table outlines
my experience of their **practical**
capability and how they may
potentially be combined. The
popularity of affordable RCTs will
encourage further developments
over the years and application of
current SCT collimating products to
RCTs. In these pages I have avoided
any methods that remove the
secondary mirror altogether and
shine a laser through the central
fixing hole; it potentially voids
the manufacturer's warranty and
is also too intrusive if one is only
wanting to update an otherwise
roughly collimated scope.
Clearly one does not have to
use all procedures to collimate
a scope but choose a coarse (or
medium) and fine adjustment
process from each column. Some
limitations are a function of the
RCT's mechanical tolerances. My
preferred methods for collimating
my RCT are highlighted with a
red border. There are many more
combinations that are equally valid.*

Summing Up

This started off as a short chapter but it soon became considerably more complicated as my research uncovered an amazing diversity of collimation methods. To avoid the "what about method x, it always works for me" retort, mandated a broader study that compared and contrasted popular collimation methods. One size does not fit all, especially when the variation in RCT construction is taken into account. In an attempt to rationalize many different methods, fig.36 summarizes the different tools, what they are principally used for and a general indication of their robustness in the presence of realistic mechanical tolerances. I had to re-assess these ratings when I realized that the focuser-mounted laser methods rely upon the focuser and primary mirror being accurately centered: During several tests, my mirror shifted on its mounting bolts and although I achieved perfect star-test and images, the laser tests suggested otherwise. As a result I only adjust the primary mirror when the OTA is in a vertical attitude.

My assessment of star-testing accuracy assumes optimum seeing conditions too; in poor conditions, this assessment is about the same as the better bench collimation methods. In fig.36, the trick is to select a few processes (highlighted in red) that address each of the adjustments and include a high-accuracy method for the mirrors. My preferred combination of methods are highlighted with red borders. Although this chapter has concentrated on RCT collimation, with minor adaptation, it can be used to assess secondary mirror adjustments on a non-adjustable primary SCT design and additionally can highlight if an instrument has issues with its primary mirror alignment that requires an adjustment by the original manufacturer.

A cluster like the one in fig.37, or a star-field, is a perfect target to check the final collimation, as well as focus and tracking accuracy. When it is done, resist the temptation to improve further but monitor the collimation from time to time. In this case, the final outcome of this marathon undertaking can be seen in several new practical examples within First Light Assignments.

fig.37 This loose cluster is an ideal subject to verify the overall collimation of a RCT. The image processing for this was basic; exposure integration, registration, RGB combine and a touch of deconvolution before basic non-linear stretching.

Bibliography, Resources and Templates

For some bizarre reason, few books on astrophotography acknowledge the work of others. This is not one of them.

Bibliography

Astronomy and Astrophotography:
Steve Richards, *Making Every Photo Count*, Self Published, 2011
This is a popular book that introduces digital astrophotography to the beginner. It is now in its second edition and is been updated to include modern CCD cameras. The emphasis is on using digital SLRs.

Charles Bracken, *The Astrophotography Sky Atlas*, Self Published 2016
This atlas is targeted at astrophotographers to enable them to plan imaging sessions. Includes common and unusual objects in this well-conceived reference, organized for latitude and season.

Allen Hall, *Getting Started: Long Exposure Astrophotography*, Self Published, 2013
This is an up-to-date book which makes use of affordable equipment on a modest budget. It has an interesting section on spectroscopy and includes several practical projects for upgrading equipment and making accessories. It also features a section on imaging processing, including some of the common tools in PixInsight.

Charles Bracken, *The Deep-sky Imaging Primer*, Self Published, 2013
This up-to-date work is focused on the essentials of image capture and processing using a mixture of digital SLRs and astronomy CCD cameras. One of its highlights are the chapters that clearly explain complex technical matters.

Robert Gendler, *Lessons from the Masters*, Springer, 2013
It is not an exaggeration to say that this book is written by the masters. It provides an insight into specific image processing techniques, which push the boundaries of image processing and force you to re-evaluate your own efforts. Highly recommended.

Warren Keller, *Inside PixInsight*, Springer, 2016
This is the first book dedicated to using PixInsight for image processing. A useful reference.

Ruben Kier, *The 100 Best Astrophotography Targets*, Springer, 2009
This straightforward book lists well- and lesser-known targets as they become accessible during the year. A useful resource when you wish to venture beyond the Messier catalog.

Thierry Legault, *Astrophotography*, Rockynook, 2016
This book provides a general overview of astrophotography, touching upon most of the available equipment options with an emphasis on solar-system photography, for which Thierry is highly regarded.

Harold Suiter, *Star Testing Astronomical Telescopes*, Willmann-Bell Inc, 2013
This book is the definitive guide to star testing telescopes. It helps to evaluate optics, their defects and possible remedies. It offers some interesting insights into the challenges that telescope manufacturers face.

Programming:

RB Whitaker, *The C# Player's Guide*, Starbound, 2015
This book is essential reading for understanding the C# language and the Visual Basic programming environment, useful for developing your own applications and drivers.

J. & B. Albahari, *C# 5.0 in a nutshell*, O'Reilly, 2012
This book is a reference guide to C# programming. Good for cloudy nights and improving the right biceps.

Stanek, ONeill & Rosen, *Microsoft PowerShell, VBScript and JScript Bible*, Wiley, 2009
The go to book for all things scripty. Good for improving grey cells and the left biceps.

Jeremy Blum, *Exploring Arduino*, Wiley, 2013
An easy introduction to the Arduino, with practical hardware and software projects.

Internet Resources

Less Common Software (or use Internet search)

Maxpilote (sequencing software)	*www.felopaul.com/software.htm*
CCDCommander (automation software)	*www.ccdcommander.com*
PHD2 (guiding software)	*www.openphdguiding.org*
Nebulosity (acquisition / processing)	*www.stark-labs.com/nebulosity.html*
Sequence Generator Pro (acquisition)	*www.mainsequencesoftware.com*
PixInsight (processing)	*www.pixinsight.com*
Straton (star removal)	*www.zipproth.com/straton*
PHDMax (dither with PHD)	*www.felopaul.com/phdmax.htm*
PHDLogViewer (guiding analysis)	*http://adgsoftware.com/phd2utils/*
EQMOD (EQ6 ASCOM)	*www.eq-mod.sourceforge.net*
APT (acquisition)	*www.ideiki.com/astro/default.aspx*
Cartes du Ciel (planetarium)	*www.ap-i.net/skychart/en/start*
C2A (planetarium)	*www.astrosurf.com/c2a/english*
Registax (video processing)	*www.astronomie.be/registax*
AutoStakkert (video processing)	*www.autostakkert.com*
Polar Drift calculator	*www.celestialwonders.com*
PlateSolve 2	*www.planewave.com/downloads/software*
Local astrometry.net plate-solver	*www.adgsoftware.com/ansvr/*
Optec ASCOM server	*www.optecinc.com/astronomy/downloads/ascom_server.htm*
ASCOM definitions	*www.ascom-standards.org/help/platform*

Processing Tutorials

Harry's Pixinsight	*www.harrysastroshed.com*
PixInsight support videos	*www.pixinsight.com/videos*
PixInsight support tutorials	*www.pixinsight.com/tutorials*
PixInsight tutorials	*www.deepskycolors.com/tutorials.html*
PixInsight DVD tutorials	*www.ip4ap.com/pixinsight.htm*

Popular Forums

Stargazer's Lounge	*www.stargazerslounge.com*	(UK)
Cloudy Nights	*www.cloudynights.com*	(US)
Ice in Space	*www.iceinspace.com*	(AU)
Progressing Imaging Forum	*www.progressiveastroimaging.com*	
Astro buy and sell(regional)	*www.astrobuysell.com/uk*	

PixInsight *www.pixinsight.com/forum*
Maxim DL *www.groups.yahoo.com/neo/groups/maximdl/info*
Sequence Generator Pro *www.forum.mainsequencesoftware.com*
EQMOD (EQ mount software) *www.groups.yahoo.com/group/eqmod*
Software Bisque (mounts/software) *www.bisque.com/sc/forums*
10Micron (mounts) *www.10micron.eu/en/forum/*

Weather
Metcheck (UK) *www.metcheck.com*
The Weather Channel *www.uk.weather.com*
Clear Sky Chart (N. America) *www.cleardarksky.com*
Scope Nights (App for portable devices) *www.eggmoonstudio.com*
FLO weather (also iOS app version) *www.clearoutside.com*
Dark Sky (also app versions) *www.darksky.net*

The Astrophotography Manual
Book resources and errata *www.digitalastrophotography.co.uk*

Useful Formulae

Many relevant formulae are shown throughout the book in their respective chapters. This selection may come in useful too:

Autoguider Rate

This calculates the autoguider rate, in pixels per second, as required by many capture programs. The guide rate is the fraction of the sidereal rate:

$$autoguider\ rate = \frac{15.04 \cdot guide\ rate \cdot cos(declination)}{autoguider\ resolution\ (arcsec/pixel)}$$

Multiplying this by the minimum and maximum moves (seconds) in the guider settings provides the range of correction values from an autoguider cycle.

Polar Drift Rate

This calculates the drift rate in arc seconds for a known polar misalignment:

$$declination\ drift(arcsecs) = \left(\frac{drift\ time(mins) \cdot cos(declination) \cdot polar\ error\ (arcmins)}{3.81} \right)$$

Polar Error

Conversely, this indicates the polar alignment error from a measured drift rate:

$$polar\ error\ (arcmins) = 3.81 \left(\frac{declination\ drift(arcsecs)}{drift\ time(mins) \cdot cos(declination)} \right)$$

Sensor Read Noise Density

Sensor read noise is often quoted in electrons but ignores the pixel size. A more effective comparison between sensors is by normalizing the read noise to the pixel area (in microns2). This equation does the conversion:

$$noise\ density = \sqrt{\frac{read\ noise^2}{pixel\ area}}$$

Periodic Error

This calculates the periodic error in arc seconds for a given declination and pixel drift:

$$periodic\ error\ (arc\ seconds) = \frac{pixel\ drift \cdot CCD\ resolution\ (arcsec/pixel)}{cos(declination)}$$

Critical Focus Zone

This alternative equation calculates the zone of acceptable focus for a given set of seeing conditions and uses a quality factor Q. Q is a measure of de-focus contribution in relation to the overall seeing conditions, expressed as a percentage (with a working value of 15%). *F* is the focal ratio. :

$$critical\ focus\ zone\ (microns) = seeing\ (arcsecs)\ \cdot\ aperture\ (mm)\ \cdot\ F^2 \cdot \sqrt{Q}$$

Coordinate Conversion from Ra/Dec to Alt/Az

(LAT=latitude, HA = hour angle, expressed in degrees)

$$HA = ((LocalHour + LocalMin\ /\ 60) - (RAHour + RAMinute\ /\ 60))\ \cdot\ 15$$

$$ALT = arcsin(sin\ (DEC)\ \cdot\ sin(LAT)\ + cos(DEC)\ \cdot\ cos(LAT)\ \cdot\ cos(HA))$$

$$AZ = arccos\ \frac{(sin(DEC) - sin(LAT)\ \cdot\ sin(ALT))}{cos(LAT)\ \cdot\ cos(ALT)}$$

When computing the Azimuth, a correction has to be made around the full circle:
If sin(HA) is negative, then AZ = A, otherwise AZ = 360 - A

Messier Objects – Suitable for Imaging from London Latitudes (~50°)

The first edition included a table of Messier objects above the imaging horizon (30° altitude or more at a London latitude) along with the month in which they first attain this altitude at dusk and the likely imaging time-span before each sets below 30°. Charles Bracken has since published *The Astrophotography Sky Atlas*, created specifically with imaging in mind. In this book he has taken this concept, born from the same initial thoughts of an aide memoir, and compiled extensive catalogs and sky charts, in a similar chronological arrangement. Many worthwhile objects are excluded from normal sky atlases, as they are too dim to observe visually. With extended exposures, however, these jewels become apparent. This book not only includes the common Messier objects but extensively maps out the Sharpless, RCW, van den Bergh, Abel and Hickson objects of imaging merit. It also provides seasonal imaging targets for other latitudes. As such, it is an excellent planning companion, especially to seek out less well-known objects or those with indistinct boundaries and I serve the reader better by making them aware of this book, rather than to reproduce a latitude-specific Messier table, confined to a few pages.

Imaging Record and Equipment Templates

Rather than break the back of this book by laying it flat to photocopy printed templates, the book's support website has downloadable spreadsheets. These include templates to record imaging sessions and documenting essential data for a particular equipment configuration (which is often required by the imaging software for a quick and repeatable setup).

I keep an A5 logbook to record the settings for each imaging event. The record sheet is a digital alternative, that can also work as an A5 printout for reference. It is not the last word by any means and serves as a starting point for further adds and deletes. In both cases, the values in green cells are automatically calculated from other data and the sheet is customized by changing the data in the yellow cells. They were generated with Apple's Numbers application for more universal appeal on PC, Mac and portable devices. (Anyone with an iCloud account can also view and edit these files using a browser.)

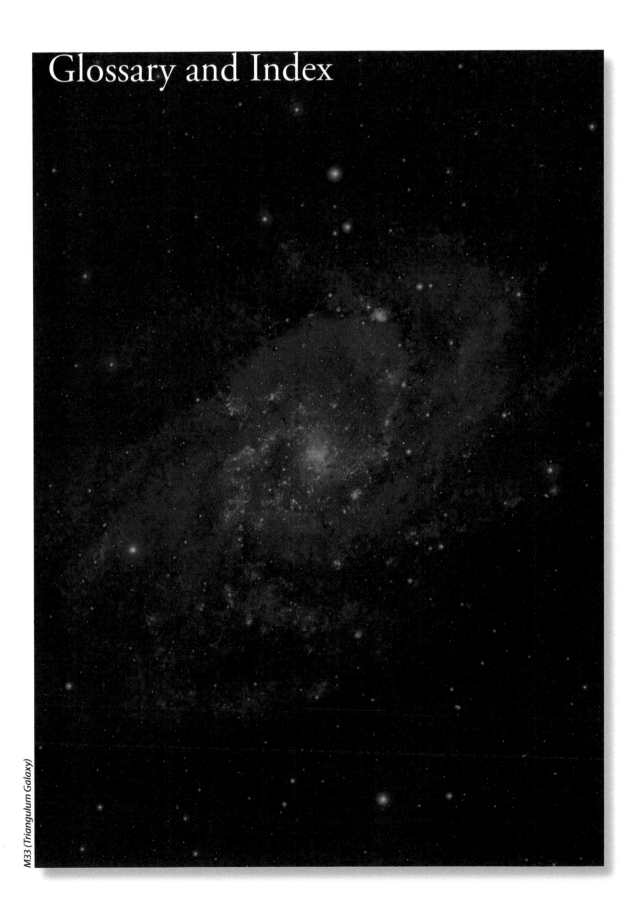

Glossary and Index

M33 (Triangulum Galaxy)

Glossary

A selection of common terms and acronyms.

This is not an exhaustive glossary but a selection of terms that may not have had extensive explanation in the main text.

AAVSO: American association of variable star observers.

Achromat: A refractor made of objective lenses of different materials to bring two colors of light to almost the same focal point.

Adobe RGB (1998): A popular color space (profile) for photographers and image editing.

ADU: Refers to Analog to Digital Units, the digital pixel values from a CCD.

Afocal Projection: In astrophotographic terms a telescope, complete with eyepiece, is coupled to a camera (with its lens) to image onto the sensor. The camera lens is in effect replacing the human eye in a visual setup. The term "digiscoping" is a form of afocal photography.

Aggressiveness: In autoguiding, the aggressiveness setting sets the proportion of the tracking error that is removed by the next guiding command.

Apochromat: A refractor made of several objective lenses of different dispersion characteristics that minimizes spherical and chromatic aberration.

ASCOM: A non-profit initiative to create an open source standard for interfacing astronomy software, and hardware, on the Windows platform.

Astigmatism: This is an optical defect that renders stars as ovals. More common with eyes than optics!

Asterism: This describes a convenient pattern of stars, often as part of a constellation. An example is "The Plough".

Astrometry: This is the measurement of a star's position and motion in relation to catalog databases.

Bahtinov Mask: A focus aid that looks like a drain cover, which, when placed over the front of a telescope, creates 3 diffraction spikes that intersect when the system is in focus.

Bias Current: This is sensor noise that occurs with every exposure irrespective of temperature or duration. It also sets the dynamic range of the sensor and its effect can any be reduced by combining techniques.

Blooming: The unsightly effect of a CCD well becoming overexposed and the excess electrons leaking into adjacent photosites. Some CCDs have electronics to reduce this effect.

C-Mount: A thread standard often used on cine lenses but also used on small CCD cameras: 1-inch diameter, 32 threads per inch and with a flange distance of 17.5 mm.

Centroid: The position of a star's center. Used during autoguiding and astrometry.

Chromatic Aberration: In glass optics, the optical elements refract light to different degrees, depending on its wavelength. The aberration arises as the different color components of white light do not focus at the same point.

Clipping Mask: In Photoshop, a clipping mask associates an adjustment layer to the layer below.

Collimation: This describes the alignment of optical elements, often in context to mirror systems, which are sensitive to mechanical stresses.

Convolution: In an astronomy sense, the smearing effect of the optical system on the signal.

Cosmic Rays: These are random high energy particles from space. They trigger electrons in a CCD detector and leave small white streaks. They are normally processed out during image calibration.

Dark Current: This is the ongoing thermally induced accumulation of non-image electrons, the number of which increase with exposure time and temperature. There is a mean and a random value; the latter can only be reduced by averaging many images.

Deconvolution: A process that models and corrects for the smearing effect of an optical system on a perfect point light source.

Diagonal: A mirror or prism that deflects the light path to enable more convenient viewing. Often fitted into the back of a focuser on a refractor or SCT.

Dither: A deliberate random image shift, executed between exposures, typically up to 1 pixel. Some references assume several pixels in cases where hot pixels are not removed by calibration frames.

Drizzle: A technique for statistically combining multiple images, typically under-sampled, to increase resolution. It requires several images that are deliberately misaligned by sub-pixel amounts. (See Dither above.)

Dovetail: A metal rail with angled edges that clamps onto a telescope mount. Popular standards are Vixen (~43 mm flange) and Losmandy (~75 mm flange).

ED (Extra-low Dispersion): Refers to glass in an optical system with little false color.

Half Flux Density (HFD): Often used by autofocus algorithms. The pixel diameter of a star within which half the energy or flux occurs. Similar to Full Width Half Max (FWHM) measurement but more robust in poor seeing conditions.

Field Rotation: If a mount is not accurately polar aligned, during a long exposure, stars will appear to rotate around the guide star.

G2V: Refers to a star of a particular spectral type and used for color calibration. Our Sun is a G2V star.

Gamma: Is a non-linear transform applied in imaging systems using a simple power-law expression. Some color spaces, such as sRGB and Adobe RGB(1998) are based on gamma 2.2. A linear image has a gamma of 1.0.

German Equatorial Mount (GEM): Most commonly used for imaging, especially with Newtonian and refractor designs.

GSC Catalog: The guide star used for control and alignment of the Hubble Space Telescope and our own more humble mounts on terra firma.

Hartmann Mask: A focus aid, comprising a mask with 2 or 3 circular apertures, placed over the front of the telescope. These align at focus.

Liveview: A mode on (typically) digital cameras that streams a live image from the sensor, facilitating focus and framing.

Meridian Transit: When an object crosses the meridian at its highest point.

Mirror Flop: Some SCTs have a moving mirror. The heavy mirror will tilt within the mechanism in different orientations.

NOVAS: Naval Observatory Vector Astrometry Subroutines. A software library of astrometry related computations.

Nyquist Sampling Theorem: In an astronomy sense it is applied to spatial resolution and that the resolution of the sensor should be at least twice the resolution of the optics.

Over-sampled: When the sampling frequency or sensor resolution exceeds that to detect the signal frequency or resolution.

Parfocal: Refers to different optical elements have the same effect on focus position. Applies to filters and eyepieces.

Periodic Error Correction (PEC): Software based system that measures and corrects for worm-gear tolerance issues, in real time, using a look up table (LUT). The LUT may reside in the mount or computer software.

Peltier: A semiconductor that exhibits a thermoelectric effect. A heat difference between surfaces generates a voltage and likewise an applied voltage generates a heat difference. When sandwiched between a sensor and a heatsink, the practical upshot is that it transfers thermal energy from the sensor to the heat-sink.

Petzval Field Curvature: Describes the optical aberration where a flat object is imaged onto a curved plane. The term Petzval lens design is also sometimes associated with telescope field-flattener designs to describe their correcting effect.

Photometry: The measurement of the apparent magnitudes of an object, in this case, mostly stars.

Pixel: An ambiguous term that refers to the sensor's light sensitive cells (photosites) as well as to composite RGB picture elements in an image or the elements of an image.

Plate-solve: The process of calculating an image's position by matching the star pattern with a catalog database.

Prime Focus: This is the typical system used in astrophotography. The eyepiece is removed from a telescope and the main objective focuses directly onto a sensor in a bare camera body.

Point Spreading Function (PSF): Describes the effect of an imaging system on a point light source. Used in the devolution process to model the opposing function.

Pulseguide: An autoguiding system that uses software rather than hardware to control the mount. Often combined intelligently with PEC. Software Bisque have something similar called Directguide for Paramounts.

Pulse Width Modulation (PWM): Power is applied on and off to regulate the average amount, typically for a dew heater system. The ratio determines the power. The frequency is usually low at 1 Hz but if using motor control modules, it may be 10 KHz.

Off Axis Guider (OAG): A small mirror, normally before the filter wheel, deflects peripheral light to a guide camera, set at 90 degrees to the optical path.

One-Shot Color (OSC): A term used for conventional digital cameras or CCDs fitted with a Bayer color array and produce a color image with a single exposure.

OTA: Optical Tube Assembly. Some telescopes are sold as systems with mounts and tripods. An OTA is just the optical telescope component.

Quantum Efficiency (QE): An expression of the efficiency of incident photon conversion into electrons in a CCD sensor.

Residuals: Refers to the error between the observed and predicted position of a body. Often used to indicate quality of a plate-solve calculation.

RJ45: 8-way connector system used for LAN / Ethernet communications. Simple robust locking connector system also used in 6-way (RJ12) and 4-way (RJ10) for serial communications, autoguider ST4 and focuser systems.

sRGB: A color space (profile) that is used extensively for consumer imaging devices and Internet use.

ST4: The name given to an early SBIG autoguiding system and now adopted to mean the "standard" interface for autoguiding inputs into a mount, based on opto-isolated switch closures.

Strehl ratio: A measure of the optical perfection of a system. A ratio of 0.85 is 85% as good as a perfect system.

T-Mount: Sometimes also called T2 thread, this a M42x0.75 metric thread for optical systems, designed for a 55-mm flange spacing (thread to sensor or film). T-thread adapters for various cameras, are deliberately sized to maintain this 55-mm flange spacing to the camera's sensor.

Transparency: Not to be confused with atmospheric turbulence or seeing, this is the clarity of the air and the absence of mist, dust and pollution.

TSX: Shorthand for Software Bisque's TheSkyX planetarium and astrophotography program.

Under-sampled: A sample frequency or spatial resolution that is insufficient to detect the full details in the system signal or image.

USNO: US Naval Observatory. Also a resource for astrometry data and star catalogs, used in addition to the GSC catalog for plate solving.

Index

Where possible, index entries are grouped logically and indicate primary references.